Praise For

BOOM

"In *Boom*, Michael Shnayerson masterfully traces the blaze-like contemporary art market back to what now seem like unassuming origins. He tells how, somewhere along the way, dealers persuaded the rest of the art world that what they were looking at was not as important as why they were looking at it. And the why, as it turns out, was money."

—Graydon Carter, former editor of *Vanity Fair*
and founder of *Air Mail* newsletter

"How did the art world—the rarefied, decorous realm of a few hundred in the 1960s—become the art market? Michael Shnayerson penetrates the mysterious conclave of taste, style and money in this sparkling, high-octane account. It's all here and beautifully bound together, from Lucien Freud's gambling debts to the AIDS epidemic to private museums to the magical question of whether the artist makes the dealer or the dealer the artist."

—Stacy Schiff, author of *Cleopatra: A Life* and
The Witches: Salem, 1692

"The high end of the contemporary art market is driven by branding, backstories, mega dealers, art fairs, art investment funds, and occasionally, a hugely talented artist. Most important, it is driven by people. Michael Shnayerson has done the best job I know in pulling all these together. Think of the book as a 400-page *Vanity Fair* article (where he is a longtime contributing editor). I offer that comparison as a compliment to its style and depth of detail.

He has captured profiles of the mega-dealers: Gagosian, Zwirner, Wirth, and the Glimchers; the billionaire collectors; and the lawsuits,

with background and astute observations. My own books on the contemporary art market would have been much improved had this come earlier. A great read."

—Don Thompson, author of *The $12 Million Stuffed Shark: The Curious Economics of Contemporary Art* and *The Orange Balloon Dog: Bubbles, Turmoil and Avarice in the Contemporary Art Market*

"Part *Painted Bird*, part *Off the Wall*, and part *Duveen*, Michael Shnayerson's *Boom* deftly captures the extraordinary dynamics at work in the contemporary art market by focusing on the global mega dealers and their constantly evolving stable of artists, many of whom together have become fabulously rich beyond their wildest dreams. In Shnayerson's confident hands, the story of their successes is riveting, informative, and often hard to fathom."

—William Cohan, author of *House of Cards: A Tale of Hubris and Wretched Excess on Wall Street*

"The book is a pleasure to read, lively, smart, and wonderfully informative, full of the big personalities, genius, passion, and skullduggery of the contemporary art world."

—Roxana Robinson, author of *Georgia O'Keeffe: A Life*

"Focusing on personalities as much as business development, Shnayerson's writing is conversational and accessible, even for those without deep art knowledge. Fast-paced and eye-opening, this is a wildly entertaining business history." —*Publishers Weekly*

"The narrative is packed with scrumptious anecdotes and revealing portraits of key players and artists.... In this rich, superbly nuanced history, Shnayerson fully demonstrates that he has his finger on the financial pulse of modern art." —*Kirkus*, starred review

BOOM

BOOM

Mad Money, Mega Dealers, and the Rise of Contemporary Art

MICHAEL SHNAYERSON

PUBLICAFFAIRS
New York

PublicAffairs
Hachette Book Group
1290 Avenue of the Americas, New York, NY 10104
www.publicaffairsbooks.com
@Public_Affairs

Printed in the United States of America

First Edition: May 2019

Published by PublicAffairs, an imprint of Perseus Books, LLC, a subsidiary of Hachette Book Group, Inc. The PublicAffairs name and logo is a trademark of the Hachette Book Group.

The Hachette Speakers Bureau provides a wide range of authors for speaking events. To find out more, go to www.hachettespeakersbureau.com or call (866) 376-6591.

The publisher is not responsible for websites (or their content) that are not owned by the publisher.

The Library of Congress has cataloged the hardcover edition as follows:
Names: Shnayerson, Michael, author.
Title: Boom : mad money, mega dealers, and the rise of contemporary art / Michael Shnayerson.
Description: First edition. | New York : PublicAffairs, 2019. | Includes bibliographical references and index.
Identifiers: LCCN 2018044679 (print) | LCCN 2018046063 (ebook) | ISBN 9781610398411 (ebook) | ISBN 9781610398404 (hardcover)
Subjects: LCSH: Art—Economic aspects—History—21st century. | Art—Marketing—History—21st century. | Art and society—History—21st century.
Classification: LCC N8600 (ebook) | LCC N8600 .S54 2019 (print) | DDC 701/.03—dc23
LC record available at https://lccn.loc.gov/2018044679

ISBNs: 978-1-61039-840-4 (hardcover), 978-1-61039-841-1 (ebook)

LSC-C

10 9 8 7 6 5 4 3 2 1

To Gayfryd

CONTENTS

Contemporary art is a hard subject to get your arms around these days. Artists rise and sometimes fall in a few years; some do work that is clearly gorgeous, others make off-putting, head-scratching, shocking, or even viscerally appalling work. There are many books, magazines, journals, and blogs that debate the relative merits of contemporary artists and the lasting value of their work. That is not the purpose of this book: I have happily yielded that task to the curators and critics.

In the pages that follow, I have looked, instead, for the story of how the market for contemporary art evolved from rather modest and uncertain beginnings in the 1940s to become a wildly unpredictable financial roller coaster in the present, with global reach, capable of making and moving vast fortunes, and with the lightest regulatory touch of any financial market in the world. Perhaps inevitably such an environment has attracted a vivid cast of characters, some with aristocratic fortunes behind them, others utterly self-made. It mixes European hauteur with American moxie. It's a space where women have had, if not quite an absolutely equal footing to the men, then a crucial role in the lives and careers of some artists—and have been innovators and trailblazers to a degree unseen in any other comparable business environment. Perhaps Peggy Guggenheim's presence at the creation of the contemporary art story ensured it would never be an all-boys-club story.

My hope is that readers will enjoy the book not only for the glimpses of some of the most memorable works of the last half-century but for the stories of the men and women who toiled over them, sponsored

them, talked them up, and in some cases even bid them up. John Kasmin, a leading dealer for decades, once sized up his role with a bit of cheek. "All artists do is produce the work, the dealer has to create its allure," he declared. And then added, "Rather a silly remark, but it's not completely untrue."

Indeed it's not.

The Kings and Their Court

2017

AT 6 P.M. ON A WARM JUNE SUNDAY evening in Basel, Switzerland, the terrace of the Grand Hotel Les Trois Rois, overlooking the Rhine River, seemed as quiet and pristine as the city itself: a study in Swissness.[1] In two days, Art Basel, the annual bellwether fair for the business of modern and contemporary art, would begin, drawing the world's best-known dealers and collectors into a whirl of six-, seven-, and even a few eight-figure sales of works by artists alive and dead. But on the terrace that served as the elite social hub of the fair, there was, so far, no hint of the crowds to come.

As the terrace slowly filled, half a dozen new arrivals slid down either side of a refectory table. The host of this group sat with his back to most of the hotel's other guests, but there was no mistaking him, with his head of short-cropped silvery hair and commanding presence. Larry Gagosian, the world's most powerful art dealer, had arrived.

There was a time when Gagosian did not come to Art Basel. He shunned crowds when he could. Notoriously aggressive in business, he preferred not to mingle if he could help it. But he had "warmed" to the fair, as he put it, and now was a fixture.

Gagosian was among close friends that evening. Across from him was Dasha Zhukova, the soon-to-be ex-wife of Russian oligarch Roman Abramovich. Zhukova was an art world celebrity in her own right, both as a collector and as the founder of Moscow's Garage Museum of Contemporary Art.[2] Here, too, were Alberto "Tico" Mugrabi and his brother David, both second-generation collector/dealers. Their father, Yosef "Jose" Mugrabi, a Colombian textile importer of Syrian Jewish descent,

| 1

had come to Art Basel in 1987 on a lark and had an epiphany. Despite knowing nothing about the painter, the elder Mugrabi paid $144,000 for four Andy Warhol panels depicting Leonardo da Vinci's *Last Supper*, just months after Warhol's death. Soon enough, they began rising in value.

The lesson Mugrabi took from this acquisition was not to become an art collector. It was to buy every Warhol of quality he could. As the family's art holdings grew, he seemed to delight in bidding up Warhols at auction to increase their market value. Why not? The more expensive each newly acquired Warhol was, the more valuable many of the Mugrabis' other Warhols might become.

As of this moment in June 2017, Jose Mugrabi and his sons reputedly owned more than 800 Warhols. Proudly, they called themselves "market makers." Their buying and selling activities did affect the Warhol market, helping make him one of the best-selling artists in the world. Theirs was a business in which millionaires and billionaires bought up the works of top artists, stored them in vast, temperature-controlled warehouses within so-called free ports, and then, if they liked, sold them tax-free to other collectors—tax-free as long as the art stayed in the free port's protective cocoon.

The art to be sold at Art Basel in 48 hours' time was mostly, though not all, contemporary, which was to say it had been made by artists who had started their careers after World War II—as opposed to modern art, created by artists who had started before the war. The nomenclature could get a little tricky: Picasso was a modern artist even though he had painted until his death in 1973. The deciding factor was the start date for his career, decades before World War II.

As time passed, the best works by the most celebrated modern artists grew ever scarcer and more expensive, as did those by top postwar artists. As the ranks of wealthy collectors grew, so did demand for even the latest contemporary artists. No one played to that yen to acquire better than Larry Gagosian, whose roster of artists included more giants of both modern and contemporary art than any other dealer.

Gagosian had flown to Basel on his $60 million Bombardier Global Express jet two days before the fair's first-choice VIP preview. He liked

checking in early at Les Trois Rois; he felt it gave him a head start. Space at the hotel was so tight that Gagosian's entourage had to sleep elsewhere: only the king got a room at the Three Kings.

Most other dealers would arrive on Monday, a day before the fair's coveted VIP opening. A few, like silver-haired blue-chip dealer Bill Acquavella, would arrive in their own planes. Others would descend at Basel's EuroAirport in NetJets filled with collectors and money, like an art world air force. Many dealers had sent images of works from their fair inventories to clients, and many of those works had been put on reserve.

Some 35 years before, Gagosian had earned scorn in SoHo for showing photographs or transparencies of paintings that weren't always his to sell. There wasn't anything illegal about that, nor was he the first to do it. Gagosian was just drumming up interest in a painting he'd seen somewhere, perhaps on someone's living-room wall. Today, images flew across the Internet from dealers to collectors, to say nothing of the advisors, assistants, and everyone in between in the art world food chain.

FROM HIS TABLE ON THE TERRACE, Gagosian occasionally looked out over the Rhine to the river's far bank. His profile was a bit rounder than it once was, though set on the still-broad shoulders of a former athlete. In the lingering heat, swimmers jumped from a dock into the Rhine's fast-moving current, bobbed downriver a stretch, then clambered up onto the shore to jump again. At his public high school in Southern California, Gagosian had been a competitive swimmer—freestyle and backstroke were his strengths—and earned a serious ranking. Then, at the University of California, Los Angeles, he'd seen his position plummet; there were just too many strong swimmers at UCLA. For some years after graduating with a BA in English literature, he had drifted from one humdrum job to the next. And then, like Jose Mugrabi, he had an epiphany about art: in his case, that he could sell it.

Half an hour later, the terrace group stood to go. Gagosian—in a uniform of dark-blue linen and black, rubber-soled Loro Piana moccasins, the ne plus ultra of slip-ons—padded off with a panther-like gait into a waiting Mercedes. Ironically, he was now one of the few dealers

at Art Basel who didn't try to presell most of his art before the fair by sending out images. "I don't like that approach," he would say later. "I like to see the action."

Competition was always keen among the nearly 300 exhibitors coming to Art Basel. It was, perhaps, sharpest among the four mega dealers whose sales far outdid the others: David Zwirner of the Zwirner Gallery, Iwan Wirth of Hauser & Wirth, Arne Glimcher and his son Marc of Pace Gallery, and Gagosian. These were galleries with annual sales in the hundreds of millions of dollars. Gagosian was reputed to gross the most: roughly $1 billion a year. The others were said to be closer to $250 million each, but claimed to do better—far better—than that. Arne and Marc Glimcher purported in 2017 to be on their way to their best year ever. When it ended, they would say they had broken the $1 billion threshold and outperformed Gagosian himself. Who knew? All four mega dealers' galleries were private, their profit reports tightly held.

For an hour or so before the doors opened on Tuesday morning, the VIP fairgoers milled in the round, open-air center of Basel's Messeplatz, drinking champagne and greeting old friends. Almost every woman carried a high-end designer bag; almost every man sported a loose linen jacket or suit, sans tie. Despite the hugs and air kisses, a sense of urgency— and competition—pulsed just below the surface. These weren't merely VIPs: they were the highest echelon of VIPs, as their timed entrance tags disclosed. No one rushed the doors when they opened at 11 a.m., but within three or four minutes, the attendees had all glided inside, headed for the booths of their favorite dealers. Many were famous in this rarefied world. Simon de Pury, former auction house co-owner and now private art advisor, tall and gaunt, a bit Uriah Heepish, slid by, customers in tow. Don and Mera Rubell, Miami-based collectors with their own museum, looked for bargains—a far harder challenge than when they'd started collecting in the mid-1960s. Here, too, was Amy Cappellazzo of Sotheby's, a dealer in her own right, also trailed by clients. Cappellazzo was a marvelous mix of charm and chutzpah. One story about her had her calling a young billionairess and telling her, tersely, to pack her bags for a flight to Paris that night: there was a painting the billionairess had

to see—and buy—right away, lest it be sold to another collector coming the next day. The billionairess jumped aboard and came home with the trophy painting in hand.

Supercharging this year's fair was the record-setting sale, a month before, of a Jean-Michel Basquiat painting for $110.05 million. It was the highest price ever paid for an American artist, displacing the record for Andy Warhol's *Silver Car Crash (Double Disaster)*, which sold for $105.4 million in 2013. The buyer of the Basquiat, Yusaku Maezawa, a Japanese e-commerce billionaire, had spent $98 million on art in two days the year before, including another Basquiat that sold for just under $57.3 million. In Basquiat's short-lived career in the 1980s, he had sold paintings for as little as $1,000. In all, eight Basquiats were for sale at Basel, with a cumulative value—in asking prices—of $89 million. This was clearly the Basel of Basquiat.[3]

Gagosian had brought no Basquiats to this year's fair—not the right "mix," as he later vaguely put it. But he did have works by many of his other stars, including one of Ed Ruscha's word works, a Warhol from the *Camouflage* series, and a Jeff Koons *Titi*—a sort of Tweety Bird that looks like a plastic inflatable toy but is in fact made of mirror-polished stainless steel.

The crowd stopper was a life-size double sculpture by Urs Fischer of legendary Swiss art dealer Bruno Bischofberger and his wife, Yoyo, fully clothed and seated, in psychedelically hued wax. Essentially, *Bruno and Yoyo* was a big candle. Fischer, 44, was a top Swiss artist, and Gagosian felt confident putting a $950,000 price tag on the piece. Whoever bought it would, presumably, light its wicks at some point, then settle back to watch the wax drip, a poignant testament to the passage of time. Replacements for the candle were available, at $50,000 each.

For the first few moments, buyers seemed hesitant to enter Gagosian's booth, and the man himself stood apart with a scowl that seemed meant to repel the less than serious. One passerby asked him if he was feeling optimistic. "Ask me in an hour," he said gruffly.

At a nearby booth, David Zwirner had adopted a more genial tone. Tall and rangy and given to casual shirts and jeans, German-born

Zwirner struck one former Gagosian director as "Larry with a smile." How else was Zwirner different? "Not really different," the former director suggested. "Same ambition, same ruthlessness, same commitment to quality, similarly good tastes, but slightly more rigid." Despite the scores of times the two megas had found themselves under the same roof, they had never broken bread, as Zwirner put it. One of the first works in Zwirner's booth that sold that day was a 1954 burlap collage by Alberto Burri, a mid-20th-century Italian artist who had discovered his calling in a Texas prisoner-of-war camp. It reportedly went for more than $10 million. By noon, Zwirner was in a very good mood.

Iwan Wirth, at 47 the youngest of the mega dealers, had the rumpled look of a student, his light brown hair unkempt, his metal-rimmed spectacles slipping down his nose, and an easy grin at the ready. He was possibly the wealthiest of the mega dealers, thanks not just to his global art business, but to his mother-in-law, Ursula Hauser, the heiress to an electronics retail chain who had started Hauser & Wirth with him in 1992.[4] Wirth looked positively giddy. Almost as soon as the fair opened, his team had sold a 1970 Philip Guston painting called *Scared Stiff*. Guston had had a dramatic career, pivoting from Abstract Expressionism in the early 1950s to scenes of cartoonish figures in a palette dominated by reds and pinks. The painting had sold in the neighborhood of $15 million.[5]

Arne Glimcher, at 79 the oldest of the mega dealers, had sent his son Marc in his stead. Glimcher was a legend, still as excited about art as when he'd started half a century ago but disenchanted by what the market had become. "This market has nothing to do with art," he declared from his private office in New York. "Art has become a hedge, and I don't like it. I'm glad I'm at this stage of my career. I think many dealers are ignorant of history; it's all about how fast one can make money."

Marc Glimcher, in his early fifties, was far more upbeat and relaxed. Pace did less of its big business here at Basel than the other mega galleries did. Its strong suit was masterworks: the Calders and the Rothkos, as Marc Glimcher put it. To sell those, he spent a lot of time on planes, paying visits to private collectors. The trick with masterworks was to keep the best of them for decades, letting the market rise and rise. At

Art Basel, Pace was showing artists who were mostly contemporary and less expensive—Adam Pendleton, for one, Kiki Smith, for another—for an audience that seemed as motivated by the hope of a profitable resale as by the art itself. The younger Glimcher found it all quite entertaining. "When did so many people start caring about contemporary art?"[6]

BY MIDDAY, GAGOSIAN HAD SOLD A four-foot-high 1986 abstract by Gerhard Richter, one of the best-selling living painters in the world, for $4.5 million. Gagosian had also sold not just the Urs Fischer double-candle sculpture he had started the day with, but two more identical copies. The second went as easily as the first. The third one Fischer had intended to keep for himself, but Gagosian had gotten on the phone and talked him into letting it go. How often, really, would Fischer be able to sell three candle sculptures for $2.85 million?

When VIPers tired of gazing at art, there were private cars available to take them to tours of artists' studios and collectors' homes. That night and the next, major dealers held exclusive receptions and dinners for their own VIPs, including collectors, curators, and advisors. An invitation to Hauser & Wirth's dinner, in the baronial banquet room of Les Trois Rois, was one of the most sought after. Half a dozen long tables, each seating as many as 50 guests, were filled with the gallery's extended network. The mood was celebratory, as news of the day's big sales spread up and down the tables. Finally, Iwan Wirth, pink cheeked and boyish, stood up to address the throng.

"This is our twenty-fifth year as a gallery, the twenty-fifth year of our Basel dinner, and I've been married for twenty years," Wirth said to cheers. Then he offered a quote from Klimt: "'Art is a line around your thoughts.' I would add to that that art is a way of bringing people together. And I think contemporary art is like a love story: it starts with passion."[7]

For many guests in that banquet hall, Wirth's sentiment rang true. Art—for these dealers and the art world denizens around them—had begun as a passionate adventure, and remained so. They weren't all millionaires and billionaires, and not all bought art intending to sell it for a profit. Still, over the last two decades, a whole new generation of

great global wealth had also fallen for contemporary art. Some deal-
ers and collectors had taken their chances with obscure or emerging
artists, as the best collectors have always done. Most had focused on
the pantheon of 100 or so brand-name artists who dominated the con-
temporary market, the ones whose value seemed likeliest to rise. The
dealers might love the art they bought and sold, but if they chose right,
their purchases could be very profitable indeed. Together with the col-
lectors whose patronage they curried, they went from fair to fair, a
traveling caravan of the art cognoscenti. "Art has become the status
symbol," noted dealer Gavin Brown, "the lingua franca of the super
wealthy." It had become an international currency too.

Gagosian by now had checked out of his suite upstairs and boarded
his plane. "Typically at most fairs, most business is done in the first
day," he explained later. "What was interesting about this fair was that
we did the last two days well." He had left at the end of the second day,
but his staff had stayed on for the third. "I felt confident—maybe not
bullish," he said. "There's a whole other level of collectors, we may not
even know them that well, but they're shopping for art."

THIS BOOK TELLS THE STORY OF how a coterie of dealers made a global
market for contemporary art—made it what it is today. It begins in the
aftermath of World War II, with the rise of Abstract Expressionism—a
New York story. It opens with Betty Parsons and Sidney Janis, the two
dealers who took on most of the artists of the 1950s known as the
New York School, and shared a floor on East 57th Street until their
bitter falling-out. It leads to their unlikely supplantation by a Euro-
pean émigré who waited until almost the age of 50 to set up a gallery
of his own in his father-in-law's town house on East 77th Street. With
luck, exquisite timing, and, not least, his wife's great eye, Leo Castelli
became the dealer of the two great artists who led the way from Ab Ex
to what came next—Jasper Johns and Robert Rauschenberg—and of
the 1960s Pop artists who followed: Roy Lichtenstein, James Rosen-
quist, Claes Oldenburg, and Andy Warhol, among others. Castelli sup-
ported these artists, emotionally and financially, and for more than

three decades remained the preeminent dealer of his day. He was also the first contemporary art dealer to create an international network of satellite dealers, all helping each other sell art.

The sixties and seventies included many fascinating dealers who made their marks on contemporary art as it expanded to Minimalism, Conceptualism, Neo-Expressionism, and more. Arne Glimcher opened his New York gallery on 57th street in 1963; there he remains, though he has moved his flagship all the way from West 57th to East 57th. Paula Cooper, the first woman dealer to open a gallery in SoHo, in 1968, is still very much in business too. Cooper is now generally regarded as Castelli's equal, if not his superior—an early and committed champion of Minimalism and Conceptualism who did at least as much as Castelli to support and shape the contemporary art of the next five decades.

It was in 1979, as New York City pulled out of a great recession, that a restless, driven Californian with little knowledge of art but a hunger to learn and make deals, Larry Gagosian, arrived to check out the bur-geoning New York art scene. A whole new generation of wealth was as eager as he was to see what contemporary art was all about. It would be overstating the case to say that dealers like Gagosian changed the business in order to corner this new market. Truer to say that they were enabled by the start of a great Wall Street bull market, the Reagan tax cuts, and a whole new financial culture of mergers and acquisitions, and happily rode that wave. These dealers made the careers of individual artists, of course, and those artists affected the course of contemporary art. But dealers also took advantage of new technology and started up the fairs that drastically changed the market, for better and perhaps worse. And some, like Gago-sian, did all that more cannily than others.

Self-taught about art, Gagosian brings to the story a deep, instinc-tive business sense. From the start, he represented both buyers and sell-ers in the secondary market, the selling of art after its initial or primary sale. He understood leverage and arbitrage. Gagosian learned from his mentor, Castelli, how to sell through far-flung venues—splitting the spoils to move more art—and took it to a whole new level, building brick-and-mortar galleries around the globe, 16 and counting.

Gagosian and Castelli's relationship had advantages for both dealers but was underscored by great and enduring personal affection. Throughout most of the 1980s, the third dominant player in the New York art world was Mary Boone, who competed with Gagosian for Castelli's blessing and, like her rival, demonstrated a gift for propelling the careers of era-defining artists.

The eighties art market ended with a terrifying crash, more sudden and severe than that of the seventies. Yet when the shock wore off, a next generation of dealers jumped in, drawn by cheap rents and a passion for bold new art. German-born David Zwirner was one, Swiss-born Iwan Wirth another. Eventually, along with Gagosian and Arne Glimcher, they became four mighty rivals. A whole generation of other influential galleries emerged in the nineties and early aughts too: Lisa Spellman, Gavin Brown, Andrea Rosen, Marianne Boesky, Matthew Marks, Jeffrey Deitch, and more. Still, the mega dealers came to dominate the market, with Gagosian's model of global gallery spaces inspiring the rest to build distant galleries as well.

The voices of all four mega dealers are in this book, along with many others whose stories have affected the contemporary art market. Together, they evoke a fascinating period, based in New York, when the market grew from a few passionate collectors to a $63 billion global bazaar.

In a sense, that $63 billion figure is misleading, since it includes all kinds of art bought and sold, from Greco-Roman to Gerhard Richter. About half that sum involves contemporary art, and roughly one third of that flows through the auction houses, while two-thirds goes through private dealers and galleries. What this suggests is that dealers are more powerful than their auction house counterparts. Moreover, they have the clout to promote an artist over a period of years and orchestrate his or her success. The $100 million painting an auction house sells is here today, gone tomorrow; the house has no roster of artists. In fact, the undisclosed seller or buyer of that $100 million painting is often a dealer, perhaps on behalf of a client, perhaps for himself, boosting that artist's market value for his own gain.

IF THE PAST FEW DECADES ARE any indication, the vast majority of contemporary artists, even those lauded today, will be forgotten. A few, however, will endure. The maddening conundrum is which few. The highest-selling ones in the market today? Gerhard Richter? Jeff Koons? Damien Hirst? Christopher Wool? Peter Doig? Or artists barely out of art school, still unknown? Which dealers will have picked the winners? And which will have failed to weather the vagaries of the market?

As of May 2019, the market outlook is, as Gagosian says, broadening: more buyers, more places to buy. But that is not to say all is sanguine in the sanctums of contemporary art.

Many small and midsize galleries—the incubators for new art—are struggling to survive, buffeted by the mega dealers as well as the Internet. The mega dealers are under pressure, too, much of it self-inflicted: most have built, or are building, vast new multistory flagship galleries at enormous cost. At the same time, some of the best-known artists are calling their own shots, playing the mega dealers against each other. Omnipotent as they seem now, the mega dealers may be under siege too. Partly that's the market, partly the passage of time: galleries almost always express their founders' spirit, and that spirit is rarely passed on. Three of the mega dealers have grown children either stepping into their fathers' shoes or possibly planning to do so. But the fit is by no means assured. The fourth mega dealer—Gagosian—has no heirs, and so the gallery he built himself, the world's most powerful, has no successor in place, a weakness his rivals have noted.

THE MOST POSITIVE SIGN FOR CONTEMPORARY art may be that over the last 150 years the selling of art has changed less than one might think. How different from the mega dealers were their 19th- and early 20th-century European counterparts? Paul Durand-Ruel sold new and challenging art from the 1870s on. Ambroise Vollard, a generation later, and Daniel-Henry Kahnweiler, a generation after that, took new and emerging artists too. They built them up over time, with patience, passion, fortitude, and cunning, the same skills dealers use today.

The novelty, by the late 19th century, was in who bought the paintings those dealers purveyed. Patrons were part of the past. The newly rich bought paintings to show their mercantile status. The artists whose works they displayed became famous. Their dealers became gatekeepers, managing who should have the privilege of buying a master's next work. The dealer was, as much as his artists, a brand. The collector bought the brand—acquiring, in the process, the greatest possible chance that his artwork's value would appreciate both canonically and commercially. Ultimately, the collector might buy the dealer's brand more readily than the artist's.

Of those celebrated dealers, the one whose story is most germane to this one is Joseph Duveen's. Like Gagosian, the future Baron Duveen of Millbank inveigled his way into the grand homes of new American industrialists, getting them to buy Old Masters at prices that made them gulp. "Europe has a great deal of art, and America has a great deal of money," was his best-known aphorism. Another was "When you pay high for the priceless, you're getting it cheap." Gagosian has admitted Duveen is a role model for him. One guest saw four copies of the S. N. Behrman biography of Duveen on a shelf at Gagosian's home. Another guest, presented with a copy by his host, blurted out, "Have you read it?" The dealer's face blackened. "I wouldn't give you a book unless I read it myself!"

Duveen died in 1939. That same year, heiress and art collector Peggy Guggenheim began buying a painting a day in Paris from artists alarmed by the looming Nazi threat. A year later, with the Nazis approaching, she sent her new collection to the south of France and then, in the summer of 1941, to New York. A year later, she rented an exhibition space at 30 West 57th Street and called it the Art of This Century gallery. Three of its four rooms constituted a museum, where she exhibited Surrealist, Cubist, and Abstract art. The last of the rooms was a commercial gallery, where she showed, among others, a promising artist named Jackson Pollock.

And then, with the war over, she made the decision to go back to Europe, bringing most of her paintings with her. That was when she put in a call to a spirited dealer named Betty Parsons, to see if Parsons, who had just opened a 57th Street gallery of her own, could take on the rest.

MIRACLE ON 57TH STREET

1947–1979

Before Downtown

1947–1957

IN THE SPRING OF 1947, two of the New York art world's most elegant women met to decide the fate of painter Jackson Pollock.[1] Peggy Guggenheim, rich and mercurial, had opened her West 57th Street gallery after fleeing Europe with her artist husband, Max Ernst, via Lisbon in July 1941.[2] Now with her divorce from Ernst finalized, she was closing her Art of This Century gallery and returning to Europe.[3] The gallery had drawn lots of attention, and Guggenheim liked that. But she had grown bored sitting in the small gallery rooms day after day. She longed to return to Venice, and with the postwar peace secured, she could. One of her few remaining tangles was the delicate matter of Pollock's gallery fate.

Betty Parsons, the other woman, came from a once-wealthy New York family that had divided its time among Manhattan, Newport, Palm Beach, and Paris.[4] Her parents had been wiped out in the Depression, along with her ex-husband and his alimony. She had opened her own gallery in September 1946, half a block from Guggenheim's at 15 East 57th Street. Part of the $5,500 to finance it had come from a cadre of her former classmates from Miss Chapin's School who called themselves the Katinkas: blue-blood Parsons admirers whose husbands had managed to hang on to their money.[5]

With one exception—Pollock—Guggenheim's artists would simply move down 57th Street to the new Betty Parsons Gallery.[6] That was what they wanted, and Guggenheim was hardly about to dissuade them. "They chose me," Parsons later declared. "The artists wanted to

be in my gallery. Barney [Barnett Newman] came to me and said, 'We want to be in your gallery.' And I said, 'Well, that would be fine.'"[7] They would join artists already signed with Parsons—Ad Reinhardt, Hans Hofmann, Mark Rothko, and Clyfford Still—all leading lights of the new postwar art that would come to be called Abstract Expressionism.

Pollock was a Guggenheim artist, too, but he took careful handling. He was so poor that he'd had to work as a handyman to make ends meet—so poor that on one occasion, he had had to shoplift his art supplies.[8] That changed when Guggenheim signed a contract with Pollock in 1943. She subsidized him at $150 a month, a stipend later raised to $300. This wasn't charity: after she had doubled the stipend, Guggenheim repaid herself from the sales of Pollock's paintings, leaving him just one painting of his choice each year to keep or sell as he liked. New York's Museum of Modern Art had bought a Pollock, *The She-Wolf*, for $600; other museums and private collectors had begun to buy his work too. Still, a number of Pollock paintings remained unsold.

Parsons had mixed feelings about taking on Pollock. She could ill afford to pay the stipend, and Pollock, despite his uptick in sales, remained a dubious prospect. He was a wild man too. Parsons had seen him drunk at downtown parties, boastful and belligerent. And yet he intrigued her. "There was a vitality, an enormous physical presence," she mused later. Pollock's emotions welled up at alarming speed. "He made you feel sad; even when he was happy he made you feel like crying....You never quite knew whether he was going to kiss your hand or throw something at you."[9] Reluctantly, Parsons agreed to take him on and to pay Guggenheim a commission on her Pollock works if they sold. She drew the line at paying the stipend.

Guggenheim agreed. She may have had no choice: Parsons, according to critic Dore Ashton, was the only dealer in New York courageous enough to take Pollock.[10]

Guggenheim said she would keep paying the stipend if Parsons gave Pollock a one-man show in the near future.[11] Before she left for her canal-side villa in Venice, Guggenheim gave away 18 of her Pollocks—gifts she would come to regret.[12]

Sometime after the deal was struck, Parsons drove out with artist Barnett Newman, her closest male friend, to the East End of Long Island to stay the night with Pollock and his wife Lee Krasner.[13] Krasner's own abstract paintings hung along with her husband's in the small farmhouse the Pollocks had bought in the Springs as a refuge from New York, though pride of place, Parsons noticed, went to the Pollock paintings. As for Newman, he was still an almost indifferent artist. Not until the next year would he break through with a painting titled *Onement, I*: flat fields of color bisected by a vertical stripe he called a "zip."[14]

That afternoon, the four talked of Pollock's new work. He had just started spreading his canvases on the floor of his studio out back and pouring loops of paint across them, some from his brushes, others from cans, as if conducting music that only he could hear. Parsons was enthusiastic; she knew better than to give artists advice. Pollock would have his first show, they agreed, the next January. "I give them walls," Parsons liked to say of her artists. "They do the rest."[15]

After dinner, the Pollocks and their guests sat on the floor like children, drawing with Japanese pens.[16] Pollock pressed down so hard that he broke one pen after another. Still, his first drawings were delicate. Then he turned angry, and the drawings grew harsh. He hadn't yet stopped drinking for what would be a two-year period of sobriety. But if he was drinking hard that night, Parsons made no later mention of it. The next morning, he was fine, as if the black mood had never enveloped him.

Parson's first show with Pollock was a commercial disappointment. The paintings, in his new "drip" style, baffled the crowd. Despite prices as low as $150, only one of the 17 sold—Lee Krasner had arranged for Bill Davis, a former lover of Guggenheim's, to buy it.[17] Under the terms of Guggenheim's contract with Parsons, the proceeds went to Guggenheim.

Still, in those packed rooms, dense with cigarette smoke, stood pretty much the entire New York art world circa 1948: a few dozen serious but impecunious artists, who lived in cold-water, walk-up studios

downtown; perhaps eight dealers, mostly with galleries on 57th Street; and a few collectors, led by the Museum of Modern Art's first director, Alfred H. Barr Jr., and one of the most influential people in American modern art, the pioneering MoMA curator Dorothy Miller. They commented on the art, but also on the new gallery look that Parsons had established. Her bright white walls and waxed wood floors were a sharp rebuke to the cozy feel of galleries past, with their plush carpeting, elegant couches, and walls of boiserie. It was a stark new look for a new kind of art.

For the artists soon to be known as the New York School, a phrase coined by artist and critic Robert Motherwell, the way forward, it seemed clear, was Abstract Expressionism.[18] It was bold and new, a breathtaking turn away from everything being done in Europe. But what was Abstract Expressionism? That was hard to say, because no two artists had the same approach. Some six decades later, Irving Sandler, an Ab Ex critic and historian and one of the last survivors of that tumultuous time in American art, would note in his art-filled Greenwich Village apartment that the Ab Exers were more agreed on what they didn't want to do than what they did. "What organized them was a negative attitude. *Not* cubism. *Not* surrealism. *Not* geometric abstraction. They didn't feel these 'isms' spoke to them. Their moment was World War II. They were looking for a much more tragic attitude—an attitude that brought into focus their postwar malaise."

Every ism was a reaction to the one that preceded it: Surrealism was the one that Ab Exers moved away from, in part because it was Europe based. In the *Surrealist Manifesto* of 1924, André Breton and his followers declared that art's mission was to unlock the unconscious, and in so doing challenged the deliberate absurdity of the ism that had come before, Dadaism. The Surrealists—Salvador Dalí, Joan Miró, René Magritte—had tried séance-like "automatic" writing and art, then turned to dream-like scenes in a search for ultimate meaning. The war put an end to all that. There were no absolute truths, no comforting myths. Artists were left to confront life's harsh realities on their own, as individuals.

The Ab Exers painted from the gut, trusting their instincts. Those who expressed themselves with vigorous brushwork became known as the action painters, a label applied by the critic Harold Rosenberg. Among them were Willem de Kooning, Philip Guston, Franz Kline, and Pollock.[19] Those who laid down more peaceable fields of color became the color field painters: Mark Rothko, Barnett Newman, and Clyfford Still, as designated by Rosenberg's critical counterpart, Clement Greenberg.[20] The color field painters were a more meditative group—individuals against the world, as the action painters were, but in pursuit of the sublime.

There were few women in the New York School, as both branches of Ab Ex came to be called. One was Helen Frankenthaler, Mother-well's wife, a color field pioneer who used a "soak stain" technique influenced by Jackson Pollock. She spread her canvases on the floor and covered them with turpentine-thinned watery washes, creating translucent abstractions. Joan Mitchell was an action painter, her large, abstract landscapes often freighted with symbols of death and depression. Grace Hartigan, a second-generation Abstract Expression-ist, made gestural, intensely colored paintings often inspired by pop-ular culture.[21] Lee Krasner was also an Ab Exer, though she would struggle for years to escape her husband's shadow and establish her own legacy. Beyond these few, the field for Ab Ex women artists grew thin: even in the rule-breaking realm of Abstract Expressionist art, men dominated.

Neither Guggenheim nor Parsons might have exhibited any of these burgeoning talents if the city's most prestigious dealer had wanted to step in. Pierre Matisse, youngest child of the painter Henri Matisse, was down the street at 41 East 57th. Matisse had the clout and connections to take on any Abstract Expressionist he liked. As it happened, he liked none of them. To a connoisseur of his generation, good art meant Euro-pean art. It was left to a handful of small dealers to show and promote the art that was about to take over the world. One of them was Charles Egan, a blustery Philadelphian who had no formal art training but was a popular character among the artists who gathered at the downtown

Waldorf Cafeteria. They encouraged Egan to start his own 57th Street gallery.

Willem de Kooning, a Waldorf regular, was 44 in April 1948 when Egan gave him his first show—a series of black-and-white paintings that led Irving Sandler to call him "the most influential artist of his generation." The Dutch-born De Kooning had grown up working-class in Rotterdam and, unlike most American artists, had formally apprenticed at a commercial decorating firm, immersing himself in Art Nouveau. He had arrived in New York as a stowaway in 1926 and supported himself by doing commercial art through the twenties. During the Depression, he had worked as a Works Progress Administration (WPA) artist, but a growing passion for his own art relegated him to penury by the late 1930s.

It was on the verge of World War II that De Kooning's circle expanded with the arrival of kindred spirits from the chaos of Europe: Marcel Duchamp, Marc Chagall, and André Breton, among others. De Kooning's work through the early 1940s produced often gloomy, figurative portraits, but these eventually began to give way to more tumultuous compositions.

From his loft on West 22nd Street, De Kooning and his vivacious wife, Elaine, entertained the artists they had come to know—artists who admired De Kooning's intense struggle with his work. Yet the artist who drew the most attention was Pollock, the big, burly Wyoming native whose figurative work was also on the verge of something new. By the midforties, Pollock was the name on everyone's lips. De Kooning had only a modest string of group shows to call his career. As Mark Stevens and Annalyn Swan note in their magisterial *De Kooning: An American Master*, those included an autumn salon at Peggy Guggenheim's Art of This Century gallery in October 1945. "Compared to Pollock's success d'estime, however, de Kooning's inclusion in these group shows was insignificant," they write. "By mid-decade, already forty years old, de Kooning had sold only one painting to a collector outside his downtown circle of friends and admirers."[22]

The show at Charlie Egan's gallery in 1948 made de Kooning an artist to be reckoned with, but the ten paintings priced between $300

and $2,000 failed to sell.[23] Egan was, perhaps, partly to blame. He was a heavy drinker and a bit sloppy in his private life: that fall of 1948 he had a passionate affair with Elaine de Kooning while still representing her husband. Even in the love-and-let-love downtown circles, that was a bit much.[24]

BETTY PARSONS NEVER DID BECOME DE Kooning's dealer; Sidney Janis went on to win that prize. But at a pivotal moment in the late forties and early fifties, Parsons became almost everyone else's—the dealer to a murderers' row of Ab Exers who transformed contemporary art.

For Parsons, a passion for radical art came early. At 13, she accompanied her parents to the seminal International Exhibition of Modern Art, which became known as the Armory Show of 1913, on Lexington Avenue between 25th and 26th Streets. It was the first time she had ever seen Impressionist and Post-Impressionist art. Here were early Cubist paintings by Picasso and Braque, Duchamp's *Nude Descending a Staircase (No. 2)*, and so much more. Parsons was fascinated. She emerged determined to be an artist. More than 30 years after her death in 1982, galleries and curators are still debating whether her art was top-notch. As a dealer, however, she was destined to be one of the greats—perhaps the greatest of the early-to-mid 1950s.

Parsons's parents divorced in the late 1910s, and she along with her two sisters was sent to live with her well-off paternal grandfather, John Friederich "the General" Pierson.[25] Parsons attended Miss Chapin's School, but dressed like a tomboy and showed no feminine graces. The General railed at her, suspecting what Betty may already have known: that she was a lesbian.

Marriage to a well-born suitor ten years her senior made Parsons respectable, but not for long. Schuyler Livingston Parsons "was in the Social Register...and was a playboy, and a homosexual."[26] The couple barely survived their passage to Europe, as her groom insisted on bossing her around and Parsons furiously rebelled. By 1923, she had filed for divorce in Paris, where she took up residence, supported by her ex-husband's alimony payments. Her life in art had begun.

At 24, Parsons had a trim, boyish figure and enough verve to ring up the city's artists and writers and introduce herself. Soon her circle included artists Alexander Calder and Man Ray, socialite-artist Gerald Murphy and his much-admired wife Sara, and author Hart Crane. She also befriended several of Paris's best-known lesbians: Janet Flanner of the *New Yorker*, bookstore owner Sylvia Beach, and the redoubtable Gertrude Stein and Alice B. Toklas.

The Depression, when it came, seemed very far away, until Parsons's alimony payments stopped arriving. The General died having disinherited her—another bitter blow. Desperate, she sailed home with her dog to New York in July 1933, then headed west to Los Angeles, where close friends insisted she stay with them as long as she wished. Her friends from Miss Chapin's School paid her bills and encouraged her to paint portraits and teach art.[27]

Parsons's sexual ambiguity fascinated the LA circle in which she now found herself. There were drunken parties with humorist Robert Benchley, actress Tallulah Bankhead, and savage wit Dorothy Parker. For Parsons, a most intriguing new friend was Greta Garbo, generally assumed—though never admitted—to be gay. Decades later, when asked if the bond had been sexual, Parsons turned coy. "She was very beautiful and I was very taken with her, but of course she was very busy and I was very busy."[28]

After two years in LA giving painting lessons to her bibulous friends, Parsons sold her engagement ring to finance her return to New York, her first-class train passage paid for by American modernist painter Stuart Davis, who even proposed.[29] (She declined.) With no other recourse, she worked up the nerve to show her paintings to a small midtown dealer, Alan Gruskin.[30] To her astonishment, he gave her a show.

Friends flooded the gallery, and works sold to prominent New Yorkers, including members of the Algonquin Round Table. Gruskin suggested Parsons stay on to sell art for commission at his Midtown Galleries—she came with a clientele. For Parsons, now in her

midthirties, it was her first real job, and one that made her feel she had found her calling at last.

The job was short-lived, but Parsons moved on to another gallery, in the basement of the Wakefield Bookshop on East 55th Street. There she developed her own roster of artists, including Saul Steinberg, Hedda Sterne, and Joseph Cornell.[31] Her next stop was the East 57th Street space of Mortimer Brandt, an English dealer. When Brandt went back to England in late September 1946, that space became the Betty Parsons Gallery.[32]

BY JACKSON POLLOCK'S SECOND SHOW AT the Parsons Gallery in early 1949, anticipation had grown, in part because Peggy Guggenheim had pulled strings to get six Pollock paintings shown at the Venice Biennale, the most prestigious and one of the oldest European art exhibitions, established in 1895.[33] This time, at Parsons's gallery, nine out of 30 Pollock paintings sold.

In little more than a year, from roughly 1947 through 1949, nearly every one of Parsons's top artists found his own style and became a vital figure of the period. Mark Rothko did his first "multiform" paintings, with their soft rectangular blocks of color, almost vibrating against monochrome backgrounds. Clyfford Still created jagged fields of contrasting colors, using palette knives to layer a thick impasto on his images. Barnett Newman made his first "zip" paintings. As for Pollock, his third show at Parsons Gallery, in November 1949, put him on an entirely new level, with most of his 27 paintings sold. Packed in among the admirers was De Kooning, who noted the wealthy prospective buyers in the crowd and famously said, "These are the big shots. Jackson has broken the ice."[34] Parsons, delighted, called Rothko, Still, Newman, and Pollock her "four horsemen."

The four horsemen were happy with the shows Parsons gave them, along with the growing critical respect. But why keep prices so low?[35] Even as Parsons encouraged her artists to paint bigger pictures—one of her key contributions—she balked at charging more than $1,000 a

piece. And why, her artists grumbled, did their dealer keep taking on more and more artists? None were as good as the artists who had made her name.

Decades after her death, Parsons would be praised for taking on women artists and gay artists, quietly using her influence to help kindred souls.[36] But her efforts were not appreciated at the time. One by one, the horsemen importuned her, to no effect. Finally, at a group dinner in early 1951, they warned her they would leave if Parsons didn't throw out the second-raters and focus solely on them. Newman, her closest companion, pleaded with her to take advantage of their growing success. "We will make you the most important dealer in the world," he declared. Parsons, indignant, refused to throw out the rest of her roster.[37]

And so Parsons's top artists did leave, one by one. Newman and Still chose to work the next years on their own in semi-seclusion.[38] Both Pollock and Rothko went with Sidney Janis, the dealer emerging as the businessman of 57th Street; Pollock left Parsons in 1952 and Rothko in 1954. They didn't have far to go. Not long before, Janis had sublet part of the floor Parsons had rented at 15 East 57th Street. All they had to do was walk down the hall, to Parsons's lifelong fury and hurt.

THAT SIDNEY JANIS WAS BETTER AT business than Betty Parsons was universally agreed. After all, he was already rich from inventing the two-pocket shirt. Janis adored art and artists, too, but he wasn't above making a profit from his passions.

Like Parsons, Janis was exposed to art at an early age—in his case, at Buffalo's Albright Art Gallery, which later became one of the country's best small museums. After a naval service tour, he worked for his brother Martin, who owned a chain of shoe stores. The job was dreary, but sales trips took the brothers to New York. At a downtown party, Sidney met his future wife, Harriet, whose garment-trade family soon moved him from shoes to shirts.[39] An entrepreneurial streak led him to design the two-pocket men's dress shirt. Demand was huge, especially in the steamy South, where men liked to doff their jackets but

keep their pens and eyeglasses handy. Soon, Janis was rich enough to indulge his passion.

The Janises took their first art-buying trips to Paris in the late twenties. Picasso was their favorite, so much so that in 1932 they waited hours in line at the Galerie Georges Petit in Paris to see Picasso's first retrospective. To their great disappointment, the artist failed to show.

The next day the Janises saw a crowd in front of a gallery, gathered around a garrulous little figure. "It's Picasso," Janis whispered to his wife. They were close enough for Picasso to see Janis mouthing his name. "What are you two Americans doing in Paris?" the artist asked.

Janis said that he and his wife had hoped to see him at his opening. Picasso gave them a look. "How long are you here for?"

"Just one more day," Janis said.

Picasso hesitated. "Well, if you're free now, come to my studio."

Upstairs, Picasso invited the young couple to peruse the painting-jammed studio and went off to work. Janis found a small picture he and Harriet liked, of a two-faced seated figure. Surely, they could afford that.

"A nice one," Picasso agreed. "I could give it to you for five thousand dollars."

Janis was shocked. "I'm afraid we can't afford that," he whispered.

The artist was in a good mood. He clearly liked Harriet, and Sidney, a dapper dresser, was wearing a tie that intrigued him. "How much *can* you afford?"

Janis named a lower figure, and Picasso agreed. Then, he carefully signed the picture. "I have to put it over the stove to dry," he explained. "Come back tonight with the money, and it will be ready."

A few hours later, the Janises returned, their pockets stuffed with French francs. Picasso opened the door and welcomed them in with a boyish grin. In the interim, he had put on a beautiful tie of his own. He touched it now, and held it out to compare it to Sidney's. A sign of solidarity, or one-upmanship? Janis wasn't quite sure, but the francs were proffered, and the young Americans went off with their tiny Picasso, set on spending the rest of their lives in art.[40]

BY THE TIME JANIS OPENED HIS gallery in September 1948 at the age of 52—the gallery to which both Pollock and De Kooning would come in time—he had left the shirt business and spent nearly a decade studying and writing about contemporary art. The space he sublet from Parsons—the other half of the whole fifth floor of 15 East 57th Street—had been occupied by another dealer, Samuel Kootz, a genial Virginian who, like Janis, had supported himself for years in the textile business.

Kootz was a fascinating character. In public letters and books during the Depression and World War II, before he had a gallery, he had urged American artists to distance themselves from Europe and forge their own bold new forms of expression. In 1942, he organized a show of 179 contemporary American paintings in Macy's department store, as sensible a place to sell art as any. The store noted that, "in line with Macy's established policy, the prices are rock-bottom as possible....Ranging from $24.97 to $249."[41] He had taken the space at 15 East 57th Street in 1945—his first gallery, which put him at the vanguard of Ab Ex—only to be diverted at a critical moment by Picasso. Kootz returned from Paris in 1946 with a cache of wartime artwork by the master, and had a hugely successful show of them. So successful, indeed, that Kootz decided to close his gallery and become Picasso's "world agent" from his apartment at 470 Park Avenue.[42] The arrangement lasted a year, after which Kootz started a new gallery. By then, most of the leading Ab Ex artists were either with Parsons or Janis, who had taken Kootz's space down the hall from Parsons.

Janis started with European favorites: Fernand Léger's colorful Cubism and Robert Delaunay's geometric shapes, along with Marcel Duchamp, Constantin Brâncuşi, and Piet Mondrian.[43] He sold little, and his savings declined. He showed Josef Albers's nesting squares, and Arshile Gorky's brilliant blends of surrealism and early Abstract Expressionism. Almost none of those sold either.

Janis hadn't made his mark yet, but the New York School artists noticed that he set higher prices than Parsons did. While hanging one show, Janis grew aware of a hulking stranger by the door noting the choices he made with the paintings. The stranger was Pollock. "The

thought crossed my mind that he probably wanted to talk to me about something," Janis recalled years later. "But since he was with Betty Parsons I wouldn't bring it up."[44]

Pollock resolved to leave Parsons at the start of 1952, but Parsons took a stern line. "All artists remain with me for a year after their (last) show," she said, "so that it gives me the possibility to realize some business on their work." Pollock tested two other dealers that winter, unhappily. By April, his wife had lost patience and pulled him into Janis Gallery. "Pollock is available," Krasner declared.[45] His first show with Janis, in November 1952, drew a worshipful crowd, but only one of 12 paintings sold. Pollock's take was all of $1,000.

Financially, De Kooning had done hardly better, but in 1950 he had had a breakthrough with a fiercely pulsating painting he called *Excavation*. His point of departure, he said, was an image of women working in a rice field from *Bitter Rice*, a 1949 Italian Neorealist film.[46] But some saw in it a swarm of city dwellers, peering through the peepholes of a building excavation site.

Another artist might have gone on to make more *Excavation*s to please his critics. De Kooning did the opposite. His *Woman* series, begun in 1950, was action painting at its most dramatic, with broad, fierce strokes, an entirely new palette of fleshy hues, and what was unmistakably a woman—a daunting, even devouring one at that, though De Kooning suggested another interpretation. "Maybe in that earlier phase I was painting the woman in me," he said. "Women irritate me sometimes."[47]

De Kooning was turning 49, still largely unknown outside the art world, when he joined the Janis Gallery in 1953. Janis gave him his first show in March of that year. On the walls was the *Woman* series, as mesmerizing as it was repellent. His fellow artists admired him for having spent long, agonizing months on a single canvas, reaching for his own synthesis of figurative and abstract art, and living in near destitution as he did. The critics raved, and the paintings sold. Blanchette Rockefeller bought *Woman II* (1952), later donating it to the Museum of Modern Art.[48]

JANIS AND PARSONS WERE BRINGING MORE of the downtown artists uptown to sales and acclaim. In this nascent stage of American postwar contemporary art, when artists defined success as selling a painting for $1,500 rather than $500, a small but eager circle of Ab Ex collectors was helping their heroes to be seen in a new light: as challengers to European art, creating entirely new postwar ideas, expressions, and markets. One of the boldest of those collectors was Ben Heller.

One summer Friday evening in 1953, Heller and his wife drove out to see friends in East Hampton. Heller was 27 that summer, tall and athletic with a full head of dark hair.[49] His father had made him president of the family's small knitwear company, but Heller had no heart for the business. What he loved was contemporary art. Already he had bought his first painting, a Cubist canvas by Georges Braque, for $8,000. Some 65 years later, he would laugh when he remembered that. "What was I doing spending $8,000 on a painting when I had all of $27,000 in the bank?"[50]

Heller's friends were staying with a charming couple, Leo and Ileana Castelli, who loved new art as much as the Hellers did but weren't dealers yet—more like dabblers.[51] Castelli was known as "a well-connected gadabout and helpmate in the downtown New York art scene, certainly not what anybody would regard as a major player."[52] Slim and soigné at 46, with a hard-to-place European accent and excellent manners, Castelli, like Janis, had spent a lot of his last decade learning about art. And, like Heller, he worked for the family clothing firm as manager of a textile factory—in Castelli's case, owned by his father-in-law.

Pollock came up in conversation soon enough. There was always some latest story, of a drunken episode at the Cedar Tavern, perhaps even of punches thrown. Heller was titillated by these, as everyone was, but equally curious about what Pollock was painting. He might even want to buy something. Did Castelli know how Heller might get hold of him? Castelli urged Heller to call Pollock directly. After some hesitation, Heller did.[53]

Soon the Hellers were parking in front of the artist's cedar-shingled farmhouse on Springs-Fireplace Road in the Springs, a stretch of scrub

pines offset by gorgeous inlets on East Hampton's rural outskirts. Heller was prepared for an awkward greeting; the artist was known to be gruff, even combative. Yet as he let the Hellers in, Pollock seemed more shy than anything else.

An afternoon chat stretched into dinner, Krasner cooking while Pollock nursed a drink at the wood-planked kitchen table. Pollock's two-year period of sobriety had ended November 20, 1950, and since then his output had diminished. But that night, Pollock seemed under control, even subdued.

Finally, Pollock invited the Hellers back to the shed he'd turned into his studio. Several finished works stretched along one side. Heller was staggered by the largest ones, more like murals than paintings. Pollock, he knew, had given numerical titles to his early drip paintings, starting again with *One* each new year. Now, having left Parsons and taken on Janis as his dealer, Pollock was heeding Janis's advice to give his new works distinctive titles, like *Autumn Rhythm* and *Blue Poles*. Clearly the mural-like *One: Number 31* preceded those.[54]

Heller was too shy to ask if Pollock would sell him the huge canvas. The Hellers made a return visit to the Pollocks' farmhouse the next day, however, to find Krasner in her own small bedroom studio and Pollock out back. Heller took the opportunity to ask Krasner if she thought Pollock would sell him *One: Number 31*.

"I wouldn't," Krasner said. "But ask him."[55]

That may have been a bit disingenuous. Sydney Janis's son Carroll recalled that Parsons had tried to sell *One* for $3,000. Pollock had finished it in 1950, according to internal documents from the Museum of Modern Art. "She couldn't sell it. When Pollock switched to Janis," recalled Carroll, "my dad had it in his [Pollock's] first show, it was a little more than $3,000, and *he* couldn't sell it. It was back out there at Pollock's studio because no one had bought it."

Out at the studio, Heller nervously asked if Pollock would sell him *One*. The artist's eyes lit up. "Sure," he said. "How much?"

"I don't want to argue over price," Heller said. He knew Pollock had sold at least one large painting for $8,000—a very sizable price in the

summer of 1953. "I'm happy to pay $8,000 for the big painting," Heller suggested. "Just let me pay over time." The painter readily agreed to increments of $2,000 a year for four years, but with one condition.

"As part of the deal," Pollock said, "I'm giving you a black-and-white enamel painting." Later it would be known as *No. 6, 1952*. "It's an expression of our friendship, separate and distinct from the other one. It has nothing to do with price."[56] Before the weekend was over, Heller had agreed to buy another painting, *Echo*.

Heller was thrilled. Now all he had to do was get *One: Number 31* to his Upper West Side apartment at 280 Riverside Drive. That was a challenge: the canvas measured nearly nine feet high by 18 feet across.[57] Pollock helped roll the painting, a risk, with all its build-ups of paint, that Heller dared not take himself. The work came by truck along with its creator. Together, the two men hauled it into the lobby like a rolled-up carpet and tried angling it into the elevator. No luck: the painting's nine-foot height made it far too tall to fit.

A friendly superintendent came up with the solution. The elevator was lowered. Pollock and Heller then climbed onto the top of the elevator cab, with the rolled painting held between them, projecting up into the shaft. The super stayed in the cab to push the button for Heller's floor, and the elevator rose with its precious cargo.

The men weren't done yet. Heller's living room ceiling was inches too low for the unfurled painting. Resolutely, they stapled the top of the painting directly onto the ceiling, a few inches out from the wall, then stapled again where the canvas met the corner, as if putting up wallpaper. Pollock had no objections: he stapled the painting to the ceiling himself.

ALONG WITH POLLOCK'S AND ROTHKO'S MIGRATION down the hall, Parsons had to accept the departures of her other two horsemen, Clyfford Still and Barnett Newman. They left not for Janis—by now her archrival—but rather to ply their mysterious paths, away from all commercial galleries.

De Kooning, who remained down the hall with Janis, was now drawn to the tawdry side of city life, as several of his titles suggested: *Street Corner Incident* and *Gotham News*. One he had just finished was called *Interchanged*, a patchwork of red, white, and yellow forms that in some ways seemed a late addition to his *Woman* series.[58] It would later be one painting in a two-painting package that David Geffen sold in 2015 for $500 million. The other was Pollock's *Number 17A*. The package, sold to Chicago hedge funder Ken Griffin, would break all sales records in the history of art, for a while.

With her four horsemen gone, Parsons was in desperate need of new artists. For that, she went to Paris, where word of mouth brought her to a young, unknown American artist who drew deceptively simple renderings of shapes he saw in nature, from leaves to barn sidings. The artist, Ellsworth Kelly, was working to reduce simple geometric shapes even further, in what would one day be called hard-edge abstraction, bathing each of his shapes with a bold primary color to show how they moved through space and interacted with each other. One day, he would be put among the greatest artists of the last half of the 20th century, but in 1954 he was just another promising talent, who under the GI Bill had studied two years at the École des Beaux-Arts and was now wondering what to do next. He and Jack Youngerman, a fellow artist, had become good friends because, as Youngerman later put it, "I felt coming from Ellsworth a kind of exceptionalism. Art requires some degree of personal peculiarity, it's the origin of any freshness in the way people look at things and talk about things. I felt this personal-ness in him. Also a kind of poetic impeccableness." Kelly had been recommended to Parsons, as had Youngerman.[59]

Parsons arrived at the Beaux-Arts in search of both artists. She liked what she saw and to both she issued the same edict. Come to New York, she declared, and she would represent them. Kelly came in 1954. Youngerman stayed on a while in Paris, but Parsons's words kept echoing in his head. "If you want a show," she told him, "you have to move to New York."

Youngerman sailed home with a Lebanese-born French wife, aspiring actress Delphine Seyrig, and an infant son. Ellsworth Kelly was there at the dock in Manhattan to greet them and take them downtown to the refuge he'd found on a gritty street near the South Street Seaport: Coenties Slip. A number of the decade's best artists were either there already or soon would be, living in abandoned lofts with sweeping views of the East River.

As its name suggested, Coenties Slip had been an inlet once, bearing goods-laden wooden sailing ships from the East River to Front Street.[60] Filled in in the 1830s and since abandoned, it drew urban pioneers willing to live in its crumbling buildings, some without hot water, others without heat, few with shower stalls, and none with bathtubs. That, in the midfifties, meant artists. What really bound them together was how and where they lived. They were the first community of New York artists to live in industrial spaces.[61]

Kelly was living in number 3-5 when he brought the Youngermans down to see it. Soon the Youngermans were living at number 27, a five-story Dutch brick house, which they rented, in its entirety, for $150 a month. They kept the top floor and attic, where sails had once been made and mended. They rented the other floors to fellow artists. Agnes Martin, whose grid-defined, highly structured abstract paintings would make her world-famous one day, was on the ground floor.

The artists loved the light and quiet and space and river views they got for what even then was nominal rent. Occasionally they gathered for dinner or a walk in freshly fallen snow: a group photo taken in 1958 by Jack Youngerman shows Lenore Tawney, Ellsworth Kelly, Robert Indiana, and Agnes Martin in a snow-covered pile.[62]

But mostly, the artists lived and worked alone. As Agnes Martin later put it, "We were smart enough to understand each other's need for solitude."

Steps away from Coenties Slip were three more artists about to change the course of American contemporary art. Robert Rauschenberg was living in the same building as Jasper Johns, and Cy Twombly was close by. One night, Youngerman stopped by Rauschenberg's loft to

find Twombly and Johns cutting aluminum sheeting for a store-window display at Bendel's or Tiffany's—he couldn't remember which—that Rauschenberg had designed. They were having fun but also doing it as a business. In fact, in the 1950s, Tiffany's window designer Gene Moore hired Rauschenberg and Johns to create a series of unorthodox displays for the company's fine jewelry pieces. The two worked together on commercial projects for the company under the name Matson Jones Custom Display.[63] The night that Youngerman came by and saw Twombly and Johns, Rauschenberg might have been uptown taking a shower: his own loft had no shower or bath.

MORE THAN A FEW PASSIONATE DEALERS, collectors, and critics were embracing contemporary art both downtown and up. Museum directors were taking an interest, too, none more so than Alfred H. Barr Jr., who had become the first director of New York's Museum of Modern Art when it opened in 1929. Barr was caught between the founders, who felt MoMA should acquire proven works by mostly dead artists, and cutting-edge critics, who slammed him for not embracing Abstract Expressionism soon enough.[64] In 1943, Barr was demoted from his post as director, a step partly provoked by his support for what the trustees considered "frivolous" art shows, such as the one involving an embellished shoeshine stand by a "primitive" artist, Joe Milone.[65] But Barr remained at the museum, still able to influence and acquire.

In 1957, Barr and his chief curator, Dorothy Miller, were working up a show to send to Europe that captured it all: *The New American Painting*.[66] As the title made clear, American artists were doing more than Abstract Expressionism now. So many new styles were emerging that Barr drew up a flowchart of them all and carried it around with him for handy reference. Most would ebb and vanish, but there was no denying the force of American art after decades of Europe's dominance with its Impressionists, Cubists, and Surrealists.

By then, Pollock had died in the car crash that also killed one of his two female passengers. Weeks before his death in August 1956, Pollock's wife, Lee Krasner, had come alone to Janis's gallery to insist that

the dealer raise Pollock's prices. He was painting so few pictures, and money was tight. Janis had agreed to raise the large-picture prices from $2,500 to $3,000. That infuriated a customer who had just agreed to buy a Pollock painting from Janis; the price had gone up before she could take delivery. She bought it anyway, through gritted teeth, for $3,000. Months after Pollock's death, Janis heard she sold it for $30,000.[67]

Ben Heller's Pollocks had shot up in value too. He could see where all this was going. "It was absolutely clear," he said years later, "for anybody who responded to those kind of things in the air, that art was going to be the big way that a lot of rich people were going to express themselves. It was just going to become the thing."

Sometime that fall, with Pollock's death reverberating amid the downtown Ab Ex crowd, Irving Sandler attended a Greenwich Village party with his wife, Lucy. Some 60 years later, Lucy would remember, as if it were yesterday, someone leaning over to say, "Hey, have you heard the news? Leo Castelli is opening a gallery."

The Elegant Mr. Castelli

1957–1963

THE MAN ABOUT TO BECOME the greatest dealer of his day was, on the eve of his gallery's opening on February 10, 1957, a dilettante in the old-world sense: a lover of the arts unburdened by any serious ambition. With money from his father-in-law, Leo Castelli and his wife Ileana had bought the works of several well-known European artists: Klee, Mondrian, Dubuffet, Léger. They were among the paintings in his family's town house at 4 East 77th Street, where he and his wife were raising their daughter, Nina, the living room of which would serve as his first gallery. For years before the gallery's opening, Castelli had worked for his father-in-law. The town house was his father-in-law's too. By American standards, Leo Castelli at 49 had accomplished very little. "In the beginning I must say I was rather ashamed of doing business," Castelli said later. "It didn't seem to me...even a gentlemanly occupation. I had some kind of a stupid attitude that you find in Europe."[1]

Castelli's knowledge of contemporary art, however, was impressive. It was impressive enough that Alfred H. Barr Jr. had served as his guide and mentor.[2] Impressive enough that Clement Greenberg, the foremost critic of the decade, had seen fit to coach him too.[3] Castelli spoke five languages—not bad for a dilettante—and dressed well from the start, so well that no one, as he became well-known, would fail to notice his Turnbull & Asser blazers and perfectly pressed gray wool slacks, as well as the Hermès ties and Gucci loafers, new as yet to most Americans. Unfailingly, he carried a leather-bound Hermès appointment book and made notations with an expensive pen.

Arne Glimcher of the Pace Gallery, one of Castelli's decades-long rivals, thought him a snob.[4] Most other dealers—and all his artists and friends—found him reserved but gracious almost to a fault. Irving Sandler, the critic, always had the feeling about Castelli that if he broke even at the end of the day, it was a successful day. As long as his artists were doing well, he was happy. "People thought he was Machiavellian," Sandler recalled, "but in fact he just loved the game."

Castelli, the son of a Hungarian Jew, had grown up as Leo Krausz (or Krauss) in Trieste, a storied seaport of the Austro-Hungarian Empire soon to be part of Italy.[5] He was one of three children of an up-and-coming banker, proper and prosperous, until World War I forced the family to seek refuge in Vienna for nearly four years. Castelli appears to have regarded the time as an idyll: it allowed him to breathe in all of Vienna's arts, especially literature, learning German, English, and French as he read.

With the family's return to Italy, Leo earned a law degree in Milan in 1924 and, with his father's help, got a job in insurance. Boredom led to a change of venue: another insurance job, but this one in Bucharest. There, in 1933, he courted and married Ileana Schapira, daughter of a wealthy Romanian industrialist.[6] Faced by anti-Semitic sentiment and the Italian government's desire for Italian surnames, the Krauszes added Leo's mother's maiden name, Castelli, to their own in 1935. (Eventually, Krausz-Castelli morphed into Castelli, the telltale Krausz dropped amid Europe's rising fascism.) The future dealer would recall being especially eager, because of his Jewishness, to "fit in with everyone."[7]

In 1933, Castelli left insurance for banking, and Bucharest for Paris, bringing his bride with him to take a job at the Banque d'Italie. There he carried out dreary tasks and lived for the nighttime social life that he and Ileana enjoyed, supported in high style as they were by Ileana's father, Mihai Schapira. By early 1939, Schapira had moved his family to Cannes on the Côte d'Azur, anticipating the war.[8] The Castellis remained more optimistic. Leo Castelli rented a storefront on the Place Vendôme and started a gallery of Surrealist art and modern furniture with René Drouin, a decorator and a friend of Ileana's. The gallery,

which opened on July 5, 1939, was an overnight success, perhaps in part because the revelers sensed their world was about to end. That September, when France and England declared war on Germany, the gallery closed its doors. Drouin joined the French army, and Castelli took his wife and two-year-old daughter to the Côte d'Azur, where his father-in-law felt the family would be safe.

With the fall of Paris in June 1940, Schapira prepared to move his entire family across the Atlantic. That December, the Schapira-Castellis boarded a boat in Marseille—part of the new Vichy government—and, after a heart-stopping series of visa examinations by the authorities, were allowed to leave France.[9]

On went the passage, from Spain to Tangier to Cuba, and finally to New York's Ellis Island. The Castellis and the Schapiras were saved. Tragically, Leo Castelli's parents died in Budapest at the hands of Hungary's fascist Arrow Cross.

At the end of 1941, Mihai Schapira moved his family into the town house at 4 East 77th Street.[10] When the war persisted, Castelli volunteered for the US Army, serving first in field artillery, then intelligence, and finally in Bucharest as a translator. Fortunately, he came back unharmed in 1946, stopping en route in Paris, where he found Drouin safe and sound. The designer even consigned him some paintings, Kandinskys, to sell.[11]

Back in New York, Castelli began a seemingly lost decade, working at his father-in-law's textile company. It was in those years, though, that the New York School emerged and evolved, and Castelli, with lunch hours and weekends to indulge his passion, soaked up contemporary art. He came to know all the dealers of 57th Street. He also attended meetings at the downtown "club," a loose consortium of New York School artists who rented a space at 39 East 8th Street and gathered to drink and debate the burning art issues of the day. Leo and Ileana Castelli were accorded the high honor of being two of the only nonartists allowed to be founding members of the club (dealer Charles Egan was the third), so liked and respected were they by their artist confreres.

Noting Castelli's growing cachet, Sidney Janis asked Castelli in 1950 to curate a show at his gallery called *Young Painters in the USA and France*.[12] The next year, Castelli curated the so-called Ninth Street Show in a soon-to-be razed building at 60 East 9th Street.[13] His choices showed a keen eye: Willem de Kooning, Franz Kline, Robert Rauschenberg, Robert Motherwell, Jackson Pollock, along with Helen Frankenthaler and Joan Mitchell, were among the 60 artists whose works graced the walls.[14]

Years passed in a seemingly aimless fashion, but Castelli was soaking up art, befriending artists, occasionally dealing, and collecting to open a gallery of his own. His timing, when he took the plunge, was brilliant.

"What everyone misses about Leo," suggested Morgan Spangle, for years a manager of the Castelli Gallery, "is what it meant that he opened in 1957. What happened? Jet flights to Europe. He spoke five languages, he could fly anywhere and sell people—anywhere—on new art. And even though he was not an aristocrat, he came across that way." The times had met the man.

Castelli's first gallery was simply an upper floor of his family's town house at 4 East 77th Street, accessible by a grand staircase and a tiny elevator. For his debut in February 1957, Castelli hung American artists next to Europeans: a statement that the school of New York could stand beside the school of Paris. But he felt, as Ileana did, that Abstract Expressionism had lost its fire.[15] He loved Surrealism and its leading artists, among them Man Ray and René Magritte. But Surrealism, too, felt dated. Where was the truly new art? Later, Castelli would say of that search, "A dealer must be able to pinpoint these moments when they occur, and to identify which artists embody these new ideas."[16]

One prospect was Robert Rauschenberg, a genial Texas-born artist whose paintings had stirred mostly negative reactions, including one at the Ninth Street Show. His initial notoriety came from all-white, pure-surface paintings, which faintly showed the shadows of observers in a room. The shadows became the subjects of the paintings.[17] This was something of a neo-Dada idea, too radical even for Betty Parsons,

who balked at the white paintings and dropped him from her roster. Without a dealer, Rauschenberg had gone his own way, using objects salvaged from the street to make hybrid painting-sculptures he called "combines."[18] The combines, with their collage-like accumulation of layered-on newspaper and magazine images, made no discernible statement, but were keenly personal and captured the cheerful chaos of contemporary life. As such, they seemed to lead away from Ab Ex toward something new.

Castelli was intrigued enough to catch a group show, *Artists of the New York School: Second Generation*, that included Rauschenberg's work. The show, in March 1957, was sponsored by the Jewish Museum and curated by celebrated art historian Meyer Schapiro. Of the 23 artists shown, Rauschenberg was certainly one of the most interesting. Castelli paused with interest, too, before George Segal's life-size white plaster cast statues, along with paintings by Robert de Niro (the actor's father was a seriously regarded artist) and works by an impressive number of women: Grace Hartigan, Elaine de Kooning, Helen Frankenthaler, and Joan Mitchell.[19] Also included was a work by an artist whose name Castelli had never heard: Jasper Johns. The painting depicted a green round target with soft hues of paint that seemed waxen, as indeed they turned out to be. Castelli made a mental note to find the artist.

Two days later, the Castellis visited Rauschenberg's loft on Pearl Street to see the artist's latest work. What transpired is one of the great stories of the contemporary art world.

Rauschenberg's loft was a riotous jumble of found objects and the combines he was making with them. What Rauschenberg lacked for guests intent on having cocktails was ice. Not to worry, Rauschenberg beamed. His downstairs neighbor, Jasper, had ice.[20]

Had Rauschenberg just said...*Jasper*? Jasper who, Castelli wanted to know.

"Jasper Johns," Rauschenberg said.

"The one who painted the green picture in the Jewish Museum show?"

Rauschenberg nodded.

"I must meet him," Castelli declared.[21]

Rauschenberg went down for the ice and returned with a 26-year-old southerner, tall, fine-boned, and gracious. Castelli tried but failed to hide his excitement. He wanted to see Jasper Johns's work—right away. Down they went.

Johns's loft was as neat and austere as Rauschenberg's was slovenly. On the walls were paintings of targets, flags, and other iconic symbols. It was one of the great moments of Leo Castelli's life. Here was the next great leap in contemporary art. Each painting was, in one way or another, a sign—objective, impersonal, yet thoroughly compelling, in part because Johns had eliminated any illusion of depth in these works, though three American flags, each smaller than the one behind it, showed actual depth. This was clearly a departure from the deeply personal art of Ab Ex. A departure to where? To wherever Johns was going, was Castelli's immediate reaction—and Castelli wanted to go there with him.

Casually, Castelli asked Johns if he had a dealer. Well, said Johns, Betty Parsons had said she would visit, but so far, she hadn't shown up.[22] Later Parsons would admit, "I just didn't like his work [at first]. . . . By the time I realized it I was five or six years too late!"[23] The failure to come see Johns's work before Castelli did was one of the biggest mistakes of her life.[24]

Castelli took Johns on then and there, committing to give him a one-man show that next January.[25] Some days later, Rauschenberg came to the gallery while Castelli was out. Ileana was the one he wanted to see. What, he asked, were they going to do about *him*? As Ileana later recounted to Calvin Tomkins in his elegant history of Rauschenberg and the period, *Off the Wall*, she was very embarrassed and suddenly aware of how much Rauschenberg had been hurt.[26]

The ice story became a legend, brooded over by, among others, Antonio Homem, Ileana's gallery manager and, later, her adopted son. After Ileana had died and Homem had become one of two heirs to her considerable art fortune, Homem would wonder aloud in the vast,

dusty SoHo loft, at 420 West Broadway, with art and books stacked all around him, if Rauschenberg and Johns had had an understanding before that meeting.[27] Had Rauschenberg told Johns that the Castellis were coming? Or had he said nothing, wanting them to himself? "I never had the courage to ask Johns whether he knew that Bob was going to bring up that question of the ice to bring Leo and Ileana downstairs to his studio," Homem admitted. "What Bob *didn't* plan was Leo's immediate enthusiasm for Jasper's work, leaving the matter of Bobby's show in limbo."

AT FIRST, CASTELLI SEEMED LITTLE DIFFERENT from other dealers of his day. Like Parsons, he ruled a small space and searched for new artists. Like Janis, he enjoyed making a profit. But he was continental in a way that they weren't, and that made him, in the still-small world of contemporary art, unique.

Castelli from the start let his art sell itself. Into his inner sanctum would come a collector, though not just any collector—Castelli sought influential people and museums, the better to boost the artist's career. At Castelli's gentle instruction, the collector would take his seat while the dealer whisked away the painting's covering. Castelli's style was to sit in worshipful silence for a long moment, gazing at the canvas as the collector was doing, then to mutter, "Incredible...fantastic." The old-world aura he projected implicitly reassured new and perhaps insecure American collectors.

Shrewd collectors soon learned that despite his passion for the works, Castelli would negotiate. His associate director, the gruff, cigar-chomping Ivan Karp, often led the buyer away to discuss the actual terms of sale.[28] But Karp couldn't divert them all. He would see Robert Scull, the notoriously pushy collector who had made a fortune with his fleet of taxis, heading into Castelli's back office and know that prices were about to be discussed. "Scull would work Leo until he was a puddle on the floor," Karp recalled. "He was a Sherman tank, and he would get these enormous, shocking discounts—20, 30, 40%. And he

was not the only one. Leo had no mechanism for rejecting people. He wanted them to have the work so much he went to the point of self-created disaster." So much, indeed, that with his ineptitude in math he sometimes shortchanged himself on the bargains he'd struck.

Castelli was even more generous with his artists than his buyers. In the European fashion, he gave nearly all of them monthly stipends—and not the modest $150 that Guggenheim had paid Pollock either. Castelli's stipends began in the low thousands of dollars a month. Eventually they grew to as high as $50,000 a month. According to Titia Hulst, a Castelli authority, "The stipends, a topic Castelli brought up frequently with the press, were often quoted as an example of his generosity towards his artists. While Castelli was indeed a generous man, the stipend system actually also made business sense. Not only did these payments ensure his artists' loyalty; they also raised Castelli's credibility as their promoter."[29] Castelli made sure that collectors (and the press) were aware of his personal financial stake in the work he sold. The plan, as with Guggenheim, was for the artists to repay the stipends with sales of future work.

At other galleries, an artist whose work didn't sell was eventually encouraged to leave. But not Castelli's artists. They were there for life—and were actually known as Castelli artists, which came to irk a few—and so were their stipends. Asked about one artist who hadn't sold anything in almost 20 years, Castelli said, "How could I cut him off? He has had no success in his life. He depends on me."[30] Castelli even paid for the actual manufacturing of large abstract works. Sculptor Richard Serra, for one, designed a 200-foot-by-122-foot piece of COR-TEN steel he titled *St. John's Rotary Arc* to be placed across from the Manhattan entrance to the Holland Tunnel. Unfortunately, Serra couldn't afford to pay the $120,000 cost of fabricating it. So Castelli underwrote it. Karp, who knew Castelli as well as or better than anyone, speculated that the dealer's generosity came out of a desperate need to be loved. Perhaps. But his generosity also led Castelli to a smart new way of doing business—one that would transform the contemporary art market.

Other dealers sold their artists' work from their 57th Street galleries—period. They kept their 50 percent commissions, standard at that time, and never ventured from their modest spaces. Early on, Castelli reached out to dealers he liked and trusted in other American cities and abroad. He sent them work to sell, and when sales were made, he split his commissions with them. With his network, Castelli became the first international dealer in contemporary art, selling more than he would have from New York alone.

One of the first of those satellite dealers was Irving Blum, a fledgling dealer in LA whose career would be inextricably linked with Warhol's—though not for a few years. The Brooklyn-born Blum was a former air force pilot who might have become an actor: he had the slicked-back black hair and piercing eyes of a matinee idol. After his military service, he had stumbled into a job at Knoll, the modernist furniture company on Madison Avenue at 57th Street, and put his good looks to use as a salesman. The office buildings that bought Knoll furniture bought art to go with it, and Blum began going to parties where he met artists, Ad Reinhardt among them. That led him to Coenties Slip, where he met Ellsworth Kelly. "They're having a barbecue on the roof," Kelly said. So Blum followed him upstairs, where he met Jack Youngerman, Bobbie Clark (later Robert Indiana), and Robert Rauschenberg.

Blum went on to see a lot more of Kelly; he bought his first piece of art from him too. "It was a small flower painting above his desk," Blum recalled. "I asked if he would sell it, and if so, for how much." Blum got it for $75.

Blum might have stayed on at Knoll for some time, but in 1955 Hans Knoll was killed in a car accident in Cuba at the age of 41. His widow kept the company going, but Blum felt the life had gone out of it. He was ready for the dare of starting a gallery—not in New York, but on the West Coast, which he had come to know and love in the air force. He moved to LA in 1957 and paid $500 to become a part owner of the small and struggling Ferus Gallery, buying out 24-year-old artist Ed Kienholz. The gallery operated inauspiciously behind an antiques store on La Cienega Boulevard.

In the late 1950s, Blum was a dealer in little more than dreams. Almost no one in Southern California collected contemporary art.[31] On a trip back to New York, he went as a supplicant to see Leo Castelli.

"Everyone in California is keenly interested in Jasper Johns," Blum told Castelli. "But they haven't seen one of his paintings." Blum felt sure he could sell a few of Johns's paintings, but only if Castelli consigned him some of the artist's work.

Ever gracious, Castelli said he would be happy to help if he could, but Johns did very few paintings. "Also, I have a waiting list for him," Castelli said, starting what would be another Castelli trademark: the long waiting list, at least for buyers whom he didn't yet know or admire. "So it's complicated."

Castelli then scribbled something on a scrap of paper and handed it over. "Here's his phone number, maybe something will happen."

Shortly after, Blum found himself at Johns's studio on Houston Street, in a former bank building. To Blum's surprise, Johns was working on two bronze sculptures. One depicted the artist's paint brushes in a can of Savarin-brand coffee. The other was two cans of Ballantine Ale. De Kooning had inspired the latter, after saying of Castelli, "That son-of-a-bitch, you could give him two beer cans and he could sell them."[32] Rauschenberg in response tried to work a couple crumpled beer cans into one of his combines. He struggled with it until Jasper Johns tried a response of his own. From that came Johns's *Painted Bronze*, two painted cast-bronze replicas of Ballantine Ale cans.[33]

"Has Leo seen these?" Blum asked.

Johns allowed that he had not.

"What about my showing these in LA?" Blum asked.

Johns called Castelli, who said fine, and Blum went on to have the first show of Jasper Johns's sculpture in Los Angeles. Only Castelli, Blum felt, would have let that happen. At the same time, the satellite system suited Castelli too. "It was really hard to sell paintings at that time," Blum said later. "Castelli wasn't making a lot of money, and the truth was that he had trouble closing a sale." The rough last push, that

wasn't Castelli's style. Sometimes his satellite dealers could better apply the nudge that got the job done.[34]

The beer cans ended up in the Museum Ludwig in Cologne. The bronze can of Savarin coffee stayed with its creator. For years after, Blum called Johns at least once a year, hoping to buy it.[35] In his soft southern accent, Johns would promise to consider the idea, but he never agreed. Finally, one year, Blum said with exasperation, "Why am I calling you? You're never going to sell that!"

"No," Johns said, "but I like talking to you."

Eventually, the piece would become a promised gift to the Museum of Modern Art by Henry and Marie-Josée Kravis.

CASTELLI, HIS ADMIRERS OFTEN SAID OF him, had the ear, and Ileana the eye. Irving Sandler was one of those admirers: he meant that Castelli listened to advice, above all from Ileana, and was wise enough to act on it. "Never separate them," warned Robert Storr, the former senior curator at MoMA, former dean of Yale School of Art, and one of the country's foremost art historians. Castelli would never have succeeded to the extent he did without Ileana telling him, fondly but firmly, what to do, Storr felt. Antonio Homem had a sterner—and perhaps more biased—view. "The great difference was that Leo was very interested in social prestige and Ileana was not," he recalled later. "I think Leo looked for success when he took an artist and wanted to be sure the artist could deliver it. Ileana looked for an adventure. Certainly she wanted to help an artist to find success, but her interest in the artist didn't change if he was not successful."

With Johns and Rauschenberg, Ileana saw more than each man's individual gift. She saw how the two of them fit into the larger, changing picture of contemporary art. Both were making art that felt fresh and new. At first, critics declared their work "neo Dada," evoking Marcel Duchamp and his embrace of "readymades," or store-bought objects. Then they began to wonder if Rauschenberg and Johns were on the cusp of a new style that celebrated, or satirized, mass consumer

culture, a style soon to be called Pop art. What the two artists offered, as Blum put it, was a path out of Abstract Expressionism.[36]

Neither Rauschenberg nor Johns intended to forge that link, much less become classic Pop artists with mass-culture images. In a sense, they were opposites: Rauschenberg with his combines holding a funhouse mirror to the outside world, and Johns with his targets and flags pulling the outside world in. Yet together they inspired, and somehow justified, the art that came after them.

To avoid any hint of favoritism, Castelli included a work by each man in his first major group show of May 1957.[37] But he couldn't help scheduling a first solo show for Johns in January 1958, two months before Rauschenberg's. Castelli was just too excited to wait any longer.

That debut show by Johns electrified the contemporary art world—and its market. His targets, numbers, and, most rivetingly, his American flags were seen, as Johns's biographer Deborah Solomon later put it, "as a brilliant assault on the high-minded strivings of the Abstract Expressionists who then dominated the art scene. What could a picture of a target, even if it was nicely painted in lush green strokes, reveal about the agony of existence? Absolutely nothing, and that was the point. As Johns himself later stated, 'I don't want my work to be an exposure of my feelings.'"[38]

Taxi magnate and burgeoning collector Robert Scull wanted to buy the whole show, but Castelli refused: that would be, as he put it, vulgar. MoMA's Alfred H. Barr Jr. rushed in on the show's first day to buy four works for the museum—Castelli was happy to sell the director as many as he wanted. The museum balked at buying more, so Barr asked architect Philip Johnson to buy a fourth and donate it. Additionally Barr and Dorothy Miller each bought small paintings for themselves, as did Ben Heller and other renowned collectors.[39]

By the show's end, only two pictures remained. One was *White Flag*, which Johns kept. The other was *Target with Plaster Casts*, which MoMA intended to buy until Barr learned that one of the small wooden-doored compartments across the top of the painting contained

a green plaster cast of a penis. "Could we keep this box closed?" Barr asked Johns weakly.

"All the time or part of the time?" Johns replied.

"I'm afraid, Mr. Johns, all of the time."

No, Johns said, that wouldn't be possible. Regretfully, on behalf of MoMA, Barr declined to buy *Target with Plaster Casts*. Castelli bought it instead.[40]

Abstract Expressionism was tapering off, but the best of its works were now part of the canon, their prices rising accordingly. In 1957, the year after Pollock's fatal car crash, the Metropolitan Museum paid Sidney Janis $30,000 for the artist's sweeping *Autumn Rhythm*, a painting Barr could have bought through Janis, a MoMA trustee, for just $8,000 a year or two before if his acquisitions committee had rallied to raise the money for it.[41] In 1959, De Kooning, whose works had sold a few years before for roughly $1,200 each, had a show at the Janis Gallery that saw buyers lined up outside at 8:15 a.m. on opening day.[42] Within hours, Janis had sold 19 of the show's 22 paintings, for a total of $150,000.[43]

A dealer very much like Leo Castelli was part of this gold rush. Like Castelli, André Emmerich had been born in Europe—Germany in his case—and fled the Nazis, reaching New York in 1940. Like Castelli, he was multilingual and enamored of art. And like Castelli, he was introduced to many of the New York School Ab Exers by Robert Motherwell. Emmerich opened his first gallery three years before Castelli, in 1954, literally down the block at 18 East 77th, though he became better known in 1959 when he opened a gallery in the Fuller Building on East 57th Street. Most of the Ab Ex action painters had dealers already. Emmerich took on the color field painters, including Morris Louis, Kenneth Noland, Sam Francis, and Jules Olitski. One of his first artists was Louis, whose early work was viewed, as Emmerich noted later, as "quite unsalable." But then Louis moved from "big, raw canvases with a single column of red or blue in the middle" to the stripes that would make his reputation. Soon Louis and Emmerich were doing extremely well.[44]

Peggy Guggenheim was "thunderstruck," as she put it, to witness these sales on her first trip back to New York since her move to Venice more than a decade before. "The entire art movement had become an enormous business venture," she wrote.[45] "Only a few persons really care for paintings. The rest buy them from snobbishness or to avoid taxation, presenting pictures to museums and being allowed to keep them until their death, a way of having your cake and eating it. Prices were unheard of. People only buy what is the most expensive having no faith in anything else. Some buy merely for investment, placing pictures in storage without even seeing them, phoning their gallery every day for the latest quotation, as though they were waiting to sell stock."[46]

Those were, of course, words that would fit the art market in 2019 as well as they did in 1959.

NO ONE WAS SURPRISED, LEAST OF all Castelli, when his wife declared their marriage over in 1959. For more than 25 years, Ileana Schapira Castelli had put up with a charming man who was a relentless womanizer. She had met someone else who loved contemporary art as much as she did but who, unlike Castelli, would be loyal to her. By 1961, she was married to German dealer Michael Sonnabend and planning a gallery for the two of them to run in Paris, bringing the American avant-garde to French art aficionados.[47] She was also on her way to assembling one of the great contemporary art collections of her time— the greatest, according to art critic and historian Allan Schwartzman. "She wasn't as knowledgeable as Leo," he suggests. "But she played a much more central role than she's been credited with."

Another man in Castelli's position might have worried that his ex-wife was trying to undermine him by opening a gallery in Paris, the more so when she showed his two top artists—Rauschenberg and Johns—to French audiences. Not Castelli, for he and Ileana were closer, with their divorce settled, than they had ever been as a couple. Ileana let Castelli keep operating his gallery from 4 East 77th Street. She remained his most trusted advisor, along with the grumpy and garrulous Ivan Karp.[48]

With Karp's guidance, and Ileana's, in a dizzyingly short time Castelli signed most of the emerging artists who would define his gallery.[49] Together, they would make Castelli the dealer of his era—through the 1960s, 1970s, and beyond—while Ileana, always unassuming and press shy, took on avant-garde artists who left her, in the long run, less famous than her ex-husband. "She took artists she felt didn't have the success they deserved," Antonio Homem suggested. "Leo looked for artists who had had, or promised to have, success. Because of that, he paid attention to the opinion of the people around him."

A fresh Princeton graduate named Frank Stella was Castelli's next discovery. He could hardly have been more different from Rauschenberg and Johns. Stella created his "flat" black pinstriped paintings on sharp-angled shapes of aluminum. The finished pieces showed no sign of the artist's involvement; they might have been manufactured.[50] "Denial of the hand," was how critics came to put it.[51] Irving Sandler attended a lecture by the new artist and came out reeling. "If that's painting," he muttered, "then anything I think is art is something else." An art historian beside him put it more bluntly. "That man is not an artist; he's a juvenile delinquent." But Ileana admired him and so did Karp, and so, soon, did most of the contemporary art world.

Next came Cy Twombly, whose penciled scribbles and seemingly primitive abstract shapes were a challenge Castelli struggled to meet. Twombly had served as a cryptographer in the US Army, and cryptology influenced his art. He and Rauschenberg had met in New York in the winter of 1951 and spent that summer as students at Black Mountain College in North Carolina, where Josef Albers, the abstract painter and theorist, taught a course. Because Rauschenberg and Johns had basically lived together before that summer, relations among the three artists grew complex.

"It's a very tight gay history story," explained art historian Robert Pincus-Witten years later. "I've forgotten who was doing what to whom first, but the point was that Johns and Rauschenberg were an item. Twombly then goes to Black Mountain. Suddenly Jasper is out. He was much more neurotic about being gay [than the others]. Somehow it

ruptures." Rauschenberg and Johns salvaged enough of their relation-
ship to work in the Pearl Street studios, where Castelli saw them and
asked for ice on that fateful day in 1957. As for Twombly, he married an
Italian baroness in 1959, settled in Rome, and had a son.[52] His absence
made his elegant scribble paintings an even harder sell in New York.
Castelli showed his work in a group show in 1959 but refrained from
signing him as a Castelli artist with a contract and stipend; the unspo-
ken feeling was that Twombly wasn't quite top tier. Twombly's critical
success would come in the early 1990s, thanks to Larry Gagosian, who
would sweep up Twombly with untypical fervor and push him ever
higher in the contemporary art market until his scribble paintings were
worth tens of millions of dollars.

Twombly wasn't a Pop artist—though he emerged as Pop was
arriving—any more than Johns and Rauschenberg were. The quin-
tessential Pop artist was Castelli's next addition to his stable: Roy
Lichtenstein.

New York born and bred, Lichtenstein began taking art courses
at 16 years old in the summer of 1940. He served in World War II,
went to college on the GI Bill, and dabbled, not very successfully, with
late-stage Ab Ex, declaring his art a "kind of straitjacket."[53] That was
when one of his young sons pointed to a Mickey Mouse comic book
and said, "I bet you can't paint as good as that, eh, Dad?"[54] From that
taunt came the first of Lichtenstein's comic-book paintings—perfectly
in tune with the mass-culture images and ironies of Pop art. As Karp
later recounted, "Leo didn't even know the comics they were based on,
he didn't have the American background, but he saw right away that
there was something going on there." Karp helped him see that, and
so did Ileana. By the opening of Lichtenstein's first solo show in 1962,
every one of the paintings, with their comic-book scenes and Ben-Day
dots, had been snapped up by a major collector.

Pop art—which is to say art that took on the images of popular
culture as its subject—had arrived. Like alchemy, it transformed a very
common element into one quite rare. The news images and advertise-
ments and comic books of pop culture were low art, commercial art,

for the most part. Taken up by the artist—appropriated, as the practice would come to be known—they were turned into high art. None of the Pop artists seemed interested in condemning or ridiculing the art they transformed; it just was what it was.

At Ileana's suggestion, Karp next steered Castelli to another Pop artist of the comic-book kind, though one working on a far greater scale than Lichtenstein. James Rosenquist was, in fact, a commercial billboard painter by day. He was also a Coenties Slip artist. Castelli was wary. Wasn't one Pop painter of commercial images enough? Despite strong support from Ileana, Castelli passed on Rosenquist, for the time being.

A pattern was emerging. Ileana and Karp were, by and large, the risk-takers, Castelli the reluctant come-along who ended up loving the artists they pushed him to sign. (Johns was the great exception, embraced by Castelli at first sight.) Even after signing, he was rather reserved with his artists. "Leo wasn't the guy the artists talked to," observed Morgan Spangle, the gallery manager. "Ivan was that guy. He was a character, and he loved being a character and was just as much a part of the underworld of New York as the artist. He was kind of outrageous, a big believer in artists, he would buy lots of work and trade heavily. Leo was the guy who understood and fulfilled an artist's needs." Almost always, a stipend was involved.

"We had a contract," explained Stella years later. "I said I don't want to work odd jobs. I wanted $75 a week—that was my stipend." With that, Stella said of Castelli, "he liberated me to be an artist full-time, then it was up to me." The stipend wasn't a gift; it was an advance against sales. "At the end of the year, if it was minus, he would buy paintings to make up the difference," Stella said, and then laughed. "I was with Leo until 1968 before I got to zero."

Being a Castelli artist was a kick, no doubt about it. "It was like a bodega," Stella recalled later. "He was very nice to everyone in the gallery. Bob and Jasper were the drivers, but he treated everyone fairly and well. He was even nice to Norman Bluhm, which took some doing." (Bluhm was a lesser-known Ab Exer.) But Stella was not as enamored

of Ileana and Karp as other artists seemed to be. "I never liked Ileana," he confessed. "She had a high estimate of herself. I thought she was a jerk. The myth is that it was all her ideas. She didn't know diddly about anything. She liked a few European painters, but Leo was the driving force." As for Karp, "I got along with him alright, but wasn't overly impressed. He was one of those guys who said he knew everything. He was good at reading."

When yet another painter of Pop images ventured up to the gallery at 4 East 77th Street, Karp, not Castelli, was there to receive him. The pale, awkward-looking figure with the white wig wanted merely to buy a Johns drawing of a lightbulb for $450 in installments, but he mentioned, in passing, that he did pictures like the one Karp had in his office by Lichtenstein.[55] Karp and Castelli came to the artist's studio, where they saw paintings of stamps, shoes, and Coca-Cola bottles.[56] How strange, they noted, that three fledgling artists unknown to each other had pounced on mass-culture images at the same time: Lichtenstein, Rosenquist, and now this character named Andy Warhol.

Again, Castelli said one comic-book artist was enough. Again, Ileana protested, as did Karp. But Castelli held firm. In truth, the artist had a fey, effeminate manner that put Castelli off. Oddly enough, Rauschenberg and Johns, whose long-standing romantic relationship had ended in anger not long before, found Warhol's manner irritating as well. "I know Ileana worked very hard to convince Leo to show him," recalled art critic Robert Storr. But Leo would not be moved, not yet. And so, in 1962 Warhol went with the smaller West 58th Street Stable Gallery, so called because it had once been a livery stable.

Irving Blum was more intrigued.[57] On the prowl in New York for up-and-coming artists he might show at the Ferus Gallery in LA, he called the artist to ask if he might stop by with his LA gallery partner, Walter Hopps. He knew that Warhol was a commercial illustrator of some renown, so he wasn't surprised to find that the artist occupied a whole residential building, powder-blue, on Lexington Avenue in the upper eighties.[58]

On this first visit, Warhol led Blum and Hopps back to the living room through a corridor with stacks of books, art pinned to the walls. As Hopps later noted in the *New Yorker*, Warhol was "a quiet guy with an ethereal look, so pale that he looked as if he lived in the dark."[59]

Much of what filled the apartment was Americana Warhol had found in thrift shops. Hopps recalled big enamel signs from gas stations, gumball machines, a barber's chair, and the pole from a barbershop. The living room was unusually large, like a meeting hall, with a stage at the far end. On the stage, the dealers saw a few easels with paintings on them. One was a painting of a telephone. Another was a canvas depicting a comic-book character. The dealers left unimpressed.

On a return visit, this time on his own, Blum saw three soup can paintings, propped up on the floor, and a picture of Marilyn Monroe torn from a magazine.[60] As they settled into the living room, Blum heard footsteps upstairs. "Don't worry," Warhol said, pointing at the ceiling. "It's just my mother." On every subsequent visit, Blum heard the footsteps. But Warhol's mother never came downstairs.

As early as June 1952, Warhol had exhibited realistic drawings at small galleries, including *Fifteen Drawings Based on the Writings of Truman Capote* at the Hugo Gallery.[61] But he desperately wanted to exhibit at a major gallery and become a well-regarded artist. Something Warhol said about Monroe made Blum sense the card to play. The Ferus, he stressed, was in Hollywood. Stars might come to the opening of his show, maybe even Marilyn Monroe. Warhol's eyes shone with excitement. Hollywood stars![62]

Warhol's show at the Ferus in LA opened on July 9, 1962.[63] It was his first one-man show as an artist, not an illustrator. On the walls were 32 hand-painted Campbell's soup can paintings, one for each flavor, priced at $100 each.[64] It was also the West Coast debut of Pop art. No stars were present, unless one counted actor/director Dennis Hopper, whose *Easy Rider* fame lay seven years ahead of him.

By the end of the show, Blum had sold five of the 32 paintings, but he had a serious case of seller's remorse. He had come to believe that

Warhol was the real thing and thought keeping the whole set of 32 paintings to himself might be wiser than pocketing $500 for the five he'd sold. Sheepishly, he called the five buyers, starting with Hopper, to ask if they would sell him back their soup cans. To his enormous relief, all agreed.[65] Blum persuaded Warhol to let him buy the lot for $1,000 on an installment plan of $100 per month, then hung them all in his tiny LA apartment on Fountain Street.

A little more than three decades later, in a deal arranged by MoMA curator Kirk Varnedoe, the paintings were acquired by the museum as a partial gift from Blum and a partial purchase by MoMA, with Blum $15 million the richer.

WARHOL HAD PAINTED THOSE SOUP CANS himself, one brushstroke at a time. Why, he thought, should painting take so long and be so hard? Why not silk-screen his images, then run off as many as he liked? He began to live by a dictum of his making: "Being good in business is the most fascinating kind of art."[66]

To eliminate his manual labor, Warhol needed a skilled silk-screener. He found one in a college student from the Bronx named Gerard Malanga, who had spent a high school summer making silk screened men's ties atop a commercial building in Greenwich Village for a designer who, as it happened, was a friend of a friend of Warhol's. Word was duly conveyed that the college student might be able to help. In June 1963, Malanga was asked to come meet the artist, ostensibly for a job interview. Warhol's first words to him, in his distinctively breathy voice, were "Oh, when can you come work for me?"

Two days later, having cleared out his desk at Wagner College, Malanga came to the decommissioned firehouse near Warhol's house that Warhol was using as his studio. It was so decrepit that New York City had rented it to him for $100 a year.

The silk-screened image Malanga and Warhol made that day was of Elizabeth Taylor: a silver Liz, as it would be known. The method behind it would revolutionize contemporary art, giving it the means to

go from unique paintings to as many nearly identical iterations of the same image as the artist wanted to run off.

Warhol started that day with an 8-by-10-inch publicity still of the film star, expanded at a photo lab to a 40-by-40-inch positive image on clear plastic. Step one was to lay tracing paper on top of a blank white canvas. Step two was to put the clear plastic on top of the tracing paper. Now Malanga could press down hard on the plastic with a pencil, imparting the lines of Liz's face to the tracing paper and canvas beneath. It was sort of like stenciling, or gravestone rubbing.

Next came the fun part. Putting the plastic and tracing paper aside, the two men outlined key aspects of the image on canvas with thin masking tape. They then hand-painted the tape-surrounded key aspects: pink for Liz's face, red for her lips, green for her eye shadow. Also by hand, they painted a silver backdrop on the white canvas. All this they did with water-based paint that dried quickly, so quickly that the colored-in sections would stay intact.

Only then came the silk-screening. A nylon mesh screen, stretched and stapled over a 40-by-40-inch wood frame, was laid over the canvas. The silk screen became the negative in what was, essentially, a photographic process. The silk screen's frame had an extra couple inches on all four sides to serve as gutters. Malanga squeezed black oil-based ink down one of the gutters. With a squeegee, he pushed the black ink across the nylon mesh screen. Warhol then took the squeegee from him like a baton in a relay race and squeegeed across from his side. In one fast, sweeping motion, Warhol pulled back the silk screen to keep the ink from muddling, and to leave shadings that made the whole picture—the final positive picture—so vivid. "We were basically repainting a photograph the old-fashioned way," as Malanga put it, "and yet doing something entirely new."

Andy's silk screens could be made at the rate of 40 or more a day with Malanga's full-time help. Each was a bit different from the others, given how the inks spread and coagulated. Each also got a bit thicker and more blurred until, after three or four renderings of the image, Gerard

stopped to clean the silk screen of ink. "Andy had an excuse for coagulation," Malanga recalled. "We called it 'embracing the mistakes.'"

The two worked together on all the large silk screens. The small ones Malanga did mostly on his own, though sometimes Warhol would do them. Later, when the Andy Warhol Art Authentication Board, Inc., denied that Malanga had helped make the large silk screens and made many of the small ones himself, Malanga shrugged. He didn't feel shortchanged, he said. He was always just Warhol's assistant.

Warhol knew just what he was doing. His silk screen prints were similar enough that they could be sold as commercial products, all monetarily equal, a brand like any other. Andy's prints made him a kind of Henry Ford of art, with his works produced on a human assembly line that grew larger when he moved from his firehouse to a former hat factory on East 47th street. How much of the art Warhol made himself, and how much was made by his factory assistants, was ultimately irrelevant. Buyers were learning to be indifferent to such nuances too. They were delighted to be buying the brand.

If Castelli had any lingering doubts about Warhol, they were wiped clean by Ileana's own Warhol show in Paris in November 1962 and then by Warhol's first New York solo show, at the Stable Gallery. But how could he ask Warhol to sever his ties with the Stable Gallery's director, Eleanor Ward? Castelli had adamantly avoided poaching artists from rival dealers. He lived by his etiquette, which all too soon would be viewed as quaint. Larry Gagosian would lure artists from their dealers; others would do the same. In the innocent early sixties, Castelli felt flummoxed, until Warhol convinced him that he would leave the Stable Gallery whether or not Castelli took him. With some hesitation, Castelli signed Warhol and weathered the Stable Gallery's indignation.[67]

Silk-screening—and more broadly the concept of multiples, whether as lithographs or fine prints—had a profound impact on the contemporary art market by the mid-1960s. Warhol could begin to tap a whole new market, running off as many silk screens as he thought he could sell. Rauschenberg, fascinated by Warhol's work, was making his own silk screens by 1962. Instead of knocking off scores of the same image, he

made one-time silk screens and incorporated them in unique artworks, delighting in the distorted sense they brought to mass-culture moments.

Not long after, in 1966, an Upper West Side mother named Marian Goodman and four other mothers started a co-op store selling prints and lithographs of well-known contemporary artists' work in editions overseen by the artists.[68] Her father, an accountant, loved modern artist Milton Avery, whom critic Hilton Kramer called "our greatest colorist," and had bought some 40 of his elemental landscapes and portraits. As a mother of young children at New York's Walden School, Goodman had embarked on what would be an extraordinary career by organizing school art shows. The other parents happily let her curate one room at each show for art she chose herself on the school's behalf. With nothing to lose, she called up Ab Ex painter Franz Kline and talked her way into his studio. "He gave me a whole pack of drawings and small oils," Goodman recalled. "I sold half of those…and then called to say I'd like to bring the other half back. He said don't worry, just keep them. I said, 'I can't do that.'"

"Well, please take your favorite," Kline said.

Goodman did—she has it still—and brought the rest back. "A week later he was dead—pneumonia," Goodman recalled. "They found him in his studio."

Through her store, Multiples, Goodman began working with Castelli and his second wife Toiny (they had married in the early sixties), and together they opened Castelli Graphics in 1969. Goodman came to revere the dealer. "He was a kind and generous man, and he did a great job for his artists," Goodman said quietly, years later. "He was selfless." Castelli helped inspire her to go to graduate school at Columbia and to leave a loveless marriage in 1968. "It was the first time I was free to pursue some of the hopes I had of my own. It was the first time I had a checkbook of my own."

Multiples would hardly compare to the gallery Goodman started, a decade later, to represent a new wave of German artists she came to admire. Nor would those early artists compare to the one she began representing in the mid-1980s. Gerhard Richter, after all, would become one of the world's top artists, widely admired and hugely profitable,

selling hundreds of works a year for prices up to more than $20 million each. But Multiples, declared critic Robert Storr, played as important a role as Warhol's Factory in broadening the market for contemporary art. "Marian opened up the grid in terms of what was possible to sell, and the numbers of people who could afford to buy them."

MAJOR COLLECTORS NOW FLOCKED INTO THE Castelli Gallery on a weekly basis, enough for Castelli to madden them with his waiting list. Robert Meyerhoff, a real-estate developer, and his wife, Jane, bought so much art that they had to build gallery wings off various parts of their home to accommodate it. Peter Ludwig, a German chocolate manufacturer, came to own more Johns and Rauschenberg artworks than the artists themselves did. Count Giuseppe Panza of Milan spent a fortune from his father's wine business buying every piece Castelli would let him, in clumps of a dozen when he could.

A young and somewhat unlikely addition to Castelli's circle of collectors was Don Marron, a tall and intense financier who had barely turned 30 when he sold the eponymous firm he had started and made contemporary art the great passion of his life. At first, Castelli all but ignored him. "As you entered the back of the gallery, you would approach a velvet rope," Marron explained. "Behind it was Leo in his office." This was the 77th Street town house; Castelli would not move to SoHo until 1971. In that office, Marron soon realized, were the dealer's best new works, and not infrequently the artists who had made them. Marron could see Castelli from the outer area; he just couldn't get Castelli to see him. Eventually Marron was allowed past the velvet rope. But that didn't mean he could buy whatever he saw on the walls of Castelli's inner sanctum. "Leo invented the 'thank you for your interest, we will consider it,'" Marron explained. "It's not like you got turned down, but your request wasn't accepted, and you never knew who you were competing with."

All these collectors were changing the art market by upping the ante on one or another of Castelli's artists, but none so much as two fiercely competing couples, one Waspy, one glaringly nouveau riche.

Burton Tremaine, an industrialist, and his wife, Emily, were eclectic in their art buying but focused early on Pop art, which, as Emily once wrote, enchanted them with its reflection of "the wonderful, vulgar, jazzy, free and crazy New York." The Tremaines were the WASPs. Robert Scull was their opposite: the brash taxi-company owner who hammered Castelli down on prices. He and his wife, Ethel, bought almost everything Castelli showed them. If they didn't love a piece, they could always take pleasure in having deprived the Tremaines of it.[69]

The pattern was set by an early Johns show. As Castelli later recalled, both couples beat a path to Johns's studio, but the Sculls got there first. They reserved two paintings. The Tremaines came in right after and picked one called *Device Circle*. "The next day," Castelli recounted, "Scull came back and wanted the same painting. He caused a terrible fuss over the fact that the Tremaines had already bought it."[70]

To give himself an edge, Scull in 1960 bankrolled a gallery, the Green Gallery, which enabled him to circumvent other collectors and their middlemen, the dealers. This was the gallery that had taken Rosenquist when Castelli declined to represent him. In charge was Richard Bellamy, one of the downtown art scene's most charming eccentrics, who drank liberally and tended to fall asleep wherever he found himself—including, once, in a wheelbarrow.

The arrangement with Scull carried a certain irony, since Bellamy was anything but a schemer, more like an Inspector Clouseau. Repelled by the idea of art as a business, he signed on as Scull's agent to benefit the artists he loved. One was Mark di Suvero, who used scrap wood and metal to make huge outdoor sculptures. Di Suvero had nearly crushed himself to death atop an elevator cab, bringing up oversized art as Pollock and Heller had done. Then there was Claes Oldenburg, who made supersized soft sculptures of everyday objects and staged "happenings" at his so-called store of handmade dry goods, which the Green Gallery helped underwrite. Nearly 60 years later, Oldenberg would still be going strong, showing new art at the Pace Gallery. Bellamy was an early supporter of George Segal's white, lifelike figures; John Chamberlain's sculpture from crushed automobile parts; and the huge, flat

paintings by promising billboard artist Rosenquist. To Scull's great annoyance, none of these artists enriched him early on, but their art delighted his dealer.[71]

Compared to Scull, Sidney Janis, still running his fourth-floor gallery on 57th Street, was an aesthete. By the fall of 1962, however, he was viewed by other dealers as the mercenary of the bunch.

Janis might have been hardheaded—a model for the future Larry Gagosian—but he did love cutting-edge art, and it was that combination of wheeler-dealer and aficionado that made him so potent in pushing the market for contemporary art. Any doubts that that market had arrived were dispelled on Halloween night in 1962, with a show so large it seeped from Janis's gallery into a huge space downstairs. The show, *New Realists*, included paintings and sculptures from France, England, Italy, Sweden, and the United States. As Janis wrote, the show belonged "to a new generation (average age about 30) whose reaction to Abstract Expressionism is still another manifestation in the evolution of art."[72]

Here was Pop art in all its daring, even bizarre, manifestations, from both sides of the Atlantic, showing the influence of Dada artists on the New York School, but also the influence of New York artists on Europe. Young Pop artists predominated. Oldenburg showed *The Stove*: plaster roasts and other faux-food products. Warhol showed *Do It Yourself* and *Dance Diagram, 5 (Fox Trot: "The Right Turn – Man")*. Lichtenstein displayed *Blam* and *The Refrigerator*.

It was all too much for the Ab Exers, whose work was dramatically absent at the milestone show. Appalled, some of the same Ab Exers who had left Parsons for Janis a decade before now left Janis too: Mark Rothko, Robert Motherwell, Philip Guston, and Adolph Gottlieb. Only De Kooning stayed on.

Unluckily for Richard Bellamy, the prevalence of American art meant, to Robert Scull, that he no longer needed a secret agent to decode who the important artists were. They were known to all. The only mystery was how rapidly their prices would rise, and Bellamy couldn't tell him that. Bellamy would stay on for some time, but Scull's dreams of cornering the contemporary art market were dashed.

Pop, Minimalism, and the Move to SoHo

1963–1979

By THE MIDSIXTIES, Castelli without question was New York's dominant dealer in contemporary art. Yet the 77th Street gallery remained a quirky place, as a young graduate student named Jim Jacobs discovered in applying to work there. At 21, Jacobs was a born salesman, and he knew it. Rather than apply for a job with whoever might be in charge of such things, he called the gallery and asked for Castelli directly. There was a pause, then a cultivated voice on the line. "Yes?"

"This is Jim Jacobs. I hear you have a job available." Jacobs was making this up. He had no idea if there was an opening.

There was a longer pause. "Yes, actually, we do."

When Jacobs arrived for his job interview, he was shown into Castelli's rear office. Jacobs never forgot the sight that greeted him: there was a man sleeping under Leo's couch. Castelli made no mention of him, so Jacobs didn't either. Halfway through the interview, the man awakened, staggered to his feet, then hugged Jacobs. "I'm Dick Bellamy," he said, and then the shambolic head of the Green Gallery shuffled off.

Jacobs was thrilled to be hired as Castelli's archivist, a job for which he found himself thoroughly unsuited. That was fine, since he proved a good salesman, and sales were what the gallery, to Jacobs's surprise, desperately needed.

"We couldn't make the rent!" Jacobs recalled later. "When it came due, we had to call Victor Ganz—a prominent collector even then—and get him to buy a painting. Or have Ivan Karp make the call to some other collector. Of all those artists in 1966—Jasper Johns, Rauschenberg,

Roy Lichtenstein, Cy Twombly, James Rosenquist—the only ones that were selling were Johns and Rauschenberg. Even Warhol—you could buy one of his flower paintings for fifty dollars. Self-portraits were one hundred dollars."

For Castelli, the rent squeeze was exacerbated by a whole new kind of art—and the conundrum about what to do with it. Castelli had heard of Minimalism, but paid it little mind until Richard Bellamy abruptly closed the Green Gallery in 1965, bequeathing him a trio of Minimalist artists.[1]

The deeply personal brushstrokes and color fields of Ab Ex had given way to Pop art, but Pop art wasn't impersonal enough for the Minimalists. The mission now was to strip art down to its core parts. Minimalists were mostly object makers. Sometimes they worked with store-bought materials like Plexiglas, fluorescent tubes, and galvanized steel. Geometric shapes were a good start, the world pared down to triangles and squares. By the late 1950s, Frank Stella was making three-dimensional shapes, many of them in black with pinstripes of bare canvas. Rarely was there a sign of the artist's hand, or any personal feelings, in these works. The Minimalists wanted art that didn't look like art. A New York–based group, the Minimalists banded around Donald Judd, who would come to be known for his copper-covered boxes stacked against a gallery wall like so many shelves.

Was Minimalism a movement Castelli should embrace, or a dead end? Certainly, it had little of the visceral appeal that Pop art did. The easy choice was to push it away and stick with the Pop artists whose prices, if not stellar, were steadily rising. But money had never been Castelli's first priority, and Bellamy's orphans were intriguing. Castelli was given first choice, taking Donald Judd, Robert Morris, and Dan Flavin.[2] Judd, in addition to his stacks of boxes, was looking toward room-sized installations. Morris was making sculptures from two-by-fours and gray-painted plywood. Soon he would be working with dirt and sliced industrial felt. And Flavin was charting his own path with white and colored fluorescent light bulbs.

Ivan Karp found Minimalism so mystifying that he felt forced to leave the gallery and start his own, OK Harris, when Castelli insisted

on supporting Minimalist art. But to Patty Brundage, one of the Castelli Gallery's longest-serving managers, Minimalism said it all—about Castelli. "Art, not money, was Leo's motivation," she would declare. "The proof is his commitment to Minimalists. He wouldn't have made it as a dealer today because it's all about the money."

One of the few other dealers who heard and heeded Minimalism's message was a young bohemian named Paula Cooper, who had come to New York in the midsixties to take art courses and support herself as a switchboard operator at Chanel.[3] Her first job in the art field was at a pre-Columbian and African art gallery in the Carlyle hotel.[4] In 1964, she opened an uptown gallery on 69th Street, across from Hunter College, in her kitchen, using her maiden name, Paula Johnson. There she gave land artist Walter De Maria his first show—of Minimalist sculptures, not land—in 1965.[5] The gallery was short-lived.[6]

Cooper's next move was downtown to an artists' cooperative called Park Place, near Washington Square. Several of the artists she came to know would soon be significant—like Mark di Suvero, the maker of outdoor sculptures who nearly died riding an elevator cab. Another was Robert Grosvenor, who worked both inside and out with brightly colored, soaring steel sculptures. Nearly half a century later, Cooper would still be working with both artists.

Divorced by 1968, Cooper used her $1,200 commission from the sale of a sculpture by Di Suvero and a bank loan of $3,000 to start a proper gallery of her own at 96 Prince Street.[7] And that, in turn, made her the first dealer of contemporary art below Houston Street. SoHo was a light-industrial neighborhood of sweatshops and small factories, with cobblestoned streets that grew desolate after dark. By the time Cooper arrived, artists were colonizing cavernous lofts in the cast-iron factory buildings, sometimes illegally, and using them as both homes and studios. "I wanted to be where artists lived," Cooper said later. "I had worked and lived uptown and thought this was a stultifying situation. . . . I just wanted to do what I wanted to do when I wanted to do it."[8]

Cooper made it all work on a shoestring budget. "I didn't have the money to fix the place up," she recalled later. "I swept the floor myself.

Any man who came in was commandeered to help change the light bulbs." A young artist named Lynda Benglis worked part-time, typing letters and paying bills.[9] Benglis would soon startle the male-dominated 1970s art scene with a gender-tweaking image, submitting a full-page ad for *Artforum* magazine in which the artist, naked, brandished an enormous dildo from her crotch. Roberta Smith, later a *New York Times* art critic, was one of Cooper's few full-time employees.

Cooper was committed to new art that defied conventional terms. Her gallery's first show, the October 1968 *Benefit for the Student Mobilization Committee to End the War in Vietnam,* included Donald Judd, Sol LeWitt, Robert Mangold, Robert Ryman, Dan Flavin, and Carl Andre.[10] Most of these artists would stay with her for years, if not decades. Cooper struggled each month to pay the rent, but she rarely despaired. "Where there's good art," she liked to say, "there's a way."

As she became a doyenne of downtown Minimalism, Cooper had enormous impact on the art she championed, but less so on its market. Minimalism would struggle to find buyers for years, until the artists moved on to Pace and David Zwirner. Judd was one of the few who sold consistently well. But Cooper would persist, year after year, arguably influencing the course of Minimalist art as much as, if not more than, Castelli.

Day-to-day, recalled James Cohan, one of Cooper's codirectors, her gallery was a "business based on nuance"—and Cooper herself. "There was no such thing as a staff meeting," Cohan explained later. "Sometimes I would discover what the next show was when the box of postcards arrived announcing the show. That was a kind of paradigm for how she operated, and how she treated her artists: total control. Not really interested in sharing her artists with other dealers." But her artists loved her and so, a bit grudgingly, did most of her staffers.

Paula Cooper wasn't the only dealer to challenge Castelli in the field of Minimalism. A tall, ascetic arrival from Boston named Arne Glimcher had opened a space on 57th Street and, by the late 1960s, was working up a roster of top-tier artists—a few of them Minimalists, many abstract—establishing the Pace Gallery as the commercial-minded challenger to Sidney Janis.

Later, Glimcher would say that some of his best moments in more than half a century as a dealer came in the late 1960s and early 1970s. Minimalists had pushed the boundaries of nonrepresentational art in site-specific situations, molding earth far from the urban gallery scene. Robert Irwin, the California-based installation and earth artist, did an early series of convex painted "dot" canvases that brought him into an association with Pace. Though rejected early on by critics, Irwin became the leading proponent of Light and Space art, pushing beyond the parameters of his studio. Subsequent works would encompass parks, neighborhoods, even vast landscapes. "Bob Irwin changed my life," Glimcher said. "He became my mentor. I visited his Venice studio and saw the dot paintings and that changed my life. The work had no relationship to anything that had ever been made before. And to this day we're together. I think he's one of the greatest living artists." Two of the other great Minimalists, Sol LeWitt and Donald Judd, were also associated with Pace, along with abstract painters Robert Mangold, Elizabeth Murray, Robert Ryman, and, on a mountain peak of her own, Agnes Martin, with whom Glimcher would have one of the most remarkable dealer-artist relationships of his life.

Like many dealers, Arne Glimcher had dreamed first of being an artist. In Duluth, Minnesota, where he spent his first years, he was often alone as the youngest of four siblings, and he spent hours drawing and painting. At his mother's urging, Arne's father—whose name was Pace—brought the family east to Boston for the children's school years. The move also exposed Arne to great art. He went to the Massachusetts College of Art, then graduate school at Boston University, where he studied alongside Brice Marden, later to be one of the foremost abstract painters of his generation, represented by Pace.[11] Glimcher found himself doing De Kooning-esque drawings, but they just weren't as good as De Kooning's.[12]

Early in 1960, when Arne was 21, his father died. The day after the funeral in Boston, Arne, his older brother Herb, and his mother walked along Newberry Street, looking at the galleries. Herb had already explained that there wasn't as much money as expected, so in addition to being in school Arne would have to work. When they noted a

ground-floor gallery at 125 Newbury Street for rent, Arne said, "What a great place for a gallery."

"Why don't you take it?" Herb responded. He was serious enough to lend Arne $2,400 as seed money to open a gallery.[13]

Arne soon after married his high school sweetheart, Milly, and the two ran the Pace Gallery together, helped by Arne's mother, who sat in when her son was at school. Arne filled it with work by the only artists he knew—his teachers—and had a first successful show; the teachers' friends bought all their work. Arne then staged the first Pop art exhibition outside New York. That got his name around. His real coup, though, was to persuade artist Louise Nevelson to let him have a Boston showing of her extraordinary wood sculptures. Nevelson was amused by his youth and came to the opening with Glimcher's promise of a room at the Ritz. There was a "click" between them, as Glimcher later recalled, the more so when he managed to sell several of her sculptures. Nevelson, who was between dealers, unsurprisingly chose Janis over Glimcher. But 18 months later, when she got into a wrangle with Janis over money, she knew whom to call.[14]

"Janis had advanced her $20,000," Glimcher explained. The dealer then locked her inventory in a warehouse as collateral. Nevelson was badly shaken. As Glimcher put it, she needed to be surrounded by her art. Without it, Nevelson was sliding into an alcoholic binge. She had sat on window ledges more than once.

Glimcher suggested that she leave Janis.

"How can I?" Nevelson wailed. "I owe him $20,000."

Glimcher, now 23, borrowed $15,000 and raised $5,000 by selling a Warhol and an Oldenburg to give Nevelson the $20,000 she needed to get out of debt. Janis was forced to return Nevelson's work to her, and Glimcher had a new client. "I loved her, and I knew what she needed," he said. "And passion is what it was always about."

In 1963, the Glimchers moved to New York and opened a gallery at 9 West 57th Street. Glimcher was thrilled to be there but felt, ever after, that had he come a year before, he would have represented Warhol and other Pop artists who had signed on with other galleries.

Shortly after opening on 57th Street, Glimcher was invited to a party at Jack Youngerman's loft on Coenties Slip. Barely 24, Glimcher was thrilled to meet Youngerman's wife, actress Delphine Seyrig, the glamorous new star of the movie *Last Year at Marienbad*. The room was filled with artists, including Ellsworth Kelly, Robert Indiana, and Agnes Martin, who lived directly below the Youngermans.

Martin was a formidable figure: a one-time competitive swimmer who had trained for the Olympics, a serious sailor, and a fiercely intense artist. "A lecture ensued about truth and beauty," Glimcher recalled. He was rapt.

Years passed before Martin agreed to take Glimcher as her dealer. Even then, she was wary. "Remember," she told Glimcher, "we are toilers together in the art field, but we are not friends."

Soon, in addition to Martin, Glimcher would represent world-renowned artists of one kind of abstraction or another, from Mark Rothko and Willem de Kooning to Robert Ryman, famous for his all-white paintings, and Robert Mangold, known for his monochrome paintings set off by geometric shapes. He would represent light artists Keith Sonnier and James Turrell, sculptor Tony Smith, and two of his other personal favorites: French artist Jean Dubuffet, whose rough conglomerations of cell-like circles challenged the very essence of representational art, and Chuck Close, the American painter whose huge, pointillist portraits dominated galleries of any size. He would have famous clients like David Rockefeller, LVMH CEO Bernard Arnault, and Hollywood agent Michael Ovitz. Yet he would never stop sparring with Castelli. "Leo had the best ear in the art world," Glimcher liked to say, meaning, a bit disparagingly, that Castelli worked the grapevine to his benefit. "Ileana [Castelli] had the best eye, and Ivan [Karp] did as well. Leo's charm carried him along. But Leo depended upon the two of them for finding talent."[15]

Castelli had the Pop artists, by now including James Rosenquist from the Green Gallery—stars that Glimcher had been a year late to sign up, so he felt. And André Emmerich had signed up most of the color field artists. "We didn't have any place to go except to highly individualistic artists," Glimcher explained. "We had old established artists, brand-new artists."

By 1968, New York was unquestionably the cultural capital of contemporary art, first with Ab Ex, then Pop, Minimalism, and a new kind of art: Conceptualism, in which the idea for an artwork was the critical element, more than the art itself. The contemporary art scene in other major capitals couldn't compare. While London led in pop music, advertising, and fashion, England had a relatively quiet gallery scene. Surprisingly, it was the notoriously uncommercial Minimalist art that began to bridge this cultural gap.

England had few art stars, and so a young English dealer was best advised to come to New York to see what the fuss was about. Which was what Nicholas Logsdail did that year at the age of 22. Few would have guessed he would go on to become one of the preeminent dealers of his day, bringing Minimalism from the United States to the United Kingdom. "Isn't it often the oddballs who become artists and dealers?" Logsdail suggested years later.

Shy and intense, Logsdail built a tree house at the age of 13 on his parents' property outside London and lived there until he left for art school four years later.[16] His interest in art, along with a streak of macabre humor, came from his uncle, writer and art collector Roald Dahl (author of *Charlie and the Chocolate Factory* and *Matilda*).[17] Dahl drove Logsdail from his family home in suburban Great Missenden—"nothing great about it"—to London in his Vauxhall Velox to shop for art. "He was so big and tall—six feet, six inches—that he'd had to extend the front seat to the back," Logsdail explained. "So on one side, no back seat." They would head for the Cork Street galleries, where Dahl knew the dealers. "Once we came back with a [1963] Francis Bacon triptych of George Dyer, Bacon's lover," Logsdail recalled of the artist whose nightmarishly distorted portraits put Bacon in a category all his own.[18] "Now it has an estimate of fifty million dollars. I remember it in his drawing room."

Logsdail enrolled at the Slade School of Fine Art. After a night of heavy drinking, he missed the last train home and slept on a bench by Lisson Grove next to a four-story house with a sign that read: For sale, no reasonable offer refused. The owner was willing to let Logsdail live at 68 Bell Street for free in exchange for fixing it up—a pledge

Logsdail could keep with skills from his tree-house years. He later took the owner up on his offer to sell the property for 2,000 British pounds. This became the Lisson Gallery, where Logsdail showed promising young artists such as Derek Jarman and even featured Yoko Ono for the gallery's fifth exhibition in 1967.

Logsdail began coming to New York every chance he got. On one of his first trips, he stopped in at the Castelli Gallery to see a show by light artist Dan Flavin.

"Louise Lawler was at the front desk, very pretty girl," Logsdail recalled. Lawler would become a major figure among artists labeled the Pictures Generation. In 1968, she was a gallery girl, as the term of the day had it, with artistic dreams. Her eyes brightened at his name. "I've got to tell Leo you're here!" Logsdail hadn't expected Castelli—or the receptionist—to know who he was.

"Out comes Leo, this elegant, dapper, sixty-one-year-old Italian gentleman. It was about ten minutes before one p.m. He looked at his watch. 'My lunch date has just canceled. Would you like to join me?'"

Over lunch, Castelli asked keen questions about the London market. When the subject of English dealers came up, he waved a finger. "They're very greedy," he said. As a result, many of his relationships with them had come unstuck. "Never expect that your gallery will make more than ten percent." Be happy with that, was Castelli's message. "One hundred percent of nothing gets you nowhere; ten percent of something gets you somewhere."

Logsdail took those words to heart. Like Castelli, he also refrained from the hard sell: people would buy the pictures or they wouldn't, it was up to them. Over time he would introduce most of the era's Minimalists and Conceptualists to London.

AT CASTELLI, THE YOUNG NEW SALESMAN, Jim Jacobs, spent much of his time coaxing artists to finish their works, nudging harder when the gallery's rent was due. He would help John Chamberlain weld his car-metal sculptures, then dash over to the Factory to do more silk screens for Warhol.

To help pay office expenses, Castelli started a poster business, with a poster for each artist's show. "We would sell them framed or unframed, for between ten and fifty dollars," Jacobs recalled. The posters were just announcements for upcoming shows; they weren't part of each artist's oeuvre. But to help sell them, the gallery did ask the artists to sign them. Often, that was a struggle.

"One day we needed twenty Rauschenberg posters signed," Jacobs said. "I jump into a taxi, head over to Bob's studio on Lafayette Street and open the door. There was Bob's studio assistant, Brice Marden, sweeping the floor." Marden waved Jacobs into the bedroom, where Rauschenberg was reclining. "Just get a pencil from Brice and sign them yourself," Rauschenberg declared. And so Jacobs did. Later, those posters would be worth hundreds of thousands of dollars.

"Jasper was the hardest to get to sign his posters," Jacobs recalled of Jasper Johns. "Always very serious. It was like pulling teeth, though he did sign them himself." Warhol was the easiest. He hated signing, so Jacobs and anyone else in the Factory that day signed them. Later, the posters took on a tradable value of their own as collectors clamored for any work associated with Castelli's artists, but that was never the intent.

Every Saturday, Castelli would throw open the gallery's doors to one and all. "By lunch it would start to fill up," recalled Jacobs. "Barney Newman, other artists, the Green Gallery's lovely dealer Dick Bellamy, collector Bob Scull." Castelli called it "friends of the gallery." On a seasonal Saturday, a newcomer could be forgiven for thinking those friends included every buyer, seller, and creator of art in New York. "The hardest thing to remember about the sixties is that it wasn't so serious," Jacobs reflected. "These works were not so valuable, and artists were more about making the work and being part of this small and wonderful art world."

INEVITABLY, WORD OF THIS MAGICAL WORLD reached the dreamers who needed it most: young aspiring artists in faraway places, teenagers with no more sense of what they were searching for than *something*,

and those who longed for the place where one just had to be. One of those was a college student named Peter Brant, who came to New York simply to meet Leo Castelli.

Unlike most such arrivals, Brant had a letter of introduction from Swiss dealer Bruno Bischofberger, the one whose life-size paraffin statue, along with that of his wife, Yoyo, would sell for $950,000 at Gagosian's Basel Art Fair booth in 2017. Brant would become one of Castelli's best clients. He would also become one of Warhol's top collectors. Like the Mugrabis, the Monaco-based art dealers Ezra and David Nahmad, and Gagosian, Brant would buy so many Warhols that he influenced Warhol's global market, bidding up the best of the works at auction.

The teenaged Brant had money to spare. His father owned a paper packaging factory, and his family had given him about $25,000, which he parlayed—so he later said—into considerable profits as an undergraduate.[19] Soon after Brant and Castelli met, the dealer sold him a Warhol drawing of a Campbell's soup can for $500, then a Warhol painting called *Shot Blue Marilyn* for $5,000. Other Warhol purchases followed. Through Castelli came word that Warhol was partly curious, partly concerned, to know who this kid was who was buying so much of his work. At Warhol's invitation, Brant went to the Factory, by then located on Union Square.

"I remember that first meeting like it was yesterday," Brant mused later. "The Great Dane with spots was in the front as you entered. Fred Hughes [Warhol's business manager] was very formal, but very generous. He introduced me to Andy, who was very frail—still recovering from a nearly fatal gunshot." Warhol had had a strange few years. He had stopped painting altogether—earning the scorn (and perhaps envy) of many artists—and was producing silk screen prints, up to 80 a day now at his new Factory. He was fascinated by photography, which the Ab Exers hated. He was also making movies, several lasting for hours.

Warhol had become famous for his art, but also famously odd. He seemed too shy to say more than "Gee!" or "Great!" Starting in 1967, he had hired an impersonator to appear at some of his scheduled

gatherings. A year later, on June 3, 1968, a radical feminist and para-noid schizophrenic named Valerie Solanas had emerged from the Fac-tory's elevator with a pistol in hand and shot Warhol, very nearly killing him.[20] It was the latest shooting in a horrifying season: Martin Luther King Jr. was assassinated in April, and Robert F. Kennedy died from an assassin's bullet on June 6, just three days after Warhol was shot.

"You felt like you wanted to protect him," Brant recalled. "After being shot, he had that great fear of appearing places." As he got to know Warhol better, Brant saw a canny businessman behind the wig and wispy voice. "I realized that he got people to deflect for him, and negotiate for him, but he was the mastermind behind the decisions. The movie deals—he was always there. He had the law firm Paul, Weiss representing him. He knew exactly what he was doing." When Warhol participated in advertisements for Absolut Vodka and Blackglama furs, Brant was not surprised. Warhol was just forging another link, this time between art and fashion, that future artists would seize as much for art and fun as for money.

BY THE LATE 1960S, CONTEMPORARY ART was a touchstone, a way of life, gathering to it the hip, the rich, and the adventurous. Dick Sol-omon, Glimcher's Boston partner, remembered a typical night. "It was October of 1968. Jake Javits was running for reelection as US senator, and there was a Rauschenberg opening on White Street. It was a hot evening, you could smell the marijuana smoke coming out. And at the top of the stairs was Marian Javits." Everyone in the art world knew Marian: she was a sultry beauty, decades younger than her husband and reputed to have lots of lovers. In 1968, she was at the height of her sensual powers. Her presence added an extra touch of glamour to the evening. "The whole art world was there," Solomon said. "And yet there couldn't have been more than two hundred people in the loft at that time."

The collectors in the crowd lived, by and large, in a sharply demar-cated zone that went from about 60th to 80th Streets, from Fifth Ave-nue over to Lexington, with a checkerboard of buildings: those that

counted and those that did not. In the fashionable buildings, noted Marc Porter, later a top executive at Christie's, was most of the great art of the postwar period. Now, in addition to Newmans and Klines, those collectors were putting up Warhols and Lichtensteins.

In the perfect world Castelli had built around himself, there was one unwelcome guest. Henry Geldzahler, a charming but undiplomatic character, was a rising curator at the Metropolitan Museum nearly 30 years Castelli's junior. He was the US commissioner to the Venice Biennale of 1966 and chose not to include Warhol, which irked both Warhol and Castelli.[21] Tensions grew on October 18, 1969, with the opening of an epic exhibit at the Met titled *New York Painting and Sculpture: 1940–1970*. It was "Henry's show" to his admirers and detractors alike, the capstone to ten years of building a contemporary art department for the museum. Castelli perceived slights in the way his artists were arranged for the show. He bristled when Geldzahler referred patronizingly to Castelli as a well-mannered continental, and when he credited Ileana Sonnabend and Ivan Karp—not Castelli—for discovering Rauschenberg, Johns, and Warhol. Above all, Castelli seemed to feel his age with Geldzahler. Castelli was, at 63, still New York's most formidable art dealer. But the new arbiter of contemporary art was Geldzahler.

In part to fend off the younger man and reassert his place, Castelli in the fall of 1971 presided over the opening of a huge cooperative gallery building at 420 West Broadway, in the heart of SoHo.[22] Overnight, the turn-of-the-century five-story building, a one-time paper warehouse, became the center of the contemporary art world.[23] Technically, it was a collective of outposts of established uptown galleries. Castelli took the second floor, Ileana and Michael Sonnabend the third, moody and hard-drinking dealer John Weber the fourth, and André Emmerich the fifth.[24] The dealers took equal spaces, but 420 was Castelli's kingdom.

Here, Castelli showed—along with a second wave of Pop artists such as Jim Dine and Claes Oldenburg—a roster of hard-core Minimalists and Conceptualists. One of the Castelli Gallery's new artists was Ellsworth Kelly, whose spare, simple geometric shapes had found

an audience at last. Kelly had gone from Betty Parsons to Sidney Janis in 1965, infuriating Parsons. In the early 1970s, he migrated to Castelli, who generously shared him with Irving Blum's new Manhattan gallery, Blum Helman. By then, Kelly had left the city, choosing near isolation in the upstate town of Chatham with his longtime partner, photographer Jack Shear. There, he would spend the next four decades depicting the bold, mostly abstract shapes he loved—circles, rectangles, squares—in the bright colors that made his work so strong and distinctive.

Sales of new work at Castelli by Rauschenberg and Johns, along with the best-known Pop artists—Lichtenstein, Rosenquist, Oldenburg, and Warhol—far outstripped most of the Minimalists and Conceptualists, Frank Stella excepted. Still, Castelli never considered cutting loose any of the laggards to better his bottom line. He was deeply loyal to them all. So would they be to him—for a while.

One of Castelli's close friends during this golden period was Ralph Gibson, a brash young photographer who would one day introduce Castelli to Larry Gagosian. Gibson lived steps away from 420 on Grand Street. Often the two men went for lunch to Da Silvano or Mezzogiorno, two nearby favorites. Castelli was fastidious about his weight: he always ordered a half portion. Just as often, the men would meet at 5 p.m. at the gallery for a glass of wine. "We discussed women and art," Gibson recalled later. "That's all we discussed!"

One night, Gibson arrived at the gallery to find a new Lichtenstein on the wall beside Castelli's desk. A call came in, as the men were sipping their wine, from a woman who wanted to buy it. "I don't think it would be right for your collection," Castelli said gently. "However, I do know one that would work for you."

As Gibson listened with amusement, Castelli called a Texan who owned part of another Lichtenstein for which he and his investors wanted about $500,000. Castelli offered to swap theirs for another Lichtenstein he had at the gallery. "By the time he got that painting out of their hands, sold his to them, then sold their painting to the lady

on the phone," recalled Gibson later, "he had lost $60,000 on the deal. And he was beaming!"

"Leo, you just lost $60,000," Gibson observed.

Leo smiled. "Some artists are more creative than others," he told Gibson. "Some collectors are more creative than others, and some dealers are more creative than others." By moving each painting to where it should be, Castelli had improved two collections. That, said Gibson, was what he lived to do.

With the opening of 420 came the first of the so-called gallery girls—the young, eager, and usually attractive receptionists who hoped to become dealers or artists themselves. Along with Louise Lawler, the future Pictures Generation artist, there was Angela Westwater, who would cofound her own gallery in 1975.[25] Her intense on-again, off-again romance with sculptor Carl Andre had brought her into the red-hot center of the SoHo art world.[26] As John Weber's gallery girl, she met one artist after another. Perhaps the most memorable, that fall, was Bruce Nauman, a West Coast artist whose claustrophobic constructions would lead him to mesmerizing performance videos—and global acclaim as a great Conceptualist.

"I met him in December 1971 when he had a show at Leo's, downstairs," Westwater recalled. "He was showing an installation with yellow lights, *Left or Standing, Standing or Left Standing*. The installation was a corridor created with plywood, one that grew narrower until a visitor felt trapped in it. Yet there was a comic absurdity in the title, a kind of joke that would appear in much of his work—for example, neon lettering that read *run from fear, fun from rear*. I just thought he had incredible composure," Westwater said. "A strong but quiet presence." Soon she would go into business with two European dealers as Sperone Westwater Fischer and represent Nauman for 40 years.

SoHo was a gritty but beguiling place in those days, with new galleries opening almost weekly. Later, Ralph Gibson would recall walking those cobblestoned streets like a Parisian flaneur, chatting up the young dealers and gallery girls. Yet already it was changing. "A certain

civility started to fall away," suggested Irving Blum, the West Coast Warhol dealer. Blum still made deals with a handshake, but the market was heating up.

A seminal event occurred on October 18, 1973, with the sale of some 50 artworks from taxi magnate Robert Scull's contemporary collection at Sotheby Parke Bernet, the art auction house. Robert Scull was considered "an amateur, parvenu collector" whom Castelli characterized "as a voracious and compulsive buyer...who wanted to collect everything—works, artists, galleries, even dealers—at very low prices."[27] The Scull auction was the first sharp financial turn of the contemporary art market, changing it from what it had been to what it would become.

Record prices were set with almost every artwork that night—the first evening sale for contemporary art. Ben Heller, the Pollock collector, caught the mood, raising his paddle again and again until he had bought *Double White Map* by Johns for $240,000, twice the record for a living American artist set by Georgia O'Keeffe's *Oriental Poppies* at $120,000. He had the money to spare: not long before, he had sold *One: Number 31*, the big Pollock he had unrolled with the artist in his apartment in 1953, to the Museum of Modern Art for $900,000.[28]

The sale stirred the crowd to a near frenzy, with works by top artists of the last 15 years—from Twombly to Warhol, Rauschenberg to Kline—soaring past their estimates for a mind-boggling total of $2,242,900.[29] At the front of the room amid the frantic bidding was Castelli. Arguably, it was he who had done more than anyone else to make this mayhem happen. And while he remained the art world's most debonair dealer, he was also the Sculls' dealer, and they his biggest clients.

Along with its record prices, the night would be remembered for a post-auction standoff between Rauschenberg and Scull, though most accounts appear to be wrong about how it played out. Rauschenberg, like most of the living artists who had just seen their work sell for unheard-of prices, was of two minds: pleased that his work had fetched so much on the secondary market and irked that none of that resale money was going to him. In one of the more dramatic moments, a

combine that Rauschenberg had sold to Scull via Castelli in 1959 for $900 went at the auction for $85,000.[30]

"I've been working my ass off for you to make that profit," an angry Rauschenberg exclaimed to Scull in an apparently staged encounter. The taxi king countered by saying that he'd done only good for the artists by raising their prices overall. "I've been working for you too. We work for each other."[31] The truth was that everyone that night was excited by the money, and almost everyone went home wealthier than when they arrived.

The prices did more than raise the value of works for sale that night. They made auction prices the new and permanent metric of value in art. This was a false measure, since auction prices were almost always higher, sometimes significantly, than primary prices: the excitement over a work with an established value drove prices up, along with the tendency of bidders to let their hearts dictate their actions. But since private sales were usually kept secret, auction prices were the only ones to go by.

All too soon, the Scull sale was overshadowed by financial turmoil in the art world. Recession was upon the land, and nowhere were the fiscal straits so dire as in New York. Few collectors felt flush enough to buy any art, let alone the Minimalism and Conceptualism of the 1960s and early 1970s. One of the few collectors who jumped in with both feet to buy more art in the 1970s despite the recession was Charles Saatchi, a brash young Iraqi-British advertising man who, with his brother Maurice, turned Saatchi & Saatchi into a global powerhouse. The firm's 1979 slogan for the Conservative Party—"Labor Isn't Working"—would help make Margaret Thatcher prime minister. By then—encouraged by his Sorbonne-educated, American-born wife, Doris—Saatchi was obsessed with buying contemporary art. He was famously press shy, a curious trait in an ad man and art promoter, and one that would arguably hurt him in the end. He could also be ruthless, offering dealers half the quoted price of an artwork or less, even if the price was modest relative to similar works. For the Baghdad-born art buyer, bargaining seemed to be a sport.

Whether Saatchi was really a collector or a dealer would be hotly debated. The truth was that, over time, he would buy and sell with an

eye toward profits and oversee what amounted to a gallery, though he would call it a museum. Certainly none of the dealers he patronized—Gagosian and Boone chief among them—cared what he was, as long as his checks cleared.

Nicholas Logsdail, the shaggy-haired young British dealer, was for a brief, heady time one of Saatchi's top dealers too. At a social dinner in the seventies, he overheard Saatchi declaring photorealists the most important artists of the day and told him flatly he was wrong. Saatchi was startled. "Alright then, who are?" he asked. Logsdail rattled off a list of Minimalists. Six months later, a brand-new Jaguar convertible pulled up in front of his London gallery. Out popped Saatchi with Doris who, as Logsdail recalled, was wearing a fur coat in May. Saatchi nodded at the works on display. "I want that one, that one, that one..."

"I thought you liked the photorealists," Logsdail said weakly.

"No, you were right," Saatchi declared. "It took me six months to sell off my photorealists. Now it's Minimalists I want."

"Even Sol LeWitt?"

Of all the Minimalists, Saatchi had seemed most skeptical of LeWitt, selling his instructions for how to make his art, but not the art itself.

"No, not LeWitt," Saatchi said. "I don't get him."

But before long, Saatchi was buying LeWitt from Logsdail too.

CASTELLI WEATHERED THE 1970S MORE ABLY than most. His top artists were still selling, Johns especially, and by the end of the decade he was planning to open a second SoHo gallery, at 142 Greene Street.[32] But where were the new artists who would galvanize the market as Rauschenberg and Johns had done two decades before? After Pop art, Minimalism, and Conceptualism, what came next?

Unknown as they might be at the start of 1979, those artists were coming. And in their midst, smelling a fortune in these new kinds of art, was a new kind of dealer named Larry Gagosian.

THE EIGHTIES EXPLODE

1979–1990

Young Man in a Hurry

1979–1980

IF LEO CASTELLI'S PROSPECTS as a young man were modest, Larry Gagosian's were a good deal more so. In his early thirties, circa 1975, he had a storefront gallery in Westwood Village, an affluent neighborhood in Los Angeles that was home to figures in the entertainment industry. The gallery, Prints on Broxton, was small, and what Gagosian showed was art photography, not great art. He had frittered away his twenties on humdrum jobs and even now seemed to harbor little ambition. As he noted later, his friends had no more ambition than he, so his own lack of it didn't really bother him. Castelli, also feckless into his thirties, at least had landed a wonderful wife and wealthy father-in-law. Gagosian had neither.

One day, as he was flipping through an art magazine, Gagosian paused at the work of a photographer who intrigued him. Gagosian assumed the photographer was based in LA. Only when he called information did he realize that Ralph Gibson was in New York. Gagosian dialed the number and gave his pitch. "I've got this gallery in Westwood," he said. Would Gibson consider letting Gagosian stage an LA show of his work?[1] "It was very naive," Gagosian admitted later. "Ninety-nine percent of the people you got on the phone like that would have blown me off. Luckily, he was a nice guy."[2]

"Well, you have to come to my studio," Gibson suggested.[3] He figured if Gagosian was serious, he would make the effort and come to New York. Gagosian readily agreed.[4]

In person, Gagosian was even more appealing—a tall, rangy guy with a piercing gaze and an olive complexion that hinted at his Armenian roots. With Gibson, he was at his most charming: brash and irreverent, with a quicksilver wit. Gibson was a strong presence himself, with Grecian blond curls, a Roman nose, and New York swagger. Over a few glasses of wine, the two formed a bond. Gibson, as it turned out, was represented by Castelli. Happily the photographer introduced his new friend Larry to Leo.[5]

Gagosian got his Ralph Gibson show in LA at the renamed and upgraded Broxton Gallery.[6] The photographer himself flew out for it and was stunned by all the attractive women who appeared at the opening; even then, Gagosian knew how to fill a room. Soon, the future dealer was making regular trips to New York, reintroducing himself to Castelli and meeting anyone else who might help him start selling art in the city where so much of it was made. He had almost no money, but he managed to stay in the Stanhope Hotel, directly across from the Metropolitan Museum, thanks to an Armenian hotel manager who gave him a small room for $40 a night.[7]

As Gagosian made his SoHo rounds and learned about art, the artist who intrigued him more than any other was Cy Twombly. He liked Twombly's cryptic but lyrical scribbles and mark making, and the titles with their allusions to classical tradition. He also liked what he heard, that Twombly was undervalued after moving to Italy in 1957, more or less dropping out of the New York art world.[8] Soon enough, Gagosian's efforts to buy Twombly drawings brought him a call from a somewhat vexed dealer named Annina Nosei. "We're looking at the same thing," declared Nosei, who had loved Twombly since her high school days in Rome. "Let's join up."

Gagosian soon realized that Nosei had an eye for new talent. Bruno Bischofberger, the Swiss dealer who had bought so much Pop art and would later be cast in wax, took her suggestions very seriously. Finding new artists and cultivating their careers—that was the primary market to which almost every dealer aspired, the market that Leo Castelli commanded. Not only was primary art more of an adventure: the split on

sales between artist and dealer tended to be fifty-fifty; a dealer selling secondary art was likelier to get a commission of 10–15 percent. Who, asked Gagosian, was Nosei's next up-and-comer? Nosei liked a young Brooklyn artist named David Salle, who had graduated in 1975 from the California Institute of the Arts, better known as CalArts, the West Coast seedbed for contemporary artists.[9]

Salle opened the door of his Brooklyn apartment to Gagosian and Nosei with some incredulity. Twenty-seven and just married, the brooding, intense artist was deeply committed to his work but also worried he might not ever make a living by it.[10] Nosei had already made a studio visit. A young dealer named Mary Boone had come more than once. Neither had bought any of his art or offered to take him on.[11]

Gagosian surprised him. The dealer was interested in the seven or eight paintings Salle showed him, each dominated by clearly recognizable figures—mostly women—in carefully delineated segments of the canvas. Salle, like his California Institute of the Arts classmates Ross Bleckner and Eric Fischl, was onto something notably different from Minimalism.[12] Gagosian liked that. He also thought he could sell Salle's work. It was sexy. Gagosian bought one of the paintings himself and said to Nosei on the spot, "Let's do a show in the loft."[13] He meant the space that he and Nosei had started using as a temporary office.[14]

The loft that would change Gagosian's life as a dealer was on the fifth floor of a building at 421 West Broadway, directly across from the Castelli Gallery at 420. Later, Nosei and Gagosian would offer differing versions of how they came by that loft. Nosei would recall that she and Gagosian rented it from her ex-husband, John Weber, one of the dealers at 420. Gagosian's version involved an art-shipping acquaintance whose company was developing 421 as a residential building and had one space left for sale. Gagosian could buy it—but only if he committed to it that day.[15]

"I said, 'I'll take it,'" Gagosian later recalled. "It was $40,000, which I didn't even have in my bank account. And then I realized, 'Jesus, I've got to pay for this thing now.'" Gagosian told the developers he had a Brice Marden painting. Would they be interested in taking it for the

loft? The painting was called *For Otis*, about Otis Redding, the late great R&B singer. The developers agreed. "So I gave them the painting and got the loft."[16]

The loft was empty, with a bathroom but no kitchen, and a back area that could serve as a bedroom if need be. Its greatest feature was the view. "We could look into Leo's windows," Gagosian later marveled, and it was true: they could literally look down at Castelli's second-floor gallery across the street, and Gagosian could imagine being the king of contemporary art himself someday.[17]

In advance of the Salle show in SoHo, Gagosian hired a young designer named Peter Marino to transform the loft. Marino, a Cornell graduate, looked very Ivy League, Gagosian recalled, which was to say the future designer of coolly elegant interiors had not yet cultivated the look that would make him notorious: the black leather and chains, black boots, and black police hat, a portrait in gay bondage bafflingly at odds with his heterosexual marriage.[18] Gagosian had met him through a diamond dealer named Ara Arslanian, who had a whole floor upstairs and had hired Marino to design it. Arslanian was another of Gagosian's Armenian friends. They were members of a diaspora who helped each other when they could. "I don't have much money," Gagosian told Marino, "but would you help me with my loft?" Marino gamely agreed. "Well, to say that Peter Marino designed it is misleading because it involved, like, a can of paint," Gagosian explained.[19] "I think I traded him a Twombly drawing for his services."[20]

Salle's show—the artist's first—opened in the fifth-floor loft one night in the fall of 1979.[21] One visitor was art critic Peter Schjeldahl, later of the *New Yorker*, who recalled finding an "'aftershave-ad-handsome' owner who said he was giving the art business two years to prove itself." If nothing came of the business by then, Gagosian told Schjeldahl, then he'd try real estate.[22]

LAWRENCE GILBERT GAGOSIAN, BORN IN LOS Angeles on April 19, 1945, differed in many ways from the dealers he would come to know and compete with so aggressively.[23] For one, he was born into a

family of modest means. For another, his grandparents were Armenian immigrants, not Europeans, with the Armenian genocide of 1915 still haunting their dreams.

Larry's forebears had lived for generations as farmers in Armenia and a half dozen villages of eastern Turkey. Life became intolerable by the 1890s, when the Turks began a series of massacres against them. Making rough ocean crossings in steerage, one or two relatives at a time, Larry's paternal grandparents and great-grandparents immigrated to the United States. Nearly all made their way to Fresno, California, 220 miles north of LA, where the first arrivals had found work in the agriculturally rich San Joaquin Valley and passed on the word to family back home.

One of Larry's grandfathers was a tailor; the other worked a conveyor belt in a dry-cleaning sweatshop. Larry and his parents made family visits most weekends, and through his early childhood, Larry spoke mostly Armenian. All his friends were Armenian. He felt the whole world was Armenian.

Larry's father, Ara, started as an accountant for the city of Los Angeles.[24] His Massachusetts-born mother, Ann Louise Tookoyan (spelled variously as Tookoian and Toakin) harbored acting ambitions.[25] "She wasn't a big actress, but she made a handful of movies," Gagosian later recounted. "She was in one called *Journey into Fear* [1943], which starred Joseph Cotten. She played a nightclub singer." The film, a noir classic, was produced by Orson Welles's company, Mercury Productions.[26] Though no Ann Louise Gagosian or Tookoyan is credited in the full cast list, an attractive woman does appear briefly at the microphone in a nightclub scene. His mother had a beautiful singing voice, Gagosian recalled, and had a local radio program.

Ann Louise's brother, Arthur Tookoyan, was also an actor and singer. He did a lot of musical comedy and at one point had a nightclub act in Manhattan at a place called the Living Room. He even reached Broadway, playing a pirate in the 1954 production of *Peter Pan* with Mary Martin. Between roles, Larry's uncle lived in the family's small downtown LA apartment where Larry spent his first years.[27] Larry's

younger sister Judy Ann made the apartment a tighter fit with her arrival in 1950. "The five of us in a one-bedroom apartment," Larry remembered. He slept on the couch, but he never felt deprived. "As a child you adapt. Tight quarters? You don't chafe." He had no idea that people had second homes. "The concept of a weekend house—I'd never heard of it. We didn't go to the country—we had one house and one car."[28]

Larry would tell one girlfriend that his father was an "ornery" man who drank too much.[29] Later, he would amend that. "He did like to drink, but...he usually had it under control. Not an alcoholic. He was in his way a workaholic, so a little unavailable emotionally. Never really made any big money, but diligent." In another interview, he would say that his mother put her acting dreams aside to become an accountant.

Desperate for larger quarters, Ara Gagosian went to night school for a stockbroker's license and, in the prosperous 1950s, did well enough to move his family to upwardly mobile Van Nuys, located in the San Fernando Valley with a bustling Armenian community.[30] In his Birmingham High School yearbook, Larry looks studious in the Latin club photo. At Ulysses S. Grant High School, from which he graduated, he competed on the swim team. He was at least six feet tall, rangy and powerful.

Art played no part in the young man's life. "I think at one point my mother might have been lent a couple of little seascapes by a friend, but we didn't really have any art at home," Gagosian told his friend and client Peter Brant. "I don't even remember if I went to a museum before I graduated from college. I may have gone to the L.A. County Museum of Art once or twice, but that would've been it," he explained.[31] What interested him was fashion. "I was always very focused on how people dressed. Appearances."[32]

Gagosian worked his way through the University of California, Los Angeles, majoring in English literature but taking no art history courses. In part because he had to support himself, in part because he dropped out a couple times, it took Gagosian six years to earn his BA in 1969.[33]

By then, the future dealer had managed to start and end a marriage, to a woman named Gwyn Ellen Garside.[34] The wedding was a five-minute ceremony in Las Vegas. Garside accused Gagosian of "extreme cruelty" that caused her "grievous mental suffering," the standard legalese.[35] In one published account, the marriage lasted all of 16 days. Legally, it was annulled some eight months later. Apparently, Gagosian was embarrassed enough by the incident to lie about it in 1991: he told a reporter the marriage had lasted five years. Confronted by the discrepancy, he said he had forgotten the details.

Upon graduating from UCLA, Gagosian landed the classic Hollywood entry position: delivery boy in the mail room of the William Morris Agency. He delivered scripts to agents and producers. He was a secretary too. He took dictation at one point from superagent Michael Ovitz, and he worked for Stan Kamen, who represented two of Gagosian's favorite actors, Warren Beatty and Steve McQueen. Still, he didn't fit. "I just didn't have that DNA, to be in an office. Whatever I was going to do, I was going to do it on my own."[36] After 12 or 18 months—accounts vary—he was fired.[37]

With no idea of what to do as a career, Gagosian fell into a succession of low-level jobs in LA. He worked at a record store, a book store, even a supermarket.[38] At one point he met a beautiful dancer, a soloist for the Merce Cunningham Dance Company, Catherine Kerr, and stopped looking for work altogether. In love for perhaps the first time, he moved into her New York apartment on Second Avenue off Houston Street, and when she went out on tour, Gagosian came with her. "I traveled around the world with the Cunningham dance company, got to meet all sorts of people," Gagosian said later. Whenever the troupe came to a new city, a prominent family would want to host a dinner. The young man who had never seen wealth up close studied every aspect of those households. "I thought it was fascinating just to see how people lived."

For a while, the two were engaged. After their breakup, Kerr later recalled, Gagosian suggested she buy a drawing from Jasper Johns, at that time the artistic director of the Cunningham company, for

Gagosian to sell.[39] "The idea was that I would ostensibly buy it, but he would pay for it and then sell it," Kerr said. "I told him that I wouldn't do that." Gagosian would go on to decades of mostly art-minded girlfriends, managing not to marry any of them.

Back in LA with no more prospects than before, Gagosian took a job as a parking lot manager. At least the money was good.[40] He noticed a man selling posters near the parking lot and thought maybe he could do that. "It was really kind of a fluke," Gagosian told *Bidoun*, a magazine covering Armenia among other Middle Eastern countries.[41]

"I started selling posters because I thought I could make more money that way than parking cars. Simple as that. I saw somebody else selling posters and I basically just copied their business. It was a total lack of imagination. Of direction, really. It was just like, I could sell posters instead of just parking cars, so I was parking cars and selling posters and making more money and it just led me to a kind of wonderful life as an art dealer. There wasn't a plan to get into the art world; I didn't see this as an entry point. It was not a professional decision—if I'd seen somebody else selling something, I might've sold that. I was very lucky that it turned out to be a career path."[42]

Possibly, something deeper than chance was at work. Don Thompson, author of *The $12 Million Stuffed Shark: The Curious Economics of Contemporary Art*, an overview of the market, suggests that a characteristic of many dealers is that they "came from émigré communities or grew up as ethnic or religious minorities and not quite accepted by their peers in their new society. Art dealing became a way of proving, over and over, that they bring a superior aesthetic and better negotiation skills than their clients who made millions as merchants or from a profession."[43] As Gagosian would put it, he had "a natural feel for selling. Innate cleverness is part of my DNA. My judgment isn't always right but I tend to be able to size things up."[44]

GAGOSIAN STARTED WITH "SCHLOCK," AS HE referred to it: pictures of big-eyed cats with balls of yarn and the like. The profit was in framing them. "I mean, it was not what you'd find in the poster shop at the

Whitney or MoMA. You would buy the poster for fifty cents. It wasn't really a poster, it was a cheap print," he explained. "The frame would cost you two, three dollars, and...it was just like, *get them to buy it*. You know—ask for twenty dollars and be prepared to take anything north of ten. It was a street business. It wasn't about psychology...this was kind of the bottom of the barrel."[45] Gagosian would "make a couple hundred bucks a night, which was a lot of money."[46]

At some point, Gagosian noticed that his posters were made by an Ira Roberts of Beverly Hills Fine Art Reproductions. "Ira Roberts would print these little pamphlets to advertise the schlock posters they were selling, but on the last page they'd have posters that were more expensive, so I started trying to see if I could put a frame on one of those and maybe get $200 or $250. That's what really got me excited about art."[47]

Soon Gagosian was hooked, both on the challenge of selling more expensive posters, and the pleasure, at age 30, of making decent money for the first time in his life. "I didn't grow up with money, so it was nice to be able to buy things and get a better place to live, you know, all the things that come along with a certain amount of success," he noted. "And that was very seductive."[48]

The posters did more than earn Gagosian good money. They opened him up to art—in particular, to Picasso. "I devoured every book on Picasso, I was fascinated by his energy, his power, his psychology, his dramatic intensity." Picasso, he realized, was an artist in whom he could lose himself, who represented a world of "beauty, wildness, sexuality." Picasso was the "absolute artist," Gagosian declared, and so his course was set.

Soon after, Gagosian opened a framing shop to frame the posters he was selling. Kim Gordon, who would become bassist and vocalist for the punk group Sonic Youth, worked briefly for him. It was her first job after high school, and Gagosian was a tough boss. "He was mean, yelling at us all the time for messing up, being too slow, just plain *being*," she subsequently wrote. "He was erratic, and the last person on the planet I would have ever thought would later become the world's most powerful art dealer."[49] Gordon would later become a receptionist for

Gagosian in New York, apparently having managed to improve her relations with him.

As Gagosian went from framing to selling photographs and fine art, he began to regard himself as an art dealer, not just a retail store salesman. As he did, he wondered how to cultivate Hollywood executives as clients. There would come a time when he could call entertainment mogul David Geffen and other top collectors whenever he liked, but in 1978 he needed a conduit. He found one in a customer who just happened by the gallery one day and walked in, amused by what Gagosian had put in the window of his shop.

While the gallery was quiet, which was most of the time, Gagosian read about serious art and, to the extent he could, began acquiring works he could sell. "Almost as a lark I put a Joseph Beuys sculpture in the window," Gagosian recounted later to *Vanity Fair*'s Bob Colacello. "Barry Lowen walked by and thought, 'What the fuck is this doing here?' And he walked in. He didn't buy the Beuys, but we hit it off, and he became one of my best clients and also a very good friend."[50]

Lowen was a television executive and passionate collector of contemporary art, a rarity in LA in the seventies. After that first visit, he started dropping by and turning Gagosian on to artists he liked and collected. "Barry was a tastemaker," Gagosian later explained. "In the way that Edward G. Robinson spawned all the Impressionist collectors in Hollywood, Lowen spawned most of the contemporary collectors. He was a real advocate of collecting. He was the hippest and the smartest."[51]

Through Lowen, Gagosian met television producer Doug Cramer (of *Love Boat* and *Dynasty*). Cramer, in turn, introduced Gagosian to his ex-wife, columnist Joyce Haber. Haber sold her collection of California art to Gagosian, and he was able to resell it at a handsome profit. Eventually, through Lowen and Cramer, Gagosian would also meet David Geffen and real-estate magnate Eli Broad, both major collectors.[52]

As an LA dealer, Gagosian was on his way. Now it was just a matter of conquering New York.

FOR A SHOW OF EIGHT OR ten paintings in a modest loft no one had heard of, David Salle's fall 1979 opening in SoHo was a slam-bang success. Along with the three paintings sold to Bischofberger, the Texas-based De Menil family bought one, and so did Charles Saatchi. The paintings were priced at about $2,000 each, or about $6,750 in present-day dollars, hardly a bargain for a brand-new artist.[53] Gagosian had already learned a key lesson of the art market: never underprice the work.

Mary Boone was another visitor that night. She came from across the street, where she had her own gallery at 420 West Broadway in a street-floor storage space that could only fit five or six paintings on its walls. It was so small that Boone wondered if Castelli even knew she was there.[54] She fit the space perfectly, petite as she was. Craning her neck to chat with Gagosian at the Salle show, she told him he was right: Salle was the real thing, and she had been wrong to hold back in her previous visits to his Brooklyn studio. She had started out, as she later put it, with grave suspicions about figurative painting. She recalled being "pretty shocked....The pictures were a combination of strange, comical, awkward and unwieldy."[55] She was just now shaking off those doubts and wanted to know how Gagosian would feel if she took on Salle as one of her artists.

Boone might be half Gagosian's size, but she had every bit as much ambition. Born in Erie, Pennsylvania, to Egyptian parents, she had suffered the loss of her father when she was just three years old and had grown up grimly self-reliant.[56] "My mother was a dreamer, but a strong woman," she recalled.[57] She had attended the Rhode Island School of Design and come to New York at 19, only to realize she was qualified for virtually nothing. She started in the midseventies as a secretary at the Whitney Museum, then moved up a rung with more responsibility at the Bykert Gallery on Madison Avenue, working for codirector Klaus Kertess, who kept to a strict diet of Minimalist, Post-Minimalist, and process art.[58] Kertess became Boone's mentor. She was sold on Minimalism, but the gallery struggled. In 1976, Boone used her

new contacts to assemble a syndicate of seven backers and went out on her own.[59] It didn't hurt that she was a beautiful woman, fine boned and charismatic.

New York City in 1977 was bankrupt, so as Boone put it, "There wasn't a lot of room for art." Conceptualism seemed to define the late seventies, at least as far as Boone was concerned. Intellectually, that seemed right; commercially, it was a hard sell.

It was in a restaurant called the Ocean Club that Boone's life as a dealer took its first dramatic turn. She had come to represent a young artist named Ross Bleckner, and Bleckner, in turn, had told her about an artist friend she really should see. The friend was working as a cook, and he strolled out of the kitchen to introduce himself. Julian Schnabel brimmed with confidence—the prodigy of a decade not yet begun. One of his sous chefs was David Salle. Bleckner was the social glue between them. "Ross had been generous to the others because he had money, and he and Mary had bonded," explained critic Robert Storr. "So he was a rich boy scene maker at a time [when] he was around much more talented guys who weren't rich." As for Schnabel, said Storr, "he made good stuff and dreadful stuff, and no one could tell the difference."

That night, Schnabel insisted that Boone come over to his studio. She was bowled over by what she saw: big, busy, painterly paintings, the bold strokes so reminiscent of Ab Ex action painters, yet somehow utterly new.[60] She had sworn never to sign an artist the first time she met him—and certainly not a figurative artist—but Schnabel pressured her: if she didn't sign him up right then and there, he would go with another dealer. That night she broke her own promise, and Schnabel became her rocket to the top of the art world.[61]

Boone put Schnabel in a group show in February 1979.[62] That September, she opened another group show with Schnabel prominently represented. It was a huge success. Two months later, in November 1979, came the show that changed Schnabel's life—and Boone's. On a trip through Europe, Schnabel had admired Antoni Gaudí's use of mosaic tiles in his public sculptures at Park Güell in Barcelona. He had come back inspired to make paintings festooned with broken crockery.

The show was a sellout.[63] It was also the night that Gagosian and Nosei opened their Salle show across the street. The downtown art world sprang to life, and the decade of Neo-Expressionism—the return to figurative art, or at least a move away from Ab Ex and Minimalism—began.

BOONE SAW SALLE IN THAT NEW context. Gagosian could hardly object to her taking him on: Gagosian's loft was not a proper gallery. Nosei was planning to open a gallery of her own on Prince Street but had not done so yet. The three struck a deal. In return for taking Salle, Boone would let Nosei have a one-time Salle show when she got up and running. "That seemed to take care of the New York side of the equation," Salle recalled. "But soon after, I started showing with Larry in LA. By then we were connected."

In his Peter Marino–designed loft, Gagosian had more shows and more parties—loud ones, he later admitted, with pulsing music, noisy enough that the building's other tenants grew furious with him. "The building freaked out. They said too many people are coming up and down the elevator. They were right. I'd have an opening with 300 people, and we'd go till four in the morning, and if I lived there, I wouldn't have been happy either."[64]

By then, though, Gagosian realized he could not hope to become a primary dealer in New York, even if he found more young, talented artists about to explode like David Salle. Those artists would go to dealers with years of experience and contacts and galleries of their own, just as Salle was going to Boone. Gagosian wasn't established in New York, and at 35 he was not about to start at the bottom of the art world, carting canvases and making coffee.

What Gagosian could do was stage LA shows for New York artists, working directly with their dealers, starting with Castelli and Boone. That way he threatened no one, everyone profited, and Gagosian got to associate himself with top artists. Like Irving Blum, he was now one of Castelli's satellites.

In the circles within circles that made up the contemporary art market, working with Castelli put Gagosian in the innermost one. He

had learned, as the *New York Times* noted in a later profile of him, that "the postwar art world is basically a stock market with a couple of thousand really valuable shares," meaning paintings.[65] "Few people have any idea where those shares are located, because they're hanging in the homes and sitting in the warehouses of collectors who, for obvious security reasons, tend to keep their holdings well-guarded secrets."[66] The more of those shares Gagosian could trace through Castelli and the other New York dealers whose artists he exhibited in LA, the more power he would command.

There was something else Gagosian could do, in both LA and New York: he could chase secondary sales with a focus and ferocity that no one had ever seen before.[67] It was his energy in exploiting the possibilities of the secondary fine-art market in the early 1980s—buying and then reselling work by blue-chip modern and contemporary artists for a commission of 10 to 15 percent—that established his reputation, earning him the hated nickname Go-Go.[68] The secondary market had been a feature of the art world since the 15th century, if not since the first time art had been traded. He threw himself into it with vigor.

Gagosian rarely waited to hear that a collector was putting a painting up for sale. He cadged invitations to collectors' homes, memorized the paintings on their walls, and on occasion—or so it was said by two collectors, Asher Edelman and Doug Cramer—took surreptitious snapshots of them. Then he called other collectors who might want to buy them. How much would the prospective buyer pay? $20,000? Back he went to the unwitting seller to announce that if he was willing to part with the painting in question, Gagosian had a buyer who would pay $20,000 for it. No? Not enough? What would it take, then, for the now-witting seller? $30,000? Back went Gagosian to the buyer who would agree to pay that much—or, if he balked, sentence himself to an onslaught of follow-up calls. "He will call twenty times without fail," one buyer related. "Most people have a set of social rules they conform to. Larry doesn't. Everything is breachable. No is never an answer."

"Larry showed up in my office, he was Mr. Glad Hand in those days," recalled Edelman. "He shows me some transparencies." Edelman

was surprised when Gagosian got to one in his stack, of a Cy Twombly painting. Edelman was a major collector of Twombly by then. More to the point, he recalled, the transparency was of a painting he owned.

"How much is this?" Edelman asked, playing along.

"The owner wants a lot of money," Gagosian warned. "I'm not sure how much, but I'll find out."

Edelman said nothing to indicate he knew any more about the painting than Gagosian did. "The next week I invite Larry to dinner," Edelman said, warming to the story, "and seated him under the painting! Larry didn't blink!"

Later, Gagosian waved off the rumors, but added, "When I hear the stories, I honestly don't think there's anything wrong with it. It sounds kind of clever."

Early on, too, Gagosian realized that his own commission on any deal could vary. If the seller wanted $20,000 and Larry could find a buyer willing to pay considerably more than that, he could keep the rest as his commission without any obligation to tell either party. The art business did have rules, counter to its reputation as the world's last great unregulated business, and actually operated on handshake agreements. But private dealers had a lot of leeway.

From the start, the man who would become the art world's most controversial dealer stirred envy and schadenfreude in equal measures. Gagosian was bumptious and cutthroat in his quest to make a deal. Yet he had his admirers. One was David Salle. At first Salle had viewed Gagosian as a stereotypical Angeleno: tanned, with a fast patter and white bucks. But Gagosian was keenly smart, no doubt about that. He had an acute visual sense as well. "A dealer is about being open to the new, otherwise you'll miss it," Salle suggested. "He was very sensitized. When you get to know Larry, you realize there is tremendous depth of information. He knew a lot about literature, jazz, architecture, a lot about a lot of things. Well read. All these were obscured in the whole juggernaut."

Salle owed his new currency to Gagosian, so his praise was perhaps to be expected. How, though, to explain the growing rapport between

Gagosian and Leo Castelli? From the day Ralph Gibson had made the introduction, Gagosian was over at 420 West Broadway every chance he had, courting favor, cultivating contacts, learning the business. Could he actually have the gall to think he might one day become Leo Castelli's partner or even successor?

The truth was perhaps more nuanced. "Leo himself cultivated the relationship with Larry," said Morgan Spangle, the Castelli Gallery manager. "It wouldn't have happened without Larry being active, and an initiator. But Leo encouraged it. There was a fundamental generosity in Leo, from his artists' stipends to his embracing of colleagues."

"Larry was part of something new and happy, and Leo didn't want to be left behind," suggested Patty Brundage, a long-time Castelli Gallery manager, of Gagosian's aggressive new sales routine. Also, said Brundage, "Leo liked bad boys." Consciously or not, Castelli nurtured a certain disdain for his European propriety. He admired Gagosian for muscling his way in without it. No one had given Gagosian anything. He was doing whatever it took to succeed. Castelli liked that. "Leo recognized a certain dash and brio in Larry that he would have liked to see in himself," explained critic Robert Pincus-Witten. The age difference helped: in 1980, Castelli had just hit 73. Gagosian, at 35, seemed more an acolyte than a rival to a legend who was slowing down and not averse to knocking off at 4 p.m. for wine and a chat with his young friend.

Gagosian knew he struck almost everyone in the downtown art world as too aggressive, and he fully appreciated how much Castelli's blessing meant. "I had a reputation, for no particular reason," he told Castelli biographer Annie Cohen-Solal, "but Leo legitimized me. He would call me to go have a margarita with him at I Tre Merli after work and would tell me all the bad things people said about me—it made him laugh! If I ever had a lot of success, I owe it to Leo. He was a *gold mine* for me."[69]

According to Patty Brundage, Castelli wasn't even put off when Gagosian started selling paintings consigned to him by the gallery, then failing to send the gallery its share of the commission in a timely fashion. "With Larry, paintings were sold, and we were to get a percentage,"

recalled Brundage. "He would sell a Lichtenstein, and Leo would be due his share. We would pester Larry—pester, pester! Because we knew that Larry had been paid. But we wouldn't get paid until he did the next deal." Gagosian, it seemed, had used his partner's commission to help buy the next painting on which he felt he could make a quick profit. In the interim, he often lay low. "The reason we couldn't find him to pay was that he couldn't pay," recalled Spangle. "He had so many balls in the air." He did pay eventually, however, so Castelli chose to be amused.

At Castelli Gallery and later more broadly, Larry Gagosian became known as "the great white shark," the killer fish that had to keep swimming or die.[70]

IN PERSON, ARNE GLIMCHER SEEMED A good deal more decorous than Larry Gagosian. But the market was rising, and Glimcher wasn't about to let a great deal go by, even if it meant moving aggressively. In 1980, he startled the art world by orchestrating a record-breaking million-dollar sale of Jasper Johns's masterpiece *Three Flags*, and therefore rearranged the chess pieces of the art business.[71]

Glimcher knew that Burton and Emily Tremaine, who owned the painting, had purchased it from Castelli in 1959 for $900 (plus $15 for shipping).[72] It was customary for collectors who chose to sell any works they had bought through dealers like Castelli to offer them back to the dealer for resale. At the same time, the Tremaines knew Castelli wouldn't pay anything close to what the painting might be worth.

And so the Tremaines gave Glimcher that chance, and the Whitney Museum, under its bow-tied director Thomas Armstrong, rose to the challenge of purchasing *Three Flags*.[73] Castelli felt hornswoggled when he read the front-page *New York Times* story announcing the historic sale. Johns was his favorite artist, the pinnacle of his career. He couldn't bring himself to blame the Tremaines, but he did blame Glimcher. "Leo didn't like Arne because he perceived him as being in the business," said Patty Brundage, by which she meant too mercenary. "He never really liked him from the get-go."

Not long after, Johns wrote Glimcher a note about the sale, for which the artist had earned not a cent. It was a secondary sale between two parties—the Tremaines and the Whitney—with nothing for the artist but consolation that the works he still owned would rise in value. Johns, in any event, seemed unconcerned. "One million dollars is a staggering figure," Johns wrote, "but let's not forget that it has nothing to do with art."[74]

The Start of a Dissolute Decade

1980–1983

THERE SEEMED LITTLE DOUBT, in those first heady days of the early eighties art market, that Mary Boone would prevail over Larry Gagosian in her campaign for Leo Castelli's blessing. Whip smart and elegant, Boone had become a stylish dresser who admitted to owning up to 200 pairs of shoes. Already she had positioned herself in the kingdom of 420 West Broadway. Her top artist, Julian Schnabel, was pushing her to find a larger space suited to his stature, and she saw a way to solve that problem.

"I said 'Mr. Castelli'—I was twenty-seven, he was seventy-two—'would you possibly consider doing a Julian Schnabel show with me in both our gallery spaces, and let me split my commission with you?'" Boone recalled.

"Absolutely not," Castelli retorted. "The last artist I took on was ten years ago—Richard Serra—and my artists would have an uproar if I showed someone like Julian."

That was the fall of 1979. Over the next year or so, friends and collectors brought Castelli around on Schnabel. When the aging dealer finally came for a close look at Schnabel's paintings, he was knocked out. "Schnabel's work," he said in one interview, "made me feel, for the first time in many years, what I had felt about Jasper, Bob, Frank and Roy when I first saw their work."[1]

The double-barreled show—in Boone's tiny main-floor space at 420 West Broadway, as well as Castelli's gallery upstairs—astonished the art world when it opened on April 4, 1981, with prices ranging

from $3,500 to $25,000 a canvas.[2] Two years later, one of Schnabel's broken-plate paintings would sell at auction for $93,000. There was the sense, that night, of a new world opening up—a world of new art and new money.

Marian Goodman had a different reaction to the party that night. Goodman was the dealer of fine-art prints and lithographs who had helped start Multiples. She had gone on to open her own gallery— all primary work by mostly German artists, a very daring program— and would soon be rewarded for her gutsiness by acquiring one of the world's highest-selling artists, Gerhard Richter. But in 1981 she was still struggling to keep her gallery going with the encouragement of Castelli, whom she had come to know by doing lithographs with his artists. The Schnabel party was where she got her first glimpse of Mary Boone. "She was young and pretty, and she was sitting on Leo's lap." Goodman came to feel that both Boone and Gagosian were playing to the older man's ego. "They were able to make him feel like he would be hot again if he showed their artists. I remember feeling so sad at the time that Leo had to do that. But he did. It was a lesson to me: don't ever give away your control."

Soon Boone had a new space, a former truck garage with 10,000 square feet. With her came the bombastic Schnabel, provocative at every turn. Boone was a dramatic presence, too, but there was a serious side to her. She was fond of citing dealer Daniel-Henry Kahnweiler, who famously said it was great artists who made dealers great. "You saw this happen with Jasper Johns and Leo Castelli," Boone observed. "For me it was Julian Schnabel and David Salle."[3]

One artist Boone did not have at the time of her blow-out Schnabel show was Jean-Michel Basquiat. At 20, he was the youngest new arrival in SoHo. He had started as a painter of provocative messages on buildings around the city, identifying himself as SAMO©. With more confidence, Basquiat had begun feverishly painting dream-like figures all inspired, in one way or another, by his Haitian and Puerto Rican heritage.

One of the first dealers to see Basquiat's promise was Annina Nosei, who had opened her Prince Street gallery.[4] The next was Larry Gagosian.

"Barbara Kruger was in a group show at Annina's," Gagosian recalled. Kruger was already known for her streetscapes emblazoned with provocative words. In the first of three rooms in the show, Gagosian saw Conceptual sculpture. The second held Kruger's work. Then he entered the third room—the Basquiat room. "I had never heard the name," Gagosian said later. "I had never seen one in reproduction. It was a completely virgin experience—I was electrified."

Three of the five large canvases were still for sale. Gagosian bought all three on the spot, for $3,500 each. "Would you like to meet the artist?" Nosei asked.

Gagosian followed her to her tiny office. He expected to see a grown-up, not a 20-year-old kid from Brooklyn wearing splattered white painter's pants and smoking a joint. The hard-charging dealer and the street kid with the French name clicked immediately.

Both Nosei and Gagosian sensed that in Basquiat they had met a brilliant talent of truly breathtaking promise. Neither, of course, could have predicted how Basquiat would influence the contemporary art market. After his tragically early death in 1988, his paintings would go on to sell for tens of thousands of dollars, then millions, then tens of millions, until the May evening in 2017 when one large Basquiat painting sold for $110.5 million.[5]

THERE WAS NO TIPPING POINT IN the early eighties when women dealers like Nosei and Boone became a greater force in the market. Little by little, their passion grew into power. Mary Boone was the most visible, but only the latest in a line of formidable female art dealers.

Still going strong through the 1970s was Betty Parsons, who had kept taking chances on emerging artists as she had in the early 1950s: all walk-ins accepted, critiques rendered on the spot. From the greats she had handled, her own collection had grown—a Rothko here, a

Newman there—and was said to be worth at least $50 million. Works filled her apartment in the Beresford building, with its three towers overlooking Central Park.

Howard Blum, a young journalist at the *Village Voice*, became a late-life friend. He found Parsons unfailingly happy and energetic. "She taught me never to be scared about growing old," Blum later recalled.

Parsons never did forgive Sidney Janis for poaching Ellsworth Kelly. One time, Blum accompanied Parsons down to Saint Martin, where she kept a vacation home at La Samanna, the island's top resort. Over a meal, Parsons tensed. "Is that Ellsworth over there?" It was indeed the great Minimalist artist. Parsons walked up to him. "What are you doing here, Ellsworth?"

Kelly took her literally. He was prying the label off his wine bottle, he said, and applying it to a piece of paper on which he'd made some markings. "Sign it and give it to Howard," Parsons demanded.

Meekly, Kelly did as he was told, handing the signed paper over to Blum.

"What are you doing here?" she asked again.

Staying with friends, Kelly said vaguely.

"This is my island!" Parsons declared. "You know that. I want you to leave."

To Blum's astonishment, Kelly went to pack his bags and did just that.

Ileana Sonnabend had weathered the 1970s recession better than most dealers. She remained in her gallery at 420 West Broadway, selling art from Rauschenberg and Johns on down, chatting daily with her ex-husband downstairs while keeping a merciful distance from his art world flirtations.

Over on Prince Street, Paula Cooper was championing Minimalists and managing to stay in business. One of her favorite artists was Sol LeWitt, the Conceptualist who sold careful instructions on how to assemble his works. The instructions—wall drawings, really—were the work, not the wall works themselves. Cooper was a good enough dealer to sell LeWitt's unique instructions to one collector after another.

Elizabeth Murray was another artist and close friend in whose career Cooper played a pivotal role. Their relationship was so intense that after they had a falling out their estrangement ended only when Murray was terminally ill.

A newcomer to the scene was Barbara Gladstone. She opened her first gallery in October 1978 at 38 East 57th Street, relocating two years later to 41 West 57th Street.[6] Paula Cooper was Gladstone's hero—nothing less, as she put it, than her "north star."

Like Marian Goodman, Gladstone came to the business after a failed marriage—two, in her case. She was older when she started than Goodman was, about 40. She had taught art history at Hofstra University, but decided to risk her future by renting a tiny shoebox of a gallery, as she put it, for $700 a month. She had never worked in a gallery when she started her own, "which was probably stupid," she admitted later. "I didn't understand the business."[7]

From the start, Gladstone was drawn to European artists; she would become one of the only New York dealers with an outpost in Brussels, for the intellectualism of its artists and its collectors. She also became one of the first New York dealers, along with Ileana Sonnabend, to embrace Arte Povera, the Italian movement of the 1960s and early 1970s based on humble, often scavenged materials: poor art, as the term had it, meant to challenge Italy's increasingly corporate mentality.

No list of 1980s women dealers was complete without the irrepressible Holly Solomon. Solomon was a fun-loving SoHo dealer with silver-streaked hair who championed emerging artists from Nam June Paik, the video artist, to Gordon Matta-Clark, a site-specific artist who filmed himself cutting holes in the walls of West Side piers and other derelict buildings. Solomon loved new people as much as new art. Richard Armstrong, the future director of the Guggenheim Museum, recalled moving to La Jolla, California, in 1975 as a young curator and receiving a letter from Solomon, whom he had never met. "She had been there for a Christo event," Armstrong recalled. That was the 24.5-mile-long *Running Fence*, which ran from ranchlands north of San Francisco along rolling hills down to the Pacific. "She wrote me a letter as if she

was a buddy. So I looked her up when I was next in New York." The two became close friends until Solomon's early death from cancer in 2002. "She was an exotic," Armstrong added. "Mildly hyperbolic. An Upper East Side matron on the outside, and an endless bohemian on the inside, always generous: 'Come to dinner,' 'Let's meet in Germany,' 'Do you know...'"

That was, in the early eighties, what SoHo was still about.

IN 1981, GAGOSIAN OPENED AN IMPRESSIVE new LA gallery on Almont Drive in Beverly Hills, one that would move the next year to an even better space on Robertson Boulevard.[8] He had a home out there designed by architect Robert Mangurian, who worked with the dealer on the house for two years.[9] But Gagosian still spent time in New York, making deals, courting Castelli, and exercising all the control he could over the brilliant, but drug-troubled, Basquiat.

Nosei, for her part, gave Basquiat studio space in her Prince Street gallery's basement, where he could work without interruption. The arrangement shocked some, with its connotations of the young black worker confined below—an image Nosei would spend the rest of her career living down.[10] "Contrary to what people say, Jean would not do what he didn't want to do," Nosei declared. "And it had a skylight and two windows. So it wasn't like a dark basement."

Basquiat was prolific, and eager to sell his fresh work for drug money, with or without Nosei's knowledge.[11] Mick Jagger came down one day to buy paintings. So did Swiss dealer Bruno Bischofberger. And so did Larry Gagosian. "He would come to Jean's studio and say 'I want these ten paintings,'" recalled Brett De Palma, a manager at Sperone Westwater Fischer. "I saw him there myself. Basquiat would get angry when Larry took unfinished work, but he didn't stop him."

One of Gagosian's best clients was Doug Cramer, the television producer. "I bought Basquiats from Larry when the paint was wet. He took me to [Nosei's] studio in the basement," Cramer recalled. "I paid anywhere from fifteen thousand dollars to thirty thousand for

the paintings. Ten years later when I sold them because I was leaving California, they were four hundred thousand dollars to eight hundred thousand. Today they would bring ten to twenty million."

Nosei was famously frugal: she would add up the cost of every paint brush Basquiat used and subtract the total from his cut of the sales.[12] But she was passionate about his work and eager to see him get the attention he deserved. Gagosian seemed more focused on the money to be made. "At parties he would come up and say 'Who is Jean-Michel talking to? Who does he trust? Who's he listening to?'" recalled De Palma. Gagosian's relationship with Basquiat was informal, but after the artist's first show at Annina Nosei's, in early 1982, there was a party at graffiti artist Keith Haring's apartment in the East Village. As De Palma described it, "There were Boone, Nosei, and Go-Go in the kitchen, huddled with Jean-Michel, and Go-Go was saying, 'Look, let's make a deal, there's a deal going down.' Next thing you know, Jean has a show with Larry in LA."

Basquiat's first trip out to LA in the early spring of 1982 to prep for that show was memorable, as Phoebe Hoban recounted in her biography *Basquiat: A Quick Killing in Art*.[13] Basquiat had insisted that Gagosian and Nosei, who were making the arrangements, buy first-class seats for the artist and his posse. Once aloft, Basquiat pulled out a huge bag of cocaine. Nosei flushed the coke down an airplane toilet and did her best to maintain order. The night of the show, Basquiat was AWOL— shacked up with a fortyish female art dealer. "What did you do?" Nosei shouted at Gagosian. "You let your artist be vampirized by this woman." Basquiat was rescued at the last moment and strolled insouciantly into Gagosian's gallery on Almont Drive, all but ignoring top collectors and other Hollywood figures who had come to the opening. Despite Basquiat's behavior, or perhaps because of it, the show sold out completely.[14]

The LA trip left Basquiat jangled—so much so that while Nosei was taking her customary summer trip to Italy Basquiat slashed at least ten of his paintings in her basement with a switchblade and poured white paint over the shreds. "Why did you do that?" the heartbroken Nosei

asked on her return. "I didn't like them anymore," Basquiat said. "Then why not paint over them?" the dealer asked. "Save the canvas." Nosei never forgot his reply. "He said something very Caribbean: 'Because I saw through them their ghosts.'"

By the end of that summer, Basquiat had moved out of Nosei's basement studio and into a nearby loft on Crosby Street. But it was Nosei who paid the rent, taking it out of sales of Basquiat's work, and it was Nosei who tried, mostly in vain, to curb his drug use. For a while she remained Basquiat's dealer. The two even worked up a show together in Rotterdam. Over time, though, Zurich-based Bruno Bischofberger began representing Basquiat, and so did Mary Boone.

Gagosian was part of the Basquiat circle, too, planning another sellout show in LA in 1983. As before, Basquiat stayed at Gagosian's house on Venice Beach.[15] Instead of bringing his posse, he flew out his girlfriend: the as-yet unknown Madonna. "Basquiat slept half the day," Gagosian recalled, "but Madonna kept to her routine. She's a very disciplined woman. She would be on the phone in the morning to her agent and doing yoga and running on the beach, and she didn't do any drugs."[16] In exchange for her stay, Madonna served as chauffeur, both to Gagosian and Basquiat.

The plan was for Basquiat to paint—a lot—between then and the opening of the next one-man show in March 1983. "The first day, he flooded the place," one of Gagosian's assistants, Matt Dike, later told Hoban. On another occasion, he burned the sofa. "It was nuts trying to deal with him." Years later, Gagosian professed not to have minded. "It was collateral damage—no big deal," he recalled. Basquiat was a natural worker, as the dealer put it. "He would draw every day, he would paint, I never kept him working—that's what he did." Still, Basquiat was safest in the back of Gagosian's car, with Madonna at the wheel and Gagosian to safeguard him.

Madonna left two weeks before Basquiat's show, having realized that romance with a serious drug addict was doomed. Basquiat was devastated and almost drank himself to death, but he finished the paintings he owed for the show. Irving Blum was among the art world

figures who jammed Gagosian's new gallery for the second sold-out Basquiat show. He was awed: Gagosian had created a brand-new, red-hot center of the art world and made it his own.

THE RISE IN PRICES FOR CONTEMPORARY art brought—in addition to artists, dealers, and collectors—a young man incongruously well dressed for SoHo who brought a whole new perspective to the burgeoning art market: of art as a business, with strategies no one had ever thought to apply to art before.

Over the next three decades, Jeffrey Deitch would nimbly jump from one art market perch to another, ubiquitous in his oversize round glasses and retro London suits. He would be an art advisor to Fortune 500 companies, a private dealer, a grand panjandrum of public happenings he called his projects—even, briefly, the first dealer to head up a public museum, shocking purists at the very thought of a dealer in charge of a museum. He would be, in short, the ultimate multihyphenate in the contemporary art market.

Deitch had opened his first gallery as a teenager in Lenox, Massachusetts, where his family had a weekend home. Deitch's father owned a heating and air-conditioning company and hired a Portuguese immigrant to do sheet-metal work for it. On the side, the man forged metal teapots and planters so artfully that Deitch's father encouraged him to make more of them and committed to showing them for sale to the Lenox summer crowd. The family rented an exhibition room at the Curtis Hotel, and filled it with the worker's crafts, but the walls remained bare. Deitch called a local artist, who was happy to oblige with paintings that sold out by summer's end. Deitch had found his calling, but the local artist was blunt. "You have a lot of aptitude for this," he said, "but you have no idea what you're doing. You need an arts education."

Deitch got it at Wesleyan, then tried something different: he studied art economics at Harvard Business School. For his senior thesis, Deitch focused on Warhol as a business artist, with his Factory-made multiples. But he went further. He saw that art would have to be analyzed

more rigorously for a whole new generation of collectors beginning to see it as an investment vehicle. So he proposed an art advisory program for banks and sent it to Citibank. Citi's chairman, Walter Wriston, was just starting to envision a partnership with Sotheby's to finance art buying. Deitch's proposal was a perfect blueprint, and the first of its kind. "It was not an art fund," Deitch clarified later. Citi and Sotheby's hoped they would make money, but the art investment department, as it came to be called, wasn't subject to standard benchmarks. "It wasn't 'we'll get you an eight percent return a year,'" Deitch explained. "It was about understanding art, knowing the context for art that Citi might buy, and keeping that art as a long-term asset, part of an intergenerational, diversified portfolio."

One day in 1980, Deitch joined Citibank to head up the art advisory program he had dreamed into reality. Over the next eight years, he would meet with all the cynosures of the art world: dealers, collectors, art historians, and conservators, evaluating and financing art. In that catbird seat, he would also come to know intimately many of the principal artists in the unfurling narrative of contemporary art, starting with Warhol. A copy of Deitch's senior thesis, sent to Warhol, brought an invitation to the Factory, and the start of a close friendship. Warhol loved it that someone so young was so enthusiastic about his work. He seemed lonely, and took to calling Deitch at his Citibank office. "Andy Warhol's on the phone," his secretary would call out.

"What are the kids doing?" Warhol would ask. He meant the kids in their twenties, setting trends that he was too old to dream up, much less follow.

BECAUSE SOHO WAS THE CENTER OF contemporary art, a new generation of European dealers came to see what the fuss was about and to bring new art home—a stunning reversal of fortune from earlier decades, when Europe ruled the art world and American artists were the parvenus. One of the youngest visitors was an Austrian, Thaddaeus Ropac, who would emerge as one of the most respected dealers in the international art market.

The son of an Austrian small-businessman, Ropac saw his first major contemporary art at the age of 19 on a family visit to Vienna. Joseph Beuys's large-scale environment *Basisraum Nasse Wäsche (Basic Room Wet Laundry)* looked like its title: a janitor's wash closet with aluminum bucket, laundry, and a hanging light bulb. Ropac's teacher called it crap. Ropac wasn't so sure.[17]

In 1981, Ropac learned that Beuys would be lecturing in Vienna and came to hear him. The auditorium was packed, so Ropac jumped atop a table. "There he was, with that hat he wore and this strange vest," Ropac recalled later of Beuys. "He said art should be charismatic, and that everyone was an artist." Ropac decided to be an artist too.

Ropac found the artist's apartment-studio in Düsseldorf and knocked on the door.[18] "I want to work in the studio," he said to the assistant who answered. "I don't want to be paid. I will clean the floors."

As it happened, Beuys was moving his studio from Düsseldorf to Berlin and could use some help. The artist put the eager boy to work hauling boxes, and Ropac ended up spending all of September 1982 with Beuys in Berlin. Beuys came to like the earnest young man, though he had no artistic talent. "You've worked very hard for us," Beuys said gently when the move was done. "Is there anything I can do for you?"

Would Beuys write him a note of introduction to Andy Warhol? That November, Ropac found himself knocking on the door of Warhol's Factory. He knew no one in New York; the note was all he had.

To Ropac's dismay, the Warhol crew thought the note a fraud. Warhol's manager, Fred Hughes, was about to throw Ropac out when Warhol held up a frail hand. "Yes, but he comes from the area I come from," he said. He turned to Ropac. "If you want, I'm going to visit an incredible artist. You can come with me."

Off went Warhol, with Ropac in tow, to Nosei's basement in SoHo, where Basquiat was working. "Warhol left me with him," Ropac explained later. "There was just one chair." When it seemed time to leave, Basquiat asked him what he wanted to do. "I want to have a gallery in Salzburg," he said. "Maybe you'll let me show your work."

"Well, do you like the drawings?"

"Yes!" Ropac blurted. "My God!"

"Then you can take them for your show," Basquiat said. He gave Ropac the whole sheaf of drawings without even counting them.

"Why have you done this for me?" Ropac managed.

"Well, you're a friend of Andy's."

All dealers were story tellers—the art they purveyed had no real currency without a back story—but Ropac was better than most. Decades later, at his sprawling compound outside Paris, he would offer a glimpse of his style when a couple at a James Rosenquist retrospective paused in front of a small painting unlike the billboard-like works for which the artist was known. Ropac let slip that he had been at the artist's studio when he finished that work. "He said to me, 'this is the last painting, I'm putting my brushes down now.'"

The couple was shocked. No more so than he had been, Ropac admitted.

"I said 'Jim, you don't mean it!'"

"He said 'No, this is it.' He was fully aware when he said to me, 'This is my last painting.' And not only did he say that, he said, *'I'm cleaning my brushes.'*"

The couple was amazed. "How did you not cry?" the woman of the couple asked.

"For an artist of this magnitude, it was very emotional," Ropac said.

The work was all the more precious, Ropac noted, because of the 2009 fire that had utterly destroyed Rosenquist's home, studio, and warehouse in Aripeka, Florida. "All of his paintings stored on his property were destroyed." The artist's wife Mimi had hesitated over whether to sell this last painting at all—there were so few works left that most of those in the Ropac show were on loan. Only a few of the show's works were for sale.

With that, the couple snapped up the small last painting. It looked different—even better than when they'd first viewed it—now that it had its story, a story that had the added advantage of being true: Rosenquist would die just months later, after a long illness, at 83.

IN 1982, GLIMCHER WAS A NEW York stalwart of nearly two decades, Mary Boone the newly crowned queen of SoHo, and Castelli still the king, with Gagosian his lurking protégé. But an edgier generation of dealers was emerging, working with young, avant-garde artists as difficult to sell as the Minimalists were in the sixties and seventies. Prominent among these new dealers were Janelle Reiring and Helene Winer of the gallery they christened Metro Pictures: "metro" because it sounded businesslike, "pictures" because it could mean paintings as easily as movies. Many of Metro's artists were breaking into the ever-expanding art market of the 1980s: Cindy Sherman, with her chameleon-like photographic self-portraits; Richard Prince, with his early ventures in appropriation; and Robert Longo, with his dramatic portraits of friends for what he called his *Men in the Cities* series of large-scale, monochrome, charcoal-and-graphite drawings.[19]

Metro Pictures opened on SoHo's Mercer Street in 1980 with a group show that included a self-portrait by Sherman from a series she would title *Centerfolds*. "She didn't dress up to look pretty," explained Reiring. "She just always loved to dress up. She has childhood pictures of her dressing like an old woman." Sherman had attended the State University of New York at Buffalo with Robert Longo, and the two were a couple when they came to New York. At some point that romance ended, and Sherman began living with Richard Prince.[20] Longo, Sherman, and Prince were all working with familiar, mass-media images, manipulating them in one way or another. Appropriating those images into their own art would be a way forward, though Prince's appropriations would ultimately lead to a number of thorny lawsuits. Louise Lawler, the former Castelli assistant, now took to photographing other artists' works in galleries, auction houses, or even storage. Sherrie Levine rephotographed photographs by, among others, Edward Weston and Walker Evans. Walter Robinson, a genial artist-turned-journalist-turned-artist, copied pulp fiction images into Neo-Pop paintings.[21] Together, they would come to be known as artists of the Pictures Generation.

Not every artist at Metro was a member of the Pictures Generation, and not all confined themselves to painting, photography, and sculpture. Mike Kelley was a multidisciplinary artist, whose assemblages of simple objects, and performances, could be unexpectedly poignant.

Kelley had come of age in the early 1970s, well after Pop art's initial impact. He found its slickness off-putting: it was art from an affluent world. In his native Detroit, he saw car factories closing and a recession coming on. Could art express middle-class culture too? Could he find art in the suburban basement? Kelley's first show, in 1982, featured work from two projects, *Monkey Island* and *Confusion*. It was a stream-of-consciousness monologue for which he made props and art related to the performance, as well as drawings and texts. All of these were then offered for sale as art.

After attending the California Institute of the Arts in the late seventies, Kelley drifted to Minneapolis, where he took a teaching job while doing art on the side. He was laying low, but word got out. "You did a studio visit, and you weren't quite sure what he was onto," Reiring recalled. "But you knew he was a genius. He had so many references in art and in what he was doing."

The show that would later make Kelley's reputation was called *Arenas*. For years, he had sifted for handmade stuffed animals at flea markets. As the *Wall Street Journal*'s Kelly Crow later noted, Kelley was interested in the exchange of time and love that those animals represented. "How many hours of love did the grannies who sewed such creatures hope to engender—and had they been paid in full?"[22] Kelley then placed the animals on afghans he knitted himself. Reiring described them as substitutes for parental love. "You could call them abject art—pathetic, toss-away things," she explained later. "But they have this incredible emotional resonance. He was playing on the idea that we have this emotional investment: the blue bunny." To Reiring's private surprise, people bought them.

Another future star at Metro was Martin Kippenberger, a Cologne-based artist whose conflicted feelings about Germany both inspired his art and contributed to his self-destruction. He was at the center of a

postwar generation of German enfants terribles, and he appeared in a group show at Metro in 1984.[23] "He had this bad-boy persona," Reiring recalled. "He started drinking when he got up in the morning. Yet he worked constantly, making politically charged conceptual pieces." On a trip to Brazil in 1986, he bought a seaside gas station and called it *Tankstelle Martin Bormann (Martin Bormann's Gas Station)*, after the Nazi war criminal, and hired employees to answer the station's phone by saying "Tankstelle Martin Bormann." Accused of harboring neo-Nazi beliefs, he made several life-size mannequin sculptures of himself, one called *Martin, Into the Corner, You Should Be Ashamed of Yourself* (1992) and placed them against the wall. Kippenberger would die of alcohol-related liver cancer in 1997, a seeming failure, yet in 2014, a self-portrait would sell at Christie's for $22.6 million, bought by Gagosian for a client.[24] Reiring found the painting fascinating, but after a lifetime in contemporary art, she had no more idea than anyone else why a Kippenberger should sell for that price.

METRO'S ARTISTS WERE SCRAPING BY IN the early 1980s, but at least they were on the roster of a reputable SoHo gallery. Hundreds more found SoHo's doors closed to them: too many artists, too few galleries to take them all in.

Almost overnight, impelled by rejection, a mass migration of hopefuls found their way to the East Village, where a half dozen hipster dealers awaited them in raw spaces they chose to call galleries. "It began around 1982, you could feel it," explained Walter Robinson, the writer and artist whose East Village coverage would read like dispatches from the front. "SoHo was full, all the spaces on the walls were taken, and yet the art world kept booming. Suddenly there wasn't enough room! So this whole new world of artists and dealers moved over, half a mile in this rundown Polish, Spanish, Lower East Village."[25]

First to the party was the Fun Gallery, founded by Barnard College dropout and underground actress Patti Astor. In September 1981, Astor and her partner, Bill Stelling, opened their gallery at 229 East 11th Street.[26] Kenny Scharf, whose signature works were the *Cosmic Caverns*,

immersive black-light and Day-Glo paint installations, came up with the name—"Why not call it Fun?"—that captured the spirit.[27] The Fun Gallery drew graffiti artists, like Fab 5 Freddy and Futura 2000, and soon moved to East 10th Street, where it really took off. Bruno Bischofberger and other collector/dealers were soon dropping in.

Timothy Greenfield-Sanders, who was taking the first of his large-format portraits of downtown artists and dealers, felt a change in the new artists' expectations. "The East Village was the start of the explosion," he said later. "Artists got out of school, thought they would sell their work there. In truth, most had no career from this. Some just kept pushing to no end." Others became dealers themselves. "It was 'let's rent a storefront for a month and show our own work,'" Greenfield-Sanders explained. "We're never going to show at Paula Cooper and Mary Boone, so why not?"

Pulsing under the slapdash shows and late-night parties was the hum of another market: real estate. Dealers had come for the bargain rents: $100 a month, maybe $175, for storefront spaces and walk-up apartments. Yet within a year, eager landlords had jacked up those rents to $1,000, even $1,800.[28] "The threat of real estate ran through all of this," Greenfield-Sanders recalled. "Cheap real estate disappearing."

On a wintry day in 1983, an artist who neither had a regular dealer nor wanted one stood outside the Cooper Union for the Advancement of Science and Art in the East Village, selling snowballs. He wore a long, lumpy overcoat, a mashed fedora, and looked cold as he stood against one of the school's stone walls, his snowballs neatly lined up in rows on a rug on the sidewalk, priced according to size. His wares were not the only atypical thing about him in the East Village art scene: David Hammons was black.

The youngest of ten children born to a single mother in Springfield, Illinois, Hammons was a poor student, steered early on by his teachers to vocational courses. At the age of 20 in 1963, he dutifully attended the Los Angeles Trade-Technical College. Over the next years in LA, he became fascinated by black avant-garde art, inspired by Conceptual artists Bruce Nauman and Chris Burden.[29] By now he was set on

being an artist himself. In 1974 Hammons settled in New York City.[30] He made body prints, as former *ARTnews* co-executive editor Andrew Russeth put it, "by pressing a grease-covered body (usually the artist's own) to paper, then sprinkling the paper with powdered pigment."[31] He had a strong social conscience, and the plight of disaffected black youth became—and remained—the focus of his art. He would become one of the most admired Conceptual artists of his era—and one of the most reclusive.

At its peak, the East Village scene drew a new wave of uptown collectors.[32] Herb and Lenore Schorr, Elaine Dannheisser, and Don and Mera Rubell all became East Village regulars. Rubell, an Upper East Side gynecologist and brother of Studio 54's Steve Rubell, cruised the galleries with his wife Mera on a weekly basis. The Rubells had begun collecting art in 1964, allocating funds to pay for it.[33] They set themselves a ceiling of no more than $25 or $50 a trip. Still, they found a lot to buy, much of it through the guidance of graffiti artist Keith Haring—and so began one of the most formidable American collections of contemporary art, eventually totaling more than 7,000 artworks by nearly 850 artists, and spawning the Rubell Family Collection museum in Miami.[34]

S. I. Newhouse of Condé Nast and his wife, Victoria, set no such limits as they were driven from gallery to East Village gallery. Newhouse's artworks, too, would be the start of a massive collection as he moved, with Larry Gagosian's encouragement, into buying modern masterworks for millions of dollars. No less avid was Thea Westreich, a vibrant and ubiquitous force who almost invented contemporary art advising, starting in 1982.[35] Her future husband, Ethan Wagner, later joined her advisory business. In 2012, Westreich and Wagner would give a significant portion of their contemporary art collection to New York's Whitney Museum and the Centre Pompidou in Paris.[36]

The East Village dealers were a vivid bunch, none more so than the fabled couple Colin de Land and Pat Hearn. Hearn was different from most dealers, her friends agreed. She had, as one put it, "panache and daring, beauty and good breeding, but the rarest thing Pat had, in

preternatural abundance, was grace."[37] As for De Land, said a friend later, "He was a Bohemian eccentric—like Oscar Wilde in a way. He was an artist, a writer, a poet. He was incredibly aesthetic about his clothing. He and Pat were like the last of the Bohemians, they would be shocked to see where the art world is today."

"She was the listener, the best listener ever," arts journalist Linda Yablonsky later wrote in a posthumous tribute to Hearn and De Land. "He was the sweetest, the drollest, the winking anti-dealer, tall and dark and handsome in his tartan plaid suit and trademark trucker's hat."[38] Critic Jerry Saltz "called him the Keith Richards of the art world."[39] Filmmaker and artist John Waters "called her the Jackie Kennedy of the art world."[40] De Land opened a gallery on 6th Street called Vox Populi, later called American Fine Arts. Just down the street was Pat Hearn with a gallery of her own.

Another young dealer, Lisa Spellman, had a gallery on the same block and, as such, a vantage point on the burgeoning romance. Spellman, soon to be a major figure of the nineties art scene, wasn't selling much art at that point, and so had time to witness the daily delivery of flowers from Hearn to De Land. "His gallery filled up with them," Spellman said later. "But the same scene was playing out over at Pat's. Flowers everywhere."[41] De Land soon moved into Hearn's loft on East 11th Street. She gave him a gun. He gave her a glazed bust of Elvis.[42]

Most East Village artists would fade with the decade, but Hearn and De Land carried an exceptional number of artists who would endure.[43] One of Hearn's was George Condo, who early on applied diamond dust to Warhol's *Myths* series and became known as a Warholian character.[44] Condo went on to large works in what he called "artificial realism": realistic paintings of artificial objects. One day his works would hang in the Metropolitan Museum. Hearn and Barbara Gladstone gave Condo simultaneous shows in 1984 and 1985; they sensed his promise.[45] Painter Philip Taaffe was another Hearn artist, whose colorful abstractions occasionally borrowed from other artists: his refashioning of Barney Newman's "zip" paintings into spirals would be among his

best-known works. Mary Heilmann, known for her striking geometric shapes and vivid colors, was a Hearn artist at that time too.

De Land did just as well in his own way. One of his standout artists was Cady Noland, daughter of Ab Ex color field painter Kenneth Noland. Cady Noland would become one of the most valued female artists of her time. Her work probed the dark side of America, especially economic, social, and political discontent. Other De Land artists included Tom Burr, Mark Dion, Andrea Fraser, and Jessica Stockholder.[46]

The East Village bred other significant dealers—such as Jay Gorney, Lawrence Luhring, Roland Augustine, and Elizabeth Koury—and galleries—such as Cash/Newhouse and International with Monument—and for three or four years, it seemed the new wellspring of American art. "It was one big alternative space disguised as 50 alternative storefront galleries," said Walter Robinson. "All were welcome—it was pluralism writ large. But then it was shot down." Critics gave graffiti art, so prevalent in the East Village, its due, but much of the rest they panned. "It was 'meretricious…insufficiently political,'" admitted Robinson. The best of the rest went to SoHo, its galleries still drawing in crowds and collectors.[47]

SoHo was still the place to be, but not every dealer was doing that well. One of the most endangered was Leo Castelli.

SoHo and Beyond

1981–1984

To THE OUTSIDE WORLD, Leo Castelli still dominated contemporary art in the mideighties. His gallery roster carried the bluest of blue-chip artists, starting with Jasper Johns and Robert Rauschenberg, in a category of their own. His Pop artists now included James Rosenquist and California artist Ed Ruscha, who had gotten his start at LA's Ferus Gallery in the early 1960s, championed by Irving Blum and inspired by Johns. Ruscha's arid landscapes were overlaid with words, sometimes phrases, the humor of them desert dry. In his late forties, Ruscha was clearly in the canon of contemporary art. So, too, was his fellow Californian Richard Serra, whose undulating sheet-metal walls had made him one of the most celebrated Minimalist artists of the eighties. Serra's outdoor works weren't always easy to sell, staggeringly heavy as they were; with Castelli's blessing, Gagosian in 1991 would take on Serra after building a reinforced gallery floor to withstand the artist's massive sculptures. Castelli's other Minimalists and Conceptualists often went even longer between sales. Castelli seemed not to care. They still burnished his bona fides as the art world's most serious contemporary art dealer. His gallery gleamed, its floors waxed every week, its white walls painted after every exhibition, its catalogues glossy and grand. And, no matter whom he lunched with, from artists to millionaires, Castelli always picked up the tab.

Not all were charmed. Castelli was in his late seventies, and he struck some of his rival dealers as too old to remain in the game. "You'd see these dealers always coming in," recalled one Castelli Gallery

employee. "They'd look around the place, like they were staking out the territory. You could almost hear them saying as they looked at each of the paintings, 'I can have this one.' It was an ugly thing to see."[1]

A direct blow came in 1984 from Joseph Helman, a dealer from Saint Louis who had gone into partnership with Irving Blum in New York. Thirty years Castelli's junior, Helman had become enamored of the older man, as Gagosian had, though perhaps Helman had drawn even closer, more like a surrogate son.[2] Much of the art that Blum Helman showed was Castelli's stock, for which the two galleries split commissions, enough that another dealer asked Helman one day why they didn't find artists of their own. "Because it's easier to take them away from Leo," Helman said with dry humor.[3]

The breach came when Helman abandoned his sales agreement with Castelli for an artist they had shared.[4] It was an abrogation of a handshake arrangement—the end, as Castelli saw it, of the old-world honor that had once defined his business. "Something has happened," Castelli told friends. "It used to be such a nice world....We had confidence in each other." Blum sought a rapprochement, meeting on his own at Castelli's office and passing over a check for the missing commission. But when Castelli tried to cash it, he learned a stop-payment order had been issued. He was furious, and he let the art world know.[5]

Another shock came in April 1984 with the departure of Julian Schnabel from Castelli and Mary Boone for Arne Glimcher's Pace Gallery. Castelli had spent the previous summer, as he always did, in the south of France, without an inkling that Schnabel might be restless. Schnabel had rented a house in the Hamptons, not far from Arne and Milly Glimcher's. Dinners led to soulful walks and ultimately the decision to go with Pace. Boone tried to take it philosophically: "Julian is not the kind of person you talk into doing something he doesn't want to do." But Castelli was livid. "I have nothing but contempt for you," he reportedly told Schnabel, and then slammed down the phone.[6] Schnabel's defection stirred talk of "erosion" at the Castelli Gallery. Helman said publicly that Castelli was just too old. Rauschenberg, after decades as a Castelli artist, resigned from the gallery by mail.[7] Wisely, Castelli

chose to ignore the letter and just keep sending the artist his stipend checks. Rauschenberg cashed them, and the resignation talk melted away.[8]

The most hurtful departure was Donald Judd. Castelli had supported the Minimalist through good times and bad, more often the latter. "Don always owed [Leo] money at the end of the year," explained Morgan Spangle, the Castelli Gallery manager. "Leo would take work in exchange. Many museum pieces are listed as being given anonymously—but they were from Leo." And yet, over drinks with Spangle before making the break, Judd was adamant about leaving Castelli. "He said it was 'kill the father time,'" Spangle recalled. "He was resentful that Leo had such control over him for so long."

Castelli raged at the jackals around him.[9] "They think I have one foot in the grave," he told journalist Robert Sam Anson. "But I am not dead yet."[10] He knew he was too old and weak. What he needed was a young, strong, powerful enforcer, one who could guard his interests and keep the rabble at bay. Someone, too, who could be a financial partner in what had become a complex and expensive business.

What Leo Castelli needed was Larry Gagosian.

"That's when he brought in Larry as protector," explained John Good, a gallery director who worked for both men. "It began in the early eighties." Gagosian had only to glower at another dealer across the dining room at Les Pleiades or Ballato—the art world's restaurants of choice—to make his message clear: "Don't fuck with Leo."

Charles Saatchi put it his own way. Whenever he saw Gagosian approaching, he said, he heard the sound track of *Jaws*.

On the subject of Gagosian, Castelli's gallery staff still harbored resentments. "He was always sniffing around, going through our racks," recalled Susan Brundage, who ran the gallery with her sister Patty. "We would say, 'Larry, get the hell out of here.'" Yet Castelli knew he could find no better protector than Gagosian, and he was willing to be extraordinarily generous to enlist his support.

Strolling through SoHo in 1985, Castelli saw one of his biggest clients across the street. Another dealer might have steered Gagosian

away from meeting Condé Nast publisher S. I. Newhouse, but Castelli took Gagosian by the arm and walked him over to meet the billionaire collector. "I asked S. I. for his telephone number and wrote it on my pack of cigarettes," Gagosian recalled later, "and the following day I called him."[11] Castelli seemed to take no umbrage from the younger man's nerve—nor from what followed.

Shortly after, Gagosian made a cold call to Burton and Emily Tremaine, the collectors who had snubbed Castelli in favor of Glimcher when they sold Johns's *Three Flags* for $1 million to the Whitney Museum in 1980.[12] Gagosian and the Tremaines hit it off.[13] He got Emily laughing, then turned the talk to whether they might be willing to sell him a Brice Marden painting they owned. Gagosian kept calling, humoring Emily Tremaine especially. Finally, she agreed to part with the Marden and two other works that Gagosian easily sold.

Gagosian next called the Tremaines with a far larger proposal. He thought he could secure $11 or $12 million for them from an unnamed client for Piet Mondrian's masterwork, *Victory Boogie Woogie*, the artist's last painting, left undone in 1944.[14] When he got the go-ahead, Gagosian simply called S. I. Newhouse and proposed that he buy it. Newhouse readily agreed. Overnight, Gagosian became the $11 million man.[15]

Castelli never complained about the deal. Almost certainly, Gagosian had cleared it with him in advance. He wouldn't have done anything to jeopardize his standing with either Castelli or Newhouse. Even as Castelli grew older and weaker, Gagosian never took on one of his artists, at least not without his blessing. As for Newhouse, Gagosian put it best himself. "You can never fuck him," he told a young staffer. "If you do, that will be the last time you do." Still, an $11 million deal by making one phone call and putting together two top collectors who knew each other already, one of whom had introduced Gagosian to the other! That took balls. Once again, neither Newhouse nor Tremaine spoke out about Gagosian's move.

Newhouse was a dream client for any dealer, and not just because he was rich. "He was the only person who picked up his phone," explained

Frances Beatty, an Old Masters and modern dealer. "If you had his private line, which most dealers did, he would pick up the phone and you would say, 'Hi S. I., it's Frances, I have a great Pollock or Johns.' He would say, 'Send me a transparency, thank you and goodbye.' Before you knew it, he would hang up. He wasn't chatty, but he was responsive. You knew, too, that he was really smart. When you offered him something really good, he knew the difference and didn't have to ask a lot of people their opinion about the price and whether to buy it."

Gagosian's sales pitch to S. I. Newhouse was actually pretty low key, as his mentor had taught him. "He can buy anything he wants," Castelli had said of Newhouse to Gagosian.[16] The trick was not to do a hard sell or, worse, to get greedy and sell the publisher merely good works. As Gagosian explained later, "You didn't show him a B painting. He only wanted the best." It was with other buyers that Gagosian turned up the pressure. As one collector put it, he came up with an airtight case for how *this* painting fit into a prospective buyer's collection, and how it represented *that* stage of an artist's oeuvre, the stage the collector needed.[17] By the time a collector answered the phone, Gagosian had all the answers and rattled them off again and again. "It's an extremely rapid rap, like a wall of sound, and he knows his stuff off the top of his head," one dealer said.[18] And it went on, call after call, hour by hour, until the collector gave in and bought the painting. Always it was secondary work from well-known artists. "He has never introduced an artist of quality," said critic Robert Storr later. "Leo and Betty, and others, were truly part of making artists' reputations. Larry is strictly a retail guy."

BY 1985, GAGOSIAN KNEW HE HAD to move his base of operations to New York. Spending most of his time at his Beverly Hills gallery made no sense with the New York market so hot. Most major LA collectors bought their art in New York anyway. New York had hundreds of galleries with deep inventories, along with the major auction houses. All roads led to New York.

For a deal maker who prided himself on staying two steps ahead, Gagosian made a bold, even rash, gamble to open a gallery on West 23rd Street between Tenth and Eleventh Avenues. He became one of the first dealers, if not the first, to settle in the desolate, wind-whistling, Lower West Side warehouse world of Chelsea.

As Gagosian later recounted, a gallerist friend, Peder Bonnier, had decided to rent upstairs space in a building on far West 23rd Street. Bonnier asked Gagosian to tag along on a site visit. The building was owned by Italian figurative artist Sandro Chia, who, along with Francesco Clemente and Enzo Cucchi, was one of the "three Cs" of the Italian trans-avant-garde. Real estate and art were having a great mid-eighties run, enough for the three Cs to be buying and selling Manhattan real estate.[19] "I'd never been to Chelsea before that," Gagosian explained. "There were no galleries, and there were crack vials all over the sidewalk."[20]

Gagosian was intrigued by the building's street-floor loading dock and asked Chia about it. "I said to him, 'What are you doing with the truck dock?' He said, 'I want to rent it.' I said, 'What are you asking?' He said, 'I want $3K a month,' and I said, 'I'll take it.'"[21]

Castelli was astonished when Gagosian told him about the loading dock on West 23rd Street. "It was a rough neighborhood with a lot of prostitutes," Gagosian admitted later. "At night they'd chase you down the block if you had a nice car."[22] But Gagosian could envision pulling a crowd this far west, if the art was compelling enough. Why not?

Gagosian still had no New York artists of his own. He might have sought out up-and-comers and filled his gallery with them, but he chose not to do that. Instead, he opened on West 23rd Street in 1985 with a show of paintings from the Tremaine collection, a show in which not one painting was for sale.[23] The show's catalogue was sleek, the better to shine a reflected glow on the gallery. Gagosian had learned that stratagem from Castelli, and it would become his signature style.

A "non-selling" or "historical" show was a way for Gagosian to associate himself with top collectors and their social circles, as well as

with superior, desirable, and valuable art. The money would come soon enough. In fact, it was already coming. "Burt was always concerned about balancing his portfolio," Gagosian later recalled of Tremaine. "He would say, 'Larry we got too much art, we need some cash.' And I said, 'I'm your guy.'"[24]

The Tremaine show was a hit, ratifying Gagosian's new full-time presence in New York. It was followed by other historical shows for Lichtenstein, Picasso, and De Kooning.[25] Among them came the 1986 show of Warhol's oxidation paintings, which Gagosian had noticed rolled up during a Factory visit. Those, Gagosian did hope to sell.[26]

The "piss paintings," as they were known, had been created in the late 1970s. Warhol covered canvases with copper paint and various staffers urinated on them, creating what one journalist called "green and gold splotches, pools and squiggling, metallic lines."[27] One friend of Warhol's, Dotson Rader, noted that the whole point of the piss paintings—for Warhol—was for the young men around him to expose their penises.

In the years since their creation, no one had expressed any interest in buying or even showing them. "One day I saw a roll of something that looked like it could be paintings," Gagosian recalled. "So we rolled them out thirty feet on the floor." There was an abstract iridescence to them that the dealer quite liked. "Andy, I bet you could sell them," Gagosian declared. In late 1986, Gagosian filled his Chelsea gallery with the piss paintings and managed to sell at least three of them to top collectors: Thomas Ammann, Asher Edelman, and Charles Saatchi. Castelli was impressed.[28]

For more salable art, Gagosian now had buyers jostling to pay. A new market dynamic was at work. The higher the prices, the more his wealthy clients vied to pay, hoping that the more they paid, the more valuable their new works would become. Some collectors who kept their works would profit in the end, enough to sustain their faith in the art world's most aggressive dealer.

Eventually, Gagosian would make the leap to selling some artists' primary work, and not just piss paintings. Even then, however, he

wouldn't be a traditional kind of dealer, one who—like Boone, Castelli, Goodman, and Nosei—nurtured younger artists and developed their careers. He would be the one who picked off rising artists from the dealers they had started with and pushed them to greater, more lucrative heights.

SCHNABEL'S DEPARTURE IN THE SPRING OF 1984 from Boone and Castelli took more out of Boone than she had let on. "I was devastated," she recalled. But not for long. "I was sitting in my office crying when Jean-Michel Basquiat came in, put his arms around me, and told me, 'I'm a much better artist than Julian anyway.'"

In fact, Boone had been Basquiat's dealer since early 1982. She just hadn't staged a show for him yet. Partly, there was the matter of how to work with Bruno Bischofberger: the Swiss dealer wanted in on Basquiat too. That April, Boone agreed to co-represent Basquiat with Bischofberger. His international contacts would be a huge help, after all.

Throughout the 1980s, Bischofberger flew by Concorde to New York City on an almost weekly basis to see fresh works by artists he loved and, in some cases, represented. He would buy his favorite new ones directly from the artists, either with cash or by wire. Many of Basquiat's new works Bischofberger kept for himself; he would come to own more of them than anyone else. Others he took back to sell to European clients. For those he sold, he would take 25 percent of the profit, Boone would get her 25 percent, and Basquiat would get the remaining 50 percent. The split seemed fair to all, but with Basquiat, it was never just about money.

"I knew this man was like a butterfly," Boone told biographer Phoebe Hoban. "I knew that I would keep my hand open, and he would light on it when he wanted to, and fly away when he wanted to.... When you look at his personality, at the extreme mood swings, he was always paranoid, and it wasn't just because of drugs. He was obsessed with his father."[29] Hoban describes Basquiat as volatile, possibly even dangerous, but Boone denies that. "He was a masochist," Boone said. "It was part of his drug addiction."

Boone gave Basquiat his first solo show in New York in May 1984 and everyone came, including Basquiat's father, which had a huge impact on the artist—a childhood of abuse was still painfully fresh in his mind.[30] She remained one of Basquiat's dealers, along with Bischofberger, and the two paid Basquiat's rent when he moved into a loft on Great Jones Street, in a building Warhol owned. Boone lived close by, in part to keep an eye on him. "I could look into his studio from my kitchen," she recalled. "It was one big family." Gagosian was part of that family, she noted later, and Gagosian did handle some of Basquiat's work—and would continue to do so, he declared, until the artist's untimely death. But his lack of a New York gallery for part of that time made his dealings less formal.

The more money Basquiat made, the more paranoid and deeply involved with drugs he became. At his peak, Boone affirmed, Basquiat earned an advance of $1 million a year against sales, and one year he sold enough to earn $1.4 million in all.[31] He would get huge sums wired to him month after month: $25,000 here, $40,000 there.[32] His drug use was rampant. "We tried to do interventions," Boone recalled. "The only person he would ever listen to was Andy. And that's why he died so soon after Andy died."

Basquiat's friendship with Warhol had hit a bad bump not long before that, in September 1985, after a show meant to build them both up. Tony Shafrazi—a downtown dealer known as much for his youthful defacement of Picasso's *Guernica* at the Museum of Modern Art as for his subsequent closeness to Castelli and many downtown artists—persuaded Bischofberger to let him exhibit paintings Warhol and Basquiat had done together at the Factory. A poster for the exhibit showed the two artists with gloves on in a faux boxing match. None of the works sold, and critics snickered. "Last year, I wrote of Jean-Michel Basquiat that he had a chance of becoming a very good painter providing he didn't succumb to the forces that would make him an art world mascot," wrote Vivien Raynor in the *New York Times*. "This year it appears that those forces have prevailed."[33] Warhol had encouraged Basquiat to participate, and the photographs accompanying the show

had been done at the Factory. That the session ended with a TKO for Warhol in the 16th round might have annoyed Basquiat too. He felt publicly humiliated and blamed Warhol as much as Shafrazi.

Warhol likely felt a bit foolish as well, and dispirited. He had come a long way down since his startling works of the late 1960s. The Marilyn portraits, the Mao series, the electric chair series—all these and many more were the paintings on which he'd built a global career. But after starting *Interview* magazine in 1969, Warhol's focus had turned to celebrity, and many of the paintings he created in the 1970s were society portraits, done on commission, their subjects roped in from Warhol's busy nightlife. He seemed to have let the rest go.

IN 1986, THE EAST VILLAGE GALLERIES began closing. Skyrocketing rents were an issue, but so was the quality of the art: much of it was slapdash street stuff that failed to sell. Also, AIDS had begun cutting its devastating swath through New York's art community.[34] Through the mid-to-late eighties and into the early 2000s, the toll would include René Santos (died 1986), Peter Hujar (1987), Robert Mapplethorpe (1989), Keith Haring (1990), David Wojnarowicz (1992), Félix González-Torres (1996), and Herb Ritts (2002). The Fun Gallery closed: the fun was over.

Not all East Village galleries flamed out. Some did well enough to move to SoHo or, later, Chelsea. International with Monument was one; others included Colin de Land and Pat Hearn. Briefly, a new kind of art emerged in SoHo, the antithesis, in a sense, of the whole East Village scene. Neo-Geo, short for Neo-Geometric Conceptualism, a term artists and dealers loathed, but seemed helpless to resist, was commercial, polished, cool, impersonal, and ephemeral. Its most notable practitioner was Jeff Koons, who had his works fabricated in his own Warhol-like atelier with dozens of staffers.

From his start in the late 1970s, working at the ticket booth of MoMA while planning his own art, Koons knew he wanted to make machine-made works that spoke to—and even imitated—the banalities of modern pop culture.[35] For those, he would need substantial

budgets. Resolutely, he spent several years as a commodities broker, doing extremely well.[36]

Koons produced work that explored one aspect of banality or another, including, eventually, the *Banality* series. He fabricated stainless-steel flowers and rabbits that looked inflated; displayed brand-new vacuum cleaners, encased in plexiglass, as ready-made art; and set basketballs afloat in distilled water, adding sodium chloride reagent to stabilize them. All could be seen as icons of American mass culture.

Most critics found his work kitschy at best. The *New Yorker*'s Peter Schjeldahl went so far as to write, "Jeff Koons makes me sick." He added, "He may be the definitive artist of this moment, and that makes me sickest. I'm interested in my response, which includes excitement and helpless pleasure along with alienation and disgust....I love it, and pardon me while I throw up."[37]

A more measured view came from essayist and curator Olivier Berggruen. "What does it say about us?" he mused about one of Koons's best-known images, his 1986 shiny, stainless-steel *Rabbit*. "Nothing too flattering. It's easy on the eye. It's full of glittering surfaces, and it's a simple idea that translates as powerful for some people. We gaze into the emptiness of our own vacuous lives." But Koons drew crowds, and that said a lot about contemporary art. "The artists who win the day," declared Berggruen, "tend to be those who are easy on the eye."

For Koons, a turning point was a 1985 group show at International with Monument, one of the many East Village galleries soon to expire. The gallery had been launched by Meyer Vaisman, a Venezuelan artist also identified with Neo-Geo, and it soon became a nexus for the Neo-Geo fantastic four: Ashley Bickerton, Peter Halley, Vaisman, and Koons. Ileana Sonnabend saw the show and sensed Koons had a big future. She suggested moving it to her gallery in SoHo, and word began to build, right up to the glowing reviews that greeted the show's reopening in October 1986. Jay Gorney, an East Village dealer who co-represented two of the show's artists, saw that Koons was on his way. "The Sonnabend show was like a rocket launch."

WARHOL WAS STILL A CASTELLI ARTIST in 1985, but he felt neglected. The dealer had had the temerity to hang Warhol's series of vividly colored dollar-sign paintings in the basement exhibition space of his new Greene Street gallery—"the lower gallery," as Warhol put it wryly—rather than on the second floor of 420 West Broadway. Though they made a striking array, few sold. Warhol was crushed.

Aaron Richard Golub, a well-known art world lawyer, remembered those dollar-sign paintings. At a Christmas party in 1985 at the town house of the fashion designer Halston, the designer stood at the door dispensing cashmere scarves as presents. Alongside Halston was Warhol, giving away dollar-sign paintings. "I looked at them and joked, 'Jeez, you're so hard up you have to paint dollar signs?'" Golub recalled. Later, in the kitchen, Warhol gave Golub two more. "I shoved them under my shirt," he recalled, "brought them home and put them away in a desk drawer, too embarrassed to hang them on a wall." Somehow, his three Warhol dollar signs disappeared in his divorce from actress Marisa Berenson. "Of course they're now worth seven hundred and fifty thousand dollars," Golub said with a laugh.

In 1986, one of the few Warhol enthusiasts in the market was English dealer Anthony d'Offay. The painstakingly polite and intense d'Offay believed in Warhol; he felt it was important that Warhol get back to serious art and salvage his reputation. Every time they ran into each other, d'Offay asked the artist if he could give him a London show, properly apart from Leo Castelli's New York turf. "Great," Warhol would say in his usual monosyllabic way.

"What subject would you like to try next?"

"Oh, Anthony, you choose," Warhol would say. "You tell me and I'll do it." Warhol confessed that he had "kinda run out of ideas" and that he had "kinda run out of money."[38]

D'Offay and his wife spent the Christmas of 1985 in Naples with Joseph Beuys and his family, where the artist was completing his last great works, *Palazzo Regale* and *Scala Napoletana*. While there, they visited a collector who had hung in his bedroom a large red portrait of Beuys by Warhol. "I thought, my God, this is the greatest portrait

painter of the twentieth century," d'Offay recalled. "What better time for another series of great Warhol self-portraits?"

A week later in New York, d'Offay pitched his idea on a visit to Warhol's latest studio at 22 East 33rd Street. He proposed a show of self-portraits. "Great," Warhol said. The artist would work up something in a few days.

Not even a week later, Warhol called d'Offay back to the studio. The Polaroids he saw before him were the first stage of the series. D'Offay loved them. They were haunting, and would only become more so as the artist developed them with acrylic paint and silk-screening. "He did say, just as I was going out the door, 'Maybe we do some with camouflage?'"

D'Offay thought this a terrible idea, but tactfully said, "Andy, you try one, and let's look at it together." When d'Offay returned, he was stunned. The camouflage self-portrait was mesmerizing. "Of course!" d'Offay declared.[39]

Warhol's self-portrait show opened at the Anthony d'Offay Gallery in London in the summer of 1986 to enthusiastic reviews.[40] Critics and audiences alike were particularly struck by Warhol's fright wig and camouflage portraits.[41] Warhol was back! Several paintings were immediately sold to major museums, including the Metropolitan Museum of Art, which bought a camouflage portrait on the spot for $30,000.[42] Later, when paintings from the series came up at auction, they were described as "the last masterpieces." In 2010, a purple self-portrait from the series would sell for $32.5 million.[43]

D'Offay wanted to capitalize on the success of the exhibit. After some thought, he called Warhol in early 1987. "Who is the greatest living writer in the world?" he asked rhetorically. "Samuel Beckett."

Yes, Warhol agreed. Sure.

"And what does he look like? Think of that great eagle's head."

Warhol seized on the idea, so d'Offay called Beckett. The writer was delighted too. A plan was made for Warhol to fly to Paris for a photo session with Beckett. Warhol's only regret with the first self-portrait show, he told d'Offay, was that the color scheme had been muted. That would

change with Beckett. "Don't worry, Anthony," Warhol said. "I promise to do the Samuel Beckett painting [in] really pretty colors for you."

Warhol just had to have a routine hospital procedure, he told d'Offay, before he went to Paris. That was in February 1987. Within the week, Warhol was dead.

DECADES BEFORE HE EVER KNEW WARHOL, Anthony d'Offay could remember air raids and a plane coming down late in the war on his street in Sheffield, England. He could remember huddling in underground bunkers with his neighbors. These experiences would one day help him form a bond with his German artists.

D'Offay's exposure to art came after the war, when the family began to visit Leicester's New Walk art museum. "My mother dropped me there," the dealer recalled, "did her errands and got coffee, and came back after two hours to ask the receptionist, 'Has he been well behaved?'"

Those lonely trips changed the boy's life. The museum had an acclaimed collection of early 20th century German Expressionist art (unique in England), romantic Victorian paintings, and even some contemporary art. The eight-year-old Anthony d'Offay took it all in, rapt.

After three years at the University of Edinburgh, d'Offay opened a tiny gallery off London's Regent Street, with rare books, drawings, and Japanese works of art.[44] The year was 1965, the swinging sixties. Paul McCartney and Mick Jagger were early clients. D'Offay moved to a bigger space on Dering Street at the top of New Bond Street in 1969. A year later, he became friends with Lucian Freud, the portraitist and grandson of Sigmund Freud.

D'Offay saw a brilliant artist yet to achieve his fullest potential. "Freud was living a very special kind of life, with a strict painting schedule of night and day models," d'Offay recalled, which was to say men and women, some elegant, some louche. "Under no circumstances should they meet each other. Lucian also liked the idea of low life and the excitement of gambling. His friends ranged from villains to the aristocracy."

Freud's presence was as memorable as his paintings. One very attractive young woman told d'Offay about passing Freud on the street; she recognized him, but the two had never met. After 30 yards, she stopped and looked back. Freud had stopped too, and was looking back at her. "She said this was the number one romantic moment in her life," d'Offay explained. He understood completely. "It was impossible not to fall in love with Lucian," he said. "I met three people who were like that: Lucian Freud, Andy Warhol, and Joseph Beuys. They were all so different, so brilliant, and so strange that you could truly say that there was nobody like them."[45]

In the late seventies, London was still a backwater of contemporary art. D'Offay's goal was to make London a rival to New York, to have a gallery with large rooms and high ceilings, showing works by Europe's top artists. He started with the German artist held in awe by all of his contemporaries: Joseph Beuys. In 1979, Beuys had shown a remarkable work titled *Unschlitt/Tallow*, involving 20 tons of fat.[46] As a German air force rear gunner in World War II, Beuys had been shot down on the Crimean front. He recalled being rescued by nomadic Tatar tribesmen who wrapped his severely injured body in animal fat, nursing him back to health. German war records showed that, in fact, Beuys was delirious when a Nazi search commando unit found him and that there were no Tatars in the vicinity. Still, the story appealed to the public, which accepted it as the true origin of Beuys's artistic identity.[47]

At a new, large London gallery, d'Offay took a chance on Beuys for his inaugural exhibit in 1980. In the role he'd taken on for himself as a modern shaman, Beuys laid out lengths of industrial felt that led to a wooden archway. The felt strips seemed to lead to another realm: from life to the afterworld, perhaps, or from Germany's haunted past to some shamanic transformation.

Other top German artists took note, one after another signing on with Joseph Beuys's new dealer. First came Anselm Kiefer in 1982, already a huge commercial success. Kiefer, like the others, was in awe of Beuys. "The most important thing in my life," Kiefer told d'Offay, "was spending time with Beuys."

Kiefer's work was haunted too: vast, dark landscapes stubbled with impasto and applied grass, straw, hunks of lead, and plaster of paris. Kiefer, born in 1945, had grown up in postwar rubble, and as a child had made his own world of wooden towers—whether as symbols of desolation or reconstruction, it was hard to tell. But when asked why his paintings and sculptures seemed so dark, he bridled. "They're not dark!" he declared. "Americans think I never have a happy day! In fact I am very happy!"

As a group, the German Neo-Expressionists were counterparts to Schnabel, Salle, Fischl, and Basquiat, but filtered through World War II and its aftermath. Georg Baselitz, who hung his double portraits upside down—a simple but radical and disquieting choice intended to draw attention to the painted surface—was another of the German artists who showed at d'Offay in London. So was Sigmar Polke, who did paintings of historical events. And so was Gerhard Richter.

By the mid-1980s, Richter was one of Europe's most celebrated artists, though no one could have predicted how high he would rise. Starting as a humble sign painter, he had appeared in a show called *Capitalist Realism*, a German send-up of Pop art, because "the artists associated with it were similarly interested in mass media and the banal."[48] Soon, he became known for putting print photographs onto canvas and painting over them to create his "blur" paintings, before exploring both landscapes and abstract work.

When Marian Goodman met him in 1984, Richter was represented in New York by Angela Westwater, who had met him in Europe through her lover at the time, sculptor Carl Andre.[49] Richter had become one of Westwater's most successful artists, along with Bruce Nauman, the multimedia Conceptualist whose diverse works with video and neon fit quite logically into her stable of European and American Minimalists and Conceptualists.[50] Nauman would remain with Westwater through the decades that followed. Richter would not.

In the two decades since Goodman had run Multiples, she had gone her own idiosyncratic, and very noncommercial, way. She had become fascinated in the mid-1970s by a Belgian surrealist named

Marcel Broodthaers and had tried to place him in a gallery. "Since no one was interested, I decided that I would try to show his work myself," Goodman recalled. "That's how I started a gallery, completely impractically, and with dreams." Broodthaers died prematurely in 1976, even as Goodman was preparing to open her gallery on his behalf. But her interest in contemporary European art had been piqued. Putting aside her considerable fears about going to Germany as a Jew, she set out to learn why so many painters and sculptors were working with photography. One of those was Richter.

In New York, Neo-Expressionism was all the rage. Goodman in the early 1980s liked the Mary Boone roster as much as anyone else, but she felt the artists she was seeing in Europe were being overshadowed, none more so than Richter. "I just wrote him a letter and told him how much I loved his work and that it could make a difference," Goodman recalled. "That led to the first time we met."

The meeting was at Richter's studio. Both Richter and Goodman were very shy in person, almost painfully so, despite their bold careers. "I felt as uncomfortable as he did," Goodman said. "I was a little starstruck, and we just couldn't get a conversation going."

"It was a hard forty minutes," Richter later admitted to the *New Yorker*'s Peter Schjeldahl. "I am not a good speaker, not an entertainer. Marian is the same. Each of us sat in front of the other and didn't know what to talk about. At last I said I was sorry, I had to work. I was a little bit angry at myself, for being so stupid." It took Schjeldahl a moment to register that Richter had told the story in praise of Goodman. "I was impressed that she came alone. Other dealers come with another person or an entourage to support them," Richter added. "Marian is a presence. She is wise. She has courage."[51]

Despite the awkwardness—or because of it—Richter chose to have Goodman co-represent him. "We worked hard at making it work," Goodman said of the shows she began to coproduce with Westwater. But ultimately Richter decided it was a mistake to have two galleries in New York represent him. He felt too much pressure to produce work for both of them.

"I thought, if he's going to leave, he's going to leave me because I'm the newer partner," Goodman recalled. But he didn't. "One day in New York he said he would pick me up on Fifth and 57th Street. I get in the car and he said, 'I've just been to see Angela, and I have told her I don't want to work with her anymore.' I had a look of such horror that he said, 'Yes, Marian, I can be very direct when I need to be.'

"So," Goodman said with a sigh, "that was it."

Boom, Then Gloom

1984–1990

For a brief time after his death, Andy Warhol's market declined, in part because he left so much work.[1] Most well-known artists left modest estates, their best works sold in their lifetimes. Warhol, thanks to years of critical disrespect and dismal sales, as well as his Factory production, left a humongous estate—4,118 paintings, 5,103 drawings, 19,086 prints, and 66,512 photographs.[2] The newly formed Andy Warhol Foundation for the Visual Arts had to battle its way through bitter probate matters with the estate's swashbuckling lawyer, Eddie Hayes— an exercise that would take years—and sell a lot of art, which, on balance, was a lot easier. The figure entrusted with selling that art, more than any other, was Larry Gagosian.

Others were involved, most critically Fred Hughes, Warhol's long-time business manager, and foundation director Vincent Fremont, who had begun by sweeping the Factory floors as a teenager.[3] They made the decision to go with Gagosian, consigning him $10 million of art. "It was like a liquidation, to be honest," Gagosian said later of the situation Fremont inherited. "He knew I had a passion for Andy's work, and I was a hustler, and a friend. He gave me the key to the warehouse," and a commission on all works sold.

It was Gagosian, in turn, who picked the collectors he felt should get first crack at the posthumous Warhol market. Swiss dealer Thomas Ammann was one, but not his fellow Swiss dealer Bruno Bischofberger, whose tight control of Basquiat may have irked Gagosian. Nor did Gagosian sell to the Mugrabis or the Nahmads. He did sell to German

collector and investor Nicolas Berggruen and to Peter Brant, by now a quite-wealthy paper-mill magnate and magazine publisher. "I would take Peter Brant and others and sell the work," Gagosian explained. Several shows were also produced with the foundation's approval, and a market once universally regarded as moribund began coming back to life.

Asher Edelman, the dealer and collector, was struck, in observing the Warhol market, by just how unregulated this unregulated business was. The Warhol buyers and sellers made far more money than even the auction results implied.

"Let's take a transaction where dealer one has a Warhol for sale," Edelman described later. "Dealer two offers to guarantee it at auction for ten million dollars." The Warhol goes to auction with all parties—dealer one, dealer two, and the auction house—knowing it will sell for at least $10 million, because that is dealer two's guarantee. "Then this bidding goes on," Edelman continued. "Dealer two makes the winning bid of ten million dollars for the Warhol." But that was where it got creative. At the same time, "dealer one on the side buys another Warhol in a private deal from dealer two." This Warhol is agreed upon by both dealers to be worth $10 million too.

The net change for both dealers, Edelman noted, is zero. "They have simply swapped Warhols notionally worth $10 million"—a complex legal maneuver known as a 1031 like-kind exchange. "But they have also created, for the public record, a $10 million value for each of two Warhols that probably sold for far less before. Each dealer has boosted the price of the other dealer's Warhol considerably and possibly avoided sales taxes in the process, since the paintings become an in-kind trade." Done often enough, Edelman suggested, dealer one and dealer two would soon have Warhol portfolios worth $100 million, based on paintings worth far less before.

As more Warhols began reaching the secondary market, Jose Mugrabi started buying all he could at auction. "Mugrabi made the judgment that Warhol was the greatest artist of the last half of the twentieth century," Anthony d'Offay declared. "The Mugrabis had a

lot of money and bought like crazy." They had barely just bought their first Warhols at the Art Basel in 1987 when they scooped up 20 Marilyns.[4] "Larry [Gagosian] bought all the Warhols he could get at auction too," d'Offay recalled. "When an important Warhol came to auction, there would be ten or fifteen collectors who wanted it very much. Larry would want it for inventory, and Mugrabi would want it as an investment. Or [hedge-fund manager] Steven Cohen or [casino king] Steve Wynn. It brought the whole game up to a higher level." Essentially, Warhol's market became a market unto itself—like the market in soy beans—and, to the extent that any one artist's could, it dominated the contemporary art market.

Mugrabi was that market's most visible advocate. "He walked around with a notebook full of Warhols and Basquiats," recalled art lawyer Aaron Richard Golub. "He would show off his collection in restaurants. He was like a kid with football cards."

The idea of Warhol as market measure was profoundly different from the measure that had preceded it. "For many years, the steadiest market artist was Jasper," noted critic Robert Storr of Jasper Johns. "Infrequent shows, a large business in prints, but not a lot of paintings. He sold to collectors who tended to hold on, so not a lot of Johns was in play. So prices stayed high." For a long time, too, Storr explained, Johns was the artist everyone wanted to be "in the way that people thought Picasso was the guy to be. The most charisma, the most consistently inventive conceptually, the guy who had the magic touch in terms of how he made things. So he, more than Warhol, was the bellwether of where art was going. Warhol was a conceptualist by quip: deeply insightful, though he insisted on the shallowness of what he said. Jasper was more like the sphinx."

Now Warhol was dead, and for all the thousands of works he had produced, there would be no more of them. That was what the cartel of dealers—Gagosian, the Mugrabis, the Nahmads, and Brant—saw and understood about Warhol's rising market value.

They weren't the only ones. The top collectors, among them Condé Nast publisher S. I. Newhouse and entertainment mogul David Geffen,

were buying feverishly, too, either from those dealers or at auction. According to a doctor who treated him, Newhouse got so frustrated in getting bid up at auction by Geffen that the doctor proposed a truce. Why not agree beforehand which one of the two collectors would bid for a painting they both wanted? If Geffen got the first one, Newhouse could get the next. Peace would reign and blood pressures fall. Both would save money, and there was nothing illegal about it.

But how, Newhouse asked, would they decide who got the first painting both wanted? Geffen proposed they flip a coin. They did—and Geffen won.

The next morning, Newhouse phoned Geffen to say he'd reconsidered. The deal was off. "I'd rather pay more money bidding against you to get the painting I love," Newhouse declared, "than buy one I'm not crazy about."

IN SOHO, THE STOCK MARKET CRASH on October 19, 1987, had a surprising effect: the art market soared, as art came to be seen as a better asset than stocks. Yet not all SoHo dealers benefitted equally. The most successful were Gagosian and Glimcher, vying for multimillion-dollar deals in the secondary market.

That New Year's Eve—1987 tipping into 1988—Jeffrey Deitch started the night with a drink alone in the basement bar of Indochine. There he found Jean-Michel Basquiat. "The greatest artist of his generation, the toast of the town," Deitch recalled, "only things had gotten so bad that he was alone."

Basquiat could be sweet or aggressive. On this night, he was sweet. Someone had given him a little noisemaker. A bit abstractly, he moved it from one hand to the other as the two men talked. As Deitch left, Basquiat handed him the noisemaker. It had a wry meaning, or at least Deitch thought it did: for Basquiat the party was over.

Basquiat's death came suddenly, and yet without surprise, in August 1988. His art would take longer to soar in value than Warhol's, but when it did, it would shoot higher faster. To anyone in the art world of 1988, the notion that Basquiat and Warhol would do more to

elevate the top end of the contemporary auction market than any other artist of their time would be mind-boggling. For that matter, the two would also likely dominate the private market—dealers selling on their own—but there were no public figures to bear that out.

That year, 1988, a slim, shy artist named Christopher Wool had a show that put him on track to be one of the highest-selling artists of the post–Basquiat/Warhol era. Wool had come to Manhattan after dropping out of Sarah Lawrence, eventually taking a job as sculptor Joel Shapiro's studio assistant.[5] The word paintings that would make him so famous were still in the future. Instead, he fiddled with what *New York Times* art critic Roberta Smith would call "vaguely neo-Expressionist cream-and-black figurative work and monochromes."[6] In 1986, Wool followed his friend and fellow artist Robert Gober to Lisa Spellman's 303 Gallery.[7] That was after he had had the epiphany that changed his art—and his life.[8]

Wool was standing on a city street when he saw a white truck go by—a white truck with the words "sex" and "luv" spray-painted on it. Words! That was the epiphany.[9] Words on a white background, jammed together in ways that raised questions and issues. At what would later be seen as a landmark show in 1988, Robert Gober and Christopher Wool showed collaborative and individual works together at 303, their art on facing walls.[10] Gober would soon be known for his mordant, surreal, often highly politicized wit: one of his best-known works, created in 1989–1990, would be a simulated human leg protruding through a gallery wall, complete with shoe, sock, pants, and lifelike hairs.

For the show at 303, Gober exhibited three urinals, a clear reference to Marcel Duchamp's 1917 ready-made, *Fountain*. On the opposite wall was Wool's first publicly shown word painting. It was titled *Apocalypse Now*, the Vietnam War movie from which Wool took a famous line, "SELL THE HOUSE SELL THE CAR SELL THE KIDS." Wool put it in rough block letters on a plain wash background.[11]

For Wool, more word paintings followed: big, black, stenciled letters of words often chopped off at the end of a line. At first, Wool painted in enamel on aluminum panels, but then, like Warhol, he went to

silk screens. Some critics regarded Wool as a one-idea artist; the word paintings would be his major focus for years. But his New York gallery, Luhring Augustine, voiced no complaints as Wool's prices for word paintings rose. By 2010 his work would sell in the $5 million range. By May 2015, a Wool painting would sell for $29.9 million at auction.[12]

The two biggest artists of the eighties had died within eight months of each other. Two stars of a new generation—Jeff Koons and Christopher Wool—were on their way to a destination unknown, somewhere past Mary Boone's Neo-Expressionists and into a future of almost unimaginable global attention, influence, and wealth. First, though, they would have to endure a bitter and bleak recession, one so severe that SoHo would seem fated to fall back into its empty and decrepit industrial past.

NO ONE SAW IT COMING, NOT even Gagosian. In November 1988, he bid on behalf of S. I. Newhouse for Jasper Johns's 1959 *False Start* in a spellbinding auction drama among three bidders, the other two unknown. Gagosian was seated next to Newhouse and entered the bidding at $10 million.[13] As the numbers rose in increments of $250,000, Newhouse nodded his head slightly or moved his left hand to signal Gagosian to go higher.[14] At $15 million, the auctioneer increased the bidding increments to $500,000 per bid. Gagosian took the dare, one and then the other unseen rival fell away, and the painting sold for $17,050,000, including premiums. The crowd rose in a spontaneous standing ovation.

"Frothy" was the word that a new breed of dealers called the late-1980s market. Many weren't dealers, exactly, more like freelance traders. In this super-heated market, who needed galleries? Not the traders. Why bother with overhead, when all they needed was a Warhol in their hot hands that some desperate uptown collector would buy at almost any price?

"The art market was the Wild West," explained former Castelli staffer Jim Jacobs of that brief, volatile time. Young corporate executives had seen this art in their companies' lobbies and corridors, like at

Chase Manhattan Bank and the brokerage firm PaineWebber, where chairman and CEO Don Marron had built a vast corporate collection. Now, in the eighties, these executives had serious money. And what serious money wanted—had to have—was art.

"I would buy a work of art and sell it in one day," Jacobs recalled. "I was on my own. People would call and say, 'Can you find me a [Warhol] flower painting?'

"I just sold it," he would tell them. "But how much can you pay?"

Then, Jacobs explained, "they'd make an offer. I'd call the person who'd just bought a flower painting and say 'How would you like to sell it back for more?' I would call the second person, sell it back, and keep going." Once, Jacobs sold the same painting three times in a day. "Yes, it's true," Jacobs said. But it was also true, he noted, that the market, not any individual dealer, was what changed prices at a moment's notice.

Partly out of affection for his mentor, but also because it was a smart thing to do in that surging market, Gagosian opened a downtown gallery at 65 Thompson Street in 1989—his second New York gallery—with Leo Castelli as his partner. The gallery showed many of Castelli's top artists, from Ellsworth Kelly to Roy Lichtenstein to Bruce Nauman, all good for establishing a better pedigree for New York's most aggressive dealer. Much of what Gagosian was selling off was actually Castelli's inventory. And being in business with Castelli was a tacit affirmation that Gagosian was the older man's successor after all. "It showed that Leo was giving him his seal of approval," Mary Boone said later. "And the prices!" Even for such a robust market, they were high—and Gagosian was getting them.

That same year, Gagosian leased the uptown space that would be his flagship gallery: the block-long, mausoleum-like structure at 980 Madison Avenue, across from the Carlyle hotel. The building, Sotheby's former New York home, would eventually be bought by developer Aby Rosen. It gave Gagosian vast new space and cachet.

A week after the opening show for 65 Thompson Street, Gagosian sat down with journalist Anthony Haden-Guest to say what he thought of

the market. A decline seemed unimaginable. He did think that the feverish prices impacted artists in unfortunate ways. "It creates a lot of expectations," he suggested. "Some artists are really fucked up by it. They are arrogant with their dealers. I'm speaking objectively—I don't have any artists right now," he said, referring to the lack of primary artists on his roster.[15] "They start getting interested in antique furniture and wine and adding another wing to the house in the Hamptons. They go and live in exotic places." Then, for the artists, come the expectations. "You've got to keep the dealer happy. You've got to keep the pipeline loaded. And the marketplace doesn't tolerate a lot of experimentation.... Artists' careers are reevaluated on a daily basis. But they don't change that fast."[16]

Somewhat tongue-in-cheek, Mary Boone told Haden-Guest that raising her artists' expectations was exactly what she set out to do. "Get them into debt. What you always want to do as an art dealer is to get the artist to have expensive tastes. Get them to buy lots of houses, get them to have expensive habits and girlfriends, and expensive wives. That's what I love. I really encourage it. That's what really drives them to produce."[17] She, too, saw only more of the same ahead.

If these were lures for some artists, they weren't for David Salle. Ever since he had signed on with Boone in the fall of 1979, he had been torn between the success Boone had brought him and the growing conviction that she might not be right for him.[18] Gagosian, he felt, appreciated his work more than Boone did, and Salle hadn't forgotten that Gagosian was the first to buy it. Then, and later, Salle denied leaving Boone for more money. "Money had nothing to do with it," he said tersely. It was more that his work had come full circle with Boone, and it was time for a change.

Boone had her own take on Salle's departure. She called it a midlife crisis and noted that Gagosian, along with taking Salle from her, had just poached another of her artists, Philip Taaffe, and was courting Eric Fischl. Gagosian was breaking the rules.

Gagosian waved off the thought. His style might not please everyone, he admitted in an interview, "but who gives a damn? I'm not running for president. I'm an art dealer, and in this world, you're allowed

some idiosyncrasies as long as you basically play straight with people. That's what's nice about it—you don't have to be a cookie-cutter kind of person."[19]

In this rougher field of play, Gagosian acted both as protector to Castelli and, it sometimes seemed, the new godfather taking what he pleased. Certainly, power was sliding from mentor to protégé. "The real game was watching Larry take over from Leo," suggested one insider. "The reason Larry could do it was his eye."

In late 1989, Gagosian tried pulling Brice Marden into his gallery. To his surprise, Marden chose to stay with Boone, at least for the moment. In time, Marden would sign up with dealer Matthew Marks and stay with him for 20-some years. Gagosian would never stop circling, however. Eventually he would get his man.

Gagosian had more immediate luck with the artist whose elegantly scribbled drawings he had bought when he first came to New York. Technically, Cy Twombly was still represented by Castelli, but Twombly had long felt that Castelli was less than excited by his work. The artist had been given a retrospective at the Whitney Museum in 1979 and one in Paris at the Centre Pompidou in 1987, but he felt Castelli had played a marginal role in those. In Europe, Twombly had been represented by Swiss dealer Thomas Ammann, but Ammann was ill with AIDS and would soon die at 43. There was, as Gagosian put it, a vacuum. After securing Castelli's blessing, Gagosian went to Italy to make his pitch to represent Twombly.

At first, Twombly seemed standoffish, and Gagosian began to fear he had blown his chance. In desperation, he blurted out, "Why don't you give the Armenian a chance?" Twombly found that hilarious, and signed on—or, rather, shook Gagosian's hand. In the two decades they would work together, they would do all their business that way. To celebrate the deal, Gagosian in December staged a New York show of eight *Untitled (Bolsena)* paintings by Twombly from 1969. It was the first time they had been shown together.

Irving Blum, the original West Coast Warhol dealer who had sold those soup cans in 1962 only to buy them back, had become a chum of

Gagosian's, cruising the Mediterranean on the latter's boat. But when Gagosian said he had just gotten Twombly, Blum was amazed. "I knew Twombly was in Europe," he said later. "But I had no idea about him. I knew who he was, I knew he was friendly with Bob [Rauschenberg] and Jasper [Johns] early on. But I didn't appreciate the significance of the art until it was too late."

The handshake deal done, all Blum could do was marvel at Gagosian's acuity in landing the artist. "We went to Gaeta, where Cy came aboard for two days, and Larry was on the phone the whole time," Blum recalled. "That's what he does. That's probably why he wanted me to come along. And he had no fear of me taking Cy."

Blum was fascinated by the older artist. "Very elegant, tall, thin, very aristocratic," Blum recalled. "He came on board with his secretary, who saw to whatever he required. He was very well taken care of! He didn't start as an aristocrat but married into Italian royalty. He lived extravagantly well—good wine, good food, a great ocean view—and felt no need to come back to the US, though he was American."

By then, Blum had made a point of studying Twombly's art. It was difficult, but brilliant. Twombly, he came to feel, was more than a smart acquisition. "He was Larry's great achievement."

Gagosian made no effort to hide his pride in taking on Twombly, and in what that implied: senior membership in the primary market at last. "I spent a lot of time with him," Gagosian said later.[20] "We vacationed together. We talked a lot. I don't know what pure means, but if it means anything, it certainly would apply to Twombly. He was unlike any artist I ever met. He never drove a car, never owned a television. He didn't really care about money—he was no fool, but he certainly wasn't driven by money. He just lived his own life and was totally an artist—all in, all the time....In his eighties, Cy was painting these huge, muscular paintings." Gagosian continued, "Most artists kind of shrivel up. They get tighter. They sometimes lose their physical strength. But Cy was just exceptional."[21]

Over the ensuing years, Gagosian would open five of his eight European galleries with a Twombly show.[22] For each show, Gagosian

would push Twombly hard to do a new body of work. "Some friends said 'Larry is so greedy, leave [Twombly] alone, he can't work that much,'" Gagosian admitted. "But he loved working those last fifteen to twenty years."

Unlike most artists, Twombly wasn't driven to the canvas every day: months might pass between one painting and the next. Gagosian's concerted pushes created a whole oeuvre of late Twombly work that wouldn't otherwise exist. It was a legacy the dealer thought of every morning when he awoke in his East Side mansion, opening his eyes to one of Twombly's greatest works, the 2003 painting *Untitled (Lexington, Virginia)*.[23]

WITH HIS CUSTOMARY BRAVADO, GAGOSIAN BEGAN pushing up prices, hard, for all the artists he showed. "No one had had the foresight and guts to name prices that were three to five times what [the works] were worth," recalled art advisor Allan Schwartzman. "So that raised the bar." Gagosian had no idea the market was cresting, about to come crashing down. Business was good, prices were booming, and Gagosian just kept busy.

So good was the market that, for the first time, the concept of art as an asset lured eager buyers, especially Japan's new generation of cash-rich real-estate moguls. Let the stock market languish; trading art was the new way to make windfall profits.[24] Robert Hughes, the brilliant and cantankerous art critic for *Time*, wrote a cover story on the art market—headlined "Art and Money"—that appeared on November 27, 1989. He deplored the obsession with rising prices that made art a mere coefficient of money. He hated most if not all of the Neo-Expressionist art that had fueled it, reserving a special place in his critical hell for Julian Schnabel. As for dealers, he predicted the largest would soon rule the market, while the rest declined and died. Hughes had no more intuition than Gagosian, however, that the market might soon collapse. Nor did Arne Glimcher, who opened his biggest gallery yet at 142 Greene Street—Castelli's former space—with an inaugural show

in May 1990. Meanwhile, auction prices continued to rise, and major collectors continued to buy.

It was from Charles Saatchi that London dealer Nicholas Logsdail got an early warning, in 1990, of just how close Saatchi & Saatchi was to bankruptcy, and of what that would mean to the contemporary art market.[25] Saatchi had blazed through the 1980s collecting contemporary art. With the opening of his London museum at 98A Boundary Road in 1985, he showed American artists, exposing British audiences for the first time to Donald Judd, Brice Marden, Cy Twombly, Andy Warhol, Jeff Koons, Robert Gober, Peter Halley, Eric Fischl, Robert Mangold, Bruce Nauman, Cindy Sherman, and Philip Guston, all presented in depth.[26] But selling was always the Saatchis' first priority. Now he had no choice but to sell. As a collector/dealer of contemporary art on a major scale, he had gobbled up too much too fast.

Soon the Saatchis' bankers began selling off the brothers' vast arsenal of art at auction.[27] By selling at fire-sale prices, the bankers ruined many artists' markets for good. "He basically [sold] the heart of his collection at the wrong time," Peter Brant said later. "He sold a lot of pictures that you could never replace." The best-known example was Italian Neo-Expressionist Sandro Chia, one of the Italian three Cs. Saatchi reportedly bought a huge tranche of Chia's work in the mid-eighties, only to sell it all off, ruining his market.

That confirmed Glimcher's suspicions about Saatchi's commitment to his artists. "A lot of the art that people thought he would keep for his museum, he sold," Glimcher declared. "He was a real menace. He bought art in the guise of being a collector, but he was a 'specullector,' as the term of the day had it, ready to flip art for a profit."

Another huge sell-off hastened the slide. Marcia and Fred Weisman had built one of the great Los Angeles art collections, with 62 museum-quality works, including a Lichtenstein, Newman, Rothko, and Clyfford Still. Now the collection was to be sold. According to the legal complaint later filed by US District Attorney James Comey, in January 1990, Gagosian and Peter Brant, along with a British socialite

named Geoffrey J. W. Kent and a tax attorney, formed a holding company to acquire the 62 paintings.[28] The partners then sold 58 of them to European dealer Thomas Ammann for $20 million. On paper, the 58 paintings had been worth roughly $2 million.

Eventually, the US government would come knocking to ask about taxes due on the capital gain of $18 million. As far as the government could see, the partners owed $6.7 million on that $18 million. Meanwhile, they had apportioned the remaining four paintings among themselves outside the holding company, Comey's complaint declared. A Roy Lichtenstein and a Clyfford Still went to Gagosian; a Barnett Newman and a Mark Rothko went to Kent "for consideration of $10." To the government's inquiry, the partners replied that their holding company had no money to pay those capital gains taxes, since its only assets—the 62 paintings—were now removed from it and the partnership dissolved. According to art industry newsletter the *Baer Faxt*, the partners would eventually be forced to pay $9.1 million to settle the charges. Gagosian felt he had just done what his partners had advised: the details were way over his head. He felt victimized by the whole thing. The lawsuit would remain off in the distance for more than a decade, but by mid-1990, Gagosian had reason enough to regret the purchase: the art market was about to collapse.

The hard slide began after the auctions of May 1990.[29] Overnight, the market slumped. Then, on August 2, 1990, Iraq invaded Kuwait, precipitating the first US Gulf War. Lisa Spellman and her 303 Gallery had survived the collapse of the East Village in the mideighties and had mourned the dead from AIDS. But in the art world, the recession of 1990 came with sudden, unprecedented force. "On August 3, it was like the lights were turned off," Spellman would recall. "It was one of the worst days ever." For every dealer in the business, including Larry Gagosian, the market had stopped dead in its tracks.

REINVENTING THE CONTEMPORARY

1990–2008

Up from the Ashes

1990–1994

THE DOWNTURN IN THE nineties came as fast for Irving Blum as it did for almost everyone else. He was accustomed to taking out a loan to see him through the dry spells. In the past, the banks had been accommodating. No longer. In the summer of 1990, the bank paid an unannounced visit. "They gave us twenty-four hours," Blum recalled. "What do you do? You sell off first-rate material for much less than you would . . . and you either survive or drown. I'm still bleeding from it. But boy, it could have been more crippling. It took three years to climb out of that."

Many of the biggest dealers got hit the hardest. Mary Boone saw her revenues slump. "Things kept dropping, dropping, dropping."[1] Larry Gagosian later called the early nineties a nightmare. "It was brutal," he said. "I remember going to Sotheby's in November of 1990. Usually after an auction you meet up with some friends—collectors and co-workers and other dealers—and you go out for dinner and have a good time. Back then, nobody wanted to talk to anybody. You were numb. You walked in, and half the auction didn't sell. People weren't even bidding. It was just unbelievable, because in May there had been an incredibly strong auction. Huge prices. Records for many artists. Vibrant market. It just turned on a dime. And the ensuing recession in the art market was absolutely the worst thing I've ever been through in my career as an art dealer. The phone literally didn't ring. . . . It was like tulip mania, like a Ponzi thing, it was crazy. Everybody was making money and everybody was happy, and then when the music stopped it was just like a crushing hangover."[2]

Gagosian, like Blum, had tense meetings with his bankers. By now he had a multimillion-dollar personal art collection and could borrow against it, though only up to a point. Banks put punishingly low valuations on the art they kept as collateral, and typically granted loans for no more than a few months. By the spring of 1991, Chemical Bank held liens on numerous Gagosian-owned artworks.[3] Sotheby's had a security interest in others.[4] The paintings under lien included works by Pollock, Twombly, Lichtenstein, Marden, Stella, De Kooning, and Warhol.[5]

Money was tight, but Gagosian bristled when asked, later on, if his business had been in peril. One Pollock alone—titled *Scent*—was valued at about $8 million in 1991. "I could sell one painting even at today's prices and pay off my entire obligation to the bank," Gagosian remonstrated.[6] To a *Washington Post* reporter, he added a key distinction. "I've never had a loan for operations," he said. "I've never borrowed money for the gallery. Sometimes you use a bank to buy a painting. At times, it's the best route and it's better than having a partner. Borrowing money for a short-term situation is a cheaper partner than somebody who's going to get 50% of the upside."[7]

The one buyer who continued coming to Gagosian's galleries during this bleak period, the one who kept him from desperate measures, was David Geffen. "When David Geffen came in," Gagosian recalled, "my gallery manager would say 'I think we'll make payroll this month.' The entertainment mogul was fearless: he bought great art when no one else was buying. David would say, 'I know there's no one coming close to this but I want it.'" Despite the recession, Geffen was starting to buy up S. I. Newhouse's collection, piece by masterpiece, spending, by one insider's reckoning, some $300 million to acquire it all. Remarkably, Geffen never had an art advisor: he just bought what he liked.

For some time now, Gagosian had been living very well, and he refused to let the recession crimp his style. Home was an art-filled stable-turned-luxury-town-house at 147 East 69th Street, worth at least $4 million, which he had purchased in 1988 from Christophe de Menil, of the Houston art-patron family.[8] It contained a sauna, steam

room, personal gym, and lap pool. One reporter given a rare glimpse described the home as "sleek and austere, empty of sentimental clutter."[9] From distillery scion Edgar Bronfman Jr., Gagosian bought, at about the same time, Toad Hall, an 11,000-square-foot modernist house in Amagansett designed by architect Charles Gwathmey for François de Menil. Gagosian reportedly paid $8 million for it. The house was on Further Lane, one of the Hamptons' most prized addresses, and was said to include a three-story greenhouse and a media room with an extra-large screen.[10]

Despite the downturn, Gagosian claimed to have a staff of 16, and was expanding his exhibition space at 980 Madison Avenue to the floor below, adding a huge gallery that would bring his total space to about 10,000 square feet.[11] One profile at the time called him a "cocky presence" with "insatiable ambition and meteoric success in the resale market."[12] He was driven around, the reporter noted, "in a limousine from which he works deals on a cellular phone"—a precious item in 1991.[13]

One of the few big New York dealers who seemed to sail through the recession of the early nineties was Bill Acquavella, a second-generation dealer who presided from a limestone mansion at 18 East 79th Street, two blocks from Gagosian's flagship but a far greater distance in personal style from the hard-charging young dealer. Acquavella's father had bought the building in 1967, and with it acquired a legacy: it had once belonged to dealer Joseph Duveen.[14] Acquavella, almost a decade older than Gagosian, had no desire to add more galleries to his realm; the building his father had bought from billionaire industrialist Norton Simon in 1967 was quite enough. Nor did he yearn to add untested artists to the well-known Impressionist and modern painters he and his father had accrued over seven decades. His far-ranging inventory— from Picasso and Monet, Bonnard, Cézanne, and Chagall, to De Kooning, Dubuffet, and Diebenkorn—afforded enough quiet sales to give him his own private plane.

Gracious and self-effacing, with a full head of lustrous white hair and rugged good looks, Acquavella socialized with an old-money crowd more comfortable at the Southampton Bath and Tennis Club than at

Gagosian's New York hangout, Mr. Chow. Yet just as the recession set in, serendipity dealt Acquavella a surprise hand in the form of a world-famous artist in his prime: Lucian Freud.[15]

England's most admired living portrait painter had benefitted considerably from his nearly 20-year representation by Anthony d'Offay. Portraits he had once sold for 5,000 pounds now went for 50,000 pounds. But as the 1980s unfolded, d'Offay had less time to chat with his dear friend—his large gallery was all consuming—and Freud had grown grumpy about that.

Money was the other reason Freud left d'Offay in 1992.[16] He liked to be paid in cash outright for works just completed, and let d'Offay or his other dealer, James Kirkman, sell them off as they saw fit. As his paintings grew larger, that meant more out of pocket for d'Offay and Kirkman. Disagreements ensued. Acquavella began to hear, through mutual friends, that Freud would be open to having lunch with him.

This was not a prospect the American dealer much relished. Polite as he was, Acquavella had spent his first 50 years doing exactly what he wanted to do, at no one's behest. His father, Nicholas, had started the gallery in 1921 on 57th Street. Acquavella had studied art history at Washington and Lee, with no intention of working in art, before going into the US Army. After getting out, he had nearly taken a job in finance at Lehman Brothers.[17] Only when his father became ill did Bill take a look at the gallery's books to find his father had $5,000—and owed the bank $30,000. "Mom," his son said, "where's the money?"

"Your father has it." But his father didn't, so the son plunged in to help.

That took a few years of doing, for the Acquavellas had lived happily above their means, touring Europe each year, staying in the best hotels and buying a lot of art, not all of which sold. "It was like we had money," Acquavella recalled, "but we didn't."

On a trip to Paris, the Acquavellas acquired a bevy of paintings by Post-Impressionist Pierre Bonnard. Color catalogues were not a common practice then, but Acquavella decided the vibrant Bonnard colors would sell better with one.[18] Then he sent the catalogues to ten of the

richest collectors he could find, almost none of whom he knew.[19] On one memorable day, the titans came in on their own, one by one—Paul Mellon, Norton Simon, David Rockefeller, Jack Dorrance of Campbell's Soups, the Wallaces of *Reader's Digest*—and snapped the Bonnards up. That was when Acquavella stopped worrying the business would go broke.

For the next quarter century, Acquavella stayed under the radar, making his quiet sales, until he swung a deal in 1990 that astounded the art world and made him famous despite himself.[20] Pierre Matisse had been the most prominent dealer of Impressionism. When he died, he left 2,300 works by all the 20th-century masters: Miró, Dubuffet, Giacometti, and Chagall included.[21] Matisse also left a tax tangle that ruled out an auction. Instead, Acquavella took on Sotheby's as a fifty-fifty partner and talked the estate into selling all the works to the partnership for roughly $150 million. Now he had to hope he could unload them all at a profit. Fearing the lesser pieces would not sell, Acquavella came up with an ingenious solution. He made his own groupings, varying the artists in each and making attractive packages. He insisted on selling the lots as he had designed them: no substitutions, no selling of individual works. The gambit worked. Within 18 months, he had sold $300 million of art.

Acquavella's first inclination, when he heard Freud wanted to have lunch with him, was to decline. Freud had a reputation for being difficult. As if that weren't enough, Acquavella knew that Freud was painting male nudes of a performance artist and sometime drag queen named Leigh Bowery. It was hard to imagine anything less salable.

"You know that if we go, he's going to ask us back to the studio afterward," Acquavella sighed to his wife.

"Oh, let's go see anyway," his wife said.

The three had lunch at a place near Freud's studio. To Acquavella's surprise, the artist was in good humor. When the inevitable question arose, Acquavella said of course he would love to see new work. When they reached the studio, Freud had them wait at the door while he walked back amid racks to pull out a very large painting.

The subject was indeed the naked and corpulent Leigh Bowery. Both Acquavella and his wife were astonished by the painting's power.

When Freud went down the racks to get another one, Acquavella whispered to his wife, "Do you think these are erotic?"

"No," she whispered back.[22] She meant not erotic in a good way.

The second was just as good. "The great portraits of the twentieth century?" Acquavella recalled later. "Picasso? You put one of these next to them, and they do not fade away. I was very excited."

Right then and there, Acquavella offered to buy outright everything Freud would paint over the next two years. "If I can represent you worldwide, let's do it....There's no contract, if it doesn't work for you, you tell me and we stop. And if it doesn't work for me, I'm gonna tell you, and we stop, it's over."[23] No papers were drawn up: the handshake deal, tenuous though it might seem, was all the two ever went by.

Perhaps six months into their partnership, Freud told his new dealer that he had some gambling debts. To be precise: $4.6 million to Alfie McLean, the largest bookmaker in Northern Ireland. McLean was a slight figure who dressed in snug-fitting suits with narrow lapels and could, on occasion, go from genial to menacing in a flash. Unperturbed, Acquavella had dinner with McLean, and a deal was reached. "I gave him a certain amount of cash, less than two point seven million pounds, and some paintings."[24]

Freud actually painted McLean and his sons, which was remarkable not just because of McLean's propensity for anger, but because sitting for Freud was a relentless process: days turned into weeks. Eventually, Freud asked Acquavella to sit for him too.

"First day I'm there, there was a heat wave in London," Acquavella recounted. "I always wore a suit and tie, and there I was in the studio with no air conditioning." The two men went out to buy a huge fan, and the sessions began. Acquavella took care to wear the same blue shirt and suit jacket for each session. "One day I show up and he says, 'What did you do to your shirt? It's not the same.'" It was the same brand, and the same color, but cleaning it had changed its hue the tiniest bit. Freud noticed.

By now Freud and Acquavella were close friends, talking on the phone three or four times a week. Acquavella was in his sixties, Freud his seventies: theirs was an autumn friendship that gave them both great pleasure. Seizing the day, they flew as often as they could in Acquavella's plane—once to Art Basel, where Freud sat in Acquavella's booth and took private glee in startling the passersby, and once to the Prado, where Freud pointed out all the pictures that had meant the most to him. "It was touching that we became friends," Acquavella said one day at his gallery years later. "What was great about Lucian was he was a very loyal guy. People would always try to go behind my back to try to take him away. He never blinked."

AS THE RECESSION WORE ON, A new generation of dealers emerged, young enough to get by on little more than passion and hope. One was Matthew Marks, a New York City kid who had graduated from Dalton and dropped out of Columbia. Few would have guessed that he would become one of Chelsea's top dealers, handling Ellsworth Kelly, photographer Nan Goldin, Brice Marden, Robert Gober...and Jasper Johns.

In fact, Marks had started collecting at 13—his first acquisition was a Marsden Hartley print for $125—and his parents, both doctors and art collectors, may have steered him to the Pace Gallery, where Arne Glimcher gave him a job as a paid apprentice. At least it was more promising than being a floppy-haired DJ at Area, the mid-1980s nightclub, which was Marks's first career.

Marks's father let it be known at Pace that Matthew as a teenager had put together his own collection of American prints. Arne Glimcher and the head of his prints department, Dick Solomon, invited him to curate a show of them. The show worked out well enough that Marks went back to college, graduating from Bennington in 1985. He returned to Pace, this time to do a show of Picasso sketchbooks on paper. Marks did a fine job, even publishing a beautiful catalogue, as Solomon recalled later. "Unfortunately Arne gave Marc Glimcher all the credit," Solomon said of Arne's son. Marks was furious, and left to spend three years in London working for Anthony d'Offay.

At the time, Marks had a sizable girth, and he would struggle with his weight throughout his twenties. One day, Mary Boone was in London and came to d'Offay's gallery to discuss artists with him. For whatever reason, she took an instant dislike to Marks and banned him from the meeting. Eventually the weight vanished, but Marks remained a self-conscious, stork-like figure, stooping from his six-foot-plus height as if pecking for grain.

Back in New York, Marks got his revenge on Boone after opening his own gallery on upper Madison Avenue in 1991 and luring away one of her biggest artists, Brice Marden, who had managed to resist Gagosian's entreaties. Marden declared Marks "a little less in it for himself" than other dealers.[25] That was quantifiably true: to the annoyance of other contemporary art dealers, Marks was said to take lower commissions, splitting sales not fifty-fifty, but more like sixty-forty or even more lopsidedly, with his artists taking the lion's share.

Marks was disliked by many of his fellow dealers—he came across as arrogant and cavalier. But he had a good eye and, like Castelli, a strong preference for artists over collectors. He was also clever enough to take Glimcher's Picasso sketchbook idea and adapt it for his first show in the fall of 1991. He wrote to every artist he admired and asked them to let him exhibit—but not sell—their sketchbooks. Artists from Jasper Johns, Lucian Freud, and Ellsworth Kelly to Robert Ryman, Julian Schnabel, Gerhard Richter, and Brice Marden were happy to oblige. Louise Bourgeois was so tickled, as *New York* magazine noted, that rather than say yes, "she just sent an assistant over with a sketchbook right away."[26] The artists themselves loved the show and some went on to become Marks's artists, including Johns. Three years later in October 1994, Marks opened his first space in Chelsea, on 22nd Street, an impressive 5,000 square feet. It was followed by another just as large on 24th Street in 1996. Together, the two galleries for a while made Marks the dealer with the largest square footage of exhibition space in Chelsea.

BY THE EARLY 1990S, MANY OF the East Village galleries had closed. A few of its hardiest denizens, though, made the leap to SoHo. One was

Lisa Spellman of 303 Gallery, who moved from the East Village to 89 Greene Street in 1989 and rode out the recession there. "It was pretty terrifying," Spellman recalled. "But at the same moment, completely liberating." Many artists from LA began coming to the city, drawn by low rents and the dream of wanting to be New York artists. "It was still thought you had to live in New York to participate," Spellman explained. "Unlike now, where artists move out of here."

In that fertile field of the young and the daring, Spellman took on artists who would be her stalwarts from then on. An unknown Karen Kilimnik wrote Spellman letters, enclosing snapshots of quirky things she had seen. Finally Spellman asked her to come in with her portfolio. Kilimnik showed her drawings she had done since the 1980s. They were soft and figurative, done in a style that reminded Spellman of Renoir. Some were almost fairy-tale art, certainly a kind of fantasy, which seemed very much what Kilimnik herself was about. To Spellman's surprise, she had no current dealer.

Doug Aitken, a multimedia artist, wowed Spellman with a film he made with a camera-equipped rocket launched over his hometown of Redondo Beach, California; future works would be strongly political and environmental, like a video about diamond mining in Namibia. Sue Williams was a fiercely feminist artist focused on political identities; a rubber sculpture depicted a battered woman, with a footprint on her thigh, huddling on the floor. Like Kilimnik and Aitken, she was an artist Spellman might not have met in less trying times.

Rirkrit Tiravanija, a performance artist born in Buenos Aires and raised around the world as a diplomat's son, came from another tradition. His first show was a communal cooked meal of pad thai at the Paula Allen Gallery in 1990, reenacted on a daily basis and served to his audience. Two years later, he brought a show with that same sensibility to Spellman's 303 Gallery.

"People were freaked out, worried," Spellman explained. "And here came Tiravanija to invoke a powerful sense of community." Eventually, Tiravanija's kitchen was sold as art to a museum. Spellman had a good eye—all these artists would rise over the next two decades—but

other artists, just as creative, were emerging nearby. Gallery by gallery, the art world was coming back to life.

Among the grateful partakers of Tiravanija's communal meals was a young Brit with a scruffy beard and rumpled clothes. Gavin Brown wasn't a dealer yet, but he soon would be. With equal measures of passion and arrogance, he would be an alternative force in contemporary art, taking chances on unknown artists, finding new ways of staging shows, and in his own way becoming one of the most influential figures in the contemporary art market. He opened his first gallery in 1994 on SoHo's Broome Street. Three years later, he would open a larger one on West 15th Street, and would eventually start an adjacent bar, called Passerby, prized for its illuminated floor of different colored squares, creating an ambient glow.

Gavin Brown was, in short, the antithesis of Larry Gagosian.

A CHILD OF DIVORCED PARENTS FROM suburban London, Brown came to Manhattan in the late 1980s with about $3,000 in his pocket. He had attended art schools (Newcastle Polytechnic and Goldsmiths) and had a scholarship to attend the Whitney Museum's prestigious independent-study program, but he needed work to help make the rent. He waited tables at two of downtown's favorite watering holes, Canal Bar and Odeon. "One week here and I was watching Run DMC demolish a tableful of lobsters," Brown recalled.[27] After a year, he wangled a part-time job as an art handler for Pat Hearn, the Jackie Kennedy of the art world, whose romance with Colin de Land was still going strong. Hearn's new space was just across Wooster Street in SoHo from Colin de Land's own SoHo gallery.

"They were mythic, romantic figures," Brown explained, "not just in terms of their relationship: they embodied a way of acting in the world of art that I hadn't known existed. I couldn't have imagined my gallery if I hadn't seen that." They were dealers, but also cultural arbiters, their galleries both showcases of important art and social hubs of the art world.

Brown still clung to his hopes of becoming an artist himself. He lit corner trash barrels to see how they looked as the trash in them burned and took photographs of the results. He bought stacks of paperback books

from sidewalk vendors and made sculptures from them.[28] He was shown by David Zwirner soon after Zwirner's 1993 opening on Greene Street, but the art, by mutual agreement of dealer and artist, went nowhere.

Restless, Brown switched from Pat Hearn's gallery to Lisa Spellman's 303 Gallery. At first he worked as an art handler there too. But Spellman sensed talent and encouraged Brown to curate a group show at the gallery. One of the works he chose was a stack of empty Rolling Rock beer bottles, a concept of Rirkrit Tiravanija. Brown adored Tiravanija's art of community, and the two became fast friends: "The brother I never wanted," Brown said wryly. His group show, titled *True to Life*, caused a modest stir when it opened in the summer of 1991. Along with Tiravanija's beer bottles, the show had a piece by Robert Gober, Christopher Wool's co-artist at 303 a few years before.

True to Life was a success, and Brown delved more deeply into working with artists he knew personally. In 1993, he created a temporary gallery at the Chelsea Hotel, where he showed small, delicate portraits by 27-year-old Elizabeth Peyton in room 828.[29] Guests had to get a room key at the desk to come up and see them. Not long before, Peyton had married Tiravanija, whom she barely knew, to help him get a green card; she and Tiravanija and Brown were now almost a family. Peyton's portraits in room 828 were of historical royals: Napoleon Bonaparte, King Ludwig II of Bavaria, the king of Thailand, and more. As Calvin Tomkins later noted in the *New Yorker*, "No artist in recent memory has sailed into the mainstream with work that seemed so far out of it."[30] At the time of the Chelsea Hotel show, though, few outside Brown's new art world had heard of Peyton. She was an early indication that Brown, like Gagosian and Castelli before him, had an eye. Later, Allan Schwartzman, a curator on his way to becoming one of the art world's most successful advisors, would call Gavin Brown "the Leo Castelli of that generation. He had his finger on the pulse more than anyone, and the creativity to do it. He thought like an artist."

IN THE LEAN EARLY 1990S, DOWNTOWN dealers like Brown and Spellman and Hearn struggled to pay the rent and waited for a sign:

something new, something urgent leading somewhere unforeseen. They knew what was past them now: those big Neo-Expressionist paintings from the Mary Boone era. Schnabel's huge canvases looked overblown, and no one was buying them for even a fraction of what they had fetched in the late 1980s.

Small-scale art, like Elizabeth Peyton's portraits, was one way to go. Conceptual art was another: the hand, once again, consigned a secondary role at best. Joseph Kosuth created self-referential installations with a focus on language—using, for example, texts from Freud in neon letters. Jenny Holzer, another Conceptualist, also worked with language, creating public art that commented on consumerism, disease, and death. Adam McEwen, an English Conceptual artist living in New York City, put standard consumer products into new contexts. Later he would make paintings using wads of chewing gum on canvas to indicate the bombing of German cities in World War II—less a work of the hand than of the mouth.

Much art of the early nineties addressed personal issues—issues that were, at the same time, fiercely social and political. The art of identity politics, as it came to be known, encompassed feminism and gay rights. Art about civil rights and racial issues continued to be largely under the radar, however.

Most poignantly at that time and place, much of the political art addressed the decimation of downtown's artistic community by AIDS. One of the best-known new artists was Félix González-Torres, whose piles of wrapped hard candies, there for onlookers to unwrap and eat, symbolized the diminishing weight of his HIV-positive lover, Ross Laycock, symbolically gone when the last candy was consumed. The piles were endlessly renewable, with an "ideal" total weight of 175 pounds, a number that corresponded to Laycock's weight before he contracted HIV. Strings of light bulbs, hung from the ceiling, also symbolized the steady advance of mortal illness, as one bulb after another burned out. Sometimes, the works assumed a more sanguine meaning: the candies were replenished, the light bulbs replaced. This was the intention. But AIDS was never far from the artist's mind. "Everyone who was centrally

involved in the art scene knew people who were dying," Jeffrey Deitch recalled. "It pervaded everything. A lot of very interesting art came out."

A full-time dealer now, Deitch staged his own group show in 1992 and called it *Post-Human*. From breast implants to genetic engineering, humans were undergoing bodily changes through technology. How else would gender identity and sexuality be affected? What new behaviors and morals would result? Eerily predictive of the age of gender fluidity, *Post-Human*'s 36 artists included more than a few who would become global stars: Paul McCarthy with his vision of post-human robots, Mike Kelley probing the undertow of violence and perversity, and Jeff Koons, whose marriage to Italian porn star Ilona Staller had led to sexual sculptures of the couple so highly charged that in Europe Thaddaeus Ropac had to cover them with white sheets and peepholes so only adults could look through.

A milestone was the Whitney Biennial of 1993, devoted entirely to identity art. Artists of color, women artists, gay artists—all had passionate messages to impart. *Time* magazine art critic Robert Hughes waved off the artists as self-indulgent whiners, but if popular culture was nothing else, it was a growing clamor of dissonant voices.

Not yet clear was where all this art was going, suggested art advisor and collector Thea Westreich. "The only thing I remember about the early nineties is that there was less young art that looked good. It just felt...not as good. It wasn't about money. There just wasn't that much...there didn't seem to be a group of artists as there had been in the early eighties—Salle and Fischl and Schnabel, plus Europe with Kippenberger and Polke and Richter. The nineties felt barren. So few artists that we got excited about."

Arne Glimcher felt unimpressed by the early nineties too. He felt that young artists of those years had no particular destination, no new world to make. "It was the end of the avant garde," Glimcher said. "There was too big an audience for everything that appeared new, and for the most part, it *wasn't* new."

Jeff Koons had another perspective on popular culture of the early nineties. He had no interest in challenging it, merely in celebrating

it—and making a lot of money from the art that reflected it. He had a philosophy to go along with his work: that it should appeal to all audiences, from museum curators to consumers of mass culture who might know absolutely nothing about art. That was what television did; why couldn't Koons be the art world's television? From his inflatable flowers and floating basketballs, Koons had gone on to fabricate his own vision of Main Street America. He had produced a life-size, gilded porcelain sculpture of singer Michael Jackson and his chimpanzee Bubbles (1988) and a 40-plus-foot topiary sculpture of a puppy (1992). No one would ever accuse Koons of not having a personal vision. Was it good art? Or just superficial images easily recognized by collectors who had little time or inclination to learn about what they were buying?

One thing it was, unquestionably, was expensive. Ileana Sonnabend had been thrilled to sign up Koons in the mid-1980s. She still loved his work, but the production costs were horrifying. "It meant one had to pay very large sums for many years until the work was finished," explained Antonio Homem, her adopted son and director of the gallery. Tensions between the gallery and Koons grew to a breaking point in 1992, with Koons's plans for a new series called *Celebration*. These were ultimately fabricated from 1995 into the 2000s. "We told Jeff we could only pay for the fabrication of one copy of each sculpture and that hopefully that copy would sell during the exhibition and we could use that money to pay for the fabrication of the other copies," explained Homem. "Jeff, at that moment, could not understand this. He saw it as us abandoning him and he left the gallery."

Koons was an interesting case, among other reasons, for what his works said about the perennial pull between figurative and Conceptual art. Koons's art was figurative, but only in the sense that toys and dolls were figurative. They originated from commercial products, readymades of a sort. His art aimed for a kind of technical perfection, hence all those production costs. Yet the result was neither figurative nor abstract, merely totems of popular culture, bland and kitschy, instantly recognizable—defined, ultimately, by their cost.

Over the next years, artists and their dealers would focus more and more on the market worth of their art, to the point that the value of a painting—its true, inherent value—would be its marketplace price. "Movements morphed into price categories," agreed Acquavella Galleries' Michael Findlay. The higher they rose, the faster they often fell. "It's reasonable to assume that Picasso will be a giant well into the twenty-second century," Findlay said. "But what happened to Ernest Trova? There was a time when everyone on Park Avenue had a Trova."

ONE OF THE FIGURES WHO MIGHT steer contemporary art from this fate to something more profound—and fun—was Gavin Brown. One of his first shows on Broome Street highlighted a figurative artist named Peter Doig, whose pictures had an almost Impressionistic feel to them, quite at odds with the prevailing winds of abstract and Conceptual art—or identity art, for that matter—yet strangely compelling. Brown had no reason to think that Doig would become one of the most celebrated—and highest-selling—artists in the world. In 1994, nobody else did either.

Brown was the first to expose Doig to the New York art world, but he was not the dealer who discovered him. For some time, Brown had been in touch with a shy British dealer named Victoria Miro, and the two had begun coproducing shows, sending art from one gallery to the other. Miro had shown Doig first, though as it turned out, Brown had known the artist in art school. Brown was frankly amazed by Doig's progress: earlier on, he had seemed an unlikely prospect at best, since he could hardly draw.

It was in 1993 that Miro heard about Doig through mutual friends. She had a gallery on London's Cork Street but was starting late: she had had her children, turned 40, and almost abandoned the hope of becoming a dealer, when her husband, a successful businessman named Warren Miro, insisted she follow through. She would always regret not doing it, he told her.

When her friends first mentioned Doig, Miro saw no point in even going to see his work since it was, as they admitted, quite figurative and Miro was a Conceptualist, or so she thought. Still, she listened as they explained how Doig's upbringing had shaped his art. Doig's father had moved the family around when Doig was young, from Edinburgh to Trinidad to Canada. All three settings had inspired his landscapes.

One night at about this time, Doig couldn't sleep, so he forced himself to open all the bills that had been accumulating for weeks. Most were second and third demands for payment: "Cut up your credit cards right now and send them to us," one bank admonished him.[31] The last envelope in the pile looked different. Doig opened it to find that he'd just won the John Moores Painting Prize, with an award of 20,000 pounds. Soon there was more good fortune: Victoria Miro came to see his work.

"Peter had racks and racks of paintings, all enormous," Miro recalled later. "He would walk around carrying them. I couldn't believe my eyes." Miro found them breathtaking, even if they weren't Conceptual. She was even more wowed by Doig's method. Since he had no drawing skills, the artist started with a photograph, usually taken from a magazine, then blurred and distorted the image, projecting it on a larger scale.[32] That was when the painting began, somehow made possible by the projection.

Miro staged her first show of Doig's work at her Cork Street gallery in 1994. Gavin Brown staged his own in New York later that year. Miro took one of Doig's large canvases to Art Basel. "I had it in the most prominent position, on the back wall, so that everyone going by could see it," recounted Miro. "People didn't like it! They would say 'Why are you showing that?' Almost no one even asked the price." His paintings were out of step with the times: landscapes had no place in a canon of Conceptual, social, and political art.

Despite the naysayers, Doig was named one of four finalists—and the youngest—for the Turner Prize in 1994. Antony Gormley won it that year, but Doig's work was purchased by the Tate. He was on his way, and so were his dealers.

A FUTURE RIDE OF CONSIDERABLE VELOCITY awaited another Gavin Brown artist, a young British painter with Nigerian roots named Chris Ofili, who first showed at Broome Street in 1995. Ofili was doing watercolor portraits that incorporated humorous references to gangsta rap. In other works, he was painting portraits in thick layers, using glitter, resin, and elephant dung. The last of these additives would earn him the furious condemnation of New York mayor Rudy Giuliani when Ofili used it in his portrait of the Virgin Mary. All that lay ahead.

The night before the opening of Ofili's show at Gavin Brown's gallery—November 20, 1995—*New York* magazine art critic Jerry Saltz happened to drive by the Broome Street storefront. "I saw something so startling, it made me pull over, stop, stare and take pictures," Saltz recalled. "Outside the gallery, a painter with his back to me worked on a large vertical painting leaning against the gallery facade." The painter was Ofili. "Placing little dots across the surface, he diligently worked with different brushes in his hand, water buckets and other things on the sidewalk all around him. A light might have been propped up as well. I sat transfixed, watching something wonderful come into being. It is simply not possible not to count him among the greatest artists alive."[33]

Brown had been among the first to recognize Ofili's remarkable talent, as well as Doig's. He would be early on to others, too, among them abstract painter Joe Bradley and hipster artist Alex Israel, whose flat LA landscapes, some with Ruscha-like declarations, were utterly affectless. And then, to his fury, he would watch as one after another got picked off by a new generation of mega dealers who brought bigger operations, better-run businesses, and more money—much more money—to the game.

The Europeans Swoop In

1994–1995

JACK SHAINMAN AND HIS first partner, Claude Simard, never set out to represent black artists. "I don't think we said, 'Let's represent black people because we can sell a lot,'" Shainman said later with a laugh. "You have to love the work first." They started in Washington, DC, in 1984, soon relocating to the East Village and then on to SoHo. They saw their gallery grow to three floors—until the market crash of 1990. "I couldn't accept failure," Shainman recalled as the phones stopped ringing. "I did everything to cut back."

In 1992, Shainman saw a postcard on the office bulletin board of a curator in Cleveland, Ohio. It was a reproduction of a painting. There were other postcards on the board, but Shainman's eye kept going back to this one. It had a flat, folk-art feel, with a scene of black life that seemed both traditional and provocative. On the back of the card was the artist's name: Kerry James Marshall. The curator had put the card up on a whim; he had heard Marshall had attended Otis College of Art and Design in Los Angeles, but knew nothing more about him.

The trail led west, then south to Texas, then north to Chicago. Finally, Shainman found Marshall about to open a show at the Chicago Cultural Center. He attended the show. "I was just blown away," he recalled. "If my socks roll up and down without touching, I know I like it."

Marshall was lovely and brilliant, as Shainman put it, but also humble and a bit wary. He didn't think he was ready for a show in New York. He didn't think he was ready for New York at all. Shainman spent

most of a year persuading him to take the risk. "We had our first show in SoHo," he recalled. "I knew I had something significant, but in a funny way, the art world wasn't ready." Three of the paintings sold for $7,000 each, two to museums, one to a collector. "I was disappointed that we hadn't sold out," he recalled, "but [Marshall] made this amazing comment. He said, 'Maybe people aren't ready to have black folks hanging in their living rooms.'"

Shainman realized he'd just been focused on selling the paintings, not on who bought and exhibited them. Marshall wanted to be represented in museum collections so that black figures would be present in a nearly all-white realm. He also wanted to sell his work to collectors of color. "Which I hadn't really thought about," Shainman admitted.

One by one, Shainman placed Marshall's paintings in settings where they might have social impact, particularly museums. As he did, Marshall began earning serious critical attention. Happily, Shainman would still be working with him in 2016, when a large solo show at the Metropolitan Museum's Met Breuer became an exhilarating, career-changing triumph, putting Marshall among the top tier of living American artists and, not coincidentally, sending the price of his paintings up: first to over a $1 million, then $5 million, and finally, in the spring of 2018, to $21.1 million at Sotheby's for a large painting called *Past Times*.

For black artists and the dealers who represented them, a blast of coverage and controversy came in late 1994 with the Whitney's landmark show *Black Male: Representations of Masculinity in Contemporary American Art*. Its instigator was the young and visionary curator Thelma Golden, who had helped organize the Whitney Biennial of 1993, along with curator Elisabeth Sussman. The 1993 Biennial had put political identity art front and center in a way that earned as much scorn as praise. For *Black Male*, Golden showcased the work of 29 artists whose paintings, sculpture, video, photography, and installation pieces were meant to "challenge and transform the 'negative' stereotypes, real and imagined," of black men.[1] Most, but not all, of the artists were black. Most, but not all, were male. Many were well known, but several were

not. David Hammons, the snowball sale Conceptualist, was among the 29. So were Robert Colescott, Adrian Piper, Lorna Simpson, Jean-Michel Basquiat, Leon Golub, Andres Serrano, and photographer Robert Mapplethorpe, whose portrait of a naked black man was a showstopper. Much of the criticism was directed at Golden herself. What right did a white Jewish woman have to curate a show called *Black Male*? Such was the assumption that some critics made about her name. Golden was, in fact, black.

Hilton Als, who would go on to win a Pulitzer for criticism in 2017, was Golden's project editor from the start, suggesting that they meet for the first time at the Odeon restaurant—Als perhaps testing her by showing up in a coat over pajamas and burgundy socks. "Well," he said when Golden shared her thoughts for the exhibition, "why not paint the galleries red, black, and green," the colors of the black liberation flag? Golden gulped. "Sounds great!" she said, and they were off and running.

"It was a watershed moment," Als said, "and not only for exposing people to black artists. It turned out if you put them in a museum context, they acquired monetary value. Having that art anointed by the Whitney meant that buyers were less freaked out about buying it—and investing in it. They didn't necessarily want to see it," Als added with a laugh, "but they wanted to make money from it."

ASIDE FROM BASQUIAT, IT COULD NOT be said that Larry Gagosian carried artists of color in the midnineties. He would have none until 1998, when he took on Ellen Gallagher, who happened to be biracial. He might have ranged farther afield, as Shainman had, but his first priority was survival.

With the contemporary art market still soft in the early-to-mid nineties, Gagosian reached back into Modern and Impressionist art history, selling the art world's biggest brand names. For the dealer whose passion for Picasso had only grown over time, selling secondary works by the master was both exciting and profitable. Year after year, Picasso ranked among the highest-selling artists, dead or alive. Gagosian's

historical shows would lead to a trend for which he could take most of the credit: hiring distinguished art historians to curate non-selling shows for him, chief among them Picasso biographer John Richardson and John Elderfield, at that time chief curator at large for the Museum of Modern Art.

At the same time, Gagosian intensified the search for primary artists. In the winter of 1992, he zeroed in on Peter Halley, one of the Neo-Geos. Shortly before Halley's next scheduled show, in February 1992, Ileana Sonnabend was informed that Halley was no longer her artist. He was Gagosian's.[2] Sonnabend was stunned. She had presold 11 of the show's paintings and paid advances to the artist.[3] If Gagosian wanted to get tough, she could too: that was money Halley would have to return to her. Sonnabend also accused Gagosian of paying Halley a $2 million bonus to change galleries. In a sworn affidavit, Halley stated that there was no $2 million bonus. Nor, he felt, did he owe Sonnabend any money.

"It was a milestone, that case," recalled art world photographer Timothy Greenfield-Sanders, whose wife, a lawyer, represented Halley. "It was a realization that this was business, and the artist was moving on because he or she could make a better deal. And the dealers were trying to emotionally blackmail them: 'Stay with us, you owe it to us.'"

Oddly enough, in the wake of a settlement, Halley was seen as Machiavellian, recalled painter John Zinsser. Gagosian emerged with more respect. He was the power broker unafraid to take on Sonnabend, a pillar of the art establishment, as well as Castelli himself. That took nerve. Two years later in 1994, Halley and Gagosian called it quits, with both parties denying that Halley's work had failed to sell as expected.[4]

The short, unhappy tenure of Halley as a Gagosian artist made clear two new rules of the game: artists could now be traded like ball players, and, just as surely, artists who failed to sell their work at Gagosian's aggressive prices might find themselves out on the street in two or three years, looking for a new home. For Halley, it was a painful period. "I think I was the only person in the art world that Leo Castelli

wouldn't talk to," he said later.[5] He eventually signed on with Mary Boone and did shows with her starting in 2002.

WITH SOHO STILL EMERGING FROM RECESSION in 1993, a tall, handsome, young German with cornflower blue eyes strode down Greene Street with dealer Barbara Gladstone, carrying a large, early work by Gerhard Richter called *Antlers*. David Zwirner had a low-key charm that reminded many of his father, Rudolf, one of Germany's best-known art dealers; David, after years of uncertainty, had plunged into the family business. He was going to meet a promising client: Iwan Wirth.

Wirth bought *Antlers* that day at Zwirner's new Greene Street gallery. Soon, Zwirner would sell Wirth a few more pieces. "Then we looked at each other," as Zwirner said later. Why not do business together? The two ambitious dealers would collaborate for the next 16 years—informally from 1993 to 1999, officially between 1999 and 2009—before breaking off to become cordial but deadly earnest mega rivals.

Both Zwirner and Wirth had grown up in Europe. Both were fascinated by contemporary art. And both sensed opportunity in the lingering early nineties recession. Surely the worst was past and this was the time to jump in, while gallery spaces were cheap and good primary artists could be signed up. Zwirner had his Greene Street space and quite the eye. His first five artists were still fairly unknown but starting to draw critical attention. Zwirner, it was clear, would be an identifier, a career maker. Wirth, for his part, was closer than Zwirner to certain rich European collectors. He could also buy promising works, because, in addition to being a genial fellow, Wirth brought to the partnership a formidable wife and mother-in-law.

ZWIRNER HAD LEARNED ABOUT ART FROM HIS FATHER. A well-known curator-turned-dealer, Rudolf was also cofounder of the Cologne art fair in 1967. His best and most enduring client, Peter Ludwig, was one of the continent's greatest collectors and an early supporter of Pop.[6]

David was 10 years old when his parents divorced. His father remarried and moved his family to a loft in SoHo, where David attended the Walden School. One of his classmates was Monica Seeman, his future wife. At 16, he moved back to Germany, where his father set him up with a car and an apartment.[7] If Rudolf hoped these perks might ease David into the family business, he was wrong. Cologne was too staid and small. David pined for SoHo; not as a future art dealer, but as a jazz drummer. For an audition tape to New York University, he played along with Charlie Parker's "Ornithology" and got in.

While studying at NYU, David took a part-time job at Brooke Alexander, a dealer known for museum-quality prints, and found he loved the art he was shepherding about town.[8] He was 28 in 1993 when he opened his SoHo gallery at 43 Greene Street. His father had given up trying to coax him back to Germany. Instead, Rudolf had retired, an exercise in grace. "I had a feeling, I don't want any competition with my son," the older Zwirner said. "I'd be the loser, this was quite clear."[9] Zwirner's timing was brilliant: by 1993, the recession was indeed ebbing.

For Iwan Wirth, the pristine landscape of northeastern Switzerland had a lot to do with why he chose the course he did. He hadn't grown up in Zurich or Basel. He came, instead, from Saint Gallen, a beautiful if sedate university town. Two world-class dealers had grown up in the region: Bruno Bischofberger in Appenzell and Thomas Ammann on Lake Constance. "Being on the periphery forces you to go the extra mile," Wirth suggested years later in his simple but spacious office at Hauser & Wirth's main gallery in Chelsea. "Your creativity and confidence are challenged in a different way."

Wirth's father was an architect, his mother a teacher.[10] They read and discussed books, and lived modestly on a farm. "I didn't know there was such a thing as a gallery," Wirth recalled. "My first memory of art was when my grandmother and father took me to the *Kunsthalle*. I remember reading the wall labels for a Giacometti show: he was the first love of my life."

Soon Wirth was devouring art books and going to the Erker Gallery, a rare repository of contemporary art in Switzerland. When he

was 15, a woman who worked at the Erker noted that another teenager was just as passionate about art as Wirth. The other boy's name was Hans Ulrich Obrist. He would go on to become the world's busiest curator, constantly traveling to give talks and preside at art shows while somehow also managing to serve as artistic director of London's Serpentine Galleries. "Yes!" Obrist said years later. "Iwan and I met when I was seventeen and he was maybe fifteen. The lady said, 'You guys should meet,' and so we did. We became friends."

Wirth was all of 16 years old when he decided he would be an art dealer. He looked up an artist whose work he liked and gave him a call. "I have opened a gallery," Iwan declared to the artist, Bruno Gasser. "Will you let me put you in my first show?" It was not quite true that Wirth had a gallery, or that he was organizing a show, only that he hoped to do so. Gasser liked the boy's pluck. He said Iwan could be his dealer under two conditions: first, that he produce a book of Gasser's work, and second, that he come to Egypt, where Gasser would be an artist in residence. Wirth agreed immediately.[11]

Wirth's time in Egypt was revelatory. Omar Sharif lived next door; Wirth and Gasser got to know him. They were also robbed in the desert and threatened with knives. Now all Wirth needed was a gallery. He found one in the basement of an apartment house in Saint Gallen, in 1986. He could not afford the rent, so he made a deal with his landlord to pay him part of the proceeds.[12] He showed Gasser and other artists he liked, but made no sales.

By now, Wirth was 18 years old, and knew a few other dealers. One took pity and offered him, at a good price, a package deal: a late Picasso of a cat and a lobster, and a Chagall. Wirth could only afford to pay half. He needed a collector with ready cash to front him the other half. The only one he could think of was Ursula Hauser, the wealthiest woman in the canton of Saint Gallen.[13] Wirth had known Hauser since childhood, well enough to ask if he could come see her. Bemused, Hauser heard him out and agreed to buy the late Picasso.[14] She also introduced him to her daughter, Manuela. "So the first day I went there," Wirth said later, "I met my wife." The new friends opened a bottle of good

cognac to toast their deal, and Wirth made the mistake of drinking three snifters of it. Manuela was underwhelmed, the more so when, in leaving, Wirth plowed his car into their fence.[15]

Ursula Hauser was happy with the Picasso her future son-in-law sold her. She was less happy to hear she had accumulated a lot of less-than-top-tier works. "I was brutal with her," Wirth recalled wryly. "I said, 'You have all the right names and all the wrong works.'" First, he convinced her to sell most of them. Then, he got her to let him do the selling. With that, the two went into business together as Hauser & Wirth. Working out of a Zurich apartment, Wirth handled Ursula's art with the help of Manuela, who became the office secretary. If she was Wirth's girlfriend, the romance appeared, to one friend, to be progressing with old-world Swiss formality.

The three lost money when the market collapsed in 1990, but not much, since they dealt in paintings one or two at a time. By 1992, they had taken an apartment in a beautiful villa in Zurich and called themselves private dealers: in homage, in a sense, to famed Swiss private dealer Thomas Ammann, who would soon die of AIDS in Zurich. That year, they opened a second space—industrial in scale—in Zurich's West End. A major show by Egon Schiele from early-20th-century Russian collector Serge Sabarsky's private collection was followed by shows of Bruce Nauman, Gerhard Richter, and more.

Zurich was stately and—as always—sleepy. Impatient, Hauser and Wirth rented a residential loft on Franklin Street in New York's Tribeca. They had no intention of making it a gallery space, but they did host lots of parties and met lots of artists. Art was cheaper now, and more artists were willing to sign with new dealers, hoping to start or reignite careers. The young couple from Zurich could feel the market growing. They wanted to be part of it, too.

DAVID ZWIRNER SENSED THE SAME OPPORTUNITY when he opened his Greene Street gallery in 1993. But, like Wirth, he had no fixed ideas about the art he wanted to show. He knew only one thing. "I didn't care what medium: painters, sculptors, video—no parameters,"

Zwirner said. "Authenticity was what I was after." How much money an artist produced in profits for the gallery was of no significance, or so Zwirner said.

Zwirner's opening show on Greene Street was Franz West, a Viennese multimedia artist, much admired in Europe but less known in the United States. Later, West would come to be known for pink outdoor sculptures made of plaster, papier-mâché, wire, and aluminum. Some were unmistakably phallus shaped, eight or ten feet tall. West had a very laid-back manner, as one close friend noted, but a keen awareness of his talent, which in time would lead to tensions with his new dealer. "Zwirner was a young gallerist, maybe a little too ambitious—he told Franz what to do all the time," the friend explained. "Franz started to hate that." Through the nineties, though, he held his tongue and enjoyed the stretch limos that Zwirner provided on opening nights.

As for Zwirner, he adored West and was truly passionate about his work. He had no doubt that he could make West a major name in the United States. It was just a matter of keeping him on track as an artist and not letting his demons get the better of him. That was a challenge, for West already had alcohol-related liver damage, and at some point he would contract hepatitis.

Wisely, Zwirner had gone to all the European art fairs of the early 1990s—there weren't many at that point—and developed a roster, or program, as it was known, of other emerging artists. They ranged from Belgian-born Luc Tuymans, a figurative painter who started with photographs and then enriched them, to Diana Thater, a video artist who made site-specific installations, some with multiple screens, depicting the contrasts between nature and modern culture. Virtually all of Zwirner's artists would stay with him the next 20-plus years—all, that is, but Franz West.

Zwirner had married Monica by now, and their son Lucas had been born in 1991. The young dealer came to work by skateboard, but that was one of his few daily pleasures. He worked with dogged perseverance, devoted to work and family. Often, though, the two got

intertwined, in no case more intimately than with installation artist Jason Rhoades.

Word of a young MFA student at UCLA came to Zwirner in the spring of 1993 from artist and sculptor Paul McCarthy, who was teaching there at the time. McCarthy had made his name with sculptures of distorted pop-culture figures and was a well-known artist now: he had just participated in the prophetic, Jeffrey Deitch–produced show *Post-Human*. McCarthy had seen in Rhoades a kindred spirit of antisocial rebellion. The older artist called three New York dealers to say a talented art student was coming to SoHo for one day, and could they see him. Zwirner was one; the others were Barbara Gladstone and Metro Pictures. All three were on Greene Street.

Uncharacteristically, Zwirner called in sick that morning. He told his first employee, Gregory Linn, that a young California artist was coming and asked if Linn would handle the visit. Rhoades arrived with a three-ring binder with eight-by-ten photographic images of his installations. "In one photograph he was a Middle Eastern rug salesman in an abandoned parking lot, dressed up as a very fat man, totally naked, smoking out of a hookah," Linn recalled. "I had never seen an artist make work like this before." Rhoades had come to the Zwirner Gallery first—it was the southernmost gallery of the three on the street, and Rhoades had started at that end. If Zwirner didn't offer him a show, Linn suspected, Gladstone or Metro might nab him. "I immediately called up David," Linn recalled. "I said, 'I know you're sick but you have to meet Jason before he flies back.'" Zwirner did. When he saw Rhoades's photographs, he was thrilled. "The last thing I thought about was whether I could sell Jason's work or not," he said later. "It was like no one I had ever seen. He was a raw talent. Anyway, whenever you show great art you sell it sooner or later."

Rhoades's first installation at the gallery, in September 1993, showed a car engine in the middle of a garage—a garage that Rhoades had built in Zwirner's gallery for the show he called *CHERRY Makita*. As Zwirner explained later, "Rhoades would turn on the car engine,

rev it up—they had to pipe out the exhaust at the front door; that was part of the sculptural aspect—and tell this story about guys working in their garages, like artists working in their galleries. It was a sellout and the show that put us on the map." Collectors bought the parts scattered around the engine, some made by the artist, some store-bought.

The installations always had an autobiographical aspect to them: humorous, freewheeling, and often mocking of conspicuous consumption. Some critics put Rhoades in the camp of "scatter artists," with installation objects spread in as random-seeming a way as a teenager's stuff strewn across his bedroom. But Rhoades, Zwirner saw, was on to something else.

For his next installation, Rhoades used household objects, like motorized toy trains, train tracks, and television monitors, as well as mundane elements like cardboard, yellow paper pads, and piles of folded clothes. The centerpiece was a large red metal sphere. It was a carnival ride called a Spaceball, self-contained, with a bar that opened and closed and a seat inside for the rider. Collectors Clayton Press and Gregory Linn paid $20,000 for this part of the installation. "You would put on a seat belt, strapped into the capsule," Press recalled. "Someone outside would turn a wheel and you would spin around. We put our architect in it—he was screaming."

IWAN AND MANUELA WIRTH MARRIED IN 1996, Iwan at 26, Manuela at 33. "A legendary wedding with lots of artists attending," Iwan recalled. "Franz West designed the wedding announcement and played at the ceremony." In their still-modest business, Manuela remained in the background but was in on every important decision the young couple made.

Hauser and Wirth knew that, despite their considerable resources, they were at a disadvantage. "Being Swiss," Wirth later explained, "you have to be a bit of a pirate—go out and find the treasures, because they won't find you. When we started our gallery in 1992, most of the important painters were taken, and local collectors already had strong relationships with others. So the niche for us was artists who were making

more complicated visual work that needed support, that was highly important but not commercially successful."[16] A lot of the artists they took on had little or no market: Wirth and Hauser's job was to build it.

One of their first, in 1997, was Pipilotti Rist, a Swiss video artist. "I said to Pippi in our first meeting, 'What do you need?'" Wirth recalled. Rist told him she needed an assistant—and Wirth's car, so she could smash its windows.[17]

Sure, said Wirth. From that exercise emerged *Ever Is All Over*, a slow-motion video of a woman smashing the windows of parked cars with a hammer shaped like a tropical flower, then encountering a policewoman who smiles in approval. Wirth's willingness to give Rist whatever she needed showed a commitment to all Hauser & Wirth artists that the gallery would do whatever work they wanted it to do. "Also the belief that we let our artists, or our estates, lead the marketing," Wirth said later. "It's not us."

Rist—who had changed her first name in childhood in homage to Pippi Longstocking, the mischievous girl in Astrid Lindgren's children's novels—was focusing already on issues of gender, sexuality, and feminism. Here, realized Ursula Hauser, was a focus for her too: women artists. As a cofounder of Hauser & Wirth—the quietest one of the three—Iwan's mother-in-law urged the gallery to take on more women. One of their first was Louise Bourgeois, the nonagenarian sculptor whose giant spiders were becoming globally iconic. Another was Mary Heilmann, an abstract painter whose use of primary colors and geometric shapes had already made her reputation.

Buying women artists was easy—selling them a bit harder. Even Bourgeois, well known as she was in 1996 when Hauser & Wirth took her on, was difficult. Hauser & Wirth gave her a solo show that year in Zurich. "We didn't sell a single piece," Wirth recalled with a laugh. "My only client was my mother-in-law." Yet more than two decades later, after Bourgeois's death in 2010 at age 98, the Wirths were still showing her. Bourgeois's explorations of feminism, family, and gender roles had come to be seen as profound—and political. In her last year, she would make a piece advocating LGBT equality.

Another early acquisition, Paul McCarthy, had also had a long career. He had been represented by other dealers over the years: Rosamund Felsen in LA from 1986 to 1994, and Luhring Augustine in New York from 1993. "He was a legend," Wirth exclaimed later. "I couldn't believe he was available."

McCarthy had started in the 1960s with performance art and was associated with two future giants of contemporary art: Bruce Nauman, the video and installation artist, and Allan Kaprow, the pioneer of mostly outdoor "happenings." McCarthy had become a multimedia artist and dared to go where pretty much no other artist had: into human neuroses about bodily excretions and orifices. His first art performance, in 1976 to a classroom of college students, was titled *Class Fool* and involved McCarthy crawling naked on the classroom floor, smeared with ketchup and retching. The performance ended when the students could stand it no longer. For the next decades, as Randy Kennedy noted in a *New York Times* profile of him, McCarthy reveled in "his version of American Gothic...so perverse and outrageous, bloody and scatological that it remains disturbing for even art-world initiates."[18] Through Zwirner, Hauser & Wirth also began representing Zwirner artists—American artists—in Europe. They showed Jason Rhoades in Switzerland with a first show in 1998, and later in London as well. Diana Thater also signed on to have Hauser & Wirth exhibit her in Europe.

Neither Wirth nor Zwirner made much money in the primary market of the 1990s. But their artists were becoming known, and the market was reviving. Zwirner, for his part, had access to his father's Rolodex and inventory of Pop art. "Unlikely as it might seem, we had a business plan in all this," Iwan Wirth later declared, "even though the business model was built around noncommercial artists."

DAVID ZWIRNER CALLED THE GAGOSIAN GALLERY a parallel universe. Gagosian had no interest in Jason Rhoades or other installation artists in the 1990s. He had brand-name artists like Ed Ruscha and Andy Warhol, but they were secondary to the real stars of the Gagosian

universe: the collectors. Leo Castelli had run an artist-centric gallery; Gagosian was buyer centric. He cultivated the very rich who thrilled to be told which artists to invest in, by the dealer who seemed never to harbor a doubt. These included Ron Perelman, the dealmaker of MacAndrews & Forbes; LA real-estate developer Eli Broad; hedge funder Steve Cohen; private equity king Leon Black of Apollo Global Management; casino magnate Steve Wynn; entertainment mogul David Geffen; British über collector Charles Saatchi; media maven Peter Brant; the Nahmads and the Mugrabis; and Condé Nast publisher S. I. Newhouse. These were Gagosian's inner circle, not unlike Gagosian in personality. "Larry is inherently impatient," noted one of his staffers, "so he gravitates to *other* impatient people." Irving Blum, the grand old gallerist of the sixties, liked to note, too, that everyone in Gagosian's circle was a man: a happy, swaggering group of high-net-worth, high-testosterone captains of finance.

With collectors like these, Gagosian saw no threat from Zwirner. He barely knew the guy. His rival was Arne Glimcher. The two dealers were often pitted against each other on a field of battle utterly foreign to David Zwirner and Iwan Wirth: Hollywood.

Gagosian had been dealing in Hollywood for some two decades now, thanks to Barry Lowen, Doug Cramer and his ex-wife Joyce Haber, and above all David Geffen, who had gone on to buy most of S. I. Newhouse's collection through Gagosian. That made Geffen probably the biggest buyer of modern and contemporary art in America.

Hollywood Superagent Michael Ovitz had begun challenging Geffen as a collector in the early 1980s, drawn to SoHo by all the articles on Mary Boone. He had bought art from Boone for a while, until his relentless bargaining so offended her that she banished him from her gallery for life. Ovitz then turned to Arne Glimcher. He might have tried Gagosian, except for a delicate issue. Gagosian was already selling art to entertainment mogul David Geffen, and Geffen and Ovitz were sworn enemies.

Glimcher became Ovitz's dealer, and Ovitz was able to make Glimcher's fondest dreams come true. The art dealer became a Hollywood

producer, bringing *Gorillas in the Mist* and *The Good Mother* to the screen in 1988, and *The Mambo Kings* in 1992. The last of these, Glimcher also directed.

Glimcher would have loved to work with David Geffen too. Early on, he did help Geffen assess the value of S. I. Newhouse's Abstract Expressionist and Pop art holdings. But so bad was the blood between Ovitz and Geffen—the result of various Hollywood battles—that Geffen refused to work with Glimcher. His fear was that Glimcher would only send him artworks that Ovitz had turned down. As Glimcher put it later, "Geffen told a friend of mine that anything I offered him had Mike's fingerprints on it." Glimcher, who admired Geffen enormously, was chagrined.

Through Ovitz, Glimcher reeled in enough other Hollywood potentates that he could hardly complain. Disney's Michael Eisner and Warner Brothers' Terry Semel bought art through Glimcher. Along with Ovitz, they were the family men: straight, Jewish, all closely allied to the movie business. Gagosian had Geffen; that balanced the scales. Soon there were sleek new LA galleries for each dealer. Glimcher hired architect Charles Gwathmey to create a PaceWildenstein gallery in 1995—Glimcher's short-lived partnership with the storied French dealer Guy Wildenstein had just begun—while Gagosian hired architect Richard Meier to do his own new LA gallery, which opened that same year.

The fight went on for four years, until Glimcher let his gallery go. There just weren't enough active collectors in LA to make the battle worthwhile, and Gagosian had the biggest one of them all in David Geffen. Glimcher would try the West Coast again, but not for a long time.

Through the Hollywood years, Glimcher never let up on the New York market, as one of his oldest rivals, Paula Cooper, knew all too well. A new director at her gallery, Steve Henry, arrived in 1997 from the West Coast to find the gallery under siege. Cooper's right-hand man, Douglas Baxter, had been wooed away by Glimcher. Baxter, in turn, had taken four of Cooper's top artists with him: Robert Mangold, Joel Shapiro, Donald Judd, and Elizabeth Murray.[19] Henry felt

strongly that Glimcher wasn't just growing his roster of artists. "It was a concerted effort to bury Paula," Henry said later. "It seemed very intentional." Cooper had to do more than find other artists: she had to rethink the whole thrust of the gallery and sell enough of the new work to survive—right after committing to a move from SoHo to Chelsea that involved buying a new gallery space.

As Cooper was fending off Glimcher, three other dealers found themselves staggering under the weight of a huge financial burden—one they had put on themselves. Together, Jeffrey Deitch, Anthony d'Offay, and Cologne-based Max Hetzler had decided to back Jeff Koons in producing his *Celebration* series after Ileana Sonnabend had thrown up her hands and severed her gallery's ties to the project. It was a commitment that would nearly bankrupt at least two of them and remain, in the end, unfinished—a sort of mad homage to the monetization of art.[20]

By now, Koons's marriage to Ilona Staller had ended, and the Italian porn star had gone so far as to take the couple's young son, Ludwig, with her to Italy. The pieces in *Celebration* were made in anticipation of Ludwig's return. The series included several versions of the stainless-steel *Balloon Dog* that would become Koons's best-known work, along with Valentine's hearts, diamonds, and Easter eggs. Most were large, some immense.

After the Sonnabend rupture, Koons had turned to Jeffrey Deitch for help. Deitch had become a private dealer, and Koons was a catch: globally famous after the explicit series with Staller and much debated in the art world. But Deitch was reluctant to incur a Sonnabend-like situation, in which the dealer underwrote the cost of fabricating works for the series—a series for which, as was typical with Koons, the end point remained somewhere out in the future, all but invisible.

More sensibly, Deitch agreed to find a dealer with deep enough pockets to finance the series and get it done by 1996, when Koons hoped to exhibit it. "It went to many dealers," Deitch later said. "But no one wanted to step up. You needed a lot of money." Finally, Deitch got d'Offay to come in for one-third of the costs, and Hetzler for another third. The last third Deitch reluctantly took on himself.

"This was highly charged," d'Offay recalled drily. "Jeff and Ilona were fighting over custody of their son and divorcing. Meanwhile we were dealing with the nightmarish problems of making artworks that had never been done before." Koons would go to Italy for two weeks to see his son, return home feeling fraught, and find some imperfection in the new fabrication, forcing the team to start all over. "Jeff pushes his dealers to the breaking point," d'Offay admitted. Now the three new dealers were reaching it. Initially they had pooled $3 million: that was what the series was estimated to cost.[21] Horrified, they watched the costs reach $30 million—and keep on going.

"All of my cash was committed to it," he said of *Celebration*. "When it came to the point where I would have to sell my real estate, I said no." He managed to talk Sotheby's into investing, but on stern terms. The auction house needed firm price quotes from Koons's fabricator, Carlson Arts, to finish the first part of the series: the large metal balloon dogs. Back came the estimate: $250,000 for each dog.[22] Based on that, Deitch presold balloon dogs for $1 million each to collectors including Eli Broad and Dakis Joannou.

With that assurance, Sotheby's committed $5 million, of which $2.5 million was sent upon signing. "The day that Carlson knew we were ready to sign a fabrication contract with them," Deitch recalled, "they suddenly shifted the cost from $250,000 a dog to $1 million a dog." The only way to keep the series from sinking them all was to add another edition—from three of each artwork to four—and to find another fabricator. As the partner who'd struck the deal, Deitch had to take the fall. He was out, with little hope of ever getting any of his money back.

Some of *Celebration*'s pieces would remain undone for the next 20 years, though the first finished ones would be shown in 2001 to critical praise and condemnation in roughly equal measures. Eventually, Gagosian would come on board as an investor—a risky move for the dealer, though ultimately a profitable one.[23] "I was so lucky to come along at that time," Gagosian would say. "Anthony [d'Offay] had the whole deal on hold for a year, and Jeff [Koons] was very loyal to

d'Offay, he didn't want to jump the gun. Finally Jeff said Anthony didn't want to do it. I jumped on the opportunity."

Deitch would get no slice of future *Celebration* pieces as they got done. Koons did give him one large balloon dog—one from the initial series of five—to amortize his investment. "I should have kept it," Deitch rued, years later. Instead, he sold it to French billionaire François Pinault, who had bought Christie's in 1998. In November 2013, one of the *Balloon Dog* series would sell for $58,405,000, a record for the highest-price work at auction by a living artist. That record would last just five years, until the fall of 2018, when David Hockney's *Portrait of an Artist (Pool with Two Figures)* fetched $90.3 million. In truth, neither artist was generally regarded by critics and curators as among the tip-top best of his era. They were, however, in the pantheon of crowd-pleasers.

Along with museum lines of the curious, those crowds included a small but growing number of buyers eager to buy trophy works, globally known, the higher the price the better. Koons at least had a steadily rising market. Hockney had an oeuvre of beautiful portraits that almost everyone liked—but a previous auction record of $28.4 million. Stroke for stroke, *Portrait of an Artist* might not be a masterpiece, but it was an icon the world knew—and that, in the market about to unfold, was what would seem to count above all.

The Curious Charm of Chelsea

1995–1999

IT WAS IN MAY 1996 that Gagosian first exhibited another power-house-to-be of the contemporary art market, Damien Hirst. The exhibition, in New York, was titled *No Sense of Absolute Corruption* and featured two formaldehyde-preserved halves of a pig in tanks that slid mechanically to create a semblance of the whole animal. Hirst, always brilliant with titles, called it *This Little Piggy Went to Market, This Little Piggy Stayed at Home.*[1]

The show was Hirst's first big one in the United States, but in England, the artist had been shocking the bourgeoisie—and pretty much the whole art world—since the late 1980s. Jay Jopling, a British dealer, had signed up Hirst early on, and Charles Saatchi had been among his first collectors. But the figure who had led Hirst to those dealers was a teacher. Arguably, by encouraging a particularly talented class of students, Michael Craig-Martin fueled the whole Young British Artist movement, which for a while in the 1990s seized the momentum of British contemporary art and made Hirst a phenomenally successful international artist.

Irish-born, Yale-educated Craig-Martin had made his name as a Conceptual artist in 1973 with a work he called *An Oak Tree*. He put a glass of water on a shelf attached to the gallery wall with a text explaining how it was, in fact, an oak tree, even if it appeared to be a glass of water.[2] "I was very interested in the nature of art itself," he later explained. "What are the parameters of art? What is the bottom line? The oak tree was a way to ask, how can I make a work that dramatically

encapsulates the essence of art? I decided that the best way would be by appearing to do nothing, while making the grandest possible claim. It needed to be something that I could not prove but that likewise no one else could disprove. Art needs no proof."

Much eye rolling greeted the work from the mainstream press, but Craig-Martin wowed his fellow Conceptualists and became a tutor at Goldsmiths, the University of London's innovative art school, where he taught from 1974 to 1988, and later from 1994 to 2000. That was where, in the mid-1980s, he started to question where contemporary art was headed. As he put it, there seemed to be "no possibility of radicalism. Everything looked like something you saw forty or fifty years ago."

It was in 1988 that Craig-Martin realized he had an unusually talented class on his hands. Its brash, self-appointed leader was Damien Hirst, the son of a mother who kept a florist shop in Leeds and a father he'd never known.[3] Dripping ambition, Hirst had not merely enrolled in the right school for contemporary art. He had also landed a part-time job with Anthony d'Offay as an art handler.[4] "Not every first-year student thinks to do that at the best gallery in town," Craig-Martin later noted. "He was trying to figure out how [the art market] works." Hirst attended Goldsmiths from 1986 to 1989.[5] In 1986, he did the first of his spot paintings: brightly colored circles of household gloss paint on board.[6] Hirst was in a hurry, but he knew that no London galleries would hang a student's work, much less a work of colored spots. In his second year, he decided to stage a show of Goldsmiths student work in a warehouse in the Docklands section of London. He called it *Freeze*; it opened in August 1988.

Many of the artists were Craig-Martin's students. Their teacher was thrilled, the more so when *Freeze* became an overnight success. Selling the works was no small achievement—not only because the artists were unknown but also because there were so few collectors. "There was very little sense of the 'art market' among young artists at that time, only the 'art world,'" Craig Martin recalled.

Hirst did not yet have the money he would need to fabricate works of dead animals in vitrines—a surprisingly pricey production. But he

took a step in that direction with a 1990 work called *A Thousand Years*, in which maggots incubated in a white box on one side of a bisected glass vitrine, then matured into flies that flew into the vitrine's other compartment, where they could feed on a decaying cow's head or be zapped by a device that killed them. Hirst pronounced death and decay his themes. And so, in short order, came the notorious shark in form- aldehyde, *The Physical Impossibility of Death in the Mind of Someone Living* (1991), and, among others, a laterally sliced cow and her calf, also in formaldehyde, *Mother and Child (Divided)* (1993).

Bold new art was on display: so too was the artist. By the mid- 1990s, Hirst would be as famous a character as Koons, cutting his brash, often drunken swath through London art circles, and stirring as much curiosity as any movie or music star.

Hirst was on the cusp of that fame in 1993, when dealer Jay Jop- ling opened the London gallery he called White Cube.[7] Like Anthony d'Offay, Jopling had been immersed in art as a child, parked at the museum—in his case the Tate—while his mother went on errands.[8] He was just 30 when he persuaded Christie's to lease him a space for free amid the Old Masters shops of Duke Street. The Young British Artists were right in step with Jopling, none more so than Hirst.

Hirst and Jopling met in a pub, an unlikely duo: Jopling a pin- striped Old Etonian and son of a former Tory agriculture minister, Hirst wearing his working-class background on his sleeve. Yet the next day Jopling signed him up, having only seen Hirst's plans. "He had very detailed computerized drawings of how these sculptures would be fab- ricated," Jopling recounted. "To see these diagrams and plans for works of art I thought were extremely strong was very exciting."[9]

Hirst was eager to take on the art world. So was Jopling, even at the expense of tens of thousands of dollars to fabricate Hirst's plans. "With Damien, there was very strong personal chemistry, shared ambition, an overriding desire to get things done yesterday," he later told the *Financial Times*. "When we met, we left each other at 4 a.m., and at 9 a.m. there he was at my house in Brixton. He showed me his plans for sculptures, fish cabinets, the shark, the first spot paintings, and we

said 'Let's make them!'" The relationship survived a personal trauma when Jopling's girlfriend, Maia Norman, left him for Hirst in 1994. "It's been an amazing journey," Jopling said. "He's pulled me along, at other times I've pulled him. We still speak most days."[10]

One of the pair's earliest and best customers was Charles Saatchi, who had kept collecting through the early 1990s recession, even as he struggled to stay out of bankruptcy. He sold whole chunks of his collection, only to buy up more. British dealer Victoria Miro found it baffling: surely he need not sell as much as he did, and with such consequences. "If he had kept the collection longer," she suggested, "he would have been a Medici." But ultimately Saatchi wasn't a collector: he was a dealer, and not the sort of dealer patient enough to play the long game of keeping artworks 20 or 30 years until a new generation prized them at a whole new multiple.

Larry Gagosian had kept in close touch with Saatchi through the bleak early 1990s. "Every time I went to London I would literally go from Heathrow straight to the Saatchi museum on Boundary Road," he recalled. In a 1992 group show, he was immediately drawn to one of Hirst's early shark vitrines, the work of an artist still largely unknown. "I don't know why—it was sort of simple: you put a shark in a box! But just the scale of it, the audacity. I went right to the phone at the office in the museum and called Charles, and I said, 'Wow, this is nuts, who did this?' And he said 'Damien Hirst, he's going to be the most famous artist in the world.' And he was right."

Gagosian's first show for Hirst—in May 1996, at a new SoHo space for the dealer at 136 Wooster Street—nearly failed to come off. "That was just when mad cow disease was at its peak," Gagosian explained later. "We couldn't get that work of art into the United States because even though it was pickled in formaldehyde and no one was going to eat it, there was a blanket quarantine." In desperation, Gagosian called Frank Lautenberg, the Democratic senator from New Jersey, and pleaded for help. "Our show is over if we can't have the centerpiece of it." Lautenberg made a few calls, and the cows came to New York after all, scandalizing and fascinating the New York art world.

In London, Saatchi decided to underwrite a museum exhibition of new, mostly YBA art, all owned and loaned by him, called *Sensation: Young British Artists from the Saatchi Gallery*. The aptly named show opened at London's Royal Academy of Arts in September 1997. Saatchi was roundly criticized for using a public exhibition space, run by artists, to showcase works from his personal collection—works he might sell at an enhanced value when the show was done. After agreeing to host the traveling show, the National Gallery of Australia backed out, calling it "too closely aligned to the commercial market."[11] As a marketer with a keen nose for trends, though, Saatchi was anticipating a time when museums and galleries would work together routinely on shows—forced, as museum curators rued, by the skyrocketing costs of acquiring and exhibiting contemporary art. Museums simply couldn't afford to host shows on their own. More and more, the larger galleries would have to pitch in, all but ignoring the conflicts of interest that arose.

ALL THROUGH THE NINETIES, AS INDIVIDUAL dealers and artists rose and fell, a slow-motion New York migration was underway. Dealers who had sworn they would never leave SoHo were feeling the pull of Chelsea. Those wide warehouse blocks in the far-west twenties might seem unwelcoming, but rents were cheap and spaces were large. SoHo, meanwhile, was being transformed into a draw for tourists, with high-end retail stores. At some indiscernible point—perhaps some Thursday spring evening in 1996, amid gallery openings up and down those looming blocks—the balance tipped definitively from SoHo to Chelsea.

One of the first of the midnineties balance tippers was Paula Cooper. SoHo's original pioneer arrived in Chelsea in 1996 after Paul Morris, Pat Hearn, and Matthew Marks. She bought a taxi garage with a vaulted ceiling on West 21st Street for a little more than $500,000—a lot of money at that time. Cooper's love of Minimalism and Conceptualism had never flagged, and in her new space she showed a dazzling array of the greats: from Carl Andre and Sol LeWitt to Robert Gober, Andres Serrano, and Rudolf Stingel. Her gallery would never have the

scale of the largest dealers, but it was powerful in its curatorial prominence and Cooper's web of art partnerships.

Of the other top women dealers, Marian Goodman stayed resolutely north on 57th Street. For a while, Barbara Gladstone remained uptown, too, near the "shoebox" of a space she had rented when first coming to the business. Success had brought a larger space—still on 57th Street—and it was there that she came to represent one of the great new artists of the 1990s, Matthew Barney.

The story began with an anguished call from SoHo dealer turned advisor Clarissa Dalrymple, known for her keen eye for fresh talent. Dalrymple and dealer Nicole Klagsbrun had given Christopher Wool his first show, before Lisa Spellman's 303. Dalrymple told Gladsone she was excited by a recent art school graduate named Matthew Barney. Unfortunately, the owner of the gallery she was advising had just announced he was closing the place that night. Dalrymple had promised the unknown Barney a show there. "He paid for all the fabrication himself," she told Gladstone. "He spent his last dime. Please just go to his studio and give him a little attention."

Gladstone found her way to Barney's studio in the Meatpacking District, down a corridor of meat lockers. "He had this little video, and these drawings unlike anything I had ever seen," Gladstone recalled of Barney. "They were tipped into the frame by him sewing them." There were sculptures, with all kinds of medical equipment, including a speculum, imbedded in them. "I remember thinking, 'This is what it must have been like to be in Bruce Nauman's studio in 1964.' It was about sport, medicine, a new sculptural language. Then he took me downstairs, to an inclined bench covered with frozen Vaseline. It was extraordinary."

Gladstone asked Barney what he wanted to do. A "visual opera," he told her. Already, he had a rough sense of how it would work: as a series of films exploring birth, procreation, and death. He called it *The Cremaster Cycle*. "I was there for hours," Gladstone recounted. "I walked out at night and called Clarissa from a pay phone. 'I wish you had never

let me into this studio,'" Gladstone said ruefully. "Who wouldn't just die to exhibit that work?" She assumed Dalrymple would be taking him on.

"You would be much better than I," Dalrymple said, to Gladstone's astonishment. "So you should do it." The next day, Gladstone did. Barney, her brilliant new artist, emerged fully formed, as art advisor Allan Schwartzman put it, as one of the great talents of the next two decades, starting with a Gladstone Gallery debut in 1991 that the *New York Times* called "an extraordinary first show."

By 1996, Gladstone had realized that her 57th Street gallery was simply too small for her artists. For nearly $2 million, she bought a large space that year on West 24th Street and took her place as one of the city's most respected—and quietly powerful—Chelsea dealers, sharing the warehouse with Metro Pictures and Luhring Augustine. "She doesn't get that bounce that Larry does," suggested one art critic of Gladstone's impact on an artist's career. "But she has picked important artists who have stuck with her. That's a gold mine."

LISA SPELLMAN BROUGHT HER 303 GALLERY with her to Chelsea in 1996. Another arrival that year was a young woman with a famous surname, Marianne Boesky. As she said years later, Boesky started with more against her than most dealers: a felon as a father.

Ivan Boesky had been caught up in one of the decade's biggest insider-trading scandals, which also netted junk-bond financier Michael Milken and sent both men to jail. "Everyone presumed I was coming with my pockets filled with money, and that I would soon be out of business," said Marianne Boesky. "In my case there was nothing—no support." Initially, before moving to Chelsea, she borrowed $55,000 to rent a small space on Greene Street for $8,000 a month, two doors from David Zwirner's first gallery. In her first year, she sold $110,000 worth of art. "Of course that was gross sales," she noted. "I owed the artists fifty percent of that."

The first of those artists was a brilliant choice. Lisa Yuskavage was a painter whose narrative portraits of women, often nude, helped stir renewed interest in figurative art—especially by female artists. "My

parents were horrified!" Boesky acknowledged, but also proud. Boesky's relationship with Yuskavage was more of a challenge. "As single women, everything was discussed and fought about—a very fraught relationship," Boesky recounted. "She used to describe me as a Prada-wearing bitch."

Two more bold choices went a long way to bolster Boesky's image as a serious dealer. Both were Japanese, each as much a pioneer in Japanese art as the other. Takashi Murakami did work that combined high art and the cartoon-like art known as anime, a style that came to be known as superflat. Yoshitomo Nara focused on images of seemingly gentle children with very bad adult attitudes. Both artists were big risks for Boesky; both, by the early 2000s, would become hugely successful. And then all three—including Yuskavage—would leave for larger dealers, forcing Boesky to reboot her program.

In 1999, Larry Gagosian made a real-estate move that showed the shape of things to come. A pioneer once before with his 23rd Street loading dock, pointing the way from SoHo to Chelsea, he intrigued the art world again with his deal to pay $5.75 million for a 21,000-square-foot one-story building on the corner of 24th Street and Eleventh Avenue. The previous owner was Thomas Gambino, son of deceased mafia boss Carlo Gambino. Gagosian told the *New York Observer* that SoHo's shift to retail clothing stores had been so pronounced that by 1999 he no longer felt happy having a gallery there. "When you feel that way," he said, "it is always a good idea to try to adjust."[12] Matthew Marks for some time had had bragging rights to Chelsea's largest art space, with his two 5,000-square-foot galleries. Gagosian's new gallery, when it opened in 2000, would be more than 100 percent larger, and remain Chelsea's largest gallery—for a while.

Over time, Gagosian's new space would come to be seen with some wariness by the artists invited to fill it. "There was a danger to its size," suggested one Chelsea dealer. "The fact that it required so much art to fill it. When Gagosian put a young artist into that space, it could be a recipe for disaster. Either it made them rock stars—or it destroyed them. It was just too much space, too much room, too much rope to hang themselves with. Very few artists could handle it."

By then, Gagosian had the money and moxie to sign almost any artist he wanted. He still had historical shows—Edward Hopper, Yves Klein, late paintings by Warhol, even a Peter Paul Rubens show—but out of choice, not necessity. His roster had grown to include Richard Serra, Frank Stella, Ed Ruscha, Cy Twombly, and Ross Bleckner. Soon his list of artists exhibited would dwarf that of any other gallery in the world.

In building his line-up, Gagosian stuck to a fairly inflexible rule. No emerging talents just out of art school. No brilliant discoveries in their twenties. True, he had taken on David Salle and Jean-Michel Basquiat all those years ago. But now, as an art world power, he liked signing up artists already known. "I like it when there's some momentum—the artist has some traction," he said later. "The economics of it [are] more attractive." Also, as he noted, "When they're up the food chain, and their prices are up, they tend to be better artists." But, he added with a laugh, "Sometimes you see a young artist who's really a genius and you have to resist the temptation to do anything!"

As they signed on, the artists experienced a new phenomenon: the Gagosian effect. His wealthy collectors stood ready to buy what Gagosian told them to buy, at whatever prices he set. The new artists, as a result, tended to see their work spike in price over the course of a year or two. If a collector put his recently bought Gagosian artwork up for auction, that might boost the artist's market too. But not every work put on the block found a buyer willing to pay that higher price, and that could hurt an artist's market.

Collectors, not artists, were the ones Gagosian had to worry most about pleasing: they made the world go round. The dealer gave elegant dinners, either at one of his homes or at Mr. Chow, with its mirrored walls and black-lacquer furniture as a sleek backdrop to its fancy version of Chinese food.

Art market lawyer Aaron Richard Golub, who had started as a social acquaintance of Gagosian's and ended up fighting him in court, attended a number of those parties and appreciated the dynamic involved. The guests, he noted, were nearly all male and, of course,

quite wealthy. Scattered among them were Gagosian's growing number of salespeople, most of them young women. "Pretty girls sell those paintings," Golub averred, "all between nineteen and twenty-five." That was perhaps stretching it, but the women, Golub insisted, were of a type: "All about five-foot-six, never good looking enough to be models, but great as salespeople."

For collectors who might, at their core, be a little bit insecure, being invited to Gagosian's soirees conferred the ultimate validation. They could drop Gagosian's name in art circles around the world—just "Larry" to them—and tell their friends that this or that painting had been bought from him. The Gagosian brand name was now as important as the artists'. To this crowd, Gagosian was the one whose opinion counted more than anyone else's. "Larry is my dealer," they would proclaim, before they were even asked.

Gagosian did the seating charts for the dinners himself, recalled Golub. "He's very careful. He's been doing it for years. If you stop getting invited to a Larry party, people get concerned about their social status." Always at these gatherings were a few of Gagosian's artists. "The artists just stand in one place; they're stationary," Golub explained. "You can talk to them and shake their hands." But not just anyone could stroll up to them. "Those who get that privilege have either bought Gagosian art or are about to do so. The handshake is very helpful."

The guests at Larry's parties had one thing in common: the art they'd bought from Larry. And so to make conversation, they talked about what artwork they had. They visited one another's vast homes to see each other's collections, and often saw familiar works.

The "Larry collection," as Golub put it, featured a Damien Hirst, for sure. Also a Mark Grotjahn, a Richard Prince, an Ed Ruscha, a Cy Twombly, and a Rudolf Stingel. And if the collector had outdoor space, a Richard Serra and, of course, a Jeff Koons sculpture.

Amid these eager buyers, Golub sensed a deeper motive than impressing their friends with art. In their pampered lives, where even private planes had become routine, art kept them feeling vital and connected. "If they get to Aspen with no one to call, what do they do?"

Golub mused. "What connects them to other human beings is the art collection. *I hear you have a great collection.*" The older those collectors got, Golub thought, the more they sought that bond.

Golub wasn't even sure most of Gagosian's collectors cared about art. It was the existential need. "Without that painting on the wall, they're not going to have anything to talk about when people come to see them. Nothing to draw people to their house, or anyone to go with for dinner."

WITH GAGOSIAN'S ARRIVAL ON WEST 24TH Street in 2000, there were now 124 galleries in Chelsea. One of the last of the old guard to make the move was Mary Boone. She had moved first to 57th Street in 1995, putting SoHo and an amazing decade and a half behind her. Well after Julian Schnabel's departure and Jean-Michel Basquiat's death, she had staged shows of major artists, among them Agnes Martin, Dan Flavin, Roy Lichtenstein, Malcolm Morley, and Richard Artschwager. She had had Ben Heller, the Ab Ex collector, stage a show of Clyfford Still. But she found it alienating to be on an upper floor of a 57th Street building, and so she, too, went to Chelsea, in 2000. From her latest gallery, she showed light artist Keith Sonnier, activist artist Ai Weiwei, painter Mickalene Thomas, and many more. Boone would remain a key dealer over the years that followed, just not as famous as she'd been in her youth. That was fine by her. "I hate celebrity," she said with real passion years later. "If I'm remembered for anything, I'd love them to do a book of all my installation shots—three hundred to four hundred shows. I hate pictures of me."

Left behind in this cultural migration was Leo Castelli. A proud, if diminished, man in his eighties, he stayed on in SoHo at 420 West Broadway. Increasingly, the art world passed him by.

Ralph Gibson, the photographer and longtime friend of Castelli, still spent frequent evenings with the dealer. So did Gagosian, though his schedule was a bit busier than it had been when the two men first met. In all that time, Gagosian hadn't tried to poach any of Castelli's

artists—he liked and respected the man too much for that. Occasionally, though, Castelli shared an artist with him. Richard Serra, for one. Frank Stella, for another. Stella had begun showing, as well as with dealer Larry Rubin of the Knoedler gallery, but he never left Castelli; he simply alternated his shows from one dealer to another. Castelli seemed not to mind. Stella remained fond of him, but took a less sentimental view of him than some. "There are those who say he wasn't a good dealer," Stella mused later. "He hardly amassed a fortune, and he was day to day, and not very successful financially. But the gallery had a lot of momentum, and a lot of presence. Also, he was very focused on the museums, he liked to get his artists represented in institutions."

As much as he could, Castelli also still courted women—much-younger women. In 1995 he took as his third wife an Italian art critic named Barbara Bertozzi, who interviewed Castelli about Jasper Johns and stayed on. Castelli was 89, Bertozzi 33. At first the two slept in separate bedrooms. One morning over breakfast, Castelli gave Bertozzi a Jasper Johns drawing. "When did things become official? I don't know," Bertozzi said later. "We did move into the same room. He was a lot more charming and beautiful than a lot of 30 year olds. He was Leo!"

Bertozzi married Castelli at his insistence, she recalled. "'You need to marry me, I'm really afraid they will take me away.' This was an 88-year-old man talking."

They married in 1995, much to the chagrin of the gallery's long-time managers, Susan and Patty Brundage, who would later declare that they and another employee had been promised certain monies when Castelli died, based on the sale of some art works. Instead, soon after Castelli and Bertozzi married, the Brundage sisters were, as they put it, "given the big ax and sent packing."

The Brundage sisters blamed Bertozzi. They also said she purloined Castelli's leather-bound Hermes appointment book to keep him from calling his friends. "The book...was his independence," Susan Brundage suggested, "his links to people he knew." Bertozzi says details about the Brundage sisters' departure are covered by a private settlement,

but vehemently denies the appointment book story. "He kept the book until he died."

Above all else, Castelli wanted to keep his business going. He closed 420 West Broadway when it became too much for him but opened a small gallery on East 79th Street. The estate was essentially moved to that new location, and Bertozzi says it was divided in thirds: one third for Castelli's son Jean-Christophe, one for his daughter Nina, and one for Leo, which Bertozzi would inherit upon his death. The children also inherited a lot of valuable art. A source close to the gallery, asked if Castelli's two grown children were treated fairly, says, "Absolutely! They did very, very well indeed." Some two decades later, Castelli's last gallery remains in business, and Barbara Bertozzi Castelli, as she likes to be known, still presides over it, proud to have kept Castelli's legacy alive.

In a last hurrah, Gagosian gave Castelli a 90th birthday party at the dealer's oceanfront home in Amagansett. After that, Castelli started fading fast. Gagosian went to visit him at the little gallery on East 79th Street that Bertozzi had secured for him—not a great space, Gagosian felt, but one that brought him nearly full circle with the town house at 4 East 77th street.

"He was lying on the couch, and we were talking about an artist—a great artist, certainly well known, who had had a storied career, still living—and we were talking about what happened to him, what happened to the work, and Leo said, 'Oh, he always fucked himself up!' Those very words." And the two men broke into laughter.

Years later, when asked what he had absorbed from Castelli, Gagosian would take a beat and say, deadpan, "Well, I absorbed a lot of . . . his clients."[13] In truth, the younger dealer had learned a whole way of doing business. Gagosian had smoothed his rough edges and learned how to consort with wealthy clients. He had learned how to tell great art from merely good art. Above all, he had learned how to exhibit art in the Castelli style, with unfailing class from the catalogues to the frames, from how the work was hung to how it appeared on opening night. "He showed me how a gallery could really make the art feel important," Gagosian said of his mentor. "Leo always had great style in the way

he presented the work—and without making it too fussy."[14] And yet, Castelli was the old world, Gagosian the new, the contrasts all too clear when it came to money and the marketing of art.

Castelli's last show, in May 1999, was of monotypes by Jasper Johns. The show made him happy, Bertozzi recalled, but shortly after, he was afflicted with shingles, and his 91-year-old body struggled without success to heal. He spent his last days in the bedroom of his Fifth Avenue apartment, with Bertozzi and his children at his side. On the walls were drawings by Johns and Roy Lichtenstein. Johns was still very much alive, but Lichtenstein had died in 1997—a shock to the dealer who had assumed all his most beloved artists would outlive him.

After a three-day struggle, Castelli died on August 21, 1999. Newspaper obituaries called him "the prince of dealers." Now his reign was done, and a new one had begun.

The Mega Dealers

1999–2002

SOMETIME IN THE LATE 1990s, a fundamental change occurred. It came in the substitution of a one word for another, and so, for a time, it went unnoticed. The art *world*, in all its manifestations, became an art *market*.

The day Leo Castelli died is perhaps as good a day as any on which to affix that change. An intimate sense of downtown community had disappeared with the migration from SoHo to Chelsea, a move all but complete by 1999. That year, photographer Timothy Greenfield-Sanders finished his series of portraits, begun in the early 1980s, of downtown artists, dealers, collectors, and other art world denizens, taken with his large-format Deardorff camera, a wooden giant of a thing on four legs. He chose a small fraction of those for the book he published that year, titled *Art World*.[1]

There, in black and white, was Castelli, proud and a bit imperious. Among the many other dealers were Paula Cooper, Anne Seymour and Anthony d'Offay, Marian Goodman, Matthew Marks, Nicholas Logsdail, Thaddaeus Ropac, Mary Boone, André Emmerich, Pat Hearn, Jeffrey Deitch, Larry Gagosian, Arne Glimcher, Janelle Reiring, Ileana Sonnabend, Holly Solomon, and Tony Shafrazi. How young they all looked, and how earnest. Their world had blown outward with centrifugal force, and they had sailed through the air amid hundreds more dealers and artists and collectors. "After that moment it went ballistic," Greenfield-Sanders recalled years later in his East Village studio, the

big Deardorff standing nearby. "I couldn't do this today. I couldn't say who the top artists and dealers are."

The Clinton bull market was booming, galleries were blooming, and a whole new class of collectors was buying in earnest: millionaires and billionaires. In 1987, when *Forbes* had started its international billionaires list to supplement its annual list of the 400 richest Americans, the total was 140.[2] By 1997, there were 224 billionaires on the list, many from countries in Asia and the Middle East.[3] This number grew to 891 in 2007 and would explode to 2,043 billionaires from more than 50 countries in 2017.[4] Globalism had arrived, with pain for the poor and perks for the rich. The ultimate perk was art.

"Everyone could have three houses, a big yacht, servants, a car," observed financier/collector Asher Edelman. "But there's only one painting of the kind that a rich person could put over his fireplace, and he could make his statement with that."

For an unknown rich person, buying a great painting was a sure-fire way to get known and welcomed by art dealers and auction houses in New York and London; they were happy to sell him or her more. "And there were very tall, good-looking art advisors," Edelman added. It was like joining a club that conferred ultimate coolness, except that all one needed in order to join it was cash. "Money and art," as Gagosian put it. "You can't separate the two."

That the very rich bought art was no great surprise, even at a scale not hitherto seen. The novelty was that art now was more than a rarefied pleasure or sign of social status. With the bursting of the dot-com bubble in early 2000, interest rates had dropped to near zero and stayed down. For many, art was perceived to be a better investment than stocks. And so grew the exciting if not always reliable notion of art as an alternative asset. Several banks with high-net-worth client divisions jumped in, making loans against brand-name art, earning fee income for the bank and building relationships with dealers and collectors, though as Gagosian and other dealers had learned in the last recession, terms tended to be short and interest rates high. Dealers

became bankers in a sense, too, making interest-free loans to collectors, sometimes even enlisting them as partners in pricey purchases. Art advisories cropped up to counsel collectors on both what to do with the art and how to invest the money they made when they sold it. A decade later, most of those bank programs would either be shut down or kept on a shoestring to please art-minded clients.

At that turning point in the early 2000s, the auction houses stepped up their game as well. Traditionally, Sotheby's and Christie's dealt only in secondary sales, letting dealers handle primary sales. That made sense: auction houses sold thousands of artworks a year, churning the goods. They had no interest in artists' long-term careers, only their immediate markets. Dealers and curators were the ones who found and nurtured artists, introducing their works to the world. Dealers might lose their artists to other galleries, but not usually to auction houses.

And yet, with fashion magnate François Pinault's acquisition of Christie's in 1998, auction houses became dealers too. Private sales, which were no different from those pursued by private dealers, were ramped up. Now the auction houses could sell art as discreetly as dealers did. An auction house might even take a commission from both sides of a deal. The house didn't need to produce a glossy, expensive catalogue, as it did with its auctions, or take the art out on tour to whet collectors' appetites. With private sales, the deal was just done.

Auction houses seemed to have the upper hand now, but Gagosian begged to differ. "If you give a very important painting to an auction house to sell in their private room, it still has the aroma of the auction house," he said. "They can't really scrub that....And also, if it doesn't work out in the private treaty sale, then the auction house comes to you and says, 'I think we should put this up for auction.' That's their two-step agenda." There, of course, the work might fail to reach its minimum, and be "bought in," making the work unsalable in the near term.

It was a back-and-forth game, for as much as the dealers and auction houses competed, they needed each other too. An auction house needed great paintings from collectors and other consignors, private dealers included, to augment its sales. Dealers, for their part, had

clients who wanted the somewhat more dependable sales—and greater visibility—that auctions provided.

At the top of the market were 19th- and 20th-century masterpieces of Impressionism and Modernism, and now Abstract Expressionism and Pop art, too, their value rising as the newly rich vied for a limited inventory. The more precious those masterpieces became, the more the work of younger, living artists rose in their wake, until brand-new artists, some just out of art school, found themselves plucked from the pile like hot stocks, their once-cheap paintings of a year or two before sold at auction for staggering sums.

Not only that: there was an endless supply of the stuff. A young, prolific artist might turn out scores of artworks each year, with decades of productivity ahead of him. He might also produce a glut or find himself a flash in the pan, but a wealthy collector might not really care. Buying art of the moment made him a collector of the moment, hobnobbing with other like-minded plutocrats. If his favorite artist plummeted, there were always new artists to try. Meanwhile, new museums were being built: scores each year in the United States alone, along with private museums, the ultimate collector's play. Those empty walls needed art—which almost always meant contemporary art.

And so for dealers, it was the best of times and the most nerve-racking, as the market took off, taking them with it on its wild ride. The largest of the galleries would come to be grouped in their own category of money and power. The mega dealers were a male cohort, unless one included Marian Goodman—quietly powerful as she was with her marquee artist, Gerhard Richter—and Manuela Wirth, Iwan's wife and partner. The megas were fiercely competitive and always aware of each other's moves in their peripheral vision. They were the ones now opening massive, multistory galleries in New York and, soon, London. Gagosian, as usual, had gone first, but the others would follow.

DAVID ZWIRNER WAS STILL ON SOHO'S Greene Street in 2001 when he felt a first sting of competition from a fellow mega dealer. He was fond of saying he wasn't a Chelsea dealer and never would be. SoHo

was old friends and cobblestone streets, the heart of downtown; Chelsea was cold and soulless. Or as Zwirner put it, a rough part of town, no fun to come to, a wasteland. His view was about to change.

In his eight years in business, Zwirner had made one prescient choice of artist after another—not financially, perhaps, but aesthetically. The one he was proudest of was Viennese sculptor Franz West, increasingly regarded as one of Europe's most important sculptors. "I loved him as a person as well as an artist," Zwirner recalled, "and we had worked so hard for him. His career was at its absolute peak."

That was when West announced he was switching dealers—to Larry Gagosian. Gagosian knew little about West when he signed him; it was one of his senior directors in London, Stefan Ratibor, who suggested West would be a good fit. "With Franz, it was all about the money," Peter Brant later declared of Gagosian's motivation in signing up West. So had it been with Warhol early on, Brant suggested. West's own motives were mixed. He liked the prospect of joining the gallery that had Cy Twombly, among other great artists. Poor health was another motive.

West's departure was a devastating and baffling blow for Zwirner. What more could the dealer have done? Slowly it sank in: nothing. Gagosian simply had more money and clout to share with the artist. For Zwirner, West's departure changed everything. "It made clear to me that I had to grow," he explained. "Growth was not an option." Greene Street was just too small. Zwirner needed a space big enough to excite an artist with its exhibition potential, a space big enough for artists from other galleries to be drawn to him. He leased one, in 2002, in the heart of Chelsea at 525 West 19th Street. Zwirner also teamed up formally with Iwan and Manuela Wirth. Zwirner would continue to take on new artists, and the partners together would handle secondary sales and curate shows for established artists.

Despite these measures, Zwirner nursed a grudge against Gagosian that would not be assuaged. Oddly enough, the two were rather alike. Both men were tall—over six feet—tightly coiled and fit. Perhaps Zwirner was in better shape, given his passion for surfing in

Montauk and his relative youth, but Gagosian, nearly two decades older, was no slouch. Both had close-cropped silvery hair and wore a uniform of casual shirts and jeans. They both had a keen eye for art, both were tough bargainers, both were fiercely combative, and both thrilled to the art of the deal. Both, as it happened, were jazz aficionados.

The contrasts were just as striking. Zwirner had grown up in a cultivated family, steeped in visual culture, European and Pop. Rudolf Zwirner, David's father, came from an extremely intellectual Cologne family. Gagosian had had no exposure to art in his youth. He was the guy with the story about selling posters that made everybody laugh. He had come by his knowledge of contemporary art on his own.

Zwirner was a family man, devoted to his wife and three young children. He had few outside friends. Gagosian's personal life was a succession of girlfriends, lavish parties, and luxurious stays on the yachts of friends who were, more precisely, business partners.

The most visible and striking contrasts between the two men, however, were in the office cultures that each had created. Zwirner did his best to instill a collegial atmosphere, to the point where staffers, especially those at the front desk, could seem a bit glazed, almost like members of a cult. Zwirner himself was a casual-seeming boss. Those who worked for him came to know a tougher underside, but he wasn't known for losing his temper. Gagosian, on the other hand, was perfectly capable of being cordial, when the deal was done or soon to be. But he was a rough boss of what some might call a dysfunctional workplace, maintained by the man at the top.

John Good was a seasoned gallery director, with a six-year stretch at Castelli and a decade as the head of his own gallery, when he came to Gagosian for what would be his most grueling, if lucrative, decade. The nineties recession had been as hard on him as everyone else. What he needed, without any delay, was a job. Good knew Gagosian fairly well and gave him a pitch over lunch. Gagosian promised to think it over. Shortly after, Good jammed his way into novelist Bret Easton Ellis's famously packed Christmas party. Suddenly, there beside him

was Gagosian. Good reminded him that they'd discussed a job. By the time the crowd moved them apart, Good had one.

Good had heard stories of the Gagosian office culture. Still, he was a bit taken aback on his first day. "It was like *Glengarry Glen Ross*," he recalled later. "Here's a phone, an office, a desk, a credit card. Go make some money!"

At Gagosian, the salary was nominal for most new arrivals—especially those who, like Good, betrayed their desperation. Those who came from successful runs at other galleries got paid whatever it took to lure them into Gagosian's lair. One young dealer courted by Gagosian recalled being told, "We have better artists, we know more people, you can meet more people and sell more and travel more. We give you your brand, you make your own client list, you can work with an artist or not as you like. And very few people get fired." The dealer chose not to go with Gagosian at that point in his career, but he was tempted. "He's this eccentric, devil-may-care character who lives life to the max," he said of Gagosian. "He spends one hundred thousand dollars at the Dorchester in a week. Artists love him, the richest and fanciest people want to spend time with him. And he does love art."

The job wasn't as glamorous and lucrative as it seemed, however. Even those with strong track records got only a portion of their income up-front; the balance came as advances on future sales. The serious money was made in one of two ways: bringing art in or selling a work from the gallery's inventory. The former brought a 10 percent finder's fee, the latter a 10 percent sales commission. A director who could both bring in a work and sell it, of course, got 20 percent. This was pretty much top dollar in the gallery world. No other gallery paid commissions at all, at least none that John Good knew of at that time. The others paid a salary, and a year-end bonus if the gallery had done well. Such bonuses fell well below Gagosian's titillating 20 percent. As his staffers soon learned, however, there were caveats.

The first of those two commissions—the finder's fee—was only paid on work that Gagosian deemed worth bringing in. A friend of Good's agreed to let the gallery take in a large painting she owned by

Ab Exer Joan Mitchell. "Ah, she's no good," Good recalled Gagosian saying. "I'm not interested."

Works that made the grade had to be brought in at the lowest possible price. Often as not, the seller would balk at the price Gagosian offered him: no finder's fee then. As for the other commission—the sales fee—it could only apply to work sold once already: the secondary market. Original works by an artist already represented by Gagosian were, of course, already found. No finder's fee for selling one of those.

There were two more caveats about those finder's fees and sales commissions. A finder's fee wasn't paid until the artwork was sold. And both the 10 percent finder's fee and 10 percent sales commission were based on profit, not 10 percent of the value of the art. If a painting deemed to be worth $1 million was brought into the gallery with Gagosian's blessing and then sold for $1.1 million, the salesperson didn't get 10 percent of $1 million, let alone of $1.1 million. The profit was $100,000, so the salesperson got $10,000. Even then, Gagosian might balk. "It was not unusual for Larry to deny a commission," Good recalled, "so it was always a bit nerve-wracking until one received the funds."

The goal of any Gagosian director was to bring in a new artist the dealer agreed to sign up. Theoretically, a show of that new artist's work did bring the director a sales commission on works sold. But not always. "Larry goes through a show that's about to open at the gallery," recalled Good. "He picks out the best pieces and keeps them for himself. He will sell them at some point in the future—or not. 'It's for my collection,' he'll say."

Like any other dealer, Gagosian had to do more than sell an artist's work. He had to befriend the artist and keep in regular touch. Gagosian liked artists—whatever his critics might say—and certainly enjoyed spending time with his favorites. But he couldn't keep up with them all, and some interested him less than others. Those artists were often assigned to young staffers—not by any particular system or criteria, just happenstance. Perhaps an artist and a new young staffer chatted at one of Gagosian's parties; that would do it. Or a starry-eyed new staffer

would say how much she loved one artist or another, and one of those artists' liaisons might unexpectedly leave. No money was paid for this socializing; it was just part of the job.

"Have you heard about the Larry ring?"

The question came a day or two into John Good's tenure. Was it, perhaps, a ring on his finger that staffers knelt to kiss? No, the colleague explained. On the gallery's phone system, Gagosian had programmed his own ring. "When you get that ring, you know he's calling," the colleague said. Good learned not just to jump off other calls, but to keep a list of three or four good-news points to bounce off the boss.

"What's going on?" Gagosian would growl. There was never any preamble.

Good would start ticking off his points. Usually by the third one, Gagosian's famously short attention span was exhausted. With a grunt or mumble, he was gone. That was if Good's news was merely promising. If it involved an imminent sale, Gagosian was all ears. "One thing about Larry: if you needed something, he was impossible to find," Good explained. "But if you were working on a deal, he was available on a moment's notice." Good would call to report a buyer wanted a Warhol, perhaps, for $800,000. Gagosian wouldn't react with pleasure, more like grim determination. "I want immediate payment," he would say. "*Immediate* payment."

Good would call the buyer back to report this news. "Okay," the buyer would say on a Wednesday, "I'll get it to you Monday."

The next day, Good would get the Larry ring. "Where's the payment?"

"Monday," Good would tell him.

"I want immediate payment!"

Back Good would go to the buyer. "Larry wants immediate payment."

There would be a pause on the line while the buyer took this in. "Monday *is* immediate payment." But not to Gagosian. Good soon learned not to share details of a pending deal with his boss. Gagosian was just too impatient; he could mess things up.

At the same time, Good felt, Gagosian notched more deals than he lost by being so aggressive. And he could be aggressive with anyone.

One day, Good found himself waiting at the elevator with Gagosian as the dealer got super collector Eli Broad on the phone. "Eli, it's Larry," Gagosian said in a voice that brooked no dissent. Back and forth went the conversation, with Gagosian ever louder. Finally, the dealer seemed to lose his temper. "You fucked me on that other deal, so if you don't want this one, forget it." There was a pause as the elevator door opened. "Yeah, okay," Gagosian said, his anger gone. "Great, thanks."

"Wow," Good said as the two men rode the elevator down. "I never tried that—yelling at a client."

Gagosian offered the hint of a smile. "Well, whatever works."

Unfortunately, with his staff, Gagosian didn't know when to stop. "His brain doesn't process things the way ours do," Good noted. "The way he abused his staff, he never felt shame or guilt about that. The goal was always to make the deal and make money."

Fergus McCaffrey, a director at Gagosian from 2000 to 2006, recalled one incident in particular. Overall, he found Gagosian one of the most engaging, smart, and literate people he'd ever met. Also, he was funny. "Out of his comfort zone he's extremely reserved," McCaffrey said later. "Behind closed doors he's hilarious." At the same time, McCaffrey admitted, Gagosian knew how to press his buttons. "He's a master of psychology. Whatever your buttons are, he will figure them out." At Art Basel one year, McCaffrey had a client ready to purchase a large Lichtenstein painting and a medium-sized *Mao* by Warhol. Gagosian didn't want to do that deal, however, as he could make more money by coupling the *Mao* to a late De Kooning. McCaffrey's job was to persuade the collector to take the Lichtenstein on its own. Gagosian called McCaffrey once, then again, then eight, ten, 12 times in the course of that day. "It was totally counterproductive," McCaffrey recalled later.

Eventually Gagosian's voice rose—as did McCaffrey's. To McCaffrey's shock, there was silence on the line, followed by a sheepish reply. For McCaffrey, it was an interesting lesson. "If Larry is yelling, and you yell, he will back off." In the end, McCaffrey did sell the Lichtenstein on its own. It just took two days rather than one. Years later, he said proudly, he found another and better *Mao* for the same client.

Gagosian's directors learned to be more aggressive, that was for sure. But the boss's volcanic temper made for a toxic atmosphere, as one director put it. "We were all afraid of Larry," one admitted. "He would get very foulmouthed." The attacks could come out of the blue. One day John Good called to report great news: he had just persuaded a collector to let the gallery handle the selling of her De Kooning. Gagosian was furious. He had just had dinner with the collector the night before. "She didn't say anything to me," he exploded. "You fucking asshole." Good realized the problem: "He sensed the rich woman liked me more than him." But that was no excuse. "You can't talk to me like that," Good said. It was the first time he'd seen Gagosian truly unhinged. It wouldn't be the last.

Not surprisingly, the tone that Gagosian set at the top trickled down. Staffers tended to lose their moral compass, as one put it. After a particularly messy deal that left all sides unhappy, one director spoke to the gallery's lawyers and came back beaming. "Great news!" the staffer reported to a colleague. "They said what we did was unethical, but not illegal!"

Sometimes, directors found reasons to demand slices from each other's commissions. One sold a Warhol portrait of Dennis Hopper to a client who wandered into the uptown gallery, only to hear from a downtown salesperson that the collector had perused Warhols there, so the two should split the commission. "Let's share the commission" was an all too common refrain. If the two directors couldn't resolve their dispute, it went to Melissa Lazarov, the mother hen who had been with the gallery since Gagosian's early LA days. "She had the wisdom of Solomon," as one staffer put it. Give one director the whole commission this time, she might say, and let the other have it next time. If the staffers held firm, their case went to the top.

Sometimes, directors wondered why it was that Gagosian had this hair-trigger temper, why he exploded as he did and seemed to have so little empathy for his employees. An interesting theory came from one director after a most untypical lunch with the boss. At the lunch for three, a director asked Gagosian if he had ever considered writing a

memoir. Surely he had enough fascinating stories to fill a book. Gago-
sian stiffened. He had no interest in introspection, he said. That's how
you lose your edge.

Rather than end the discussion there, Gagosian started talking
about his family. The scene he depicted was a less-than-happy one. His
parents had abused drugs and drank a lot, he said, and he and his sister,
Judy, had suffered for it. The director recalled him saying, "The reason I
never had kids was I saw what people could do to children, and I never
wanted to repeat that." Yet perhaps in a way, Gagosian was repeating
his parents' behavior.

Zwirner by contrast was calm and contained, or at least seemed
to be. He, too, had a good eye—arguably a better one than Gagosian,
since Zwirner in his first decade of handling primary art had worked
almost entirely with emerging artists. Yet he had fewer admirers than
might be expected of a dealer of his stature. "David is not collegial,"
declared one Chelsea dealer. "He has pissed off collectors, dealers....
People don't want to work with him." Later the *Wall Street Journal*
would quote Zwirner as saying that Paula Cooper hated him.[5] "I can
tell you *twenty* people who hate Zwirner," the unnamed Chelsea dealer
declared. "David has this mythology that he's a good guy. With Gago-
sian, at least there's a certain honesty. What David puts up is the facade
of being a good guy."

ONE OF THE TRICKIEST ASPECTS OF running a gallery—and one that
Gagosian did extremely well—was pricing. Secondary prices for living
artists weren't the challenge. They were generally set in accordance
with an artist's gallery-sales record and auction history, always higher
than what they were the last time the artist's work was sold. Dealers
rarely lowered an artist's prices, even if that artist's work had done
poorly at auction of late. Instead, they offered discounts—not to just
anyone but to collectors they knew and trusted. These discounts might
reduce a painting's cost by 30 to 35 percent, but no one outside the deal
would be the wiser. A $1 million painting with a 30 percent discount
to its buyer was still a $1 million painting.

It was with primary work that the dealer's instincts came into play. Often a gallery set modest prices, in order to raise them next time. Sometimes it took more of a chance. Jenny Saville, a figurative painter from the Young British Artists whose fleshy nudes brought Lucian Freud to mind, joined Gagosian in late 1999 and let him set the prices for her first New York show. It was a rare gambit for Gagosian, who was taking few artists unproven in the high-end market. To much art world muttering, he set Saville's prices shockingly high, a strategy known as "live or die pricing." If the works failed to sell, there would be no second show, and Saville, 29, would be left with a tarnished reputation. The show consisted of six large nudes priced at about $100,000 each.

Was Gagosian being too greedy? The show opened, the art world held its breath—and the paintings, every one of them, sold. When he needed it, Gagosian clearly had the feel for setting prices for the primary market.

Pricing masterpieces by dead masters was a whole other matter, as much to do with the collector's ego, or insecurity, as with the artwork's private and auction sales records.

Gagosian's relationship with S. I. Newhouse was a good case study. Newhouse, by the late 1990s, had sold off most of his collection through Gagosian—much of it to David Geffen—only to start buying all over again. By now, the Condé Nast chairman had come to rely on Gagosian almost completely. One art advisor sensed the new Gagosian dynamic on a visit to Newhouse's apartment at United Nations Plaza. This was a meeting at which Gagosian was not present. "[Newhouse] had a great Rauschenberg, which we discussed," recalled the advisor. Talk turned naturally to *Rebus* (1955), another Rauschenberg work, considered one of the greatest of the artist's combines. It had been out of circulation for some years, stored in Victor and Sally Ganz's private collection. Now it was back on the market. Newhouse told the art advisor that Gagosian had let him know it could be had for $34 million.

The advisor was surprised. "Are you sure? That much?" He told Newhouse he thought *Rebus* was priced at about $26 or $28 million, but that Newhouse could get it for $24 million.

"No," Newhouse said. "It's $34 million. That's what I heard."

Again the advisor explained it could be had for $24 million.

Newhouse waved him away. "No, it's $34 million."

"I realized after the third time that he didn't want to hear that," the advisor recalled. "It was more desirable to believe that the price was $34 million. The more expensive the artworks, the more significant they were to him." Also, the advisor noted, "He didn't want to be made a fool of."

Gagosian was tough in his pricing, but many collectors, including Newhouse, preferred doing business with him over Zwirner. Collectors and dealers knew Gagosian had a great eye. They also knew he was utterly consumed with making his next sale, and they liked getting caught up in the passion of it. If he was blunt, even brutal, at least he didn't try to be anything he wasn't. And if he set higher prices than Zwirner, so what? His buyers were, after all, getting a work with Gagosian's imprimatur on it.

ONE ISSUE WAS BEYOND DISPUTE: GAGOSIAN was the dealer who first saw the potential in putting up galleries around the world, taking the Castelli satellite system and recreating it in brick and mortar. He started with London in 2000, opening a gallery on Heddon Street. That put him in London a full dozen years before Zwirner.

"I don't think he had a strategy of taking over the world," said one of his directors at that time, Stefania Bortolami. "It just literally happened." In fact, there was a logic to each venue. Gagosian would open galleries where his clients lived, owned property, or vacationed. Athens, for example. The gallery in Rome was about showing Cy Twombly in his home city, but also about the Italian collectors who sought out his work there.

Opening in London wasn't a business move, exactly. Gagosian would never make the preponderance of his profits there—too few collectors. But it was the world's second-most important auction market. It also provided a pool of new prospective buyers to bring into his social gatherings and coax, sooner or later, into purchasing an artwork or two.

The London gallery was also a way of keeping one of Gagosian's favorite New York staffers, Mollie Dent-Brocklehurst, from leaving. A family situation in England had saddled her with an estate situation that all but forced her to move back to her ancestral home, Sudeley Castle. By opening a London office, Gagosian could keep Dent-Brocklehurst in the tent. The fact that she handled Damien Hirst was no small aspect of the matter. She and Hirst were close, and keeping the artist happy was especially important when Gagosian was pushing as much of Hirst's work as he was.[6] "How many Hirsts do you think they sold?" asked an art consultant who dealt often with Gagosian, before providing the answer: "*Thousands.*"[7]

Dent-Brocklehurst knew just how intense her boss could be; she had seen him in action in New York. But now that she had started the London operation in a small office on Berkeley Square, with Gagosian usually thousands of miles away, the calls came without surcease. "You would talk to him at eleven a.m., then the calls would come again at four in the morning. You would think someone had died."

"What's new?" he would say.

"You mean between eleven and four?"

Gagosian wanted the news—all the news. "He needed to know you had a list of things when he called. Not even major things, it just needed to be a list. 'This museum has been in touch' and so forth. Lots of positive news." Dent-Brocklehurst was "vaguely" on maternity leave and felt it her right not to answer all calls. At one point, Gagosian grew so irked that he had a telephone couriered to her by bicycle.

With the London move, Gagosian was again a pioneer, the first American dealer to open a gallery there. Hauser & Wirth, still Switzerland based, would follow in 2003. But Gagosian's New York rivals would take a decade to come to London. Later, Marc Glimcher would marvel at that. "Larry opened in London in 2000—he didn't even know how brilliant a move that was. He was stepping into the first wave of Russians coming to London. He kind of stepped right into it."

Back in New York, Stefania Bortolami had a ringside seat to her boss's new yen for international growth. Bortolami had grown up in

Rome studying Old Masters, only to be hired by Anthony d'Offay and brought to London for what became a marvelous education. D'Offay was meticulous. "Everything was discussed. Should we do a catalog nor not? Should it be hard cover or soft cover? Who's the right person to write it?" Bortolami might have stayed longer than she did, but her girlfriend, a rising dealer named Dominique Lévy, got hired by Christie's in 1999 to pump up private sales in New York. Bortolami followed her and landed at Gagosian as a senior director.

Life at Gagosian was definitely different. "With Anthony [d'Offay] you were much more like a family, you got given artists to look after, you worked with this or that one," Bortolami explained. At Gagosian, Bortolami, like all new hires, was expected to produce. "And produce is not just selling art," she noted. "It can be bringing in an artist, or producing a show. With Gagosian, you have to have hard elbows, or start working with an artist no one wants to work with."

To her surprise, Bortolami was often invited to have lunch with her boss. "It was about strategy: which artist to take. But you would be surprised how last minute everything was. He was always: 'We have to find someone to do the Oscar show in LA.' I think that Larry resisted the corporate structure that a gallery like Pace had [for] a long time. Larry was the one in charge—it was his company."

Remarkably, Gagosian in 2000 had no computer: 18 years later, he would still not have one. His assistants did, but Gagosian relied entirely on his BlackBerry. He just needed to reach people. Anything else a computer offered him, as far as he was concerned, was just shopping and gossip, neither of which he had any interest in doing. One collector familiar with Gagosian doubted that. "Gagosian likes to look helpless," he suggested. In fact, the dealer could look at images on an assistant's laptop as easily as on one of his own and have all the documents he needed printed out for him. But he liked trusting his gut and, perhaps more, having others feel a bit awed by his instincts. Gagosian may have had only a BlackBerry in 2000, but he had a keen sense of how electronic communication was changing the art market—and what it meant, already, that he could buy and sell instantaneously around the world.

IN 2001, ANOTHER CHANCE EVENT PLAYED into Gagosian's hands. After two decades of running the biggest contemporary art gallery in London, Anthony d'Offay decided he had had enough and announced he was leaving the business. "Larry got lucky," Bortolami said later. "He was expanding just as Anthony closed."

What made d'Offay such a rival—and made his departure that much more of a relief—was that he represented in London several of the artists Gagosian represented in New York, including Cy Twombly and the Warhol estate. Nicholas Logsdail of the Lisson Gallery should have pounced on all of d'Offay's artists, Bortolami noted, but he didn't act fast enough. In a nanosecond, as she put it, Gagosian hoovered up several of those artists. *Vruuup!* The most important was Cy Twombly—now Gagosian's artist in London as well as everywhere else.

Getting to know Twombly was as sublime a pleasure for Dent-Brocklehurst as it had been for Gagosian. "I was the point person," she recalled later. "I spent every summer with them. Cy loved Larry—his energy, and the fact that there was no pretention about him. He didn't like pretentious people. In some way, he probably liked the fact that it pissed people off that he had this relationship with Larry."

D'Offay's departure from the market shocked Gagosian. "He had by far the best gallery in London, and arguably the best gallery in Europe...and great artists," Gagosian mused later. "And he was in his fifties still. I heard...that he saw a recession coming, and he just didn't want to go through it. He miscalculated: there *was* a downturn, but he thought it was going to be a devastating blow to the art world." Instead, the dot-com bubble came and went as far as the art market was concerned, taking with it the dealer Gagosian had thought would be his greatest London threat.

From another direction—Cologne—came the next serious gallery to be reckoned with. Monika Sprüth and Philomene Magers might have lacked Gagosian's raw aggression, but they were steely in their own way and had impressed their fellow dealers by championing women artists. Sprüth had started on her own in 1983 with a gallery in Cologne and brought a background in Marxist philosophy to the art market,

which raised a question in her mind: Why weren't women artists as widely represented as men? She showed early paintings by the playfully figurative Andreas Schulze as well as George Condo and Rosemarie Trockel, who produced machine-knitted "paintings" on industrial knitting machines. She also showed several Metro Pictures artists, including Louise Lawler and Cindy Sherman. In 1985, she staged the first of three all-women art shows at her Cologne gallery, publishing a magazine titled *Eau de Cologne* to go along with it. She showed Jenny Holzer early on and Barbara Kruger before Mary Boone did. Sprüth and Magers teamed up in 1998 and made their London move in 2003.

Women artists were a priority, but the partners were clear on what that meant, and didn't mean. "It's not only our job to show an artist because she's a woman," Magers noted. "It would not have helped if we reduced the gallery's program to woman artists." At the same time, even then, they could see that women faced a greater artistic challenge than their male counterparts. "It's harder for women artists to be accepted and recognized in major positions in the arts," Sprüth said later. "The power is still in the hands of men, same as in the movie business. You see female actors but they don't make as much as male actors. And this is the same story in the art world. You'd think this would have changed by now, but it hasn't."

This made for a very different perspective. "Female artists definitely have a different understanding of power," Sprüth suggested. "For example, male artists, when they are successful, tend to have big studios with many employees. Women artists have less of this tendency. Maybe because they have different values." Sprüth and Magers would keep doing what they could until, by 2018, 17 of their 64 artists were women, a far higher percentage than that of any other gallery.

Between male and female dealers, too, there was at least one cultural difference. Far more women, it turned out, had earned formal degrees in art than their male counterparts. Richard Bellamy hadn't gone beyond high school. Nor had Sidney Janis, Ivan Karp, and Iwan Wirth. Irving Blum had majored in English and drama at the University of Arizona, Larry Gagosian had majored in English at UCLA, Leo Castelli had studied law and economic history, and David Zwirner

had studied music at New York University. Matthew Marks had studied art at Bennington but had no graduate degree. One of the few major dealers who did have a graduate degree was Arne Glimcher, who had graduated first from the Massachusetts College of Art and Design and then pursed an MFA at Boston University.

Of the women, Mary Boone had earned degrees from the Rhode Island School of Design and Hunter College in art. Paula Cooper had studied art at the Sorbonne, Goucher College, and the Institute of Fine Arts at NYU. Barbara Gladstone had degrees from C. W. Post College and Hofstra in art history. Milly Glimcher majored in art history at Wellesley and had an MFA from NYU. Marian Goodman had studied art history at Columbia.

Why the disparity? Given the workplace limitations at the time for women—both in and out of art—more women than men may have earned graduate degrees with the thought of becoming art historians or curators. Opening a gallery not only took money, it also required clients willing to buy from women entrepreneurs. The irony was that even with graduate degrees, most women struggled to find a job of substance. Especially for those who married and had children, opening a gallery became one of the few prospects available. Other women found it easier—perhaps more sensible—to ally themselves with husbands as business partners, among them Ileana Sonnabend, Milly Glimcher, Holly Solomon, and Manuela Wirth.

However they got to the point of making a gallery work, women dealers brought with them all the advantages that men had—and often more education at that.

ALONG WITH SPRÜTH MAGERS, A WELCOME contrast in London to Larry Gagosian's testosterone-rich gallery scene was Victoria Miro, the low-key dealer now hitched to the rise of landscape painter Peter Doig.

By the late 1990s, both Victoria Miro and Gavin Brown had realized they had a world-class talent on their hands, perhaps even one whose work might show the contemporary art world—at least the figurative side of it—where it was going. More shows followed, including two

more at Gavin Brown's Enterprise gallery in 1996 and 1999. The next year, Miro moved into a far larger space—8,000 square feet—on London's Wharf Road, financed in part by Doig paintings. She was becoming known as "the quiet woman of British art," a catchphrase that denoted her rising profile and her reputation for bedrock integrity.[8]

In those charmed years for Miro—the late 1990s and early 2000s—Doig and his wife became close friends with Miro and her husband, Warren. It was a circle that included another painter, figurative in his own very different way.[9] Doig and Chris Ofili were already close friends, brought together by their early shows at Miro and Gavin Brown's Enterprise. In 2000, the two artists went to Trinidad for a one-month artists' residency, where Doig introduced Ofili to the island he had come to love in his youth.[10] The next thing Miro knew, Doig was announcing that he and his family were decamping to Trinidad to live and paint.[11] They loved the island's exotic appeal and its sanctuary from the whirl of the art market that had been pulling them in.

"That was very strange for me," Miro confessed later. "Here is this artist, his studio was next to my gallery, I had seen him nearly every day. He was such a lovely guy, he used to come and do barbecues at lunchtime. He had even helped design my new gallery. And now he was off to Trinidad." The Miros went down to visit and appreciated the island's raw, rough charm: unspoiled, a little bit edgy. Doig had taken a space in a big arts complex on the island, and he started the Studio Film Club in 2003.[12] For each screening of a classic film, he would do a poster, loosely and quickly; they would become well-known and prized artworks.[13] Trinidad provided Doig with beautiful backdrops for his new work. Ofili, whose work was denser and more allegorical, found inspiration from his own trips to the island and began spending more time there too.

Miro couldn't say when German dealer Michael Werner began courting Doig, only that it had to have started sometime before 2002, the year Werner gave Doig a show at his New York gallery. Werner represented most of the German Expressionists, including Georg Baselitz and Sigmar Polke—more than before, since d'Offay had just shuttered

his London gallery. Doig seemed drawn to the prospect of having the Germans' art dealer as his own. "There was never any formal departure from the gallery," Miro said sadly of Doig. "Peter is not a brash, inconsiderate person. He is lovely, warm, everything you would want from an artist, so it was very painful. You had all these fears about it happening, but it took such a long time to realize that he really was with Werner. With a formal separation you get over it, but this way it carried on much longer."

BY NOW, GAGOSIAN HAD REALIZED HE had a passion for new galleries—and the places they took him to. "New York was still the center of the art world, but I felt that was changing," Gagosian said later. "I also liked the adventure of opening galleries in different cities. Finding a building, getting an architect, the complexity, getting to know a new city in a way you can't by being a tourist." His next was a second gallery in London, which became the city's biggest exhibition space, on Britannia Street in the spring of 2004. To no one's surprise, the artist Gagosian chose to highlight for its opening was Cy Twombly.

The new Twombly works proved hugely lucrative, especially since Twombly let Gagosian keep two-thirds of the price for every work sold, noted Bortolami. "If you sell ten Twomblys at five million dollars each, and you make sixty percent of that, you make more than thirty million dollars, [and] you say, 'Hey, why not open a gallery in Paris, and Rome, and do more Twombly shows?'"

"It was a great way to pay for the renovation," Gagosian noted later. It also got Twombly's adrenalin going: the deadline effect. Gagosian would tell him the launch date for his next gallery, and Twombly would nod slowly. "Okay, let me see what I can do."

"He wasn't the kind of artist who would go to the studio every day and work," Gagosian explained of Twombly. "He had to have an idea of what he wanted to paint. He had to literally see the painting. And when he saw it, and felt good about it, then he would go execute. So that's how he worked—in spurts. He would work for a month all day,

every day. And then he wouldn't work for six or seven months. Most artists I know go to work in the morning and make a painting that day or that week. He was an unusual artist in that way."

Gagosian didn't say it in so many words, but he felt as proud of his friendship with Twombly, and the art that those deadlines helped produce, as anything else in his life. That art was there for keeps, and its very existence was, to an extent, Gagosian's doing. There was just one time when the deadline strategy appeared to backfire.

Twombly had two homes, one in Italy and one in his native Virginia. "He would stage a show in Virginia and then decide he couldn't stand the crappy food, and say he had to go back to Italy," Gagosian recalled. "And then he'd say, 'These Italians are driving me nuts, I have to go back to Virginia.' He had studios in both places, and he was going to have a show on his seventy-fifth birthday. I went down to Virginia, checked into a little bed and breakfast where I always stayed. That night, Cy said, 'Larry, I'm sorry, I'm not going to be able to do the show.'"

"Really?" This was horrible news: the show was supposed to open in two months.

"I'm sorry, but I don't want to disappoint you," Twombly said. "The paintings are terrible, they're just mud."

Gagosian tried to hide his chagrin, without much success.

The next morning at 7 a.m., the dealer was awakened by a call from Twombly. "Don't leave!" the artist commanded.

Somehow, after Gagosian had gone to bed, Twombly had figured out how to paint over the "mud" paintings in a way that worked. He had done one or two while Gagosian was sleeping; now he was all fired up to do the rest. "He repainted every canvas that day," Gagosian said later. "And those paintings are at Glenstone, they're at the Broad." The series was pale blue, with no trace of dark hues underneath. Twombly called the series *Passage of Time, or the Birthday Paintings*. Before Gagosian left, he and Twombly indulged in their favorite Virginia pastime: going to Walmart. "We would wander up and down the aisles for a couple hours," Gagosian explained. "He just liked looking at the stuff. It

was a kind of Zen thing. And Walmarts in these rural areas are almost like civic centers, people come and congregate."

RUNNING A GALLERY COULD BE BOTH hard and lonely work. That was one reason the four young founders of the Lower East Side gallery called Canada started as a group in 1999. Also, they had no choice. "There was no money!" declared Phil Grauer, one of the four, years later from a windowless room above Canada's latest space on Broome Street. "A lot of dealers have a pool of wealth. We were cleaning houses, Suzy [Butler] was doing bookkeeping, I was doing construction."

Still, the vision of starting a New York gallery had brought Grauer down from Nova Scotia—hence the name—and led him to rent, with the others, a black-painted basement for $500 a month in Tribeca. They called it a studio, but it was more of a party room. Nevertheless, Canada's founders did hang shows, and they pressed their art on anyone they knew. Their clients were more like sponsors, buying a painting when money got tight.

After 9/11, the gallery nearly failed, until the partners realized they qualified for federal funding. To their own surprise, they struggled on, moving to a space on Chrystie Street. That was when a number of young downtown artists became part of Canada's clan—partying, smoking weed, and bringing their art. One, Michael Williams, made paintings that seemed cartoonish. Another, Matt Connors, did colorful abstracts with broad stripes. And then there was Joe Bradley, who was doing something nautical, as Grauer recalled: "Seascapes, sort of, with sailors' rope around them, like portholes." The seascapes were meant to be ironic, Grauer said, but Bradley was trying to do them in an unironic way. Or was it the other way around? No one at Canada thought much about money, including Bradley, Connors, and Williams. Certainly no one associated with the gallery could have imagined that Bradley would end up a Gagosian artist, selling his works for millions of dollars, with his downtown pals Connors and Williams not that far behind.

In that ragtag fellowship of downtown artists and dealers, Pat Hearn had earned a special place, and her death at 45 in the summer

of 2000 brought the art world's best-known romance to an end. Hearn had established a memorable career, not only running her own gallery but cofounding the Gramercy International Art Fair—a precursor of New York's Armory Show—with Lisa Spellman, Matthew Marks, Paul Morris, and her own Colin de Land in 1994. She had championed artists, including abstract painters George Condo and Mary Heilmann, video artist Joan Jonas, and installation artist Jack Pierson. She had staged a posthumous show for sculptor Eva Hesse, whose own life had been cut short. Above all, she had inspired a whole era of downtown contemporary art dealers, including Gavin Brown.[14]

When Hearn's insurance company refused to cover her care, more than 200 artists, collectors, curators, and dealers protested and raised money for her; the insurance company reversed itself. "After each round of chemotherapy," recalled arts journalist Linda Yablonsky in her tribute, "Pat would arrive at an opening or a premiere in yet another new outfit, in gold lamé or sequins and pearls, her head wrapped in a chic turban or topped by a red or white pageboy wig."[15] In the spring of 2000, 20 friends gathered at City Hall to witness Hearn's marriage to Colin de Land. "Was a song ever more bittersweet?" as Yablonsky put it. By August, Hearn was dead of cancer.

In her obituary for the *New York Times*, Roberta Smith praised Hearn as "a very complex woman, at once sophisticated and wholesome, stringent in her taste, yet extremely generous. Slim, dark-haired and usually dressed in a stylish mixture of designer and vintage clothes, Ms. Hearn resembled a bohemian Holly Golightly."[16] Less than three years later, in March 2003, Colin de Land died of cancer too. With Hearn, he left the legacy of having helped found the Gramercy International Art Fair. He, too, was beloved by an entire community of dealers and downtown artists.

Now the market seemed headed straight up, leaving only a few dealers behind.

LA Rising

2003–2008

By THE EARLY 2000S, the mega dealers were pulling far ahead of smaller galleries in a market growing with astonishing speed. All four megas were privately held and published no financial statements detailing revenues, expenses, profits, and losses. Even their corporate statuses were unclear. Still, soundings could be taken from art fair sales wrap-ups, when mega dealers broadcast their triumphs, and from the auction houses, where works sold by the mega dealers and their clients sometimes went for multiples of their retail prices. Overall, the total art market in 2002 was $21.151 billion. In 2008, it would grow to more than $62 billion, nearly tripling in volume.[1] These were the years in which Larry Gagosian became the best-known art dealer in the world, his gallery's growth paralleling the growth of the art market.

With that growth came a new degree of brazenness on many dealers' parts for luring away artists from rival dealers. A case in point came in December 2003, with the very popular John Currin, whose figurative paintings seemed plucked from the Renaissance, though not without a satirical edge. Andrea Rosen, a midsize dealer, had nurtured his career from 1991, with slowly but steadily rising prices. She had just celebrated the launch of a three-city retrospective, from Chicago to London to New York, when news broke of the 41-year-old's jump to Gagosian. Artists went from dealer to dealer, but to do so in the artist's hometown at the end of the tour?

Gagosian was amused by how much ink, as he put it, the *New York Times* gave to the news, but irked by a quote from David Zwirner, who

called Currin's move "a real shock" and added that "our generation doesn't have that aggressive behavior."[2] That was "fucking bullshit," as Gagosian later put it. "Everyone operates about the same way. To take the high road, or burnish his ethics on my hide—it pissed me off. If the tables were turned, he'd do the same thing. Why try to come off so PC?" No one, he added, had a gun to the head of any artist. "In my experience, it starts with you hearing the artist isn't happy. In extreme cases, you have a gallery that's not paying the artist. That's less likely with a good artist. But it can happen. Or the artist and dealer have just had a falling out. If it's an artist you like, you pay attention. *That's* how I got John Currin."

Zwirner might feel his generation was different, but he was doing his share of poaching too. "David has actively poached artists," sniffed one Chelsea dealer. "True, it's common. But he will court an artist in a certain way. And it's hypercompetitive." So it went with Lisa Yuskavage, whose sexually suggestive portraits of women had found an eager market through her shows at the Marianne Boesky Gallery.

Between Yuskavage and her dealer, success had bred tension. "Lisa was going to leave no matter what," Boesky admitted later of Yuskavage. The artist's rise had left her critical of Boesky's "context," as dealers and artists put it: the other artists at the gallery. She wanted Boesky to kick out certain artists, just as Betty Parsons's artists had wanted her to do decades ago. Boesky thought of altering the context by taking on artists Yuskavage might like, but how could she be sure the new ones would satisfy Yuskavage in the long run? Still, Boesky was hurt and embarrassed when Yuskavage went with Zwirner.[3] The departure of Japanese artist Takashi Murakami for Gagosian was even more painful, coming as it did after nearly a decade of steering his career from obscurity and widespread rejection to global acceptance.

Murakami had perfected the style he called superflat. As in a Walt Disney animation cell, there was no visual depth, no brushstrokes or evident human imperfections. Boesky had first become aware of Murakami through a small but plucky gallery called Feature Inc., from which Boesky had poached *him*. Galerie Perrotin in Paris would

also play a role with Murakami. But credit for building his career in the United States went mostly to Boesky and a pair of laid-back Santa Monica dealers, Jeff Poe and Tim Blum, whose story said a lot about how the contemporary art market took off.

Poe was the quiet, even taciturn, one, Blum the upbeat salesman. They had started with a small gallery in Santa Monica in 1994 and found themselves struggling to get by. They had one unusual card to play, and so, in desperation, they played it.[4] Tim Blum had become fascinated with Japan in his twenties, enough to live there for four years, learn the language, fall in love with contemporary Japanese art, and work in a Tokyo gallery.[5] Both Blum and Poe were particularly drawn to the then-unknown Murakami. They began to exhibit his work in 1997 and became his Los Angeles dealers. Boesky became his New York dealer, first including him in a group show in 1998, then giving him a solo show the next year.

In 1999, Blum & Poe first showed Murakami at Art Basel: ten paintings, surrounding a sculpture of mushrooms with a typical Murakami character beside them.[6] "We were looked at as complete idiots by the rest of the fair," Poe later admitted. "Superflat wasn't there yet; we were ushering into Western history an Eastern history that had been excluded."

Murakami had fabricated those first works at his own expense. In 2001, as his reputation grew, he opened a production space in Japan and began hiring dozens of workers.[7] Clearly influenced by Warhol, he worked in both fine art and commercial art, blurring the line between the two. Ultimately, he wanted to make everything from paintings to scarves to keychains, all with his Murakami brand. In 2003, Murakami also embarked on a handbag partnership with designer Marc Jacobs of the fashion brand Louis Vuitton.[8] The handbags were a huge hit.

By now, Murakami had begun asking his dealers to underwrite production costs—not for Vuitton bags, but for much of the rest of his work. Blum and Poe knew that Murakami was no spendthrift. He slept in a converted crate in his office, just outside Tokyo, and worked every waking hour, making all design decisions, no matter how small.[9]

The problem was his ambition: it was just so sweeping. They underwrote as much as they could, as did the artist's other dealers, but when Murakami announced that his next project would be a 19-foot-high platinum and aluminum Buddha, his dealers balked. Boesky was pregnant in 2006, and Murakami, she recalled, didn't like the timing of that at all. "You're lactating, you can't be my business partner," she recalled him saying.

After ten years on Boesky's roster, Murakami severed relations with her and signed with Gagosian as his New York dealer. Blum & Poe stayed in as Murakami's LA gallery, going so far as to charter a plane from Japan to bring the still-unfinished Buddha to the Los Angeles Museum of Contemporary Art (LA MOCA), where it would be shown as part of a Murakami retrospective. They also bought $50,000 worth of tickets for the opening night gala and provided a six-figure contribution to help finance the show itself. Even more was needed, so Gagosian and Murakami's Paris dealer, Perrotin, kicked in. And so did Boesky.[10]

Boesky could accept that Murakami would leave her for Gagosian. What galled her was LA MOCA's subsequent request to borrow key Murakami works that she owned, followed by Murakami's reaction. As soon as her Murakami paintings were hung on LA MOCA's walls, the artist stopped communicating with her. "Murakami is a fucking genius," Boesky said later. "I hate him, but he's a genius. What I hate is the way he left—without honor."

IT WAS NOT BY CHANCE THAT a paradigm-shifting artist like Murakami was shown at LA MOCA. Nor was the Blum & Poe gallery situated in Santa Monica because its partners preferred sunny California to New York City. For dealers like Blum and Poe, the West Coast was no longer as arid an art scene as it had once been. A new chapter in contemporary art was opening in LA, and it had a lot more to do with the art being made than dealers poaching each other's artists.

LA's recent history had begun, in a sense, in 1979, with the opening of LA MOCA that year. At last, the city had the makings of an art

center—and one founded by artists, at that. Four years later, the Geffen Contemporary at MOCA added 40,000 square feet of exhibition space in LA's Little Tokyo historic district. MOCA director Richard Koshalek made a brilliant move in 1984, purchasing part of Count Giuseppe Panza's historic collection of Abstract Expressionist and Pop art.[11] Trustees groaned at the $11 million price; soon they would realize the purchase had made MOCA one of the world's top museums of contemporary art—for a song.

With those arrivals, gradually more galleries opened in half a dozen neighborhoods. Richard Kuhlenschmidt opened a basement space on Wilshire Boulevard and made a point of showing challenging art, much of it conceptually based and from the Pictures Generation. Daniel Weinberg brought New York artists to the West Coast, among them Jeff Koons, Robert Gober, Sol LeWitt, and Bruce Nauman. There was no core area until galleries began congregating in West Hollywood, on the Beverly Hills border. Then, in the early 1990s, Santa Monica became the core. Kuhlenschmidt came. So did Weinberg. From New York and Europe came an early international gallery partnership: Luhring Augustine and Max Hetzler. Yet another new gallery in Santa Monica was Blum & Poe.

For Rosamund Felsen, one of LAs longest-lived dealers, who had opened her first gallery in 1978, the move to Santa Monica from West Hollywood was bittersweet.[12] One after another artist left her, culminating in the departures of Paul McCarthy and Mike Kelley. McCarthy explained that he was about to start making major, expensively fabricated works, financed by his new global gallery, Hauser & Wirth. "Then Mike Kelley came in.... He needed to leave too," Felsen rued. "All the artists that he had been seen in context with were no longer there." Santa Monica had grown, but at a cost for small and midsize dealers.

Irving Blum wasn't surprised. The affable pioneering Warhol dealer had had his own struggles in the LA market, first in the 1960s with the Ferus Gallery, then in 1986, when he gave LA another go with his New York gallery partner, Joe Helman. He was soon reminded why he had

left LA in the first place. "The Los Angeles scene is always two steps forward, one step back," Blum said. "It's needed some centrality, and Santa Monica has provided it. But the truth is, it hasn't happened yet that LA has become a major art center. With thirty or so galleries, there just isn't the density that New York has. Everything seems to be focused here now, and that's great. But the ongoing problem is that collectors will still only spend up to a certain level. When they want to spend more, they go to New York. That's what makes the situation ultimately provincial."[13]

Blum and Poe were set on proving the skeptics wrong. From their tiny gallery in Santa Monica, they had an outsize influence on artists as far away as Murakami in Japan and as close to home as Mark Grotjahn in LA. Grotjahn started as a shy aspiring artist who came to the gallery to see other artists' work. By the time Blum and Poe met him in the midnineties, he had been struggling for nearly a decade to find his way. When his world looked bleak, he went on drinking binges.[14] With a friend, Brent Peterson, he opened a small gallery named Room 702 in Hollywood and started working with other artists.[15] The conversation, at least, helped. To earn money for his family he played Texas Hold'em for serious stakes.[16]

As an artist, Grotjahn was struggling without success to find his own style—to the point that in 1993 he started painting the handmade store signs he saw in his neighborhood. Many of the signs, as critic Jerry Saltz later noted, were for dives and quick marts, burger joints and newsstands—and liquor stores, lots of liquor stores. "I deduce someone scared, strange, on the margins, avoiding big, glitzy stores," Saltz speculated, "invoking a hardscrabble, old-school Raymond Chandler vibe, an almost alcoholic loner."[17]

True or not, Grotjahn felt that the signs he'd copied weren't as good as the originals, so he went to the store owners and asked to exchange them. Most agreed, since as far as they were concerned the signs were the same. The sign chapter taught Grotjahn a lot about line and color. It also pulled him out of his cafard. By 1998, he was painting in a new way he liked.

"Mark used to come to the gallery," Poe recalled, "and see every show and talk to us." He never showed work of his own. "One time we said, 'Why don't you bring in some drawings?'" Grotjahn did, and Poe gave them a look but was unimpressed. Out of politeness, and because Grotjahn was a nice guy, Poe agreed to visit his studio to see more. Poe saw a different body of work there, one that really intrigued him. Grotjahn was doing what looked like landscapes, with what seemed to be rays beaming out from a setting sun. The artist called them two-tiered perspective paintings. Later, they would be known as his butterfly paintings.

Grotjahn's paintings in his first show at Blum & Poe in 1998 failed to sell. At a second show two years later, Grotjahn sold exactly one, for $1,750. He called the experience a "whipping."[18] Sometime after that, he bought two large stretched canvases that some other artist had ordered from a vendor but failed to pick up and let them lead him to a new approach. The first of them he painted as one of his horizontal, two-tiered perspective works. After studying the finished painting, he decided he didn't like its orientation. So he shifted it on the wall from horizontal to vertical. He liked how it looked—enough to make his second canvas vertical from the start. The vertical perspectives looked intriguing and fresh: not sunsets but vortexes.[19] At a third solo Blum & Poe show, in 2002, Grotjahn's latest paintings stirred growing excitement.

Don Marron, the financier/collector who would soon add Grotjahn to his collection, saw a lot of artists with their dealers. This was a relationship that stood out. "Grotjahn with Blum and Poe is one of the great examples of how steadfast commitment to an artist you believe in can yield tremendous results—rather than seeing how they do for a year and then dumping them. It was real commitment, like Leo [Castelli] and [Jasper] Johns, and like Ellsworth Kelly and Brice Marden with Matthew Marks." Ironically, Grotjahn would later be one of the first artists of his generation to have multiple dealers—four in his case—and call his own shots.

LA'S ART SCENE WAS ON THE map, but not just because of new galleries and museums. The California Institute of the Arts, founded in 1961 and known as CalArts, had lured a whole generation of future artists and dealers. Some of its teachers were well-known artists. Several had participated in *Helter Skelter: L.A. Art in the 1990s*, a groundbreaking 1992 show in which 16 artists explored alienation, dispossession, perversity, sex, and violence. Among the curious drawn to LA by that show was David Kordansky, an aspiring artist and dealer who came west from Connecticut. He was fired up by the vision of learning from his heroes—Paul McCarthy, Mike Kelley, and the ultimate mentor, Conceptual artist John Baldessari—and set on being a dealer of contemporary art that mattered.

Kordansky arrived at CalArts to find a seismic shift underway. A number of teachers, led by Baldessari, had left CalArts for UCLA or the ArtCenter College of Design in Pasadena. "It was no longer about the monastery up in Valencia," as Kordansky put it. Teachers and students were challenging CalArts' rigor and tradition, where professors mercilessly critiqued students' work and sent them off in tears. At UCLA and the ArtCenter, students were artists even if they never picked up a paint brush. As CalArts lost its allure, there were fewer painters to be found there either.

Upon graduating in 2003, Kordansky, with a partner, Ivan Golinko, opened his first gallery at 510 Bernard Street, a tiny cul-de-sac in Chinatown. The gallery had a mission: to take on CalArts artists and in so doing promote painting, which CalArts had de-emphasized, and help restore the school's luster. Kordansky's first artist was Jonas Wood, a friend and assistant to Kordansky's wife Mindy Shapero, herself a sculptor. Wood was becoming known for his portraits of friends. In 2019, he would still be a Kordansky artist, though by then he would be a Gagosian artist as well.

Another of Kordansky's early finds was the British-born Thomas Houseago, whose outsize sculptures, in bronze among other materials, sometimes depicted figures, sometimes abstractions, and often featured

exposed rebar, giving a sense of incompletion. The artist and his dealer became fast friends. "We were young and dumb and were partaking in pretty reckless behavior," Kordansky readily admitted. "There was an explosive and intoxicating energy between us." Only one solo show, and one group show, had come out of their alliance by 2005. But Kordansky felt sure that would change in 2008, when he moved to a larger gallery in Culver City. A first Houseago show in the new space came and went—and so, to Kordansky's shock, did Houseago. "I put my heart and soul into him," the dealer recounted, still hurt years later, "and he ends up leaving me." For Kordansky, a career-making artist was gone, a friendship torn asunder. "I was 26," he recalled. "It was the greatest life blessing." Like Zwirner after Franz West's shocking departure, Kordansky saw he needed to grow—to not focus on any single artist, but instead promote all his artists equally.

LA HAD ART SCHOOLS, AND ITS ranks of galleries and museums were growing, but one thing the city seemed destined to lack in perpetuity was auction houses. It was in 2004, in New York and London, that the auction numbers for contemporary art shot straight up, clarifying just how fast the market was growing. An auction of contemporary art that year brought $100 million for the first time and set more than two dozen records for artists from Pollock to Murakami.[20] A year later, that record was obliterated by an evening sale of $157.5 million. As prices soared to new heights, Sotheby's and Christie's resold art of the 1980s and 1990s and then went all the way, selling paint-fresh art too.

These sales figures were forged by the banging of gavels at public auctions. The three main auction houses that sold contemporary art—Sotheby's, Christie's, and Phillips—were also moving a lot of art through private sales. Sotheby's, the only publicly owned house, and thus the only one that published all its sales figures, sold $271 million in private sales in 2005, though this included every kind of collectible the auction house sold, from contemporary art to vintage cars and valuable wine. Christie's, while publishing no comparable numbers,

was clearly doing well in private sales, too, thanks in part to a chic Swiss woman with crackerjack instincts named Dominique Lévy.

Lévy, the daughter of a wealthy Jewish Egyptian currency trader, had studied art history and politics and at 21 curated her first exhibition in an 18th-century mansion.[21] The owner had tried without success to sell the property, so Lévy proposed she hang an art show on its walls. "I'll show young artists, and you'll get lots of attention." The paintings sold—and so did the house. Lévy had found her way. "To me, being around art is freedom," she said years later. "Everything is possible."

Lévy's father had the means to make life easy for his daughter. Instead, he was brutally stern. Lévy would spend years proving herself to him. Perhaps not coincidentally, she found herself drawn to strong male authority figures. One was François Pinault, the new owner of Christie's, who put Lévy in charge of developing the auction house's international private sales department.[22] Dealers hated her—she threatened their very existence—and so did much of the rest of the art market. "I swam against the tide for five years," Lévy recalled. "I suffered aloneness and discouragement like I had never done in my life." Her girlfriend, former Gagosian director Stefania Bortolami, was of some comfort, but success was perhaps even more encouraging. By 2003, Lévy was generating, she later said, $100 million a year in private sales.[23] It was time to break off on her own, as an art advisor with a golden Rolodex.

IN 2003, GAGOSIAN WAS NAMED BY *ArtReview* as the figure who had had the most impact on contemporary art's value and reputation. He would stay at or near the top of every such annual list from then on. Jackie Blum, wife of dealer Irving Blum, suggested that Gagosian's brilliant strategy was to live rich before he got rich—to have the fancy Hamptons house and the plane before he could afford them and therefore start socializing with the very rich who would become his clients.

Rivals conceded Gagosian's dominance but still rolled their eyes. "Why do you deal with him?" a Christie's staffer asked a collector at

lunch one day. The collector sighed. "It's...Larry, I don't know, it's *Larry*. I know he's a rogue but he's offering me the best stuff." Others winced at perceived slights from the lord of the realm. "Larry will say hello to me if I'm with someone he wants to meet," observed one dealer. "In the elevator, if it's just the two of us, he'll barely say hello."

Along with the half-dozen or so largest collectors from the previous two decades, a new generation of Gagosian collectors had come aboard. One was real-estate developer and art investor Aby Rosen, another was hedge-fund manager David Ganek, and a third was television producer Bill Bell Jr., a keen Koons collector with his wife Maria Arena.[24] The parties Gagosian threw for these collectors were lavish but, for their host, obligatory. The truth, suggested one observer, was that Gagosian didn't much enjoy his own parties. "He shows up for fifteen minutes, then leaves unless [Microsoft billionaire] Paul Allen shows up. Larry is great at this. He is unavailable—and then suddenly he *is* available. He knows how to play it. But he's not that interested in people as people."

One of Gagosian's great gets in this period was artist Richard Prince, who had gone from Metro Pictures to Barbara Gladstone. In the mid-2000s, Prince's *Nurse* paintings, with their images of nurses taken from 1950s paperback covers, reportedly struck Gagosian as "curator art," reported the *Wall Street Journal*.[25] He wasn't the only one: Arne Glimcher declared that Prince didn't have a touch. "They're mildly interesting as book covers—photographing art on art," Glimcher acknowledged. "But how big was that idea?"

Still, as the artist's market rose, Gagosian began taking an interest. He was seen socializing with Prince—affecting plaid shirts as Prince did. The turning point was a major Prince show at the Guggenheim. Despite Gladstone's help in making it happen, the artist's mind seemed set. He left, as Gladstone noted, right after the Guggenheim show.

Clearly, money figured into the decision. According to the *Observer*, Gagosian granted Prince a generous sixty-forty split on all sales, with the greater share going to the artist.[26] He also put a Prince on pretty much every one of his collectors' walls. At Gladstone, Prince's *Nurse* paintings had sold in the low six figures. In July 2008, a painting from

2002, titled *Overseas Nurse*, sold for a record $8.4 million at Sotheby's, indicative of what Gagosian was doing with his primary work to goose the market.[27] It was the start of a hugely lucrative run for Prince and Gagosian, but one that would be tested by lawsuits brought against Prince and the Gagosian gallery by photographers indignant at Prince's appropriation of their work for his own.[28]

POWERFUL AND WEALTHY AS HE WAS, outpacing all his rivals, Gagosian was not generally regarded as the most adventurous of the mega dealers. Neither was Glimcher. Hauser & Wirth was still feeling its way. Zwirner at this time was the one taking the most chances on edgier artists. A decade or so after signing up his first primary artists, nearly all remained with him, their stars still on the rise, including political painter Luc Tuymans, site-specific installation artist Diana Thater, socially satirical pen-and-ink illustrator Ray Pettibon, and Stan Douglas, the noirish filmmaker.

As if taking on a sideline hobby, Zwirner had also signed up several of the Minimalists and Conceptualists who had made their names in the 1960s and 1970s only to be preempted by the splashy Neo-Expressionists of the 1980s. Most were dead, so signing them up meant working with their estates. Abstract painter Ad Reinhardt, with his monochrome black paintings, was one; he had died in 1967. Fred Sandback, who died in 2003, was a Minimalist/Conceptualist sculptor who had worked with yarn, stretching single strands from floor to ceiling at geometric angles that created sculptural volume.

Minimalism was very much New York based, which left out another Zwirner acquisition, California artist John McCracken, though he, too, worked with simple geometric shapes. McCracken, still living when Zwirner took him on, was best known for his leaning, highly polished planks, somewhere between surfboards and the monolith in *2001: A Space Odyssey*. He worked with lacquer, fiberglass, and plywood, ending up with sleek, brightly colored forms that earned him and a few of his West Coast fellow artists the classification of "finish fetishists," a term he rejected. McCracken was sort of a stoner and believed

in the existence of aliens, with whom he said he had had encounters. With McCracken's death in 2011, Zwirner started working with his estate too.

The most prized of the ten or so estates Zwirner had, though, was clearly Donald Judd's. Judd was the acknowledged father of Minimalism, known for his stacked boxes and his extensive writings on the philosophy of art. He had denied that his works were sculptures, preferring to call them "specific objects."[29] He had also denied that he was a Minimalist, yet the term would stick to his work. Drawn to the sweep and solitude of western landscapes, Judd had traveled extensively through the Southwest, developing desert-based architectural projects.[30] The town of Marfa, Texas, was where he came to rest. Judd created the Chinati Foundation, which showed works by fellow artists John Chamberlain, Dan Flavin, Carl Andre, and Claes Oldenburg, among others. Over time, the foundation came to maintain 70 square miles of undisturbed ranchland.

Zwirner had barely opened his first gallery when Judd died in 1994, at 65. The artist's works began to rise in value, to the point that in 2013, one of his large-scale sculptures would sell at auction for $14,165,000.[31] That was an all-time high for an esoteric work from 1963; as of 2018, only seven of Judd's works would have been sold for over $5 million at auction. Still, Judd was clearly a dealer's prize. Pace represented him for 20 years, both before and after his death, but after a last solo show with Pace in 2011, Judd's estate moved to Zwirner.

With this Minimalist lineup, Zwirner struck many as the true successor to Leo Castelli. One dealer conceded that Zwirner had, as he put it, "very much of a European tilt to what he's doing. Gagosian would have hot artists, artists that collectors bought because they thought they'd make money on them. David is a little more cerebral, a little more subtle."

Over time, Arne Glimcher had worked with Minimalists, Conceptualists, and other kinds of abstract artists too. Agnes Martin, who called herself an Abstract Expressionist, was perhaps his personal favorite. Her friendship and philosophical conversations, especially

that night in 1963 at Coenties Slip, had influenced him profoundly. He could hardly have predicted how long and intense his friendship with her would be.

In 1967, as Martin's acclaim was growing, she abruptly stopped making art and left New York. For the next year and a half, she traveled the United States and Canada in an Airstream trailer. She had been close to the artist Ad Reinhardt, and his death that year may have motivated her travels, during which she had little or no human contact, but Martin was also a diagnosed schizophrenic. Eventually, she settled on a remote mesa in New Mexico and began building an adobe compound. Another four years passed before she worked as an artist again.

Glimcher had no expectation he would ever see Martin again, much less represent her. Then one day, she walked into his gallery. "I'm painting again," she said tersely. "Would you show them?"

Yes, Glimcher spluttered. Yes!

"I'll let you know when to come," Martin said, and vanished.

The call came on a Friday afternoon. "There's a plane tomorrow morning to Albuquerque," Martin said. "It leaves at nine a.m. I'll meet you at the airport." Glimcher and his business partner, Fred Mueller, made sure they were on that plane.

Martin had finished her compound by now. There were small outbuildings, and sheds for the farm equipment that had been used to clear the land. After months of having no one to speak with who knew about art, Martin happily jumped from subject to subject. She told Glimcher her concept of beauty. "Some people don't like this landscape, all they see is dirt and dust—but they can't see beauty," Martin declared. "Blake saw beauty in a grain of sand—he saw the whole world. Beauty is something we know rather than see." As Martin talked, strains of Beethoven filled the compound. He was the most perfect composer of all time, Martin felt.[32]

Glimcher would visit many more times, and there were always new paintings. Glimcher was thrilled by them all. He had to accept, however, that Martin would destroy much of the work, because that's what she did. She would do 12 paintings and ask Glimcher which two he

liked best. With a sigh, he would pick two. Martin would proceed to slash the others with a matte knife. And so he wasn't surprised when, in 2004, she told him to come visit her a last time because she was dying and needed him to help destroy more of her work.

"I sat by her side one morning and although her eyes were closed, I sensed she was awake," Glimcher later wrote. "Agnes beckoned me to come closer to the bed. 'There are three new paintings in the studio,' she whispered. 'The one on the wall is finished and the two on the floor need to be destroyed.' Would I go to the studio and destroy them for her? This was her last request."[33] Glimcher explained, "Using her matte knife, I reluctantly shredded two and spared the one that hung on the wall."

After Martin's death, Glimcher learned that a studio assistant had failed to cut up many of the paintings Martin had wanted destroyed. He knew it because of the puddles. "If a puddle forms in the paint, she called it a mistake, and she would destroy the paintings," Glimcher explained. Yet some Martin paintings with puddles had reached the market. For Glimcher, this posed a conundrum. They were Martin's work: by the hand of the artist, as the phrase had it. As such, they'd been included in the artist's catalogue raisonné. Yet Glimcher knew Martin would have been horrified to learn they were there. All Glimcher could do was note in the catalogue that some of Martin's paintings were unsigned—and refuse to have Pace buy or sell them.

MARTIN WOULD HAVE BEEN ALARMED TO hear her work was being shown at art fairs, but by the early 2000s, it almost certainly was, on the secondary market and beyond Glimcher's control. Most artists, in contrast, wanted their work shown at every significant art fair. This was creating new demands on dealers: more fairs to attend, more work by their artists to show, and more sales to rack up if the dealers wished to avoid going home empty-handed except for a fat stack of expenses. In a sense, the dealers had only themselves to blame. They had cheered the spread of fairs as a way not just of expanding markets and developing new client relationships but of pushing back against auction houses.

Dealers had the upper hand at fairs, since auction houses weren't allowed to rent booths.

Free to flit from one booth to another was a new breed of art advisor, with wealthy clients in tow. For the most part dealers loathed them, because advisors could monopolize their clients. It irked them, too, that art advisors needed no credentials; they could come and go as they chose. They did, of course, occasionally buy art on behalf of the dealers' clients, and the dealers had to be happy with that.

Every art advisor in this freewheeling time had a story: of first jobs and mentors and chance encounters, of hearing what some big collector was seeking and learning where it might be found. Allan Schwartzman had started as a founding staff member of the New Museum in New York City, then struggled as an art journalist. Dallas collectors Howard and Cindy Rachofsky liked his writing enough that, when they needed help assembling an art collection, they called him.[34] Lisa Schiff, like any good saleswoman, followed the money. "I had a good friend who married into a lot of money," she explained. "I went away with all of the wives," who took extravagant trips—and talked their husbands into buying a lot of art.

In the fluid world of art advisors, one client was enough, if that client was wealthy and eager. Philippe Ségalot had worked at Christie's until 2001, then become an advisor to François Pinault of Kering. Sandy Heller took on hedge-fund billionaire Steve Cohen. Jeanne Greenberg Rohatyn, daughter-in-law of financier Felix Rohatyn, had three New York galleries of her own and was primarily a dealer, but found herself advising rapper Jay-Z. Lisa Schiff somehow fell in with actor and collector Leonardo DiCaprio. Often, the same artist's work popped up in one client's home after another. "All of my clients have a Christopher Wool," Schiff acknowledged. "But I am very happy about that overlap."[35]

For this new breed of art advisor, Art Basel Miami Beach was the market's new epicenter, starting in December 2002. "That was the real bonfire of the vanities," Schiff noted. "Suddenly there was this excitement about contemporary art. I was quite young, so I wasn't on top of

what was happening at auctions." But in Miami, Schiff didn't need to be. The game was in hearing who bought what in the opening minutes of Art Basel Miami Beach, and then snapping up those same artists before everyone else did.

Don and Mera Rubell, who had lobbied hard for Art Basel Miami Beach, had come a long way since their $25 art buying trips to the East Village. They had kept collecting—almost always the work of emerging or even completely unknown artists, often at prices that turned out to be bargains later on. They had also moved to Miami, where in 1993 they purchased and repurposed a US Drug Enforcement Agency warehouse as a noncommercial gallery, which soon enough became a non-profit, publicly accessible one. They continued to buy several hundred pieces of art a year, and by 2018 would have a collection of more than 6,800 works by more than 800 artists. Though they prized all their art and held on to most of it, they did occasionally sell or barter.[36] At that first Art Basel Miami Beach, the Rubells established a new tradition with an opening night party for hundreds at their warehouse, showcasing the work of new artists they liked. The work wasn't for sale, but the show promoted the Rubells' new finds and put them into the orbit of top dealers and art advisors.

The Rubells started every day with an hour of singles tennis on the court beside their warehouse; they played hard, and they pushed hard for each new artist they felt was potentially great. When asked what he thought of the soaring contemporary market, Don Rubell would scowl and wave the question away. The Rubells cared about art, they declared, not the art market. But in art, as in tennis, they liked to win.

ART BASEL MIAMI BEACH DID MORE than bring dealers and collectors together for three days of art talk and fun. It pushed prices of hot artists ever higher, as did its precursor, Art Basel. "One day Mark Grotjahn was an artist making a living," Schiff noted. "The next, all his work is being sold at auction." Grotjahn's butterfly paintings were soaring higher than almost anyone else's work. "He went from five thousand dollars to five hundred thousand," Schiff rued. "It was at the

beginning of this new phase of short-term profits in contemporary art. 'Let's dump our butterfly paintings!' became the rallying cry. I did too," Schiff sighed. "It was the dumbest thing I've ever done but I was scared. All that upswing for your clients. You couldn't afford *not* to sell."

Art advisors had to be lucky, and perhaps no advisor was luckier than Meredith Darrow, whose story seemed to thread its way from one art-market hot spot to another like a Hollywood movie. As a 21-year-old just out of Columbia art school, luck, timing, and a winning smile landed Darrow an internship at London's White Cube, by then one of the city's hottest galleries. On a plane between New York and London, she found herself seated next to Gavin Brown, and a friendship was forged. "You could just fall into those connections," Darrow recalled later. "I'm not sure it happens so organically anymore."

Back in New York, Darrow manned an Armory Show booth for downtown dealer Daniel Reich. Major Miami collectors Carlos and Rosa de la Cruz happened by and another key contact was made. From there, Darrow landed a job at a gallery newly opened by Stefania Bortolami, the now ex-Gagosian director. At 25, Darrow also had an artist boyfriend, Aaron Young, whose art involved riding his motorcycle over plywood boards covered with fluorescent paint.

Then came a patch of bad luck. Darrow's relationship with Aaron Young ended, along with her job at Bortolami's gallery. Darrow was depressed—and broke. That was when a friend suggested she become an art advisor. After all, she knew a lot of artists. Her friend, who worked at Pace, insisted she come as his guest to Art Basel. Maybe something would happen.

Something did. At one of the large, festive dinners given every night at the fair, Darrow reconnected with Miami collectors Carlos and Rosa de la Cruz. Before she knew it, Darrow was advising the de la Cruzes on art to buy for their new Miami museum and starting to fly around the world, from art fair to art fair, living the dream.

THE MEGAS WEREN'T THE ONLY DEALERS having banner years in the mid-2000s. Gavin Brown was backing new and promising young

artists, and doing well by them too. He had Conceptual artists like Martin Creed, famous for a piece that consisted of lights being switched off and on. One light switch, one room. That was the work.

One of Brown's closest artist pals was Urs Fischer, who tested their friendship with a Conceptual work in 2007. One day while Brown was elsewhere, Fischer showed up at his gallery with a work crew toting drills. In short order, the workers jackhammered a deep wide hole, removing earth and debris with a backhoe, in the gallery floor. The process of making the 38-by-30-foot crater was the art.[37]

"I never saw it fresh," Brown recalled later with a shrug. "But I wasn't surprised."

The earth work, titled *You*, earned lots of critical attention, most of it positive—the more so when Brown sold it to collector Peter Brant.[38] What exactly was Brant buying? "He bought the energy," Brown said. "He maintained his position in front. Then he went and dug a hole in his own place."

"It was an environmental piece that could be reproduced," Brant explained later, "and I reproduced it for an Urs Fischer show. One of our galleries had the hole dug up." It could be reproduced again—as often, it seemed, as Brant liked.

Brown admitted the whole exercise was a bit crazy. "I think it shows a kind of insanity," he agreed. "He knew that, the artist knew that, we all knew that. I think we're in an insane age. I guess you either get on that train or walk to another destination."

"What's it worth?" Brant echoed when asked about the value of his pit. "I don't know. Probably nothing. But it's an important piece of our history."

FOR THE WARHOL MARKET, 2007 WAS a record breaker. It was in May of that year that Warhol's *Green Car Crash (Green Burning Car I)*, painted in 1963, brought $71.7 million, including premium, at Christie's, an all-time high for any Warhol.[39] Gagosian was an underbidder that night. Neither the seller nor the buyer was identified, but Gagosian's was the name that mattered. He was the one, more than anyone else, who had

made Warhol's posthumous market. "This is arguably his signal accomplishment," suggested Eric Konigsberg in a *New York* magazine profile some years later, "paving the way for everything else he's done."[40]

Green Car Crash, it turned out, was not the end of the bidding mania in 2007, only the beginning. For nearly two decades, Jasper Johns's *False Start*, the painting that S. I. Newhouse had bought for $17 million in 1987, had held the record for the most expensive work by a living artist. In May 2007, he set another record with *Figure 4* for $17.4 million. But almost overnight, that record fell. First came Damien Hirst's *Lullaby Spring*, sold in June 2007 for $19.2 million; then Jeff Koons's enormous *Hanging Heart* for $23.6 million that November; and then Lucian Freud's *Benefits Supervisor Sleeping* for $33.6 million in May 2008. Gagosian was still Hirst's and Koons's dealer; Bill Acquavella was Freud's. For now, at least, Gagosian and Acquavella were likely the world's highest-earning dealers. Hirst's *Lullaby Spring* went to the family of Sheikh Saud bin Mohammed al-Thani, who was reputed to have spent $1.5 billion in half a dozen years to fill Qatar's new and future museums.[41] Koons's *Hanging Heart*, a 3,600-pound, nine-foot-tall, stainless-steel red-and-gold-colored heart went to Ukrainian oligarch Victor Pinchuk, another Gagosian client.[42] As for the Freud, it went, reportedly, to Russian oligarch Roman Abramovich.[43]

The economy was showing serious signs of stress by the end of 2007, but Gagosian seemed unconcerned. He put down $200 million in April 2008 to buy part of Ileana Sonnabend's collection.[44] The grande dame of the downtown art scene had died the previous October, and her heir Antonio Homem sold off the works with what turned out to be extraordinary timing. Gagosian got an all-Warhol group of paintings including *Four Marilyns*, two portraits of Elizabeth Taylor, and three small canvases from the *Death and Disaster* series. Three years later, Gagosian would be spotted in Abu Dhabi, showing some of those same works, apparently still trying to sell them.[45]

For all of his instincts as a dealer, Gagosian had stayed oblivious to the last recession—the one that started in mid-1990—until it descended. He seemed no more attuned to the one about to hit, ignoring

the over-leveraged banks and the teetering real-estate market. But he was not responsible for the art world drama that played itself out on the very day of Lehman Brothers' implosion, September 15, 2008. Damien Hirst took full credit for that.

As Lehman collapsed in New York, an auction of 218 Damien Hirst works unfolded at Sotheby's in London, masterminded not by the auction house but by the artist himself. Either he was chafing at the commissions he paid his dealers, or his off-duty penchant for Old Master paintings had left him in debt that needed expunging. With Hirstean hubris, he had chosen to stage his own auction at Sotheby's, titling it *Beautiful Inside My Head Forever*. "I think the art world is definitely already going in this direction," Hirst declared, "and my auction is just a fast-forward." Gagosian and Hirst's London dealer, Jay Jopling, were furious; the whole art market was aghast. Hirst was unswayed. "Even if the sale bombs," he told the *New York Times*, "I'm opening a new door for artists everywhere."[46]

From outside the auction house, the two-day sale seemed a great success. It brought 21,000 visitors and generated $200.7 million in sales.[47] But many of the works sold were propped up by Gagosian and Jopling, who bid on them hoping to elevate Hirst's market enough that they could quietly sell off the works they had on their hands.[48] In fact, Hirst's market was too far down for that: works he had sold between 2005 and 2008, his highest-selling years, were selling at 30 percent discounts, if they sold at all. In the following weeks, rumor had it that more than a few buyers had reneged.[49]

The meltdown stirred alarm, even panic. But cooler heads saw how much the contemporary art market had grown: by 600 percent between 2003 and 2008, suggested Clare McAndrew of the European Fine Art Fair. McAndrew was the art market's most admired economist, whose annual analyses illuminated the $63 billion market. Lean as times suddenly were, that rise left dealers feeling cautiously hopeful about the years to come.

APOCALYPSE NOT

2009–2014

A Most Astonishing Revival

2009–2010

IN JUNE 2009, LARRY Gagosian had a revealing phone chat with Alberto "Tico" Mugrabi, on the eve of the London auctions. The subject they discussed was fairly mundane for them. What made the conversation memorable was that Mugrabi, talking from the lobby of Claridge's hotel in London, apparently spoke within earshot of an art world insider who wrote down everything Mugrabi said and got the drift of what Gagosian was saying in return. It was, in short, a remarkably intimate glimpse into how two very powerful art world figures did business together—an exchange recounted later in detail by journalist Eric Konigsberg in a profile of Gagosian for *New York* magazine.[1]

Roughly eight months after Lehman Brothers' demise and the start of the Great Recession, Gagosian was back up to speed. New York might still be flattened, but the drop hadn't hurt him the way 1990–1991 did. "This has been a totally different dynamic," he told one reporter at the time. "We're in a much more global art market."[2] Gagosian wasn't even sure New York would stay the art world's epicenter. "There's been a shift, particularly to Europe. Obviously, you have a lot of buying power in the Middle East, and this exciting expansion of museums in Abu Dhabi, and Doha, that's kind of an outlier," he said. "But I think, in general, there's been a move toward Europe."[3] The market was moving, and not down but up, so the atmosphere that night in London was tinged with expectation.

Gagosian and Mugrabi were focused on three Warhol paintings to be auctioned that evening, June 25, at Sotheby's. Unfortunately,

Mugrabi had just learned directly from a Sotheby's executive that two of the three might not reach their reserves, the privately set minimum prices at which their owner, a German collector named Josef Froehlich, had insisted they be sold.[4] The two paintings might be "bought in," meaning unsold, which in turn might hurt the overall Warhol market in which Gagosian and Mugrabi were central players.

Both of the market-weak Warhols had been created long after the artist's early, prized period and were priced accordingly. Even so, they might not sell. A large *Hammer and Sickle* from 1976 might fetch $3.8 million, Sotheby's estimated, while a silver silk screen, *Shoes*, done in 1980, might fall a bit shy of $1 million. The question was: Should Mugrabi and Gagosian bid on the two lesser paintings, at or above their reserves, to keep them from being bought in?

"Do you like the shoe painting or not really?" Mugrabi asked Gagosian, and added, "I'm gonna try to buy it cheap if I can."[5] Cheap was a matter of interpretation. Mugrabi and Gagosian still wanted the paintings to sell well enough to protect the Warhol market.

Apparently Gagosian was interested.

Mugrabi rang off to negotiate with a Sotheby's director in advance of the sale. He suggested that he and Gagosian would have trouble justifying a price of $3 million plus for *Hammer and Sickle*.[6] "If he wants to sell the picture," he said of the seller, "tell him to be realistic."

Mugrabi, still in Claridge's lobby, then called his father, spoke mostly in Spanish, and called the Sotheby's director back. "My dad said that he can pay for the two pictures—for the *Hammer and Sickle* and the shoes—£2 million, all inclusive." Mugrabi, then, was telling Sotheby's—and the seller—what to set as the reserves, and at the same time establishing what he and Gagosian would pay to keep the paintings from being bought in.

Mugrabi and Gagosian would be going in with information no other bidder possessed: what the reserve was. But that wasn't to say the outcome was fixed. Another buyer might come out of nowhere to outbid Gagosian and Mugrabi. That was fine with them; let someone

else prop up the Warhol market. The dealers could save their auction money for another day.

As it turned out, all three of Froehlich's Warhols sold at the mid-range of their estimates. Konigsberg reported that Gagosian bought the shoe painting on his own, selling it at a profit a year or so later. He passed on *Hammer and Sickle*, so Mugrabi bought it, though after all that blustering, he paid $3.2 million for it.[7]

THAT SAME MONTH, DAVID ZWIRNER ENDED his partnership with Iwan Wirth, the arrangement by which, for nearly a decade, they had bought and sold secondary works together when it suited them.[8] There was no discernible rancor about the decision. Iwan and Manuela Wirth simply wanted to start a New York gallery of their own and take on more of their own new artists, both European and American. From Zwirner they had gotten Jason Rhoades and Diana Thater, but Zwirner got all the credit for discovering them; Iwan and Manuela had merely made new markets for the artists in Zurich and London.

In September of that year, Iwan and Manuela opened a gallery on three floors of their town house at 32 East 69th Street. The space had resonance. Back in the 1950s, on its walls, dealer Martha Jackson had hung the work of Ab Exers she loved: Sam Francis, Louise Nevelson, Richard Diebenkorn, Grace Hartigan, and many more. Now Hauser & Wirth could stage New York shows for their own artists and not be limited to exhibiting them in Europe.

The market was still recovering, and for Zwirner, hanging on to the deep-pocketed Wirths might have seemed prudent. But he had had an epiphany. "In 2009, everything fell apart, values came down, and I thought, Shit, this is going to be rough, this is going to last years," he later said. "But the structure of the art world stayed intact. We all flew to the fairs, showed up for the dinners. Collectors weren't buying, but they were there, they were in our net. When I saw the mechanisms in place, and I saw the pull that what we do has on people's lives, [I realized] they don't want to miss out."[9]

The Wirths had barely opened their New York gallery at East 69th Street when Zwirner bought an old parking garage on West 20th and hired architect Annabelle Selldorf—already the architect of choice for several new or expanding galleries—to plan the biggest exhibition space Chelsea had yet seen: a five-story colossus. The old building on the lot was razed, and four years of construction ensued, disrupting and irksome enough that Zwirner would reap widespread jeers when it opened. Iwan and Manuela Wirth followed suit, though instead of building a new gallery at this point, they leased the former Roxy roller rink and dance venue on West 18th Street, itself a massive space. The two new galleries would open within weeks of each other in early 2013, a new stage for two of the four mega dealers.

Boom and counter-boom: the larger the galleries, the higher the overhead, the greater the dare. The art market had never been for the timid; more and more, it seemed a Darwinian arena in which only the strongest would thrive.

FOR SMALLER DEALERS, THE GREAT RECESSION was a difficult time, one that called for new strategies. In the doldrums of 2009, Elizabeth Dee, a midsize dealer in Chelsea, decided to work up a vast communal exhibition space as a way for artists to get by. What she needed was a space—for free. She got one from a collector who owned the shuttered Dia Art Foundation building, dedicated to the arts, on West 22nd Street. "I told him, 'I don't think you'll be able to run this building through the recession. So, let's get a cross section of the art world into it for lectures and programming.' He loved the idea and gave me the keys." In one year—from 2009 to 2010—Dee and a team of curators staged 12 exhibits, had 50 events, and welcomed 75,000 visitors.[10] Dee called it the X Initiative. Building on its success, Dee went on to cofound New York's Independent Art Fair.

Dee's moves cheered dealers and artists in a challenging time. Over in England, Anthony d'Offay did more. Since his unexpected decision to close his London gallery at the end of 2001, d'Offay had embarked on

a collecting phase with his wife, Anne Seymour, and his art partner, Marie-Louise Laband, that lasted until 2009. "We felt we had been part of a wonderful movement to bring London into the spotlight," d'Offay explained later of his gallery years. That was done, he felt. Perhaps, too, for all his successes, d'Offay's era as a dealer had come to an end. An extraordinary list of future dealers had started out with d'Offay over the years, often simply as art handlers. Together, they made up a whole new generation, from Matthew Marks and Gavin Brown to Dominique Lévy and Stefania Bortolami. They were, in their way, as much a legacy for d'Offay as the artists he'd shown. But they were gone and, more often than not, were now his rivals.

Merely collecting to fill his walls held no interest for d'Offay. He wanted more people to see contemporary art. Museums like the one in Leicester where d'Offay had spent so much time in his childhood could no longer afford to buy or even borrow important works of art. Together with Seymour and Laband, d'Offay began to assemble a collection of international contemporary art showing artists' work in depth, which could be used as a resource for the entire United Kingdom.

By the time d'Offay approached Nicholas Serota, director of the Tate museums, he had a collection of 40 rooms, including 100 paintings and drawings by Warhol and 100 drawings by Beuys. Through the so-called d'Offay donation, in 2008, some 725 works of art valued at 125 million pounds went jointly to the Tate and the National Galleries of Scotland. D'Offay took a reported 26.5 million pounds from the British government in return, the dealer's original investment.[11] His vision, which Serota heartily endorsed, was a novel idea he called the Artist Rooms.[12]

The Artist Rooms gallery opened on the fourth floor of the new Tate Modern extension, with ever-changing shows.[13] Soon there would be some 1,600 works in the collection, with more than 150 exhibitions going out to more than 75 galleries and museums and visited by over 50 million people all over England. The *Telegraph*'s chief art critic, Richard Dorment, would write that Artist Rooms "is the most

important thing that has happened in the art world in this country in my lifetime."[14] The Tate's Nicholas Serota would go further, declaring the program "without precedent anywhere in the world."[15]

STILL STRUGGLING TO LEAVE THE DOWNTURN of 2008–2009 behind, dealers began vying more fiercely for a different group of lower-risk modern and contemporary artists: famous dead ones. Warhol led the way again, in death as in life. He died rich in 1987, and he left the first truly valuable artist's estate of his time. Basquiat had died a year later, leaving a modest estate, but one that would, of course, skyrocket in value. The next wealthy departees, in chronological order, were Judd (1994), De Kooning and Lichtenstein (1997), and Rauschenberg (2008).

With hardly an exception, the biggest estates went to the biggest dealers. The megas had more money, but they could also do more with what they acquired. A well-known dead artist who left a modest estate—not much art to sell—could still enhance a dealer's reputation and help lure living artists who wished to bask in the late one's glory. An estate might also have a weighty Rolodex of collectors who had bought the artist's work, helping a gallery track down hard-to-find pieces and perhaps acquire them. As the megas expanded to new gallery spaces, they also needed more brand-name artworks to hang on those walls, either for sale or for historical, nonselling shows. Estates could provide them. For all this, the dealer got bragging rights. More and more, dealers exercised those rights in how they listed the artist on their rosters. Before, they had tended to list their affiliation with a dead artist's estate as just that: "estate of." Now their rosters often listed the late artist simply by name, with no mention of estate. Amid still-active and breathing colleagues, the artist reaped the best prize of all: eternal life.

There was, among the megas, a tendency to tout the estates as proof of serious scholarship. David Zwirner's growing collection of 1960s and 1970s Minimalist and Conceptualist artists might not be any more lucrative for him than Castelli's had been, but it was one that Zwirner saw as an aesthetic undertaking. He retained experts and scholars to organize exhibitions and write intelligent catalogues. So did his fellow

megas. Gagosian had certain aspects of the estates of Picasso, Man Ray, and Henry Moore, with modest reserves of material but lots of star power. Pace had Alexander Calder, Louise Nevelson, and Agnes Martin, all legends. One long-time observer of the market suggested that, of the four megas, Hauser & Wirth actually deserved the lion's share of credit for amping up the estate business. "They've changed it from dusty to sexy." With money as no object, Iwan and Manuela Wirth were on a course to sweep in the estates of Louise Bourgeois, Arshile Gorky, Philip Guston, and David Smith.

James Tarmy of *Bloomberg* called the estate business "the future of the art world's money—monumentally lucrative." A key, Tarmy noted, was control over pricing, which the dealers wielded once they were hired by the artist's estate or foundation. But that was just the half of it. Sales sent up a "bat signal," as Tarmy put it, to any collector who might wish to sell a work by that now-dead artist: best to go through the estate and its sanctioned dealer. The dealer was the one who could persuade the estate to buy that work and set a price that pleased all parties. "There's just one problem with this entire set up," Tarmy noted. "It means that galleries are taking over the role of what academics did for the past 100 years. Which is to decide how and what and where major artists will be exhibited, including which museums."

WITH THE DEATH OF ROBERT RAUSCHENBERG in 2008, Arne Glimcher and Larry Gagosian found themselves pitted against each other in an estate drama with at least $600 million of art at stake. Glimcher had known Rauschenberg since 1963 but had not represented him until 1998. In the interim, Rauschenberg had had several dealers, but never been committed to any particular one. His work had stayed strong for the most part, but personally he had struggled. "Bob had gone through a bad time with drink," Glimcher acknowledged. "He came out of it and we formed our alliance." Glimcher helped Rauschenberg land a major retrospective at the Guggenheim Museum in 1997–1998 that then traveled to Houston, Cologne, and Bilbao. It sparked glowing reappraisals of his work. Glimcher, as his dealer, made the public announcement of

Rauschenberg's cause of death: congestive heart failure. In fact, according to one insider, Rauschenberg had ended his life peacefully with an overdose of morphine.

Rauschenberg, it turned out, had formed an irrevocable trust in 1994 with three trustees, including his assistant and companion of 25 years, Darryl Pottorf.[16] The trustees had been Rauschenberg's constant pals in New York and on Captiva, the Florida island where the artist had lived for decades. One of the trustees' early moves was to cut ties with Glimcher and the Pace Gallery. Glimcher was heartbroken, as he put it later, but the trustees had a point. Some 90 percent of the estate was Rauschenberg's art. To prevent the kind of market run that all too often followed an artist's death, the trustees chose to remove from the market all the Rauschenberg art the estate owned, get it appraised, and then perhaps sell it over time. In the near future, there seemed no point in retaining a dealer, even one as sympathetic as Glimcher.

Roughly two years after Rauschenberg's death, the trustees submitted their bills for services rendered to the newly formed Rauschenberg Foundation. First, they wanted $8 million for various estate duties. Then there was the matter of the art itself. Christie's had appraised the estate at about $600 million.[17] Usually in estate cases, a cap was put on trustees' fees—how much of the value of the estate they could take for themselves in exchange for lending their expertise to the estate process—but not in this one. Rauschenberg, in his trust, had made no mention of what the fees should be. So the trustees asked for a standard 5 percent—in this case, a whopping figure of $30 million, minus the $8 million they had already requested. The proceeds were to be split three ways.[18]

The trustees, however, felt the estate was worth much more than $600 million. That was when they brought in Gagosian. His job was to sell a few key works at prices higher than current market estimates and boost the estate's overall value—admittedly at its nadir in 2008, when Christie's had done its appraisal. Gagosian managed to place one of Rauschenberg's earliest and most highly regarded combines, *Short Circuit* (1955), at the Art Institute of Chicago for about $15 million.[19]

This was considered a significant achievement for a very important work of art. With that, the trustees declared the whole estate should be reappraised. They felt it was worth $1.2 billion, and that they, in turn, should get $60 million.

Not long after the sale of *Short Circuit*, the Rauschenberg Foundation hired a New York–based director, Christy MacLear, formerly of Philip Johnson's Glass House in New Canaan, Connecticut. She joined the foundation as its inaugural director in 2010.

The Rauschenberg Foundation was very different from the estate. Ultimately, when the estate was settled, its proceeds would pass over to the foundation, where they would be used primarily for education and philanthropy, as the artist had directed. MacLear was astounded to see that three of her new board members were the trustees. She started by pointing out the obvious conflicts of interest and slid the trustees off the foundation board.

As for the trustees' demand of $60 million, MacLear thought it outrageous. "Our response was, not only did you not do the work commensurate with such a fee, but you are the friend, business partner, and lover of Rauschenberg," MacLear recalled later. "You know the intention is to give the money to philanthropy. How could you act so selfishly in the role of confidant and self-stated expert?"

MacLear and her other foundation colleagues felt that, instead of $60 million, the three trustees should take $375,000—and split *that* three ways.

As the estate case went to court, Gagosian stuck around. He had no horse in this race; he just wanted to sell art. That put him on a collision course with MacLear, who had the authority to let him sell a work—or not. "Sometimes the foundation did give permission, sometimes not," MacLear said. With Gagosian, it was never enough. "He would always say, 'I'm not a church,'" MacLear recalled, doing a pretty fair imitation of him. "I'm not a church!" He meant that his job was to sell art, not build a shrine to the artist. "I don't want to vilify him," MacLear declared later of Gagosian. "He did an excellent job of recognizing a market."

As the drama unfolded, Glimcher made no effort to hide his anger at the trustees for firing him. "It was incredibly hurtful," he said later, "and they did it." He seethed at Gagosian too. Gagosian had promised the trustees and foundation that he could sell each and every significant Rauschenberg work for $5 million, Glimcher said. In fact, Gagosian hardly sold anything. "He ruined the market for three or four years. He just wanted the estate from Pace. He didn't care about Rauschenberg. But he didn't know how to deal with it; it wasn't his sensibility."

Not until August 2014 would a verdict be reached. Circuit judge Jay Rosman would deny the trustees their $60 million but grant them about half that much: $24.6 million, minus the $8 million in fees they'd already received, for a total of about $16 million, again to be split three ways. An appraiser testifying on behalf of the trustees would argue that the estate's value had grown to $2.2 billion, in large part because the market had risen so much since Rauschenberg's death in 2008. To everyone's surprise, the judge would have a few respectful words for the trustees. "The court finds that the trustees made very good decisions and rendered very good service."

That verdict lay in the future. As foundation director in 2010, MacLear was left to ponder, among other issues, whether to keep Gagosian as the foundation's dealer or replace him with someone else—Arne Glimcher, perhaps.

GLIMCHER WOULD HAVE TO WAIT THREE years for MacLear to make up her mind. Meantime, he could claim a certain revenge in winning the De Kooning estate from Gagosian. "Lisa [Johanna Liesbeth de Kooning] didn't like Larry,"[20] Glimcher recalled of the artist's troubled grown daughter, "and she just impetuously made a decision. We were having dinner one night, maybe it was [in] East Hampton. She said she wasn't happy with Larry." It was a profitable dinner: the De Kooning estate, including many late paintings, would be appraised at $425,596,181.

For Glimcher and Gagosian, the work and estate of artist John Chamberlain, best known for sculptures made from scrapyard auto

parts, became another battleground in 2011 while the Rauschenberg estate was sorting itself out. Glimcher had first met Chamberlain in 1961. A year later, he had given Chamberlain an exhibition in the Boston gallery—that was how far back the two went. Chamberlain had gone on to a brilliant career, managed by Castelli for a quarter century, then by Pace, with his sculptures selling for as much as $5.5 million. But by late 2010, as Glimcher saw it, the artist's best work was behind him. The *Wall Street Journal* reported in 2011 that Chamberlain had made recent works with a Belgian fabricator.[21] Glimcher had his doubts about the fabrication. "It was just a sad thing," said Glimcher. "The work didn't have the power."

That was when Gagosian swooped in. In early 2011, he drove to Chamberlain's studio on Shelter Island, New York, to view the recent work. Chamberlain waved him to the studio and stayed in his living room while Gagosian looked around. The dealer returned within minutes, grinning, the *Journal* recounted, and told the artist, "I want it all." Some weeks later, the artist officially switched galleries and had a show at Gagosian to celebrate in May 2011. Chamberlain was asked at that time how he felt about the change. "Sometimes artists need to shift gears, and Larry is always ready to go," Chamberlain said. "What should I do, sit in a corner?"[22]

Whether Gagosian truly admired the late works or not was almost beside the point. The dealer, the artist, and the artist's wife all knew Chamberlain had a brief time to live. However much late work Gagosian might struggle to sell, he would be in line to represent the estate, which likely contained a lot of Chamberlain's best works. In fact, the artist died in December 2011, and Gagosian did get the estate.

Glimcher took a dim view of it all. "The [Chamberlain] market has come down by thirty to forty percent since Larry put them out in his show," Glimcher complained some years later, "with auction sales in the hundreds of thousands of dollars, down from two to three million." A collector familiar with Chamberlain's market disputed that. Chamberlain's early work continued to do well—underscoring Gagosian's shrewdness in taking him on—and prices for the late work might well tick up over time. So it had gone with De Kooning's late-life abstract

paintings. Dismissed initially as work done on the verge of dementia, the paintings now sold for millions of dollars.

At about this time, David Zwirner sought and won an estate at least as important as Chamberlain's: that of Dan Flavin, the fluorescent-light artist who had died in 1996 at age 63. With it came a troubling conundrum.

Flavin hadn't set out to be a Minimalist. He didn't even call his artworks sculptures. They were "monuments," meant to last no longer than the 2,100 hours of their bulbs' promised life. He had made them with simple, store-bought materials: light fixtures, electric cords, two-by-fours, and the like, many bought on Canal Street. His art was a rejection of Abstract Expressionism with its action painting and color field brushstrokes. These simple constructions could be art too. What mattered was the light: the colors and intensity of those fluorescent bulbs.

The question of whether and how to replace those bulbs when they burned out had come up long before Flavin's death. "I had many talks with Dan, both drunk and sober, about exactly these issues," recalled Morgan Spangle of his years at Castelli when Flavin was an artist there. "He understood the technology would change. He wavered somewhat about what should happen. He did feel his work should be perfect—you shouldn't show fixtures that were rusty." Flavin's feelings about the bulbs seemed to change over time, however. After Sylvania stopped making a kind of green bulb that he favored, his studio assistants stockpiled some 600 of them while he was alive.

Initially, Flavin's estate elected not to make new work for sale. That was likely what the artist would have wanted: "I believe in temporary art wholeheartedly," he said at one point.[23] The estate did have the legal right to make more works if it chose, however, and in a sense the late artist had pointed the way. Typically, Flavin created editions of three or five identical pieces. But numerous editions, it turned out, lacked one or more of their pieces. All this was easy to determine, since Flavin had kept records, on three-by-five index cards, of each edition and how many units had been fabricated. When a work was sold, Flavin issued

along with it a certificate showing a diagram of the work, its title and number in the edition, and the artist's signature and stamp. The certificate was the work's proof of authenticity.

At some point after his father's death, Stephen Flavin began working with Zwirner. New works began to be fabricated under the estate's auspices, completing editions unfinished by the artist and being quietly sold. On older works owned by collectors, burned-out bulbs were replaced. That came as a surprise to Paula Cooper. Since 2003, the doyenne of downtown dealers had served as an informal advisor to the Flavin estate. She was actually on a panel of experts, helping buyers and sellers assess Flavin works with the estate's approval. She became aware that new work was being fabricated and sold. "David [Zwirner] talked Stephen into it, because Stephen needed money, I guess," Cooper told the *New Yorker*'s Nick Paumgarten. "It would have behooved David to at least make it public."

These new works of course lacked the artist's certificates of authenticity. The roughly two dozen sold in the period from 2008 to 2013, all through the Zwirner gallery, did have certificates issued by the estate. Some collectors might not care that they bought a Flavin finished after his death, Cooper allowed. As for the new bulbs that went with them, available through Zwirner, perhaps new buyers would like to be able to turn on their Flavins without worrying so much about burning out the bulbs, as older collectors did. But to the cognoscenti, nuances mattered. "A lot of us who worked with Flavin still have the *old* bulbs," Cooper told Paumgarten with a sly smile.[24]

Zwirner felt the whole debate was ridiculous. Why not produce more Flavins? Wasn't it good to get that much more of the artist's work out to the world, as long as new works were sold as such? As far as Zwirner could see, this was just sour grapes from Cooper.

CUTTING A FEW CORNERS, CHANGING A few bulbs—for a dealer in the scrum of contemporary art, that was, perhaps, business as usual. But in the spring of 2010, Zwirner found himself mired in a messy lawsuit with a lot at stake.

The case was brought by a Miami-based real-estate developer and collector named Craig Robins, who accused Zwirner of breach of contract and fraud in regard to a painting Robins had sold through him. The painting was by South African artist Marlene Dumas, much admired for her portraits, which were done primarily in oil on canvas, using newspapers, magazine cuttings, and photographs as source material. Robins was a great fan of Dumas: he had bought 29 of her paintings, all but one of which, he said, remained in his possession.[25] In 2004, however, he had felt the need to sell one work, *Reinhardt's Daughter* (1994), when he was going through a divorce.

Both men knew the risk involved. Dumas seethed with anger whenever she heard that one of her paintings had been sold for a quick profit. Robins had owned *Reinhardt's Daughter* for ten years, but he knew that if news of its sale became known, he still would be put on her private blacklist. Anyone put on that list was regarded as a flipper who would never again be given a chance to buy more of her paintings. Robins felt that after 29 paintings he could take a small liberty in selling just one, assuming Zwirner kept the sale confidential.

Zwirner sold Craig Robins's painting, quietly and privately, to Hauser & Wirth for $925,000.[26] Hauser & Wirth, in turn, hoped to resell it to a Swiss collector. At some point, though, Zwirner informed Dumas's studio, which maintained the artist's archive, of the sale of the work. Later, Robins claimed that Zwirner did this to curry favor with Dumas in the hope of becoming her dealer before her 2008 retrospective at the Museum of Modern Art in New York. Incensed, Dumas put Robins on her blacklist. Zwirner did in fact become Dumas's dealer and allegedly pulled Robins aside to say he would make up for the misunderstanding by selling him some other Dumas paintings.[27]

Art world lawyer Aaron Richard Golub brought suit on Robins's behalf against Zwirner for $8 million. Zwirner, said Golub, had "snitched on a confidentiality agreement." Robins argued that Zwirner "always intended to inform Dumas of the sale, using that as a way to ingratiate himself with the artist."[28]

In his statement to the court, Zwirner disputed Robins's account. "I never promised or stated to Mr. Robins that I would sell him a painting by Marlene Dumas," Zwirner said, meaning a painting sold after he became Dumas's manager, as a way of compensating Robins for his place on the blacklist. "Additionally, I never promised or stated to Mr. Robins that I would give him first pick or a right of first refusal after museums for any works by Dumas from any show of her art."[29] As to the painting Robins had sold to Zwirner in the first place, the dealer said he had only agreed to keep the sale confidential until it was completed. After all, he noted, the new owner would have the right to loan or sell the painting if he or she wished, and its provenance would have to be noted. Zwirner couldn't just keep the sale a secret from Dumas forever.

Two months after the suit was brought before a US district judge of the Southern District of New York, it was dismissed. Robins had provided no written evidence that Zwirner agreed to keep their deal a secret. The judge, a neophyte in the art world, found the case a most unflattering portrait of Zwirner and Robins's milieu, and he advised "collectors in this seemingly refined bazaar [to] heed the admonition caveat emptor."[30]

Zwirner was embarrassed by the lawsuit and would stay out of legal entanglements for some years. Gagosian would have no such luck. He was about to be hit with a pair of intertwined lawsuits. Each would cast light on how the very private dealer did business, showing him to be hard-eyed—and endowed with a very dark sense of humor.

Lawsuits and London

2010–2011

THE LAWSUITS WERE INTERRELATED, each saying a lot about how Larry Gagosian sold art in tough times. The first story began in the fall of 2008, when the Dow Jones Industrial Average fell 34 percent from mid-September through December. A portly, somewhat scattered collector/dealer named Charles Cowles, pressed to raise cash for his own gallery, consigned a Roy Lichtenstein painting, *Girl in Mirror* (1964), to Gagosian.[1] The work was a portrait in porcelain enamel on steel—one from an edition of eight—of a girl looking into a hand mirror. Cowles said he owned the work himself and wanted $3 million for it.[2] Gagosian thought he could get that. If he did, Gagosian would take a $500,000 commission from Cowles—generous but not extreme.

What Cowles failed to mention was that the work was actually owned by his mother.[3] Jan Cowles, a 93-year-old New York socialite from a well-known publishing family, was apparently not in her Fifth Avenue apartment when Charles invited Gagosian to stop by and examine it. Asked about its provenance, Cowles said his family had bought the painting from the Castelli Gallery in 1983, and that it was his to sell. Gagosian had no idea Cowles was misrepresenting who owned it. In the whole nightmare that followed, he felt an unwitting victim.

At the time of the visit, the painting's condition was not deemed a problem.[4] In fact, a Gagosian staff member made a condition report and valuation that did not note any significant issues, describing the work as being in "excellent condition overall" and valuing it at $4.5 million.[5] After shopping the work around, Gagosian's salesperson reported

to Cowles that "multiple buyers had declined to purchase the work because it was badly damaged." Gagosian might have to drop the price significantly.

Neither Gagosian nor his salesperson, Deborah McLeod, told Cowles that in fact the gallery had found a possible buyer in Thompson Dean, a managing partner and co-CEO of Avista Capital Partners, a private equity firm. Dean was a collector who had bought from Gagosian before, but he wanted a bargain. For months, into the summer of 2009, he resisted making an offer.[6] Finally, in July 2009, McLeod wrote Dean again. This time she asked him bluntly to say how much he would pay for *Girl in Mirror*. "Seller now in terrible straits and needs cash," she wrote, meaning Cowles. "Are you interested in making a cruel and offensive offer? Come on, want to try?"[7]

Apparently, Dean came back with $2 million as his price. "Approximately half price, so I like it," McLeod wryly responded.[8] A similar Lichtenstein had sold for about $4.1 million, including premiums, in 2007.[9]

Later, in his deposition for the case, Gagosian was asked what he thought of Deborah McLeod's language. He granted it was kind of unusual. But, he added, it "was based on, I think, the nature of their repartee and that he is a distressed-asset guy, and maybe she was trying to appeal to his animal instincts.... I find it amusing, to be honest with you...because it was so hyperbolic, kind of excessive to the point of being amusing."[10]

With Dean in at $2 million for the Lichtenstein, Gagosian could proceed. No one at Gagosian mentioned Dean to Cowles; no one said that Dean was willing to pay just $2 million for the picture. Gagosian or one of his salespeople just asked Cowles how he would feel about getting $1 million for it, rather than the $2.5 million he had envisioned.[11] If Gagosian could get Cowles to agree, the picture would be sold, with Cowles and Gagosian each getting $1 million.

The deal wasn't done yet, however. Cowles apparently balked at getting merely $1 million. So Gagosian came back with a sweetener. Cowles had consigned to him a second painting that he claimed to

own: *The Innocent Eye Test* (1981), by the historical painter Mark Tansey. Again, Cowles asserted—wrongly—that the painting was his to sell. Gagosian proposed finding a buyer for it, and thus securing Cowles a much bigger lump sum for the two works. Each would earn Cowles a relatively modest amount, but Gagosian's genius was to see into Cowles's heart. What Cowles wanted was more money, even if two pictures, not one, were needed to generate it.

The beauty of this deal was that Gagosian already had a buyer for the Tansey. British collector Robert Wylde had bought a comparable Tansey from Gagosian, before the global financial crisis, at roughly $5 million.[12] So when Gagosian offered him this Tansey for $2.5 million, it looked like a bargain in bad times. Wylde bought it in July 2009 and took possession of the painting.[13] A month later, Thompson Dean bought Lichtenstein's *Girl in Mirror* for $2 million.

Gagosian sent Cowles $2 million for the Tansey after pocketing $500,000—a handsome 20 percent commission in itself.[14] For the Lichtenstein, he eventually sent Cowles his $1 million. Cowles was happy: he had his $3 million in hand for the two pictures. As for Gagosian, he had $1.5 million from selling the pair: $1 million for the Lichtenstein, $500,000 for the Tansey. "Overall, the most monstrous commission anyone's ever heard of in the art world," as one advisor put it.[15]

There both stories might have ended but for Jan Cowles, or perhaps her accountant, who realized around the end of 2009 that her son had sold two of the family's paintings through Gagosian without her knowledge. Two federal lawsuits followed. One was brought by Robert Wylde, the collector who had bought Tansey's *The Innocent Eye Test*. Wylde charged the gallery with knowing it had sold him a painting without legal title.[16] His lawyer was the ubiquitous Aaron Richard Golub. The Gagosian gallery fiercely denied having any knowledge of the painting's true ownership. The dealer himself felt totally blindsided. What due diligence, he asked friends, could he have done to determine the painting wasn't Cowles's to sell?

In October 2011, the Gagosian gallery agreed to pay $4.4 million to Robert Wylde for selling him Tansey's *The Innocent Eye Test* without proper title and to return the painting to Jan Cowles, who in turn donated it, as long planned, to the Met.[17] The Lichtenstein painting, *Girl in Mirror*, took longer to hash out, since Jan Cowles demanded $14.5 million from the Gagosian gallery. That was the other suit.

Jan Cowles accused Gagosian of selling the painting without her knowledge and consent. She also charged that he undersold the painting by claiming, falsely, that it was seriously damaged and so had to be sold for far less than its market value. Lastly, she declared that Gagosian should have known that the painting was hers, not her son's.[18]

In a deposition, Gagosian was asked if he had not in fact worked both ends of the deal. Did Gagosian not feel "any duty of loyalty whatsoever to the seller?"[19]

"I just don't think about it in those terms," he answered. "I think about, 'It's a financial transaction, and the seller wants to get paid.' My objective is to pay the seller and to make a profit for the gallery."[20]

Jan Cowles's lawyer, David Baum, claimed that such representation of both parties without disclosure is "blatantly unlawful under New York agency law."[21] Gagosian's lawyers begged to differ. They said the gallery's practices were fully consistent with both the law and the standards in the art world. They were right.[22]

Jan Cowles's lawyer went at Gagosian one more time on his ethics. "Do you believe," the lawyer asked, "that under a consignment agreement with a seller you have a duty to be loyal to the seller?"

"I don't know what loyal means," Gagosian replied.

"That's a shame," the interrogating lawyer said. "A big shame."

A settlement in the case would be announced in March 2013.[23] All but one of its terms would remain confidential: that Tom Dean, who had paid $2 million for *Girl in Mirror*, would be keeping the work.

NONE OF THIS SLOWED GAGOSIAN DOWN. The world's most formidable dealer was growing more powerful each year. Each new Gagosian

gallery proved that. The Gagosian retail model of ever more galleries was no longer questioned: other dealers merely weighed which markets to storm first. London was the obvious and essential next venue for most, irrespective of revenue and profitability, which could be modest compared to New York. Expanding the brand—that was what the new London scene was all about. Londoners and travelers passing through might not buy their next artworks there, but they liked making London gallery tours and seeing their favorite galleries represented.

The critical years for other galleries to open in London were 2012 and 2013.[24] Not insignificantly, the city was five and a half hours closer than New York to Qatar, where the world's biggest spender on contemporary art at that time was upending the market. Sheikha Al-Mayassa bint Hamad bin Khalifa al-Thani was chair of Qatar's nascent network of idiosyncratic museums and seemed willing to pay any price for top-tier works.

Gagosian, with his galleries in Mayfair and King's Cross, was being hotly pursued in London by Hauser & Wirth, which had opened its first space on Piccadilly Circus in 2003, followed by a humongous space on Savile Row in 2010. Zwirner, arguably the most cautious of the four megas, had finally made his London move in 2012, taking over an 18th-century Georgian town house at 24 Grafton Street in the heart of Mayfair. That same year, Pace opened its own London gallery at 6 Burlington Gardens in Mayfair. As a shot across Gagosian's bow, Arne Glimcher and his son Marc hired well-connected advisor Mollie Dent-Brocklehurst, who had left Gagosian in 2004 to manage her family's Sudeley Castle and then helped Russian oligarch Roman Abramovich and his wife Dasha Zhukova run the Garage Museum of Contemporary Art in Moscow.

"Larry was quite angry that I joined Pace and didn't consult him," Dent-Brocklehurst admitted later with a sigh. "I probably should have, but didn't. I didn't want to work for him again. He found out about it."

Dent-Brocklehurst found herself in the unique position of working closely and over a long period of time with two intensely different mega dealers. The contrasts were striking. "Larry was intense and impetuous

and immediate," she said. "Arne is planned and thoughtful, the way he engaged with an artist.... Everything needs a place and a meaning and connection." Yet in a sense Gagosian was the easier gallery to work with, because one person ruled. Pace was Arne Glimcher but also, increasingly, his son Marc. "Without a very bullish head, like Larry's," Dent-Brocklehurst said, "it's less easy direction."

Marian Goodman, the unofficial fifth mega, was a few years behind: she wouldn't open a London gallery until 2014, choosing an 11,000-square-foot space in a former factory warehouse just off Golden Square. But square footage wasn't the only measure of mega success in Europe. Goodman had represented Gerhard Richter for a quarter of a century, and Richter was, by some measures, the best-selling living artist in the world.

From that first awkward meeting with the artist in 1985, Goodman had had the profound pleasure of seeing Richter sail through his sixties and seventies with ever-new bodies of work. In 2000, he made 118 works from photos of Florence: the *Firenze* cycle.[25] Over the next years, a dozen would reappear at auction, with a top selling price of $97,276 in 2017. Richter had delved into science, conjuring up images from natural phenomena. He had done a book of photographic details and texts on the Iraq War. Most dramatically, he had continued making huge abstract paintings, employing large squeegees dripping with paint that mimicked the warp and woof of brilliantly rich fabrics.

The problem, if that's what it was, was that everyone wanted one—or more—of Richter's abstracts. They were uncannily gorgeous and immediately identifiable. Whether Richter worked to meet the demand, or just worked fast, his abstracts, especially the squeegee-assisted ones, proliferated. Inevitably, as they did, some from a decade or more ago surfaced at auction. Over the years, they sold at such exponentially greater prices than what Goodman had originally sold them for that Richter became one of the most frequently resold living artists at auction.

The way the auction houses had affected the art market maddened the artist. "It's just as absurd as the banking crisis," Richter hissed. "It's

impossible to understand and it's daft."[26] He wasn't angry because auction houses were making a mint on his art while he made, from those secondary sales, not a dime. He was angry because ultimately what might define him was not his art but the prices it brought.

From the book-filled office on West 57th Street that she had occupied since 1981, Goodman did all she could to keep Richter's market from growing any dafter than it already was. She sought out museums to buy his work, usually with the help of a board member who would buy the painting and donate it to the museum. She also kept Richter's primary prices low. As Richter's work at auction began to approach $20 million, Goodman kept the new ones, ten feet tall, at about $2.5 million. That was strictly at the artist's insistence. "At first I thought, 'My god, this man doesn't want to raise his prices,'" Goodman said later. "But it was what he wanted. He wanted real prices, and I wasn't about to argue with him." Goodman did try to assure Richter that the fortunate buyers of this primary work would not flip it in a year or two—or ten. "If they sell, they're off the list," Goodman said, revealing a touch of steel beneath her grandmotherly mien.

Richter was Goodman's best-known artist, but not her only artist of exclusively primary work. The other megas now relied, for the bulk of their business, on secondary sales of brand-name artists. Goodman had never done that, other than reselling the work by artists she represented. It was all primary with her. Nor had she started with any family money. In her low-key, self-effacing way, she had stuck to the challenge of new artists—artists little-known or unknown when she took them on—strictly on her own instinct and budget.

One of Goodman's newer artists was Julie Mehretu, whose wall-sized paintings of what looked like bird's-eye views of human migrations addressed issues of diaspora and displacement. Her best-known work was a mural that covered the lobby walls of Goldman Sachs' headquarters in lower Manhattan. She had drawn criticism for working with the controversial investment bank, but Goodman had encouraged her to do it, and Mehretu hadn't regretted it. "It's not so often that a painting has a chance to be public art," Mehretu told the *New Yorker*.

"I could never make a painting on this scale anywhere else."[27] In fact, by the fall of 2017, she would be doing exactly that: two even larger paintings (27 feet high by 32 feet wide) for the San Francisco Museum of Modern Art. The museum tried to pay upon completion of them; Goodman insisted on full pay up front. Eventually the trustees would cave.[28]

Another of Goodman's artists was German photographer Thomas Struth, best known for his overscale images. These were bold risks but they paled beside Goodman's Conceptual and time-based media artists (the latter no longer known as "video and film" artists). Like Castelli, whom she revered, Goodman had taken on artists she felt might never sell but made art she felt was important. "There were six or seven filmmakers whom I invited to show in the gallery, which was crazy because no one was buying film," Goodman said with a laugh. "But I went with my feelings. It's not as easy as selling a painting, but there's an audience."

GOODMAN WAS CLEARLY ONE OF THE dealers whose program a young, unconventional artist most hoped to join. The odds of that happening were crushingly small. Of the tens of thousands of artists who now came to the city each year, a mere dozen or two would end up making a living from their art. Most would be lucky to earn $10,000 after taxes for art they made in the few waking hours they had between day jobs. Yet ever more hopefuls were coming, because a new fantasy had taken hold among aspiring artists. Instead of years spent starving in a garret hoping gritty life experience might someday pay off, an artist might go the academic route, earn his MFA, and in no time become as worthy of recognition as his grizzled forbears.

In fact, quite a number of young artists had graduated in the 2000s from the top art schools with an MFA and gone on to some success. At the peak of that mountain were Mark Grotjahn (University of Colorado, Boulder), Matthew Barney (Yale), Alex Israel (Yale), Joe Bradley (Rhode Island School of Design), Doug Aitken (ArtCenter), and Kara Walker (Atlantic College of Art). Of the various schools, Yale seemed to

offer a young graduate the largest constellation of contacts: in a survey of 500 top artists, *Artnet News* determined that over a 50-year period nearly 10 percent of them had graduated from Yale. In the overheated market for contemporary art, youthful ambition was stoked, and each June graduates sallied forth, dreaming of a group show by age 25, a solo show by 30, and global fame by 35.[29]

One problem was that art school graduates tended to make art that looked a lot like the art that other art school graduates were making. Pleasing but formulaic, there was more process than passion in it. The bigger problem, as art advisor Allan Schwartzman put it, was that even the best young artists—with or without an MFA—faced a grim reality.

"Look at Wade Guyton, who I think is significant," suggested Schwartzman of the artist whose digital paintings were produced on inkjet printers. "There are probably 50 others who have developed in a similar market, making abstract paintings, or representative paintings, working from a process that is driven by mechanical production and contemporary production," Schwartzman noted. After Guyton, what could the market do with those 49 others? "As the population of artists increases," Schwartzman said, "and as the number of people seeking to have art increases, the number of great artists does not increase. Why? There is just so much brilliance and invention in any age."

Even the very few artists lucky enough to land a dealer and sell their work for, say, $25,000 a piece—a princely sum for most primary work—were unlikely to go further. "In the past," Schwartzman suggested, "the artist who jumped up from one price level to another more often than not ended up being a significant artist of that time." In other words, artists who slowly rose in critical esteem and saw their prices rise accordingly, through three or four shows over a decade or more, stood a good chance of becoming artists of their time, their prices still rising. Now the market gave the few lucky artists their brief time to shine, then cast them aside and took up the next class.

But not always. To any artist contemplating the challenge of staying relevant year in, year out, Alex Katz was an inspiration: a figurative

painter who had stayed true to his flat, geometric style, decade after decade, as markets and tastes changed; a steadily successful artist who had turned out quiet, contemplative pictures without ever becoming a star; a portraitist who painted his friends. Irving Sandler, the art critic from the downtown Abstract Expressionist days, had a Katz painting over the fireplace mantle of his New York apartment. It was a double portrait of Sandler and his wife, Lucy, on the occasion of their wedding some 60 years ago. Lucy Freeman Sandler was the one who had called out at a cocktail party in 1957, "Hey, have you heard the news? Leo Castelli is opening a gallery." All an artist like Katz needed to keep going was a dealer who kept him in circulation.

In recent years, Katz had come to feel that his dealer, the Pace Gallery, was less focused on that task than it might have been. "When I make three telephone calls, I expect them to be returned, you know?"[30] Katz, a proud, tall man in his mideighties, with his bald pate and still-evident physical prowess, was a bit cantankerous about that. Gavin Brown found it astounding that Katz was being treated as any less than a top-tier artist. "Coming from Europe, to me he was the find in American visual reaction," Brown later said. When he heard that Katz had left Pace, Brown gave him a call. Gagosian, as it turned out, called the same week. Both galleries wanted to explore working together with Katz.[31]

Katz was hardly unaware of Gavin Brown. He went to the younger man's openings. He breathed in the air of Brown's downtown crowd. "I want to compete with these kids," he told himself. At the opening of Brown's latest gallery, the two men had gotten to talking, and Brown had said what he loved about Katz's work. "He talked about the immediacy of light," Katz explained later. "Subject matter is what people usually talk about. I realized he knows what I'm doing. Not many people know what I'm doing."[32]

Katz liked what he heard, but he owed it to himself to meet with Gagosian too. He wasn't that optimistic. "He has great style, great taste, but he's generally in an airplane."[33] The mega dealer came accompanied by the director of his uptown gallery and got right to the point. His

was a vastly larger operation than Gavin Brown's, Gagosian noted: 11 galleries and counting. He could put Katz in shows around the world. Implied was the prospect of much more money. Katz listened, but in the end the choice seemed clear. "You have more taste," Katz told Gagosian, but then added about Brown, "he has more style."[34]

Gagosian smiled, Katz later recalled. "He said 'You're right. He does have a hot crowd. He knows what's going on.'"[35]

Gavin Brown did more that year than reboot an iconic American artist. Always in search of the next venue, he moved in 2011 to Harlem with his partner, artist Hope Atherton, whom he would soon marry, and began planning a vast gallery in his new neighborhood.

OF THE FOUR MEGA DEALERS, IWAN Wirth, the least seasoned, was the one most coming into his own—with his wife, Manuela, very much his offstage partner.

Like Marian Goodman, Wirth had become a dealer for artists outside the mainstream—way outside—whom he was managing, over time, to both financial and popular success. One of his most gratifying stories was Paul McCarthy. In the dozen or so years that Hauser & Wirth had worked with him, McCarthy had gone on to appropriate icons of mass culture, including Santa Claus, Barbie, and Heidi, recast as violent and depraved. With a little hair adjusting and makeup, McCarthy bore an eerie resemblance to Walt Disney.[36] For his first New York solo show at Hauser & Wirth, in 2009, he produced mixed-media works inspired by *Snow White and the Seven Dwarfs*. The dwarfs were life-size and misshapen, like partly burned-down candles. One was a dwarf holding a sex toy known as a butt plug. According to the gallery, some sold for more than $1 million each.

Overall, McCarthy's market remained fitful: by 2018, he would sell just one work at auction above $4.5 million, and that was in 2011. Including the sex-toy-brandishing dwarf, he would sell only seven works at auction above $1 million. Still, McCarthy was a major addition to Hauser & Wirth, an artist whose acclaim, along with the gallery's investment, pushed him into a league with such contemporary

artists as Jeff Koons, Cindy Sherman, and Richard Prince. And Hauser & Wirth had helped make that happen.

MOST GALLERIES, LARGE AND SMALL, WERE doing well in 2011, the financial crisis behind them. But no one was doing better than Larry Gagosian. No one was even close. Other dealers marveled at the 60 shows he put on each year at the 11 galleries he now maintained around the world. An analyst for *Forbes* concluded that the king of the art market grossed $1 billion or more each year. How did he do it? "Overhead," he liked to say, "is the mother of invention." In 2011, Gagosian went big on real estate in his personal life as well, buying the former Harkness mansion in New York, a vast town house at 4 East 75th Street that had last sold in 2006 for a record-breaking $53 million. Gagosian got it for a tidy, recession-trimmed $36.5 million. For the moment, he kept his carriage house at 147 East 69th Street; when it was no longer useful as a base for renovating the Harkness mansion, he would sell it for $18 million.

Gagosian was doing well and in a mood to show off. In a rare spirit of media openness in April 2011, Gagosian invited a *Wall Street Journal* reporter for a glimpse of his world in action: the opening of his new $15.5 million home in the Holmby Hills section of Los Angeles to a crowd of collector clients. Gagosian had been years ahead of the pack in LA; his Beverly Hills gallery, designed by architect Richard Meier, had opened in 1995.[37]

Gagosian was in a gregarious mood, and why not? His glass-enclosed house was gorgeous, embellished on this day by a pop-up art show by Richard Prince. Many of Prince's portraits of beach beauties and pulp-novel nurses hung on the walls. The reporter noticed that the guests, including financier Ron Perelman and his partner at the time, actress Renée Zellweger, were passing a rolled-up piece of paper among themselves like a joint. Only it wasn't a joint: it was the price list for all of Prince's works on the walls. Gagosian never missed a chance to sell.

That July, Cy Twombly died in Rome at age 83, after a years-long struggle with cancer. Gagosian flew over to Rome to bid him goodbye.

When he saw his friend's inert body, Gagosian cried. Every summer after that, he kept up the ritual of visiting Twombly's seaside house in Gaeta, bringing a boatload of people like Irving and Jackie Blum to toast his deceased friend.

To anyone who asked, Gagosian was bullish as could be on the market. "Only a few are buying works of art over $100 million a piece now, but I'm seeing the middle of the market moving up," he told one reporter in 2012. "Is a $10 million, $20 million picture considered mid-range now? That's still a lot of money but a lot of collectors are buying art at those price levels now."[38] Gagosian was on top of the world. But he had proven a less-than-clairvoyant market reader before. Now he was about to experience the worst year of his career.

Larry's Annus Horribilis

2012

FOR LARRY GAGOSIAN, 2012 began with an overhanging shadow from 2011: a lawsuit involving Richard Prince, one of Gagosian's most successful artists. The suit accused Prince of illegally appropriating another artist's copyrighted images in his art. For good measure, the suit named not just Prince but the gallery—and Gagosian.

This was not the first time Prince had been challenged on copyright infringement. The photographer of a 1976 nude image of actress Brooke Shields had hauled Prince into court for rephotographing it and using it otherwise unchanged.[1] Prince had settled that suit. He went on to appropriate the famous Marlboro cowboy ads, again using images by the original photographer, Sam Abell, with no discernable change. Abell had made the images as a photographer for hire in an advertising campaign and relinquished all rights to Philip Morris, so he wasn't able to sue.

French photographer Patrick Cariou raised subtler issues in his own suit against Prince when Prince used Cariou's images without permission. Prince had used photographs of Rastafarians from Cariou's book *Yes Rasta* without permission in a 2008 series of collages called *Canal Zone*, which were shown at Gagosian's West 24th Street gallery. In early 2011, a New York district judge found that Prince had, indeed, infringed on Cariou's copyright.[2] The district court ordered Prince's unsold *Canal Zone* works destroyed. Prince and Gagosian, of course, appealed.

Meanwhile, in galleries and gatherings, the case stirred debate. Most in the New York art world understood and accepted appropriation. And

who could say where the line should be drawn between proper and improper borrowing? But Prince seemed bent on ignoring copyright infringement altogether, copying other artists' work unchanged. If an artist couldn't protect his own image, how could he keep the Richard Princes of the world from using it again and again? The suit, however it turned out, would have an enormous impact on the contemporary art world.

The next sign of a bad year to come was impatience from Damien Hirst. The artist had made a ton of money in his 16 years at the Gagosian gallery, and Gagosian had made a significant amount of money from his work. But nothing had been quite the same after the artist's self-initiated auction of September 2008 at Sotheby's in London.

To shore up Hirst's market value, Gagosian launched a worldwide show of his spot paintings in early 2012. Of the 1,365 spot paintings that Hirst had made, some 300 would fill all 11 of Gagosian's galleries in eight countries, in an exhibit solemnly titled *The Complete Spot Paintings, 1986–2011*, for January through March 2012.[3] The show would either push Hirst to new heights or possibly end his long tenure at Gagosian as one of the gallery's highest-earning artists.

The spots were barely up when a personal tragedy befell the gallery. Mike Kelley, the multimedia Gagosian artist whom *New York Times* critic Holland Cotter described as "one of the most influential American artists of the past quarter century and a pungent commentator on American class, popular culture and youthful rebellion," committed suicide at age 57.[4] Friends spoke of him as depressed and isolated in his LA suburb after developing a fear of driving. He had also gone through a troubled relationship. But there was something more.

Kelley had been a Metro Pictures artist for nearly 25 years when he moved to Gagosian in 2005.[5] He loved Metro's cofounders Janelle Reiring and Helene Winer; they were family to him. Still, Gagosian had painted a vivid picture of how much larger his business was than theirs. Kelley was at that midpoint all artists seemed to reach, needing a fresh start, and for a few years Gagosian seemed to provide one. But the gallery had seemed to push Kelley for more art than he could churn

out. One critic acknowledged that Kelley was "very alcoholic," but suggested that "Gagosian and the demand for product broke his heart." Metro's Reiring agreed—sort of. "People close to him say it was because he left our little family," Reiring said. "But I don't buy that. He was very ambitious, and I think he wanted to be as famous as Jeff Koons. And he went to Gagosian, and that just didn't happen."

Reiring added, "Jeff Koons spends hours with collectors, and Mike was never going to do that. He wasn't very pleasant around the public, started drinking a lot." Still, Reiring was stunned by his death. "If there was one person I thought that would never happen to, it was Mike," she said sadly. "He had ideas he would have spent the rest of his life on. So intellectually prolific."

Another artist's death that year rocked Gagosian. In the case of Viennese sculptor Franz West, it wasn't a surprise—he had been ill a long time. The surprise was what happened in his deathbed days, and after. Since his departure from Zwirner in 2001 and his new career chapter at Gagosian, West, already a star in Europe, had become increasingly visible in the US market. His Switzerland-based dealer, Eva Presenhuber, had helped elevate him too. So had Ealan Wingate, a Gagosian director based in New York, who had been West's conduit to the gallery. Wingate probably deserved as much credit for supporting the artist's career as blame for the financial shenanigans to follow.

Shortly after signing on with Gagosian in 2001, West hired a pixie-ish studio assistant 25 years his junior and fell in love with her. Tbilisi-born artist Tamuna Sirbiladze became his wife. But when a young writer named Benedikt Ledebur began working with West, she found herself drawn to him, too. Ledebur responded, despite the fact that he, too, was married, and had two children. An open marriage ensued, with all three studio partners entwined.[6] From this ménage a trois came a son, Lazare Otto, born in 2008, and a daughter, Anouk Emily, born in 2009. Who had impregnated Tamuna each time was not an issue any of the three cared to pursue. "Franz said he wanted them as his own," Ledebur explained. It was, as Presenhuber put it, a very Viennese tale.

By early June 2012, West began failing, and was checked into a Viennese hospital. The putative members of a Franz West foundation visited the artist in his hospital bed to get all the signatures needed to set it up. Into the foundation would go all of West's art and assets, with a value of perhaps 50 million euros. According to Christoph Kerres, the estate's lawyer, the arrangement would leave West's family with some real estate, and very little more.

Erich Gibel, a lawyer for the foundation, says that in fact, establishing the foundation was the artist's dying wish. Gibel says West had initiated divorce proceedings in 2011, and that Sirbiladze had demanded a "substantial part of his assets." Setting up the foundation, according to Gibel, was the artist's way of protecting his assets. Less than a week later, West was dead.

To Kerres, one clause of the new foundation's documents in particular jumped out at him. The legal papers West had signed called for all of his artworks to be put in the foundation. That violated a fundamental tenet of Austrian law, Kerres noted. In Austria, children are entitled to 50 percent of a parent's inheritance, period.[7] Kerres suggests that if the foundation had given 50 percent of West's art to his children, it might have withstood any legal sallies and kept the rest of West's art. Instead, it was now open to legal challenge on the children's behalf.

Foundation lawyer Gibel confirms the Austrian law, but says the children would be beneficiaries of the foundation when they come of age, and that the family would be represented on the foundation's board by a nephew of Franz West. Still, neither West's widow nor his children, he acknowledges, would have any say over the foundation's doings, even after the children came of age: that, he says, was also in accordance with West's wishes. In any event, Gibel noted, the children were inheriting significant assets: a luxurious villa, five apartments in Vienna, five cars, cash, and more. All this, he said, added up to 15 million euros.

Named as the foundation's "protector," a lifetime appointment, was Ealan Wingate, who also served as the Gagosian gallery's New York

director. Kerres, the family's lawyer, suggests Wingate could decide to whom the foundation would sell any Franz West works, as well as retail lines of the artist's playful furniture. Gibel says, on the contrary, that there are no relationships between the foundation board and the Gagosian gallery, and that if the board ever had to deal with matters concerning the gallery, Wingate would recuse himself to avoid any conflict of interest.

Benedikt Ledebur was not persuaded. On behalf of the children, he sued the foundation for a flagrant breach of Austrian inheritance law. A first court sided with the family; the foundation appealed. Then came a tragic surprise: Tamuna died of cancer in 2016 at 45. That June, in a separate suit, the Austrian Supreme Court found that three West foundation board members had paid themselves "suspicious" sums: salaries totaling $563,425 over a five-month period in 2012, followed in 2013 by payments of $901,480. The three were ordered off the board. (Wingate was not among them.)

Undaunted, the foundation would fight on in court to be allowed to keep West's complete oeuvre—fighting to keep it from West's children and their adoptive father. As the legal wrangling worked its way up to the Austrian Supreme Court, Franz West's legacy—his quirky, uncommercial-seeming art—would keep rising dramatically in value.

LABOR DAY 2012 HAD BARELY PASSED when two longtime friends and collectors who had socialized at each other's Hamptons mansions for years sent their lawyers to sue each other in New York State Supreme Court. "It's been ages since we've had a really good ding-dong between two rich public figures," enthused Emma Brockes of the *Guardian*. "Now here's Ron Perelman suing Larry Gagosian, his erstwhile friend and long-time art dealer, over a deal gone bad, and Gagosian suing him right back."[8]

Several artworks were involved, and several large and changing sums of money, but the gist was simple enough. Perelman, the financier worth an estimated $12 billion, alleged that Gagosian, his dealer and mentor of some 20 years, had cheated him out of serious money

in several swaps of art.[9] Gagosian contended that Perelman was the one who had cheated and, on top of that, failed to pay the dealer what Perelman knew he owed.

The story began in May 2010, when Perelman agreed to buy a large granite *Popeye* from Jeff Koons's eponymous series for $4 million, going through the Gagosian gallery to do so.[10] Delivery of the statue was promised in 19 months. Koons, as usual, fell behind on his production schedule. Finally, Perelman decided to cancel the deal.[11]

To Perelman, this wasn't a matter of just getting his $4 million back. Perelman felt the statue's value had shot up by as much as 70 percent, and that he, as its owner in that time, should be duly compensated.[12] Perelman wanted $12 million.[13]

Only then did Gagosian disclose a private agreement he had struck with Koons when he sold the *Popeye* to Perelman. Koons, clearly worried that Perelman might flip his statue for a quick profit, had stipulated that if Perelman sold the statue, at least 80 percent of the profit would revert to Koons.[14]

Perelman was furious. But in April 2011, he saw a work of art in Gagosian's Madison Avenue gallery he liked so much that it might resolve the dispute. The painting was a classic Cy Twombly, titled *Leaving Paphos Ringed with Waves* (2009). In his lawsuit, Perelman alleged that Gagosian told him the price was $8 million.[15] Great, Perelman reportedly said. He would renounce his rights to the *Popeye*. Gagosian would then send the Twombly to Perelman's East Hampton home.

For reasons not quite clear, this was not the deal that went forward. Instead, Gagosian sold the Twombly to the Mugrabis. A few months later, Perelman again asked Gagosian about *Leaving Paphos Ringed with Waves*. The price was now $11.5 million. Perelman ranted, but he still wanted the painting. Now fully focused, he talked Gagosian down to $10.5 million. Gagosian got the Mugrabis to sell it back, probably yielding them a fast $1 to $2 million profit and Gagosian a $500,000 to $1 million commission.[16]

Perelman had his painting at last, but the more he thought about Gagosian's wheeling and dealing on it, the angrier he became. Finally,

he sued on various grounds, from breach of contract to fraud. "He is the most charming guy in the world," Perelman mused in a rare interview after the suit was filed. "Everyone thinks when they're doing business with him, they're the one guy being treated honestly."[17] Ultimately, Perelman felt, Gagosian was manipulating all his deals for his own gain.

To the art world's delight, Gagosian made his own rare public appearance, describing Perelman as a "deadbeat" and "bully" in court papers and adding that Perelman should be sanctioned by the judge for bringing his "frivolous" action.[18]

The dueling lawsuits were filed in September 2012. Gagosian abandoned his a few months later, but Perelman fought on. For more than two years, the legal action would hang over both men, each so angry at the other that when the two entered a public gathering the air grew supercharged and one had to leave. In December 2014, however, Perelman's suit was dismissed in a unanimous ruling by the New York State Supreme Court. "Justice was done today," declared Gagosian's lawyer Matthew Dontzin.[19]

Gagosian may have actually won some sympathy in the dustup, so brash and litigious was Perelman, but his next move reminded the art world just how bruising he could be, sometimes for no other reason than to spite a rival.

THADDAEUS ROPAC—THE DEALER WHO, AS A young man in the 1980s, had come to New York with a letter of introduction to Andy Warhol from Joseph Beuys—was now 50 years old and fast becoming one of the most significant European dealers of his generation. From his gallery in Salzburg he had jumped over to Paris's Marais section in 1990, starting with one floor and eventually taking the whole building. Among the artists he represented in Europe were Anselm Kiefer, Georg Baselitz, and Alex Katz.

Ropac wasn't finished with France yet. In the spring of 2012, he announced the purchase of a former factory in the Paris outskirt of Pantin. He would be transforming its eight buildings into galleries,

performance spaces, artists' studios, and more. For its grand opening in October 2012, Ropac would display 38 secondary-market paintings and sculptures by Anselm Kiefer, as well as works by Georg Baselitz. Pantin was well situated, not just near a regional express train and a metro stop but also 20 minutes away from Le Bourget, Paris's airport for private planes. Ropac predicted that both the mass public and the Gulfstream-riding ultra-high-net-worthers would find their way there.

Six weeks later, Gagosian announced that he, too, had acquired a vast space outside Paris and would be opening it as a gallery. He, too, would open in October, though perhaps before Ropac. His gallery, too, would be near the private airport of Paris-Le Bourget. In fact, it would be adjacent to the airport. Oh, and Gagosian, too, would be opening with a show of works by Anselm Kiefer. A Gagosian spokesperson sniffed that Kiefer would be making all new work for Gagosian's show.

It was true that both dealers worked with Kiefer and Baselitz, but this was ridiculous. "I have been planning my show for two years," Ropac said incredulously.[20] Not long before, in fact, Kiefer had consigned three very big new paintings to Ropac, paintings the dealer was planning to show as a huge installation for the Pantin opening. But no, Gagosian would now be showing that installation. His hold on Kiefer was greater.

The two dealers jockeyed through the summer over who would open first. In the end, Ropac did, by five days. To inaugurate his space, he presented a new series of Kiefer paintings and sculptures titled *Die Ungeborenen (The Unborn)*. Gagosian's was a splashier event, highlighted by the now-famous Kiefer installation *Morgenthau Plan*. After the 250 or so guests had admired it, they were taken by train to a hangar for dinner and a light-and-sound show, where three private jets were parked. A DJ kicked off the pounding music with an illuminated dance floor that pulsed to the beat. Ropac, poorly placed at a table near the exit, left the party quickly.[21]

Gagosian's sales were soaring, but a growing number of his artists felt restive with a dealer who seemed to be traveling all the time, with little or no time for them. To British dealer Victoria Miro's private

delight, one of the frustrated artists was Yayoi Kusama, who had first exhibited with Gagosian in a group show in London in 2007. When Gagosian took her on at age 80, the Japanese-born Kusama was a truly eccentric figure. She had lived voluntarily at the Seiwa Hospital for the Mentally Ill since 1977 while maintaining a nearby studio.[22] She was the dot lady, creating rooms and pumpkin sculptures festooned with dots for what she called her *Infinity Mirror Rooms*. These had grown out of the works she'd done for most of her career, the *Infinity Net* paintings "without beginning, end, or center," as she put it. Kusama had a following, but nothing on the scale she was soon to achieve.

Kusama had been doing her *Infinity Net* paintings since the 1950s, starting as a lissome and somewhat mysterious artist of the downtown New York scene. A photograph from that time shows her as a delicate Japanese beauty, an arm draped over an early *Infinity Net* painting nearly as tall as she. The year was 1959; Kusama was 30 years old, her artistic vision as clear and confident as that of an artist three times her age.

In her long and winding career, Kusama had gone from Abstract Expressionism to Pop art, Conceptualism, feminism, Surrealism, and Minimalism.[23] She had organized public happenings of polka-dotted nudes and created her series of *Infinity Mirror Rooms*, in which neon-colored balls were hung in mirrored rooms, some incorporating music.[24] Haunted by her father's dalliances, which her mother had forced her to observe and report on as a young girl, Kusama had incorporated sexuality in her art even as she shunned physical relationships.[25]

After her return to Japan in the early eighties, Kusama had "fulfilled the promise of her self-obliteration," as one critic put it, "by promptly suffering a nervous breakdown."[26] During her recovery, she painted somber, dark collages and watercolors with morbid titles such as *Remember that Thou Must Die*, *Graves of the Unknown Soldier*, and *Tidal Waves of War*.[27]

Kusama's New York dealer through most of the years that followed was Robert Miller, a chic bastion of East 57th Street, and a strong advocate of women artists, including Diane Arbus, Eva Hesse, and Lee

Krasner. Kusama was a hard sell, and Miller did little to push her work, but he kept her on his roster until 2006. Victoria Miro was limited to coproducing Kusama exhibits with Miller—first at his New York gallery, then at her London space on Wharf Road—and hoping the artist would eventually choose a more aggressive New York dealer for the benefit of all. That Kusama did, at last, when she dropped Miller for Gagosian in 2009.

At first, Miro was pleased. She would have preferred to have Kusama to herself, but Gagosian would surely push the artist hard, and if Miro kept working with her in London, sales would ensue. Gagosian, however, made no real effort to nurture Kusama. He later admitted he'd never met her. "She's a wonderful artist," he said, but her art "wasn't really my DNA." In fairness, Kusama spent nearly all her time in Japan and rarely felt well enough to travel. Gagosian would have had to fly over to her. Regardless, Kusama might have stayed with Gagosian if not for the Tate Modern's retrospective of her work in 2012, for which Gagosian failed to show up on opening night. "I didn't go," the dealer admitted sheepishly. "That was not a smart thing for me . . . to do, because she's a very good artist [and] sells very very well."

Kusama moved to David Zwirner in New York in early 2013, keeping Miro for London. At last, working with Zwirner, Miro was able to help boost Kusama to the global audience she deserved.

Kusama, it turned out, was the ultimate Instagram artist. Nearly 160,000 people would visit a 2017 Hirshhorn Museum show in Washington, DC, with lines of several hours.[28] Though reticent to do interviews, Kusama would snatch each new write-up and read it avidly. Zwirner and Miro would cash in on this late-life bonanza, as would the auction houses, which sold more than 50 works by Kusama for more than $1 million each between January 2013 and December 31, 2017.[29]

If Kusama's departure was a setback for Gagosian, so too was Jeff Koons's declaration in December 2012. Koons's next show of new work, he said, would be at the Zwirner gallery in May 2013. Koons denied he was leaving Gagosian. "As an artist, I've always worked with multiple galleries," he declared. "Gagosian Gallery has represented my

work since 2001 and continues to do so. I enjoy working with Larry."[30] Gagosian retaliated against Zwirner the same week, announcing his own Koons show of new and recent work—also in May 2013, and also in New York's Chelsea.

The nasty year of 2012 wasn't over quite yet. That same December, Damien Hirst announced that he was leaving Gagosian after all.[31] The worldwide spot paintings had not sold well enough, and Hirst had become restless. A tumultuous home life had not helped: Hirst's girlfriend of 19 years and the mother of his three children, Maia Norman, had left Hirst for a former officer in the Scots Guards.[32] Hirst's business manager, James Kelly, acknowledged to *New York* magazine that after 17 years Hirst and his dealer had drifted apart. "Larry has a very, very large machine, that's part of it," Kelly said of Gagosian. "He's representing a lot more estates now, dead artists."[33] Hirst also felt under pressure to churn out more and more art for Gagosian's many galleries. "Damien told me, 'I want to slow down,'" Kelly reported, "and therefore there's no point in staying with Gagosian."[34]

VICTORIA MIRO WAS THRILLED TO BE working with Kusama, but the Japanese artist was hardly her only star. Stan Douglas was still making the noir films he had done as an early Zwirner artist, and English artist Grayson Perry, known as much for his cross-dressing and art world commentary as for his Greek-influenced ceramics and large tapestries, was Miro's artist too. Also on her roster was Chris Ofili. But her long ride with Peter Doig was at an end. In stiff-upper-lip fashion, nothing was ever said about it, but that year Doig formally moved to Michael Werner.

Doig's departure from Miro—and his own painful divorce—took a toll on his longtime friendship with Ofili. Market prices were another pressure: Ofili's were impressive, but Doig's were astonishing. A painting that Doig had sold for several thousand dollars, back in the days of those threatening bank letters, went at auction for 7 million pounds. A painting done in 1994, *Pine House (Rooms for Rent)*, went for $18.1 million at Christie's in November 2014. The trajectory was mind-boggling

and, to Doig, quite upsetting. All reason seemed to have vanished from the process. "The auction houses talk of masterpieces," Doig would say with mortification. "There's no such thing as a contemporary masterpiece. It can't be decided in your own time, really. So, it's all marketing."

In retaliation, Doig would start works he described as deliberately difficult—not the nuanced and beguiling landscapes of his childhood in Canada or of the Caribbean, but primitive pictures that seemed the work of a young, unproven artist. "His thought is that only the really committed collectors will buy them," Miro explained. "So the art market has literally changed his style." Another prominent dealer went further. Why, he wondered, was Doig sabotaging himself like this?

MARIANNE BOESKY WAS HAVING A BAD 2012 too. She was pushing through her gallery walls, doubling her Chelsea space to 10,000 square feet, after taking construction loans she planned to repay with her first two shows: one by Lisa Yuskavage, the other by Takashi Murakami. But the artists had left her, and she was strapped for cash. She also felt that Arne Glimcher was courting Japanese artist Yoshitomo Nara behind her back. And she had just been diagnosed with breast cancer. She was, as she put it, on autopilot. Then came deliverance, in two words: Frank Stella.

That was the year that a forgery scandal rocked the Knoedler gallery. Stella had been loyal for years to Knoedler president Ann Freedman. Now it was clearly time to go. Meanwhile, a young gallerist named Ricky Manne, who had worked with Stella at Knoedler, began lobbying Boesky for a job and urging her to pay Stella a studio visit. Boesky wasn't sure Manne was right for the gallery and worried she would feel beholden to him for making an introduction to Stella. "Finally I said, 'Fuck it, I'll hire him,'" regardless of whether Manne set up a visit, Boesky recalled. Happily, Stella agreed to meet her, and the visit went well. Usually Stella got bored and restless with guests, Manne explained after they left. With Boesky, he had stayed engaged. At the start of a follow-up visit, Stella came right out and told Boesky

she could represent him. It was what she'd wanted, and yet the words stunned her. "No," she said.

"You can do it," Stella assured her.

"Give me a little time," Boesky said. "I'm not ready to take this on my own."

Boesky knew that Stella had shown at the L&M Arts gallery on East 78th Street, so called for its partners, Dominique Lévy and Robert Mnuchin. Lévy had gone from her top job at Christie's, pumping up private sales, to a new gallery with the former Wall Street financier and Goldman Sachs partner. Boesky had known Lévy for years. "So I approached her," Boesky explained, and suggested they co-represent an American contemporary legend. "She loved it."

Sharing Stella was a coup for both women, and great news to Adam Weinberg, director of the Whitney Museum. "Is it true you're going to represent Frank?" Weinberg asked. He had long hoped to schedule a Stella retrospective, but felt wary of working with Knoedler, even before the scandal. "Now I know we can put him on the calendar and everything will be okay," Weinberg said. And so it was: the Stella retrospective, one of the first in the Whitney's new downtown building, celebrated one of America's foremost living contemporary artists from October 2015 to February 2016. As for Boesky, her new, double-sized gallery got finished at last—and she won her battle with breast cancer.

DAVID ZWIRNER WAS THE MEGA DEALER who seemed to benefit most from Larry Gagosian's difficult year. In early 2013, Zwirner opened a second Chelsea location, a new five-story concrete building at 537 West 20th Street, constructed from the ground up by Annabelle Selldorf, the German-born architect of sleek, understated spaces whose art gallery clients, after Gagosian and Zwirner, included Barbara Gladstone, Michael Werner, Bill Acquavella, and Hauser & Wirth.

Including his string of rented garages at 519, 525, and 533 West 19th Street, two of which had additions on top, Zwirner now commanded 70,000 square feet of New York exhibition space. He had his upcoming show for Jeff Koons on 19th Street—the news of which had

so irked Gagosian that he'd scheduled his own Koons show. At his 20th Street gallery, he had a show for Richard Serra, another artist long associated with Gagosian. He had a battery of other art stars lined up: Dan Flavin and Donald Judd in a two-person show, Ray Pettibon's drawings, and Ad Reinhardt's black paintings. On his website, Zwirner described his galleries as "artist-centric," a clear slap at Gagosian, who was, by implication, collector centric. Artists, as a result, were being drawn to Zwirner, explained the dealer. "That's kind of what happened with Jeff," Zwirner said of Koons in an interview. "We didn't seek him out. He came to us."[35]

The new building was part of that push. Zwirner now had enough space to do broad historical shows. More space, too, for up-and-coming artists. "We're ready for them," Zwirner declared of the next generation. "That's the idea. I want to be ready." Increasingly, being ready, for the megas, meant being ready to outdo each other and, ultimately, to leave the competition behind.

A Market for Black Artists at Last

2013

Iwan Wirth, too, sensed opportunity as Gagosian struggled. In early 2013, he opened his huge new Chelsea gallery in the former Roxy discotheque and roller-skating rink on West 18th Street. Rather than buy and replace the building, as Zwirner had done with his, Wirth leased it, keeping its gritty exterior even as the interior became a classic white cube. Hauser & Wirth called it "a grand industrial counterpoint to the intimacy of 69th Street's domestic-scaled rooms."[1] With its growing clout, the gallery made a shrewd strategic move to sign up artists of color and, in so doing, set itself apart from the other three megas, just as a new generation of black artists were coming into their own.

Later, Hauser & Wirth's longtime partner and vice president Marc Payot would admit that in 2012 he knew almost nothing about the work of an artist named Mark Bradford. A terminally ill friend of Payot's had made a deathbed request: *Look at the work of this man*. In a sense, Bradford was hard to miss. He stood six feet seven and a half inches, a proud and handsome black artist on the cusp of international stardom. He had been represented for nine years by Chelsea gallery Sikkema Jenkins, which had given him three solo shows, the most recent in October 2012 just days before Hurricane Sandy. His reputation was solid and growing, but nothing like it was about to become.

Bradford had spent his early childhood in a black neighborhood of South Central, Los Angeles, called West Adams, near where his mother, a single parent, had a beauty salon. At 11, he moved with her to Santa Monica, in large part for the better public schools. Bradford's

mother kept her shop and, after graduating from high school, he began working full-time for her as a "beauty operator."[2] He was actually not the first contemporary artist in the United States who started his career hairdressing: John Chamberlain had learned the profession on the GI Bill and used it as a way to meet women.

In his twenties, Bradford began daring to think he might be an artist. Inspired by the writings of James Baldwin, he made his way to Amsterdam for what became a transformative experience. "I felt liberated from U.S. racial constraints," he explained later. "It was the first time I felt that people weren't just seeing my color."[3] When he returned, he enrolled at Santa Monica College.[4] Jill Giegerich, Bradford's instructor at the college, pushed him to apply to California Institute of the Arts, where he took a BFA in 1995 and an MFA in 1997.

Bradford was now an artist, just an unknown one. His life changed with a visit in 2000 from Thelma Golden, curator of the Whitney's 1994 *Black Male* show, and later director and chief curator of the Studio Museum in Harlem. Golden was amazed by what she saw: abstract paintings using perm end papers from the beauty salon where Bradford still worked part-time. On the spot, she asked if she could include Bradford in a show she was planning for 2001 called *Freestyle*, in which black artists would respond to the theme of "post black art."[5] The idea, which Golden developed with her close friend, artist Glenn Ligon, was that artists in the show would be "adamant about not being labeled 'black' artists, though their work was steeped, in fact deeply interested, in redefining complex notions of blackness."[6] Golden chose two of Bradford's end-paper collages for the exhibit, which drew widespread attention. At Sikkema Jenkins, which he joined in 2005, Bradford constructed a huge ark of salvaged plywood and showed it in New Orleans for a show commemorating Hurricane Katrina. Already, social issues were a key part of his artistic practice.

Of the 27 other artists in *Freestyle*, the one who benefitted the most was Rashid Johnson. Johnson had had a middle-class upbringing in Chicago, where his mother was a professor of history at Northwestern University. His parents divorced when Johnson was two, and his

mother married a man of Nigerian descent.[7] "I grew up in a situation where experiences had as much to do with class or gender as with race," Johnson noted later.[8]

After earning a BA from Columbia College in Chicago and attending the School of the Art Institute of Chicago from 2003 to 2004, Johnson began taking photographic portraits of homeless men and was picked up by Chicago gallery Monique Meloche. By 2009, he was using a wide range of media to explore black history, as well as his own story. In interviews, he spoke of "narrative embedding," using every day materials to tell a visual story. One was shea butter, a fat extracted from the nut of the African shea tree, used by black people to moisturize their skin. Another was a black soap made from any number of ingredients: plantains, coca pods, palm tree leaves, and shea tree bark. Both were off-the-shelf products found in black communities. Johnson showed great hunks of shea butter and black soap, incorporating them on surfaces of the artist's choosing.

Freestyle became the first in the "F-show" series at the Studio Museum of Harlem: *Frequency* (2005–2006), *Flow* (2008), *Fore* (2012–2013), and *Fictions* (2017–2018). Both mid-level and mega galleries were now vying for black artists. One reason was that first-rate black artists had been previously overlooked. Another was that white collectors had begun to hang black artists' work on their walls. And so the number and range of black artists in mainstream galleries had grown.

A key member of this group was Kara Walker, represented since 1995 by Sikkema Jenkins, who made cut-paper silhouettes of black figures against white walls, sometimes as friezes or murals, depicting scenes of black antebellum life. "Kara was someone white collectors wanted on their walls," observed *New Yorker* critic Hilton Als. "The gentility of the form of cutouts was contradicted by the fierceness of what she was talking about." In 2014, Walker would take a tremendous step into large-scale Conceptual art with a female sphinx made of sugar, 75 feet long and 35 feet high, in the disused Domino Sugar factory in Brooklyn. The sphinx was unmistakably a black "mammy accompanied by 15 young male figures."[9] Its title: *A Subtlety, or the Marvelous*

Sugar Baby. As agreed upon beforehand, both the sculpture and the refinery were destroyed at the end of the show.

Another seminal artist was Glenn Ligon, who used language as a medium. His work was dominated by racially and historically charged text that he then muted or even erased. "He's doing something interesting, in terms of distancing through language," Als felt. "When you see a Glenn Ligon painting, it's who is the victim, and who is the victimizer? How complicit are we in looking at these hateful words?"

The young West Coast dealer David Kordansky, who had started in LA's Chinatown and had just lost his prized artist Thomas Houseago, met Rashid Johnson at Art Basel Miami Beach in December 2008, "or maybe it was 2009, that time is a blur," admitted Kordansky. Johnson was being represented by New York dealer Nicole Klagsbrun, whose early sponsorship of Christopher Wool had helped launch his career. Don and Mera Rubell had recently included Johnson in a bold group show at their collection titled *30 Americans*. All 30 were black artists. The show had been widely admired for advancing a dialogue about contemporary black artists. It was Don Rubell who made the introduction to Kordansky. He was wowed. "I felt in love with his mind and work."

Johnson flew out from New York and spent a liquid evening with Kordansky at the dealer's gallery. Johnson hadn't decided whether to make him the artist's LA dealer—the guy could be intense—but he was open to the idea. That night, the talk turned to the black avant-garde, which both men had studied and embraced. They named obscure artists they loved, testing each other's bona fides. One of their mutual favorites was Sam Gilliam, by then in his late seventies. Where was he now, they wondered?

Gilliam, based in Washington, DC, had debuted his drape paintings—large, multicolored canvases freed from their frames and knotted into distinctive shapes—in 1969 at the Corcoran Gallery of Art.[10] He had been selected to represent the United States at the 1972 Venice Biennale. But health issues had intervened, and for a period Gilliam had been unable to work or function. Across the country, two people

Gilliam had never met, one an artist and one a dealer, reached out to see what Gilliam had been up to.

Wary of their motives, Gilliam rebuffed the first overture, then the second. Eventually, the two men flew to Washington, DC, to visit the artist. To their delight, Gilliam was still doing great work. What would he say to a solo exhibition? At that, Gilliam began to cry. "I actually thought he was laughing at us," Kordansky said later.[11] "Like, 'you little burgermeisters, coming into my studio, thinking I would let you do anything with my work.' Then it turned out he was crying."

"I did cry," Gilliam later admitted, "at the idea that I might make some money and guarantee myself a future. It really caught me off-guard."[12]

A first show in LA at Kordansky's gallery in March 2013 focused on Gilliam's hard-edge paintings and was curated by Johnson. Kordansky also began placing Gilliam drape paintings with museums like MoMA and the Met. At 80, Gilliam had a whole new career. "I feel like I'm starting all over," Gilliam said. "I feel like I'm just beginning."[13] Kordansky was thrilled too. "There is no money in the world," he said, "that can buy an experience like that." It didn't hurt that by then Rashid Johnson had agreed to have Kordansky be his LA dealer.

THE STATE OF BLACK CONTEMPORARY ARTISTS in America in 2013 was both encouraging and complex. Encouraging, given Mark Bradford's quickening rise and the new attention paid to a handful of other black artists. Complex because...it was. "It used to be said that there was no more segregated place than a Baptist church at high noon on a Sunday," critic Hilton Als noted over a downtown New York lunch. "I think there's no more segregated world than a gallery opening on a Thursday evening in Chelsea."

All Als had to do to make his point was look around. "For instance at a book party at [*New Yorker* editor] David Remnick's, I had to introduce Elizabeth Peyton to Lorna Simpson," Als recounted. "They had never met! Even though they were in the same avenue of experience, and in the same sort of league for the last twenty or thirty years. And

that's because so much of the art world is really based on social life." Peyton was the white portrait painter whom Gavin Brown had shown more than a dozen times, starting in the mid-1990s with his impromptu gallery in room 828 of the Chelsea Hotel. Lorna Simpson was a photographer and multimedia artist who often combined text with staged images, raising questions about gender, race, and history. Simpson, a lifelong resident of Brooklyn, was black. "One of the things that happens is that the market dictates who people see," Als explained. "So if Barbara Gladstone is now representing a black artist—let's say there's no other black artist in her stable—you wouldn't be friendly until that black artist is signed because it's not the social mores of the time. Why would you want to belong to a black society? It's not blue chip enough." And so it was with black art and black artists.

Recently, Als acknowledged, the social strata had begun to shift a bit. "I do know some [white] dealers and collectors who get involved in black art, but I think they feel it's a moral obligation. As opposed to aesthetic considerations. You can feel it—with the solemnity with which black artists are viewed. It's like, 'The other stuff is fun, but I really should pay attention to this black art! Which is such a bore!' Because it then disqualifies the artist to be seen as a great artist. He becomes an ideologue, or a spokesperson."

By 2013, black art was not just financially appealing to collectors; it was obligatory for dealers. "They have to pay attention to shit they didn't used to have to notice," Als suggested. "Different kinds of artists. There have to be women, there have to be blacks. It's a very interesting mandate. That doesn't mean there will be great black art everywhere. There will be a lot of clunkers, but it's a time that has given visibility to some people who are important." At the same time, Als felt, it was a mistake to categorize black artists in any way. "You lose sight of nuance and individuality. What's great is that there are enough people out there that you can just say 'I like this one' or 'don't like that one.' You don't have to take it all in as a movement. It's not a movement—people have been making art forever."

INTRIGUED BY HIS DYING FRIEND'S STRONG recommendation, Marc Payot of Hauser & Wirth had flown to LA in 2012 to meet Mark Bradford and see his work. Like Thelma Golden, indeed like almost everyone, Payot was dazzled by Bradford's mastery. Many of his paintings were aerial urban views, at such a height that buildings and streets became abstract grids.[14] Bradford by now was using thick layers of paint, then partially scraping them away to create an impasto effect reminiscent of De Kooning. Payot was awed by the visual impact of Bradford's large canvases, woven with cross-cultural references—traces, for example, of urban maps, perhaps cultural landscapes.

"The narrative isn't directly about blackness," Als explained. "It's about the city, and a lot of that work is about how do we make the city...how does the city speak about racial division, about the black community.... So it can be a map of Compton—or just an abstract painting."

For the moment, Bradford remained with Sikkema Jenkins and with White Cube in London, so his talk with Payot was strictly hypothetical but intriguing. Bradford had started a nonprofit in LA called Art + Practice, working with foster children.[15] The Wirths were excited by just that sort of community interaction. Art + Practice was an urban sanctuary for needy children, a world away from Hauser & Wirth's new plan for a sprawling art farm in the English countryside. But both visions were framed by the desire to do social good—and to use art to do it. "At the core," explained Payot, "it's the belief that with art you can actually change society."

For Bradford, it was a hard choice. Sikkema Jenkins had stayed with him through ups and downs, as critic Jerry Saltz noted in *New York* magazine. "And I do mean downs: During Bradford's exhibition [in 2011], his dealer, Michael Jenkins, somehow made his way to the gallery through Hurricane Sandy and propped up the paintings on file cabinets, keeping them above the water line, saving them from destruction and sacrificing the gallery's paperwork to do it."[16] Could he really leave the gallery that had supported him so passionately?

Bradford wasn't the only black artist Wirth was pursuing. As much as he could, the ebullient dealer with the Swiss lilt was making the case for a new generation of artists of color. He had the same mission as Jack Shainman—the dealer who had tracked down Kerry James Marshall in the 1990s and dedicated his career to supporting black artists. Wirth just had a lot more money to underwrite it.

To Wirth's delight, Rashid Johnson came into the fold in 2011. He would remain Kordansky's artist in LA, but Hauser & Wirth would be his dealer for all other domains. A year later, Mark Bradford became a Hauser & Wirth artist too. Bradford was now producing large-scale paintings for $1 million at his industrial-sized studio in South Los Angeles. Hauser & Wirth was not just finding him buyers; the gallery was backing up its talk of social engagement with sizable contributions to Art + Practice, as was White Cube, Bradford's London dealer. In 2015, Hauser & Wirth donated $800,550 to the nonprofit, while White Cube donated $1,474,270. The next year, Hauser & Wirth gave $3,646,555, while White Cube gave . . . nothing. That was the year, 2016, that Bradford left White Cube to become a globally managed artist at Hauser & Wirth.

Bradford put the squeeze on collectors, too, instituting a "buy two, get one" policy. "You had to donate the second work to a museum," explained dealer and art world chronicler Kenny Schachter. An art advisor told Schachter how a client of hers bought two Bradfords and conveniently "forgot" to donate the second.[17]

One artist who continued to keep his distance from dealers was David Hammons, the one-time snowball seller. Hammons had gone on to global fame as a Conceptual artist whose work spoke strongly to racial, social, and economic issues. A black hoodie hung from a white wall (1993), a basketball hoop and backboard draped with a chandelier (2000), a half-dozen fur coats hung on antique mannequins, with their backs painted, burned, and stained (2007)—all showed Hammons's trademark mix of social anger and mordant humor. Or, as one critic suggested: shamanism, politics, consumerism, animism, and jokes.[18] When he felt he was ready for a new show, Hammons got in touch

with a gallery he liked, most recently the Upper East Side's Mnuchin Gallery. "When glimpsed in person, he's a watchful dandy sporting a colorful knit cap, but sightings are few and far between," noted Peter Schjeldahl in the *New Yorker*. "Hammons so successfully shuns and fascinates the art world that he is almost an art world to himself."[19]

Hilton Als agreed. "I feel his real contribution is fucking with the art world," Als said of Hammons. "I'm less visually interested in [his art] than in his performance as an elusive black artist."

DAVID KORDANSKY WAS DOING HIS BEST to boost the LA gallery scene, and black artists were only part of his vision. Having gotten over his heartbreak of losing Thomas Houseago, he now had Mary Weatherford, an LA-based abstract painter who, in a tip of the hat to earlier light artists as well as the Italian movement Arte Povera, incorporated neon into her work. Kordansky's latest gallery was on La Cienega Boulevard, in the Culver City arts district. Once again, the space was somewhat remote. "I have always been on the outskirts, something difficult to find," he said later. "The notion of location, location, location has never stuck with me. Do your artists make you a destination? That's the question."

Kordansky's LA story was, like the gallery scene in which he found himself, expanding. Another East Coast transplant, Jeffrey Deitch, was seeing his own LA story—his first LA story—come to a fiery close.

Deitch's latest chapter had begun in early 2010, when he startled the art world by agreeing to head up LA's Museum of Contemporary Art. It was the first time a dealer had been appointed to run the museum. Even old friends found the appointment galling. "I won't set foot in MOCA," one told him bluntly. To the art world, the potential conflicts of interest seemed staggering. Surely Deitch would nudge his curators into staging shows of artists whose work he'd either collected or sold—or might sell yet. How could his judgment be trusted?

Deitch's challenge was complicated by a fiscal crisis not of his making. A previous director had misallocated museum monies and been investigated for it, the Great Recession had reduced MOCA's endowment

from $40 million to $6 million, and much of the staff, as a result, had been let go.[20] "It was a super tough period for a very damaged institution," as Deitch put it, "an institute of great promise that had almost destroyed itself." But he was willing to try to revive it.

From his arrival in mid-2010, Deitch struggled against what he felt to be a daily whisper campaign. A show early in his tenure, of multimedia works by recently deceased *Easy Rider* director and star Dennis Hopper, was denounced by MOCA's chief curator Paul Schimmel, who would have nothing to do with it. *Los Angeles Times* art critic Christopher Knight wrote that "Hopper just isn't a very interesting artist.... Failed promise characterizes this mostly listless art, however celebrated the actor-director's movie career."[21] Knight would prove one of Deitch's implacable foes.

"Jeffrey had a tough start due largely to the poisonous personality of [Paul] Schimmel, who really put him down at every opportunity," Irving Blum told *Vanity Fair*.[22] "The guy's a brilliant curator," Blum said of the longtime MOCA curator, "but, finally, too divisive. I think that a big mistake that Jeffrey made was not getting rid of Schimmel right at the start."[23] However, Schimmel had his supporters, and the curatorial history to justify their faith in him.

Art in the Streets, a 2011 show about graffiti and global street art, was rapped by Knight for its "head-turning claim" that graffiti was the most influential art movement since Pop. Yes, some of the art was interesting, Knight allowed. But the claim was overblown. And why was the show curated by Deitch himself anyway? Wasn't fund-raising the director's top priority?

Later, Deitch declared he had done more than his share of fundraising—an endless job because MOCA, unlike other LA museums, had limited government funding, less than 1 percent of its annual budget. "I worked eighteen hours a day, starting with fund-raising breakfasts to dinners at collectors' homes," Deitch recalled with some bitterness. "I would get home after midnight. I'm a runner, I would have to get up at five-thirty or six a.m. to go running. I didn't have gray hair in 2010, when I arrived," Deitch added. Within a year, he did.

All Deitch could do was tell his side of the museum's story to important collectors and hope they came on board. Later, he would tick off the names of donors he had cultivated: Maurice Marciano of Guess Jeans, collector Eugenio López, hedge funder Steve Cohen, activist investor Dan Loeb, collector Peter Brant, and international jeweler Laurence Graff, among others. On Deitch's watch, MOCA's endowment grew to $12 million in 2012 and to $95 million in 2013.

In June 2012, the board backed Deitch in voting to fire Paul Schimmel. In the resulting uproar, pro-Schimmel board members resigned, including Pictures Generation artist Barbara Kruger, photographer Catherine Opie, painter Ed Ruscha, and Conceptual artist John Baldessari. "Baldessari had never gone to a single board meeting," Deitch fumed. "Never saw any of my shows."

By mid-2013, Deitch had not only built the endowment back up but reinvigorated the museum, anticipating the young, iPhone-wielding crowds that would soon be filling contemporary art museums to post images on Instagram. Deitch's decade of SoHo performance projects were a perfect seedbed for the shows MOCA would soon embrace. Yet no matter how much money Deitch raised and how much vigor he instilled, the aftereffects of the board purge continued to dog his tenure.

Deitch's decision to leave came as the result of a telling moment. "An important artist was going to do a show with me," Deitch recalled. "He then calls and cancels. 'All my friends are telling me I can't do a show with you. It will hurt my reputation.'" With that, Deitch declared his day done, two years before fulfilling his five-year contract. He had his supporters, but fewer than he had anticipated.

One New Yorker was leaving LA, his hopes for building a new LA art scene dashed for the moment. Another was arriving. In late 2012, Gavin Brown helped sponsor a nonprofit, artist-run space just east of downtown Los Angeles in partnership with Laura Owens, a close friend and artist on his roster. The space was on the outskirts of Boyle Heights, a largely Hispanic neighborhood where few artists lived. Its name was its address: 356 Mission. Owens had no plans to turn it into a gallery, but she did envision showing her own work, as well as that of other

artists. Owens staged a first show of new work in early 2013. She was on her way to great critical acclaim, with a mid-career retrospective at the Whitney in her future. But the higher she rose, the more her Boyle Heights neighbors would rebel against what she seemed to represent.

THOUGH 2012 WAS RECEDING, GAGOSIAN'S STREAK of bad luck hadn't ended quite yet. He was having trouble hanging on to estates. In a sense, Mike Kelley didn't count: the Kelley foundation had a close relationship with Paul Schimmel, who served as its codirector. There was nothing Gagosian could do to keep the estate from choosing the Kelley foundation over his own gallery. Less explainable were the estate departures of David Smith, the Abstract Expressionist sculptor, and Arshile Gorky, the Armenian American painter who had helped influence Abstract Expressionism in its earliest days. Both Smith's and Gorky's estates went in 2016 to Hauser & Wirth.

For Gagosian, losing the Rauschenberg estate was a much harder blow. For some time, Gagosian had continued to be the Robert Rauschenberg Foundation's dealer of record. In 2013, the foundation began having second thoughts and chose to solicit bids from various dealers. Thaddaeus Ropac proposed sharing the honor with Arne Glimcher and another dealer, Luisa Strina, in São Paulo. Having different dealers for different markets—that was the new model that worked best with a global artist like Rauschenberg, Ropac felt. "I think the idea of world representation for artists is not in the artist's favor," Ropac said, taking direct aim at Gagosian's more traditional global model. "Maybe the gallery's, but not the artist's. I want to be fair to the artist. Better to have two or three galleries competing for you." The foundation agreed, and Gagosian was sent packing. "I was disappointed," Gagosian admitted. "But I got over it pretty quickly."

Gagosian's woes notwithstanding, the overall contemporary art market soared through 2013, reaching a fevered pitch with the fall auctions. New records were set, with the auction world teetering between exultation and fear that the ride was about to end. "It was raining money in New York this week," Georgina Adam reported that

November for the *Financial Times*, "as the contemporary art auctions pulverized most of the existing market records. In an epic buying spree, collectors, dealers and investors splurged more than $1.1 billion on the giants of 20th-century art—Bacon, Rothko, de Kooning and Warhol— as well as propelling a living artist—Jeff Koons—to an unprecedented new price high." That was when Peter Brant put Koons's orange *Balloon Dog* up for auction and got $58.4 million for it. A Bacon triptych sold for $142.2 million. Warhol's *Silver Car Crash (Double Disaster)* exceeded its own $60 to $80 million estimate to sell for $105.4 million. "Mere money started seeming almost meaningless," Adam wrote, "and even the audience gradually stopped clapping as records fell thick and fast."[24]

A LOT OF CHELSEA DEALERS WERE doing as well as their auction counterparts, but art wasn't all that was making them rich. Being in Chelsea had turned out to be as much a story of real estate as of art. The biggest winners were not the mega dealers: they bought big parcels of property at market value for their big new gallery spaces. It was the occasional smaller dealer, like Lisa Spellman, who just came up lucky, as if blessed by the gods for championing artists she loved.

One reason Spellman had survived as a dealer since 1979 was that she had found a rent-controlled loft downtown. In 2007, she heard about a Chelsea property that might be even more advantageous. The property was a 5,000-square-foot, one-story garage with air rights on West 21st Street, literally on the corner of the West Side highway by the Hudson River.

The deal hinged on architect Jean Nouvel, who had just designed a soaring new condominium building at 19th Street and Eleventh Avenue. Nouvel needed a showroom for buyers to view mock-ups of the condos to come. When Spellman heard that, she proposed that she buy the low-slung garage and then rent it to Nouvel for the year or so he needed it. Both sides benefitted, and Spellman got her garage.

Spellman might have kept the garage as her gallery for the rest of her life. But a new real-estate opportunity arose. A big developer named Scott Resnick bought the building next-door to the garage.

Resnick knew he would knock down the building to build a much larger one. The only question was whether he would buy the air rights to Spellman's garage and perhaps cantilever his new building over it— or do something more creative.

Resnick decided to go the creative route. Spellman was surfing on Christmas Day in Montauk when one of Resnick's development partners approached her. They ended up at the Shagwong, a famously shabby Montauk bar. The developer suggested that Resnick buy the garage, knock it down, and have his new, even larger building rise from the two adjoining lots. Where would that leave Spellman? That was where the creative thought came in. What if Resnick, after knocking down her garage, gave the dealer two floors of corner space in the new, bigger building? To illustrate, the developer drew the plan on Shagwong cocktail napkins.

Spellman was intrigued. "But what about the columns?" she said. If this two-floor corner space was to house her gallery, she wanted it to be column-free space. Could that really be done? The developer drew on more cocktail napkins.

"I got two stories, no columns, and 12,000 square feet," Spellman later said proudly. The developers got her air rights and her garage, which gave them 18 new stories. Both parties were thrilled, though as more than one dealer would glumly note, deals like this were changing Chelsea, and the contemporary art market. More money, more condos, and less—much less—of the culture that dealers had brought with them from SoHo in the first place.

To Jerry Saltz, irrepressible art critic of *New York* magazine, the changing Chelsea landscape was depressing, but not nearly so much as the art he saw in the Chelsea galleries. Too many artists were making what Saltz called "decorator friendly art" or "process painting," abstractions pushed to all four sides of the frame, like wallpaper. Process painting was perfect for the walls of expensive homes, with cute inside references to artists and art trends, but signifying nothing. Saltz slammed it as all technique and no content, pushed to a wider market by social media, with ever more money making that market spin

round. Artist and critic Walter Robinson called the process painters zombie formalists. He didn't mean the term to be disparaging, exactly, but that was how it came out.[25]

The chief offenders? Saltz targeted Dan Colen, who used everything from street trash, grass, and tar to flowers, bird droppings, and Disney films to produce abstract installations; Adam McEwen, who produced obituaries of living people and photographs of chewing gum baked into sidewalks that replicated bombing patterns from World War II; and Parker Ito, who mass-produced art objects and painted immense still lifes. Saltz saved his sharpest jabs for a Colombian-born artist named Oscar Murillo, whose work seemed, as Saltz put it, "ridiculously derivative."[26]

Perhaps. But Oscar Murillo had just been picked up by David Zwirner. Maybe Murillo was on to something. Or maybe not. Over the next two years, the Oscar Murillo story would play out in ways that fascinated the contemporary art market, the more so for how much Zwirner's credibility as a leading dealer was at stake.

A Colombian Fairy Tale

2013–2014

IN MANY RESPECTS, OSCAR Murillo's story was about money. But there was more to it than that. Like the hero of a 19th-century French or English novel who comes from the provinces to the capital and manages a meteoric rise, Murillo had made his way from poverty in Colombia to the epicenter of the contemporary art market. Murillo's abstract paintings had panels of turbulent color, some with collages, some with news photos. They included dust and grime from the artist's studio, contained expressive if somewhat mysterious markings, and were often dominated by one painted word, like "yoga" or "burrito." By early 2014, when David Zwirner signed him up, he was art world famous and 28 years old.

Murillo had spent his childhood in La Paila, a village of about 5,000 people best known for raising sugar cane. His father was a mechanic at a sugar cane factory; his mother worked at a candy factory. "We had a sweet life!" he quipped.[1] As a boy, Oscar dabbled in art. That meant playing around with wooden boards, a bit of paint, and any objects that lay nearby.

Murillo was ten when his father lost his job and moved the family to London for a better life. Murillo said his father chose London out of naivete.[2] It wasn't a better life for Oscar: he spoke no English and spent several years feeling isolated and lonely. At age 16, he met his future wife, Angelica, his English improved, and life got better. He got a BFA at the University of Westminster in 2007 when he was 21, worked as a secondary school teacher, and then moved to his wife's hometown in

Venezuela. When Angelica got pregnant, he was shocked into a reappraisal: art was his only hope, and he better get serious about it.

Back went Murillo to London with his growing family. While studying for a graduate degree from the Royal College of Art, he spent his nights as a janitor in a high-rise building. Cannily, Murillo turned his night job into performance art. At the Serpentine Galleries, he convinced super curator Hans Ulrich Obrist to let him stage *The Cleaners' Late Summer Party with Comme des Garçons*, in which fellow janitors danced with the art world.[3]

Something of a feeding frenzy followed. In London, dealer Jonathan Viner vied for Murillo with Carlos/Ishikawa; Murillo had worked for Viner as an installer. In LA, dealer François Ghebaly saw the work and immediately put Murillo into a group show he was curating in mid-2011. "Oscar came to LA for the show—he was still at school," Ghebaly recalled. "Everyone wanted to work with him." By keeping him close, Ghebaly hoped to sign him up. That October, Ghebaly came to the Frieze London art fair and, at Murillo's invitation, stayed at the artist's home. "He was still cleaning offices, waking up at three a.m., then going to the Royal College."

Ghebaly offered to put Murillo in a group installation with two other artists that December 2011 at the New Art Dealers Alliance, a Miami fair concurrent with Art Basel Miami Beach. "I put the three artists together, but Oscar wanted to show a massive painting," Ghebaly recalled. "I thought it was taking too much from the other artists. Oscar got upset, and gave it to another dealer in the same fair." With that, Ghebaly said, he "lost control" of the artist everyone was now talking about. By then, he had noticed something about Murillo. "If you put Oscar into a room with hundreds of people," Ghebaly said, "I guarantee that within minutes, he will be talking to the most important person in the room."

London dealer Stuart Shave was the one who debuted Murillo's work in New York, at the Independent Art Fair in March 2012. Murillo was in New York that winter as a foreign-exchange student at Hunter College. The chatter began on the fair's opening day, March 8. Soon, it

reached Don and Mera Rubell, up from Miami for the nearby Armory Show. The Rubells moved fast, but not fast enough: by the time they circled back to buy a Murillo, Shave's booth was picked clean. The Rubells were shocked. "I told Stuart we wanted to meet [Oscar]," Mera Rubell recalled, "even though there was nothing left to buy."

Murillo agreed to meet the Rubells two days later at his tiny Hunter College studio. He spent the intervening hours working furiously. As Mera Rubell recalled, he had completed seven or eight paintings by the time they arrived. "They blew us away," she said. The Rubells immediately bought every one of those still-wet paintings. Then they invited him to come down that summer to be the first resident artist at their art foundation.[4]

In the meantime, Murillo participated in his first New York group show. Its organizer was Nicole Klagsbrun, Christopher Wool's early champion, who had seen Murillo's work in LA at the Ghebaly Gallery. Klagsbrun was thrilled at the buzz Murillo stirred from the Independent Art Fair. "My career is based on discovering talent and having them leave and make a lot of money," she said later. "But I had never seen it go so fast." Murillo was playing his role in the game too. "He was already playing it—the way he played me against other dealers... trying to figure out who the hot dealers were in New York," Klagsbrun noted. "He was also very charismatic—and he made himself look very much like Basquiat."

Brie Ruais, who worked in clay, was one of the group show's other artists. On opening night at the gallery, she and Klagsbrun were stunned by the arrival of a salsa group, playing loud, festive Latin music. The musicians proceeded to play for a good 45 minutes. Murillo had hired the band without telling Klagsbrun or his fellow artists. He thought it would be fun. The loud music made Murillo the focus of all conversation, which Klagsbrun suspected was entirely the point.

Throughout his five-week summer residency at the Rubells' in Miami in 2012, Murillo worked hard—so hard that by the end of it he had more than 40 paintings. The arrangement with his new patrons was that whatever he created in that residency became the Rubells'. A

later summer resident, Allison Zuckerman, described the pay as a stipend. "They gave me a stipend: 'Everything you make here, we'll keep.' The stipend was the price. I had in effect sold the paintings to them." Zuckerman wasn't unhappy about that. As she noted, "I could have done stick figures on toilet paper. The stipend would have still paid for that work."

For Murillo, it was a deal that made sense. The Rubells would add their new Murillos to their private collection and exhibit some of them to the public in their warehouse-turned-*Kunsthalle*. If the value of the work rose, so would the value of the Rubells' contemporary art foundation. The publicity that all this reaped for Murillo would more than compensate for the work done—at least so agreed the Rubells and Murillo.

By now, Murillo had begun selling new paintings to a controversial LA collector/dealer named Stefan Simchowitz, who in his own way exemplified the eager speculation and rising prices of the current art market as much as Murillo did.[5] "I saw his art, I pounced, I pounced hard, I pounced fast," Simchowitz would say of the artist whose work he ran across by chance at LA's Nicodim Gallery in 2011. Simchowitz bought all the Murillos he could find. "I certainly helped promote him at the early stages because I took such an aggressive and swift position. It was like pushing the sleigh out of the gate at the luge, you know?"

Simchowitz hadn't yet become the notorious "patron Satan" of the art world, as the *New York Times Magazine* would characterize him in early 2015, but he was considered a speculator.[6] He was also a character to all who met him, bristling with genial arrogance, riffing in philosophical terms about the market that he was about to transform. "I want authentic structures of cultural distribution," he would exclaim, "based on people collecting the work in different price points!" Often he referred to himself in the third person, as if plucked from a Saul Bellow novel. "There's not a guy in the world who has helped more young artists than Stefan Simchowitz, who's risked more," he declared. "But people don't see it."

The son of a South African corporate raider and art collector, Simchowitz had early success with a tech start-up—MediaVast, which he

sold for a reported personal profit of $4 million—and embarked on a seven-year quest to build a collection of unknown but, so he felt, commercially promising artists.[7] He claimed to buy works for as little as $500, and whenever he could, he bought in quantity.[8]

One of Simchowitz's first finds was Joe Bradley, the young abstract artist who had spent his formative Lower East Side days partying with his pals in the windowless Canada gallery. Simchowitz began buying Bradley paintings in 2010 for very little: $6,000 each, by one report, or $4,000, by another.[9] Five years later, Bradley would be a Gagosian artist, opening shows around the world and selling primary works for hundreds of thousands of dollars.

"I was the biggest collector of Joe Bradley!" Simchowitz declared years later. Simchowitz thought he would become Bradley's dealer. Instead, Bradley went with Gavin Brown who, as Simchowitz told the story, then gave Bradley six weeks to produce a whole new body of work for a show in Brown's gallery. And when Bradley managed the feat and invitations to the opening went out, Simchowitz didn't get one. "I was so livid because I'd supported this guy! And I realized, this system is never going to appreciate what I've done, so I must ignore it, I must find my own base, my own coalition, my own client base, my own artists and system of distribution."

Social media would be fundamental to Simchowitz's vision. He posted at the drop of a hat, promoting his newest discoveries online and trying to sell them directly to third- and fourth-tier Hollywood executives who felt they needed art on their walls. In doing this, Simchowitz routinely met scorn and rejection from other dealers.

Not all the old guard rebuffed him, however. Irving Blum, still moving briskly some 50 years after his seminal Warhol show in LA at the Ferus Gallery, was close to Simchowitz's father, Manny. They lunched together often, and Stefan would join them. Jeffrey Deitch was intrigued by Simchowitz too. Deitch was one of Simchowitz's heroes: back in SoHo, Simchowitz had gone to just about every one of the street-art performances that Deitch called his "projects."

Singed by his experience with Joe Bradley and Gavin Brown, Simchowitz moved with more stealth on his next find: Oscar Murillo. Later, he claimed to have bought 34 paintings by the then-unknown artist for as little as $1,500 each and kept them for himself.[10] One dealer familiar with Murillo's market suggested that Simchowitz could not possibly own more than 16 or 17 works by the artist. If so, Simchowitz had still done well. He felt Murillo was "probably the most significant artist to have arisen on the art scene in the past forty years." The art market groaned; Simchowitz got press.

As paintings by the young Colombian began showing up at auction and causing his secondary market to soar, other dealers cried foul. Simchowitz was flipping them, one after another, they declared. *New York* magazine christened him "the greatest art-flipper of them all."[11] Simchowitz flatly denied this. "I never flipped." One thing was clear: whoever was putting early Murillos up for auction was making money. Between November 2012 and January 2014, 46 of Murillo's paintings were sold on the secondary market for prices that went as high as $401,000.

What Simchowitz did do, gleefully, was bait the press and the mainstream market. What was so wrong with flipping anyway, he teased? "The more flipping, the more 'viralization,'" he declared, using one of his favorite philosophical tropes. Primary and secondary sales were pushing each other up. Simchowitz rolled his eyes when he heard galleries talk of "placing" work in the right collections. "It goes to rich old people! Who live in badly designed houses in Beverly Hills. Better to sell art online or directly to buyers, and not fancy buyers either." Simchowitz had no waiting list, he said proudly. He sold to anyone willing to buy.

By mid-2014, Simchowitz was the bête noire of the contemporary art market. But his approach seemed to be working. In his modest Beverly Hills gallery, he maintained a staff of at least six. He wasn't just a dealer, he said. That paradigm had changed. "Collector, dealer, consultant—I'm a Swiss Army knife," he chortled. "If you pay me enough money I'll shine your shoes right now."

How much business Simchowitz did was impossible to tell. "In my opinion I am the new center of the art business," he declared. "I am amongst probably the five most famous art dealers in the world. Larry Gagosian, David Zwirner, Iwan Wirth, maybe one other—and me! Would you agree with me?" Simchowitz made his claim with care. He didn't say he was among the world's most successful dealers, only among the most famous. True, he drew a lot of coverage, starting in 2014. But a Google search of his name in 2018 would produce about 30,000 hits; a search for Larry Gagosian came up with 274,000 hits. Perhaps there were different ways of measuring fame.

THE OSCAR MURILLO PAINTING THAT SOLD at auction for $401,000 on September 19, 2013, did not benefit the artist financially, but it established a new market for his work. The anonymous buyer was said to be actor and collector Leonardo DiCaprio; whether he would ever make a profit on his purchase remained to be seen. The more important question was who would guide the market's hottest new artist? Simchowitz? Murillo's small London dealer Carlos/Ishikawa? Isabella Bortolozzi of Berlin, who had also dealt in Murillo's work? Or one of the megas?

Murillo took almost a year to make his choice, after his Art Basel Miami Beach debut at the Rubell Family Collection in December 2012. He moved with care, showing works in numerous solo shows at small galleries. But if he had hoped to stay under the radar, he failed. After viewing Murillo's latest solo show at LA's Mistake Room, a small nonprofit of which Murillo was a founding board member, the *Los Angeles Times'* David Pagel called the show a Mannerist mess.[12] "Think Cy Twombly on a very bad day, his deft touch replaced with ham-fisted brutality."

Soon after, Murillo signed with David Zwirner. "With Oscar, I made clear to him that his gallery was completely mismanaging him," Zwirner recalled later. "It was opening his career to speculators, pushing the prices up, making a market—and making money." Making money, but not building respect.

Jeffrey Deitch had his doubts about the move. "Is Oscar Murillo's career going to be more interesting and dynamic and rewarding to him by being with David Zwirner than if he had stayed with Carlos/Ishikawa in London, where he's hanging out with other artists of his generation?" Deitch mused. "I'm always more enthusiastic about the model where the gallerist is about the same age as the artist, and they grow up together and establish something together."[13] In fact, Murillo would be represented by both dealers—the one in London and the other in New York—but Deitch clearly felt Murillo would be more influenced by Zwirner than Carlos/Ishikawa, and not necessarily for the better.

A lot was riding on Murillo's first solo show at Zwirner in New York, set for April 2014. It could be a career maker—or a giant buzzkill. Murillo's concept was to import 13 workers from Colombia and create a semblance of the candy factory where four generations of his family had worked. Zwirner duly ordered the necessary assembly-line machinery and helped secure visas for the workers. *A Mercantile Novel*, as Murillo titled the exhibit, opened with the workers at their stations, turning out the silver-foil-enclosed, chocolate-covered marshmallows marketed in La Paila as Chocmelos. The show seemed meant to raise issues of globalization, outsourcing, and immigrant workers, but as one critic noted, it seemed as sterile as the gleaming assembly line and the white plastic body suits the workers wore. "Obvious," "laborious," "macho," and "self-flattering," were some of the judgments, harsh for an artist not yet 30. And why was Murillo selling factory parts from the show, rather than paintings? At up to $50,000 each, the parts seemed a risible exercise in ready-mades for a concept not quite thought-out. The *New York Times*' Roberta Smith wondered if there wasn't a mercantile motive behind it all. "As the little packages of candy pile up in the front of the gallery," she suggested, "it seems likely that a similar excess of fresh Murillo canvases is changing hands in the back."[14]

Murillo would have future shows, and Zwirner would support him, whatever private embarrassment he might have felt in the aftermath of *A Mercantile Novel*. "Everyone can have their opinion," he would say later, "but I'm dealing with a young artist who has boundless energy

and is supported by a lot of collectors. That speculative bubble is behind us, and we have a real career here."

OSCAR MURILLO'S SHOW HAD BARELY CLOSED in mid-June when a career retrospective for Jeff Koons opened uptown at the Whitney. The two artists were as different as Koons's gleaming, imperfection-free sculptures were from Murillo's messy abstract paintings. Yet both were brilliant at courting controversy and contradictory reactions. Perhaps, in 2014, that was what contemporary art was really all about: talk boosted prices, which led to more sales. The higher the sales, the better the art. Or so Koons seemed to believe.

Koons, in talking about his art, sounded so superficial as to seem robotic, though one had the sense, after hearing his cheerful explanations, that he knew exactly how he was being perceived and strove for just that effect. His commentary was the verbal equivalent of his art. Yet here he was at the Whitney—and, to many critics, deservedly so.

How much Koons impacted contemporary art was debatable. It was probably fair to say he influenced his fellow factory-line artists, among them Paul McCarthy, Gerhard Richter, Urs Fischer, Takashi Murakami, and a burgeoning LA-based star, Sterling Ruby. Yet for better or worse, he had created a brand so recognizable that no one tried to imitate it. Perhaps his greatest influence was in how other artists saw him exercise power—art-market power—by showing at multiple dealers in one venue: New York.

For Koons, the trend had begun with his short leave of absence from Gagosian to show at Zwirner in 2013. In doing so, Koons had demonstrated that even a top Gagosian artist—especially a top Gagosian artist—could pretty much do as he liked. Soon he would do shows with Robert Mnuchin and French dealer Almine Rech, all while remaining, in some sense, a Gagosian artist.

Richard Serra, a close friend of Gagosian's for decades as well as his artist, had tried Koons's move with a show at Zwirner too. "I have no intention of leaving Larry," Serra declared of Gagosian.[15] But the Zwirner show would be the first of several collaborations between

Zwirner and Serra. Richard Prince was another apostate. In a period of 18 months, as Gagosian noted, Prince showed in five different New York galleries: Barbara Gladstone, Blum & Poe, Luxembourg & Dayan, Nahmad Contemporary, and Skarstedt. And all this as a Gagosian artist! "Which I thought was crazy," Gagosian declared later. "Then he wanted to be his own dealer, so he was basically selling work out of his studio, which thank God he doesn't do anymore, as far as I know."

Soon other Gagosian artists, among them Mark Grotjahn, would be taking on multiple dealers, both in and out of New York. And Grotjahn, according to the *New York Times*, would also be selling directly from his studio.[16]

Gagosian just didn't get that. "Collectors want provenance, they want to know there's some control," he noted later. "You can't sell stuff out of the studio." That wasn't quite true: painters from Courbet to Manet to Picasso had all sold from their studios, and those sales had not clouded the paintings' provenance. But they did muddy the business, sometimes to the dealer's detriment.

Gagosian was hardly an unbiased observer, but his pitch against multiple dealers seemed heartfelt. "I think it's a mistake in most cases," he maintained. "They get kind of a sugar high, they get a little extra distribution. But...it can look like the artist is desperate. Why does he need so many shows? Do they have to sell something every minute? I mean, Cy Twombly, no one else worked with him in the whole time that I did. He said, 'I just want to talk to one dealer.'"

The trend was bigger than any dealer, even Gagosian, could control. The fact that an artist like Hirst had assets estimated to between $300 and $400 million liberated him from anything he declined to do. "These artists are so much richer than at any time in the history of art," noted one New York City dealer. "They no longer have the loyalty they used to." With that kind of freedom, top artists were choosing when and where to exhibit, which dealer was right for which show, and what the financial terms would be. Jasper Johns had led the way in that regard, calling his own shots for decades. The elusive David Hammons, despite his ever-growing success, remained dealer independent as well.

With many of these artists and their primary dealers, the profit split was changing from fifty-fifty to sixty-forty, in the artist's favor. One prominent downtown dealer was said to grant a ninety-ten split to his most prominent artist. The cachet of representing that artist was apparently well worth the sacrifice of representing him almost for free. "The question for Gagosian," one art world insider suggested, "was what slice of Prince's primary sales he could still demand, when his marquee artist kept showing at other galleries, which presumably wanted their share of the pie too."

Of all these small desertions, the ones that hurt Gagosian the most were Koons and Serra. "I was very upset about those," he admitted later. But he could see as well as anyone that times were changing, and top artists were calling the shots in a way they never had before. "These artists...they kind of do what they want," Gagosian said with a shrug of resignation. "They want to try another gallery; they want another context. Or Jeff [Koons] wants to sell a lot of work....It's sort of his thing, he needs more coverage, more sales." Some 90 percent of Koons sales were still through Gagosian, the dealer hastened to add. But there was, for the first time in his career, a hint of defensiveness about where things might go from here.

The Art Farmers

2014

WITH THE OPENING OF their 24,700-square-foot New York gallery on West 18th Street in early 2013, Hauser & Wirth had sealed a reputation as the most high-spending—and idiosyncratic—of the megas. There was a perception—which Iwan Wirth did nothing to discourage—that the gallery was happy to wait as long as it took to bring slow-emerging artists to fame. Wirth's artists might have great futures, but they needed his unstinting support. "It kind of suited me," Wirth said. "I'm a facilitator—a fixer. That's why I get up in the morning. So to have an artist who says to me, 'I've always wanted to do this.' That's what gets me going. What does the artist need? What can I do? If you follow that, I was convinced, great business would follow."

Gagosian, for one, felt Hauser & Wirth was all about money, and declared himself unimpressed. "Money can help for sure, but it's a funny business," he said later. "You can't just throw money at Jasper Johns. And that's what gives it an integrity....Business people who collect art, they say, 'Why don't you just write a big check?' It's not that easy!" Perhaps. But Iwan and Manuela were probably having more fun than any of their rivals—and their fun had a serious purpose.

It was in July 2014 that the Wirths opened their newest gallery, Hauser & Wirth Somerset, on the 100 acres of Durslade Farm, in England's West Country on the outskirts of Bruton. The vision that brought the Wirths and their four children to this rural setting was Manuela's, and it said a lot about her.

After a bucolic childhood in a mountain-backed town in eastern Switzerland, where Manuela and her two younger siblings skied and hiked, the children's father unexpectedly died. Manuela, ten years old at the time, was told she would have to pitch in and care for her siblings while her mother took over the family firm. This was no doubt true, but not the whole story. The family business was Fust AG, a Swiss chain of household-appliance retail stores. In 1987 it would go public, and in 2007 it would be sold to Coop Group for approximately $800 million.

Manuela trained as a teacher and spent several years instructing Swiss schoolchildren aged 7 to 16 in home economics, arts, crafts, and sports.[1] She was in her early twenties when the teenaged Iwan came knocking at her family's door, daring to ask her mother to invest in two paintings with him—the quirk of fate that led to marriage and art dealing, first in Zurich, then New York.

Both Iwan and Manuela had realized that London was the next frontier and had opened their first gallery there, in 2003, on Piccadilly. Two years later, the family moved from New York to a mansion in Holland Park. The plan was to raise the children in London, but in 2005, Manuela put her foot down: she wanted a country life. Art would just have to fit in.

Soccer star David Beckham and his wife, Victoria, eventually bought the Holland Park mansion for 31.5 million pounds cash in 2013. By then, Manuela was long gone, having packed her husband and four children into a camper van and headed out to Somerset, where she and Iwan had bought a 15th-century farm with 500 acres. For more than a year, that was how the family lived, in the camper van, as daily work crews fixed up the medieval house that they would call home.[2] The children befriended sheep and pigs and learned how to milk cows. They went to the local schools, and friendships were struck, among both the children and parents.

Iwan and Manuela found themselves wondering how they could help make art available to their neighbors in Somerset. In 2009, they bought a nearby 100-acre property, Durslade Farm, with its various derelict outbuildings. The fields had lain fallow for 20 years. "We felt

it was morally wrong not to work the farm," Wirth said, "and not to do it in a good way." The couple got planning permission to restore the buildings, and construction started later that year. Durslade would be a functioning farm again, albeit an elegant, even elitist, one. The stables became an art library. Other outbuildings became galleries, five in all. For guests wishing to make a stay of it, the old Durslade farmhouse had six guest rooms, charming if rather dear. A single midweek night in summer cost 600 pounds, a three-night weekend 3,500 pounds.

By the time Durslade opened to the public in July 2014, the Roth Bar & Grill was there to serve, with farm-to-table local specialties. Art had arrived too. Subodh Gupta's 16-foot-high, stainless-steel milking pail dominated the farmyard. In the threshing barn, Phyllida Barlow's multicolored pom-poms hung from the ceiling; out back, two large granite eyes by Louise Bourgeois seemed to observe the crowd, like a giant cat. Artist Pipilotti Rist—the one who had smashed Iwan Wirth's windshield for a video project—was one of the first to stay on as an artist in residence, even before Durslade opened to the public. As an artwork to be donated to the farm, Rist made a chandelier of underwear.

For Manuela Wirth, Durslade brought all of her passions together: food, family, community, and art. For her and her husband both, women's art was a passionate priority. "I'm a feminist," Iwan flatly declared.[3] "I've always felt that women artists in the twentieth century are dramatically underrated, underrepresented, and underpriced." Manuela's mother had felt that way too; she had long collected the work of women artists, and now Manuela carried that on. Despite her quiet influence behind the scenes, Manuela publicly downplayed her role. "I don't like art fairs," she told a British interviewer. "I'm the worst salesperson, and I've never sold a piece of art."[4]

To the surprise of the art world, Durslade Farm became an overnight success. The expected 40,000 guests in its first year swelled to 175,000. Along with a steady flow of art weekenders, Hauser & Wirth welcomed its artists to stay in nearby Bruton, in an historic building converted to studios. Happily ensconced, they made more art. All this was part of Manuela's vision. "We are the art farmers," Iwan said with

a laugh from his New York Chelsea office. "And this will change our business. I do think the role of art, and artists, and of the art industry, in an increasingly challenged world, has to step up. It's not enough to give drawing classes to children, and give the access but miss the need."

To other dealers in London and New York, there was, admittedly, something about Durslade Farm that stuck in the craw. Was this art philanthropy that Wirth was embracing, or high-grade experiential tourism? And was Durslade Farm an inspired foray of art into the countryside, or a way of building loyalty among its artists to fatten its bottom line? "On the one hand, the farm is great," said one dealer. "On the other hand, how does it detract from servicing and building the careers of your artists? I'm not going to start a vineyard, or restaurant, or open a hotel—all this bougie bullshit. What's next: Hauser & Wirth shoes?"

Actually, what was next was a limited-edition perfume named Manuela, its price available on request.

THE GRUMBLING DEALER WAS RIGHT IN one sense: what shoes and sculpture had in common was branding, and the megas, all four of them, were branding with a vengeance by 2014. Hauser & Wirth had the only gentleman's farm, but the others had sleek new galleries in multiple markets, PR departments, and books and articles cranked out by art historians, art critics, and journalists happy to lend their names to essays that paid, on average, $10,000. The better the branding, the more likely a collector was to buy his art there.

Out in LA, one mid-level dealer was fighting this trend, and succeeding. In September 2014, David Kordansky relocated again and opened his latest gallery, just off South La Brea, a wide boulevard in a bleak zone between two established LA gallery clusters, Highland Avenue and Culver City. Once again, he would have to hustle, though this time he had the kind of space that artists would want to call home: 12,700 square feet. It was a compound large enough to put him in league with Blum & Poe, and with another rival, Regen Projects, whose founder, Shaun Regen, had planted her flag in LA back in 1989 and

given Matthew Barney his first solo exhibition. Would collectors come to this cheaper but more remote venue? At least they needn't fear getting lost as they once had, not with GPS and Uber.

Whether collectors would seek them out remained an open question. "LA is not a functional gallery city," declared dealer Michele Maccarone. "It never has been and may never be. It's large and spread out. Wealthy Malibu clients will not come downtown." And downtown was a world apart from the West Side and Santa Monica, which had their own gallery enclaves. Yet Maccarone was planning her own downtown gallery at 300 South Mission. It would open in a year, in September 2015, literally the day before real-estate developer Eli Broad's new museum, the Broad, opened its own doors. The point, as she put it, was that LA was where the artists—a lot of them anyway—lived and worked now. "I want to build a beautiful space to do exhibitions that may or may not sell." Either way, she would strengthen the bonds with her artists.

THAT FALL OF 2014 IN NEW York, MoMA curator Laura Hoptman gathered work for a generation-defining show, a cross-pollination of East and West Coast contemporary artists. Hoptman picked 17 artists for *The Forever Now: Contemporary Painting in an Atemporal World*. The artists were all painters—or, as she put it, "stalwart practitioners of painting qua painting."[5] Her choices said as much about the contemporary art market as they did about the art on its walls.

Hoptman started with a term that science fiction writer William Gibson had coined in 2003: atemporality. He meant it to describe a "new and strange state of the world in which, courtesy of the Internet, all eras seem to exist at once." This, Hoptman wrote, was "the Forever Now." This was where art now lived, too, Hoptman suggested, so that whatever an artist tried to do, he couldn't help but imitate and repurpose the past. Roberta Smith of the *New York Times* deplored the show's "lack of daring," and said it looked "far too tidy and well behaved... validating the already validated and ready for popular consumption."[6] David Salle, the artist, concluded in his review that "two words one

should probably avoid using in exhibition titles are 'forever' and 'now,' and Hoptman uses both."[7]

Of the show's artists, most were already art-market stars. Mark Grotjahn's newest "circus" paintings, their oscillating rays obscuring what might be circus-clown faces, were being sold for $5 to $6 million at auction now. Rashid Johnson, now Kordansky's artist in LA and Hauser & Wirth's in New York, showed black wax abstractions—the wax, at least, reminiscent of Jasper Johns. Julie Mehretu's Goldman Sachs mural had made her famous. Laura Owens, the cofounder with Gavin Brown of 356 Mission in downtown LA and the pioneer who mixed playful figurative drawing with colorful zigzags and bursts of bright color, was being spoken of as one of the West Coast's most promising artists. "Most of these artists already fetch enormous prices for their work," noted one critic. "Indeed, the show's opening found dealers and art advisors parked in front of artists' work taking sales orders, as if at an art fair." Even the best-known artists, it seemed, were being seen as self-promoters.

Justifiably or not, the artist who took the most critical abuse was 28-year-old Oscar Murillo. "While it's not his fault for being shot out of the canon too early," punned David Salle in his review, "I feel one has to say something. . . . His grasp of the elements that engage people who paint—like scale, color, surface, image, and line—is journeyman-like at best." Murillo was too young to hide his ambition, and the hubris of his solo show at Zwirner had put him much too close to the sun. He needed what one of his fellow "Forever Now" artists, Joe Bradley, had: a somewhat weathered, aw-shucks sense of cool.

At 39, Bradley still dressed like a San Francisco beat poet, with moppish hair, a Fuller Brush mustache, lumpy jackets, and jeans. Fellow artists admired the chances he took. Dealers saw a talent whose quirky and changing styles, rather than hindering his market prospects, made him that much more compelling. Collectors could learn about Bradley's three different bodies of work and invest in all three. They could also see the dry humor in his work, if their art advisors pointed it out to them.

Bradley's inclusion in the MoMA group show ratified his growing fame. As his secondary prices rose to the low seven figures, he began to seem the iconic contemporary artist, the one whom the zeitgeist had chosen to bless with glowing reviews *and* money. He wasn't quite in the epicenter of contemporary art, not yet. But after Grotjahn, he was probably the fastest-rising artist in MoMA's show, with another big career move soon to come.

Bradley had grown up in Kittery, Maine, a coastal town at the southern tip of the state. His father was an emergency room doctor, his mother a homemaker who raised nine children. Joe was somewhere in the middle, a quiet child who loved comics and drew them for fun: everything from Marvel superheroes to Robert Crumb. Not until after high school did he stop to notice a painting. One of the first that stuck in his mind was by Alex Katz.

Bradley enrolled in the Rhode Island School of Design in the mid-nineties. Experimental music was all the rage. Bradley joined a band called Barkley's Barnyard Critters. Its members wore different animal costumes—Bradley, a passable drummer and guitarist, wore a lamb outfit, going by the name Charlotte. Reputedly, the group ended their gigs with episodes of general mayhem.

After graduating in 1999, Bradley came to New York City, found work at an antiques store, and painted on the evenings he wasn't playing in a band called Cheeseburger. One night, a bemused young art collector and dealer saw Bradley perform. "I remember him wearing only over-tight white jeans and rainbow-colored suspenders and writhing on the floor," recalled Kenny Schachter, who was not yet the chronicler of the contemporary art market he would become. Schachter bought one of Bradley's paintings, though "painting" was perhaps too grandiose a word for it. Schachter called it "a fey landscape with pinkish colors and this atmospheric sky with little boats in it. There was something extraordinarily great in its badness."

Schachter gave Bradley an early show, in 2003, in a tiny West Village project space. None of Bradley's works sold, so Schachter bought them all, and had the prescience to keep them. For the next two years,

Bradley vacillated between playing in bands and getting his art into small group shows. That was when the four founders of the Canada gallery took him up.

By now, Bradley was doing what he called his robot paintings. Using simple pieces of colored paper, he made basic figures, blocks of color that seemed to embody humor and wistfulness. He had a solo show of them at Canada in 2006, to no particular end.

For Bradley, the turning point was the 2008 Whitney Biennial. He installed a whole room of his robot paintings, and the work brought buyers. That was it for the robot paintings, Bradley decided: on to the next thing.

Bradley started making figures even more elemental. They were simple line drawings, made with a grease pencil on raw canvas. Some were stick figures—truly a five-year-old's métier. Some were emblems: *Superman*, for one, was a simple S enclosed by a single, crest-shaped line. Bradley called them his Schmagoo paintings—a beatnik term for heroin. The paintings had a gritty feel to them—for good reason. "He basically got down on his hands and knees in the gallery and drew pictures on monochrome painting," explained Canada's Phil Grauer. Then he dragged the white canvases around on the floor, unprimed so they collected dust and dirt. "Jesus, Joe," said Grauer, only half joking. "Way to destroy what little career you had." Critics did trash the Schmagoo pictures. But a curious thing happened. People began talking about them, debating them, and then buying them.

Gavin Brown heard about them too. Rob Pruitt, one of his artists, took Brown to Bradley's studio. Brown came away with mixed feelings. "There was something impolite about the way he thought about painting," he mused later. That was a plus. He didn't particularly like the work when he saw it. "But it did stick with me," Brown admitted. "It annoyed me and I returned to it."

"Joe didn't go to Gavin directly from us," said Canada's Sarah Braman. "We consigned a show to Gavin." But, as Grauer noted, "With Gavin you get along, and then it falls apart."

After a brief period, it did fall apart, and Bradley joined Brown with a first show in 2011, embarking on a new body of work: colorful, smudgy, abstract portraits in blues, yellows, blacks, and greens, not unlike Joan Mitchell's Ab Ex paintings of the 1950s. "When you put all your stock into a character," said Canada's Grauer, "and a guy across the street who doesn't even understand the art takes him away..." To Gavin Brown's annoyance, Bradley insisted on handing the occasional painting over to his four friends at Canada. Its sale could cover a big chunk of their yearly overhead.

COMPARED TO CANADA, GAVIN BROWN WAS establishment now, and he was duly noted in the *Guardian's* list of key art world figures in May 2014. In sizing up Brown's impact on the market, the *Guardian* saw beyond money. "British bearded ex–bad boy, self-described misanthrope, and erstwhile proprietor of Passerby, New York's much missed 90s art-world nightclub," the British newspaper gushed. "The man who proved you can make it big in the art world without selling out."

Brown had known for some time that he would have to give up his sprawling West Village space on Greenwich Street; the rent, as at every gallery he had ever occupied, had grown prohibitively high. In 2015, he shifted his base to another gallery on Chinatown's Grand Street and, just for the fun of it, opened a gallery in Rome. Gagosian had established his own footing in Rome with a majestic former bank building. Brown's was a tiny eighth-century church, more like a family shrine. "It's not that I was looking to open a place in Europe," he declared. "I was looking to open this place in this building."[8]

Would the Grand Street space be enough in New York? Or was it a segue? By the spring of 2015, Brown had his answer. He would maintain Chinatown—and open a vast new gallery in Harlem.

Before closing his West Village space, Brown staged a four-day farewell show on Greenwich Street. His inspiration was *Untitled (12 Horses)*, a 1969 show by Arte Povera artist Jannis Kounellis featuring 12 live horses. At 80, Kounellis was thrilled to have his radical work recreated

in New York. The horses were tethered to the walls in the capacious gallery, with plenty of hay. It was a farewell of sorts for Kounellis as well: he would die in 2017.

Brown had moved his family to West Harlem four years before, so the one-time brewery at 439 West 127th had long intrigued him as a possible gallery space. Finally, he took the dare. "After 50 years of being empty—it had been waiting for me," Brown declared. "And I've never looked back."

Among Brown's rough charms was faith. Faith that he could find inspiring artists and mold their careers, faith that as a midsize dealer he could somehow make a living. It was faith, and only faith, with no proof to back it up, because in truth the mega dealers were growing ever more powerful, and the big money was flowing to them. There didn't seem to be a place, in that circle of money and art, for midsize galleries, let alone galleries all the way up in Harlem.

Or was there? Soon enough, Gavin Brown would know, one way or the other.

VYING FOR SUPREMACY

2015–2019

A Question of Succession

2015

L ARRY GAGOSIAN TURNED 70 in April 2015 with a big dinner at Mr. Chow, his favorite New York restaurant, where he was serenaded by singer-poet-artist Patti Smith. He had built his way up to 16 galleries and spent most of his time flying from one to another. "He likes cars, he likes boats, he likes planes, and he likes paintings," said his friend Jean Pigozzi. "I think that's his main reason to have galleries around the world, so that he will have action twenty-four hours a day."[1] From his flagship gallery at 980 Madison Avenue, where he now leased 60,000 square feet, Gagosian presided at a massive desk adorned with trinkets from his travels, among them a jack-in-the-box of George W. Bush and Russian nesting dolls painted to resemble various despots. On the walls were works by Francis Bacon, Pablo Picasso, and Cy Twombly. Despite the art, the office had a closed-in feeling about it—it wasn't a corner office, and across its one wall of windows, the shades were drawn, perhaps to safeguard the art. Nor, despite the art, did it have any sense of grandeur, as one might expect of an art world luminary. It seemed, in short, the office of a man too focused on his work to worry about the furnishings around him.

By now, the dealer's annus horribilis was behind him. Don Marron, the financier and longtime collector, felt his old friend had reached a new level. "In the first place, he has every mega buyer," Marron noted. "First stop is Larry. And like any great dealer, he doesn't sell to just one or two collectors, he sells to a broad range. Also, while he makes some high-profile money on the secondary market, it's the selling of primary

paintings now that yield fifty percent." From his early, scuffling days trying to deal in primary art, Gagosian had become exactly the dealer he wanted to be. And no one was more aware of the irony ingrained in that success.

"I mean, nobody really needs a painting," the dealer mused around the time of his birthday to the *Wall Street Journal* about what he did for a living. "It's something you kind of create value for in a way that you don't with a company. It's an act of collective faith what an object is worth. Maintaining that value system is part of what a dealer does, not just making a transaction, but making sure that important art feels important."[2]

After decades of serial monogamy, Gagosian had settled into a more peaceable life with a gentle blonde divorcée. He shared season tickets to the New York Knicks with hedge funder Steve Cohen, perhaps his biggest client, and spent Thanksgiving with Ronald and Jo Carole Lauder, two of his other biggest clients. He had a villa in Saint Barts and often entertained there, but then he entertained, too, in New York, Miami Beach, and Beverly Hills.

"I think he's much more comfortable in his own skin now," suggested artist Jenny Saville.[3] "He can have a temper but it doesn't explode in the way it used to, over the lateness of a bill in a restaurant or the taxi driver who goes the wrong way. He's not as angry as he was—but I've never seen him angry with his clients."

Gagosian was said to read voraciously on his Gulfstream jet. The gallery published some 40 art books a year, many with texts by well-known curators and critics. Soon he would happily declare that he had published, in all, 500 books. He would start up a new magazine too— not some humble monthly easily rolled up to swat flies, but the lush, perfect-bound *Gagosian Quarterly*, with lavish, heavy-weight paper and articles on the gallery's artists, and more luxury-goods advertisements than most high-end magazines.

Gagosian was reputed to have an astonishing personal collection by now, valued at $1 billion, including works by Koons, Lichtenstein, Serra, and, of course, Twombly. He said he had sold almost none. "If

you start doing that, then you don't have a collection, it's just inventory you hang in your house," Gagosian told one interviewer. "I'd like to be able to keep it together...somewhere. Probably I'm not going to build a private museum, but I would like it to live on as a beautiful collection."[4]

Gagosian didn't have a succession plan for his business either, at least none that he chose to reveal. "I've built this monstrosity of a business," he told the *Wall Street Journal*, "and I've got no choice. It's like Sisyphus." Recently, a number of top Gagosian directors had begun meeting on a regular basis to plan a succession—a "star chamber," as one rival dealer put it—but it was no substitute for a son or daughter who had grown up in the business and had the smarts to take it on.

Or was it? Scott Galloway, a professor of brand strategy at New York University's Stern School of Business, made the case that luxury brands—like Yves Saint Laurent (owned by Kering, and collector François Pinault) or Louis Vuitton (owned by LVMH, and collector Bernard Arnault)—often managed to survive their founders, as long as they had five key attributes. How many of those did Gagosian have? *Artnet News* toted them up.[5]

The first key attribute a luxury brand needed for corporate immortality, Galloway opined, was an iconic founder. By that, he meant a founder whose story was larger than life. Gagosian, with his humble start selling posters on sidewalks, then relentlessly dealing his way to the top of his field, was certainly iconic. The next was vertical integration. Absolutely: the gallery did it all. Global reach? Sixteen galleries in three continents checked that box. Premium price? Yes, again. Gagosian's goods, which happened to be art, sold at top prices.

The one key attribute that some might deny Gagosian was artisanship, but that wasn't really fair. The art on his gallery walls might stir debate, but it was always high-quality, as was everything else in his galleries, from frames to catalogues. Gagosian, like Saint Laurent, denoted class. With those five attributes instilled in a founder's business, the founder's death might actually enhance prospects. It served to airbrush imperfections and start the founder on his way to being a timeless legend.

There was, to be sure, an equally compelling counterview on the tricky business of succession in art dealing: art was unique, so was a founder's eye, and so, for that matter, was a founder's bond with his artists and buyers. Handing all that down to a second generation was a matter of delicate personal dynamics that few galleries had managed. Of the galleries that had lasted past their founders, Europe had Colnaghi, Marlborough, and Gimpel Fils, the United States had Acquavella in New York, Vose Galleries in Boston (founded in 1841), and that was about it.

David Zwirner had a promising candidate in his 27-year-old son, Lucas, who had joined the family business by developing its publishing arm. But while Lucas was tall, handsome, very smart, and extremely good at addressing a crowd, his father was just 53. One of Zwirner's daughters worked at the gallery, too, but she faced the same issue: a relatively young father.

Iwan and Manuela Wirth had four young children, but they might never get involved. "I don't believe in second-generation galleries because every gallery needs to have an identity, one soul," Wirth declared. Wirth was just as tough on Arne and Marc Glimcher of Pace. "Marc needs to prove he can leave his footprint on Pace," Wirth declared. "Whenever you walk in, you need to feel it."[6] Wirth didn't feel that footprint, not yet.

Perhaps that was selling the Glimchers short. Marc in his early 50s was now president and CEO of Pace. He was selling a lot of very expensive modern art and had a compelling second-generation vision based on the ways new technology could impact contemporary art. No one would know if he could stand alone until he did it. But he had learned a lot about how to get to where he was.

Marc had grown up not just with art but artists. "There were artists like Dubuffet whom you had to call monsieur," Glimcher recalled. "And others like Lucas Samaras and Bob Irwin, who were crazy uncle types." The talk would not be tailored for Marc and his older brother Paul; they had to step up. But the artists weren't the problem. "The toughest person in the room was my father," Marc said. "Expectations

were high." Samaras once asked the Glimcher family to pose in the nude for a series of Polaroid portraits he called the *Sittings*. Marc at 15 was the holdout. His father took a hard line. "You are embarrassing the family," he told his son. "You will go to Lucas's studio, and you will get undressed, and you will pose for him, or you will be in big trouble, mister." Reluctantly, Marc did.

Marc studied biological anthropology at Harvard, set on steering clear of the art business. But upon graduating he felt "a bit lost," as he put it, "and when you're a bit lost you want the familiar." At Pace, Marc shared a desk with another young seeker, Matthew Marks, and the two did the show of Picasso's notebooks that drove Marks to England when Arne, the proud father, gave his son too much of the credit. Between father and son there were tensions in the nineties, when Marc chose to study immunology at Johns Hopkins. But the real family break came in 1999 when Marc and his first wife, a pediatrician, went to Santa Fe to vaccinate local children, severing all gallery ties. His father was deeply hurt, and the son refused to communicate with him for the better part of two years. Marc spent a lot of that time in New Mexico with Agnes Martin, figuring things out. Finally, he called his father to say he wanted back in.

"A family business is a hard thing," Marc mused over a cup of hot chai in his modest, den-like Pace Gallery office. "If you have the ambition to succeed, you wish it was yours from the get-go, and that yours was the rags to riches story, and it takes 20 years to make you realize you will never be the founder. If you're very lucky, you become comfortable with it, and start to look forward instead of looking back."

Looking forward brought Glimcher to Palo Alto, California, where engineers and artists were talking to each other about a new kind of art: experiential. Seeing art in galleries was one kind of experience. But so was a 400-person collective from Japan called teamLab, which set up 18 simultaneous installations and sold tickets to cover their costs. And so was Studio Drift, a two-person collaboration, which under Pace's aegis and BMW's sponsorship sent 300 Intel drones into the night sky over Art Basel Miami Beach in 2017. Like starlings, they appeared to fly

in planned formation; like starlings, they actually moved to their own rhythms of movement and flight.

At Marc's urging, Pace established a new gallery in Palo Alto in April 2016—Pace's return to California—and focused on the urban implications of art. "We believe this whole form of experiential art connects to cities," he enthused. "It means that as cities are redesigned, artists are engaged in that process—all of which was predicted in the 1960s by Robert Irwin. Artists will create spaces with architects, because people want to engage with art, to have it be part of their lives."

Pace was still selling the works of modern masters: Alexander Calder, Willem de Kooning, Mark Rothko. But the future was what captivated Glimcher. "I have to go to the collectors, the fairs, they want to buy their $100 million artwork from me," he acknowledged. "But if that's the only solution, if you don't find a way to build out a team that carries a message of inspiration, then you will eventually be spread too thin and it won't work." Could a gallery be about neither its founder nor its founder's son? Marc Glimcher's bet was that it could—and must.

A DIFFERENT LEGACY CHALLENGE CONFRONTED VITO Schnabel, a first-generation dealer in a second-generation art family. At 30, Schnabel had grown up surrounded by his father Julian's big, splashy paintings—and his father's big, splashy persona. He had the connections to produce pop-up gallery shows for free as a teenager: real-estate developer Scott Resnick was a basketball pal and let Schnabel use unoccupied spaces. So did developer/collector Aby Rosen. Early on, Vito also showed a penchant for glamorous older women. But his parents had divorced when he was young, and being Julian Schnabel's son wasn't always easy. He found a first mentor in Arne Glimcher, his father's dealer at the time. "I remember Arne being around the most," he recalled. "I really love him." Bruno Bischofberger, his father's dealer in Europe, was another. Beginning in his early twenties, Schnabel spoke with the world-renowned Swiss dealer nearly every day: an education more useful, he felt, than any college could be. In those early downtown shows, he exhibited, among others, Rene Ricard, the poet,

painter, and critic who had helped launch Vito's father. In 2013, he opened a gallery of his own in the West Village on Clarkson Street. Eventually, he knew, he would take a space outside New York, and so, when an aging Bischofberger said in 2015 that he was letting his Saint Moritz gallery go, Schnabel jumped at the chance to take it on.

Schnabel knew exactly whom he wanted to show first in Saint Moritz: Urs Fischer, by then one of Switzerland's most admired living artists. But he also wanted to pay tribute to Bischofberger. "Urs had done candle sculptures before," Schnabel explained. "It was my idea for him to do Bruno."

At first, Fischer was hesitant. He didn't do portrait commissions, he told Schnabel. He chose his subjects out of love. "But I do respect that man immensely," he added. "Let me think about it." Soon enough, Fischer agreed, with one caveat. "He said, 'I want Yo Yo to be in there. She's so important—a great art mind and writer.' So he made the first multicolored candle, and the first woman, sitting with Bruno in their two favorite chairs." The inaugural Saint Moritz show opened in December 2015. Those were the statues that would travel to Art Basel in June 2017. Schnabel was just as clear about the show after that. It would be a presentation of new work by his father, evoking his most famous creations: his *Rose* broken-plate paintings, like the ones that had startled the art world back in 1979 at the Mary Boone Gallery.

Julian Schnabel's last few decades had been mixed. He had made three much admired films, but interest in his art was inconsistent, and his braggadocio had alienated much of the art world. His 14 years at Gagosian, after 20 years at Pace, had been an exercise in frustration. "He needs to come home," Arne Glimcher had told Vito, and so Schnabel had done just that. "I think he's really one of the great artists," Glimcher said, with the news of Julian Schnabel's return, and promised a "re-examination" of his work in museums around the world. Gagosian's response to the move, through a spokeswoman, was terse. "Gagosian Gallery never formally represented Julian Schnabel," she said, "and he was not one of the gallery's artists. We wish him all the best." In fact, Schnabel was among the artists listed on Gagosian's

website, and as recently as April 2014 he had been the subject of a solo exhibition at one of the galleries.

"I just left the baggage of what people would say or not say," Vito Schnabel said of the broken-plate paintings he made the subject of his second show in Saint Moritz. It was a chance to do something for his father that mattered as much as anything his father had done for him. And it was a success, to the extent that shows in Saint Moritz could be. For a while after that, Schnabel remained Saint Moritz's new kid in town. Then, in late 2018, there came word that a big-footed rival was coming: Hauser & Wirth was opening a large new gallery in Badrutt's Palace Hotel, its latest gambit in experiential art dealing.[7] Schnabel would just have to take that as good news.

ONE OF GAGOSIAN'S FEW UNFULFILLED DESIRES in his 70th year was to coax Damien Hirst back to his gallery, assuming the terms were right. Hirst's market still had ground to regain after his lackluster global spot painting show of 2012, and not every dealer thought he could get it all back. "His moment has passed," one English dealer suggested. "His early shows—sharks, flies—were amazing, but he kept on trying to make his work more and more sensational. Art has to endure to have meaning; his doesn't mean much." Gagosian was sure the doubters were wrong, and so was Jose Mugrabi. "Damien Hirst is in the same situation as Warhol was in the 1990s," the relentless collector said. "I love Damien at $10,000 and I love him at $10 million. The price is secondary because I know people love him, and in the end, they will pay for him."[8]

As Hirst's market inched back up, the artist had a lot to console himself with. He was reputed to be the world's richest living artist, with a fortune of more than $350 million.[9] He was so rich that he had been able to spend $38 million creating his Newport Street Gallery in London, which opened to the public in 2015, to exhibit his personal art collection. At the same time, he had spent $57 million for one of London's grandest mansions. It wasn't even to be his primary home; that was 24 acres in Combe Martin, a village on the North Devon coast. His

country home was Toddington Manor, a 19th-century estate with 300 rooms. As for working space, Hirst used a vast foundry near Stroud, Gloucestershire, and oversaw an art factory in the suburb of Dudbridge, where his company, Science Ltd., operated with a team of technicians.

All Hirst needed was a new idea, an idea as brilliantly commercial and compelling as his sharks in formaldehyde. In fact, he had one, and was pushing ahead in strict secrecy. One of the few people who had seen it was Gagosian. The dealer was very, very pleased.

GAGOSIAN'S NEWEST ARTIST HAD SIGNED ON in November 2015. Through most of that year, Joe Bradley had stayed at arm's length from Gagosian, doing shows at Gavin Brown and other galleries in a sort of waiting game. But at 40, with a wife and young children, he could ill afford to ignore the dealer's enticements forever.

"I don't think Larry particularly liked the work when he saw it," Gavin Brown suggested later. "Larry wasn't interested until it was lucrative." Other dealers, of course, noticed the spiking auction sales too. Bradley's average auction price in 2015 was $841,000; one work sold for $3.1 million. The artist himself exuded a crowd-pleasing mix of courage and uncertainty. Suddenly he was the artist that every dealer wanted.

The press release in November confirmed what the art world had been expecting. Joe Bradley was now a Gagosian artist.[10] He would have nothing more to do with Gavin Brown's Enterprise, but he would keep consigning the occasional painting to Canada; even Gagosian hadn't been able to talk him out of that. He would also do shows with Eva Presenhuber in Zurich.

Kenny Schachter, Bradley's old friend and the organizer of his tiny 2003 show in the West Village, wrote an affectionate column addressing what it meant—and didn't mean—that Bradley had become a Gagosian artist. "Fear not," Schachter wrote. "Joe is a bawdy, incorruptible soul. He would sooner sabotage himself before surrendering to the market Mephistopheles; his constitution wouldn't and couldn't allow it."[11] Peter Brant, a longtime collector of Bradley's work, was less sanguine

about the switch. "I think it's too much too soon," he declared. "You get this meteoric rise that's not healthy. I hope Joe survives it. He's a serious painter, and I hope he does well there. But Gagosian is good when you're hot; he's not when you're not."

Michael Findlay, now a director at Acquavella Galleries and author of two books on modern and contemporary art, had misgivings of his own about Bradley's move to the big time. "Joe Bradley is a budding celebrity—a terrible trap," Findlay said sadly. "The only person who could manage that was Andy [Warhol], because he never took it seriously." Wise words, perhaps, for another new Gagosian artist, Alex Israel, though so far the LA-born painter had managed his own rise to celebrity with remarkable sangfroid.

THAT FALL, ANOTHER ARTIST LEFT HIS dealer. After some 35 years, Eric Fischl left Mary Boone, and a core relationship of the Neo-Expressionist eighties art world fell away. "We went as far as we could go together," Fischl said. Both, as he put it, were prisoners of the eighties. It was time to try something new.

"Many times artists feel that changing galleries will change the perception of their work," Boone replied, perhaps with a hint that those changes might not always work. Fischl was going to Per Skarstedt, primarily known as a secondary-market dealer who showed George Condo, as well as other figurative artists who had come of age in the 1980s. Fischl admitted that he—and they—were mid-career artists, maybe even late-mid-career, which brought a particular challenge. "The middle is like purgatory," Fischl said. "You have no idea whether it's going to last or where you're going to go once it's over."[12]

Perhaps Fischl and his fellow Neo-Expressionists were due for an upswing. That fall of 2015, sensing growing interest in figurative art, two of the art market's deepest insiders—Jeffrey Deitch and Larry Gagosian—staged a collaborative group show at Art Basel Miami Beach. Competitors for decades but confederates, too, Deitch and Gagosian had looked for some time for a project that might engage them. Deitch was intrigued by the work of emerging figurative painters, many of them

women. But when the two teamed up, they took established artists too: John Currin, Urs Fischer, Elizabeth Peyton, David Salle, Julian Schnabel, and others. The show, called *Unrealism*, also underscored a rise in figurative art sales. Among the highest earners: Alex Katz, Peter Doig, John Currin, Kerry James Marshall, and Marlene Dumas.

As always, Art Basel Miami Beach in December 2015 was judged more by its celebrity sightings and over-the-top parties than by its seriousness about art. Actor Leonardo DiCaprio showed up with Lisa Schiff, his art advisor. So did actor Adrien Brody, with *X-Men* director Brett Ratner. Actor and singer Miley Cyrus was now an artist exhibiting at the fair; so was actor James Franco. Musician Lenny Kravitz did photography now, and actor Sly Stallone was painting…paintings that Rocky would love.

As in Switzerland's Art Basel, news of the top sales, both figurative and abstract, crackled across the fair. A little secret of the booths, however, was that relatively few fairgoers actually went from viewing to buying, and of those sales, few exceeded $50,000.

Auction houses were still where the highest-known sales of living artists occurred. Over a four-year period from 2012 through 2016, Gerhard Richter ranked first in auction sales, with total sales of $1 billion for those four years, on average $200 million a year. Koons's auction sales over that four-year period totaled $400 million, Christopher Wool $377 million, Yayoi Kusama $203 million, Peter Doig $192 million, Richard Prince $166 million, Ed Ruscha $129 million, Damien Hirst $114 million, and Anselm Kiefer $69 million.[13]

THE MARKET CERTAINLY SEEMED ROBUST IN the fall of 2015 as LA's newest museum of contemporary art, the Broad, played to sell-out crowds. Financed by insurance and real-estate magnate Eli Broad and Edythe, his wife, the museum had cost $140 million to build and had a reported endowment of more than $200 million. It housed a collection valued at $421.9 million.

The Broad was its founders' museum, but in one sense it was partly Gagosian's. No less than 40 percent of the 2,000 pieces in the Broad

had been bought through the dealer.[14] Turn-of-the-century English art dealer Joseph Duveen had noted with pride that 124 European paintings in the Metropolitan Museum's collection had come through his galleries one way or another. Gagosian could claim that some 800 of the Broad's artworks had passed through him, either sold to its founders directly or to others who donated them to the museum.

Gagosian wasn't the only mega dealer making his mark on major institutions of contemporary art. The rest were too, with consequences both admirable and, on occasion, disconcerting.

Turbulence at Two Citadels of Art

2016

BEFORE AB EX, THE living rooms of New York's wealthiest patrons had been hung with Old Masters, Impressionists, Post-Impressionists and the occasional realistic painter, like John Sloan, Thomas Eakins, or George Bellows. Now modern and contemporary art were the most sought after segments of the market. At auction houses, modern and contemporary dominated, with Picassos, Richters, and Doigs selling for millions, then resold for more. Dealers were integral players for the auction houses, coaxing their collectors to buy and sell. So they were at major museums, where curators needed the art that dealers and collectors could loan to produce crowd-pleasing shows. In both realms—auction houses and museums—a woman was playing a dominant role at the start of 2016, pushing contemporary art.

At Sotheby's, a bitter proxy battle had put the 270-year-old auction house at the mercy of activist investor Dan Loeb in 2014. Out went a number of old-timers. In, as president and CEO, came Tad Smith, directly from Madison Square Garden, a capable manager but with no art world experience. The art world had barely recovered from this broadside when Smith brought in a boutique advisory firm called Art Agency, Partners. He had agreed to pay AAP $50 million for its consulting services, with a possible extra $35 million if performance standards were met.

In the clubby world of auction house experts, those numbers were simply unfathomable. Yet the new administration's move could prove to be sage. Sotheby's stock was down 60 percent from its 2014 high,

and its sales of contemporary art were far below those of Christie's. In 2015, Christie's had taken in $1.5 billion from its New York and London contemporary art sales, along with an additional $1.2 billion from two themed crossover sales, while Sotheby's had generated just $1.1 billion.[1] The house needed a shake-up from the top down. If anyone could do that, it was AAP and its most-visible member, the glamorous Amy Cappellazzo.

While in her thirties, Cappellazzo had made her name at Christie's as co-head of postwar and contemporary art, specializing in private sales. She had an awesome Rolodex and was second to none in sheer tenacity. Her business partner was Allan Schwartzman, the art advisor who counseled Howard Rachofsky of Dallas, among others. He, too, knew everyone in the business. Cappellazzo and Schwartzman had formed AAP in 2014 and taken on a lawyer, Adam Chinn. They were impressive—and yet, in a world where relationships meant everything, how different could they be from the mega dealers, who had their own long-standing relationships with buyers and sellers?

Cappellazzo and Schwartzman had a thought about that: across-the-board financial advising. Traditionally, auction houses stopped thinking about the buyer and seller once the deal was done; they were on to the next sale. The partners of AAP could act a lot more like deal-ers, they felt, maintaining long-term ties with artists and collectors alike, brokering private art sales for their clients, and more. If they could pull that off, hindering dealers in the process, they could rise to the pinnacle of power in the art market.

The new Sotheby's started making more loans to buyers and sellers—loans secured by works of art that would allow them to "unlock the value in their collections," as Sotheby's put it in its annual report. True, loans could be found elsewhere at lower rates than an auction house could offer. But, as Sotheby's noted, "few lenders...are willing to accept works of art as sole collateral for loans." This was the game the auction houses had played in the early 2000s without much success, but Sotheby's was hungry, so it would try all-art loans again. It would also provide financial advice to artists and collectors. For those getting on in age, estate planning was in order.

Cappellazzo was tough. In her glass-walled Sotheby's office, on one of the bookshelves behind her, was a sign that read, "I'll be nicer if you'll be smarter." She fielded questions briskly while bobbing a fur-lined Gucci backless shoe below her glass desk. Clearly, she was resolute enough to preside over the firings that had occurred since her arrival. But what choice did she have? "There was a lack of literacy among experts on the financial workings of the business," she explained of how she found Sotheby's when she arrived. "Since it was clear the marketplace for art was in massive disruption, things had to shift quickly to ensure pending doom would not have its way with Sotheby's."

Old hands were still being let go in April 2016, four months after her arrival, but Cappellazzo felt vindicated by the David Bowie collection. Christie's had been willing to take on the late pop star's estate sale almost for free. Cappellazzo held firm. "We told them we needed an incentive to perform," she explained. "If you took that away, we would still be motivated to win the business but not to execute success." Bowie's estate respected that and went with Sotheby's. It wasn't a turn-around for the house, but it was a start.

IN ANOTHER SMALL OFFICE, THIS ONE oblong, with one square window onto Central Park, Sheena Wagstaff, the new Leonard A. Lauder chairman of modern and contemporary art at the Metropolitan Museum, planned how to bring contemporary art to a museum that had largely shunned it for decades, with the exception of a brief period in the late 1960s and 1970s when director Thomas Hoving and his brash young curator Henry Geldzahler had embraced it. A diminutive, delicate figure bristling with ideas, Wagstaff had come from London's Tate Modern, where as chief curator she had worked directly for renowned director Nicholas Serota. She knew contemporary art very well—though reorienting the Met and expanding its collections presented a new kind of challenge.

Modern and contemporary art in New York were the long-established fare of three major museums: the Whitney, the Guggenheim, and the Museum of Modern Art. Into that grouping, some added the smaller

but ambitious New Museum. It was a non-collecting museum, but it did have modest holdings from its 33-year tenure. Of the four institutions, MoMA had the largest number of 20th- and 21st-century works, about 200,000. The Met, by comparison, had 13,400.

The Met's view, historically, was to wait for artists' legacies to come clear, often until after their lifetimes. Meanwhile, prices rose. By the Pop era, the Met was too late to buy contemporary works in any quantity, even with a huge endowment that would rise to $2.8 billion; most of that money was earmarked for other needs. The museum in 2016 would spend $54 million on all art purchases, hardly enough for a handful of brand-name contemporary pieces. "What we have nothing of is postwar Europe," admitted Ian Alteveer, Aaron I. Fleischman curator in the Met's department of modern and contemporary art. Or if not nothing, nearly so, with a handful of works from such European giants as Yves Klein (five works, two major), Gerhard Richter (seven works, two significant), and Sigmar Polke (six works). The Met had even less from mid-career 21st-century artists.

Tom Campbell, the museum's curator of European sculpture and decorative arts, had made clear upon becoming the Met's director and CEO in 2009 that contemporary art was one of his top priorities. But first he had to reel in cosmetic heir Leonard Lauder's 78 Cubist drawings, paintings, and sculptures, including 33 Picassos and 17 Braques. Cubism was another gap in the Met's collection, and Lauder was a long-time Met supporter. Later, Lauder would say there was never any doubt as to his collection's destination, but if there wasn't a doubt, there was definitely a hoop or two to be jumped through, for other museums were courting him. Lauder was chairman emeritus of the Whitney in addition to his role at the Met, and he had to consider all options. There was also the question of the Whitney building itself.

Lauder knew that the Whitney had outgrown its five-story, Brutalist museum on Madison Avenue at 75th Street. He was resigned to the Whitney moving to its brand-new downtown building overlooking the Hudson River. But he loved the old Whitney and saw a way to preserve it as a museum, at least for a while. The Met could lease it for eight years

as a temporary showcase for contemporary art. At the same time, the Met could raze and replace the widely disliked southwest wing of its main building. In eight years, when the lease on Madison Avenue was up, the parties could decide whether to extend it or not. Most likely, the Whitney would find some other use for the Breuer building while the Met consolidated its contemporary art holdings in its new southwest wing—assuming it had raised the requisite $600 million and gotten the wing built.

Lauder drove a hard bargain. The operating costs for the Met to run the newly named Met Breuer would be at least $17 million a year. But what choice did the Met really have if it wanted Lauder's priceless art? With a plenitude of English charm, Campbell made the juggling act work, and Lauder's Cubist collection came to the Met in 2013 as promised. Now what Campbell needed was a world-class curator of contemporary art who shared his vision for the Met and could bring it to life. He found one in Wagstaff.

An earnest academic dedicated to both contemporary and global art, Wagstaff had overseen some 60 exhibitions at the Tate under Serota. Campbell admired her energy and was especially intrigued by her international interests in Middle Eastern and North African art. Art from those underappreciated parts of the world was not only fascinating and fresh, but relatively inexpensive to acquire. Neither Campbell nor Wagstaff was under any illusions about the challenge they faced in boosting the museum's holdings of modern and contemporary art. But they did have one great advantage. Unlike its rivals, the Met was an encyclopedic museum, which was to say it covered several thousand years across all geographies, beginning with Iranian art from 3800 to 3700 BC. Wagstaff's vision was to put new art together with its antecedents. "So what The Met offers is not just a lens to history," as Wagstaff explained, "but also a reverse telescope."

When the Breuer building reopened its doors as the Met Breuer in March 2016, one of its two shows was dedicated to a deceased Indian Minimalist artist, all but unknown in the West, named Nasreen Mohamedi. The top of the bill for that opening was a daring show called

Unfinished: Thoughts Left Visible, one that drew crowds and widespread critical praise, beautifully illustrating Wagstaff's "reverse telescope" concept. On the walls were works from the Renaissance to the present, all unfinished in one way or another. Here was a portrait by Titian, the subject's hands unfinished, there a Jackson Pollock and a Robert Rauschenberg, both unfinished in some sense. Nearly 40 percent of the more than 190 works on display were from the Met's permanent collection.

For contemporary shows, the Met couldn't rely on its modest holdings. It could hope for loans of course. Better yet, it could encourage the museum's benefactors to buy new works and either donate them or bequeath them to the museum. That, as Campbell observed, was what the southwest wing was all about. "It doesn't take too many contemporary masterpieces to reach a cost of $600 million," he said one day from his corner office. "It's easier to build the wing for a one-time cost of $600 million and hope that some very rich people start putting art on its walls."

Some muttering about the role of museum boards in this process was occasionally heard. A board member could theoretically push for shows by artists he or she liked—or collected. There was no law against it, not in the art world. Even without lobbying at all, a board member could get an early word on upcoming shows, two or three years in the making, and in the meantime buy one or two of that artist's works on the market. Guggenheim director Richard Armstrong scoffed at that. "Do galleries or collectors propose ideas? Of course they do. And of course we listen. But the way that a project is realized correctly and deeply is because one or two or three curators want to devote three or four years to it."

That said, a museum could only schedule so many solo shows, and to bring them off, it needed a gallery's help, as Armstrong readily acknowledged. Not just any gallery would do. "We need a well-organized gallery that has data, proper files, good images—a gallery with great records that can be a good coworker with us." Those tended to be the megas, as the *Art Newspaper* confirmed after an investigation

of solo shows, over six years, at New York's five major museums: the Whitney, the Guggenheim, the Museum of Modern Art, the Metropolitan Museum, and the New Museum.

Nearly one-third of those shows featured artists represented by one of the four megas or Marian Goodman, the dealer often mentioned as the fifth mega. Armstrong had no apology for that. "Great galleries attract great artists," he said with a shrug, "and museums are frequently attracted to great artists." Nevertheless, the *Art Newspaper*'s 2015 story was cited in a lawsuit by 77-year-old artist Robert Cenedella, who argued that the five museum defendants were a "corporate museum cartel" working with the megas to increase prices for the artists they represent. As of May 2018, the suit was still in court, with Cenedella, a former student of German artist George Grosz, demanding $100 million. The galleries called him a disgruntled provocateur "disappointed" that his works had not entered their collections.

Collectors and dealers loved loaning art to museums: it was the ultimate validation for their artists. They were less sanguine about the museum's inevitable request that the gallery whose artist was to be shown help pay for the show. Perhaps a dealer would like to pay to produce the show's glossy catalogue. Or the banners that advertised the show around the city. Or the show-opening dinner for 300. "The only thing I have not been asked for is postage," declared Angela Westwater of the Sperone Westwater Gallery. Generally, she said, she would be asked to pitch in at least $10,000 to help a museum mount a solo show of one of her artists, she told the *New York Times*. "Certainly this can be onerous and complicated for many reasons, including potential conflicts of interest."[2]

The Guggenheim's Armstrong dismissed that concern too. "Historically, going back to the seventies, the definition of the gallery's role was typically to underwrite the cost of the catalogue," he noted. Galleries were much richer now, and could afford to pay more—but so were museums. "Instead of forty thousand people a year paying a few dollars each, we have more than a million visitors, many here for the first time, paying twenty-five dollars with happiness. Admissions cover

a lot more than they did." In fact, the majority of budgets for exhibitions came from museum funds, private donors, and foundation grants. Nevertheless, the museums needed the megas, the megas needed them, and money was needed to bring those shows to life.

THE MET BREUER HAD BEEN OPEN barely a month, with gratifyingly large crowds for *Unfinished*, when a front-page *New York Times* story reported that the Met had "overreached" financially and was in significant peril. It was too late to avoid a $10 million deficit; without serious cutbacks, the deficit would soon grow to $40 million.[3]

A $10 million gap in a $300 million budget wasn't that catastrophic, and the Met had run deficits in recent years without making major news. But the deficit disclosed larger issues. The Met's commitment to contemporary art, it seemed, was not embraced by all departments, and neither was Campbell. Later, a scathing report by the *New York Times* would quote unnamed insiders rapping Campbell for doing too much too fast, including overspending on the Met Breuer and "emphasizing Modern and contemporary art at the expense of core departments."[4] The new $600 million southwest wing for contemporary art came in for criticism too. Campbell issued a mea culpa and said that staff reductions would follow, along with a slower construction schedule on the new wing. Three dozen staffers took voluntary retirement packages, and the hole began to fill. But the wing seemed far off indeed.

"We will have the wing," Wagstaff declared not long after from her square-windowed office. "We have to have the wing. The trustees, even at their last meeting...there is no diminishment of appetite to build this wing. They are simply trying to ready the ship, and that's their ship, that's the director's job to do."

The next day brought more bad news. Entertainment mogul David Geffen was giving $100 million to the Museum of Modern Art to help fund an expansion and renovation, with a wing named after him. Geffen had no relationship with the Met. Still, given its new commitment to contemporary art, mightn't the magnate have been talked

into allocating a sliver of that gift to the Met? Especially when he had just sold two of the treasures from his private collection—De Kooning's *Interchanged* and Pollock's *Number 17A*—for $500 million in a record-breaking package deal to hedge-fund billionaire Ken Griffin? Somehow, despite the Met's earnest efforts to recast itself as a citadel of contemporary art, one whose halls art collectors would surely want to adorn with their names, one of the biggest collectors had just buzzed off.

LARRY GAGOSIAN, GEFFEN'S FRIEND AND DEALER for more than three decades, was at the top of his game in 2016, showing and selling many of the art world's biggest names: Francis Bacon's late paintings, Richard Prince, Cy Twombly, and more. He was no less a familiar sight at auctions, shoring up the Warhol market and bidding for clients. For one of the biggest deals of his life, however, he was nowhere to be seen.

Until recently, record-breaking sales had usually come at auction. Sellers were coaxed by huge guarantees into putting their trophies for bid; buyers knew they had to be willing to keep raising their paddles if they wanted to prevail. That was how, in May 2015, Picasso's *Women of Algiers (Version O)* (1955) sold for $179.4 million and everybody knew about it.

Auction prices were going so high for some very rare works, however, that sellers and buyers had begun to balk at all the publicity. More were choosing the private-sale route instead, often not disclosing a sale until later, if at all. So had gone Cézanne's early 1890s masterpiece, *The Card Players*, one of five in a series, in 2011, sold quietly by the estate of collector George Embiricos for more than $250 million to Sheikha Al-Mayassa bint Hamad bin Khalifa al-Thani of Qatar. So, too, went the $500 million Pollock and De Kooning dual sale, consummated by the David Geffen Foundation and Ken Griffin in September 2015 but kept secret until early 2016.

Right about that time—early 2016—another trophy sale became known belatedly. This one was a bust of one of Picasso's lovers, for $106 million, sold by Gagosian to billionaire Leon Black of Apollo

Management. The work, *Bust of a Woman (Marie-Thérèse)* (1931) became a cause célèbre in international art circles, not so much because of the price but because a rival bidder came forward to say he had bought the piece already, on behalf of his Qatari clients, and then proceeded to sue Gagosian for interfering.

The large plaster bust at stake belonged to 80-year-old Maya Widmaier-Picasso, daughter of Picasso mistress Marie-Thérèse Walter. Gagosian noted that back in 2011 he had shown the bust in a Picasso show in Chelsea. During the show, he later said, he had received offers of more than $100 million for the piece. But Widmaier-Picasso had declined to sell it. Four years later, Widmaier-Picasso's daughter Diana, who worked at the Gagosian gallery, told her boss that her mother was finally ready to sell the piece. Gagosian called Leon Black, and a deal was reached. The sale was consummated with four payments. By May 2015, the bust belonged to the gallery, soon to find a new home in Leon Black's home, or so Gagosian believed.

In the meantime, Maya Widmaier-Picasso had done something that seemed very odd. She had signed a contract with the Qataris' representative in November 2014 to sell the bust to them for $47.4 million in three installments. Why would she take a lower offer, after hearing the first offer of $100 million? A source close to Gagosian suggested the octogenarian might have been suffering from dementia. But her lawyers suggested a family rift was partly to blame.

Maya Widmaier-Picasso had done the Qatari deal at the urging of her son Olivier, a lawyer and art dealer, without disclosing it to her daughter Diana. Neither mother nor son wanted Diana involved—she and Gagosian were just too close, they felt. They may also have felt that the earlier Gagosian offer of $100 million was less than solid; better to go with the $47.4 million that was, at that time, a record price for a Picasso sculpture.

The Qataris claimed that they were on the verge of making their third and final payment for the bust in April 2015 when Diana learned of the sale. "As a petulant child is wont to do," the counterclaim later related, "when Diana learned of the sale to the Qataris' representative,

Pelham Holdings, she flew into a rage, demanded that the Pelham Sale Agreement be repudiated, and that a new sale be made to Gagosian and his gallery. As indulgent mothers are wont to do, Maya acceded to her daughter's demands." Gagosian claimed this was the first he'd heard of the Qataris' deal.

The Qataris, of course, had made a grave tactical error: they had failed to buy the sculpture in one lump sum—a challenge to most collectors but surely not to the royal family of Qatar. If fully purchased back in November 2014, the bust would have changed hands with no recourse. Instead, their first two payments were handed back to them, their deal torn up. The counterclaim pointed out that Diana, in steering the deal to Gagosian, secured "an extremely lucrative" commission from the dealer.

As details of the suit and countersuit reverberated through the winter of 2016, Gagosian saw himself as an unwitting victim, his gallery unfairly tarred. A source close to Gagosian noted the gallery was removed from the suit, its right to purchase the bust affirmed. As for the Qataris, they were left to reach a settlement with their representative, Pelham Holdings. What the Qataris got by way of compensation for their quashed deal was never acknowledged.

GAGOSIAN PLAYED HARDBALL, NO DOUBT ABOUT that. Iwan Wirth, by contrast, seemed almost cherubic. But in his own genial manner, Wirth was challenging Gagosian with an alternative way of doing business. Durslade Farm had been Hauser & Wirth's first venture into the experiential art gallery model. In March 2016 came its block-long gallery in LA. There was, at Hauser & Wirth, a philosophy guiding these big moves: that art could help bring social change. That was one incentive of Durslade Farm. Working with artist Mark Bradford's non-profit Art + Practice in LA was another way to do that. The vast new LA compound—an urban art center in itself—was yet another. At the same time, Hauser & Wirth was pursuing a long-term business strategy that had as much to do with profit and market share as helping society. Its ultimate goal was to dominate the field.

That had been the gallery's ambition since 2009, when Iwan and Manuela opened their first New York location in the 69th Street town house. Over the next decade, they had seen how the field would change. Most of the big players would retire. Marian Goodman would celebrate her 90th birthday in 2018. Could she keep the gallery going much longer than that? Barbara Gladstone and Paula Cooper were a decade or so behind, but surely they would have to retire soon too. So, for that matter, would Gagosian. Not next year, perhaps not for a decade. Whenever he did retire, though, his artists would be fair game. They would hardly stay loyal to some corporate functionary yet unpicked. No, Gagosian couldn't stop them, the Wirths felt, and nor could Arne Glimcher, who was nearing 80 himself; whatever assurances he gave Pace artists about his son Marc's brilliant instincts, Hauser & Wirth wasn't buying it. The calculus always came down, in the long run, to Hauser & Wirth versus Zwirner. Or so the Wirths believed. Of all the competitors, Zwirner was the strongest—both in business and in youth. And with just one top contender of global size and scale guarding the field, why not take him on?

Almost overnight, as hoped, Hauser & Wirth's new LA gallery became a destination. Coffee houses proliferated; weekenders explored. Inexorably, in this latest case of art world gentrification, rents began to rise. The new space—four huge buildings' worth, with large open-air exhibition areas—was the former Globe Grain and Milling Company. Once the largest private producer of flour in the western United States, it had sat abandoned for the last 45 years.

Annabelle Selldorf's design kept the four buildings around the mill's central courtyard, along with the original brick walls and 18-foot-high trussed wooden ceilings. In all, the complex had 100,000 square feet, not all of it exhibition space but enough to put it on par with the new Whitney Museum. A farm-to-table restaurant, as at Durslade, underscored the message that art and life were intertwined. Over his wife's shy protests, Wirth named the restaurant Manuela. Across the courtyard stretched a flower and herb garden. Several live chickens strutted and clucked nearby.

The gallery's first show was *Revolution in the Making: Abstract Sculpture by Women, 1947–2016*. By showing exclusively women artists, Hauser & Wirth sent a clear signal about its values. Just as important, it was an historical show: not a single piece for sale. Some of those pieces belonged to Ursula Hauser, Iwan's mother-in-law, mentioned as one of the show's 66 lenders. For Hauser & Wirth, the most immediate reason to open the old Globe mills wasn't to sell art—it was to build the brand, extend its presence in a growing market, and retain artists, especially LA-based ones. Even before the LA gallery opened, Hauser & Wirth had strengthened its ties with Mark Bradford, Paul McCarthy, Thomas Houseago, and others.

One prominent dealer found the entertainment angle baffling. "I question whether art galleries should have restaurants," he declared. "I'm interested in art, not the circus of art." Gagosian was pretty underwhelmed, too, by Hauser & Wirth's choice of artists and how the gallery had worked with them. "I try not to disparage competitors, but I think that Paul McCarthy was a more interesting artist before he started working with Hauser & Wirth," Gagosian said later. "Because then he just started making these editions. There was a quirky kind of rough aspect to his work before. Whether you liked it or not, that's another story, but they kind of overproduced him a bit, in my opinion. Other galleries are guilty of the same thing."

This was exactly what some in the art market were saying about Gagosian. "I feared when he expanded, he would not be able to keep up that quality," said John Good, the former Gagosian staffer. "If you have sixteen galleries, each one doing five shows, that's seventy-five shows a year!" Too much, Good felt, to keep them all top-notch. "I do see a diminution. I think there's an opening that Hauser & Wirth is jumping into. People can put up with Larry's craziness, but they won't put up with the brand slipping."

Los Angeles wasn't New York or even London, but Hauser & Wirth's arrival had once again fanned hopes that a new LA scene was dawning. Into that space came Monika Sprüth, who, with her German-based partner, Philomene Magers, had decided to bypass New York and go to

LA instead. Sprüth Magers actually opened a month before Hauser & Wirth's LA gallery, in February 2016. "We almost opened in New York five or six years ago," Sprüth explained. "But we had always worked with artists in LA—Barbara Kruger and John Baldessari, for example, also Sterling Ruby and Kaari Upson. So the artists proposed we open in LA because most didn't have LA dealers anymore. We were sure about the idea of LA because it's an artist-oriented city."

In some LA neighborhoods, it had to be said, the prospect of an artist-oriented enterprise had not been greeted as warmly as in others. Painter Laura Owens's space at 356 Mission Street on the downtown fringe of Boyle Heights, an Hispanic neighborhood, had grown just as she and her partners—Gavin Brown and Wendy Yao—had hoped it would when they opened it in 2012. Owens had shown her work; other artists had shown theirs. The onetime piano factory had become one of the city's most talked-about art spaces. By 2016, though, the residents of Boyle Heights had begun a loud and angry campaign against Owens and her fellow artists. To them, she was a gentrifier, and they knew what gentrification brought: residential and commercial developments, fancy clothing stores, and skyrocketing rents. Over the next two years, the protests would grow until Owens was forced to close it down. Once again, the future of downtown LA as a gallery hub seemed in doubt.

LOOMING ACROSS THE PACIFIC OCEAN WAS another new market, one far more promising than LA. The story of Chinese art was 5,000 years old, but its recent history as an art market was about ten years old. One of the first Western dealers to give it a try was James Cohan, a lean and ascetic midwesterner who had worked for Paula Cooper and Anthony d'Offay before starting his own 57th Street gallery. Cohan had gone to China in 2008, hoping to be the dealer who introduced Asia to Western art. He opened a space in Shanghai and set about selling Western art to Chinese collectors. Then came the global financial crisis. For the Chinese art market, it was a second devastating blow.

Cut off from the outside world in the 1970s, artists in China had begun to form an underground, which grew through the 1980s. To the

astonishment of all, the government sanctioned a first group show of their art, titled *No U-Turn*, in February 1989. The show was shut down twice in its two-week run, but it fostered new hopes. Those hopes were dashed on June 4, 1989, with the Tiananmen Square massacre. Many artists fled abroad; the rest went back to the shadows.

The government's lockdown actually provoked bold and exciting art, though it remained mostly unseen. It even led to two new genres: Cynical Realism inspired artists Yue Minjun, Fang Lijun, and Liu Wei, and Political Pop included Wang Guangyi, Yu Youhan, and Li Shan. In 1995, Hans Ulrich Obrist was able to cocurate a show with Hou Hanru of contemporary Chinese art called *Cities on the Move*. Though the show was based in Vienna, it traveled. "For many artists of the 1990s, that was their first exposure to the West," Obrist recalled. "What became clear then was an amazing Chinese avant-garde."

Meanwhile, a new generation of Chinese billionaires was emerging—nearly 2,000 of them. Cohan figured that all he needed was 20 of them to buy serious Western art. With the fall of Lehman Brothers in 2008, some buyers melted away. But over the next year alone, the Chinese stock market nearly doubled. At that point, China's government did a U-turn of its own. It declared visual art a bulwark of Chinese culture and vowed to build 3,500 museums across the country by 2015. It beat that deadline by three years.[5] Most of the museums had no art in them; many looked like an empty McDonald's. But there was no turning back now. The new freedom had its limits, as the artists clearly knew: no art disparaging party leaders or Chinese history, no references to sex and sexuality. Within those boundaries, however, a lot could be done—even art that seemed to refer to Tiananmen Square.

Cohan was all for China's museum campaign. He was less pleased by the arrival, in 2013, of Sotheby's and Christie's on the mainland. Chinese buyers loved buying from the auction houses, more than going to Cohan's Shanghai gallery. They felt there was more transparency. They also liked buying Chinese artists—particularly historical and traditional—more than the Western icons Cohan had hoped to sell. Cohan did show a few Chinese artists, but not with great enthusiasm.

The artists all wanted to be shown in New York, and Cohan didn't want to be the dealer who sold Chinese artists on 57th Street. By 2015, he was ready to come home.

Arne Glimcher and Pace had come to China shortly after Cohan, but not with the mission of selling Western art to Chinese collectors. "We came to support the Chinese artists," Glimcher later declared. "We were not carpetbaggers." He felt sure the market would grow, even if it never broadened from Chinese art. After all, a single collector—former Swiss ambassador to China Uli Sigg—had come to Beijing in the late 1970s and started collecting four decades worth of Chinese art. He had ended up China's most important collector, donating 1,453 pieces in 2012 to the future M+ museum in Hong Kong and selling many others. Was this not a market? "Something is amazing in China," Glimcher declared, "and I think the West is myopic. You can't have a power like that, with the history they've had, which is so perfect for the production of art, and not have great art."

A decade in, Glimcher would claim no fewer than 18 Asia-born artists on his program of nearly 100, from Liu Jianhua and Kohei Nawa to Qiu Xiaofei, Yue Minjun, and Zhang Huan. He had opened a Hong Kong gallery, plus two other spaces in Asia. Now he was eyeing a new Hong Kong harbor-front tower called H Queen's. Designed specifically for high-end galleries, H Queen's was aiming to be nothing less than Asia's new epicenter of contemporary art. By 2017, Glimcher's fellow megas would conclude he was right. Admittedly, the China market had nosed down and up in the last few years. In 2011, it had reached a high market share that put it ahead of the United States—the first time ever—only to dip in 2012. From there, however, China had risen more steadily, and by 2017, a new order seemed fixed. The United States would notch a 42 percent market share that year, but China would be second at 21 percent, edging out the United Kingdom at 20 percent. Ed Dolman, head of Phillips auction house, said he saw China as "potentially the largest growth market for the art business, anywhere."[6] It was also the only new market with such a concentration of wealth.

Gagosian had been only a step behind Pace, opening a Hong Kong office in 2008, then a gallery of 5,000 square feet in 2011. With Western art still a sales struggle, he had also signed up Asian artists, but not as many as Pace. In 2018, he would have eight among his roughly 100 artists, including Hao Liang, Jia Aili, and Shio Kusaka. Gagosian sensed he would make serious money in China eventually. He had no doubts that in the meantime he would make really serious money by putting on the most ambitious show yet conceived and produced by his prodigal artist, Damien Hirst.

Art Fairs Forever

2016

UNTETHERED FROM GAGOSIAN FOR more than three years, Damien Hirst had let his own blend of irony and sincerity lead him to a new idea, one so sprawling and audacious that it had consumed him for nearly ten years. Hirst was overseeing teams of artisans schooled in nearly forgotten specialties to make almost 200 simulated deep-sea treasures from a shipwreck of Hirst's perfervid imagination.

One of the few people allowed to view Hirst's progress was Irving Blum, who took a helicopter to the artist's capacious country studio and came away hugely impressed. Hirst was not only creating an underwater world of fabricated treasures; he was also shooting a mock documentary about the adventurers in search of the Titanic-like shipwreck. The whole production was costing Hirst $65 million, or so he said. Always a gambler, Hirst was betting that this top-secret project would make him a global sensation again when it appeared in collector François Pinault's two palatial spaces in Venice in early 2017. Hirst hoped he would, once again, be an artist who mattered—if not to critics then at least to the market. Blum, for one, thought he would win his bet. So did Gagosian, who was angling to take Hirst on again.

Hirst's two-building studio 100 miles from London gave him all the space he needed for a whole production line of manufactured treasures, some of which were two stories high. But in the contemporary art market of 2016, he was merely one of several artists with staggeringly large studios. Bigger was better, for artists both to make the art they wanted and, at their dealers' urging, make large-scale art for outsize prices.

Better, that is, until an artist felt overwhelmed by the obligation to produce more—and larger—art for his or her gallery and all its satellites.

One of the largest and most spectacular of these spaces was just outside Paris, at a former airport in Croissy-Beaubourg near the small French airfield of Paris-Le Bourget, where Gagosian had established the gallery that took on Thaddaeus Ropac's bid for the Paris suburbs. The airport, some 35,000 square feet in all, was Anselm Kiefer's fiefdom, where the world-renowned artist used random materials from the shelves that lined one side of the studio to apply to canvases that grew into dark, haunting landscapes. So vast was Kiefer's studio that when guests arrived, the artist, thoroughly fit at 71, would often emerge from its recesses on a bicycle to greet them.

Another of the great spaces was in New York's Chelsea district, at 601 West 29th Street, a studio of 10,000 square feet where for years Jeff Koons had overseen a team of production assistants that swelled with new commissions. At its peak, in 2015, the Koons studio reportedly employed more than 100 painters to finish his *Gazing Ball* series: 35 well-known paintings, many of them Impressionist, each one exactingly reproduced, with the addition of a blue glass "gazing ball" image to provide a Koonsian touch. The balls were meant to evoke the lawn ornaments of Koons's suburban youth, or so he said.

Koons's space was among the largest artists' studios, but was not the largest. That honor appeared to go to Sterling Ruby, whose latest compound just outside LA weighed in at 120,000 square feet—larger than most museums. Ruby was a talented, driven artist who, like dealer David Kordansky, had come to LA to immerse himself in contemporary art and ended up a vital part of it—though not without earning a reputation as a dealer's nemesis.

Ruby had grown up in New Freedom, Pennsylvania, a farm town in the eastern part of the state. Later he called it a "macho community in the middle of nowhere." To amuse him, his mother gave him a sewing machine, and he started making his own punk-influenced clothing.[1] At a local art school, Ruby stumbled upon a catalogue for *Helter Skelter: L.A. Art in the 1990s*, the groundbreaking contemporary art

exhibition curated by MOCA's Paul Schimmel in 1992. Ruby had never seen art like that before.[2] Eventually he earned a BFA from the School of the Art Institute of Chicago, then went to Pasadena, California, to attend the ArtCenter College of Design. There he studied for an MFA but neglected to turn in his thesis; the degree was later granted to him by the college.[3] Even without a degree, however, his world opened up.

"I met everyone in LA," Ruby told one interviewer later, artists from Mike Kelley and Diana Thater to Barbara Kruger.[4] "It was a great period: everyone was still teaching." For a period, Ruby became Mike Kelley's teaching assistant. "Now that was a rigorous education," he recalled. "There was nothing you could bring to the table that Mike didn't already know about and have a strong critical opinion on."

In 2008, Ruby was invited to do a solo exhibition at the MOCA Pacific Design Center. *Supermax 2008* alluded to the toughest prison in the United States and was the culmination of three years of work reflecting on the American prison system. It was perhaps a double entendre, underscoring Ruby's drive to push various art forms to the max. The installation included 16-foot-tall stalagmites made from PVC, Formica, urethane, and wood; stuffed fabric sculptures; abstract canvases covered with spray paint; collages; and ceramics.[5] Ruby also made bronze sculptures and iron sculptures. The show made his reputation— and set him on a course from one dealer to the next, forming a reputation, fair or not, for caring more about money than art.

Ruby's first major New York dealer was Metro Pictures, where three Pictures Generation artists from the early 1980s—Louise Lawler, Robert Longo, and Cindy Sherman—remained happily ensconced. Metro's Janelle Reiring did her best for Ruby and gave him shows in 2007 and 2008, but she came to feel that for this artist loyalty was less important than advancing his career. "He was a lot more ambitious than we thought," Reiring recalled. "He really pushed back against any kind of advice we offered, like where he should show."

That attitude may have been fostered by movie-agent-turned-collector Michael Ovitz. In 2010, Ruby did a very large installation at Ovitz's new home in Beverly Hills. That led to Ovitz acting, at least

informally, as Ruby's advisor. "We had a meeting with Sterling and Mike Ovitz," recalled Metro's Reiring. The artist and his advisor called it "reassessing his career." That led to Ruby's 2009 departure for Pace/ Wildenstein (soon to be Pace again). Marc Glimcher of Pace was thrilled and spoke of Ruby as a new cornerstone of Pace's contemporary art program.

In early 2012, Ruby was on the move yet again. Glimcher blamed himself. "It wasn't a great match," he admitted, "and maybe we weren't ready. We didn't have the people and curatorial connections we have now. Had he come three years later, he'd still be here, in my opinion." Next stop for Ruby was Hauser & Wirth, where Ruby had a solo show in London in 2013 and another in New York in 2014. At first, the gallery also professed to be thrilled with its new artist and his white-hot career. Then Iwan Wirth learned that Ruby wanted to be represented in Hong Kong and Paris by Gagosian. That wasn't the deal Hauser & Wirth had made: it had expected global representation. Hauser & Wirth's Marc Payot was fond of saying that no artist had ever left the gallery. That was still true, he clarified, even as Ruby took his leave. "We left him," Payot said drily. "He didn't leave us."

In an interview, Ruby hinted at why he'd kept changing galleries. "Very early on, I started to think about what it is to share 50 percent of your income with a dealer," he said. He cited Mike Kelley and Chris Burden, a Conceptual artist who'd once had himself crucified to the top of a Volkswagen Bug, as other artists with working-class roots who taught him to be pragmatic about money. "I have to say that I can't do this without the dealers. But I think that at some point in the future, they will have less of an impact on the market, and artists will do things differently."[6]

Back in 2008, in his first, relatively modest studio space on LA's Fishburn Avenue, Ruby had welcomed a guest—Larry Gagosian—on a memorably rainy day. Gagosian was wearing a cashmere coat. To the artist's horror, a stray dog, completely mud covered, charged the dealer and jumped up on his coat. The visit was a disaster, Ruby recalled. "I didn't talk to anybody from the gallery for years after that!"[7] In 2014,

he became, at last, a Gagosian artist. But he was doing shows, too, with a wide array of other dealers: Sprüth Magers, Xavier Hufkens (Brussels), Taka Ishii Gallery (Tokyo), and Vito Schnabel (Saint Moritz).

Ruby's latest studio—the one that measured 120,000 square feet— was in Vernon, five miles from downtown LA. There, Ruby worked from 9 a.m. to 5 p.m. every day on art of almost every medium, from tapestries and textile works to paintings, collages, and monumental sculptures to ceramic basins that looked like oversize ashtrays. All were part of the same practice. Ruby's latest venture was clothing. In 2005, Belgian fashion designer Raf Simons had arranged to visit Ruby's studio to buy a work of art. The two hit it off, enough that in 2009, they worked together on a line of bleached denim wear and jackets. Now Simons was chief creative officer at Calvin Klein, which he had joined in 2015. At his request, Ruby designed a new look for Klein's headquarters on West 39th Street and then for its Madison Avenue flagship store. The once austere, multistory space was now bathed with bright colors, principally yellow. Scaffolding crisscrossed the space. From it hung quilts, reminiscent of Ruby's first hand-sewn creations as a 13-year-old in rural Pennsylvania.[8]

SPACE HAD BECOME A MEASURE OF prestige in contemporary art, and not just for artists in their studios, the artworks they made, and the dealers who sold those works in their supersize galleries. Space was a point of pride in a whole new class of private museums, funded by wealthy collectors.

These new Medicis created vast, elegant spaces for exhibiting their art. At the same time, they wielded leverage over all players involved in the contemporary art market: over artists, whose works they might buy, but could perhaps negotiate for; over collectors, who might find themselves iced out by dealers preferring to sell their most prized pieces to private museums; and over museum curators, who might feel pressured to show artists the private museums had bought in depth, especially when the private museum proved willing to underwrite the cost of a show.

In a sense, this was nothing new. America had a tradition of privately founded, nonprofit museums, among them the Whitney, the Guggenheim, and MoMA. The difference now was in scale, sheer numbers, and, ultimately, power. As of 2018, there would be, by one count, 266 private museums around the world that were open to the public, the greatest fraction of those in Germany, with the United States not far behind.[9] Just six years before, the total had been 216.[10]

Mitch and Emily Rales of the Glenstone museum were good examples—probably the best examples—of this new world of private museums. They were building a compound on 230 acres in Potomac, Maryland, that, when finished in 2018, would make Glenstone, at roughly 204,000 square feet, one of the largest private museums in the world. Rales had made his fortune in the 1980s with his brother using junk-bond financing to buy companies that made drill chucks, vinyl siding, wheel balancers, and other construction and automotive necessities. He was reputed to be worth $3.5 billion, his brother Steve worth $6 billion.[11] For most of his leveraged-buyout years, Mitch Rales had bought a few artworks—a Mary Cassatt painting, a Matisse drawing—but no more than the average billionaire.[12]

Then came the fishing trip in Russia that changed Rales's life in 1998. His helicopter touched down in a village for refueling; as Rales and his friends walked away from the chopper, a plane on the tarmac exploded. "We were ten feet away," Rales recounted. "Flames shot more than two stories high. I was lucky to have escaped. I left Russia barefoot with only a torn T-shirt and gym shorts. From then on it was no longer about making money."[13] Rales divorced the next year, and soon began dating a smart, attractive sales director, Emily Wei, of the Gladstone Gallery. Working closely with New York dealer Matthew Marks, the Raleses set out to build a world-class collection spanning the whole postwar era.

"I've never known a couple who are so thorough," Marks later said. "Normally people wait for the auction catalogs or buy from gallery shows. But Mitch and Emily decide what they want and then research it."[14]

"This is not buying what they like," added Jeffrey Deitch of the Raleses. "This is a very systematic program to encompass the history of the great art from the New York School period on up. It's an amazing thing they're doing."

Glenstone opened to the public as a Gwathmey Siegel–designed private museum in 2006, though with barely a peep. Long press shy, Rales gave no interviews and did little if anything to promote the museum. Between 2006 and 2013, just 10,000 visitors came to Glenstone.[15] By 2016, the Raleses had lightened up a bit on press access, and far more museumgoers had found their way to the museum. As for the art world cognoscenti, they came to behold the growing splendor of Glenstone: a vast addition designed by Thomas Phifer would make Glenstone larger than New York's Whitney and LA's Broad. "The Rales[es] have built a museum where there are no museums—almost the countryside," noted critic and curator Hans Ulrich Obrist. "That adds to the polyphony of institutions. It's also unbelievably serious."

DESPITE THE SPREAD OF HUGE SPACES, the overall art market by mid-to-late 2015 had entered a period of retrenchment, as was evident in auction prices and slowing gallery sales. Outwardly, the mega dealers were doing just fine. A whole host of other, smaller dealers were struggling with a downturn in demand coupled with rising costs. The art fairs contributed to the problem, though so did collector fatigue, overheated prices, excess supply, exceptional competition from too many art-selling entities—and the presumed impact of the Internet.

Traditionally, dealers large and small had traveled to a handful of fairs: FIAC in Paris, New York's Armory Show, and the most established fair, Art Basel Switzerland. When Art Basel Miami Beach joined the pack in 2002, and Frieze London in 2003, the pace remained, for a while, manageable. Yet each year, more new fairs sprouted, in one country after another. From Frieze Masters and Frieze New York in 2012 to Art Basel Hong Kong in 2013, the list of major shows had steadily expanded. Clare McAndrew, the consulting art-market economist who now worked for Art Basel, counted 260 major fairs, with

almost 50 added in the last decade, including the newest: Frieze Los Angeles, opening in February 2019. With more and more art to be seen and sold, dealers felt they had no choice but to be a presence in at least a few of the proliferating shows.[16]

It was a costly decision. The average dealer in 2017 attended five fairs, each of which could cost between $50,000 and $100,000, including booth rental. The major fairs—Basel, London, Paris, New York, Miami Beach, and, soon enough, Hong Kong—were also social hubs for an international crowd with an exceptional level of endurance, and no dealer wanted to be seen as falling away. Yet all too often for small and midsize galleries, the costs outweighed the sales.

For Lisa Cooley, a bubbly young former dealer from Houston who had opened her first New York gallery on the Lower East Side weeks before the stock market crash of 2008, the art fairs of 2016 became the breaking point. Cooley had weathered the fairs year after year, "globalizing," as she put it. She had thought it couldn't get worse than the time she arrived pregnant and exhausted to the Berlin fair, only to find that an artist she didn't like had sent a gargantuan trash sculpture from Vienna—at her expense. Cooley had ended up not even in a booth at that fair, just a booth divider, sitting on a backless chair. The trash piece didn't sell, the artist was indignant, and Lisa had to pay $20,000 to ship the art back.

After an August so listless that hardly anyone even walked into her gallery, Cooley had begun packing the work she would send to the next fair, when in came a bill of $7,000 for art-shipping charges. These were over and above the charges she had already put in her budget, based on estimates she had been given. She called the gallery she was partnering with; the gallery refused to split the bill. "That was it. I just said that's it, I'm done," Cooley recalled. "I couldn't see a way forward. It's a brutal business. And you're supposed to be on a plane every month, every two months, or twice a month."

Not long after, one of Chelsea's stalwarts, Andrea Rosen, announced the closing of her gallery, too, after 27 years. Rosen was the dealer who had represented portrait painter John Currin before he jumped

to Gagosian in 2003. Her other best-known artist was Félix González-Torres, the late mixed-media and installation artist whose assemblages of wrapped candies dramatized his lover's decline and death from AIDS. Rosen would share management of that estate with Zwirner—more a matter of honor than profit for Zwirner, but one that he was happy to lord over Gagosian. "Rosen's closing was bad on its own," *New York* magazine critic Jerry Saltz wrote, "but also represented something much bigger that's been gathering on the New York art world horizon for a while, as a handful of galleries...have closed or moved citing difficult market conditions."[17]

Thaddaeus Ropac, the patrician Austrian dealer who had come to SoHo all those years ago with a letter of introduction for Warhol from Joseph Beuys, struggled in his own way with the ceaseless schedule of art fairs. Ropac was a success, one of Europe's most admired dealers. In May 2017, he opened a new gallery in London's Mayfair, a new outpost for his two galleries in Salzburg and two in Paris. Yet he, too, felt the punishing pace of constant travel and wondered how long he could go on like this.

"This constant growth is something I could live without," Ropac sighed one evening in the Fifth Avenue apartment where he spent his small slices of leisure time. "But I am too ambitious to let it go because if I didn't do it, someone else would." Someone like Gagosian. "I like the more conservative model: a dealer from Paris, or London, or New York—but today this doesn't exist. You need to be global; you need all the service the artist expects, and more so, that the market expects."

New York was Ropac's haven. He felt freer of business there, freer still when the European galleries closed and he had the rest of the day on New York time with no more problems to solve. But just to get to New York on this trip, he had had to fly from Stockholm to Doha, then to Abu Dhabi, then to New York. He had landed in New York in the evening after a 15-hour flight and collapsed into bed at midnight.

The next day, Ropac had gone to Christie's to inspect some 30 works due to be auctioned that week—works in which various collector clients had expressed an interest. Like an art detective, he had scrutinized

them up close, studied them from behind, and jotted down notes for his clients. That evening he had gone over to the Pace Gallery for an equally important purpose: attending the opening of a show by a new young Romanian artist of great promise, Adrian Ghenie, whom he represented with Arne Glimcher. The next evening, he had nearly missed the Christie's auction, so grueling was the traffic. That night he had packed his bags at home for an overnight flight back to Europe—and a next round, in Paris and London, of more auctions, more art fairs, more openings, more meetings, and more deals. How much longer could any dealer—even a major one like Ropac—go on this way?

Yet the future, for any successful dealer, held the promise of much longer flights to Asia, especially China, and many more of them at that.

Dirty Laundry

2016

ON A JULY DAY in 2016, Larry Gagosian agreed to a $4.28 million settlement with the New York attorney general. He had shipped almost $40 million of art between 2005 and 2015 from California customers to their New York addresses without collecting New York state and local sales taxes on their behalf and paying them to the Department of Taxation and Finance. One prominent accountant suggested that the practice was hardly restricted to one or two dealers and that collectors played a role too. "Let's say you have a house in Florida and a house in New York," he explained. "If you buy the art in New York and ship it to Florida, you pay no taxes because Florida has no sales tax on art. The next week you could ship it back to New York. Yes, you owe sales tax for bringing it to New York, but who's to know?" The settlement came without any admission of wrongdoing.

For a 70-year-old dealer with more than four decades of complex financial transactions behind him in a business as largely unregulated as the art market, Gagosian's legal docket was actually pretty light, just a handful of cases. Most were disagreements on deals or misunderstandings about the status of an artwork. The Cowles cases, the Ron Perelman dustup, and the Picasso bust—Gagosian had never been found guilty of any charge in those cases.

Gagosian's great rival of the 1980s, Mary Boone, had fared less well of late. In the fall of 2016, actor Alec Baldwin charged her with switching the Ross Bleckner painting he had agreed to buy from her for $190,000 with another Bleckner work. The paintings were similar

enough that one might pass for the other, but Baldwin had noticed a difference. He sued, and in November 2017 Boone agreed to pay him a reported seven-figure sum to settle the case.[1]

Not long after, Boone ran afoul of the IRS for claiming her business had lost $52,000 in 2012. In fact, she had made a $3.7 million profit and used much of the difference to renovate her apartment, citing those expenses as business deductions. She had claimed other unjustified business deductions in 2009 and 2010. Boone pled guilty and in a public statement bemoaned "the worst day of my life."[2]

Stories of outright fraud among dealers were far rarer. The most spectacular of recent times was the Knoedler gallery scandal of 2012. Dozens of supposedly lost paintings by mid-20th-century modern masters, from Pollock to Rothko, reappeared courtesy of a shy Long Island woman who brought them one by one, over time, to Knoedler's director Ann Freedman. Glafira Rosales had a wacky backstory about why the paintings had vanished for so long: a wealthy collector, "Mr. X" from the Philippines, had bought them through a gay cabal in the 1950s and needed to keep his past a secret. When a buyer tried to sell his Knoedler-bought Pollock at one of the auction houses and had no luck because the painting lacked any plausible provenance, the whole house of cards came down. Rosales pled guilty to fraud and was released with time served. Freedman insisted, until she could no longer, that she had thought the paintings were real. Named in a $25 million lawsuit brought by collectors Domenico and Eleanore De Sole over the fake Rothko they had bought from Knoedler, she and the gallery reached a private settlement with the plaintiffs.[3] As for the Chinese forger, Pei-Shen Qian, he fled to his homeland, never to return to the United States.[4]

Contemporary art was even less likely to be forged than mid-century modern art: the more recent the work, the more likely its provenance was clear, and thus unassailable. The Warhol Foundation was an exception: it had struggled with works signed and unsigned by Warhol that appeared to have been run off by Factory workers on their own—or by outsiders. When lawsuits mounted, the Warhol authentication board

shut down. Other late artists' authentication boards faced the same dilemma: Jean-Michel Basquiat's for one, Keith Haring's for another. Ultimately, both closed. Buyers would just have to take their chances that what they bought was genuine: caveat emptor.

Money laundering was thought to be the more prevalent art-market crime. For 19 years, Sharon Cohen Levin had kept a vigil as chief of the money laundering and asset forfeiture unit in the US attorney's office for the Southern District of New York. Now a litigator at WilmerHale, she saw both sides of a complex business. Collectors had a right to keep their art holdings private, both for security and pleasure. But criminals had no right to use art for laundering ill-gotten cash.

As a prosecutor, Levin had felt crimped by the art market's loose rules. Sellers didn't need to disclose their names to buyers, and buyers didn't need to disclose theirs either. That was one of the gaping holes that let laundering through. Another was that art wasn't a financial asset, and so it went ungoverned by financial regulations.

The auction houses did have their own ways of checking that a client wasn't trafficking in dirty money to buy or sell art, Levin acknowledged. They didn't accept cash, and they worked with the client's bank to be sure his funds were legit. "But a regular dealer doesn't do that," she added, meaning a private dealer as opposed to an auction house. "And there's no legal obligation." If a dealer chose to avert his eyes when buying or selling a work with possibly illegal money—drug proceeds, stolen government funds, and the like—there was almost nothing the law could do about it. "When it goes through a private dealer," Levin declared, "art is the easiest money-laundering vehicle there is."

Levin liked to cite a Basquiat painting, *Hannibal*, that Brazilian banker Edemar Cid Ferreira had shipped to the US with a stated value of $100. The customs agents knew nothing of Basquiat; they just waved the painting through, letting the owner avoid all state and local sales tax on an asset actually purchased for $10 million. Were there hundreds or thousands of other such cases where art slipped in unnoticed, allowing an owner to sell it at market prices and bank the proceeds as "clean"? Marion Maneker of the *Art Market Monitor* thought not. She

noted that Levin, after all her years of pursuing laundered art, ought to have at least another example. Yet in an interview with the *Wall Street Journal*, Levin brought up *Hannibal* again—by now a dead horse.[5]

The truth was that no one really knew how much laundering went on through art. Few art laundering cases came to court, which could suggest there was little of it—or a lot that went undetected. Levin did note that once a trafficker managed to sell a painting for cash, his laundering was done. "No financial institution will investigate," Levin said. "Billions of dollars get laundered that way."

When a new angle presented itself, the authorities were that much less likely to stumble onto it. "Here's one being done mostly in London by real-estate developers," one art dealer explained. "The deal is you buy a mediocre painting for, say, two hundred thousand dollars ($200,000). Then you doctor the documents, so that the selling price appears to be one million two hundred thousand dollars ($1.2 million). Then you get insurance on the painting for that inflated price. And then you go to the bank to get a loan based on your one-million-two-hundred-thousand-dollar artwork as collateral. Maybe you do that with not just one artwork but eight or ten, gathering bank loans for altogether eight or ten million dollars. And with that you can actually build a building!"

ANY HONEST DEALER OR COLLECTOR REGARDED laundering not just as criminal but bone-headed. After all, there was a completely legal way of maximizing an investment in art by minimizing taxes due: by putting that art into free ports. These huge, fenced compounds contained warehouses filled with art, usually at airports. The world's largest were in Geneva, Zurich, Beijing, and Hong Kong.[6] Geneva was said to house $100 billion of art. Even the smaller ones were said to store $10 billion here, $10 billion there. The purpose was to let a collector suspend all taxes due on the art he or she stored in them—as long as the art remained in those free ports.

It was a beautiful deal. No sales tax, no capital gains. Nor was there any sales tax due if a collector sold a work stored in a free port to a

buyer within the free port. No tax for the buyer, either, as long as the work stayed in the free port. Collector one could simply pass his carefully wrapped Picasso or Richter down the aisle to collector two. No taxes for either party—unless and until the owner of a work took it out of the free port. At that point, the taxes suspended by its stay were meant to come down on the owner.

Neither seller nor buyer could showcase and enjoy the art as long as it remained in the free port, but there was a consolation. Once featureless warehouses, free ports now had viewing rooms where the owner could visit his art. Now, too, new free ports were popping up in the United States—including one in Harlem. A thrifty collector no longer needed to fly to Geneva or Beijing to buy and sell his free-port art. The transaction was a short trip away.

Still, why not pay the onetime US taxes for bringing an artwork home from a far-flung free port, then get to enjoy it for the rest of one's days? Because in New York State, the sales tax was 8.875 percent. On a $10 million painting, the tax would be $887,500. For some collectors, viewing illuminated pdfs of their art, instead of the real thing, was worth the pleasure of avoiding that tax bite.

For art being taken out of the Zurich free port, say, a bit of clever accounting might keep those taxes from descending any time soon. "The minute you bring it back to your home in New York, let's say, you're supposed to file a 'use' tax return with New York State, and remit the sales tax," one prominent accountant said. "But the state can't keep track of it."

IT WASN'T JUST DEALERS AND COLLECTORS who were sometimes accused of being on the wrong side of the law. Artists who used appropriation in their work had been taken to court as well. In the first two decisions of the case brought against Richard Prince by French photographer Patrick Cariou, alleging illegal appropriation by Prince, the law had agreed with Cariou. True, the first judge's finding that all 30 of Prince's *Canal Zone* works must be destroyed for copyright infringement had been set aside, but an appeals court in 2013 had taken a Solomonic

view. Its judges declared that 25 of the 30 pictures had been changed enough to make them Prince's work, but the remaining five would have to be pondered further by the lower court.

Prince wasn't the least subdued by this ruling. In 2014 at Gagosian in New York, the artist showed *New Portraits*: 37 Instagram pictures. These were pictures of real people on Instagram, taken directly from the site and enlarged, with each person's name included. All Prince added were his own comments and emojis to the existing text. One of the images in the Instagram show was a picture taken by photographer Donald Graham, who was startled to see it used in Prince's show. He was more taken aback to learn that Prince was apparently getting $90,000 for each enlarged Instagram picture, while Graham was getting not even a copyright fee. Graham sued Prince, Gagosian, and the Gagosian gallery in 2016. When taken to court, Prince and the Gagosian team argued that, as in the Cariou case, the artist's use of Graham's photograph was transformative and that the debate over appropriation was settled at last. But their motion to dismiss was rejected, and so the story continued.

Perhaps Prince was enjoying these legal skirmishes; perhaps they were part of his art. But when another appropriation suit based on the Instagram series hit Gagosian's desk on June 3, 2016, tempers seemed to flare—enough that the dealer and artist were reported, days later, to have cut ties.[7] Later, Gagosian would deny this. "I have paid a lot of money to defend Richard in court," he would say. "I've always stood by Richard in this litigation." Three years later, with the artist very much in Gagosian's stable, and yet another appropriation suit in the courts, Gagosian would only feel stronger about underwriting the legal costs. "I'm not equipped to see the line between copying and appropriation, but [Prince] is tantalized by walking that line, and that's part of what makes his art so original."

The Dealer Is Present

2016–2017

THE MEGAS HAD GREATER worries in the summer of 2016 than any particular lawsuit, even one about appropriation. For all the headline-grabbing auction prices, the market was down, significantly so—enough to stir talk, again, of market decline or stagnation.

As diligently chronicled by Clare McAndrew of Arts Economics—whose annual report for the European Fine Art Fair was the market's best measuring stick—a steady three-year rise had ended with 2014. That year, gross sales in the global art market—all genres and all sales channels—were estimated at $68.2 billion, a healthy uptick from $63.3 billion in 2013 and way up from $56.7 billion in 2012. But in 2015, sales had dipped back to $63.8 billion. Now, with England's astonishing vote to withdraw from the European Union, the future seemed more uncertain. Brexit had no immediate effect, to be sure: two years would pass before its final form was set and adopted. Possibly in that time top-tier art would come to seem a better asset than stocks. Still, the news was jarring, and many dealers were worried.

David Zwirner was feeling all that; he also had a bad start to the fall season with his latest push to elevate the career of Oscar Murillo. Murillo's new show, at Zwirner in Chelsea, was titled *Through Patches of Corn, Wheat and Mud*. It showed a keen interest in social issues on a global level. Still, the media focused only on Murillo's market. "Where Is the Market for Oscar Murillo Three Years after His Blazing Debut?" blared *Artnet News*. That wasn't quite fair. Since his high-water-mark sale of $401,000 for a painting in 2013, Murillo's market had dipped

dramatically, but soon would be on the rise again, with his auction total up from $428,000 in 2016 to $1.1 million in 2017, and with several paintings at $350,000 or above. It was far too early to declare Murillo over and done.[1]

Zwirner could take solace that fall from one of his newest artists: Kerry James Marshall. The Met's Sheena Wagstaff could claim victory too, for the Marshall show, *Kerry James Marshall: Mastry*, was her next triumph at the Met Breuer. Marshall was the black figurative artist that Jack Shainman had tracked down from a postcard back in the early 1990s. Together with the Museum of Contemporary Art Chicago, the Met curators had assembled an exhibition of some 80 works, 72 of them paintings, that captured a world unseen by most museumgoers: black urban life. Zwirner helped the Chicago team, and Shainman remained a resource as well, having represented Marshall for 25 years after that life-changing postcard.

Mastry was a museum show; none of those 72 paintings was for sale. But Marshall's market was rising fast. Before it, he might have sold a full-size canvas for $1 million. With the Met show, Marshall's auction prices began nosing up to $2 million.

A curious twist would come with a Marshall painting titled *Still Life with Wedding Portrait*, a double portrait of abolitionist Harriet Tubman and her husband on their wedding day in 1844. The painting was donated by Marshall for a charity auction in Chicago—an auction in which the winning bid of $700,000 was made by a private equity investor. Less than five months after *Mastry* closed, the painting turned up at a Christie's auction, with a high estimate of $1.5 million. That night, the painting sold for $5 million.[2]

Tom Campbell, the Met's ambitious director, should have ridden the Marshall show to a long and storied tenure. It was exactly the kind of groundbreaking contemporary art show that he and Sheena Wagstaff had envisioned to bring more contemporary art to the country's largest museum. Instead, at the end of February 2017, Campbell was forced to resign. He had spent heavily on a digital overhaul, the Met Breuer would keep costing at least $17 million a year, and the planned

$600 million southwest wing seemed chimerical. The irony was that Campbell's grand plans had all been approved by the board, and attendance was up 40 percent, more than enough to fix the museum's budget hole with time. But Campbell had lost respect. He left Wagstaff to salvage what bits she could of her plans for contemporary art and to hope that the wing would be approved one day after all. Unlikely, for the Met's trustees would soon vote to off-load the Met Breuer, saving that $17 million a year by handing over the building to the Frick Museum as temporary space while the Frick pursued its own expansion. "Our future is in the main building," Met president and CEO Daniel Weiss would say tersely. How the Met would even contemplate a new wing while occupying the old one was anyone's guess. For now, the Met's glittering vision of a major new contemporary art space was dashed.[3]

DAVID ZWIRNER HADN'T DISCOVERED KERRY JAMES Marshall. He hadn't nurtured Marshall's career as he had his earliest artists. More and more, Zwirner was adding older, market-proven artists. He was, in short, acting a lot more like his competitors, especially Gagosian. Estates continued to be hot plays these days. One recent coup for Zwirner was the Josef and Anni Albers Foundation. Albers was the 20th-century abstract painter known for his vibrant colored squares. Another was Ruth Asawa, with her distinctive hanging steel-mesh sculptures, one of several recent additions of women artists to Zwirner's roster.

Hauser & Wirth was challenging its rivals on estates, too. Sculptor Eva Hesse, dead at 34 of a brain tumor, had worked in latex and fiberglass—a possible factor in her death. Though not an artist likely to generate great sales, and not one who left much salable art, Hesse was important, and Hauser & Wirth got a lot of art world glory for representing her. For profits, the gallery could milk another newly signed estate: that of Philip Guston, whose late conversion from Abstract Expressionism to figurative, almost cartoonish, paintings was conjuring up a new market. It was at the 2017 Art Basel that Hauser & Wirth would sell a late Guston for what it claimed was $15 million.

Eva Presenhuber, a Swiss dealer who had partnered for years with the Wirths in Zurich, saw the upsurge in estates, especially at Hauser & Wirth, in a different way. Yes, they brought in distinguished artists. But maybe the market for living artists, especially emerging ones, wasn't as strong as galleries would have liked. "If the primary market was so great, why would they take on all these estates?" Presenhuber asked rhetorically. "Because the real money is in the art of dead artists. If you have an estate of an established artist, or one who can be brought up, you can make a lot of money, and your reputation is clean because it's secondary. I think that's how Hauser & Wirth makes its money."

As for Gagosian, he had taken on a potentially lucrative estate of his own. The late Pop artist Tom Wesselmann had been a well-regarded painter whose portraits of women in the late sixties and seventies were often sexually explicit, with curvaceous nudes in bright colors. He was always mentioned with his Pop art colleagues—Lichtenstein, Rosenquist, Oldenburg, and Warhol—but never quite as an equal. Perhaps the blame lay, in part, with the dawn of feminism: some critics labeled Wesselmann's work sexist. He kept producing big, bold paintings until his death in 2004, and he left a lot of work—music to the ears of any estate-hungry dealer. Gagosian was handling Wesselmann in partnership with New York and Paris dealer Almine Rech. He might just make the overlooked Pop artist pop again.

Among the underwhelmed by this trend was critic Jerry Saltz. Wesselmann was a perfect example of mega dealers exhuming second- and third-tier midcentury artists and proclaiming them overlooked stars. Why? Because, as Saltz put it, "supply is running low on the big guys."[4]

FOR GAVIN BROWN, ESTATES WERE BESIDE the point. His first priority, in the fall of 2016, was proving to the art world, and to himself, that he could make a success of his new Harlem gallery. By late October, the gallery was up and running. "If we have tested any theory, it's that people will come up here," Brown declared one chilly morning. "My impression is, anecdotally, that people don't go to galleries anymore

anyway. So the model of a place of viewing art seems to be questionable. Why then be in the busy neighborhood?"

Brown answered his own question: because that's where the mega dealers were, and wealthy buyers felt reassured by doing business with them. Brown understood that. "The prices are so insane at Gagosian that a business like Larry's provides people with some security that they can get their money out." But speculation and trading, as Brown put it, had become the loudest voices at the table. Brown was hoping that a more discerning buyer might come to Harlem because it was the art that mattered, not the brand.

The street outside Gavin Brown's Enterprise in Harlem lay quiet, with hardly a passing car. Inside, a handful of visitors sat on the floor of a vast dark space where a remarkable video was playing. Arthur Jafa's *Love Is the Message, the Message Is Death* was a seven-minute, searing sequence of images depicting black life in America. It went from scenes of police brutality to star basketball players dunking baskets to fire hoses being turned on civil rights protesters. The score was Kanye West's hip-hop gospel song "Ultralight Beam."

In a space at the rear of the gallery, six or eight young gallerists sat at a long table, silently working. With his usual reluctance, Brown settled into an old sofa and tolerated a few queries about where all this was going. Would it work? "Well, I'm in it now so I don't think in those terms," Brown said. "It's all one bank account—this, and Grand Street, and Rome, and the fairs. If I can make it work, it will pay all kinds of different categorizations of dividend."

Brown had a theory these days that a new era of galleries was beginning—not mega galleries maximizing profits but smaller galleries dedicated to nurturing the culture. In a sense, he sounded like a dealer of the midforties—a Betty Parsons or Sidney Janis—selling art for art's sake. He hoped his Harlem gallery would do that. But what if the Harlem location failed? "It has a high likelihood of not working," Brown agreed. But he was dug in. "I don't really have another option," he said. "I'll just keep going until I stop."

WITH A FIRST FAIRLY SUCCESSFUL CONTEMPORARY art auction behind them, Amy Cappellazzo and her partners at Sotheby's had dared to think that calm might be returning. Then, in June 2016, came the Brexit vote and its art-market reverberations. Would enough buyers and sellers at the highest levels ignore Brexit and keep the sales churning? Or was the market in for a rough patch? In the London sales that followed the news, Sotheby's did surprisingly well, and Cappellazzo presided with aplomb. "In less than two months," wrote market observer Marion Maneker, "Sotheby's has gone from being the source of market doubt to the provider of market confidence."[5]

Sotheby's wasn't quite in the pink yet. Its first-half sales for 2016 were down, and Christie's were up. What Sotheby's needed, as Cappellazzo readily admitted, was more great art to sell. In the run-up to the big fall sales, she got it with a private collection from Steven and Ann Ames that included seven Richters and a De Kooning. The collection did come at a nail-biting cost: a guarantee of more than $100 million from Sotheby's to the consignors. That October in London, all three houses—Sotheby's, Christie's, and Phillips—did well, and a relatively new young artist, Romanian Adrian Ghenie, stirred the market with his dark, figurative scenes that looked almost like Old Masters paintings. For that, Arne Glimcher credited his son Marc, now Pace Gallery's guiding spirit. "Marc found Adrian Ghenie's work several years ago," Glimcher said. "And he kept showing it to me. The early work showed such sheer facility that I worried it might be hard to overcome. Every artist has to do that; I didn't know if he could. Then another body of work happened, and it was magic. I was completely sold. I think he may be the best figurative artist since postwar Europe."

Ghenie used a palette knife to create an impasto style for his haunting portraits of mostly historical figures from Romania's painful past: Nicolae Ceaușescu, Joseph Stalin, Adolf Hitler, and Auschwitz doctor Josef Mengele. He worked slowly—10 to 15 paintings a year—which excited the market into bidding far above the $600,000 that Pace charged for his new works. In fact, getting a new Ghenie painting was almost

impossible. Marc Glimcher crowed that "one hundred and thirty-four people think they're first in line." Thaddaeus Ropac, Ghenie's Parisian dealer, worried as the disparity of prices between primary and secondary sales grew. "The market is overreacting," he said with a sigh. "We would be happy if everything were strong but not crazy." But crazy it was: that October, Ghenie's *Nickelodeon* sold at Christie's for more than four times its estimate: $9 million.

Ghenie himself was mortified by the prices his works were achieving at auction. "He lives in a modest apartment, which he doesn't own," Arne Glimcher reported. "He told Milly and me on a visit to his Berlin studio, 'I cannot walk into the studio and think that this canvas could be worth a million dollars.' It makes it very hard to paint. In Berlin, he lives like a recluse but his notoriety precedes him. Curators from Berlin institutions don't come to see his work."

"I feel I'm being speculated," Ghenie told the *New York Times*. "It's not me. It's the new art world."[6]

Ghenie was right: one report from 2017 would conclude that 50 percent of all collectors surveyed were in the art market to make a profit, with another 35 percent wanting to diversify their portfolios.[7]

AT AGE 85, GERHARD RICHTER WAS far better equipped to deal with this kind of fame. A good thing, because the world's best-known living abstract painter, and Marian Goodman's most prominent artist, dominated the fall New York auctions. Sotheby's put a high estimate of nearly $5 million on one work and saw it go for $12.7 million. Over at Christie's, rocker Eric Clapton sold the last of his three Richter panels, each seven feet tall. He had bought the three for $3.4 million in 2001. His profit: $74 million. And that wasn't all. Six other Richters went for a combined $63.3 million. As for the Ames collection that had lifted all boats, Sotheby's took in well over its $100 million estimate.

The art world had bucked Brexit, at least for the moment. Outside the auction houses, another historic vote rocked the world that November. How President Donald Trump would affect the market—or if he would at all—would not become clear for some time, and perhaps it

was a bit churlish even to consider the art market's fate above that of the globe. But about Sotheby's and Art Agency, Partners, the picture was clear. In just a year, the consultants had redefined and expanded Sotheby's from an old-style auction house with a private treaty arm to an across-the-board advisory, and art was the currency that made the firm work. "Now we're just a big transactional organization that has an advisory division," Cappellazzo said happily. "Kind of like Goldman Sachs and UBS and all those guys."[8] Cappellazzo had good reason to be thrilled by that: at year's end, she and her partners at Art Agency, Partners, would reach the performance standard they'd hoped to meet. "For improved market share in the contemporary art collecting category," a Sotheby's SEC filing would note, the partners would share their bonus of $35 million.[9]

Whether the Wall Street approach of Sotheby's would work in the long run remained to be seen. Michael Findlay of Acquavella Galleries felt no real threat from Sotheby's. "Why will they never be able to do what a gallery does?" he asked rhetorically of the auction houses. "It's because they aren't prepared to put enough resources in private treaty sales to make them really independent. A client here can look at the paintings all afternoon, maybe take one home and live with it for a day or two. We're not under pressure. Auction houses—and art fairs— don't do this."

Perhaps the answer wasn't one or the other—dealers or auction houses—but a mix of the two. The big news of December 2016 was that Brett Gorvy, the head of Christie's, had left to team up with Dominique Lévy, the Swiss-born dealer. Lévy had ended a seven-year partnership with financier turned dealer Robert Mnuchin. On her own now in a handsome former bank building on Madison Avenue at 73rd Street, Lévy, 48, had joined forces with Gorvy for personal reasons—they had worked together happily at Christie's—but also in recognition of fundamental shifts in the market.

Lévy wanted to do, on the dealer side, what Sotheby's was doing on the auction house side: grow into a bespoke advisory firm in which the buying and selling of art was just one part. Like Cappellazzo, with

whom she had worked at Christie's, Lévy wanted to follow the money, to go where the biggest pools of money converged. Hiring away the chairman and international head of postwar and contemporary art at Christie's, along with his Rolodex, gave Lévy the best imaginable partner in that quest.

For Gorvy, the appeal of throwing in with Lévy was not quite as obvious. He had stood atop the world's biggest auction house with a 23-year record of success, leading up to three recent world-class coups: $144 million for a Francis Bacon triptych in 2013, $179.4 million for Picasso's *Women of Algiers (Version O)* in 2015, and in that same year, $170.4 million for Modigliani's *Reclining Nude*. Why leave now for an uncertain venture?

Gorvy had a ready answer for that. Among the auction houses— Sotheby's, Christie's, and Phillips, the always distant third—competition for the best art had grown fierce, with ever-higher guarantees paid out to attract sellers and higher risks taken as a result. "It was a crazy world, the market was ugly, it was all deal, deal, deal," Gorvy told the *New York Times* after the news of his move became known. "Huge risk was taken on board to maximize the market. You were pushing things to the highest level, and it was incredibly stressful."[10]

Gorvy's logical move might have been to Sotheby's, but if the stress of ever-higher consignments was his motivation, Sotheby's was just more of the same, and Cappellazzo had the only job he could imagine wanting. With Lévy there was the chance, Gorvy felt, to be led more by art than by money. He and Lévy shared the same heroes, Leo Castelli and Anthony d'Offay among them. They wanted to operate as those two dealers had, in a decorous way, cultivating underrepresented artists—a dream come true for Gorvy. At the same time, they hoped to work more closely with auction houses and museums to sell that much more of the art they loved.[11]

Inevitably, the move stirred talk of a rivalry between two of the art market's most successful women. Lévy, for her part, dismissed the thought of a standoff with Cappellazzo. "I am doing a very different job from Amy," she said. "She is trying to get the value stock of Sotheby's

up, then perhaps cash in and leave. She is making money for the company. I'm happy when what I do is successful, but my goal is not to sell all the paintings I can. My goal is to show art in the best possible way I can."

Lévy added, "I don't see her as my direct rival, it's more Iwan Wirth." She meant that he, too, was taking chances with the artists he signed up, and the spaces he created to show them. "I think there's something incredibly exciting about what Hauser & Wirth is doing with the farm and the publication and the restaurants," Lévy said. "It's like a world within a world, and I think it has a true mission statement."

At the same time, Lévy had no wish to go the global network route. She had a London gallery, it was true, but that was enough. "I'm scared of size," she said, meaning the megas' big spaces. "We can put aside the fact that they're all men," she said with a laugh. "I don't identify with that idea of bigger and bigger. I look more to Marian Goodman. I have a gallery, not a global business. If this gallery is to keep the soul that Brett and I believe in, it can't have twelve locations." Maybe Lévy was right. Maybe for some dealers, smaller spaces were better after all. But what if, in the future, even one space was too much?

Not long before Gorvy left Christie's, he happened to post an image on his personal Instagram account of a 1982 Basquiat portrait of the boxer Sugar Ray Robinson. He had 57,900 followers at that point—a goodly number, but hardly earth-shattering. He posted the image just as he boarded a plane for Hong Kong, then turned off his phone and settled in for the flight. Upon landing, Gorvy saw he had messages from three collectors—in the United States, London, and Asia—inquiring about the painting. Within two days, the American collector had bought it for a reported $24 million.[12] "From the buyer's point of view," Gorvy later said, "this was a total Instagram sale."[13] And from the dealer's point of view? Was it the harbinger of a whole new market, or the beginning of the end of the market as Gorvy knew it?

Of Sharks and Suckerfish

2017–2018

Weeks before the Venice unveiling of Damien Hirst's newest extravaganza in April 2017, salespeople from Gagosian and White Cube made the rounds of top collectors, giving them sneak peeks on their iPhones of jewel- and coral-encrusted sunken treasures made from lapis lazuli, gold, marble, and granite. Many of the 189 pieces in *Treasures from the Wreck of the Unbelievable* were statues, some life-size, one as high as 60 feet. The sales staff were under strict instruction not to share the images. Together, the treasures would fill both of François Pinault's Venetian venues, Punta della Dogana and Palazzo Grassi.

The art media was, as usual with Hirst, sharply divided when the art was unveiled. Kenny Schachter, the dealer and modern-day Samuel Pepys of auctions and fairs, chose to see the show as Hirst's dealers probably saw it: a commercial gambit. Every one of the pieces on view, as he noted, was in an edition of three. Each of the three was in a different stage of recovery by the fictional treasure hunters: first the sea-floor relic, then a restored, cleaner version, and finally a pristine "copy" said to be made from ancient originals. "So if each of the 189 works in the show sells for an average of $500,000 a piece, the potential return is nearly $1 billion. Genius!" Maybe that number was inflated; maybe the *Treasures* cost less than $65 million to produce. Still, Hirst was back—and with Larry Gagosian as his dealer.

THE ACTION AT THE TOP OF the market was spirited enough to make 2017, by many measures, an encouraging time for dealers. Arts

Economics' Clare McAndrew concluded at the end of 2017 that, after languishing for two years, the global market had gone up 12 percent to $63.7 billion. This was a modest figure compared to the $2 trillion global media and entertainment industry, to take one somewhat related field, but a step up from US book publishing's $26.3 billion. And yet not all dealers were doing equally well.

Dealers with annual sales below $500,000 faced declines on average of 4 percent, a second straight year of losses, while dealers in the lowest category—annual sales below $250,000—were down even more. At the other end of the spectrum, dealers with annual sales over $50 million were on track to increase their 2017 sales by 10 percent. Once again, the biggest dealers were doing better. The rest were just trying to survive.

The buyers of art reflected the market. By early 2018, the ranks of the world's billionaires would swell to 2,208, sitting atop $9.1 trillion, the greatest concentration of wealth since the American Gilded Age of the late 19th century. They and their demi-billionaire counterparts—people with a net worth in excess of $500 million—were among the largest buyers of high-end, brand-name art. The vast majority of sales they enacted were in postwar and contemporary art (46 percent) and modern art (31 percent). The top-selling 25 artists whose work they bought accounted for nearly 50 percent of all auction sales.[1] For better or worse, the mega galleries were a big part of all this. "The rise of mega galleries has concentrated power, taste and value," suggested Allan Schwartzman of AAP, "often at the expense of the pioneering spirit of collectors and patrons that shaped art collecting for well over a century." The top of the art market, Schwartzman added, "is becoming a kind of self-sustaining beast, digesting and expelling art while foraging to re-evaluate some of the same old things from new perspectives."[2]

Top-end transactions, however—those over $1 million—constituted no more than 1 percent of the market. Of the respondents to McAndrew's annual survey, 69 percent of collectors reported buying works of art for less than $5,000. An additional 20 percent spent no more than $50,000.[3]

It was a bifurcated market, its two branches spreading further and further apart, like the two, broader markets of global inequity: the rich and everyone else. In 2017, small-to-midsize dealers were struggling to stay in business. By one count, no fewer than 40 of them had closed between 2015 and mid-2017.[4]

High rents in global art centers—New York, London, Paris, and Hong Kong—posed one obstacle, to be sure. Saturation was another: too many artists brandishing their newly minted MFAs, hoping for quick success. Overproduction of art created its own saturation. Fast as the market grew, contemporary artists could turn out art faster.

Saturation plagued art fairs: too many fairs, too much art on display. Yet dealers felt they had no choice but to attend five or six a year, if not more—for that, as Willie Sutton had famously said about banks, was where the money was. Or at least where they hoped to find it. And so they came weighted down by lots and lots of art, much of it already familiar to many of the buyers strolling by. In McAndrew's survey, the dealers' top concern was finding new clients. All too many went home without them.

In 2017, art fairs remained both the lifeblood and bane of all small and mid-tier galleries. That year, McAndrew found, dealers did more of their business at fairs than the year before: 46 percent, up from 41 percent. But many did less and less business at home, with less foot traffic and fewer buyers. Meanwhile, the strain and expense of art fairs left many dealers racking up losses. "The forced march is becoming numbing and rote," declared Kenny Schachter. "Fairs seem exhausted and indistinguishable from each other."[5] Dealers were desperate for new alternatives.

José Freire of Team Gallery, a well-regarded SoHo dealer who opened in 1988, took drastic action. For the past several years he had lost money at fairs. "The loss was never that substantial, but I would also lose ten days of my year," Freire explained. "And I would lose my artwork. I couldn't sell it for a long time after that—it had been burned." After a particularly depressing Art Basel Miami Beach in 2017—$35,000 in

sales after paying $200,000 for a booth and expenses—Freire declared, quite publicly, that he was completely forgoing art fairs from now on.

Freire's hope was to revitalize his gallery by extending the length of his artists' shows to a whole season or more. The longer a show ran, the more time Freire had to get curators and collectors and critics to see it, so that when the show closed, Freire would feel he had done all he could for his artist. If longer shows were not the answer, Freire had an exit strategy. "You take the one or the five most profitable artists in your gallery," he said grimly, "and you go to another gallery with them, and say, 'Here I am, I have clients, I have these artists who are currently money makers, can I be a director at your gallery.'" If he had to do it, Freire said, he would.

Freire's strategy was back to basics. Emmanuel Perrotin's was to go big. The French-born Perrotin had started with no family money or graduate degree. Yet soon he had a little gallery in his apartment in Paris where he sold small works by Damien Hirst, before White Cube picked him off. He was among the first to appreciate Takashi Murakami, and had started courting him. And when Maurizio Cattelan chose to test the dealer's loyalty in 1995 by asking him to do something truly embarrassing, Perrotin did it.

Cattelan, always something of a cerebral prankster, proposed that Perrotin—who hoped to be his dealer——wear a costume throughout an upcoming show. It was to be a bunny costume, complete with floppy ears. Perrotin was a 27-year-old bachelor, known as something of a womanizer; wearing the bunny suit would make him a laughingstock, which was Cattelan's point. "I was almost naked inside the suit," Perrotin recalled. Articles appeared showing Cattelan the artist and Perrotin his bunny. But when Perrotin emerged from the suit after six weeks, he found himself admired. "The fact that I took the risk to do it was a devotion." Cattelan became his artist. So did Murakami. Perrotin was on his way.

"From the beginning, I felt I had to go big," Perrotin said of his gallery spaces. He had a good-sized gallery in Paris, a 17th-century hôtel

particulier, and came to be known as the Gallic Gagosian. Always, he focused on building a larger market, not just sustaining the one he had. "I was always placing all my money on red—like in the casino," Perrotin said. "Always at risk of losing everything, including my private life. Because everything was together." In 2013, Perrotin opened his first gallery in New York, in a large, red-brick, Georgian-style former bank building on Madison Avenue at 73rd Street. Dominique Lévy took the upper floors, Perrotin the ground floor. "But quickly it was too small," said Perrotin. "We needed more staff."

In 2017 Perrotin went big—really big—with a former fabric factory on the Lower East Side's Orchard Street. The new space gave him—and him alone—25,000 square feet. Lévy stayed uptown in the bank building, taking on the ground floor as well as the upper floors and partnering with Brett Gorvy from Christie's. For Perrotin, Orchard Street was a base from which to take on the megas.

By late 2018, Perrotin would be in nine locations in six cities—Paris (three), New York (two), Hong Kong, Seoul, Tokyo, and Shanghai. "I'm a mega dealer in the sense that I'm in many cities," Perrotin declared. But he was not Gagosian-like in his choice of artists. "I get the success with my gallery taking very young artists. I started with primary, and I'm still strongly primary." Yet both Murakami and Cattelan were still with him. No longer did Perrotin have to prove himself: he had arrived, and was over the midrange hump, with a staff of 80 participating in 20 or more fairs a year.

If Freire's strategy was to go small, and Perrotin's was to go big, Stefania Bortolami's was to go slow. Formally, the one-time Gagosian director called it the "slow art movement." The idea was to put art—and artists—into interesting, unexpected settings far from the New York art scene and let them evolve. Artist Eric Wesley occupied a former Taco Bell in Cahokia, Illinois. Tom Burr took over an unoccupied Brutalist office building, designed by Marcel Breuer, in his native New Haven, Connecticut, and created site-specific works on the main floor.

Into this stir of innovations to the art fair dilemma came a public suggestion by David Zwirner. "I do feel that something is wrong

with the current system," Zwirner said of art fairs at a *New York Times*–sponsored art business conference in Berlin.[6] "It's not good that a few galleries are getting more and more market share and the younger galleries are having a harder time to compete." It was the smaller galleries, after all, that nurtured the emerging artists who would become the future art market's stars. And yet all too often, the megas were poaching those artists before they could sell well enough to help their first galleries grow.

Zwirner declared that he was willing to pay more for booth rental at art fairs if the extra money could go to helping small galleries participate. Also speaking at the conference were Marc Glimcher of Pace and Elizabeth Dee, cofounder of the Independent Art Fair. Both heartily endorsed the idea.

The problem was how to carve up the pie. Would every profit-making gallery help subsidize every losing one? And to what degree? Art Basel director Marc Spiegler was on the panel too. "In principle, it's great," he said of Zwirner's proposal. "But the question is how many galleries at the top of the market are willing to subsidize the rest of the fair?"

ART BASEL MIAMI BEACH HAD BARELY begun that December 2017 when word went around the convention center: the secret buyer of Leonardo da Vinci's *Salvator Mundi* had been unmasked. The controversial 500-year-old painting, put up for sale just two weeks before at Christie's in New York, had gone into auction with a $100 million guarantee by an unidentified party. Nineteen dramatic minutes after the bidding began, it had sold for $450 million. The art market had found a new top, way up in the stratosphere. The buyer was Prince Bader bin Abdullah bin Mohammed bin Farhan al-Saud, a pal of the new Saudi crown prince. *Salvator Mundi* would go to the new Louvre Abu Dhabi—a perfect counterpart to the *Mona Lisa* in Paris's own Louvre.

In the room as the gavel came down was Loïc Gouzer, Christie's 37-year-old chairman of postwar and contemporary art. Gouzer was the one who had had the brilliant notion of taking *Salvator Mundi* out

of Christie's Old Masters sale and putting it front and center at the house's contemporary art sale. How did a 500-year-old painting fit into contemporary art? Because that was where the billionaire buyers were. To them, *Salvator Mundi* was utterly contemporary. It had been in the news, with a noirish provenance involving a Russian oligarch and his dubious, free-port-owning art agent—and because it was, so Christie's declared, the last Da Vinci in private hands, which meant that only the world's richest buyers could afford it.

Also in the room that night were Eli Broad and Michael Ovitz, collector and real-estate developer Martin Margulies from Miami, and collector and philanthropist Stefan Edlis from Chicago. Among the top dealers were David Zwirner, Marc Payot of Hauser & Wirth, and Larry Gagosian who, as the winning price was announced, could clearly be heard exclaiming "Christ!"

Gouzer's move was a masterstroke of branding—and not his first. In high school, the Swiss-born specialist had passed himself off as the son of dealer Ileana Sonnabend.[7] At Sotheby's, then at Christie's, he had pushed what he called "irreverent juxtaposition." His first big success at Christie's was the 2015 themed sale he called "Looking Forward to the Past," in which he put a work by Claude Monet next to one by Peter Doig, and erotic works by Duchamp near contemporary ones by Richard Prince. The sale had set a Picasso world record with $179.4 million for *Women of Algiers (Version O)*. With the market down after that, Gouzer had expected his next themed sale to fail—and so called it "Bound to Fail." It was a huge success.[8]

Salvator Mundi had given Gouzer his greatest chance yet for irreverent juxtaposition, with a global marketing campaign to beat the drums for it. Tens of thousands had come to view it.[9] The muttering of skeptics had only heightened the drama. Was the painting even the work of Da Vinci's hand? And had its restoration been too harsh, brightening the painting but ruining its original hues? *New York* magazine critic Jerry Saltz shared the running joke that the reason a 16th-century painting was in a contemporary art sale was because 90 percent of it had been painted in the last 50 years.[10] But Gouzer had had the last laugh.

Irreverent juxtaposition: maybe that was the mantra that all should be taking to heart. That and optimism. Gouzer, for one, had no doubt that *Salvator Mundi* pointed the way to a first billion-dollar work of art. What would it be? "I have a few ideas but I don't want to put them on the record because I don't want someone to steal my idea," Gouzer declared. He felt sure, though, that it would come soon.[11] Almost certainly, the first billion-dollar painting, even if another Da Vinci, would be called "contemporary" art too.

IN JANUARY 2018, ZWIRNER CELEBRATED A milestone: his 25th anniversary as a New York dealer. His latest New York gallery—the $50 million, five-story Chelsea flagship designed by Renzo Piano on West 21st Street—was due to open in the fall of 2020. Until then, he had his two other Chelsea galleries plus a recently rented town house gallery on East 69th Street, on the same block as Hauser & Wirth. He would close his West 19th Street gallery when the new one opened, he predicted, though keep the others.[12]

"How do you keep [a gallery] intimate while being able to compete in the increasingly competitive art market?" Zwirner asked rhetorically. "If you don't move, some artists will feel you're not doing enough for their careers. They want to have intimacy, but they also want to have the reach."[13] Despite the new real estate, Zwirner hadn't duplicated Gagosian's strategy of ever more galleries in ever more cities. At this juncture in early 2018, he was in only one other city, London, with a Hong Kong gallery opening that spring. Fairs were his mainstay: Zwirner was said to do more in a year than any other mega, up to 20 fairs in 2017.

Beaming out at the crowd in his gallery, Zwirner made an announcement that probably excited him more than anyone else in the room. Once again, he declared, the gallery would represent Franz West, the late Viennese artist. Despite the ongoing legal battle—or perhaps, more aptly, because of it—the family had embraced Zwirner as its dealer. And so the Franz West saga ended where it began, with the dealer who had admired him most, only to have his heart broken.

WHATEVER HIS INVOLVEMENT IN THE LAST legal throes of the Franz West case, Gagosian had emotionally moved on. Nearly every one of his 100 or so artists excited him more than West. One of his newest artists who seemed poised for major commercial success was Joe Bradley, the abstract artist in his early forties.

With Gagosian's support, Bradley in mid-2017 had a first mid-career retrospective at the celebrated Albright-Knox Art Gallery in Buffalo, New York. The Albright-Knox was happy to have him—and to have the show underwritten, in part, by the Gagosian gallery.

Despite Gagosian's push, Bradley's prices were languishing. From his auction peak of $3 million in 2014, Bradley's market had drifted downward, to the point that his average price in 2017 would be $485,000. What Bradley needed was a bigger push. In the fall of 2018, he would get one: Gagosian would give him a one-man show in London, rattle all his collectors' cages, and sell every last work at prices from $850,000 to $1.2 million.[14] Ultimately, the work would have to rise on its own momentum, but Gagosian had just shown how much muscle he still had when it was needed.

Every artist Gagosian took on was a bet on the future. But he had never been just a dealer, hoping those bets paid off. From the start, he had acted on business hunches no one else had had yet: The first dealer to open in Chelsea. The first American mega dealer to open in London. The first to build galleries around the world in key locations. After Castelli, the first to build a global brand. The first to use that brand to maximize prices for buyers who trusted it more—much more—than the art itself.

As online possibilities emerged, Gagosian was also among the first to invest in one of the most promising. Artsy was an online global gallery whose founder, Carter Cleveland, had come up with the idea in 2009 in his senior dorm room at Princeton. Fellow backers included Rupert Murdoch's then wife Wendi, Russian oligarch Roman Abramovich's ex-wife Dasha Zhukova, Marc Glimcher of Pace Gallery, members of the Bill Acquavella family, assorted Rockefellers, Jared Kushner's

brother, Joshua, Silicon Valley investor Peter Thiel, and, recently, David Zwirner.

Opening for business in 2012, Artsy had made a simple pitch to galleries. Someone, as Cleveland declared, would soon manage to build a platform potentially capable of showing millions of artworks and enabling them to be bought and sold. That was where the Internet was going. Why not be the first to profit from that future? For a modest price, the galleries put their images on Artsy. When an Artsy browser saw a painting he liked, Artsy passed him on to the gallery that had the work. The gallery, not Artsy, set the price. Artsy just made a commission when the artwork was sold. Five years after its start, Artsy had images of 800,000 artworks from 4,000 galleries around the world. At the same time, Artsy had become a serious player in live auctions, working with all the major houses. In 2017, it was on track to hold 160 auctions: not fancy evening sales, but definitely comparable to day sales at Sotheby's and Christie's.

Artsy had a third component that helped the other two: an online magazine of the arts, also called *Artsy*. On two high floors in a Tribeca building, rows of young journalists clicked out daily news articles and feature stories to a global audience. The magazine was a great way to get out the word and stay atop Google rankings. Museums were represented on the website too. It was a research tool not just for journalists but for curators and collectors.

There was, to be sure, a strong element of faith needed on the part of Artsy's investors: six years after its founding, Artsy still published no earnings figures to back up its rosy reports. Moreover, none of its relationships with galleries was exclusive. Zwirner, for one, had his own online sales and took advantage of every social media outlet he could. In fact, the big threat to Artsy was social media, where art could be viewed for free. One of Artsy's main rivals was Artnet, which had accumulated some 25 years of auction sales and sold access to its archive. Artnet also conducted auctions and published its own 24-hour news site, *Artnet News*.

Early on, Gagosian had seen the potential of Instagram, too, both as a brand builder and as a lure to get buyers into the gallery. As of June 2018, he had 866,000 followers to Pace's 656,000, Zwirner's 396,000, and Hauser & Wirth's 314,000. The principal social media and networking apps—Facebook, Instagram, Twitter, and Tumblr—reached a broader audience, including younger viewers, better than anything else. Few people bought art directly from social media, but the images stirred interest and might bring buyers to request more information or even lure them into a gallery to see the work up close—perchance to close the deal.

Selfies were a part of this social media revolution. Users took pictures of themselves in front of art—moving like schools of fish through museums and galleries—then posted them on Instagram. Ann Temkin, the Marie-Josée and Henry Kravis chief curator of painting and sculpture at the Museum of Modern Art, sighed as she watched selfie throngs hover in front of Van Gogh's *The Starry Night*—a selfie top choice. "It's as if taking a photo of a work in a museum means 'seeing' it to a viewer, even though someone like me worries that taking the photo replaces seeing it in the slow and thoughtful way I would ideally wish. And the problem with all the photo-takers is that they make it impossible for someone who wants to do that kind of looking to do so."[15] Museum and gallery selfies might not sell art, but they, too, stirred widespread interest. And who was to say that millennials waiting two hours in line at Zwirner's Chelsea galleries to spend time in a Yayoi Kusama infinity mirror room did not go off and buy shawls, socks, caps, T-shirts, and ties by the artist? Though to some degree, millennials seemed to regard selfies and commercial spin-off products as a replacement for the art itself.

Gagosian might have the lead among mega dealers for Instagram followers, but Hauser & Wirth was showing it might just have more of a grasp on the changing market, with its new emphasis on art and lifestyle. With its rural Somerset location, and then its block-size LA arts compound, Hauser & Wirth had taken its first bold steps. Next up was the renovated Fife Arms Hotel in Braemar, Scotland, which would have

no formal gallery but would hold up the Hauser & Wirth brand with prominent displays of art by internationally renowned artists. Due after that was an art center on the small Balearic island of Minorca, an hour's plane ride from Spain. And the new gallery in St. Moritz. Ultimately, all roads for Hauser & Wirth led to art.

"The lifestyle approach doesn't necessarily sell more art," the gallery's partner and vice president Marc Payot suggested one day in his cavernous Chelsea office. "It's all about perception. You build up who you are, and what you believe in." Hauser & Wirth still contributed a tax-deductible percentage of every Mark Bradford painting sold; both artist and dealer passed that money on to Art + Practice, Bradford's ongoing nonprofit to support the needs of foster children in Los Angeles. "We love these links, between education and art, and social outreach, and art and food and communication," Payot said.

THANKS TO MARC GLIMCHER, PACE GALLERY had made its own move to attract a new generation of collectors with experiential art. Pace had produced great visual artworks, illuminating the bridges over the Thames in London, creating immersive mixed-reality experiences, and more. The challenge, for any dealer, was to sell the experience. Few collectors would pay large sums to experience an ephemeral work of art. But what if two million viewers experienced art on their computers for, say, $1 each? That might generate a lot more income for the artist and dealer than a single painting. It might also coax millennials into buying art after all.

Experiential art might well be the future. But Pace's greatest strength—and potential profits—lay in its keen familiarity with China's art market, for in the spring of 2018, China officially became the global new frontier for contemporary art. Until then, neither Zwirner nor Hauser & Wirth had opened an Asian gallery. Both galleries had let Pace, and then Gagosian, take the risks of opening in Asia—Pace in 2008, Gagosian in 2011. But in late March 2018, the two other megas took the plunge, taking soaring spaces in the H Queen's building at the same time that Pace opened a new gallery there too. Their arrival

coincided with the sixth edition of Art Basel Hong Kong, youngest of the three Art Basels.

Brett Gorvy came to Art Basel Hong Kong bearing a vintage De Kooning from 1975, called *Untitled XII*, put up for sale for $35 million by Microsoft cofounder Paul Allen—perhaps a hint, in retrospect, of his impending, premature death. Barely had the doors opened when it sold. No less impressive in its own way was Hauser & Wirth's solo Mark Bradford show. All of the dozen paintings sold out almost immediately. Plenty of Chinese art was shown that week at Art Basel Hong Kong, but a corner had been turned: Western art was now part of the mix too.

ONCE AGAIN, ON AN EARLY SUNDAY evening in June 2018, the balcony of Les Trois Rois in Basel, Switzerland, filled with dealers and collectors, spilling into the bar as the crowd grew. Once again, the mood was buoyant and the market strong, or at least stronger than the year before.

Jeffrey Deitch had more to celebrate than most: he was taking another chance on LA opening a 15,000-square-foot gallery in the old Hollywood studio zone, where one of his new gallery neighbors would be David Kordansky. He wanted to do socially meaningful art, starting with a solo show for Ai Weiwei, the Chinese activist artist.

Deitch acknowledged that the mega dealers had changed the game, but it was *plus ça change*. "It's not that different from before," he mused. "I was there to experience it. The Marlborough—they were as big as Gagosian. They had their own plane, and they had the best stable in the post-war world: Francis Bacon, Mark Rothko..." And before that, Paul Durand-Ruel had Paris, New York, London, and Munich. "He was really the inventor of the modern gallery structure, and solo shows— that's more than a hundred years ago. The field still revolves around big personalities, big vision—it's more personalities than structure."

Deitch was one of them: private, low on affect like his beloved Warhol, but always alert to the next turn in contemporary art.

At 11 a.m. on the fair's opening day, the doors of the Messeplatz opened to a flood of card-toting VIPs. Again, within an hour, major

sales were made. Gagosian would go on to declare the fair his best Basel ever. A host of other prominent dealers soon had lots to boast about too. The sales at Art Basel seemed signs of good seasons to come. One, though, seemed to suggest a more troubled future. A large painting by Abstract Expressionist Joan Mitchell, titled *Red Tree* (1976), sold to a European collector for about $6 million. The sale was made by Cheim & Read, a small but highly respected Chelsea gallery that had represented the Joan Mitchell Foundation for years.

It was also the gallery's last Mitchell sale. Shortly before the fair, Zwirner announced it was taking over representation of the Mitchell foundation. For Cheim & Read, losing the foundation was a blow. In late June 2018, the partners would announce they were closing the gallery after 21 years, moving uptown, and easing into what they called a private practice, concentrating on the secondary market. That might be a smart move—a way for Cheim & Read to fight another day. But the news sent a chill through the contemporary art market: the end of Cheim & Read was, in a sense, the end of an era.

John Cheim and Howard Read had opened their Chelsea gallery in 1997, after years at the elegant Robert Miller Gallery, which had represented Joan Mitchell among others. When they opened on their own in a dark taxi garage on West 23rd Street, the partners took the Joan Mitchell Foundation with them—the artist had died in 1992—and built their success, to some extent, on her legacy.

Until recently, Mitchell had been viewed as a lesser figure among Ab Exers. That she was a woman may have held her back. The growing interest in women artists certainly helped, and so did the fact that Mitchell had done far more work than previously realized. In 2018, one of her works sold at auction for $16.6 million. An artist overlooked amid famous others, in a well-defined group, with a surprising amount of great art still held by her foundation, and now a startling new auction high—all this made Mitchell a target. Amid sharp competition, Zwirner won the day.

Paula Cooper, for one, found the Mitchell Foundation's move to Zwirner depressing. "I know Joan Mitchell would have been very unhappy

about this," she said.[17] "Cheim & Read actually worked with the artist for so many years. And they're going to get better scholarship from some gallery that's going to look things up in a book? This art world has become so uncivilized."

Cooper, the longest-operating dealer of contemporary art in New York—and, many would say, the best—had seen a lot in her 50 years in the business. She knew of what she spoke. But there was nothing she could do to stop the flood of money and all it had brought. It was a different market than the one she had entered all those years ago, a market profoundly and permanently changed. There was no fighting it now. All one could hope for was good art, at whatever the price. Perhaps neither big nor small galleries would prosper as they had until now. Maybe the art would have to find its own way.

"I am not sure the model of the 'local' gallery has a future—in New York anyway," Gavin Brown declared. "The ecosystem may be reduced to whale sharks and suckerfish with nothing in between. But is there even a future for such Megalodons? While the economic model for anything smaller seems in doubt, I also wonder about the social, philosophical, even ethical foundation of these enormous entities. The systemization necessary for these places to function has a byproduct— or perhaps a central aim—of taming art and artists. It feels like an inevitability, like a natural balance. And once art is tamed, it tends to disintegrate, and then reemerge in other places in our society. It is not anyone's fault necessarily. If money is water, then it does what it does best and rushes in. And as it does, it pushes air (art) out. And we are all left gasping, wondering where all the air went."[18]

For now, at least, the air remained, and so did the art.

ACKNOWLEDGMENTS

My first call, when I hit upon the notion of a narrative history of contemporary art focused on the dealers, was to artists Eric Fischl and April Gornik, neighbors and friends in Sag Harbor, New York. Not only are Eric and April major figures in contemporary art—they're also restoring Sag Harbor's burned-down movie theatre and building a park, but that's another story. Over dinner, they encouraged me to give the book a try and sent me in the direction of Victoria Miro, one of London's most admired contemporary dealers. Victoria, in turn, sent me to her New York partner, Gavin Brown. One by one, other dealers agreed to talk, and the story began filling out.

I knew from the start that this history would move inexorably to the mega dealers: the art market's four most powerful figures. I could write it without their cooperation if I had to, but I hoped they would see fit to talk. A chance meeting with Arne Glimcher led to hours of wonderful conversation. Iwan Wirth and David Zwirner were a bit harder to pin down, but did eventually sit for long, substantive interviews. Larry Gagosian, the undisputed mega of megas, was the most hesitant, yet when he finally agreed to speak, he did so candidly and mostly on the record. I am grateful to all four of them.

The megas lead the market, but this would be a half-baked book if it failed to include dozens of other dealers who have contributed to the history of contemporary art. I am grateful to all of those who spoke with me, and to many other sources, from critics to collectors. In alphabetical order they are:

Bill Acquavella, Alex Adler, Hilton Als, Ian Alteveer, Max Anderson, Richard Armstrong, Andy Augenblick, Frances Beatty, Olivier Berggruen, Donald and Vera Blinken, Howard Blum, Irving and Jackie Blum, Marianne Boesky, Mary Boone, Stefania Bortolami, Adam Boxer, Sarah Braman, Peter Brant, Gavin Brown, Patty Brundage, Susan Brundage, Suzanne Butler, Priscilla Caldwell, Tom Campbell, Amy Cappellazzo, James Cohan, Lisa Cooley, Paula Cooper, Michael Craig-Martin, Doug Cramer, Anthony d'Offay, Meredith Darrow, Brett De Palma, Elizabeth Dee, Jeffrey Deitch, Mollie Dent-Brocklehurst, Catherine Dunn, Asher Edelman, Milton Esterow, Richard Feigen, Michael Findlay, Jack Flam, José Freire, François Ghebaly, Ralph Gibson, Barbara Gladstone, Marc Glimcher, Aaron Richard Golub, John Good, Marian Goodman, Jay Gorney, Phil Grauer, Timothy Greenfield-Sanders, Patty Hambrecht, Ben Heller, Steven Henry, Antonio Homem, Jim Jacobs, Carroll Janis, Julia Joern, John Kasmin, Paul Kasmin, Bill Kelly, Christoph Kerres, Anselm Kiefer, Nicole Klagsbrun, James Koch, David Kordansky, Sharon Cohen Levin, Dominique Lévy, Nicholas Logsdail, Michele Maccarone, Christy MacLear, Gerard Malanga, Don Marron, Fergus McCaffrey, Jamie Niven, Annina Nosei, Hans Ulrich Obrist, Marc Payot, Emmanuel Perrotin, Inigo Philbrick, Robert Pincus-Witten, Annie Plumb, Jeff Poe, Marc Porter, Eva Presenhuber, Dotson Rader, William Rayner, Janelle Reiring, John Richardson, Walter Robinson, Jeanne Greenberg Rohatyn, Thaddaeus Ropac, Brie Ruais, Don and Mera Rubell, David Salle, Irving Sandler, Kenny Schachter, Lisa Schiff, Vito Schnabel, Allan Schwartzman, John Seed, Tony Shafrazi, Jack Shainman, Stefan Simchowitz, Richard Solomon, Morgan Spangle, Lisa Spellman, Ron Spencer, Monika Sprüth, Frank Stella, Robert Storr, Andrew Terner, Sheena Wagstaff, Thea Westreich, Angela Westwater, Jack Youngerman, John Zinsser, Allison Zuckerman, Lucas Zwirner.

In addition, several journalists offered generous guidance, among them Brian Boucher, Eileen Kinsella, Mike Miller, Scott Reyburn, and James Tarmy.

For consultation on a far deeper order of magnitude, I am indebted to Clayton Press and Greg Linn of Linn Press, specialists in contemporary art. Thanks also to my tireless fact-checker and all-around good guy, Walter Owen.

For agreeing to publish this book, I am indebted to Peter Osnos and Clive Priddle of PublicAffairs. Esther Newberg, my extraordinary agent, as always put her formidable strength to the task. Thanks, too, to the rest of the PublicAffairs' team: Athena Bryan, Melissa Veronesi, and Elizabeth Dana.

Throughout this two-year process, I often lunched with my father and shared my frustrations; an editor emeritus, he invariably gave me sage advice.

Thanks, above all, to my wife, Gayfryd, who cheered me on from the start and never lost faith in my ability to finish this book, even if I sometimes did.

Prologue: The Kings and Their Court

1. Grand Hotel Les Trois Rois is translated as "hotel of the three kings."

2. It was originally named Garage Center for Contemporary Culture.

3. Julia Halperin, "Here Are All the Basquiats at Art Basel, Worth a Combined $89 Million," *Artnet News*, June 14, 2017, https://news.artnet.com/market/here-are-all-the-many-basquiats-at-art-basel-991865.

4. Dodie Kazanjian, "House of Wirth: The Gallery World's Power Couple," *Vogue*, January 10, 2013, www.vogue.com/article/house-of-wirth-the-gallery-worlds-art-couple.

5. Alexander Forbes, "Art Market Rebounds at Art Basel in Basel," *Artsy*, June 13, 2017, www.artsy.net/article/artsy-editorial-art-market-rebounds-art-basel-basel.

6. Brenna Hughes Neghaiwi, "As Art Flies Off the Walls at Basel, Buyers Beware, Experts Warn," Reuters, June 15, 2017, www.reuters.com/article/us-art-basel-idUSKBN19623G.

7. The original German was "Kunst ist eine Linie um deine Gedanken."

Chapter 1: Before Downtown

Interviews: Ben Heller, Carroll Janis, Irving Sandler, Jack Youngerman

1. See Peggy Guggenheim to Betty Parsons, 5 May 1947, Betty Parsons Gallery records and personal papers, Archives of American Art, Smithsonian Institution.

2. Susan Davidson and Philip Rylands, eds., *Peggy Guggenheim & Frederick Kiesler: The Story of Art of This Century* (New York: Guggenheim Museum, 2004), 370.

3. Ibid., 379.

4. Lee Hall, *Betty Parsons: Artist, Dealer, Collector* (New York: H. N. Abrams, 1991), 17.

5. Ibid.

6. Parsons took Rothko, Newman, and Still immediately. See Steven Naifeh and Gregory White Smith, *Jackson Pollock: An American Saga* (New York: C. N. Potter, 1989), 545.

7. Hall, *Betty Parsons*, 77.

8. This incident has been reported, but Deborah Solomon qualified it as "apparently," as there was only one recorded incident. See Deborah Solomon, *Jackson Pollock: A Biography* (New York: Simon & Schuster, 1987), 127–128.

9. B. H. Friedman, *Jackson Pollock: Energy Made Visible* (New York: McGraw-Hill, 1972), 180.

10. Dore Ashton, "Artists and Dealers," in *A History of the Western Art Market: A Sourcebook of Writings on Artists, Dealers, and Markets,* ed. Titia Hulst (Oakland: University of California Press, 2017), 317.

11. Guggenheim stopped paying the stipend in 1948. "No Limits, Just Edges: Jackson Pollock Paintings on Paper," Guggenheim Museum, www.guggenheim.org/exhibition/no-limits-just-edges-jackson-pollock-paintings-on-paper.

12. Philip Hook, *Rogues' Gallery: The Rise (and Occasional Fall) of Art Dealers, the Hidden Players in the History of Art* (New York: Experiment, 2017), 239.

13. This happened in December 1947. See Harold Rosenberg, *Barnett Newman* (New York: Abrams, 1978), 234.

14. Ann Temkin, *Barnett Newman* (Philadelphia: Philadelphia Museum of Art, 2002), 158.

15. Requoted in James E. B. Breslin, *Mark Rothko: A Biography* (Chicago: University of Chicago Press, 1993), 251, 335.

16. Solomon, *Jackson Pollock*, 177–178.

17. Requoted in Mary V. Dearborn, *Ernest Hemingway: A Biography* (New York: Knopf, 2017), 691.

18. See Robert Motherwell, "The School of New York," manifesto, January 1, 1951, transcribed by Smithsonian Digital Volunteers, Archives of American Art, Smithsonian Institution.

19. The term "action painting" was coined by Harold Rosenberg. See Harold Rosenberg, "The American Action Painters," *ARTnews*, December 1952, 22.

20. "Colour Field Painting," Tate, www.tate.org.uk/art/art-terms/c/colour-field-painting.

21. William Grimes, "Grace Hartigan, 86, Abstract Painter, Dies," *New York Times*, November 18, 2008, www.nytimes.com/2008/11/18/arts/design/18hartigan.html.

22. Mark Stevens and Annalyn Swan, *De Kooning: An American Master* (New York: Knopf, 2004), 209.

23. Ibid., 251.

24. Ibid., 271.

25. Hall, *Betty Parsons*, 20.

26. Ibid.,178.

27. Ibid., 41.

28. Ibid., 54.

29. John Yau, "The Legendary Betty Parsons Meets the Not-So-Legendary Betty Parsons," *Hyperallergic*, July 9, 2017, https://hyperallergic.com/389386/betty-parsons-invisible-presence-alexander-gray-associates-2017/.

30. Hall, *Betty Parsons*, 61.

31. Ibid., 72.

32. Ibid., 81.

33. "Jackson Pollock," Collection Online, Guggenheim Museum, www.guggenheim.org/artwork/artist/jackson-pollock; "The Post-War Period, 1948–1973," La Biennale di Venezia, www.labiennale.org/en/history/post-war-period-and-60s; "History, 1985–2018," La Biennale di Venezia, www.labiennale.org/en/history.

34. Patricia Albers, *Joan Mitchell: Lady Painter* (New York: Knopf, 2011), 139.

35. Hall, *Betty Parsons*, 94–95.

36. Artspace Editors, "Dealer Betty Parsons Pioneered Male Abstract Expressionists—But Who Were the Unrecognized Women Artists She Exhibited?" *Artspace*, April 3, 2017, www.artspace.com/magazine/interviews_features/book_report/dealer-betty-parsons-pioneered-male-abstract-expressionistsbut-who-were-the-unrecognized-women-54682.

37. Hall, *Betty Parsons*, 102.

38. "Chronology," Barnett Newman Foundation, www.barnettnewman.org/artist/chronology; Hilarie M. Sheets, "Clyfford Still, Unpacked," *Art in America*, November 1, 2011, www.artinamericamagazine.com/news-features/magazine/clyfford-still-unpacked/.

39. Breslin, *Mark Rothko*, 335.

40. Interview with Sidney Janis, October 15–November 18, 1981, Archives of American Art, Smithsonian Institution.

41. Clayton Press, "Motherwell to Hofmann: The Samuel Kootz Gallery, 1945–1966 at Neuberger Museum of Art, Purchase, NY," *Forbes*, February 18, 2018, www.forbes.com/sites/claytonpress/2018/02/18/motherwell-to-hofmann-the-samuel-kootz-gallery-1945-1966-at-neuberger-museum-of-art-purchase-ny/#30a553e443c0.

42. Hall, *Betty Parsons*, 102; Jennifer Farrell et al., *The History and Legacy of Samuel M. Kootz and the Kootz Gallery* (Charlottesville: Fralin Museum of Art at the University of Virginia, 2017), 78.

43. "Sidney Janis Gallery," Archives Directory for the History of Collecting in America, Frick Collection, http://research.frick.org/directoryweb/browserecord.php?-action=browse &-recid=6222.

44. Interview with Sidney Janis, October 15–November 18, 1981, Archives of American Art, Smithsonian Institution.

45. Laura De Coppet and Alan Jones, *The Art Dealers* (New York: Cooper Square Press, 2002), 37.

46. Willem de Kooning, *Excavation*, 1950, oil on canvas, 205.7 x 254.6 cm, Art Institute Chicago, www.artic.edu/aic/collections/artwork/76244.

47. Barbara Hess and Willem de Kooning, *Willem de Kooning, 1904–1997: Content as a Glimpse* (Cologne: Taschen, 2004), 42.

48. "Willem de Kooning," Art Bios, March 8, 2011, https://artbios.net/3-en.html.

49. Ben Heller, interview by Avis Berman, Museum of Modern Art Oral History Program, April 18, 2001, 5.

50. Ibid., 26.

51. Ibid., 5; Jed Perl, "The Opportunist," *New Republic*, October 20, 2010, https://newrepublic.com/article/78555/the-opportunist-leo-castelli-art.

52. Perl, "The Opportunist."

53. Ben Heller, interview by Avis Berman, Museum of Modern Art Oral History Program, April 18, 2001, 5.

54. Jackson Pollock, *One: Number 31, 1950*, 1950, oil and enamel paint on canvas, 8' 10" x 17' 5 5/8" (269.5 x 530.8 cm), Museum of Modern Art, New York, www.moma.org/collection/works/78386.

55. Naifeh and Smith, *Jackson Pollock: An American Saga*, 765.

56. Ibid; Budd Hopkins reported that the additional painting was "in recognition of his [Heller's] commitment to Pollock's work"; see also Friedman, *Jackson Pollock: Energy Made Visible*, 199.

57. Laurie Gwen Shapiro, "An Eye-Popping Mid-Century Apartment Filled with Pollocks, Klines, and De Koonings," *New York*, October 27, 2017, www.thecut.com/2017/10/ben-hellers-mid-century-nyc-apartment.html.

58. Though the painting is sometimes referred to as *Interchange*, *Interchanged* (1955) is the correct title. See John Elderfield, *De Kooning: A Retrospective* (New York: Museum of Modern Art, 2012), 32.

59. Hall, *Betty Parsons*, 94–95, 180; Holland Cotter, "Ellsworth Kelly, Who Shaped Geometries on a Bold Scale, Dies at 92," *New York Times*, December 27, 2015, www.nytimes.com/2015/12/28/arts/ellsworth-kelly-artist-who-mixed-european-abstraction-into-everyday-life-dies-at-92.html; John Russell, "Art: Jack Youngerman at the Guggenheim," *New York Times*, March 7, 1986, www.nytimes.com/1986/03/07/arts/art-jack-youngerman-at-the-guggenheim.html?pagewanted=all; "Ellsworth Kelly: Biography," Hollis Taggart, 2017, www.hollistaggart.com/artists/ellsworth-kelly.

60. Holland Cotter, "Where City History Was Made, a 50's Group Made Art History," *New York Times*, January 5, 1993, www.nytimes.com/1993/01/05/arts/where-city-history-was-made-a-50-s-group-made-art-history.html.

61. Ibid.

62. Hans Namuth, *Artists on the Roof of 3-5 Coenties Slip* (left to right: Delphine Seyrig, Duncan Youngerman, Robert Clark, Ellsworth Kelly, Jack Youngerman, and Agnes Martin), ca. 1967, photograph, Hans Namuth Archive, Center For Creative Photography.

63. Alanna Martinez, "How Rauschenberg Elevated Tiffany's Window Displays into an Art Form," *Observer*, December 30, 2016, http://observer.com/2016/12/robert-rauschenberg-tiffany-windows/.

64. Grace Glueck, "Alfred Hamilton Barr Jr. Is Dead; Developer of Modern Art Museum," *New York Times*, August 16, 1981, www.nytimes.com/1981/08/16/obituaries/alfred-hamilton-barr-jr-is-dead-developer-of-modern-art-museum.html?pagewanted=all.

65. Ibid.

66. *The New American Painting* toured eight European countries in 1958 and 1959.

67. Interview with Sidney Janis, October 15–November 18, 1981, Archives of American Art, Smithsonian Institution.

Chapter 2: The Elegant Mr. Castelli

Interviews: Irving Blum, Patty Brundage, Susan Brundage, Marian Goodman, Antonio Homem, Jim Jacobs, Gerard Malanga, Don Marron, Robert Pincus-Witten, Irving Sandler, Morgan Spangle, Frank Stella, Robert Storr

1. Leo Castelli, interview, May 14, 1969–June 8, 1973, Archives of American Art, Smithsonian Institution.

2. Annie Cohen-Solal, *Leo and His Circle: The Life of Leo Castelli* (New York: Knopf, 2010), 171, 176.

3. Ibid., 177.

4. Ibid., 361.

5. Titia Hulst, "The Right Man at the Right Time: Leo Castelli and the American Market for Avant-Garde Art," (PhD diss., New York University, 2014), 67.

6. Cohen-Solal, *Leo and His Circle*, 122.

7. Hulst, "The Right Man at the Right Time," 67.

8. Cohen-Solal, *Leo and His Circle*, 151.

9. Ibid., 178.

10. Ibid., 151.

11. Ibid., 186.

12. Hiroko Ikegami, *The Great Migrator: Robert Rauschenberg and the Global Rise of American Art* (Cambridge, MA: MIT Press, 2010), 21.

13. "The Ninth Street Exhibition—1951," in *Art Now and Then*, a blog by Jim Lane, September 6, 2015, http://art-now-and-then.blogspot.com/2015/09/the-ninth-street-exhibition-1951.html.

14. Marika Herskovic, *New York School Abstract Expressionists: Artists Choice by Artists, a Complete Documentation of the New York Painting and Sculpture Annuals, 1951–1957* (Franklin Lakes, NJ: New York School Press, 2000), 13–14.

15. De Coppet and Jones, *Art Dealers*, 87.

16. Ibid., 88.

17. John Cage, *Silence* (Middletown, CT: Wesleyan University Press, 1967), 102.

18. Olivia Laing, "Robert Rauschenberg and the Subversive Language of Junk," *Guardian*, November 25, 2016, www.theguardian.com/artanddesign/2016/nov/25/robert-rauschenberg-and-the-subversive-language-of-junk-tate.

19. Leo Steinberg, *The New York School: Second Generation* (published in conjunction with the exhibition of the same title, organized by and presented at the Jewish Museum, New York, March 10–April 28, 1957), cover.

20. Ann Fensterstock, *Art on the Block: Tracking the New York Art World from Soho to the Bowery, Bushwick and Beyond* (New York: Palgrave Macmillan, 2013), 49.

21. Deborah Solomon, "The Unflagging Artistry of Jasper Johns," *New York Times*, June 19, 1988, www.nytimes.com/1988/06/19/magazine/the-unflagging-artistry-of-jasper-johns.html?pagewanted=all.

22. Ibid.

23. Editors of *ARTnews*, "From the Archives: Betty Parsons, Gallerist Turned Artist, Takes the Spotlight, in 1979," *ARTnews*, June 16, 2017, www.artnews.com/2017/06/16/from-the-archives-betty-parsons-gallerist-turned-artist-takes-the-spotlight-in-1979/.

24. Ibid.

25. Solomon, "Jasper Johns."

26. Calvin Tomkins, *Off the Wall: A Portrait of Robert Rauschenberg* (New York: Picador, 2005), 131.

27. There are questions about how large this fortune really was. See Carol Vogel, "A Colossal Private Sale by the Heirs of a Dealer," *New York Times*, April 4, 2008, www.nytimes.com/2008/04/04/arts/04iht-04vogel.11673988.html.

28. Hulst, "The Right Man at the Right Time," 154.

29. Ibid., 79.

30. Robert Sam Anson, "The Lion in Winter," *Manhattan, Inc.*, December 1984.

31. Hunter Drohojowska-Philp, "Art Dealer Irving Blum on Andy Warhol and the 1960s L.A. Art Scene (Q&A)," *Hollywood Reporter*, November 4, 2013, www.hollywoodreporter.com/news/art-dealer-irving-blum-andy-653195. In 1962, Blum would take full control of Ferus when his remaining partner, Walter Hopps, became curator of the Pasadena Museum.

32. Calvin Tomkins, *Lives of the Artists: Portraits of Ten Artists Whose Work and Lifestyles Embody the Future of Contemporary Art* (New York: Henry Holt, 2008), 178.

33. Emma Brockes, "Master of Few Words," *Guardian*, July 26, 2004, www.theguardian.com/artanddesign/2004/jul/26/art.usa.

34. Cohen-Solal, *Leo and His Circle*, 367–369.

35. This 1960 work, titled *Painted Bronze*, was on loan from Jasper Johns's private collection to the Philadelphia Museum of Art before being sold to New York collectors Marie-Josée and Henry R. Kravis in 2015. See Museum of Modern Art, "MoMA Announces Recent Acquisitions, Including 'Painted Bronze' by Jasper Johns," press release, March 16, 2015, http://press.moma.org/2015/03/new-acquisitions-johns/.

36. Sidney Janis Gallery, *Sidney Janis Presents an Exhibition of Factual Paintings & Sculpture From France, England, Italy, Sweden and the United States: By the Artists Agostini, Arman, Baj... Under the Title of the New Realists* (New York: Sidney Janis Gallery, 1962).

37. "4 East 77th Street—1957–1976," Castelli Gallery, http://castelligallery.com/history/4e77.html.

38. Solomon, "Jasper Johns."

39. Christine Bianco, "Selling American Art: Celebrity and Success in the Postwar New York Art Market" (MA diss., University of Florida, 2000), 32.

40. Tomkins, *Off the Wall*, 133.

41. "Collecting Jackson Pollock," in *Greg.org*, a blog by Greg Allen, September 4, 2007, http://greg.org/archive/2007/09/04/collecting_jackson_pollock.html.

42. Sebastian Smee, *The Art of Rivalry: Four Friendships, Betrayals, and Breakthroughs in Modern Art* (New York: Random House, 2016), 351.

43. Ibid.

44. Charles Darwent, "Andre Emmerich," *Independent*, October 10, 2017, www.independent.co.uk/news/obituaries/andre-emmerich-396448.html.

45. Patricia Zohn, "CultureZohn: Peggy Guggenheim, Art Addict," *Huffington Post*, November 4, 2015, www.huffingtonpost.com/patricia-zohn/culturezohn-peggy-guggenheim-art-addict_b_8461548.html.

46. Ibid.

47. Ann Temkin and Claire Lehmann, *Ileana Sonnabend: Ambassador for the New* (New York: Museum of Modern Art, 2013).

48. Cohen-Solal, *Leo and His Circle*, 255–256.

49. Ibid., 257.

50. Ibid., 261.

51. Jenna C. Moss, "The Color of Industry: Frank Stella, Donald Judd, and Andy Warhol," *CUREJ: College Undergraduate Research Electronic Journal*, April 17, 2007, https://repository.upenn.edu/cgi/viewcontent.cgi?referer=https://search.yahoo.com/&httpsredir=1&article=1062&context=curej.

52. Randy Kennedy, "American Artist Who Scribbled a Unique Path," *New York Times*, July 5, 2011, www.nytimes.com/2011/07/06/arts/cy-twombly-american-artist-is-dead-at-83.html.

53. Michael Kimmelman, "Roy Lichtenstein, Pop Master, Dies at 73," *New York Times*, September 30, 1997, www.nytimes.com/1997/09/30/arts/roy-lichtenstein-pop -master-dies-at-73.html.

54. "Roy Lichtenstein," Teaching Page, Madison Museum of Contemporary Art, www.mmoca.org/learn/teachers/teaching-pages/roy-lichtenstein.

55. Cohen-Solal, *Leo and His Circle*, 263.

56. Ibid., 264.

57. Drohojowska-Philp, "Art Dealer Irving Blum."

58. Cohen-Solal, *Leo and His Circle*, 264.

59. Walter Hopps, Deborah Treisman, and Anne Doran, "When Walter Hopps Met Andy Warhol and Frank Stella," *New Yorker*, June 5, 2017, www.newyorker.com /culture/culture-desk/when-walter-hopps-met-andy-warhol-and-frank-stella.

60. Drohojowska-Philp, "Art Dealer Irving Blum."

61. "Andy Warhol," About page, Gagosian, www.gagosian.com/artists/andy-warhol.

62. Abigail Cain, "An L.A. Gallerist Bought Out Warhol's First Painting Show for $1,000—and Ended Up with $15 Million," *Artsy*, June 27, 2017, www.artsy.net /article/artsy-editorial-la-gallerist-bought-warhols-first-painting-1-000-ended-15-million.

63. "Warhol's 32 Soup Flavors," *Unbound*, a blog by the Smithsonian Libraries, July 9, 2010, https://blog.library.si.edu/blog/tag/ferus-gallery/#.WkvkjrYrJBw.

64. Hillary Reder, "Serial & Singular: Andy Warhol's *Campbell's Soup Cans*," *Inside/ Out*, a blog from MoMA, April 29, 2015, www.moma.org/explore/inside_out/2015/04/29 /serial-singular-andy-warhols-campbells-soup-cans/.

65. "Warhol's 32 Soup Flavors."

66. "Andy Warhol and the Business of Art," *Andy Today*, a blog by Christie's, http:// warhol.christies.com/andy-warhol-and-the-business-of-art/.

67. De Coppet and Jones, *Art Dealers*, 96.

68. Peter Schjeldahl, "Dealership," *New Yorker*, February 2, 2004, www.newyorker .com/magazine/2004/02/02/dealership.

69. Cohen-Solal, *Leo and His Circle*, 368–370.

70. De Coppet and Jones, *Art Dealers*, 96.

71. "Robert C. Scull; Businessman Who Aided Young Artists," *Los Angeles Times*, January 4, 1986, http://articles.latimes.com/1986-01-04/news/mn-24198_1_young-artists.

72. Sidney Janis Gallery, *Sidney Janis Presents*. Janis further wrote "the new Factual artist [was] (referred to as the Pop Artist in England, the Polymaterialist in Italy, and here [the United States] as in France, as the New Realist)."

Chapter 3: Pop, Minimalism, and the Move to SoHo

Interviews: Peter Brant, Patty Brundage, James Cohan, Paula Cooper, Ralph Gibson, Arne Glimcher, Jim Jacobs, John Kasmin, Nicholas Logsdail, Janelle Reiring, Dick Solomon, Thea Westreich, Angela Westwater

1. Judith E. Stein, *Eye of the Sixties: Richard Bellamy and the Transformation of Modern Art* (New York: Farrar, Straus and Giroux, 2016), 218–219.

2. Ibid.

3. Judy Collischan, *Women Shaping Art: Profiles of Power* (New York: Praeger, 1984), 140, 184.

4. M. H. Miller, "Clock Stopper: Paula Cooper Opened the First Art Gallery in SoHo and Hasn't Slowed Down Since," *Observer*, September 13, 2011, https://observer .com/2011/09/clock-stopper-paula-cooper-opened-the-first-art-gallery-in-soho-and -hasnt-slowed-down-since/.

5. Roberta Smith, "Walter De Maria, Artist on Grand Scale, Dies at 77," *New York Times*, July 26, 2013, www.nytimes.com/2013/07/27/arts/design/walter-de-maria-artist-on-grand -scale-dies-at-77.html.

6. Matthew Higgs, "Paula Cooper," *Interview*, August 2, 2012, www.interviewmagazine.com/art/paula-cooper.

7. Collischan, *Women Shaping Art*, 146.

8. Ibid., 140.

9. Miller, "Clock Stopper."

10. Ibid.

11. Arne Glimcher, "Oral History Interview with Arne (Arnold) Glimcher, 2010 Jan. 6–25," interview by James McElhinney for the Archives of American Art, Smithsonian Institution, www.aaa.si.edu/collections/interviews/oral-history-interview-arne-arnold-glimcher-15912.

12. Ibid.

13. Ibid.

14. Ibid.

15. Ibid.

16. Josh Spero, "Nicholas Logsdail on 50 Years of Pioneering Artistic Talent," *Financial Times*, June 9, 2017, www.ft.com/content/5a4572f8-4625-11e7-8519-9f94ee97d996.

17. Nicolas Niarchos, "Dahl's Bacon," *New Yorker*, June 27, 2014, www.newyorker.com/culture/culture-desk/dahls-bacon.

18. Mark Brown, "Francis Bacon Triptych Sells for £23m—Three Times Its Estimate," *Guardian*, 2011, www.theguardian.com/artanddesign/2011/feb/11/francis-bacon-lucian-freud-triptych.

19. David Segal, "For Richer or for . . . Not Quite as Rich," *New York Times*, January 24, 2010, www.nytimes.com/2010/01/24/business/media/24brant.html.

20. Joyce Chen, "Valerie Solanas: 5 Things to Know about Lena Dunham's 'American Horror Story' Character," *Rolling Stone*, September 19, 2017, www.rollingstone.com/culture/culture-news/valerie-solanas-5-things-to-know-about-lena-dunhams-american-horror-story-character-253318/.

21. Paul Goldberger, "Henry Geldzahler, 59, Critic, Public Official and Contemporary Art's Champion, Is Dead," *New York Times*, August 17, 1994, www.nytimes.com/1994/08/17/obituaries/henry-geldzahler-59-critic-public-official-contemporary-art-s-champion-dead.html.

22. Aaron Shkuda, "The Art Market, Arts Funding, and Sweat Equity: The Origins of Gentrified Retail," *Journal of Urban History* 39, no. 4 (June 2012): 606.

23. Richard Kostelanetz, *Artists' SoHo: 49 Episodes of Intimate History* (New York: Empire State Editions, 2015), 75.

24. Shkuda, "Art Market," 606.

25. "About," Sperone Westwater, www.speronewestwater.com/gallery.

26. Calvin Tomkins, "The Materialist," *New Yorker*, December 5, 2011, www.newyorker.com/magazine/2011/12/05/the-materialist.

27. Baruch D. Kirschenbaum, "The Scull Auction and the Scull Film," *Art Journal* 39, no. 1 (Autumn 1979), 50–54.

28. James Coddington, "MoMA's Jackson Pollock Conservation Project: *One: Number 31, 1950*—Characterizing the Paint Surface Part 1," *Inside/Out*, a blog from MoMA, February 22, 2013, www.moma.org/explore/inside_out/2013/02/22/momas-jackson-pollock-conservation-project-one-number-31-1950-characterizing-the-paint-surface-part-1-the-archival-record/.

29. Kirschenbaum, "Scull Auction," 50–54.

30. Sotheby Parke Bernet, *A Selection of Fifty Works from the Collection of Robert C. Scull* (published in conjunction with the exhibition and auction of the same title, held at the New York Galleries of Sotheby Parke Bernet, October 18, 1973).

31. Kirschenbaum, "Scull Auction," 50–54.

32. "142 Greene Street—1980–1988," Castelli Gallery, http://castelligallery.com/history/142greene.html.

Chapter 4: Young Man in a Hurry

Interviews: Mary Boone, Doug Cramer, Jeffrey Deitch, Asher Edelman, Larry Gagosian, Ralph Gibson, Annina Nosei, Robert Pincus-Witten, David Salle, Morgan Spangle, Robert Storr

1. Peter M. Brant, "Larry Gagosian," *Interview*, November 27, 2012, www.interview magazine.com/art/larry-gagosian.

2. Elisa Lipsky-Karasz, "The Art of Larry Gagosian's Empire," *WSJ. Magazine*, April 26, 2016, www.wsj.com/articles/the-art-of-larry-gagosians-empire-1461677075.

3. Brant, "Larry Gagosian."

4. Ibid.

5. Ibid.

6. "Exhibitions," Ralph Gibson, www.ralphgibson.com/exhibitions.html; Brant, "Larry Gagosian."

7. Larry Gagosian, "My Marden," interview by Amy Larocca, in "My New York: 50th Anniversary Issue," *New York*, October 22, 2017, http://nymag.com/daily/intelligencer /article/my-new-york-50th-anniversary-issue.html.

8. Christopher Masters, "Cy Twombly Obituary," *Guardian*, July 6, 2011, www .theguardian.com/artanddesign/2011/jul/06/cy-twombly-obituary.

9. David Pagel, *Unfinished Business: Paintings from the 1970s and 1980s by Ross Bleckner, Eric Fischl and David Salle* (Munich: Prestel, 2016), 30–37.

10. Paul Taylor, "How David Salle Mixes High Art and Trash," *New York Times*, January 11, 1987.

11. Ibid.

12. Pagel, *Unfinished Business*, 30–37.

13. Brant, "Larry Gagosian."

14. Thomas Lawson, "David Salle," *Flash Art* 3, no. 3 (1980), www.davidsallestudio .net/'80%20Lawson_Flash%20Art%20'80v3.pdf.

15. Gagosian, "My Marden."

16. Ibid.

17. Anthony Haden-Guest, *True Colors: The Real Life of the Art World* (New York: Atlantic Monthly Press, 1996), 168.

18. Gagosian, "My Marden."

19. Brant, "Larry Gagosian."

20. Gagosian, "My Marden."

21. Haden-Guest, *True Colors*, 97.

22. David Segal, "Pulling Art Sales out of Thinning Air," *New York Times*, March 7, 2009.

23. "Larry Gagosian: The Fine Art of the Deal," *Independent*, November 2, 2007, www.independent.co.uk/news/people/profiles/larry-gagosian-the-fine-art-of-the-deal -398567.html.

24. Ibid.

25. Pagel, *Unfinished Business*, 30–37.

26. Brant, "Larry Gagosian."

27. Lipsky-Karasz, "Larry Gagosian's Empire."

28. Siranush Ghazanchyan, "WSJ: The Art of American Armenian Dealer Larry Gagosian's Empire," Public Radio of Armenia, May 2, 2016, www.armradio.am/en/2016 /05/02/wsj-the-art-of-american-armenian-dealer-larry-gagosians-empire/.

29. Segal, "Pulling Art Sales out of Thinning Air."

30. Lipsky-Karasz, "Larry Gagosian's Empire."

31. Brant, "Larry Gagosian."

32. Ibid.

33. Ibid.; Gagosian's father died in 1969 and his mother in 2005. They are buried in Forest Lawn Memorial Park near Los Angeles.

34. Andrew Decker, "Art À GoGo," *New York*, September 2, 1991, 42.

35. Ibid.; Segal, "Pulling Art Sales out of Thinning Air."

36. Lipsky-Karasz, "Larry Gagosian's Empire."

37. Ghazanchyan, "WSJ: The Art of American Armenian Dealer Larry Gagosian's Empire."

38. Eric Konigsberg, "The Trials of Art Superdealer Larry Gagosian," *New York*, January 20, 2013.

39. Grace Glueck, "One Art Dealer Who's Still a High Roller," *New York Times*, June 24, 1991.

40. Lipsky-Karasz, "Larry Gagosian's Empire."

41. "Editorial and Creative Team," *Bidoun*, http://archive.bidoun.org/about/team/.

42. Negar Azimi, "Larry Gagosian," *Bidoun* 28 (Spring 2013), http://bidoun.org/articles/larry-gagosian.

43. Don Thompson, *The $12 Million Stuffed Shark: The Curious Economics of Contemporary Art* (New York: Palgrave Macmillan, 2008), 29.

44. Jackie Wullschlager, "Lunch with the FT: Larry Gagosian," *Financial Times*, October 22, 2010, www.ft.com/content/c5e9cf78-dd62-11df-beb7-00144feabdc0.

45. Brant, "Larry Gagosian."

46. Andrew Russeth, "Larry Gagosian on Jazz, Selling Posters, One of His First Art Buys," *Observer*, April 9, 2013, http://observer.com/2013/04/larry-gagosian-on-jazz-selling-posters-one-of-his-first-art-buys/.

47. Brant, "Larry Gagosian."

48. Azimi, "Larry Gagosian."

49. M. H. Miller, "How to Kill Your Idols: Kim Gordon Takes No Prisoners in New Memoir," *ARTnews*, February 10, 2015, www.artnews.com/2015/02/10/girl-in-a-band-by-kim-gordon-reviewed/.

50. Bob Colacello, "The Art of the Deal," *Vanity Fair*, April 1, 1995, www.vanityfair.com/culture/1995/04/art-of-the-deal-199504.

51. Ibid.

52. Ibid.

53. "U.S. Inflation Rate, $2,000 in 1979 to 2017," CPI Inflation Calculator, www.in2013dollars.com/1979-dollars-in-2017?amount=2000.

54. Julie L. Belcove, "A New Boone," *W*, November 1, 2008, www.wmagazine.com/story/mary-boone.

55. Taylor, "David Salle."

56. Gini Alhadeff, "Mary Boone Is Egyptian," *Bidoun*, http://bidoun.org/articles/mary-boone-egyptian; Eric Fischl, "Mary Boone," *Interview*, October 22, 2014, www.interviewmagazine.com/art/mary-boone.

57. Anthony Haden-Guest, "The New Queen of the Art Scene," *New York*, April 19, 1982, 24–30.

58. Andrew Russeth, "Klaus Kertess, Foresighted Art Dealer and Curator, Dies at 76," *ARTnews*, October 9, 2016, www.artnews.com/2016/10/09/klaus-kertess-foresighted-art-dealer-and-curator-dies-at-76/.

59. Fischl, "Mary Boone."

60. Haden-Guest, "New Queen of the Art Scene," 24–30.

61. Ibid.

62. "Mary Boone Gallery, New York, 1979," Exhibitions page, Julian Schnabel, www.julianschnabel.com/exhibitions/mary-boone-gallery-new-york-1979.

63. "Julian Schnabel Biography," Gagosian Gallery, https://gagosian.com/media/artists/julian-schnabel/Gagosian_Julian_Schnabel_Listed_Exhibitions_Selected.pdf.

64. Gagosian, "My Marden."

65. Segal, "Pulling Art Sales out of Thinning Air."

66. Ibid.

67. "Gagosian the Great," *Economist*, August 18, 2007, www.economist.com/node/9673257.

68. Ibid.

69. Cohen-Solal, *Leo and His Circle*, 406.

70. Eileen Kinsella, "From Schnabel to Sashimi? Gagosian Opens Sushi Joint," *Artnet News*, September 8, 2014, https://news.artnet.com/market/from-schnabel-to-sashimi-gagosian-opens-sushi-joint-95984.

71. Kelly Crow, "Keeping Pace," *WSJ. Magazine*, August 26, 2011, www.wsj.com/articles/SB10001424053111903596904576517164002381464; Peter Schjeldahl, "Leo the Lion," *New Yorker*, June 7, 2010, www.newyorker.com/magazine/2010/06/07/leo-the-lion.

72. "A Connecticut Couple Has Sold a Painting, 'Three Flags,'..." UPI, September 27, 1980, www.upi.com/Archives/1980/09/27/A-Connecticut-couple-has-sold-a-painting-Three-Flags/1780338875200.

73. Ibid.

74. Isabelle de Wavrin, "Arne Glimcher: For the Love of Art," Sotheby's, May 17, 2017, www.sothebys.com/en/news-video/blogs/all-blogs/76-faubourg-saint-honore/2017/05/arne-glimcher-for-the-love-of-art.html; Rachel Wolff, "Fifty Years of Being Modern," *New York*, September 12, 2010, http://nymag.com/news/intelligencer/68096/.

Chapter 5: The Start of a Dissolute Decade

Interviews: Richard Armstrong, Howard Blum, Mary Boone, Doug Cramer, Brett De Palma, Larry Gagosian, Marian Goodman, Timothy Greenfield-Sanders, Annina Nosei, Janelle Reiring, Walter Robinson, Thaddaeus Ropac, Lisa Spellman

1. De Coppet and Jones, *Art Dealers*, 107.

2. Jeffrey Hogrefe, "Julian's Crock of Gold," *Washington Post*, May 20, 1983, www.washingtonpost.com/archive/lifestyle/1983/05/20/julian-schnabels-crock-of-gold/116e6138-1405-48a8-a518-b04af209b4dd/.

3. Mary Boone, "30th Anniversary Issue / Mary Boone: The Art of the Dealer," interview by Phoebe Hoban, *New York*, April 6, 1998, http://nymag.com/nymetro/news/people/features/2419/.

4. Christie's, "'It's Culture or It's Not Culture': An Interview with Annina Nosei," *Artsy*, March 4, 2014, www.artsy.net/article/christies-its-culture-or-its-not-culture-an.

5. "Auction Results: Contemporary Evening Auction," Lot 24, Sotheby's, May 18, 2017, www.sothebys.com/en/auctions/2017/contemporary-art-evening-auction-n09761.html.

6. Collischan, *Women Shaping Art*, 224–225.

7. Linda Yablonsky, "Barbara Gladstone," *Wall Street Journal*, December 1, 2011, www.wsj.com/articles/SB10001424052970204449804577068852011763014.

8. Lipsky-Karasz, "Larry Gagosian's Empire."

9. "Larry Gagosian: The Fine Art of the Deal."

10. ASX Team, "Jean-Michel Basquiat and 'The Art of (Dis)Empowerment' (2000)," *ASX*, October 30, 2013, www.americansuburbx.com/2013/10/jean-michel-basquiat-art-disempowerment-2000.html.

11. Phoebe Hoban, *Basquiat: A Quick Killing in Art* (New York: Viking, 1998), 90ff.

12. Haden-Guest, *True Colors*, 136.

13. Estate of Jean-Michel Basquiat, "The Artist," Jean-Michel Basquiat, www.basquiat.com/artist-timeline.htm.

14. Hoban, *Basquiat*, 125ff.

15. Lipsky-Karasz, "Larry Gagosian's Empire."

16. Hoban, *Basquiat*, 164.

17. Joseph Beuys, *Basisraum Nasse Wäsche*, 1979, galvanized iron gutters, tables, chair, soap, aluminum bucket, light bulb, laundry, 29.53 in. x 295.28 in. x 90.55 in., Museum Moderner Kunst Stiftung Ludwig Wien, www.mumok.at/de/basisraum-nasse-waesche.

18. "Zuhause bei Familie Beuys," *Zeit Online*, July 20, 2016, www.zeit.de/news/2016-07/20/kunst-zuhause-bei-familie-beuys-20092004.

19. "Past: 1981–1980," Exhibitions page, Metro Pictures, www.metropictures.com/exhibitions/past/all/1981-1980; Gary Indiana, "These '80s Artists Are More Important

Than Ever," *T*, February 13, 2017, www.nytimes.com/2017/02/13/t-magazine/pictures
-generation-new-york-artists-cindy-sherman-robert-longo.html.

20. Roberta Smith, "Film Starlet Cliches, Genuine and Artificial at the Same Time,"
New York Times, June 27, 1997, www.nytimes.com/1997/06/27/arts/film-starlet-cliches
-genuine-and-artificial-at-the-same-time.html.

21. Charlotte Burns, "Walter Robinson: 'I'm Just a Stupid Painter. We're Like Dumb
Horses,'" *Guardian*, September 17, 2016, www.theguardian.com/artanddesign/2016/sep
/17/walter-robinson-artist-paintings-interview.

22. Kelly Crow, "The Escape Artist," *Wall Street Journal*, March 14, 2013, www.wsj
.com/articles/SB10001424127887324678604578340322829104276.

23. "Past: 1984–1982," Exhibitions page, Metro Pictures, www.metropictures.com
/exhibitions/past/all/1984-1982.

24. "Lot 40: Martin Kippenberger (1953–1997), *Untitled*," Christie's, www.christies
.com/LotFinder/lot_details.aspx?intObjectID=5846095.

25. Dan Cameron, *East Village USA* (New York: New Museum of Contemporary Art,
2004), 42.

26. Fensterstock, *Art on the Block*, 104.

27. Ibid.

28. Craig Unger, "The Lower East Side: There Goes the Neighborhood," *New York*,
May 28, 1984, 32–44.

29. Peter Schjeldahl, "The Walker: Rediscovering New York with David Hammons,"
New Yorker, December 23, 2002, www.newyorker.com/magazine/2002/12/23/the-walker.

30. "David Hammons," Biography, Mnuchin Gallery, www.mnuchingallery.com
/artists/david-hammons.

31. Andrew Russeth, "Looking at Seeing: David Hammons and the Politics of Visi-
bility," *ARTnews*, February 17, 2017, www.artnews.com/2015/02/17/david-hammons-and
-the-politics-of-visibility/.

32. Cameron, *East Village USA*, 42.

33. Diane Solway, "Family Affair," *W*, December 1, 2014, www.wmagazine.com
/story/rubell-family-art-collection.

34. Ibid.

35. "The Advisory," Thea Westreich Art Advisory Services, http://momentsound
.com/twaas/advisory/.

36. Carol Vogel, "New York Couple's Gift to Enrich Two Museums," *New York Times*,
March 15, 2012, www.nytimes.com/2012/03/16/arts/design/hundreds-of-works-to-go-to
-whitney-museum-and-pompidou-center.html.

37. Gary Indiana, "One Brief, Scuzzy Moment," *New York*, http://nymag.com/ny
metro/arts/features/10557/index3.html.

38. Linda Yablonsky, "Oh Pat. Oh Colin. How We Knew Them," in *Pat Hearn, Colin
de Land: A Tribute* (New York: Pat Hearn and Colin de Land Cancer Foundation, undated),
www.phcdl.org/articles/patcolin_article1.pdf.

39. Ibid.

40. Ibid.

41. Ibid.

42. Ibid.

43. Roberta Smith, "Pat Hearn, Art Dealer in New York, Dies at 45," *New York Times*,
August 20, 2000, www.nytimes.com/2000/08/20/nyregion/pat-hearn-art-dealer-in-new
-york-dies-at-45.html.

44. Gillian Sagansky, "George Condo Recalls His First (and Last) Real Job," *W*, Febru-
ary 27, 2016, www.wmagazine.com/story/george-condo-recalls-first-last-real-job; Calvin
Tomkins, "Portraits of Imaginary People," *New Yorker*, January 17, 2011, www.newyorker
.com/magazine/2011/01/17/portraits-of-imaginary-people.

45. "George Condo: Biography," Simon Lee, www.simonleegallery.com/usr/documents
/artists/cv_download_url/28/george-condo_bio-biblio.pdf; Brendan Smith, "The Artificial

Realism of George Condo," *BmoreArt*, May 15, 2017, www.bmoreart.com/2017/05/the-artificial-realism-of-george-condo.html.

 46. Yablonsky, "Oh Pat. Oh Colin."

 47. Fensterstock, *Art on the Block*, 122.

Chapter 6: SoHo and Beyond

Interviews: Frances Beatty, Olivier Berggruen, Mary Boone, Susan Brundage, John Good, Marian Goodman, Jay Gorney, Anselm Kiefer, Dotson Rader, Robert Storr, Angela Westwater

 1. Anson, "The Lion in Winter."

 2. Cohen-Solal, *Leo and His Circle*, 416.

 3. Anson, "The Lion in Winter."

 4. Cohen-Solal, *Leo and His Circle*, 416.

 5. Malcolm Goldstein, *Landscape with Figures: A History of Art Dealing in the United States* (Oxford: Oxford University Press, 2000), 297.

 6. Jeffrey Hogrefe, "Schnabel Makes the Switch," *Washington Post*, April 21, 1984.

 7. Cohen-Solal, *Leo and His Circle*, 418.

 8. Anson, "The Lion in Winter."

 9. Paul Taylor, "Art; Leo Castelli in His 85th Year: A Lion in Winter," *New York Times*, February 16, 1992, www.nytimes.com/1992/02/16/arts/art-leo-castelli-in-his-85th-year-a-lion-in-winter.html?pagewanted=all.

 10. Requoted in Cohen-Solal, *Leo and His Circle*, 417.

 11. Georgina Adam, *Big Bucks: The Explosion of the Art Market in the 21st Century* (London: Lund Humphries, 2014), 5.

 12. Segal, "Pulling Art Sales out of Thinning Air."

 13. Judd Tully, "A Master of the Mix of Big Art and Big Money," *Washington Post*, June 6, 1993, www.washingtonpost.com/archive/business/1993/06/06/a-master-of-the-mix-of-big-art-and-big-money/7a20079d-cdb4-476c-8486-323f921fe08b.

 14. Ibid.; Kathleen L. Housley, *Emily Hall Tremaine: Collector on the Cusp* (Meriden, CT: Emily Hall Tremaine Foundation, 2001), 213–214.

 15. Housley, *Emily Hall Tremaine*, 209.

 16. Lipsky-Karasz, "Larry Gagosian's Empire."

 17. Decker, "Art À GoGo," 41.

 18. Ibid.

 19. *Art & Auction* 27, nos. 1–4 (2006).

 20. Gagosian, "My Marden."

 21. Ibid.

 22. Ibid.

 23. Housley, *Emily Hall Tremaine*, 213–214.

 24. Lipsky-Karasz, "Larry Gagosian's Empire."

 25. Michael Brenson, "Art: Rothenberg Horses at the Gagosian Gallery," *New York Times*, January 23, 1987, www.nytimes.com/1987/01/23/arts/art-rothenberg-horses-at-the-gagosian-gallery.html?pagewanted=all.

 26. Konigsberg, "Art Superdealer Larry Gagosian."

 27. Ibid.

 28. Haden-Guest, *True Colors*, 153.

 29. Hoban, *Basquiat*, 236.

 30. Ibid.

 31. Ibid., 250.

 32. Ibid., 249.

 33. Eric Fretz, *Jean-Michel Basquiat: A Biography* (Santa Barbara, CA: Greenwood, 2010), 144.

 34. Michael Shnayerson, "One by One," *Vanity Fair*, April 1987, 91–97, 152–153.

35. Jeff Koons, interview by Claire Dienes and Lilian Tone, Museum of Modern Art Oral History Program, May 26, 1999, www.moma.org/momaorg/shared/pdfs/docs/learn/archives/transcript_koons.pdf.

36. Ann Landi, "Top Ten *ARTnews* Stories: How Jeff Koons Became a Superstar," *ARTnews*, November 1, 2007, www.artnews.com/2007/11/01/top-ten-artnews-stories-how-jeff-koons-became-a-superstar/.

37. Kelly Devine Thomas, "The Selling of Jeff Koons," *ARTnews*, May 1, 2005, www.artnews.com/2005/05/01/the-selling-of-jeff-koons/.

38. Anthony D'Offay, "My 15 Minutes," interview by Leo Hickman, *Guardian*, February 4, 2002, www.theguardian.com/culture/2002/feb/04/artsfeatures.warhol.

39. Ibid.

40. Charlotte Cripps, "Arts: Andy Warhol's World of Fears," *Independent*, February 3, 2005, www.independent.co.uk/arts-entertainment/arts-andy-warhols-world-of-fears-1528459.html.

41. Jennifer Higgie, "Andy Warhol," *Frieze*, September 5, 1996, https://frieze.com/article/andy-warhol-1?language=de.

42. Andy Warhol, *Self-Portrait*, 1986, acrylic and silk screen on canvas, 203.2 x 203.2 cm, Metropolitan Museum of Art, https://metmuseum.org/art/collection/search/484952.

43. "Lot 9: Andy Warhol, *Self Portrait*," Contemporary Art Evening Auction, Sotheby's New York, May 12, 2010.

44. "Art & Craft," *ES Magazine*, June 27, 2008.

45. Anthony D'Offay, interview by Marta Gnyp, *Monopol*, March 2016, www.martagnyp.com/interviews/anthony-doffay.php

46. Joseph Beuys, *Unschlitt/Tallow*, 1977, stearin, tallow, chromel-alumel thermocouples with compensating cables, digital millivoltmeter, and alternating current transformer, 955 cm x 195 cm x 306 cm, Skulptur Projekte Archiv, www.skulptur-projekte-archiv.de/en-us/1977/projects/82/.

47. Andreja Velimirović, "Joseph Beuys," *Widewalls*, November 3, 2016, www.widewalls.ch/artist/joseph-beuys/.

48. *Capitalist Realism*, Tate, www.tate.org.uk/art/art-terms/c/capitalist-realism.

49. Elizabeth Day, "Marian Goodman: Gallerist with the Golden Touch," *Guardian*, October 11, 2014, www.theguardian.com/artanddesign/2014/oct/12/marian-goodman-gallerist-golden-touch.

50. "About," Sperone Westwater, www.speronewestwater.com/gallery.

51. Schjeldahl, "Dealership."

Chapter 7: Boom, Then Gloom

Interviews: Irving Blum, Peter Brant, Anthony d'Offay, Larry Gagosian, Arne Glimcher, Aaron Richard Golub, John Good, Jim Jacobs, Nicole Klagsbrun, Allan Schwartzman, Lisa Spellman, Robert Storr

1. Carol Vogel, "Value Put on Estate of Warhol Declines," *New York Times*, July 21, 1993, www.nytimes.com/1993/07/21/arts/value-put-on-estate-of-warhol-declines.html.

2. Paul Alexander, "Putting a Price on Andy," *New York*, May 2, 1994, 26.

3. Michael Shnayerson, "Judging Andy," *Vanity Fair*, April 4, 2012, www.vanityfair.com/culture/2003/11/authentic-andy-warhol-michael-shnayerson.

4. Don Thompson, "The Supermodel and the Brillo Box," *Artnet News*, May 27, 2014, https://news.artnet.com/art-world/the-supermodel-and-the-brillo-box-22897.

5. Peter Schjeldahl, "Writing on the Wall," *New Yorker*, November 24, 2013, www.newyorker.com/magazine/2013/11/04/writing-on-the-wall-3.

6. Roberta Smith, "Painting's Endgame, Render Graphically," *New York Times*, October 24, 2013, www.nytimes.com/2013/10/25/arts/design/a-christopher-wool-show-at-the-guggenheim.html.

7. "Robert Gober and Christopher Wool," installation view, 303 Gallery, www
.303gallery.com/gallery-exhibitions/robert-gober-christopher-wool.

8. Schjeldahl, "Writing on the Wall."

9. Ibid.

10. "Galleries," New York, May 10, 1988.

11. Schjeldahl, "Writing on the Wall."

12. Daniel Grant, "Is the Art World in for a Spring Sales Slump?" Observer, May 6, 2016, http://observer.com/2016/05/is-the-art-world-in-for-a-spring-sales-slump/.

13. Rita Reif, "Jasper Johns Painting Is Sold for $17 Million," New York Times, November 11, 1988, www.nytimes.com/1988/11/11/arts/jasper-johns-painting-is-sold -for-17-million.html.

14. Ibid.

15. Haden-Guest, True Colors, 177.

16. Ibid., 178.

17. Ibid., 197.

18. See, for example, Grace Glueck, "In the Art World, as in Baseball, Free Agents Abound," New York Times, January 14, 1991, www.nytimes.com/1991/01/14/arts/in-the -art-world-as-in-baseball-free-agents-abound.html?pagewanted=all.

19. Decker, "Art À GoGo."

20. Brant, "Larry Gagosian."

21. Ibid.

22. Lipsky-Karasz, "Larry Gagosian's Empire."

23. Ibid.

24. Suzanne Muchnic, "Art in the Eighties: An International Bull Market," Los Angeles Times, December 25, 1989, http://articles.latimes.com/1989-12-25/entertainment /ca-782_1_bull-market.

25. Alison Fendley, Saatchi and Saatchi: The Inside Story (New York: Arcade, 1996).

26. Grant Pooke, Contemporary British Art: An Introduction (London: Routledge, 2011), 27; John Russell, "Art View; In London, a Fine Home for a Major Collection," New York Times, February 10, 1985, www.nytimes.com/1985/02/10/arts/art-view-in-london-a-fine -home-for-a-major-collection.html?pagewanted=all.

27. David Cottington, Modern Art: A Very Short Introduction (Oxford: Oxford University Press, 2005), 35.

28. Thomas S. Mulligan, "Noted Art Dealer Cited in Tax Fraud," Los Angeles Times, March 30, 2003, http://articles.latimes.com/2003/mar/20/local/me-gallery20.

29. Carol Vogel, "The Art Market," New York Times, May 15, 1992, www.nytimes .com/1992/05/15/arts/the-art-market.html?pagewanted=all.

Chapter 8: Up from the Ashes

Interviews: Bill Acquavella, Irving Blum, Gavin Brown, Jeffrey Deitch, Michael Findlay, Larry Gagosian, Arne Glimcher, Antonio Homem, Victoria Miro, Allan Schwartzman, Lisa Spellman, Thea Westreich

1. Boone, "30th Anniversary Issue."

2. Sarah Douglas, "Emerging Markets," National, November 19, 2009, www.thenational .ae/arts-culture/art/emerging-markets-1.497901.

3. Glueck, "One Art Dealer."

4. Ibid.

5. Ibid.

6. Ibid.

7. Tully, "Big Art and Big Money."

8. Rey Mashayekhi, "Gagosian Sells UES Carriage House for $18M," Real Deal, October 15, 2015, https://therealdeal.com/2015/10/15/gagosian-selles-ues-carriage-house-for-18m/.

9. Decker, "Art À GoGo," 42.

10. Alex De Havenon, "Blaze at Art Dealer's Amagansett House," *East Hampton Star*, June 29, 2011, http://easthamptonstar.com/News/2011629/Blaze-Art-Dealer%E2%80%99s-Amagansett-House.

11. Glueck, "One Art Dealer."

12. Ibid.

13. Ibid.

14. Grace Glueck, "Self-Effacing William Acquavella, Who Struck Art's Biggest Deal," *New York Times*, May 10, 1990.

15. See Tom Vanderbilt, "The Master and the Gallerist," *Wall Street Journal*, March 24, 2011, www.wsj.com/articles/SB10001424052748704893604576200641567330346.

16. Phoebe Hoban, *Lucian Freud: Eyes Wide Open* (Boston: New Harvest, 2014), 98.

17. Glueck, "Self-Effacing William Acquavella."

18. Peter Aspden, "Lunch with the FT: William Acquavella," *Financial Times*, September 30, 2011, www.ft.com/content/24f76a90-e8f5-11e0-ac9c-00144feab49a.

19. Glueck, "Self-Effacing William Acquavella."

20. Ibid.

21. Ibid.

22. Hoban, *Lucian Freud*, 134.

23. Ibid.

24. Adam Luck and Dominic Prince, "The Bookie Who Bet on Freud—and Won £100m Collection," *Daily Mail*, July 14, 2012, www.dailymail.co.uk/news/article-2173584/The-bookie-bet-Freud—won-100m-collection-Bizarre-40-year-friendship-led-artist-paying-colossal-gambling-debts-treasure-trove-paintings.html.

25. Lisa Gubernick, "De Kooning's Uptown Upstart Art Dealer Slouches Toward Success Despite Slump," *Observer*, April 25, 1994.

26. Eric Konigsberg, "Marks Nabs Johns," *New York*, May 9, 2005, http://nymag.com/nymetro/arts/art/11892/.

27. Gavin Brown, interview by Tom Eccles, *Art Review*, January and February 2014, https://artreview.com/features/jan_14_great_minds_gavin_brown/.

28. Diane Solway, "The Enterprising Mr. Brown," *W*, July 16, 2013, www.wmagazine.com/story/gavin-brown-artist-and-curator-profile.

29. Ibid.

30. Calvin Tomkins, "The Artist of the Portrait," *New Yorker*, October 6, 2008, www.newyorker.com/magazine/2008/10/06/the-artist-of-the-portrait.

31. Katie Razzall, "Peter Doig: Famous Artists 'Are Quickly Forgotten,'" Channel 4 News, August 1, 2013, www.channel4.com/news/peter-doig-famous-artists-are-quickly-forgotten.

32. Artspace Editors, "Q&A: Peter Doig on the Haunting Influence of Place," *Artspace*, February 2, 2018, www.artspace.com/magazine/interviews_features/book_report/qa-peter-doig-on-the-haunting-influence-of-place-55208.

33. Jerry Saltz, "Chris Ofili's Thumping Art-History Lesson," *New York*, November 3, 2014, www.vulture.com/2014/10/chris-ofilis-thumping-art-history-lesson.html.

Chapter 9: The Europeans Swoop In

Interviews: Hilton Als, Jeffrey Deitch, Anthony d'Offay, Steve Henry, Gregory Linn, Jack Shainman, Hans Ulrich Obrist, Iwan Wirth, John Zinsser, David Zwirner

1. Lynell George, "The 'Black Male' Debate: Controversy over the Whitney Show Has Arrived ahead of Its L.A. Outing—Alternative Exhibitions Are Planned," *Los Angeles Times*, February 22, 1995.

2. Carol Vogel, "The Art Market."

3. Ibid.

4. Ibid.

5. Phoebe Hoban, "Peter Halley's New Gallery in Germany," *Observer*, August 24, 2011.

6. Cohen-Solal, *Leo and His Circle*, 328.

7. Nick Paumgarten, "Dealer's Hand," *New Yorker*, December 2, 2013, www.newyorker.com/magazine/2013/12/02/dealers-hand.

8. Ibid.

9. Ibid.

10. Nick Clark, "Iwan Wirth: The More Public Half of the Art World's Most Powerful Couple Is a Creative Pirate Who Shares His Treasures," *Independent*, October 23, 2015, www.independent.co.uk/news/people/iwan-wirth-the-more-public-half-of-the-art-world-s-most-powerful-couple-is-a-creative-pirate-who-a6706771.html.

11. Jackie Wullschlager, "Lunch with the FT: Wirth's Fortune," *Financial Times*, September 30, 2005, www.ft.com/content/335357bc-2fc8-11da-8b51-00000e2511c8.

12. Ibid.

13. Cristine Ruiz, "Manuela Wirth," *Gentlewoman*, no. 13 (Spring and Summer 2016), http://thegentlewoman.co.uk/library/manuela-wirth.

14. Ibid.

15. Kazanjian, "House of Wirth."

16. Ibid.

17. "Net Wirth," *W*, December 1, 2009, www.wmagazine.com/story/iwan-wirth.

18. Randy Kennedy, "The Demented Imagineer," *New York Times Magazine*, May 10, 2013, www.nytimes.com/2013/05/12/magazine/paul-mccarthy-the-demented-imagineer.html.

19. Miller, "Clock Stopper."

20. Thomas, "The Selling of Jeff Koons"; Lorena Muñoz-Alonso, "Ronald Perelman's Lawsuit against Larry Gagosian Is Dismissed," *Artnet News*, December 5, 2014, https://news.artnet.com/art-world/ronald-perelmans-lawsuit-against-larry-gagosian-is-dismissed-189948\.

21. Thomas, "The Selling of Jeff Koons."

22. "The Turnaround Artist," *New Yorker*, April 23, 2007, www.newyorker.com/magazine/2007/04/23/the-turnaround-artist.

23. "The Turnaround Artist."

Chapter 10: The Curious Charm of Chelsea

Interviews: Marianne Boesky, Patty Brundage, Susan Brundage, Michael Craig-Martin, Larry Gagosian, Ralph Gibson, Victoria Miro, Lisa Spellman, Frank Stella

1. Damien Hirst, *This Little Piggy Went to Market, This Little Piggy Stayed at Home*, 1996, glass, pig, painted steel, silicone, acrylic, plastic cable ties, stainless steel, formaldehyde solution, and motorized painted steel base, two parts, each 1200 x 2100 x 600 mm, www.damienhirst.com/this-little-piggy-went-to-mark.

2. Michael Craig-Martin, *An Oak Tree*, 1973, glass, water, shelf, and printed text, Tate, www.tate.org.uk/art/artworks/craig-martin-an-oak-tree-102262.

3. Damien Hirst, "On the Way to Work," interview by Gordon Burn, *Guardian*, October 5, 2001, www.theguardian.com/books/2001/oct/06/extract.

4. Michael Craig-Martin, "My Pupil Damien Hirst: Michael Craig-Martin on the Making of Art's Wunderkind," *Independent*, March 30, 2012, www.independent.co.uk/arts-entertainment/art/features/my-pupil-damien-hirst-michael-craig-martin-on-the-making-of-arts-wunderkind-7600564.html.

5. "Biography: Damien Hirst," Damien Hirst, http://damienhirst.com/biography/damien-hirst.

6. Damien Hirst, *Spot Painting*, 1986, household gloss on board, 2438 x 3658 mm, http://damienhirst.com/spot-painting.

7. White Cube, http://whitecube.com/.

8. Jackie Wullschlager, "Lunch with the FT: Jay Jopling," *Financial Times*, March 2, 2012, www.ft.com/content/1d9a1d56-6145-11e1-a738-00144feabdc0.

9. Sarah Lyall, "Is It Art, or Just Dead Meat?" *New York Times Magazine*, November 12, 1995, www.nytimes.com/1995/11/12/magazine/is-it-art-or-just-dead-meat.html?pagewanted=all.

10. Wullschlager, "Jay Jopling."

11. Jason Nichols and Richard Phillips, "National Gallery of Australia Cancels Sensation Exhibition," *World Socialist Web Site*, December 29, 1999, www.wsws.org/en/articles/1999/12/sens-d29.html.

12. Jeffrey Hogrefe, "Gagosian Pays $5.75 Million for Largest Gallery in Chelsea," *Observer*, August 23, 1999, https://observer.com/1999/08/gagosian-pays-575-million-for-largest-gallery-in-chelsea/.

13. Glenn Fuhrman in discussion with Larry Gagosian, 92nd Street Y, New York, February 6, 2018.

14. Brant, "Larry Gagosian."

Chapter 11: The Mega Dealers

Interviews: Stefania Bortolami, Peter Brant, Susanne Butler, Mollie Dent-Brocklehurst, Asher Edelman, Larry Gagosian, Marc Glimcher, John Good, Phil Grauer, Timothy Greenfield-Sanders, Michele Maccarone, Fergus McCaffrey, Victoria Miro, Monika Sprüth, David Zwirner

1. Timothy Greenfield-Sanders, *Art World* (New York: Fotofolio, 1999).

2. Sean Kilachand, "Forbes History: The Original 1987 List of International Billionaires," *Forbes*, March 21, 2012, www.forbes.com/sites/seankilachand/2012/03/21/forbes-history-the-original-1987-list-of-international-billionaires/#7fec4df0447e.

3. "The Complete List of World's Billionaires 1999," Areppim, http://stats.areppim.com/listes/list_billionairesx99xwor.htm.

4. Ibid.; Luisa Kroll and Kerry A. Dolan, "Forbes 2017 Billionaires List: Meet the Richest People on the Planet," *Forbes*, March 20, 2017, www.forbes.com/sites/kerryadolan/2017/03/20/forbes-2017-billionaires-list-meet-the-richest-people-on-the-planet/.

5. Arthur Lubow, "The Business of Being David Zwirner," *WSJ. Magazine*, January 7, 2018, www.wsj.com/articles/the-business-of-being-david-zwirner-1515343734.

6. Mollie Dent-Brocklehurst, "Keeping Up with London's PACE: Mollie Dent-Brocklehurst on Richard Tuttle and the Future of the Gallery," interview by Kitty Harris, *LUX*, April 17, 2017, www.lux-mag.com/pace-london-mollie-dent-brocklehurst/.

7. Aaron Gell, "Deconstructing Larry: Defections and Lawsuits Chip Gagosian's Enamel," *Observer*, December 18, 2012, http://observer.com/2012/12/deconstructing-larry-defections-and-lawsuits-chip-gagosians-enamel/.

8. Sean O'Hagan, "Victoria Miro, Queen of Arts," *Guardian*, July 10, 2010, www.theguardian.com/artanddesign/2010/jul/11/victoria-miro-interview-grayson-art.

9. Calvin Tomkins, "Into the Unknown," *New Yorker*, October 6, 2014, www.newyorker.com/magazine/2014/10/06/unknown-6.

10. Dodie Kazanjian, "Lisa Brice, Peter Doig, and Chris Ofili Bring Trinidad to New York," *Vogue*, September 20, 2017, www.vogue.com/article/chris-ofili-peter-doig-lisa-brice-embah-trinidad-exhibitions-new-york.

11. Calvin Tomkins, "The Mythical Stories in Peter Doig's Paintings," *New Yorker*, December 11, 2017, www.newyorker.com/magazine/2017/12/11/the-mythical-stories-in-peter-doigs-paintings.

12. Peter Doig, interview by Joshua Jelly-Schapiro, *Believer*, March 2012, http://michaelwerner.com/artist/peter-doig/news-item/1798.

13. Ibid.

14. Smith, "Pat Hearn."

15. Yablonsky, "Oh Pat. Oh Colin."

16. Smith, "Pat Hearn."

Chapter 12: LA Rising

Interviews: Marianne Boesky, Peter Brant, Gavin Brown, Meredith Darrow, Larry Gagosian, Arne Glimcher, David Kordansky, Don Marron, Jeff Poe, Lisa Schiff, Allan Schwartzman

1. Clayton Press and Gregory Linn, "Art Market Overview 2000–2018," unpublished analysis by Linn Press (last modified August 14, 2018), Microsoft Excel file.

2. Roberta Smith, "Art World Startled as Painter Switches Dealers," *New York Times*, December 23, 2003.

3. Dorothy Spears, "The First Gallerists' Club," *New York Times*, June 18, 2006.

4. Jeff Poe, "How to Nurture an Artist's Career: Jeff Poe on Following His Intuition, Building Audiences Slowly and Taking Chances from L.A., to Tokyo, to New York," interview with the Art Dealers Association of America, http://the-adaa.tumblr.com/post/103577156486/how-to-nurture-an-artists-career-gallery-chat-jeff-poe.

5. Ibid.

6. Sarah Thornton, *Seven Days in the Art World* (New York: W.W. Norton, 2008), 207.

7. "About Kaikai Kiki," Company Information page, Kaikai Kiki Co., Ltd., http://english.kaikaikiki.co.jp/company/summary/; Murakami had previously opened a factory in 1996, the Hiropon Factory, titled after the drug hiropon, which was developed by the Japanese army during World War II with the aim of forcing personnel to work without sleeping; See Dong-Yeon Koh, "Murakami's 'Little Boy' Syndrome: Victim or Aggressor in Contemporary Japanese and American Arts?," *Inter-Asia Cultural Studies* 11, no. 3 (2010): 393–412.

8. Hannah Ghorashi, "Louis Vuitton Ends Its 13-Year Relationship with Takashi Murakami," *ARTnews*, July 21, 2015, www.artnews.com/2015/07/21/louis-vuitton-ends-its-13-year-relationship-with-takashi-murakami/

9. Takashi Murakami, "Takashi Murakami's Colorful Journey From a Tokyo Duplex to a Warehouse Loft," interview by Marc Myers, *Wall Street Journal*, January 9, 2018.

10. Jori Finkel, "Museums Solicit Dealers' Largess," *New York Times*, November 18, 2007, www.nytimes.com/2007/11/18/arts/design/18fink.html.

11. Michael Brenson, "New Coast Museum Buys $11 Million Collection," *New York Times*, February 29, 1984, www.nytimes.com/1984/02/29/arts/new-coast-museum-buys-11-million-collection.html.

12. Rosamund Felsen, "Oral History Interview with Rosamund Felsen, 2004 Oct. 10–11," interview by Anne Ayres, Archives of American Art, Smithsonian Institution, www.aaa.si.edu/collections/interviews/oral-history-interview-rosamund-felsen-11719#transcript.

13. Grace Glueck, "Galleries: Westward Ho to Santa Monica," *New York Times*, January 23, 1990, www.nytimes.com/1990/01/23/arts/galleries-westward-ho-to-santa-monica.html.

14. Jori Finkel, "Childlike, but Hardly Child's Play," *New York Times*, May 11, 2014, www.nytimes.com/2014/05/11/arts/design/mark-grotjahns-new-work-stars-with-castoff-cardboard.html.

15. M. H. Miller, "Behind the Mask: Mark Grotjahn Lifts the Veil on His Secret Sculptures," *Observer*, September 17, 2012, http://observer.com/2012/09/behind-the-mask-mark-grotjahn-lifts-the-veil-on-his-secret-sculptures/.

16. Finkel, "Childlike."

17. Jerry Saltz, "How Art Star Mark Grotjahn Became Art Star Mark Grotjahn: By Repainting Signs for Local Mom-and-Pop Stores in L.A.," *New York*, January 20, 2016, www.vulture.com/2016/01/mark-grotjahns-sign-painting-breakthrough.html.

18. Finkel, "Childlike."

19. "LA Artist Mark Grotjahn: Interviews and Commentary," *Fireplace Chats*, a blog by Vincent Johnson and Jill Poyourow, May 20, 2013, https://fireplacechats.wordpress.com/2014/05/11/la-artist-mark-grotjahn-interviews-and-commentary/.

20. Carol Vogel, "Contemporary-Art Bidding Tops $102 Million in Sales," *New York Times*, May 12, 2004, www.nytimes.com/2004/05/12/nyregion/contemporary-art-bidding-tops-102-million-in-sales.html.

21. Piera Anna Franini, "Art World Women at the Top," *Swiss Style*, www.swissstyle.com/art-world-women-at-the-top/.

22. Sarah Douglas, "Flying Solo," *Observer*, April 8, 2014, http://observer.com/2014/04/flying-solo/.

23. "Dominique Lévy Gallery," International Federation of Dealer Associations (CINOA), www.cinoa.org/cinoa/dealer?dealer=Dominique%20L%C3%A9vy%20%20Gallery.

24. Alexandra Peers, "A Collector of Koons Waves Goodbye at the Whitney," *Observer*, October 23, 2014, http://observer.com/2014/10/the-collector/.

25. Kelly Crow, "The Gagosian Effect," *Wall Street Journal*, April 1, 2011, www.wsj.com/articles/SB10001424052748703712504576232791179823226.

26. Andrew Russeth, "Patrick Cariou Fires Back in Richard Prince Copyright Fight," *Observer*, January 26, 2012, http://observer.com/2012/01/patrick-cariou-fires-back-in-richard-prince-copyright-fight/.

27. "Lot 22: Richard Prince, *Overseas Nurse*," Contemporary Art Evening Auction, Sotheby's London, July 1, 2008, www.sothebys.com/en/auctions/ecatalogue/2008/contemporary-art-evening-auction-l08022/lot.22.html.

28. Eileen Kinsella, "Artist Richard Prince Has Cut Ties with Gagosian Gallery," *Artnet News*, June 9, 2016, https://news.artnet.com/exhibitions/richard-prince-split-from-gagosian-515597.

29. Donald Judd, "Specific Objects," in *Donald Judd: Early Work, 1955–1968*, ed. Thomas Kellein (New York: D.A.P., 2002).

30. "Architecture and Design," Judd, Donald Judd Foundation, https://juddfoundation.org/artist/architecture-design/.

31. "Auction Results: Post-War and Contemporary Evening Sale," Lot 29, Donald Judd, *Untitled (DSS 42)*, Christie's, November 12, 2013.

32. Arne Glimcher, *Agnes Martin: Paintings, Writings, Remembrances* (London: Phaidon Press, 2012).

33. Ibid., 203.

34. Laura van Straaten, "Art Adviser Allan Schwartzman—Cupidity's Cupid," *ArtReview*, November 2014, https://artreview.com/features/november_2014_feature_art_adviser_allan_schwartzman/.

35. Adam, *Big Bucks*, 96.

36. Solway, "Family Affair."

37. Jerry Saltz, "Can You Dig It?" *New York*, November 25, 2007, http://nymag.com/arts/art/reviews/41266/.

38. Liz Markus, "Art and Death in Connecticut: Urs Fischer at the Brant Foundation Art Study Center," *Huffington Post*, July 19, 2010, www.huffingtonpost.com/liz-markus/art-and-death-in-connecti_b_640650.html.

39. "Auction Results: Post-War and Contemporary Art Evening Sale," Lot 15, Andy Warhol, *Green Car Crash (Green Burning Car I)*, Christie's, May 16, 2007, www.christies.com/lotfinder/Lot/andy-warhol-1928-1987-green-car-crash-4913707-details.aspx.

40. Konigsberg, "Art Superdealer Larry Gagosian."

41. Paul Vitello, "Saud bin Mohammed al-Thani, Big-Spending Art Collector, Is Dead," *New York Times*, November 17, 2014, www.nytimes.com/2014/11/17/arts/design/saud-bin-mohammed-al-thani-art-collector-for-qatar-is-dead.html.

42. "Auction Results: Contemporary Art Evening," Lot 14, Jeff Koons, *Hanging Heart (Magenta/Gold)*, Sotheby's, November 14, 2007.

43. Stephen Adams, "Roman Abramovich 'Revealed as Freud and Bacon Buyer,'" *Telegraph*, May 18, 2008, www.telegraph.co.uk/news/uknews/1981367/Roman-Abramovich-revealed-as-Freud-and-Bacon-buyer.html.

44. Walter Robinson, "Art Market Watch," *Artnet News*, January 27, 2009, www.artnet.com/magazineus/news/artmarketwatch/artmarketwatch1-27-09.asp.

45. Faisal Al Yafai, "Gagosian's Art of the Art Deal," *National*, September 4, 2010, www.thenational.ae/arts-culture/gagosian-s-art-of-the-art-deal-1.524250.

46. Carol Vogel, "Damien Hirst's Next Sensation: Thinking Outside the Dealer," *New York Times*, September 14, 2008, www.nytimes.com/2008/09/15/arts/design/15auct.html.

47. Walter Robinson, "Art Market Watch," *Artnet News*, September 16, 2008, www.artnet.com/magazineus/news/artmarketwatch/artmarketwatch9-16-08.asp.

48. David Batty, "Damien Hirst's Split from Larry Gagosian Turns Heads in Art World," *Guardian*, January 6, 2013, www.theguardian.com/artanddesign/2013/jan/06/damien-hirst-larry-gagosian-art.

49. Ibid.

Chapter 13: A Most Astonishing Revival

Interviews: Elizabeth Dee, Anthony d'Offay, Larry Gagosian, Arne Glimcher, Christy MacLear, Morgan Spangle, James Tarmy, David Zwirner

1. Konigsberg, "Art Superdealer Larry Gagosian."

2. Charlie Powell, "Larry Gagosian on Emerging Markets," *Art Reserve*, December 12, 2009, www.theartreserve.com/blog/larry-gagosian-on-emerging-markets.

3. Ibid.

4. Konigsberg, "Art Superdealer Larry Gagosian."

5. Ibid.

6. Ibid.

7. Carol Vogel, "Buyers for Warhol and Calder," *New York Times*, June 25, 2009, www.nytimes.com/2009/06/26/arts/design/26vogel.html.

8. "Zwirner and Wirth," http://www.zwirnerandwirth.com/.

9. Paumgarten, "Dealer's Hand."

10. "X Initiative Is Closing," press release, e-flux, January 5, 2010, www.e-flux.com/announcements/37339/x-initiative-is-closing/.

11. "New £125 Million National Collection Will Bring Contemporary Art to Audiences across Britain," press release, Tate, February 27, 2007, www.tate.org.uk/press/press-releases/new-ps125-million-national-collection-will-bring-contemporary-art-audiences.

12. "Artist Rooms," Tate, www.tate.org.uk/artist-rooms; Jackie Wullschlager, "An Art Dealer's Gift to the British," *Financial Times*, February 17, 2009, www.ft.com/content/10e08418-045c-11de-845b-000077b07658.

13. Anthony d'Offay, "Conversation with Anthony d'Offay," interview by Angela M. H. Schuster, BlouinArtinfo, June 15, 2016, www.blouinartinfo.com/news/story/2531568/conversation-with-anthony-doffay.

14. Alastair Sooke, "Artist Rooms—Interview with Anthony d'Offay," *Telegraph*, April 16, 2009, www.telegraph.co.uk/culture/art/5163760/Artist-Rooms-interview-with-Anthony-dOffay.html.

15. Arifa Akbar, "A Collector's Item: Art Dealer's £125m Gift to the Nation Is Celebrated," *Independent*, February 28, 2008, www.independent.co.uk/arts-entertainment/art/news/a-collectors-item-art-dealers-163125m-gift-to-the-nation-is-celebrated-788578.html.

16. Philip Boroff, "Judge Awards Three Pals of Robert Rauschenberg $25 Million," *Artnet News*, August 3, 2014, https://news.artnet.com/art-world/judge-awards-three-pals-of-robert-rauschenberg-25-million-71989.

17. Tamara Lush, "Late Artist's Trustees Seeking $60 Million in Fees," *San Diego Union-Tribune*, January 6, 2014, www.sandiegouniontribune.com/sdut-late-artists-trustees-seeking-60-million-in-fees-2014jan06-story.html.

18. Ibid.

19. Carol Vogel, "Now Starring in Chicago, a Prime Rauschenberg," *New York Times*, June 9, 2011, www.nytimes.com/2011/06/10/arts/design/prime-rauschenberg-at-chicago-art-institute.html; Department of Public Affairs, "Art Institute Announces Acquisition of

Seminal Rauschenberg Combine," press release, Art Institute of Chicago, June 10, 2011, www.artic.edu/sites/default/files/press_pdf/Rauschenberg.pdf.

20. Johanna Liesbeth de Kooning was the daughter of Willem de Kooning and Joan Ward, a commercial artist. She was born while De Kooning was separated from his wife, Elaine. Lisa was the only beneficiary of De Kooning's will. See Douglas Martin, "Lisa de Kooning, Painter's Daughter, Dies at 56," *New York Times*, November 30, 2012, www.nytimes.com/2012/12/01/arts/lisa-de-kooning-56-dies-sought-to-preserve-fathers -legacy.html.

21. Stan Sesser, "The Art Assembly Line," *Wall Street Journal*, June 3, 2011, www.wsj .com/articles/SB10001424052702303745304576357681741418282.

22. Crow, "Gagosian Effect."

23. Greg Allen, "The Dark Side of Success," *New York Times*, January 2, 2005, www .nytimes.com/2005/01/02/arts/design/the-dark-side-of-success.html.

24. Paumgarten, "Dealer's Hand."

25. Daniel Grant, "Collector Claims Gallery Landed Him on Marlene Dumas 'Black-list,'" *ARTnews*, April 20, 2010, www.artnews.com/2010/04/20/collector-claims-gallery -landed-him-on-marlene-dumas-blacklist/.

26. Ibid.

27. Ibid.

28. Ibid.

29. Ibid.

30. Randy Kennedy, "Collector's Motion for Court Order against Gallery Is Denied," *ArtsBeat* (blog), *New York Times*, May 21, 2010, https://artsbeat.blogs.nytimes .com/2010/05/21/art-collector-fails-to-get-court-order-against-gallery/.

Chapter 14: Lawsuits and London

Interviews: Gavin Brown, John Good, Marian Goodman, Allan Schwartzman, Iwan Wirth

1. Coincidentally, Charles Cowles was the publisher of *Artforum* from the mid-1960s to 1980.

2. Jan Cowles v. Larry Gagosian, Gagosian, Inc., and Thompson Dean, Exhibit A, New York County Clerk, index no. 650152/2012, March 26, 2012, http://blogs.reuters.com /felix-salmon/files/2012/03/document-4.pdf.

3. Randy Kennedy, "Gagosian Sued for Selling Lichtenstein Painting without Own-er's Consent," *ArtsBeat* (blog), *New York Times*, January 19, 2012, https://artsbeat.blogs .nytimes.com/2012/01/19/gagosian-sued-for-selling-lichtenstein-painting-without -owners-consent/.

4. Jan Cowles v. Larry Gagosian, Exhibit A.

5. Ibid.

6. Marion Maneker, "How Gagosian Sells, a Case Study," *Art Market Monitor*, March 28, 2012, www.artmarketmonitor.com/2012/03/28/the-selling-of-girl-with-a-mirror-what -really-happened/.

7. Konigsberg, "Art Superdealer Larry Gagosian."

8. Ibid.

9. "Auction Results: Contemporary Art Evening Sale," Lot 20, Roy Lichtenstein, *Girl in Mirror*, Sotheby's New York, Tuesday, May 15, 2007, www.sothebys.com/en/auctions /ecatalogue/2007/contemporary-art-evening-sale-n08317/lot.20.html.

10. Konigsberg, "Art Superdealer Larry Gagosian."

11. Ibid.

12. Daniel Grant, "Collector Sues Gagosian Gallery over Two Contemporary Sales," *ARTnews*, March 22, 2011, www.artnews.com/2011/03/22/collector-sues-gagosian-gallery -over-two-contemporary-sales/.

13. Ibid.

14. Jan Cowles v. Larry Gagosian, Exhibit A.

15. Gell, "Deconstructing Larry."

16. Grant, "Collector Sues Gagosian."

17. Jan Cowles v. Larry Gagosian, Exhibit A.

18. Ibid.

19. Randy Kennedy, "Gagosian Suit Offers Rare Look at Art Dealing," *ArtsBeat* (blog), *New York Times*, November 7, 2012, https://artsbeat.blogs.nytimes.com/2012/11/07/gagosian -suit-offers-rare-look-at-art-dealing/.

20. Ibid.

21. Ibid.

22. Ibid.

23. Ibid.

24. Clare McAndrew, *TEFAF Art Market Report 2014: The Global Art Market, with a Focus on the US and China* (Helvoirt, Netherlands: European Fine Art Foundation, 2014), 79.

25. "About Firenze," Gerhard Richter, www.gerhard-richter.com/en/art/microsites /firenze?sp=20&p=6&l=100#.

26. Mike Collett-White, "Prized Painter Richter Calls Art Market 'Daft,'" Reuters, October 4, 2011, www.reuters.com/article/us-gehardrichter-market/prized-painter-richter -calls-art-market-daft-idUSTRE7932RF20111004.

27. Calvin Tomkins, "Big Art, Big Money," *New Yorker*, March 29, 2010, www .newyorker.com/magazine/2010/03/29/big-art-big-money.

28. Julia Halperin, "How Julie Mehretu Created Two of Contemporary Art's Larg- est Paintings for SFMOMA," *Artnet News*, September 5, 2017, https://news.artnet.com /exhibitions/julie-mehretu-sfmoma-commission-debut-1069271.

29. Ben Davis, "Is Getting an MFA Worth the Price?" *Artnet News*, August 30, 2016, https://news.artnet.com/art-world/mfa-degree-successful-artists-620891.

30. M. H. Miller, "The Quotable Alex Katz," *ARTnews*, May 22, 2015, www.artnews .com/2015/05/22/the-quotable-alex-katz/.

31. Ibid.

32. Sarah Douglas, "When Gavin Brown Met Alex Katz: An Artist's New Show Is at an Unexpected Venue," *Observer*, September 13, 2011, http://observer.com/2011/09 /when-gavin-brown-met-alex-kat-an-artists-new-show-is-at-an-unexpected-venue/.

33. Miller, "The Quotable Alex Katz."

34. Douglas, "When Gavin Brown Met Alex Katz."

35. Ibid.

36. Kennedy, "Demented Imagineer."

37. Marion Maneker, "What Is the Gagosian Effect?" *Art Market Monitor*, April 1, 2011, www.artmarketmonitor.com/2011/04/01/what-is-the-gagosian-effect/.

38. Kelly Crow, "An Art Mogul Talks Shop," *Wall Street Journal*, October 11, 2012, www.wsj.com/articles/SB10000872396390443294904578050380114780310.

Chapter 15: Larry's Annus Horribilis

Interviews: Marianne Boesky, Larry Gagosian, Jim Jacobs, Christoph Kerres, Victoria Miro, Thaddaeus Ropac, Robert Storr

1. Michael Kaplan, "This Artist Is Making Mega-Millions 'Stealing People's Work,'" *New York Post*, September 17, 2017, https://nypost.com/2017/09/17/this-artist-is -making-mega-millions-stealing-peoples-work/.

2. Ben Mauk, "Who Owns This Image?" *New Yorker*, February 12, 2014, www .newyorker.com/business/currency/who-owns-this-image.

3. "Spot Paintings, 2012," Damien Hirst, www.damienhirst.com/texts1/series/spots; Graham Bowley, "Hirst Counts the Dots, or at Least the Paintings," *New York Times*, June 11, 2013, www.nytimes.com/2013/06/12/arts/design/damien-hirsts-spot-paintings-the -field-guide.html?pagewanted=all&_r=0.

4. Holland Cotter, "Mike Kelley, an Artist with Attitude, Dies at 57," *New York Times*, February 1, 2012, www.nytimes.com/2012/02/02/arts/design/mike-kelley-influential-american-artist-dies-at-57.html.

5. Kim Levin, "Mike Kelley," *Art Agenda*, October 30, 2015, www.art-agenda.com/reviews/mike-kelley/.

6. Olga Kronsteiner, "Franz Wests Erbe: Kampf durch die Instanzen," *Der Standard*, August 19, 2017, https://derstandard.at/2000062822321/Franz-Wests-Erbe-Kampf-durch-die-Instanzen.

7. "2018 Worldwide Estate and Inheritance Tax Guide," Ernst & Young, www.ey.com/gl/en/services/tax/worldwide-estate-and-inheritance-tax-guide---country-list.

8. Emma Brockes, "Ron Perelman v Larry Gagosian: When Rich Men Hurt Each Other's Feelings," *Guardian*, September 13, 2012, www.theguardian.com/commentisfree/emma-brockes-blog/2012/sep/13/perelman-gagosian-rich-men-feelings.

9. Luisa Kroll, "Forbes World's Billionaires 2012," *Forbes*, March 7, 2012, www.forbes.com/sites/luisakroll/2012/03/07/forbes-worlds-billionaires-2012/#139873812c9d.

10. Brockes, "Ron Perelman v Larry Gagosian."

11. Patricia Cohen, "New Blow in Art Clash of Titans, *New York Times*, January 18, 2013, www.nytimes.com/2013/01/19/arts/design/larry-gagosian-and-ronald-perelman-in-a-new-legal-clash.html.

12. Brockes, "Ron Perelman v Larry Gagosian."

13. Cohen, "New Blow in Art Clash of Titans."

14. Specifically, Gagosian's contract with Koons entitled Koons to 70 percent of any amount over the original sale price of $4 million if Gagosian resold the work. Furthermore, if Gagosian bought back the work before it was finished, delivered, and fully paid for, Koons would be entitled to 80 percent of the profit on any subsequent sale. See Mostafa Heddaya, "Gagosian to Face Fraud Charge over Sale of Koons Popeye," *Hyperallergic*, February 5, 2014, https://hyperallergic.com/107357/gagosian-to-face-fraud-charge-over-sale-of-koons-popeye/.

15. Stephen J. Goldberg, "Art Brief: Clash of the Titans," *Artillery*, May 5, 2015, https://artillerymag.com/art-brief-3/.

16. Ibid.

17. Cohen, "New Blow in Art Clash of Titans."

18. Ibid.

19. Muñoz-Alonso, "Ronald Perelman's Lawsuit."

20. Georgina Adam, "The Art Market: And So to Basel...," *Financial Times*, June 15, 2012, www.ft.com/content/413d087e-a3f1-11e1-84b1-00144feabdc0.

21. Adam, *Big Bucks*, 16.

22. Lynne Lamberg, "Artist Describes How Art Saved Her Life," *Psychiatric News*, September 14, 2017, https://psychnews.psychiatryonline.org/doi/full/10.1176/appi.pn.2017.9a21.

23. "Yayoi Kusama," About the Artist page, Victoria Miro, www.victoria-miro.com/artists/31-yayoi-kusama/.

24. Elizabeth Blair, "'Priestess of Polka Dots' Yayoi Kusama Gives Gallerygoers a Taste of Infinity," National Public Radio, March 1, 2017, www.npr.org/2017/03/01/516659735/priestess-of-polka-dots-yayoi-kusama-gives-gallerygoers-a-taste-of-infinity.

25. Claire Peter-Budge, "Yayoi Kusama: The Chaste Sexual Revolutionary," LinkedIn, July 27, 2017, www.linkedin.com/pulse/yayoi-kusama-chaste-sexual-revolutionary-claire-peter-budge.

26. Ellen Pearlman, "The Long, Strange Art and Life of Yayoi Kusama," *Hyperallergic*, July 20, 2012, https://hyperallergic.com/54328/the-long-strange-art-and-life-of-yayoi-kusama/.

27. Ibid.

28. "Hirshhorn's 'Yayoi Kusama: Infinity Mirrors' Breaks Records," news release, Smithsonian Institution, May 15, 2017, https://newsdesk.si.edu/releases/hirshhorn-s-yayoi-kusama-infinity-mirrors-breaks-records.

29. Artnet, http://www.artnet.com.

30. Konigsberg, "Art Superdealer Larry Gagosian."

31. Carol Vogel, "Damien Hirst Leaves Gagosian," *ArtsBeat* (blog), *New York Times*, December 13, 2012, https://artsbeat.blogs.nytimes.com/2012/12/13/damien-hirst-leaves-gagosian/.

32. Ian Gallagher, Caroline Graham, and Amanda Perthen, "Damien Hirst 'Devastated' after Mother of His Children Leaves Him for 59-Year-Old Dog of War," *Daily Mail*, June 9, 2012, www.dailymail.co.uk/news/article-2157028/Damien-Hirst-devastated-mother-children-leaves-59-year-old-Dog-War.html.

33. Konigsberg, "Art Superdealer Larry Gagosian."

34. Ibid.

35. "Gagosian Commotion: Zwirner Poised for Artists Seeking New Gallery (with Video and Q&A)," *CultureGrrl*, a blog by Lee Rosenbaum, February 4, 2013, www.artsjournal.com/culturegrrl/2013/02/gagosian-commotion-zwirner-poised-for-artists-seeking-new-gallery-with-video-and-qa.html.

Chapter 16: A Market for Black Artists at Last

Interviews: Hilton Als, Jeffrey Deitch, Larry Gagosian, David Kordansky, Marc Payot, Lisa Spellman

1. Hauser & Wirth, press release; see also Dan Duray, "The Constant Gardener: Iwan Wirth's Hauser & Wirth Gallery Will Open a 15,000-Plus-Square-Foot Space Downtown This Year," *Observer*, January 17, 2012, https://observer.com/2012/01/the-constant-gardener-iwan-wirths-hauser-wirth-gallery-will-open-a-15000-plus-square-foot-space-downtown-this-year/.

2. Brian Keith Jackson, "How I Made It: Mark Bradford," *New York*, September 24, 2007, http://nymag.com/arts/art/features/37954/.

3. Carolina A. Miranda, "After Traveling the World, L.A. Artist Mark Bradford Gets a Solo Show in His Hometown," *Los Angeles Times*, June 19, 2015, www.latimes.com/entertainment/arts/miranda/la-ca-cam-mark-bradford-scorched-earth-hammer-20150621-column.html.

4. Calvin Tomkins, "What Else Can Art Do?" *New Yorker*, June 22, 2015. www.newyorker.com/magazine/2015/06/22/what-else-can-art-do.

5. Ibid.

6. Holland Cotter, "Art Review; A Full Studio Museum Show Starts with 28 Young Artists and a Shoehorn," *New York Times*, May 11, 2001, www.nytimes.com/2001/05/11/arts/art-review-a-full-studio-museum-show-starts-with-28-young-artists-and-a-shoehorn.html.

7. *Rashid Johnson: Message to Our Folks*, Educator's Guide (Kansas City, MO: Mildred Lane Kemper Art Museum, 2013), http://kemperartmuseum.wustl.edu/files/Rashid%20Johnson%20Ed%20Guide%20-%20FINAL_0.pdf.

8. Ibid.

9. Kara Walker, "Interview: Kara Walker Decodes Her New World Sphinx at Domino Sugar Factory," interview by Antwaun Sargent, *Complex*, May 13, 2014, www.complex.com/style/2014/05/kara-walker-interview.

10. Geoff Edgers, "The Not-So-Simple Comeback Story of Pioneering Artist Sam Gilliam," *Washington Post*, July 9, 2016, www.washingtonpost.com/entertainment/museums/the-not-so-simple-comeback-story-of-pioneering-artist-sam-gilliam/2016/07/08/78db60e0-42ae-11e6-bc99-7d269f8719b1_story.html.

11. William Fowler, "Searching for Sam Gilliam: The 81-Year-Old Art Genius Saved from Oblivion," *Guardian*, October 15, 2015, www.theguardian.com/artanddesign/2015 /oct/15/frieze-sam-gilliam-artist-comeback-interview.

12. Ibid.

13. Ibid.

14. Tomkins, "What Else Can Art Do?"

15. "About and Location," Art + Practice, www.artandpractice.org/about/.

16. Jerry Saltz, "Saltz on the Trouble with Mega-Galleries," *New York*, October 13, 2013, www.vulture.com/2013/10/trouble-with-mega-art-galleries.html.

17. Kenny Schachter, "Kenny Schachter Tries (and Fails) to Keep His Mouth Shut at Gallery Weekend Beijing," *Artnet News*, April 3, 2018, https://news.artnet.com /opinion/kenny-schachter-on-gallery-weekend-beijing-2018-1258175.

18. Jerry Saltz, "Fur What It's Worth," *Village Voice*, February 27, 2007, www.village voice.com/2007/02/27/fur-what-its-worth/.

19. Peter Schjeldahl, "Laughter and Anger," *New Yorker*, March 21, 2016, www .newyorker.com/magazine/2016/03/21/david-hammons-at-the-mnuchin-gallery.

20. Bob Colacello, "How Do You Solve a Problem Like MOCA?" *Vanity Fair*, February 5, 2013, www.vanityfair.com/culture/2013/03/problem-moca-la-jeffrey-deitch.

21. Christopher Knight, "Art Review: 'Dennis Hopper Double Standard' @ MOCA's Geffen Contemporary," *Culture Monster* (blog), *Los Angeles Times*, July 11, 2010, http:// latimesblogs.latimes.com/culturemonster/2010/07/art-review-dennis-hopper-double -standard-moca.html.

22. Colacello, "How Do You Solve a Problem Like MOCA?"

23. Ibid.

24. Georgina Adam, "The Art Market: Records Tumble in $1.1bn New York Auction Spree," *Financial Times*, November 15, 2013, www.ft.com/content/c745a510-488d-11e3 -8237-00144feabdc0.

25. Walter Robinson, "Flipping and the Rise of Zombie Formalism," *Artspace*, April 3, 2014, www.artspace.com/magazine/contributors/see_here/the_rise_of_zombie _formalism-52184.

26. Jerry Saltz, "Seeing Out Loud: Why Oscar Murillo's Candy-Factory Installation Left a Bad Taste in My Mouth," *New York*, May 7, 2014, www.vulture.com/2014/05 /saltz-on-oscar-murillos-candy-art.html.

Chapter 17: A Colombian Fairy Tale

Interviews: Larry Gagosian, François Ghebaly, Nicole Klagsbrun, Brie Ruais, Mera Rubell, Stefan Simchowitz, David Zwirner.

1. Karen Wright, "In the Studio with Oscar Murillo, Artist," *Independent*, September 7, 2013, www.independent.co.uk/arts-entertainment/art/features/in-the-studio-with-oscar -murillo-artist-8803147.html.

2. Carl Swanson, "Oscar Murillo Perfectly Encapsulates the Current State of the Contemporary Art World," *New York*, July 3, 2014, www.vulture.com/2014/06/oscar-murillo -perfectly-represents-contemporary-art-world.html.

3. Nina Rodrigues-Ely, "The Market Rise of Oscar Murillo," *Observatoire de l'art contemporaine*, November 12, 2013. www.observatoire-art-contemporain.com/revue _decryptage/analyse_a_decoder.php?langue=en&id=20120532.

4. Katya Kazakina, "From Office Cleaner to Art Frenzy: The Rise and Rise of Artist Oscar Murillo," *Sydney Morning Herald*, September 18, 2013, www.smh.com.au/world /from-office-cleaner-to-art-frenzy-the-rise-and-rise-of-artist-oscar-murillo-20130918 -2tzxf.html.

5. Swanson, "Oscar Murillo."

6. Christopher Glazek, "The Art World's Patron Satan," *New York Times Magazine*, December 30, 2014, www.nytimes.com/2015/01/04/magazine/the-art-worlds-patron-satan .html.

7. Dan Duray, "Stefan Simchowitz vs. the Art World," *Observer*, May 7, 2014, http:// observer.com/2014/05/stefan-simchowitz-vs-the-art-world/; Andrew M. Goldstein, "Cultural Entrepreneur Stefan Simchowitz on the Merits of Flipping, and Being a 'Great Collector,'" *Artspace*, March 29, 2014, www.artspace.com/magazine/interviews_features/how _i_collect/stefan_simchowitz_interview-52164.

8. Goldstein, "Cultural Entrepreneur Stefan Simchowitz"; Katya Kazakina, "Art Flippers Chase Fresh Stars as Murillo's Doodles Soar," Bloomberg, February 7, 2014, www .bloomberg.com/news/2014-02-06/art-flippers-chase-fresh-stars-as-murillo-s-doodles -soar.html.

9. Duray, "Stefan Simchowitz vs. the Art World"; Michael Kaplan, "How Stefan Simchowitz 'Makes' an Artist," *Los Angeles Magazine*, February 24, 2015, www.lamag.com /culturefiles/stefan-simchowitz-makes-artist/.

10. Kazakina, "Art Flippers Chase Fresh Stars."

11. Jerry Saltz, "Saltz on Stefan Simchowitz, the Greatest Art-Flipper of Them All," *New York*, March 31, 2014, www.vulture.com/2014/03/saltz-on-the-great-and-powerful -simchowitz.html.

12. David Pagel, "Art review: 'Oscar Murillo: Distribution Center' at the Mistake Room," *Los Angeles Times*, February 20, 2014, http://articles.latimes.com/2014/feb/20/entertainment /la-et-cm-art-review-oscar-murillo-distribution-center-at-the-mistake-room-20140217.

13. Ulrich de Balbian, "Figurative art is back, post-internet art, Zombie Formalism," LinkedIn, November 29, 2015, www.linkedin.com/pulse/figurative-art-back-post-internet -zombie-formalism-ulrich-de-balbian.

14. Roberta Smith, "Oscar Murillo: 'A Mercantile Novel,'" *New York Times*, May 8, 2014, www.nytimes.com/2014/05/09/arts/design/oscar-murillo-a-mercantile-novel.html.

15. Shane Ferro, "Parsing Gagosian: The Six Best Quotes from NYMag's Epic Profile of the Art World's Richest Dealer," *Blouin Artinfo* (blog), *Huffington Post*, January 22, 2013, www.huffingtonpost.com/artinfo/parsing-gagosian-the-six-_b_2528838.html.

16. Robin Pogrebin, "When an Artist Calls the Shots: Mark Grotjahn's Soaring Prices," *New York Times*, July 30, 2017, www.nytimes.com/2017/07/30/arts/design/mark -grotjahn-auction-gallery.html.

Chapter 18: The Art Farmers

Interviews: Sarah Braman, Gavin Brown, Phil Grauer, David Kordansky, Iwan Wirth

1. Ruiz, "Manuela Wirth."

2. Kazanjian, "House of Wirth."

3. Ibid.

4. Ruiz, "Manuela Wirth."

5. Laura J. Hoptman, *The Forever Now: Contemporary Painting in an Atemporal World* (New York: Museum of Modern Art, 2014), preface.

6. Roberta Smith, "The Paintbrush in the Digital Era," *New York Times*, December 11, 2014, www.nytimes.com/2014/12/12/arts/design/the-forever-now-a-survey-of-contemporary -painting-at-moma.html.

7. David Salle, "Structure Rising: David Salle on 'The Forever Now' at MoMA," *ARTnews*, February 23, 2015, www.artnews.com/2015/02/23/structure-rising-forever-now-at -moma/.

8. "Gavin Brown," *Alain Elkann Interviews*, a blog by Alain Elkann, June 21, 2015, www.alainelkanninterviews.com/gavin-brown/.

Chapter 19: A Question of Succession

Interviews: Peter Brant, Gavin Brown, Michael Findlay, Larry Gagosian, Marc Glimcher

1. Lipsky-Karasz, "Larry Gagosian's Empire."

2. Ibid.

3. Ibid.

4. Fuhrman in discussion with Larry Gagosian.

5. Tim Schneider, "The Gray Market: Why Gagosian Might Be Death-Proof (and Other Insights)," *Artnet News,* February 12, 2018, https://news.artnet.com/opinion/gagosian-iconic -founder-1220936.

6. Crow, "Keeping Pace."

7. Andrew Russeth, "To the Mountains! Hauser & Wirth Will Open Gallery in St. Moritz, Switzerland," *ArtNews,* September 17, 2017, http://www.artnews.com/2018/09/17/mountains -hauser-wirth-will-open-gallery-st-mortiz-switzerland/.

8. Kelly Crow, "Betting on a Damien Hirst Comeback," *Wall Street Journal,* September 17, 2015, www.wsj.com/articles/betting-on-a-hirst-comeback-1442513594.

9. "These Are the World's Five Richest Artists," *Firstpost,* December 20, 2014, www .firstpost.com/world/these-are-the-worlds-five-richest-artists-1175545.html.

10. Ryan Steadman, "Updated: Gagosian Snags Art Star Joe Bradley from Gavin Brown," *Observer,* November 5, 2015, http://observer.com/2015/11/joe-bradley-joins-gagosian -gallery/.

11. Kenny Schachter, "Kenny Schachter on Joe Bradley's Unlikely Rise to Art World Eminence," *Artnet News,* January 11, 2016, https://news.artnet.com/opinion/kenny -schachter-joe-bradley-404936.

12. Robin Pogrebin, "'Four Marilyns' Is Back on the Auction Block," *New York Times,* November 5, 2015, www.nytimes.com/2015/11/06/arts/design/four-marilyns-is-back-on -the-auction-block.html.

13. Eileen Kinsella, "Artnet News Names the 100 Most Collectible Living Artists," *Artnet News,* October 24, 2016, https://news.artnet.com/market/artnet-news-100-most -collectible-artists-717251.

14. Lipsky-Karasz, "Larry Gagosian's Empire."

Chapter 20: Turbulence at Two Citadels of Art

Interviews: Ian Alteveer, Richard Armstrong, Amy Cappellazzo, Larry Gagosian, Arne Glimcher, John Good, Marc Payot, Monika Sprüth, Hans Ulrich Obrist, Angela Westwater

1. Scott Reyburn, "With Acquisition, Sotheby's Shifts Strategy," *New York Times,* January 22, 2016, www.nytimes.com/2016/01/25/arts/international/with-acquisition -sothebys-shifts-strategy.html.

2. Robin Pogrebin, "Art Galleries Face Pressure to Fund Museum Shows," *New York Times,* March 7, 2016, www.nytimes.com/2016/03/07/arts/design/art-galleries-face -pressure-to-fund-museum-shows.html.

3. Robin Pogrebin, "Metropolitan Museum of Art Plans Job Cuts and Restructuring," *New York Times,* April 21, 2016, www.nytimes.com/2016/04/22/arts/design/metropolitan -museum-of-art-plans-job-cuts-andrestructuring.html.

4. Robin Pogrebin, "Is the Met Museum 'a Great Institution in Decline'?" *New York Times,* February 4, 2017, www.nytimes.com/2017/02/04/arts/design/met-museum -financial-troubles.html.

5. "Mad about Museums," *Economist,* January 6, 2014, www.economist.com/special -report/2014/01/06/mad-about-museums.

6. Andrew Goldstein, "Phillips CEO Edward Dolman on His Formula for Outfoxing Christie's and Sotheby's (Hint: It Involves Guarantees)," *Artnet News,* September 19, 2017, https://news.artnet.com/market/dolman-part-two-guarantees-phillips-sothebys-christies -1085600.

Chapter 21: Art Fairs Forever

Interviews: Irving Blum, James Cohan, Lisa Cooley, Arne Glimcher, Marc Payot, Janelle Reiring, Thaddaeus Ropac, Hans Ulrich Obrist

1. Sean O'Hagan, "Sterling Ruby: Making It Big," *Guardian*, March 11, 2016, www.theguardian.com/artanddesign/2016/mar/11/sterling-ruby-artist-interview-work-wear-fashion-sculpture.

2. Piero Golla, "Interview: Sterling Ruby," *Kaleidoscope* 27 (Summer 2016).

3. Kevin West, "Sterling Ruby: Balancing Act," *W*, May 9, 2014, www.wmagazine.com/story/sterling-ruby-california.

4. Golla, "Interview: Sterling Ruby."

5. West, "Sterling Ruby: Balancing Act."

6. Ibid.

7. Jonathan Griffin, "Interview: On the Road with the US Artist Sterling Ruby," *Financial Times*, August 26, 2016, www.ft.com/content/99091fde-6855-11e6-a0b1-d87a9fea034f.

8. Megan Johnson, "Raf Simons and Sterling Ruby on Art Versus Fashion," *New York*, April 24, 2018, www.thecut.com/2018/04/raf-simons-and-sterling-ruby-on-art-versus-fashion.html.

9. Hans Ulrich Obrist, "I Don't Think Anybody Has Been to All These Places," About the Guide page, BMW Art Guide, www.bmw-art-guide.com/about-the-guide.

10. Marta Gnyp, "The Big Mystery of Contemporary Art," *Welt am Sonntag*, trans. Marta Gnyp, June 27, 2014, www.martagnyp.com/articles/the-big-mystery-of-contemporary-art.php.

11. "#652 Mitchell Rales: Real-Time Net Worth," *Forbes*, accessed August 27, 2018, www.forbes.com/profile/mitchell-rales/#6671eb6441f7.

12. Carol Vogel, "Like Half the National Gallery in Your Backyard," *New York Times*, April 18, 2013, www.nytimes.com/2013/04/21/arts/design/mitchell-and-emily-rales-are-expanding-glenstone-museum.html.

13. Ibid.

14. Ibid.

15. Michael Shnayerson, "Inside the Private Museums of Billionaire Art Collectors," *Town & Country*, January 16, 2017, www.townandcountrymag.com/leisure/arts-and-culture/a9124/private-museums-of-billionaires/.

16. Carolina A. Marinda, "Frieze to Launch a Los Angeles Art Fair at Paramount Studios in 2019," *Los Angeles Times*, February 22, 2018, www.latimes.com/entertainment/arts/miranda/la-et-cam-frieze-fair-los-angeles-20180222-story.html.

17. Jerry Saltz, "The Great Gallerist Andrea Rosen Has Decided to Close Up Shop. This Is a Major Loss," *New York*, February 23, 2017, http://www.vulture.com/2017/02/andrea-rosen-is-closing-up-shop-this-is-a-major-loss.html.

Chapter 22: Dirty Laundry

Interviews: Larry Gagosian, Sharon Cohen Levin

1. Henri Neuendorf, "Mary Boone Will Write Alec Baldwin a Seven-Figure Check to Settle Dispute Over Bleckner Bait-and-Switch," *Artnet News*, November 13, 2017, https://news.artnet.com/art-world/alec-baldwin-mary-boone-settlement-1147589.

2. Eileen Kinsella, "Veteran Art Dealer Mary Boone Pleads Guilty to Tax Evasion," *Artnet News*, September 5, 2018, https://news.artnet.com/art-world/mary-boone-pleads-guilty-to-tax-evasion-1343447.

3. Eileen Kinsella, "Domenico De Sole Speaks about the Knoedler Fraud Trial," *Artnet News*, February 17, 2016, https://news.artnet.com/market/domenico-de-sole-speaks-knoedler-forgery-427817.

4. Michael Shnayerson, "A Question of Provenance," *Vanity Fair*, April 23, 2012, www.vanityfair.com/culture/2012/05/knoedler-gallery-forgery-scandal-investigation.

5. Marion Maneker, "Does a Former US Atty Have a Better Example of Art & Money Laundering than Basquiat's Hannibal?" *Art Market Monitor*, March 1, 2017, www.artmarketmonitor.com/2017/03/01/does-a-former-us-atty-have-a-better-example-of-art-money-laundering-than-basquiats-hannibal/.

6. Artsy Editors, "The Role of Freeports in the Global Art Market," *Artsy*, July 14, 2017, www.artsy.net/article/artsy-editorial-freeports-operate-margins-global-art-market.

7. Kinsella, "Prince Has Cut Ties."

Chapter 23: The Dealer Is Present

Interviews: Gavin Brown, Amy Cappellazzo, Michael Findlay, Arne Glimcher, Marc Glimcher, Dominique Lévy, Eva Presenhuber

1. Brian Boucher, "Where Is the Market for Oscar Murillo Three Years after His Blazing Debut?" *Artnet News*, September 12, 2016, http://news.artnet.com/market/oscar -murillo-market-david-zwirner-639365; see also *Contemporary Art Market Confidence Analysis – June 2017* (London: ArtTactic, 2017).

2. "Post-War & Contemporary Art Evening Sale," Lot 3B, Christie's, November 15, 2017, www.christies.com/lotfinder/paintings/kerry-james-marshall-still-life-with-wedding -6110557-details.aspx.

3. Robin Pogrebin, "The Frick Likely to Take Over the Met Breuer," New York Times, September 21, 2018, www.nytimes.com/2018/09/21/arts/design/met-breuer-frick -collection.html.

4. Jerry Saltz, "Watch Jerry Saltz Hold an Impromptu Art Class at Banksy's Latest," *New York*, October 21, 2013, www.vulture.com/2013/10/jerry-saltz-banksy-seminar.html.

5. Marion Maneker, "With Strong Sotheby's Contemporary Sale, Amy Cappellazzo Makes Her Point," *Art Market Monitor*, June 28, 2016, www.artmarketmonitor.com/2016/06/28 /with-strong-sothebys-contemporary-sale-amy-cappallazzo-makes-her-point/.

6. Robin Pogrebin, "How the Artist Adrian Ghenie Became an Auction Star," *New York Times*, November 7, 2016, www.nytimes.com/2016/11/08/arts/design/how-the-artist -adrian-ghenie-became-an-auction-star.html.

7. *Art & Finance Report* (New York: Deloitte, 2017).

8. Nate Freeman, "House Arrest: How One Topsy-Turvy Season at Sotheby's Could Change the Auction World Forever," *ARTnews*, August 10, 2016, www.artnews .com/2016/08/10/house-arrest-how-one-topsy-turvy-season-at-sothebys-could-change -the-auction-world-forever/.

9. Marion Maneker, "Art Agency Partners Earns Its $35m Bonus," *Art Market Monitor*, November 8, 2017, www.artmarketmonitor.com/2017/11/08/art-agency-partners-earns-its -35m-bonus/.

10. Robin Pogrebin, "Christie's Contemporary Art Chief Departs to Become Dealer," *New York Times*, December 7, 2016, www.nytimes.com/2016/12/07/arts/design/christies -contemporary-art-chief-departs-to-become-dealer.html.

11. Nate Freeman, "Why the Auction World's Top Brass Are Leaving for Galleries," *Artsy*, February 15, 2018, www.artsy.net/article/artsy-editorial-auction-worlds-top-brass -leaving-galleries.

12. Katya Kazakina, "Want to Sell a $24 Million Painting Fast? Instagram for the Win," Bloomberg, December 21, 2016, www.bloomberg.com/news/articles/2016-12-21 /want-to-sell-a-24-million-painting-fast-instagram-for-the-win.

13. Scott Reyburn, "Art Market Mines Gold on Instagram," *New York Times*, January 24, 2017, www.nytimes.com/2017/01/20/arts/art-auction-instagram.html.

Chapter 24: Of Sharks and Suckerfish

Interviews: Stefania Bortolami, José Freire, Jamie Niven, Marc Payot, Emmanuel Perrotin

1. Julia Halperin and Eileen Kinsella, "The 'Winner Takes All' Art Market: 25 Artists Account for Nearly 50% of All Contemporary Auction Sales," *Artnet News*, September 20, 2017, https://news.artnet.com/market/25-artists-account-nearly-50-percent-postwar -contemporary-auction-sales-1077026.

2. Valentino Carlotti, Allan Schwartzman, and Julia Halperin, "The natural disposition is to not want to believe the numbers because it just can't be this bad," September

20, 2018, in *In Other Words*, podcast, www.artagencypartners.com/podcast/podcast-20-september-2018/.

3. Clare McAndrew, *The Art Market 2018* (Basel, Switzerland: Art Basel and UBS, 2018), 20.

4. Sarah Douglas, "A Recent History of Small and Mid-Size Galleries Closing [Updated]," *ARTnews*, June 27, 2017, www.artnews.com/2017/06/27/a-recent-history-of-small-and-mid-size-gallery-closures/.

5. Kenny Schachter, "Who Bought That Record-Breaking Jenny Saville? Kenny Schachter Eavesdropped at the Auctions—and Braved Frieze—to Bring You the Scoop," *Artnet News*, October 10, 2018, https://news.artnet.com/art-world/jenny-saville-kenny-schachter-at-the-london-auctions-and-frieze-1367542.

6. Farah Nayeri, "David Zwirner Proposes 'Tax' on Large Galleries at Art Fairs," *New York Times*, April 26, 2018, www.nytimes.com/2018/04/26/arts/design/david-zwirner-large-galleries-art-fairs.html.

7. Ted Loos, "Christie's Loic Gouzer Has the Gift of the Gavel," *Cultured*, June 2018, www.culturedmag.com/christies-loic-gouzer/.

8. Rebecca Mead, "The Daredevil of the Auction World," *New Yorker*, July 4, 2016, www.newyorker.com/magazine/2016/07/04/loic-gouzer-the-daredevil-at-christies.

9. Scott Reyburn, "Get in Line: The $100 Million Da Vinci Is in Town," *New York Times*, November 13, 2017, www.nytimes.com/2017/11/13/arts/design/davinci-leonardo-dicaprio-christies.html.

10. Jerry Saltz, "Christie's Is Selling This Painting for $100 Million. They Say It's by Leonardo. I Have Doubts. Big Doubts," *New York*, November 14, 2017, www.vulture.com/2017/11/christies-says-this-painting-is-by-leonardo-i-doubt-it.html.

11. Loos, "Christie's Loic Gouzer."

12. Robin Pogrebin, "A Mega-Dealer Expands: David Zwirner Plans a New Art Gallery," *New York Times*, January 8, 2018, www.nytimes.com/2018/01/08/arts/design/david-zwirner-expands-in-chelsea.html.

13. Ibid.

14. Schachter, "Who Bought That Record-Breaking Jenny Saville?"

15. Francis X. Clines, "A Starry Night Crowded with Selfies," *New York Times*, September 23, 2017, www.nytimes.com/2017/09/23/opinion/sunday/starry-night-van-gogh-selfies.html.

16. Kenny Schacter, "Kim Jong-Who? At Art Basel, $165 Million Sales and Other Dizzying Disclosures Made the Rest of the World Disappear," *Artnet News*, June 19, 2018, https://news.artnet.com/opinion/kenny-schacter-on-art-basel-2018-1305194.

17. Eileen Kinsella, "Cheim and Read, Storied New York Gallery, Will Close Its Chelsea Space after 21 Years and Transition to 'Private Practice,'" *Artnet News*, June 28, 2018, https://news.artnet.com/market/cheim-read-quits-chelsea-private-upper-east-side-space-21-years-1311122.

18. Gavin Brown, interview by Tom Eccles.

BIBLIOGRAPHY

The bibliography does not include any conversation, interviews, letters, periodicals, journals, online sources or other nonbook sources. That material is specifically referenced in individual chapter endnotes.

Adam, Georgina. *Big Bucks: The Explosion of the Art Market in the 21st Century.* London: Lund Humphries, 2014.

Adam, Georgina. *Dark Side of the Boom: The Excesses of the Art Market in the 21st Century.* London: Lund Humphries, 2017.

Albers, Patricia. *Joan Mitchell: Lady Painter.* New York: Knopf, 2011.

Ashton, Dore. "Artists and Dealers." In *A History of the Western Art Market: A Sourcebook of Writings on Artists, Dealers, and Markets.* Edited by Titia Hulst, 317–319. Oakland: University of California Press, 2017.

Bianco, Christine. "Selling American Art: Celebrity and Success in the Postwar New York Art Market." MA thesis, University of Florida, 2000.

Bockris, Victor. *The Life and Death of Andy Warhol.* New York: Bantam, 1989.

Breslin, James E. B. *Mark Rothko: A Biography.* Chicago: University of Chicago Press, 1993.

Burnham, Sophy. *The Art Crowd.* New York: D. McKay Co., 1973.

Cage, John. *Silence.* Middletown, CT: Wesleyan University Press, 1967.

Cameron, Dan. *East Village USA.* New York: New Museum of Contemporary Art, 2004.

Chave, Anna C. "Revaluing Minimalism." In *A History of the Western Art Market: A Sourcebook of Writings on Artists, Dealers, and Markets.* Edited by Titia Hulst, 338. Oakland: University of California Press, 2017.

Cohen-Solal, Annie. *Leo and His Circle: The Life of Leo Castelli.* New York: Knopf, 2010.

Collischan, Judy. *Women Shaping Art: Profiles of Power.* New York: Praeger, 1984.

Cottington, David. *Modern Art: A Very Short Introduction.* Oxford: Oxford University Press, 2005.

Davidson, Susan, and Philip Rylands, eds. *Peggy Guggenheim & Frederick Kiesler: The Story of Art of This Century*. New York: Guggenheim Museum, 2004.

Dearborn, Mary V. *Ernest Hemingway: A Biography*. New York: Knopf, 2017.

De Coppet, Laura, and Alan Jones. *The Art Dealers*. New York: Cooper Square Press, 2002.

De Domizio Durini, Lucrezia. *The Felt Hat: Joseph Beuys, a Life Told*. Milan: Charta, 1997.

Doss, Erika. *American Art of the 20th–21st Centuries*. New York: Oxford University Press, 2017.

Elderfield, John. *De Kooning: A Retrospective*. New York: Museum of Modern Art, 2012.

Fairbrother, Trevor J., and Bagley Wright. *The Virginia and Bagley Wright Collection*. Seattle: Seattle Art Museum, 1999.

Farrell, Jennifer, Diana Bush, Serge Guilbaut, Agnes Berecz, Rebecca Schoenthal, and Barbara L. Michaels. *The History and Legacy of Samuel M. Kootz and the Kootz Gallery*. Charlottesville: Fralin Museum of Art at the University of Virginia, 2017.

Farrell, Jennifer, ed. *Get There First, Decide Promptly: The Richard Brown Baker Collection of Postwar Art*. New Haven, CT: Yale University Art Gallery, 2011.

Fendley, Alison. *Saatchi and Saatchi: The Inside Story*. New York: Arcade, 1996.

Fensterstock, Ann. *Art on the Block: Tracking the New York Art World from Soho to the Bowery, Bushwick and Beyond*. New York: Palgrave Macmillan, 2013.

Findlay, Michael. *The Value of Art: Money, Power, Beauty*. Munich: Prestel, 2012.

Fraser-Cavassoni, Natasha. *After Andy: Adventures in Warhol Land*. New York: Blue Rider Press, 2017.

Fretz, Eric. *Jean-Michel Basquiat: A Biography*. Santa Barbara, CA: Greenwood, 2010.

Friedman, B. H. *Jackson Pollock: Energy Made Visible*. New York: McGraw-Hill, 1972.

Glimcher, Arne. *Agnes Martin: Paintings, Writings, Remembrances*. London: Phaidon Press, 2012.

Glimcher, Mildred, and Arnold B. Glimcher. *Adventures in Art: 40 Years At Pace*. Milan: Leonardo International, 2001.

Gnyp, Marta. *The Shift: Art and the Rise to Power of Contemporary Collectors*. Stockholm: Art and Theory Publishing, 2015.

Goldman, Kevin. *Conflicting Accounts: The Creation and Crash of the Saatchi & Saatchi Advertising Empire*. New York: Simon & Schuster, 1997.

Goldstein, Ann, and Diedrich Diederichsen. *A Minimal Future?: Art as Object 1958–1968*. Los Angeles: Museum of Contemporary Art, 2004.

Goldstein, Malcolm. *Landscape with Figures: A History of Art Dealing in the United States*. Oxford: Oxford University Press, 2000.

Graw, Isabelle. *High Price: Art Between the Market and Celebrity Culture*. Berlin: Sternberg Press, 2009.

Greenfield-Sanders, Timothy. *Art World*. New York: Fotofolio, 1999.

Gudis, Catherine, Mary Jane Jacob, and Ann Goldstein. *A Forest of Signs: Art in the Crisis of Representation*. Cambridge, MA: MIT Press, 1989.

Hackforth-Jones, Jos, and Iain Robertson, eds. *Art Business Today: 20 Key Topics*. London: Lund Humphries, 2016.

Haden-Guest, Anthony. *True Colors: The Real Life of the Art World*. New York: Atlantic Monthly Press, 1996.

Hall, Lee. *Betty Parsons: Artist, Dealer, Collector*. New York: H. N. Abrams, 1991.

Hatton, Rita, and John A. Walker. *Supercollector: A Critique of Charles Saatchi*. London: Ellipsis, 2000.

Herskovic, Marika. *New York School Abstract Expressionists: Artists Choice by Artists, a Complete Documentation of the New York Painting and Sculpture Annuals, 1951–1957*. Franklin Lakes, NJ: New York School Press, 2000.

Herstatt, Claudia. *Women Gallerists in the 20th and 21st Centuries*. Ostfildern, Germany: Hatje Cantz, 2008.

Hess, Barbara, and Willem de Kooning. *Willem de Kooning, 1904–1997: Content as a Glimpse*. Cologne: Taschen, 2004.

Hoban, Phoebe. *Basquiat: A Quick Killing in Art*. New York: Viking, 1998.

Hoban, Phoebe. *Lucian Freud: Eyes Wide Open*. Boston: New Harvest, 2014.

Hook, Philip. *Rogues' Gallery: The Rise (and Occasional Fall) of Art Dealers, the Hidden Players in the History of Art*. New York: Experiment, 2017.

Hoptman, Laura J. *The Forever Now: Contemporary Painting in an Atemporal World*. New York: Museum of Modern Art, 2014.

Horowitz, Noah. *Art of the Deal: Contemporary Art in a Global Financial Market*. Princeton, NJ: Princeton University Press, 2014.

Housley, Kathleen. L. *Emily Hall Tremaine: Collector on the Cusp*. Meriden, CT: Emily Hall Tremaine Foundation, 2001.

Hulst, Titia. *A History of the Western Art Market: A Sourcebook of Writings on Artists, Dealers, and Markets*. Oakland: University of California Press, 2017.

Hulst, Titia. "The Right Man at the Right Time: Leo Castelli and the American Market for Avant-Garde Art." PhD diss., New York University, 2014.

Ikegami, Hiroko. *The Great Migrator: Robert Rauschenberg and the Global Rise of American Art*. Cambridge, MA: MIT Press, 2010.

Jetzer, Gianni, Robert Nickas, and Leah Pires. *Brand New: Art & Commodity in the 1980s*. Washington, DC: Hirshhorn Museum and Sculpture Garden, 2018.

Judd, Donald. "Specific Objects." In *Donald Judd: Early Work, 1955–1968*, edited by Thomas Kellein. New York: D.A.P., 2002.

Kostelanetz, Richard. *Artists' SoHo: 49 Episodes of Intimate History*. New York: Empire State Editions, 2015.

Lind, Maria, and Olav Velthuis. *Contemporary Art and Its Commercial Markets: A Report on Current Conditions and Future Scenarios*. Berlin: Sternberg Press, 2012.

Lindemann, Adam. *Collecting Contemporary*. Cologne: Taschen, 2006.

Mamoli Zorzi, Rosella. *Before Peggy Guggenheim: American Women Art Collectors*. Venice: Marsilio, 2001.

Mason, Christopher. *The Art of the Steal: Inside the Sotheby's-Christie's Auction House Scandal*. New York: G. P. Putnam's Sons, 2004.

McAndrew, Clare. *The Art Economy: An Investor's Guide to the Art Market*. Dublin: Liffey Press, 2007.

McAndrew, Clare. *The Art Market 2018*. Basel, Switzerland: Art Basel and UBS, 2018.

McAndrew, Clare. *Fine Art and High Finance: Expert Advice on the Economics of Ownership*. New York: Bloomberg Press, 2010.

McAndrew, Clare. *The Global Art Market in 2010: Crisis and Recovery*. Helvoirt, Netherlands: European Fine Art Foundation, 2011.

McAndrew, Clare. *The Global Art Market, with a Focus on China and Brazil*. Helvoirt, Netherlands: European Fine Art Foundation, 2013.

McAndrew, Clare. *Globalisation and the Art Market: Emerging Economies and the Art Trade in 2008*. Helvoirt, Netherlands: European Fine Art Foundation, 2009.

McAndrew, Clare. *The International Art Market 2007–2009: Trends in the Art Trade During Global Recession*. Helvoirt, Netherlands: European Fine Art Foundation, 2010.

McAndrew, Clare. *The International Art Market in 2011: Observations on the Art Trade over 25 Years*. Helvoirt, Netherlands: European Fine Art Foundation, 2012.

McAndrew, Clare. *TEFAF Art Market Report 2014: The Global Art Market, with a Focus on the US and China*. Helvoirt, Netherlands: European Fine Art Foundation, 2014.

Mesch, Claudia, and Viola Maria Michely. *Joseph Beuys: The Reader*. Cambridge, MA: MIT Press, 2007.

Meyer, James. *Los Angeles to New York: Dwan Gallery, 1959–1971*. Washington, DC: National Gallery of Art, 2016.

Naifeh, Steven, and Gregory White Smith. *Jackson Pollock: An American Saga*. New York: C. N. Potter, 1989.

Pagel, David. *Unfinished Business: Paintings from the 1970s and 1980s by Ross Bleckner, Eric Fischl and David Salle*. Munich: Prestel, 2016.

Perl, Jed. *New Art City*. New York: Knopf, 2005.

Pooke, Grant. *Contemporary British Art: An Introduction*. London: Routledge, 2011.

Rachleff, Melissa, Lynn Gumpert, Billy Klüver, and Julie Martin. *Inventing Downtown: Artist-Run Galleries in New York City, 1952–1965*. New York: Grey Art Gallery, 2017.

Rosati, Lauren, and Mary Anne Staniszewski. *Alternative Histories: New York Art Spaces, 1960 to 2010*. Cambridge, MA: MIT Press, 2012.

Rosenberg, Harold. *Barnett Newman*. New York: Abrams, 1978.

Rublowsky, John, and Ken Heyman. *Pop Art*. New York: Basic Books, 1965.

Saatchi, Charles Nathan. *My Name Is Charles Saatchi and I Am an Artoholic: Answers to Questions from Journalists and Readers*. London: Booth-Clibborn Editions, 2012.

Sanders, Joel. *Stud: Architectures of Masculinity*. New York: Princeton Architectural Press, 1996.

Sandler, Irving. *Abstract Expressionism and the American Experience: A Reevaluation.* Lenox, MA: Hard Press Editions, 2009.

Sandler, Irving. *Abstract Expressionism: The Triumph of American Painting.* London: Pall Mall, 1970.

Sandler, Irving. *American Art of the 1960s.* New York: Harper & Row, 1988.

Schimmel, Paul, Catherine Gudis, Norman M. Klein, and Lane Relyea. *Helter Skelter: L.A. Art in the 1990s.* Los Angeles: Museum of Contemporary Art, 1992.

Schneider, Tim. *The Great Reframing: How Technology Will—and Won't—Change the Gallery System Forever.* Self-published, Amazon Digital Services, 2017. Kindle.

Schwartz, Eugene M. *Confessions of a Poor Collector: How to Build a Worthwhile Collection with the Least Possible Money.* New York: New York Cultural Center in association with Fairleigh Dickinson University, 1970.

Sidney Janis Gallery. *Sidney Janis Presents an Exhibition of Factual Paintings & Sculpture from France, England, Italy, Sweden and the United States: By the Artists Agostini, Arman, Baj…Under the Title of the New Realists.* New York: Sidney Janis Gallery, 1962.

Sidney Janis Gallery. *25 Years of Janis.* New York: Sidney Janis Gallery, 1973.

Smee, Sebastian. *The Art of Rivalry: Four Friendships, Betrayals, and Breakthroughs in Modern Art.* New York: Random House, 2016.

Solomon, Deborah. *Jackson Pollock: A Biography.* New York: Simon & Schuster, 1987.

Sotheby Parke Bernet. *A Selection of Fifty Works from the Collection of Robert C. Scull.* Published in conjunction with the exhibition and auction of the same title, held at the New York Galleries of Sotheby Parke Bernet, October 18, 1973.

Stein, Judith E. *Eye of the Sixties: Richard Bellamy and the Transformation of Modern Art.* New York: Farrar, Straus and Giroux, 2016.

Steinberg, Leo. *The New York School: Second Generation.* Published in conjunction with the exhibition of the same title, organized by and presented at the Jewish Museum, New York, March 10–April 28, 1957.

Stevens, Mark, and Annalyn Swan. *De Kooning: An American Master.* New York: Knopf, 2004.

Storr, Robert. "A Man About Town." In *Get There First, Decide Promptly: The Richard Brown Baker Collection of Postwar Art,* edited by Jennifer Farrell. New Haven, CT: Yale University Art Gallery, 2011.

Stupples, Peter, ed. *Art and Money.* Newcastle upon Tyne, UK: Cambridge Scholars Publishing, 2015.

Temkin, Ann. *Barnett Newman.* Philadelphia: Philadelphia Museum of Art, 2002.

Temkin, Ann, and Claire Lehmann. *Ileana Sonnabend: Ambassador for the New.* New York: Museum of Modern Art, 2013.

Thompson, Don. *The Supermodel and the Brillo Box: Back Stories and Peculiar Economics from the World of Contemporary Art.* New York: Palgrave Macmillan, 2014.

Thompson, Don. *The Orange Balloon Dog: Bubbles, Turmoil and Avarice in the Contemporary Art Market.* Vancouver: Douglas & McIntyre, 2017.

Thompson, Don. *The $12 Million Stuffed Shark: The Curious Economics of Contemporary Art*. New York: Palgrave Macmillan, 2008.

Thornton, Sarah. *Seven Days in the Art World*. New York: W. W. Norton, 2008.

Tomkins, Calvin. *Lives of the Artists: Portraits of Ten Artists Whose Work and Lifestyles Embody the Future of Contemporary Art*. New York: Henry Holt, 2008.

Tomkins, Calvin. *Off the Wall: A Portrait of Robert Rauschenberg*. New York: Picador, 2005.

Velthuis, Olav. *Talking Prices: Symbolic Meanings of Prices on the Market for Contemporary Art*. Princeton, NJ: Princeton University Press, 2007.

Velthuis, Olav, and Stefano Baia Curioni. *Cosmopolitan Canvases: The Globalization of Markets for Contemporary Art*. Oxford: Oxford University Press, 2015.

Wagner, Ethan, and Thea Westreich Wagner. *Collecting Art for Love, Money and More*. London: Phaidon Press, 2013.

Wool, Christopher, and Marga Paz. *Christopher Wool*. Valencia: IVAM, 2006.

Würtenberger, Loretta, and Karl von Trott. *The Artist's Estate: A Handbook for Artists, Executors, and Heirs*. Ostfildern, Germany: Hatje Cantz, 2016.

Zinsser, William K. *Pop Goes America*. New York: Harper & Row, 1966.

Holden Steinberg

MICHAEL SHNAYERSON is a longtime contributing editor to *Vanity Fair* and the author of six other narrative histories and biographies on a wide range of subjects. His first was a biography of writer Irwin Shaw (1989), followed by *The Car That Could: The Inside Story of GM's Revolutionary Electric Vehicle* (1996), *The Killers Within: The Deadly Rise of Drug-Resistant Bacteria* (2002), and *Coal River* (2008), about mountaintop coal removal in Appalachia. With Harry Belafonte, he wrote the entertainer and activist's autobiography (2011), and most recently published *The Contender*, an unauthorized biography of New York governor Andrew Cuomo (2015). He is married to Gayfryd Steinberg and divides his time between New York and Sag Harbor.

PublicAffairs is a publishing house founded in 1997. It is a tribute to the standards, values, and flair of three persons who have served as mentors to countless reporters, writers, editors, and book people of all kinds, including me.

I. F. Stone, proprietor of *I. F. Stone's Weekly*, combined a commitment to the First Amendment with entrepreneurial zeal and reporting skill and became one of the great independent journalists in American history. At the age of eighty, Izzy published *The Trial of Socrates*, which was a national bestseller. He wrote the book after he taught himself ancient Greek.

Benjamin C. Bradlee was for nearly thirty years the charismatic editorial leader of *The Washington Post*. It was Ben who gave the *Post* the range and courage to pursue such historic issues as Watergate. He supported his reporters with a tenacity that made them fearless and it is no accident that so many became authors of influential, best-selling books.

Robert L. Bernstein, the chief executive of Random House for more than a quarter century, guided one of the nation's premier publishing houses. Bob was personally responsible for many books of political dissent and argument that challenged tyranny around the globe. He is also the founder and longtime chair of Human Rights Watch, one of the most respected human rights organizations in the world.

· · ·

For fifty years, the banner of Public Affairs Press was carried by its owner Morris B. Schnapper, who published Gandhi, Nasser, Toynbee, Truman, and about 1,500 other authors. In 1983, Schnapper was described by *The Washington Post* as "a redoubtable gadfly." His legacy will endure in the books to come.

Peter Osnos, *Founder*